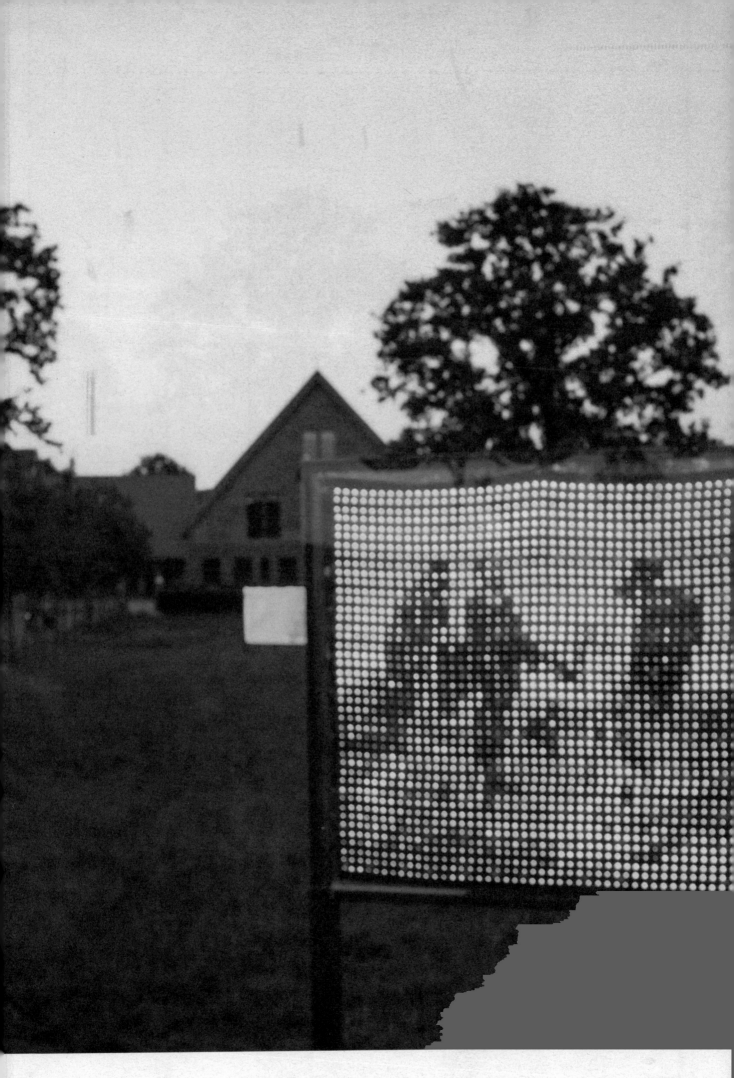

Ei Arakawa

→ 127

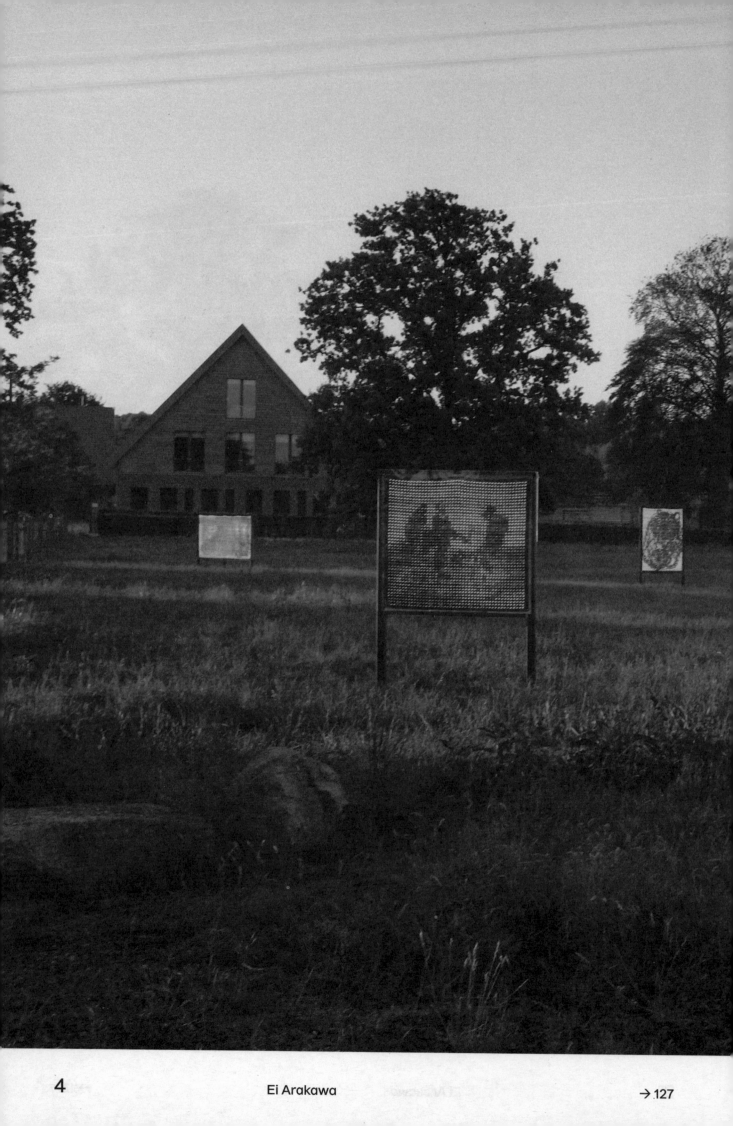

→ 127

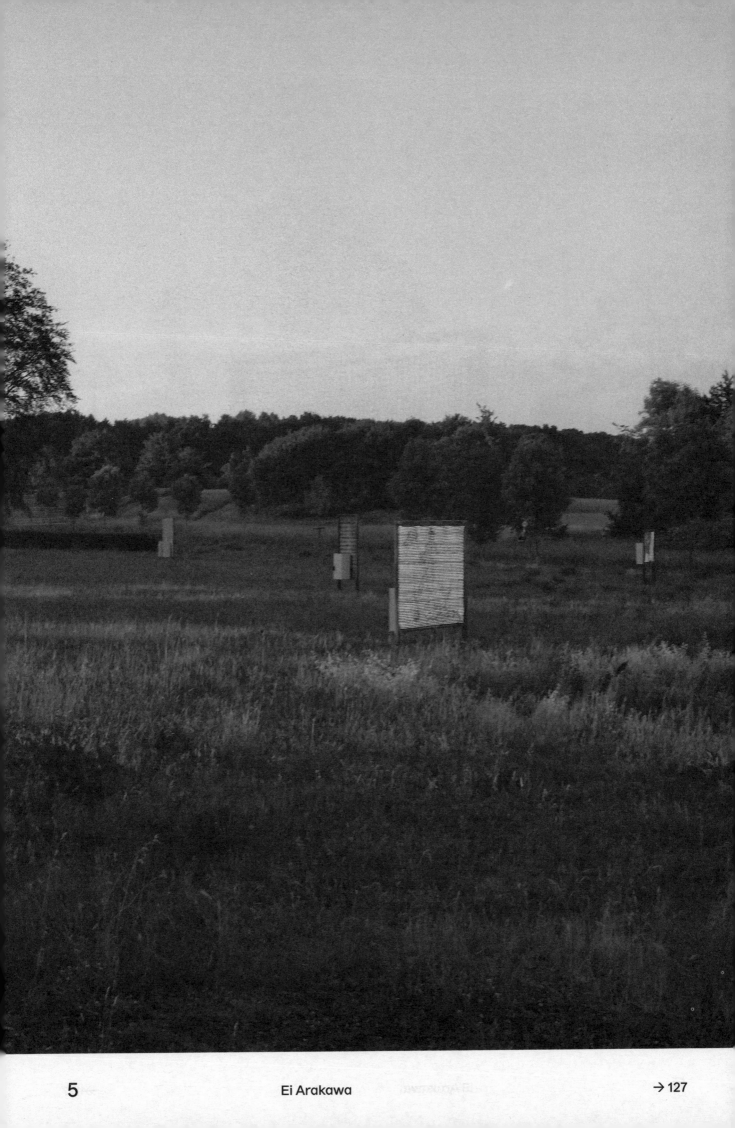

Ei Arakawa

→ 127

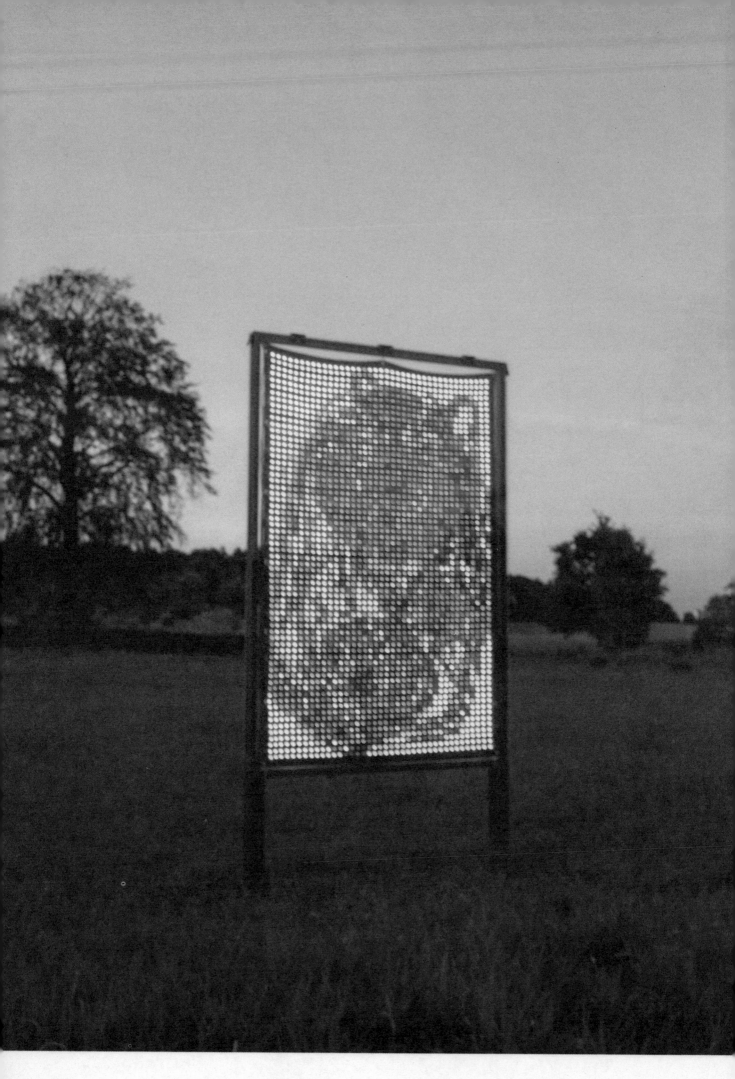

Ei Arakawa

→ 127

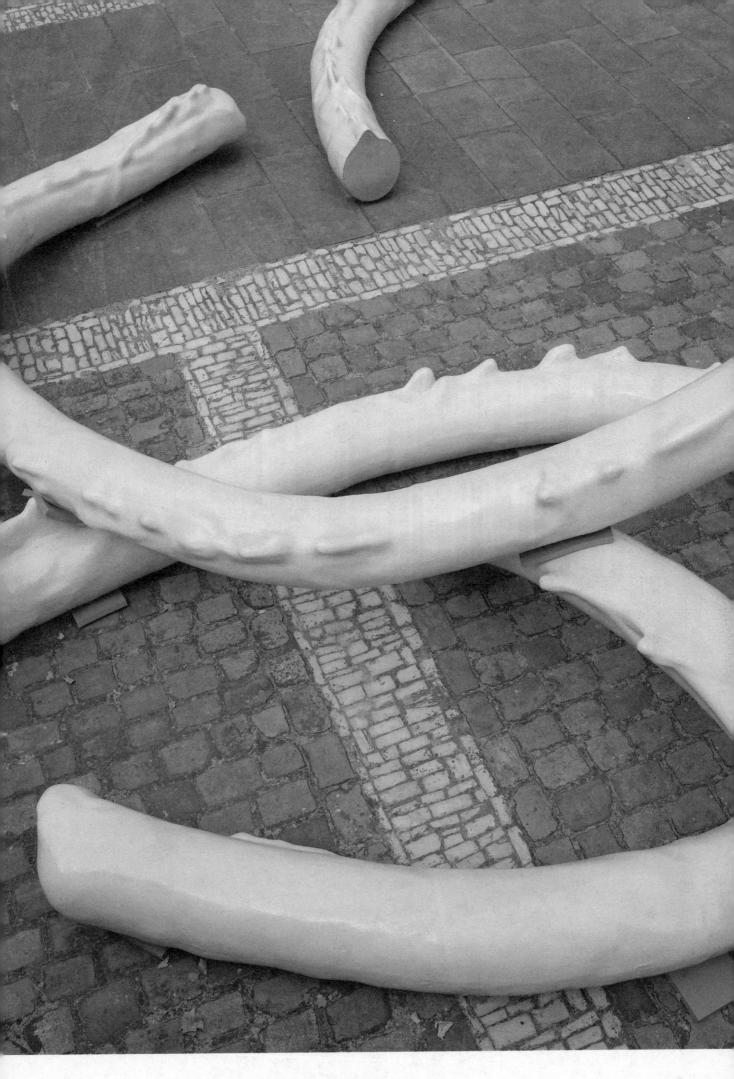

Nairy Baghramian

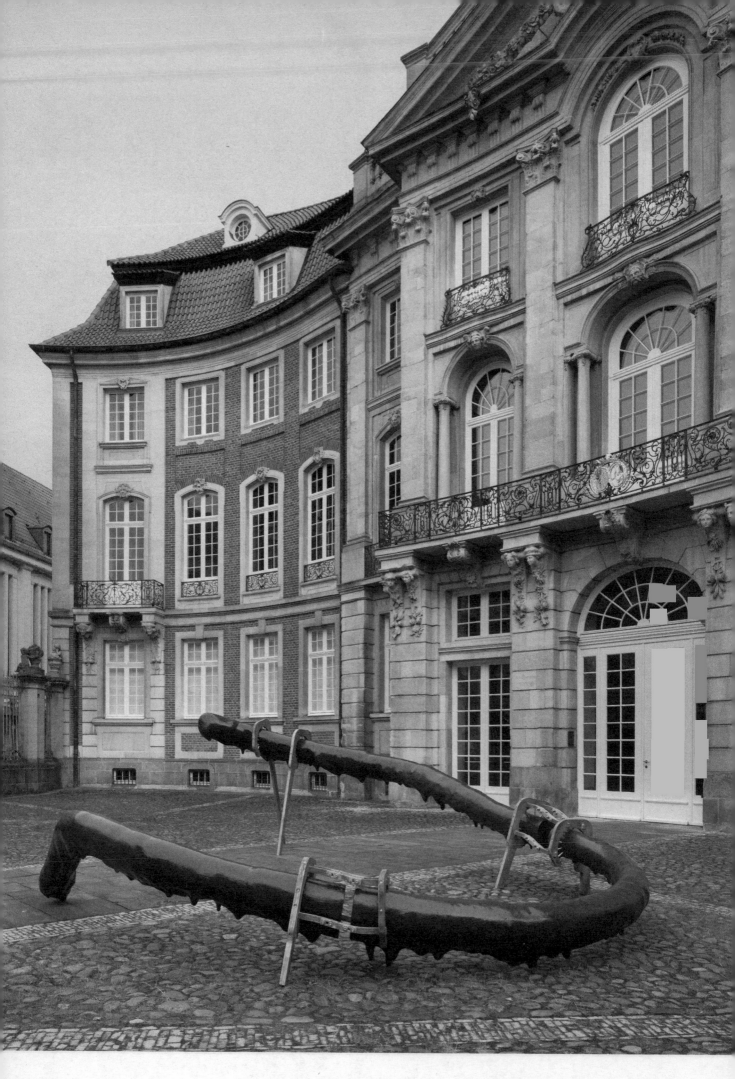

Nairy Baghramian

→ 133

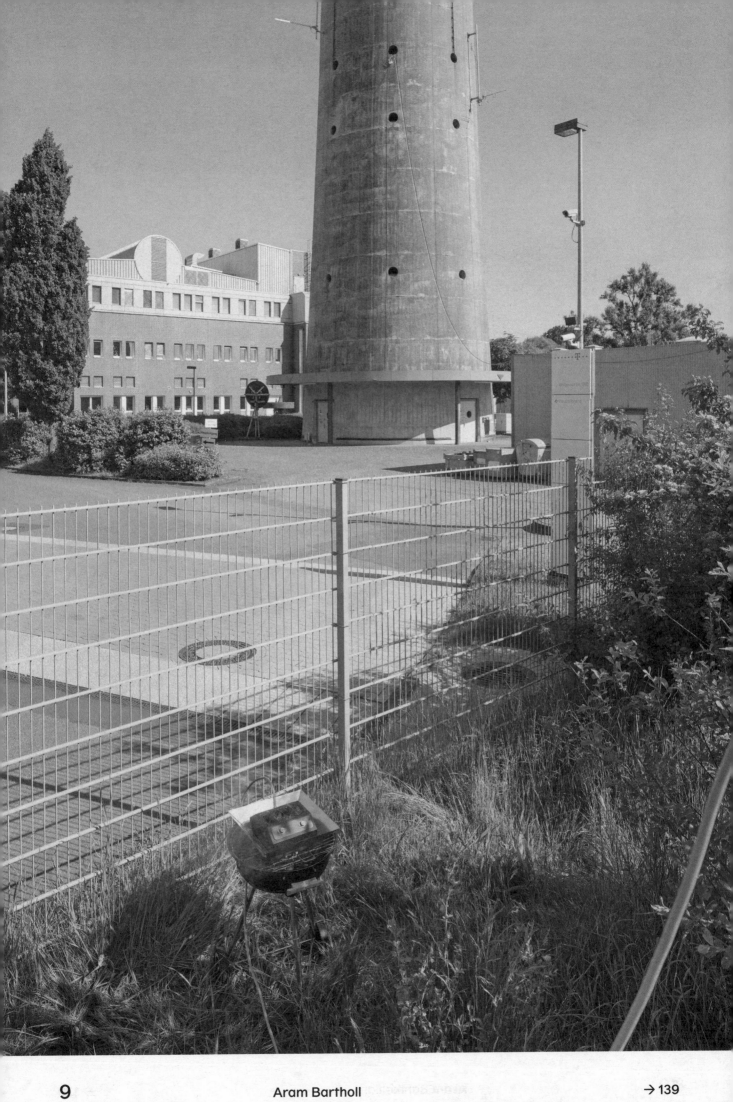

Aram Bartholl → 139

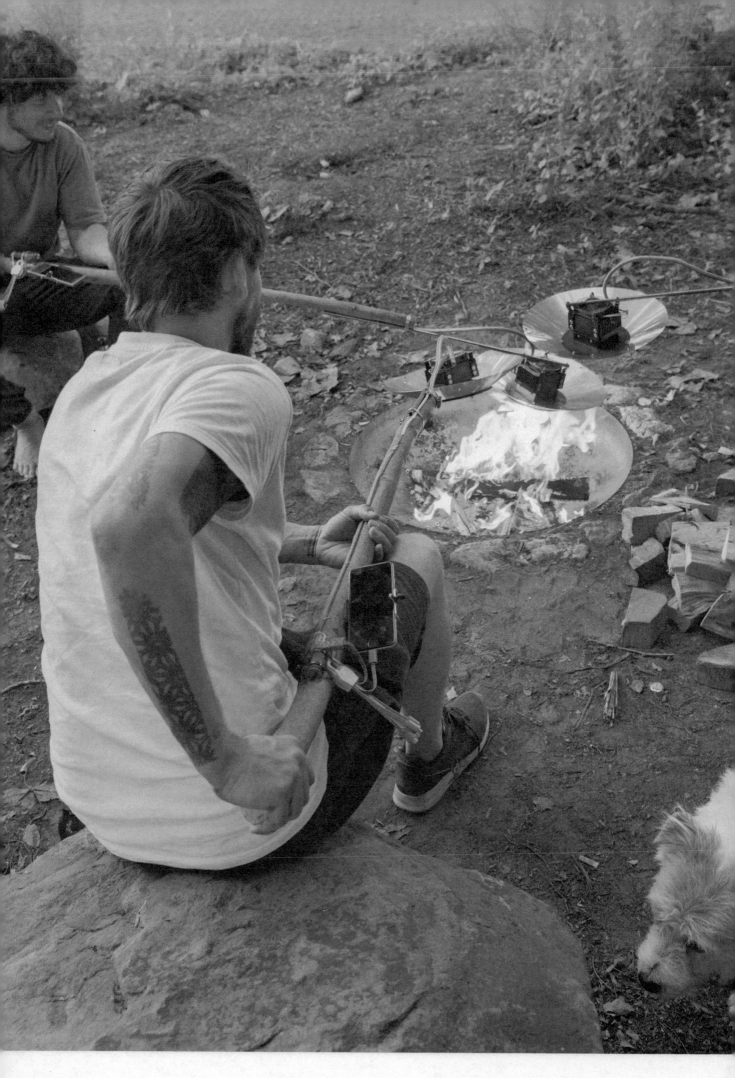

Aram Bartholl

→ 139

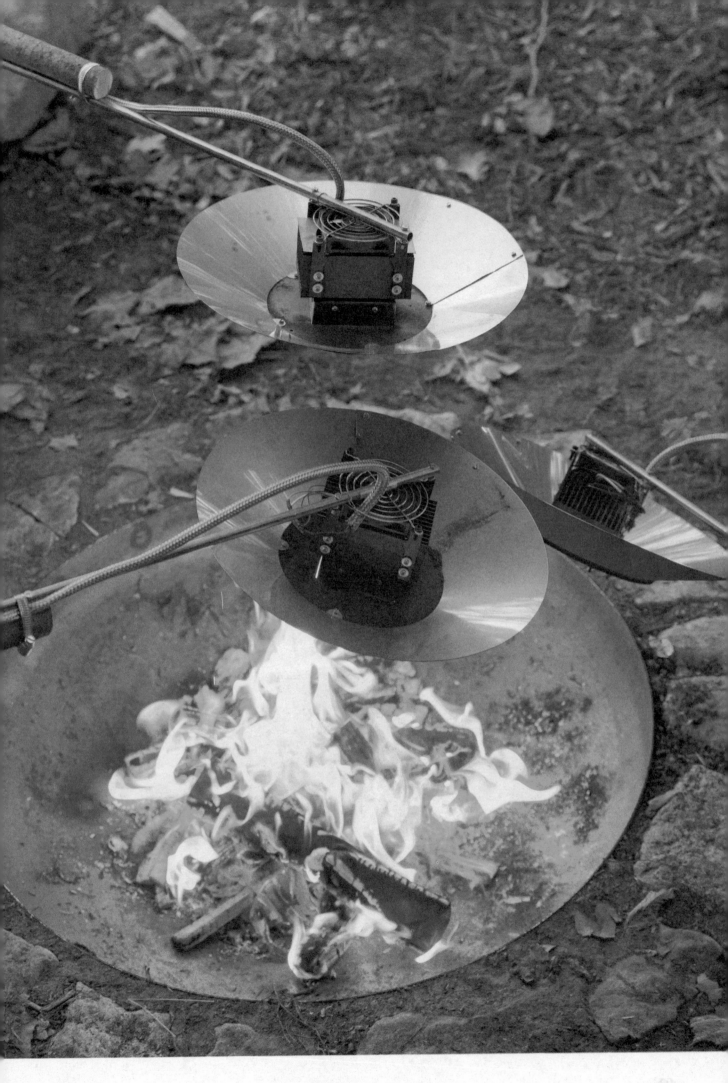

Aram Bartholl

→ 139

Cosima von Bonin / Tom Burr → 145

Cosima von Bonin / Tom Burr → 145

Andreas Bunte

→ 149

Andreas Bunte

→ 149

Gerard Byrne → 155

Gerard Byrne → 155

Gerard Byrne → 155

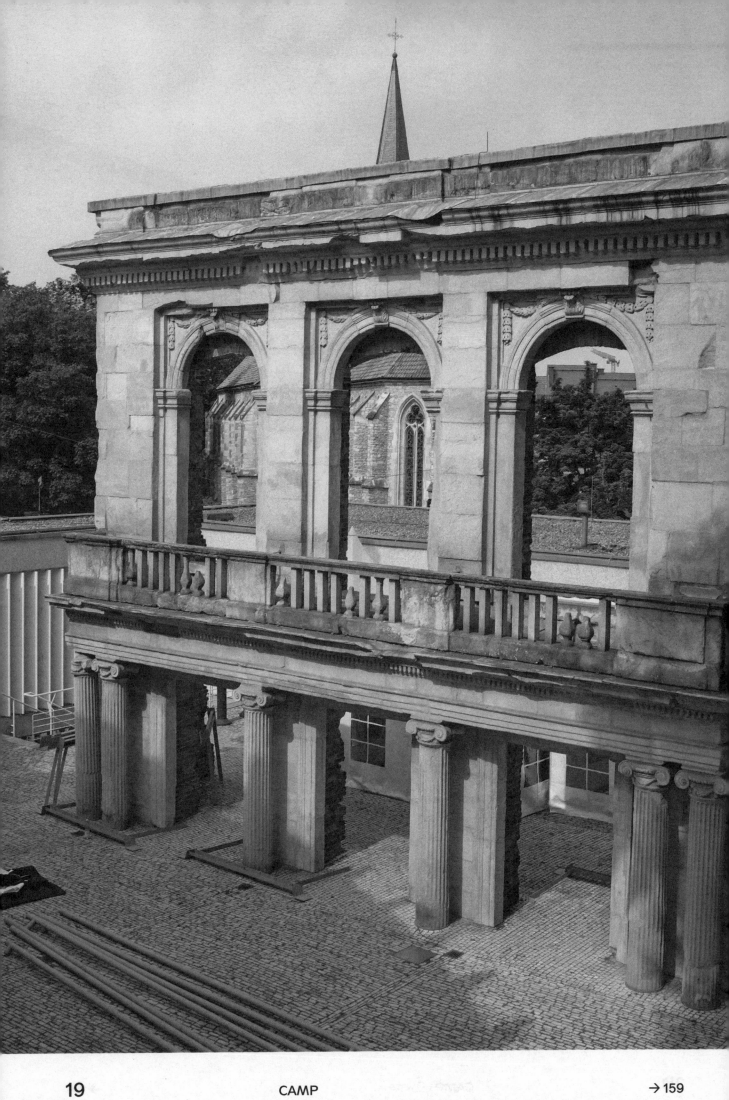

→ 159

CAMP

→ 159

Michael Dean

→ 165

Michael Dean → 165

Jeremy Deller

→ 169

Jeremy Deller

→ 169

Jeremy Deller

→ 169

Jeremy Deller

→ 169

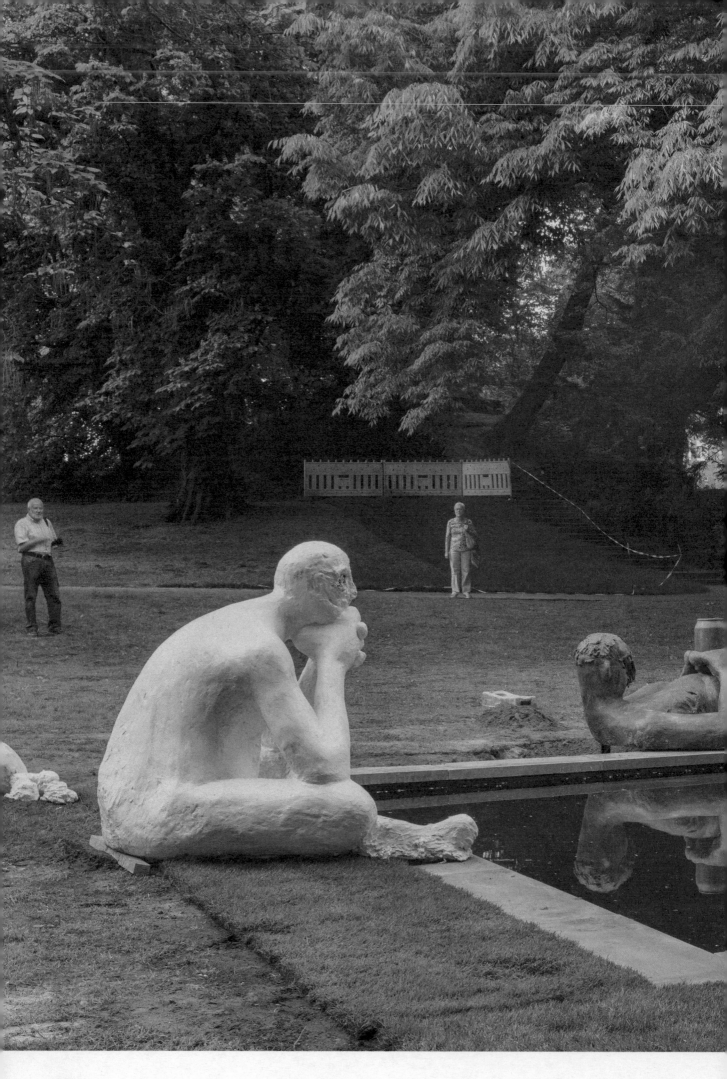

Nicole Eisenman

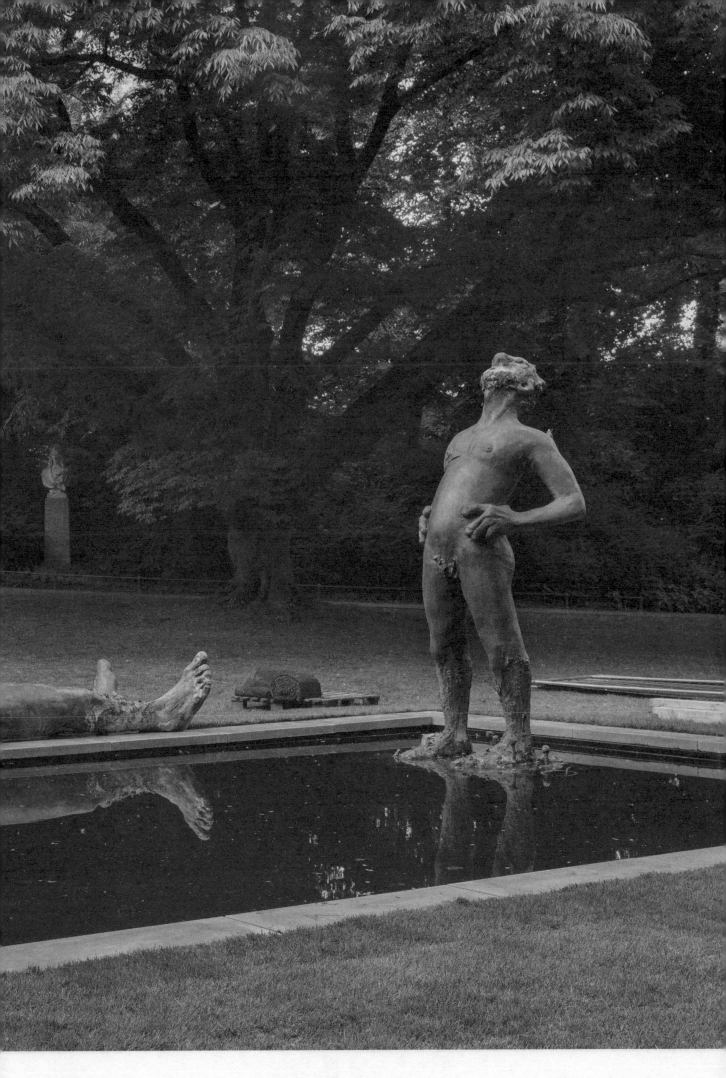

Nicole Eisenman

→ 175

Nicole Eisenman

→ 175

Ayşe Erkmen → 181

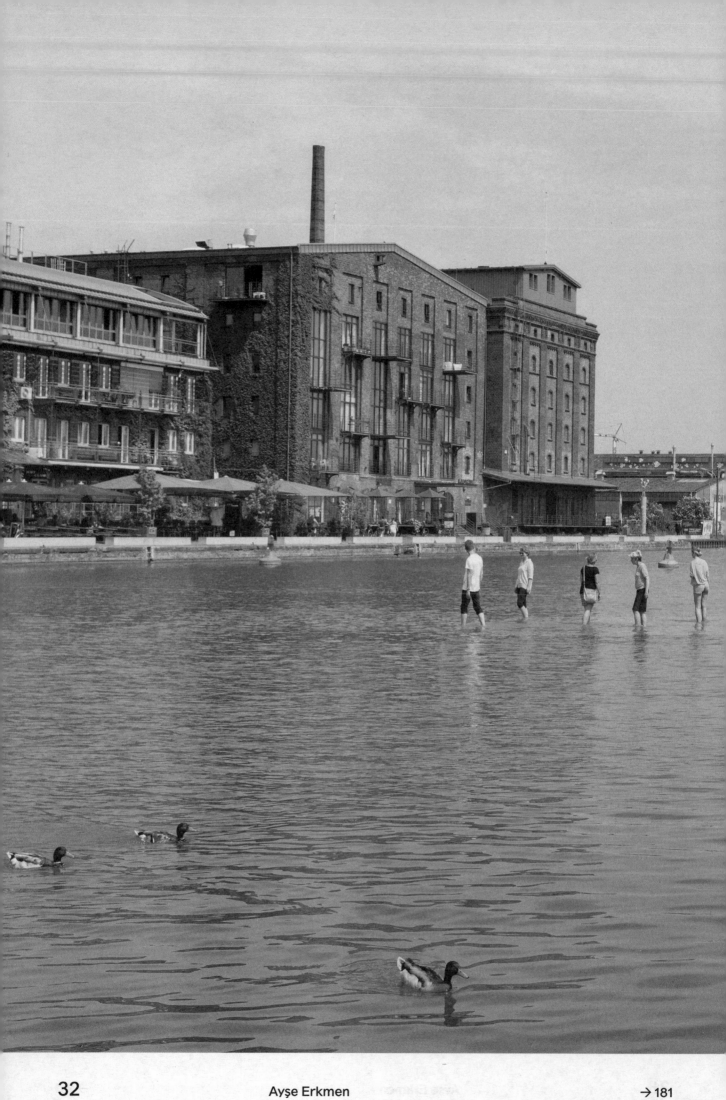

Ayşe Erkmen → 181

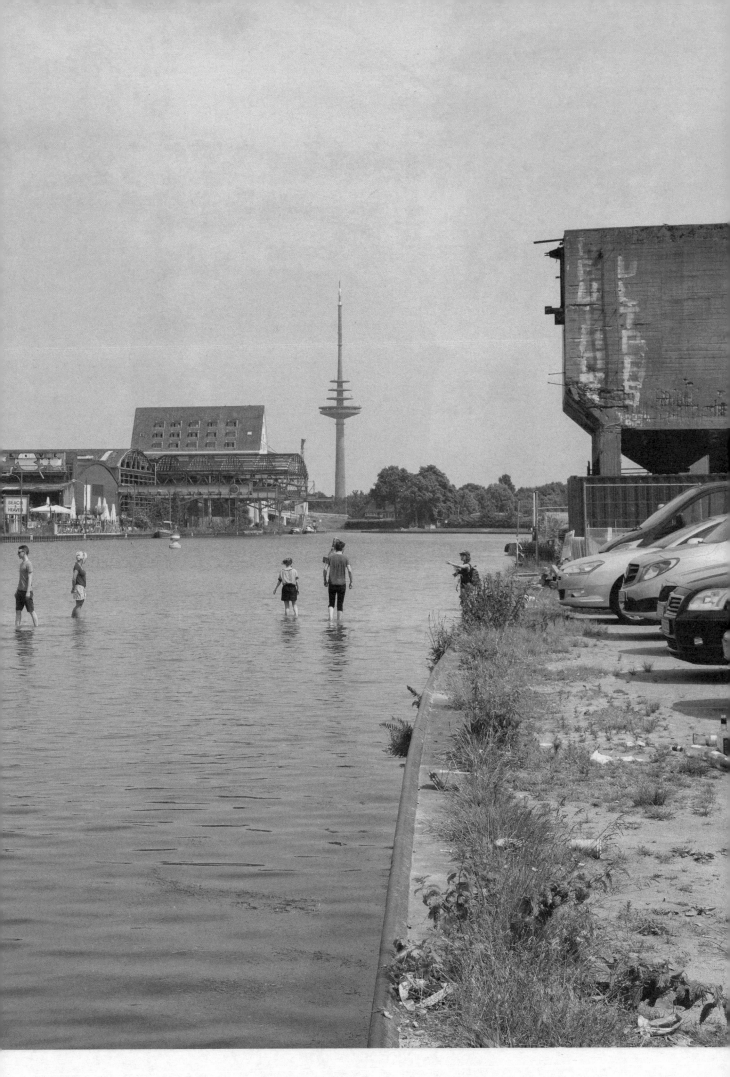

Ayşe Erkmen → 181

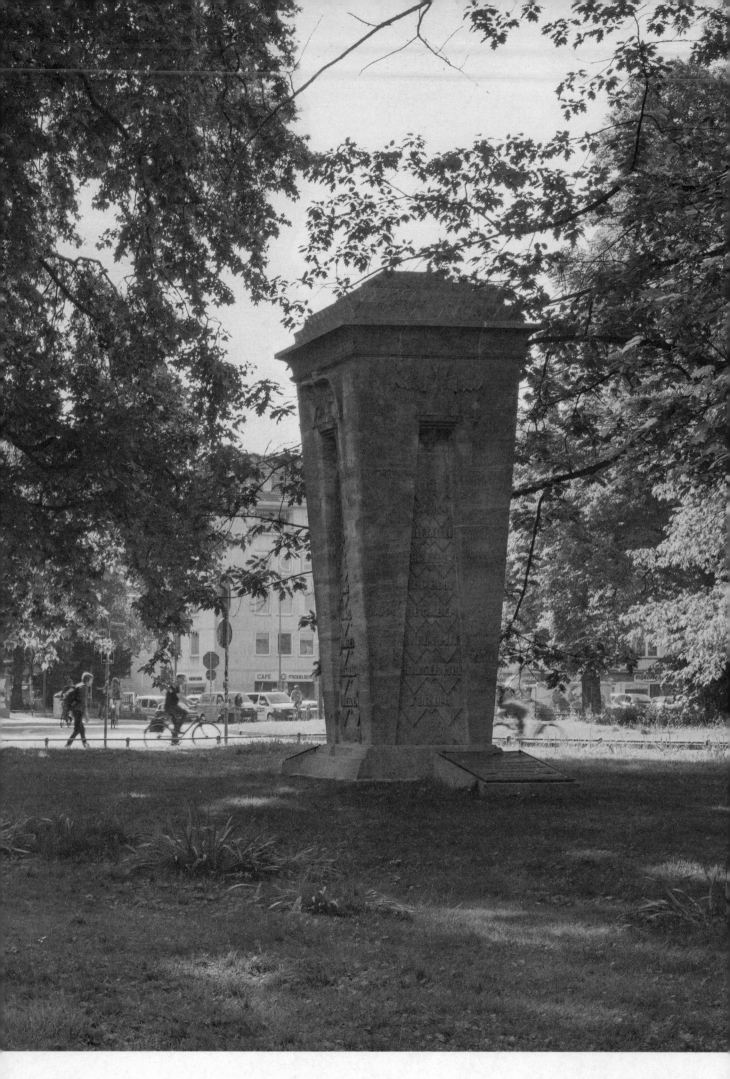

Lara Favaretto → 187

Lara Favaretto → 187

Hreinn Friðfinnsson → 195

Hreinn Friðfinnsson → 195

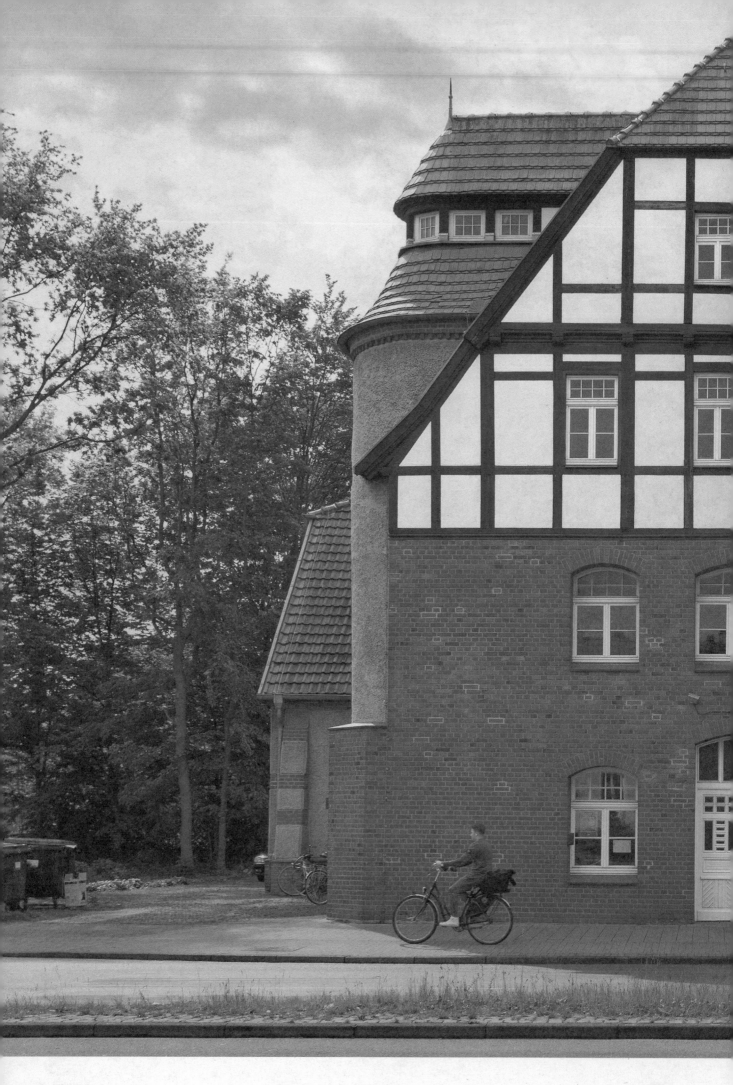

Gintersdorfer / Klaßen

→ 201

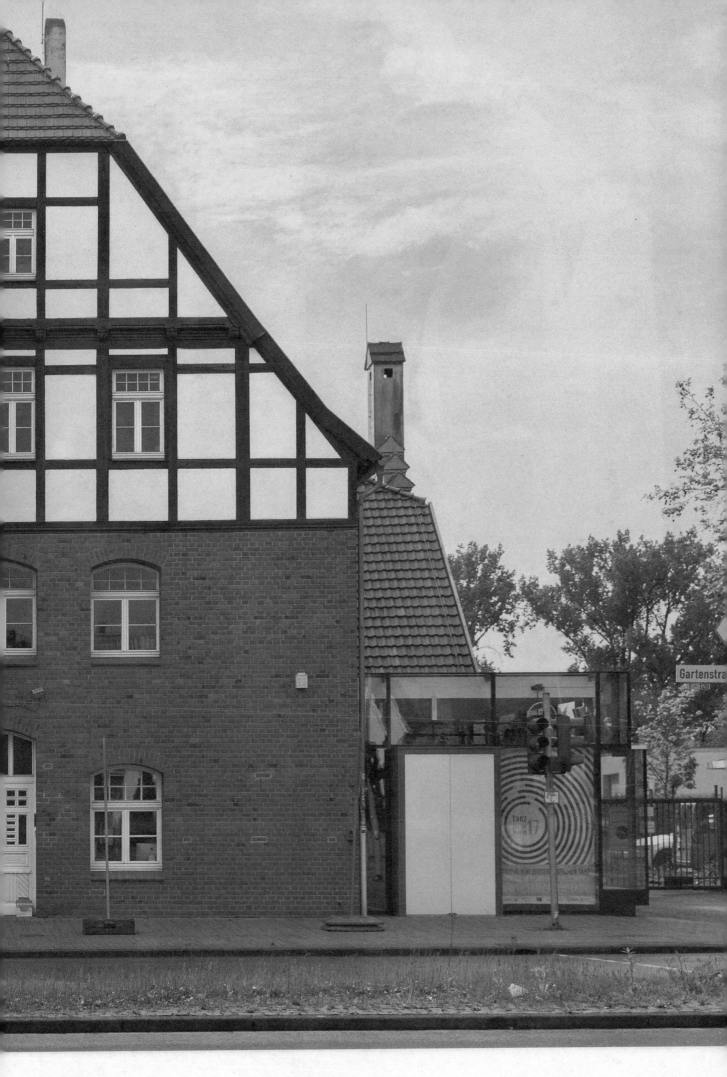

Gintersdorfer / Klaßen

→ 201

Gintersdorfer / Klaßen

→ 201

Pierre Huyghe → 209

Pierre Huyghe → 209

Pierre Huyghe

→ 209

John Knight

→ 215

Justin Matherly

→ 221

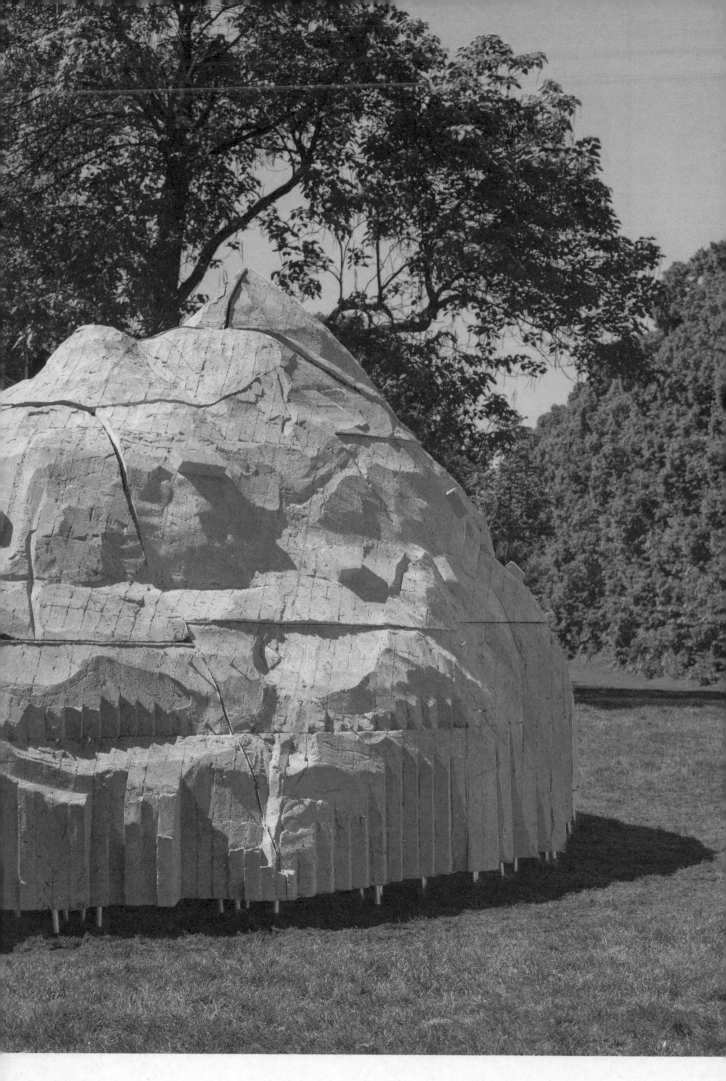

Justin Matherly → 221

Christian Odzuck → 227

Christian Odzuck

→ 227

Christian Odzuck → 227

Emeka Ogboh

→ 233

Emeka Ogboh → 233

Emeka Ogboh

→ 233

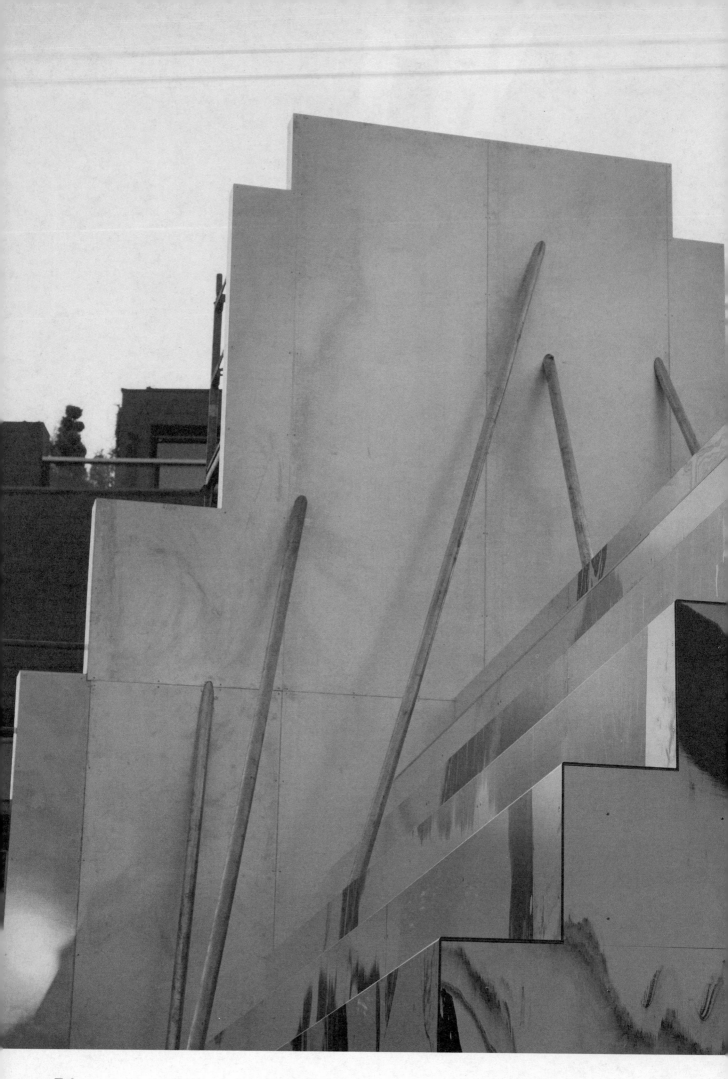

Peles Empire → 237

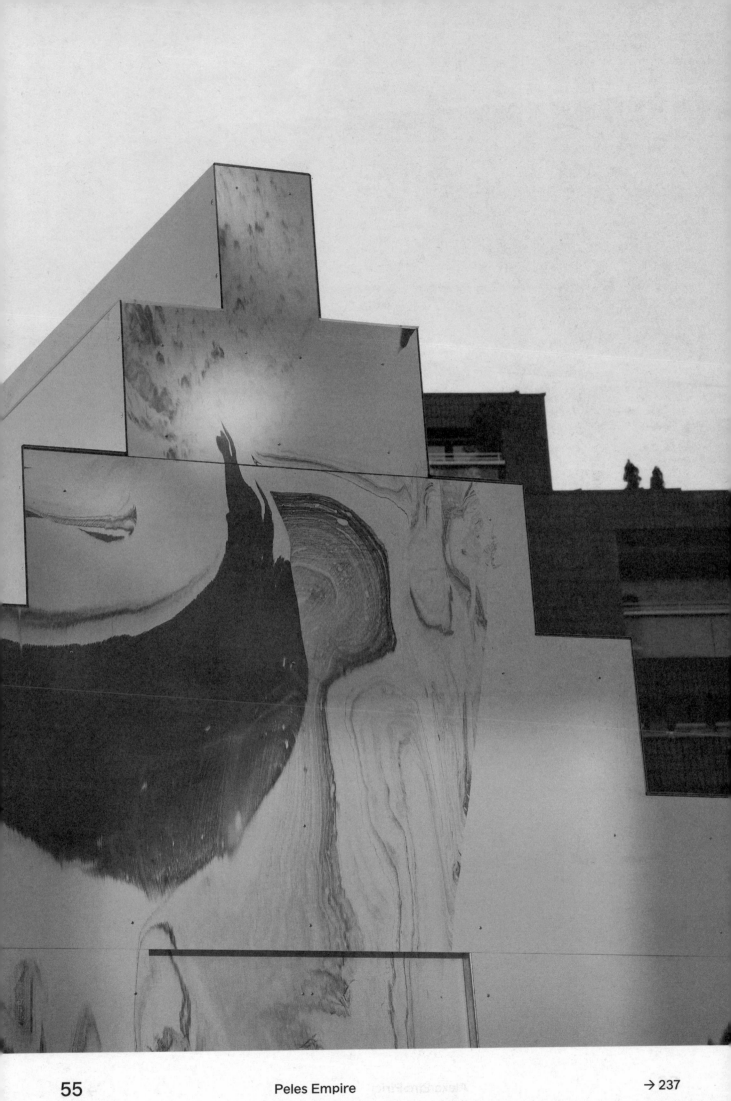

Peles Empire

→ 237

Alexandra Pirici

→ 243

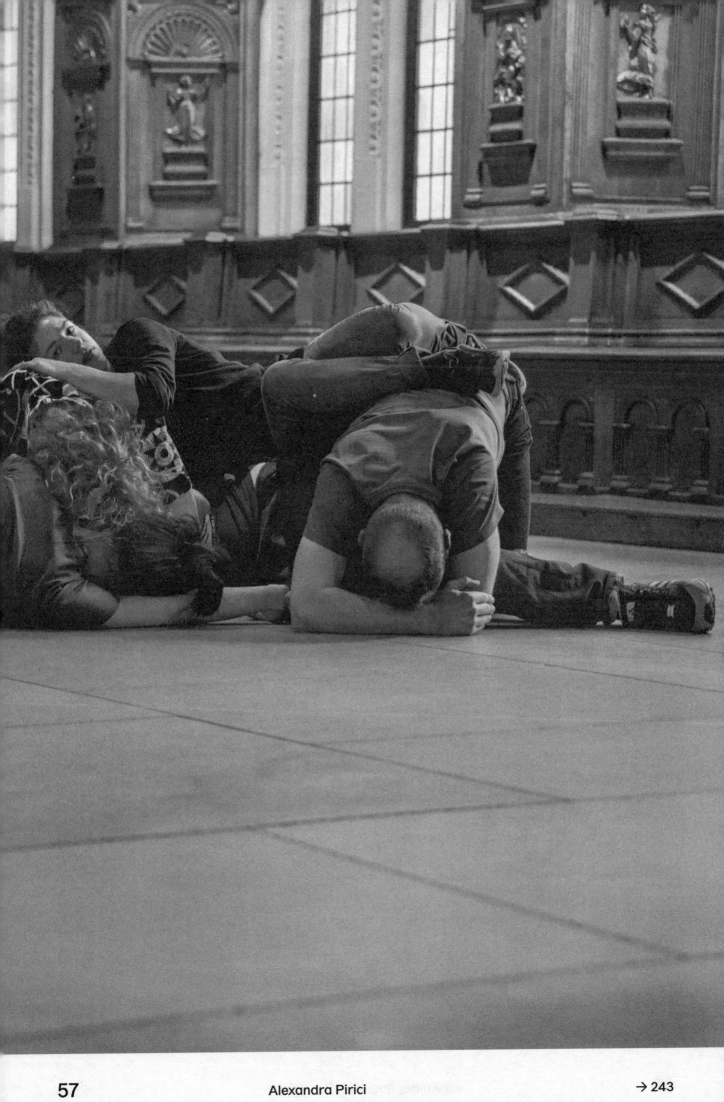

Alexandra Pirici → 243

Alexandra Pirici → 243

Mika Rottenberg

→ 249

Mika Rottenberg → 249

Mika Rottenberg → 249

Xavier Le Roy / Scarlet Yu

→ 257

Xavier Le Roy / Scarlet Yu

→ 257

Sany (Samuel Nyholm)

→ 263

Sany (Samuel Nyholm)

→ 263

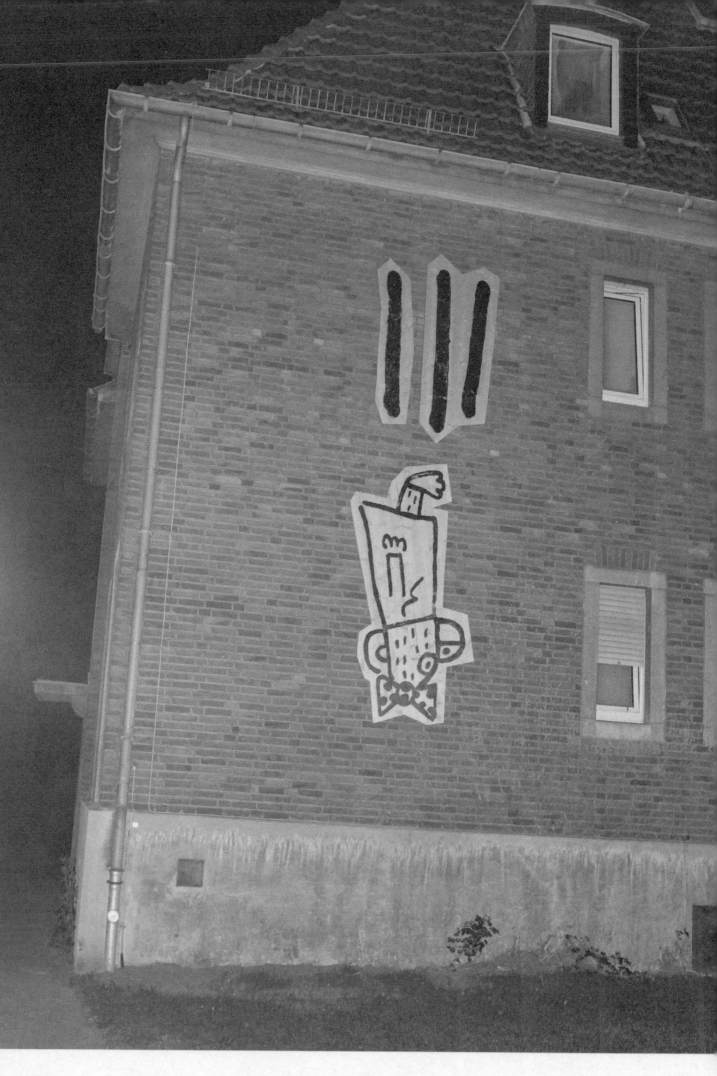

Sany (Samuel Nyholm)

→ 263

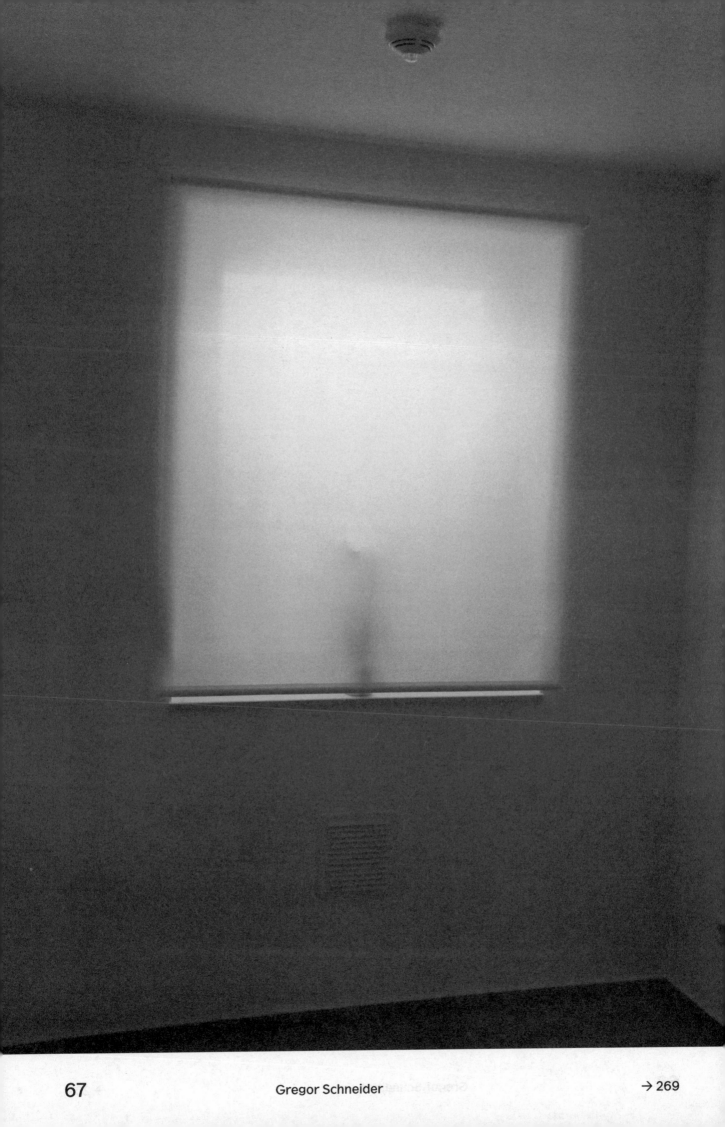

Gregor Schneider

→ 269

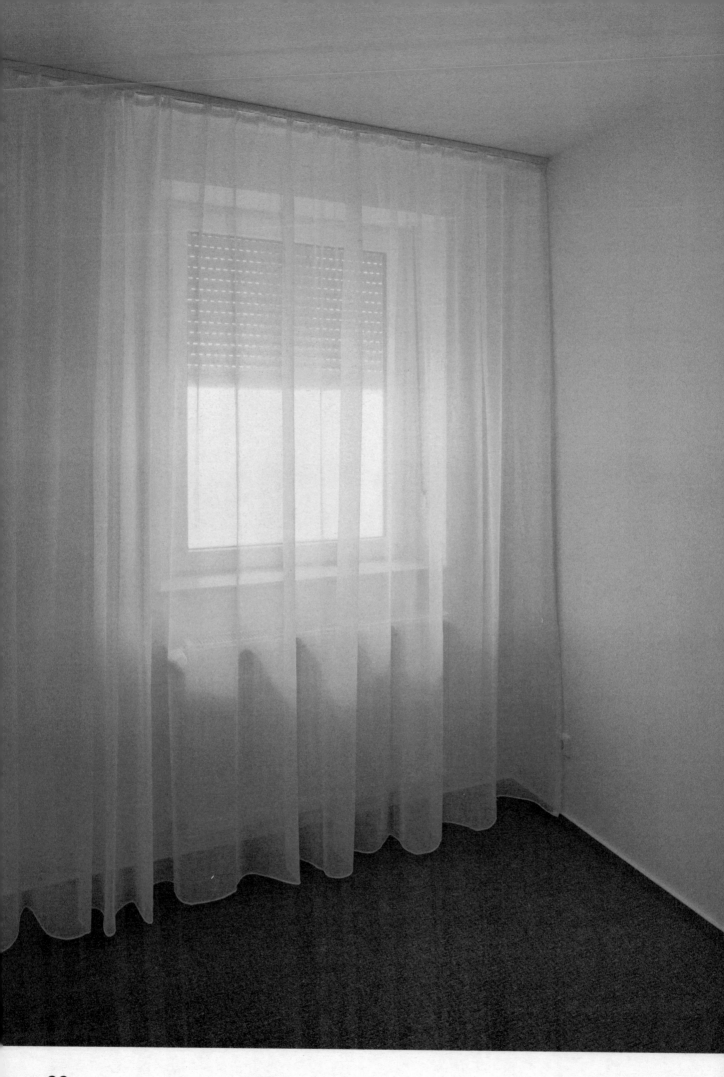

Gregor Schneider

→ 269

Gregor Schneider

→ 269

Gregor Schneider

Nora Schultz

→ 275

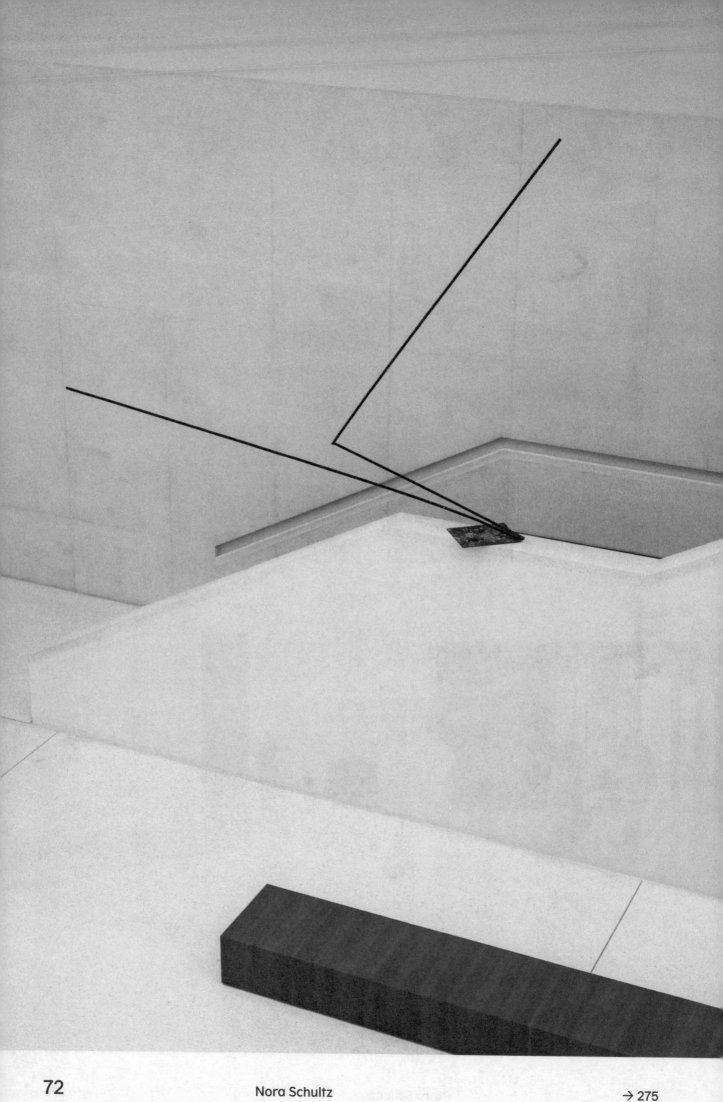

Nora Schultz

→ 275

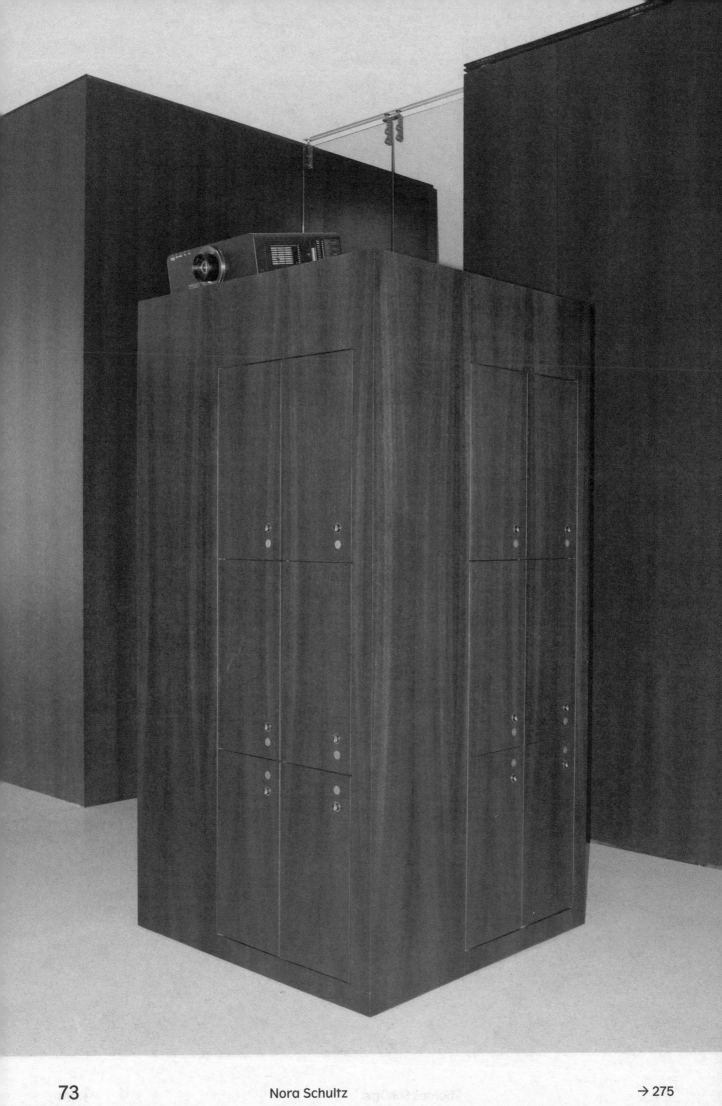

Nora Schultz → 275

Thomas Schütte → 281

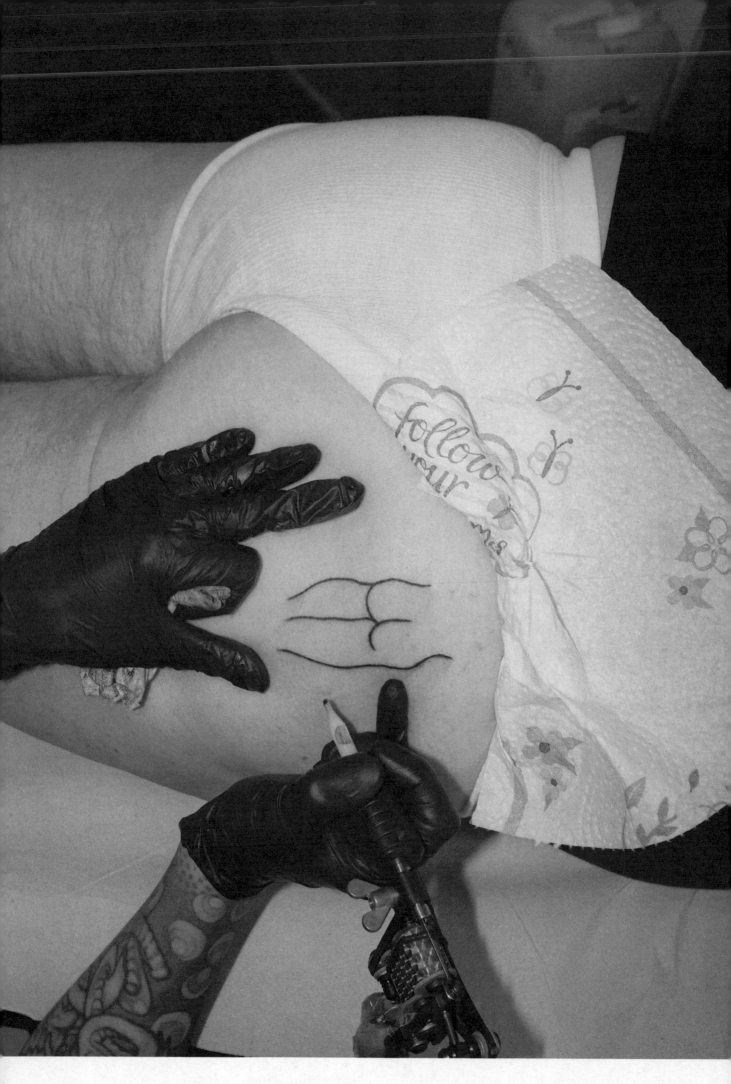

Michael Smith

→ 287

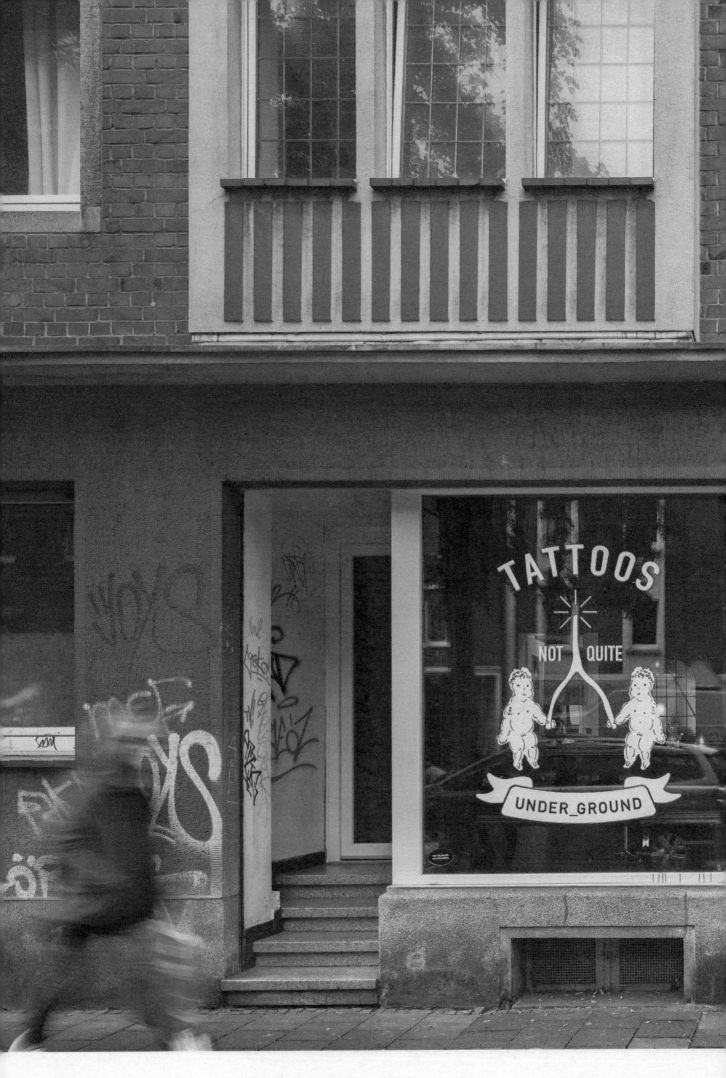

Michael Smith → 287

Michael Smith → 287

Hito Steyerl

→ 293

Hito Steyerl

→ 293

Hito Steyerl → 293

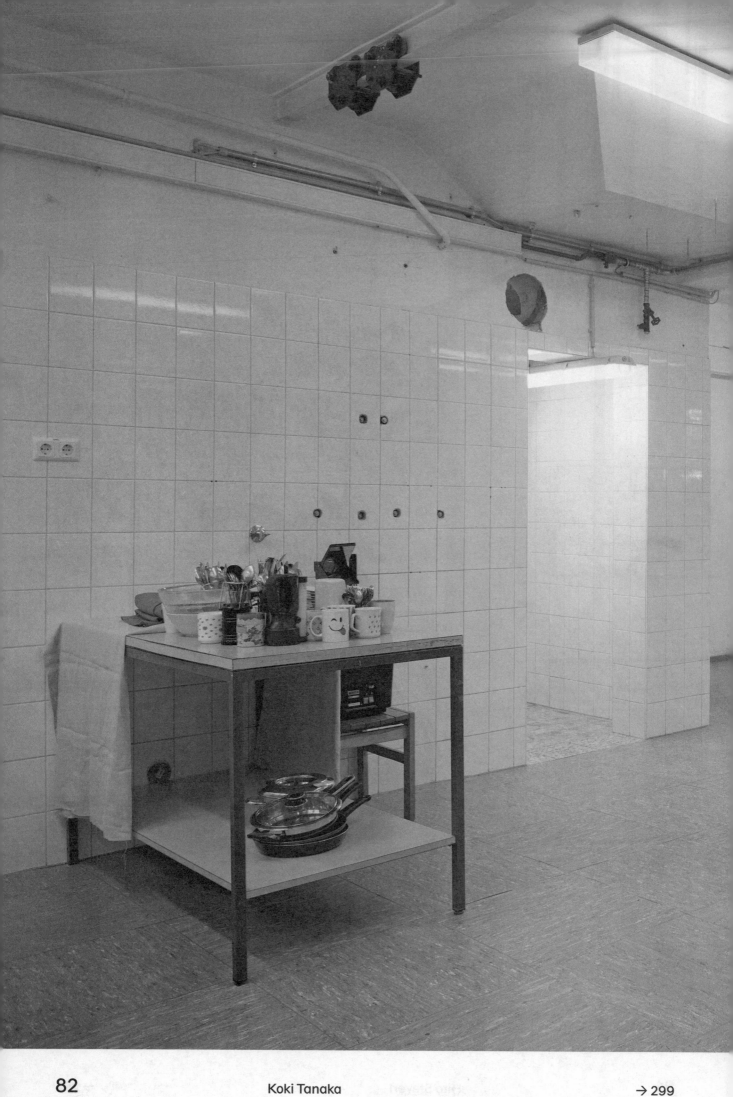

Koki Tanaka → 299

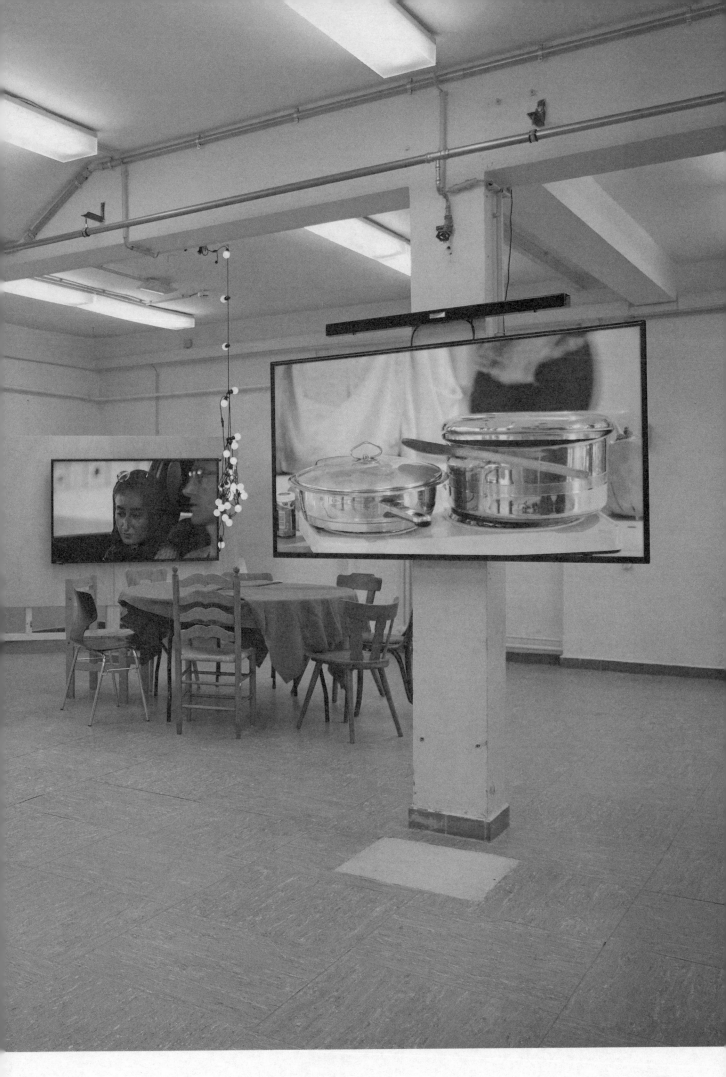

Koki Tanaka → 299

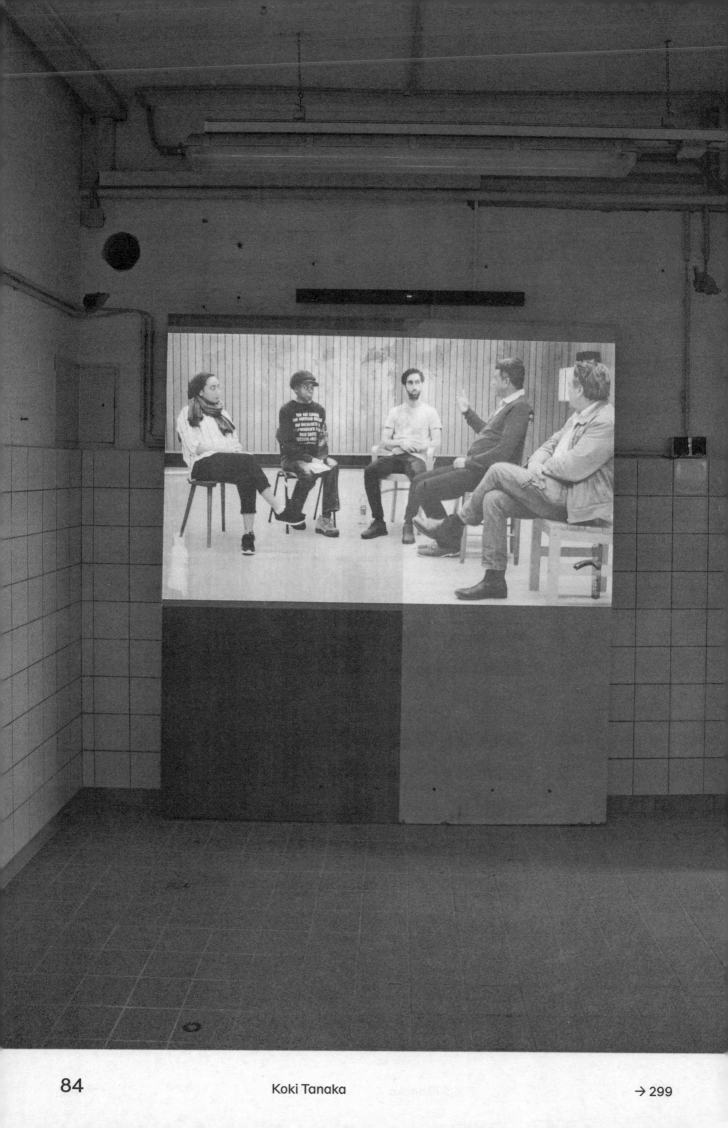

Koki Tanaka → 299

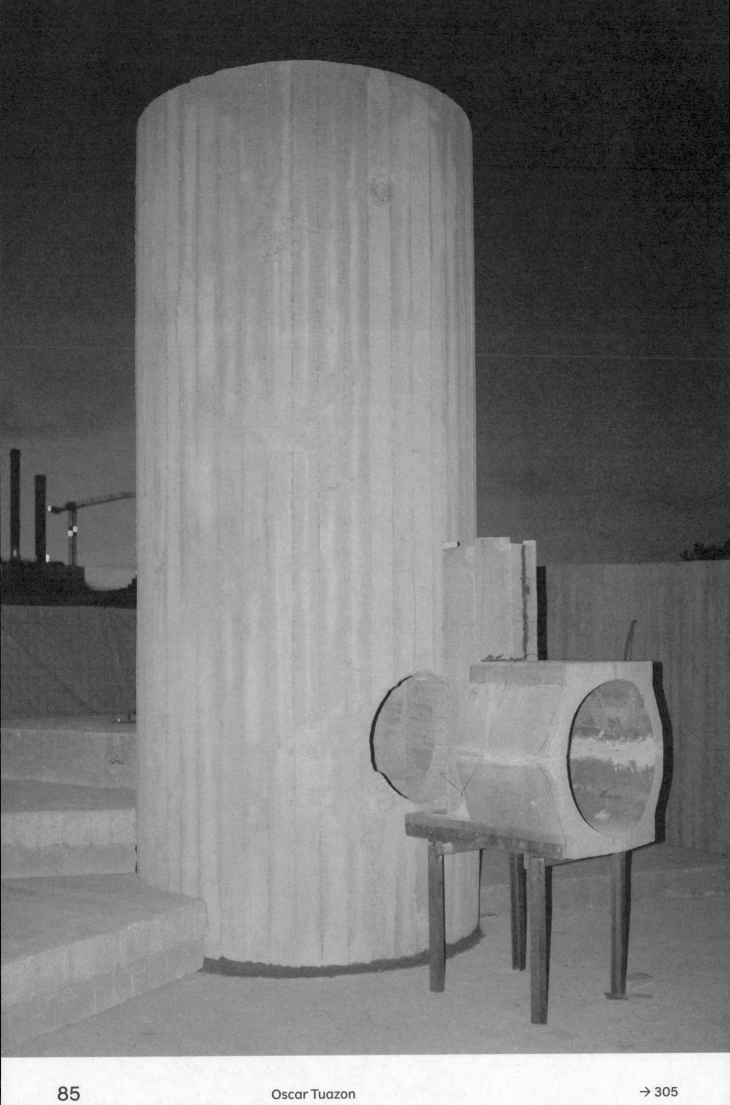

Oscar Tuazon

→ 305

Oscar Tuazon

→ 305

Oscar Tuazon

→ 305

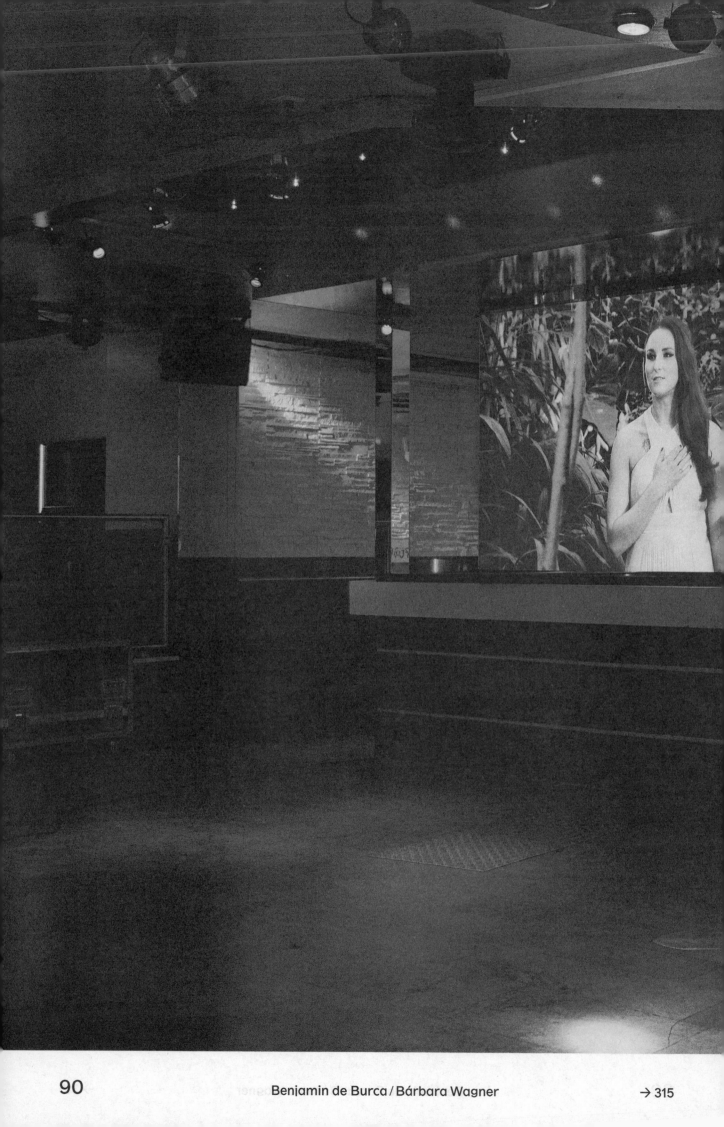

Benjamin de Burca / Bárbara Wagner

→ 315

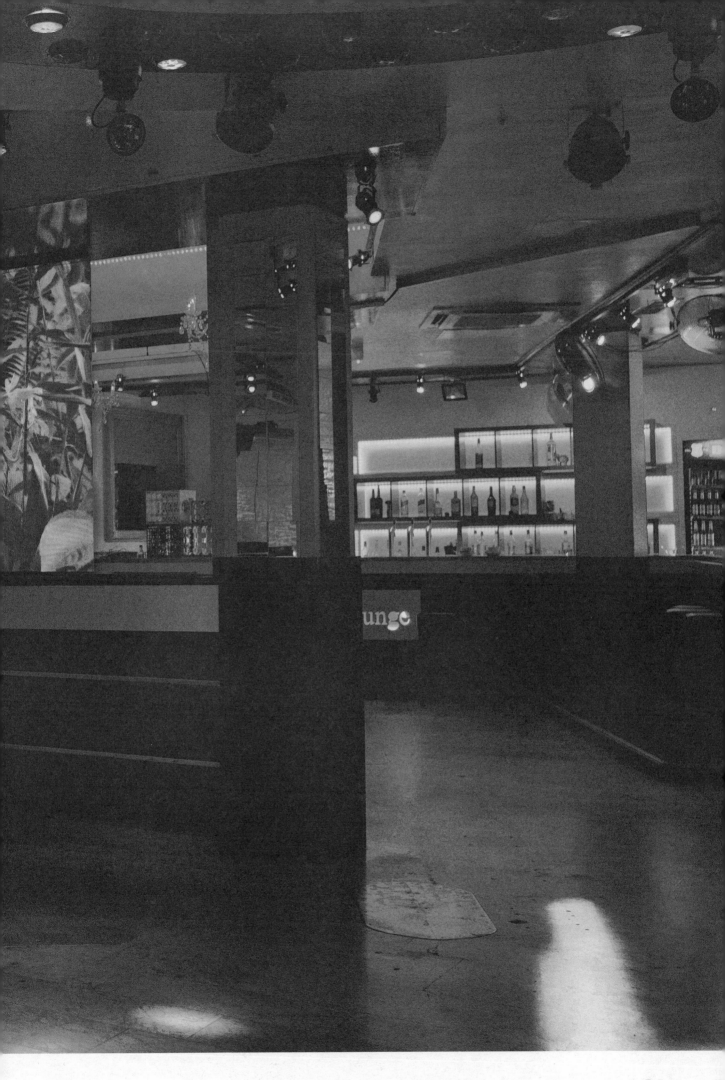

Benjamin de Burca / Bárbara Wagner

→ 315

Cerith Wyn Evans

→ 321

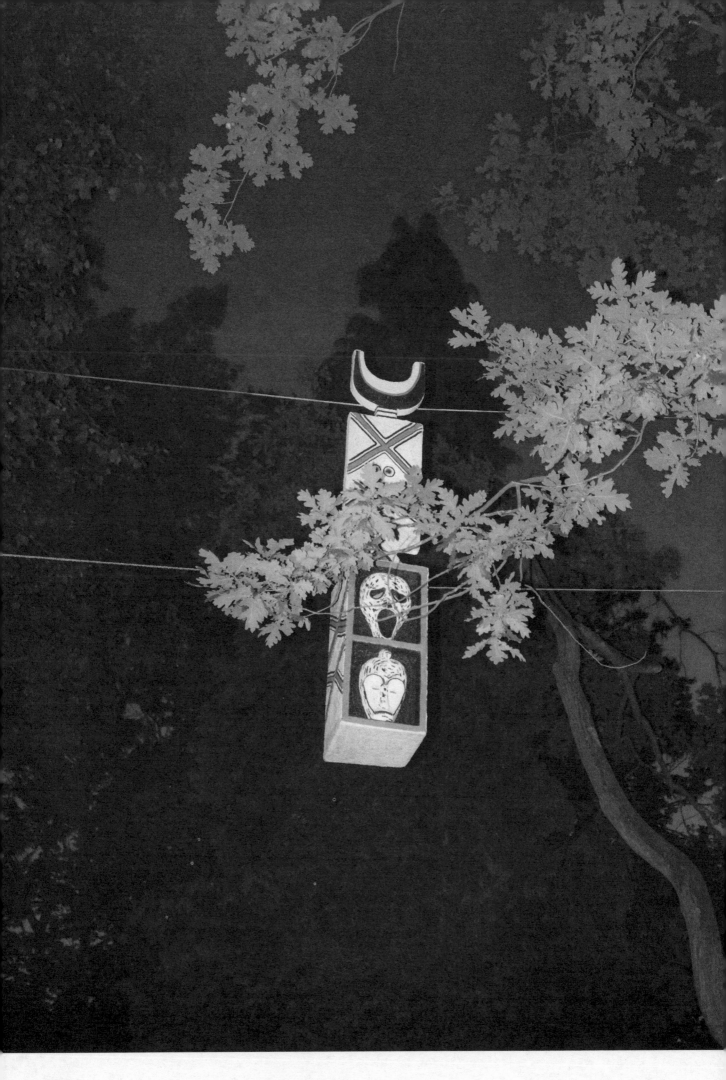

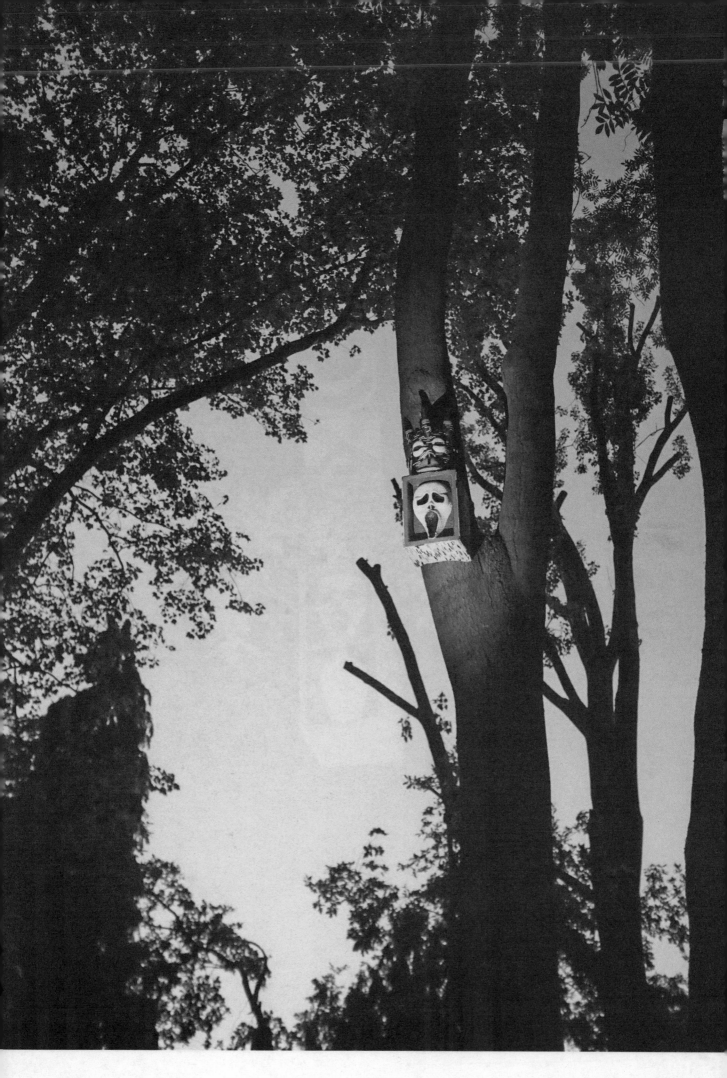

Hervé Youmbi

→ 329

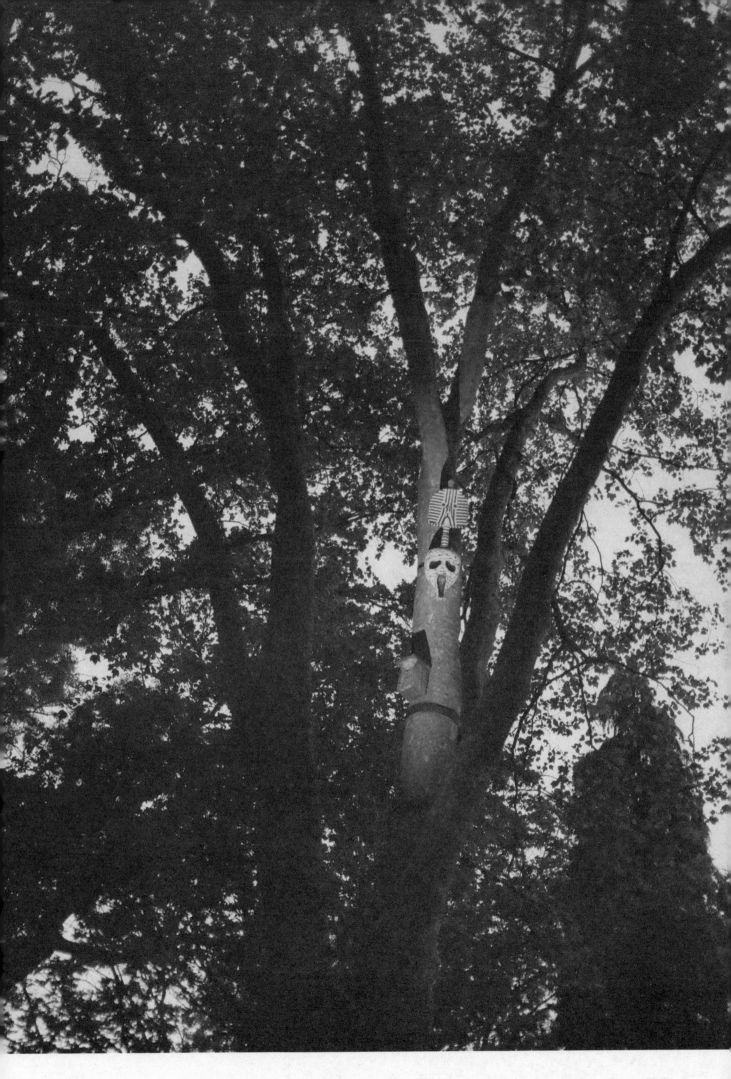

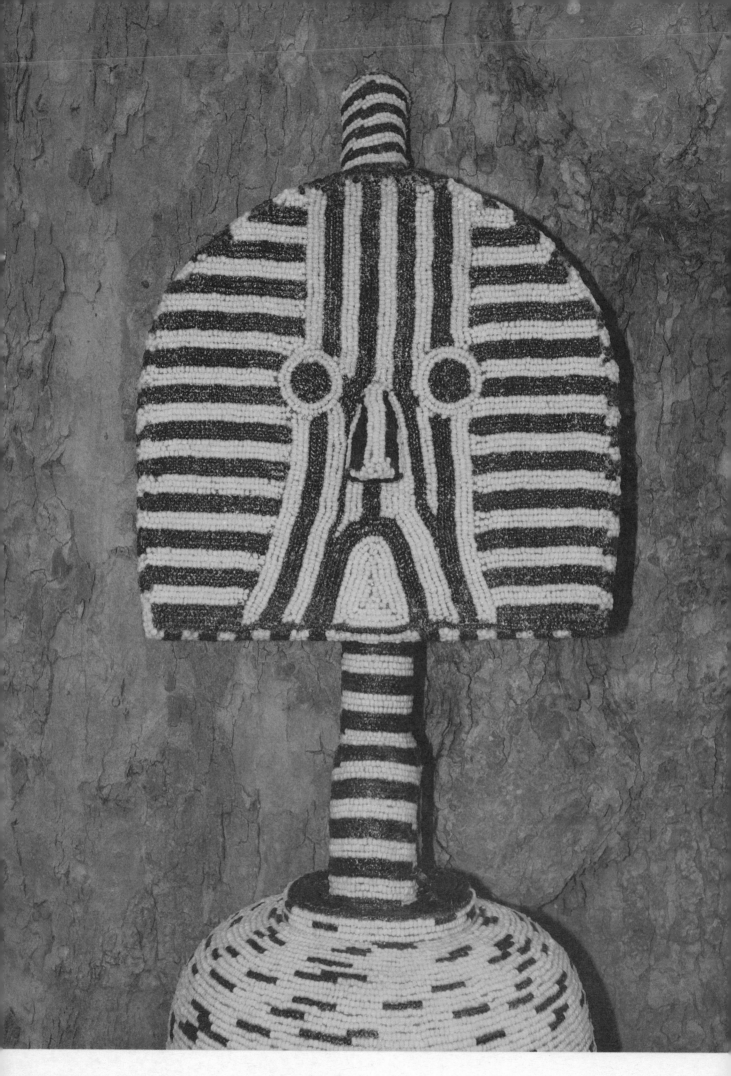

Hervé Youmbi

→ 329

Skulptur Projekte Münster 2017

Skulptur Projekte Münster 2017

Inhaltsverzeichnis / Contents

Skulptur Projekte Münster 2017

Grußwort

Die Kunstwelt blickt auf Münster: Vom 10. Juni bis zum 1. Oktober 2017 ist es wieder so weit – die Skulptur Projekte verwandeln die Stadt 100 Tage lang in ein riesiges Ausstellungsgelände. Bereits mit der ersten Ausgabe 1977 katapultierte sich Münster auf die Landkarte der internationalen Kunst. Seither strömen alle zehn Jahre begeisterte Gäste aus der ganzen Welt in die westfälische Metropole und lassen sich von der einzigartigen Atmosphäre begeistern.

Kultur gehört zu den Kernaufgaben des Landschaftsverbands Westfalen-Lippe (LWL). Mit seinen rund dreißig Museen und Kultureinrichtungen ist er der bedeutendste Kulturanbieter in der Region. In dieser Rolle hat der LWL auch die Skulptur Projekte von Anfang an umfassend finanziell unterstützt und durch die Verankerung im LWL-Museum für Kunst und Kultur auch infrastrukturell gestärkt. Gemeinsam mit der Stadt Münster ist der Landschaftsverband 2017 erneut Träger der mittlerweile fünften Ausgabe der Skulptur Projekte. Wir sind stolz darauf, dass sich die Ausstellung in den vergangenen Jahrzehnten zu einem internationalen Großereignis entwickelt hat und heute in einem Atemzug mit der documenta in Kassel und der Biennale in Venedig genannt wird. Münster ist damit zu einer internationalen Top-Adresse für zeitgenössische Kunst geworden.

Damals wie heute zeichnet der Kurator Kasper König als künstlerischer Leiter verantwortlich für die Skulptur Projekte: Aus einer Idee, getragen durch den damaligen Kustos des Westfälischen Landesmuseums für Kunst und Kulturgeschichte Klaus Bußmann, wuchs gemeinsam mit dem damals in New York lebenden Kurator eine große Ausstellung zur Skulptur heran. Die 1977 eingeladenen Künstler_innen waren jung und noch nicht international bekannt, heute gehören ihre Namen in den Kanon der Kunst des 21. Jahrhunderts: Donald Judd, Claes Oldenburg, Carl Andre, Ulrich Rückriem, Richard Serra, Richard Long, Michael Asher und Joseph Beuys.

Vierzig Jahre später schaut Kasper König mit seinem Kuratorinnenteam Britta Peters und Marianne Wagner erneut auf die Begriffe Skulptur, Stadt, Öffentlichkeit, Wandel. Dass die inhaltliche Ausrichtung der Ausstellung keinem festgelegten Motto folgt, sondern sich die Themen aus den Projektvorschlägen der eingeladenen Künstler_innen entwickeln, ist ein wesentlicher Charakterzug der Skulptur Projekte. Wofür interessieren sich Künstler_innen heute? Wie interpretieren sie die Gegenwart? Und welchen Blick werfen sie auf Münster? Diese Fragen stehen im Mittelpunkt der Schau, die zu den weltweit wichtigen Ausstellungen 2017 gehört. Wir laden Sie ein, Ihre eigenen Antworten darauf zu finden bei einer anregenden Entdeckungsreise durch den ganzen Stadtraum.

Foreword

Münster will be in the eye of the art world from 10 June to 1 October 2017 when it once again plays host to the Skulptur Projekte, converting the city into a giant exhibition site for a period of a hundred days. Its first manifestation in 1977 put the city on the international art map. Every ten years since then, enthusiastic visitors from all over the world have poured into the Westphalian metropolis to be enchanted by the event's unique atmosphere.

Culture is a key part of the remit of the Landschaftsverband Westfalen-Lippe (LWL). It includes around thirty museums and cultural organizations, making it the most important cultural institution in the region. In this role, the LWL has supported the Skulptur Projekte right from its inception, providing ample funding and infrastructural backing anchored in the LWL-Museum für Kunst und Kultur. In 2017, together with the City of Münster, the Landschaftsverband is once again sponsoring what is now the fifth incarnation of the Skulptur Projekte. We are proud that the exhibition has evolved in the last decades into a major international event to be mentioned in the same breath as the Kassel documenta and the Venice Biennale. Münster has thus become a key venue on the international scene for contemporary art.

Then as now, artistic director Kasper König has had responsibility for curating the Skulptur Projekte. The brainchild of Klaus Bußmann, the curator of what was then the Westfälisches Landesmuseum für Kunst und Kulturgeschichte, it developed— with the support of König, who was living in New York at the time—into a major exhibition of sculpture. The artists invited in 1977 were young and still unknown to an international audience, yet their names have now become part of the canon of twenty-first century art: Donald Judd, Claes Oldenburg, Carl Andre, Ulrich Rückriem, Richard Serra, Richard Long, Michael Asher, and Joseph Beuys.

Forty years on, Kasper König, together with his curatorial team Britta Peters and Marianne Wagner, is re-examining the terms sculpture, city, the public sphere, and change. One of the characteristic features of the Skulptur Projekte is that the show's conceptual direction does not follow any fixed rubric but rather develops its thematic coherence through the projects proposed by the invited artists. What are artists interested in today? How do they interpret the present? And how do they see Münster? These questions are at the heart of the exhibition, which is set to be one of the most important international exhibitions of 2017. We invite you to find your own answers in a stimulating journey of discovery through the city.

Matthias Löb
LWL-Landesdirektor

Dr. Barbara Rüschoff-Thale
LWL-Kulturdezernentin

Matthias Löb
LWL Director

Dr. Barbara Rüschoff-Thale
LWL Head of Cultural Affairs

Seit 1977 liegen an Münsters Aasee drei große Betonkugeln. Sie sind Teil des Kunstwerkes *Giant Pool Balls* von Claes Oldenburg. Vor 40 Jahren hatten die Kugeln noch Empörung in der Stadtgesellschaft ausgelöst. Heute gehören sie zu unserem Bild von Münster. Entstanden sind die Kugeln im Rahmen der ersten Skulptur Projekte, die den öffentlichen Raum der Stadt zum Thema erhob: damals ein radikal neuer Ansatz, der von Klaus Bußmann gemeinsam mit Kasper König entwickelt wurde.

Claes Oldenburgs Plan, über die gesamte Stadt Betonkugeln zu verteilen, wurde nicht realisiert. Dennoch sollte sein Konzept, Münster zu einem dynamischen Spielfeld zu erklären, Leitidee aller Skulptur Projekte werden, die nun 2017 das fünfte Mal stattfinden.

Seit den vierten Skulptur Projekten in 2007 ist viel passiert. Dabei denken wir nicht allein an Smartphones und mobiles Internet, die unser Sehen, Kommunizieren und Handeln ebenso grundlegend beeinflusst haben wie das Verhältnis von privat und öffentlich. Münsters Innenstadt hat sich in den vergangenen zehn Jahren stark verändert, etwa durch die Umgestaltung der Stubengasse oder den Neubau des LWL-Museum für Kunst und Kultur. Gravierender jedoch sind die ungeahnten globalen Entwicklungen. Vieles, was aus der Sicht von 2007 noch solide schien, ist ins Wanken geraten. Spielen feste räumliche Bezüge in einer Stadt heute überhaupt noch eine Rolle für das Verständnis von Öffentlichkeit?

Vor allem die Skulptur Projekte führen mit uns einen Dialog über Münster, den öffentlichen Raum und unser Leben in der Stadt. Die eingeladenen internationalen Künstler_innen setzen sich intensiv mit dem Vorgefundenen auseinander – und bringen zugleich ihre ganz eigenen Erzählungen mit. Die daraus entwickelten Kunstwerke stellen Fragen, lassen Vertrautes in neuem Licht erscheinen oder decken bisher Unbekanntes auf. Nicht nur lässt Kunst uns unsere Stadt immer wieder anders erleben. Auch bietet sie eine außergewöhnliche Chance, über die eigenen Vorstellungen von Münster zu sprechen *und* zu streiten.

Um hier nicht in Formeln oder vordergründigen Gewissheiten zu erstarren, sind die Skulptur Projekte auf Wiederholung angelegt. Die Dekade dazwischen bedeutet für uns keine Karenzzeit, sondern eine Phase der Überprüfung und Anwendung kritischer Qualitätsmaßstäbe. Ein solches Verfahren, das gleichsam Feldforschung und Langzeitstudie ist, gibt es nur in Münster. Es hat die Stadt urbaner und internationaler gemacht. In diesem Sinne sind wir in Münster nicht Lehrer, sondern beständig Lernende, die ihren Wissensschatz gerne mit Gästen und Interessierten teilen. Mit ihnen verbindet uns eine nicht nachlassende Neugier auf das Kommende in einer offenen, demokratischen Zukunft.

Dorthin zu gelangen, heißt für uns als Stadt Münster, der Kunst in Münster die größtmögliche Freiheit einzuräumen und ihre Umsetzung immer wieder zu unterstützen.

Three large concrete spheres have been part of the landscape at Münster's Lake Aa since 1977. They are elements in Claes Oldenburg's artwork *Giant Pool Balls*. Forty years ago, the balls caused quite a stir in the city, but they have now been incorporated into our image of Münster. They were created for the first Skulptur Projekte, which made the city's public space a focus of discussion. At the time this represented a radical new approach, jointly developed by Klaus Bußman and Kasper König.

Oldenburg's plan to distribute the concrete spheres throughout the city did not come to fruition, but his concept of identifying Münster as a dynamic playing field was to become a guiding principle for all the Skulptur Projekte, whose fifth iteration is set to take place in 2017.

A great deal has happened since the fourth Skulptur Projekte in 2007. This extends beyond smartphones and mobile Internet services, which have had as profound an influence on our ways of seeing, communicating, and acting as they have on the relationship between public and private. Münster's city centre has changed dramatically in the last ten years: for example, through the redesign of the Stubengasse or the new building for the LWL-Museum für Kunst und Kultur. More important, though, are the unexpected developments that have taken place at the global level. Much of what still seemed solid in 2007 is now tottering. Do fixed spatial relationships in a city now play any kind of role in our conception of the public sphere?

Above all, the Skulptur Projekte engage us in a dialogue about Münster, the public space, and our life in the city. The international artists invited to take part undertake a vigorous exploration of the space as found, at the same time bringing in their own personal narratives. The artworks that emerge from this raise questions, casting the familiar in a new light or revealing something that was hitherto unknown. Art not only gets us to experience our city again and again in a different way, it also offers us a rare opportunity to discuss *and* dispute our own images of Münster.

To prevent any ossification in rigid formulas or specious certainties, the Skulptur Projekte are set up to be a recurring event. The decade between each exhibition does not imply a waiting period for us but rather a phase of review when critical quality standards are applied. This kind of process—a blend, as it were, of field research and long-term study—is unique to Münster. It has made the city more urban and more international. In this sense, we are not teachers but rather perennial students, happily sharing our stock of knowledge with guests and other interested parties. We are connected to them by an unflagging curiosity in what lies ahead in an open, democratic future.

For us, as representatives of the city, achieving this means granting the greatest possible freedom to art in Münster and providing ongoing support to facilitate its realization.

Markus Lewe
Oberbürgermeister der Stadt Münster

Cornelia Wilkens
Kulturdezernentin der Stadt Münster

Markus Lewe
Mayor of the City of Münster

Cornelia Wilkens
Head of Cultural Affairs for the City of Münster

Grußwort

Foreword

„Indem sie sich von der Erkundung ihres spezifischen Mediums und ihrer spezifischen Eigenschaften abwandte," – so hielt Benjamin H.D. Buchloh in einem Aufsatz über Hans Haacke fest, „hatte die Skulptur einen Punkt erreicht, an dem sie sich dem unerwarteten Verlust und Verschwinden von Materie, Form und Masse stellen musste". Für die Skulptur Projekte war dieser Punkt in den 1970er Jahren in doppelter Weise ein springender: Einerseits, so machte der Titel unmissverständlich klar, gewährte die Ausstellung der Skulptur in Münster in der Regel nur eine auf Projektdauer reduzierte Daseinsfrist. Und erteilte hiermit (fast) allen Erwartungen auf fortlaufende Präsenz der Arbeiten eine Absage. Andererseits wirkt die Ausstellung wie ein alle zehn Jahre stattfindendes Großexperiment zur Frage, in welche ontologisch diversen Richtungen sich die Skulptur in Zukunft entwickelt. Vor vierzig Jahren standen die Zeichen auf Abkehr von den Traditionen der Klassischen Moderne: Es ging hinaus aus dem Museumsraum und hinein ins Alltagsleben. Weg von Werk- und Subjektzentrierung, hin zu Prozessen öffentlichen Handelns mit breiter Publikumsbeteiligung und vor allem auch breiter Beforschung der Stadt Münster, die nie nur als temporäre Freiluftgalerie herhielt, sondern – wie im Ausstellungjahr 2017 – Versuchsfelder eröffnet, in denen das Nachdenken über die Kunst ebenso befördert wird wie die Kunst des Nachdenkens: etwa über die bauliche Verfasstheit der Stadt, das Verhältnis von privat und öffentlich, die Eigenzeitlichkeit von Naturräumen, über digitale Kommunikation, Roboter, Kleingärten, Tattoos, Drohnen oder über die gänzlich unerwartete Begegnung mit Performer_innen, die mit einer zufälligen Passantin oder einem Passanten in Münster ein kurzes Gespräch beginnen mit der Frage: „Darf ich Ihnen eine Skulptur zeigen?" Sie dürfen. Mehr noch: Sie müssen es tun. Denn auch in dieser ephemeren Gestalt – als *living action* – kehrt die Skulptur wieder, wenn das Performative zu den spezifischen Eigenschaften zählt, in denen sich skulpturale Prozesse heute vergegenwärtigen lassen. Und mehr noch, wenn auf diese Weise eingelöst werden kann, was Gustav Metzger – Teilnehmer der Skulptur Projekte 2007 – in einem Interview kurz vor seinem Tod als die zentrale künstlerische Aufgabe beschrieb: „To light, light up the world, light up issues facing the world." Die Kulturstiftung des Bundes dankt den beteiligten Künstler_innen sowie den Kuratorinnen Britta Peters und Marianne Wagner, dem künstlerischen Leiter Kasper König sowie der Projektleiterin Imke Itzen für all die weiträumige Weltzugewandtheit, mit der die Skulptur Projekte auch im Jahr 2017 zu dieser Erhellung beitragen.

In an essay on Hans Haacke, H. D. Buchloh wrote, 'In turning its back on the exploration of its specific medium and specific properties, sculpture reached a point where it had to face the unexpected loss and disappearance of material, form, and mass.' For the Skulptur Projekte this point in the 1970s was a crucial one in two respects: on the one hand, as the title of the exhibition made crystal clear, the presentation of sculpture in Münster was typically geared to a limited period, so that the life of a work was reduced to the duration of the project. This gave short shrift to any expectation that a work might become a permanent fixture. On the other hand, the exhibition acts as a large-scale experiment—taking place every ten years—addressing the question of what ontologically diverse directions sculpture might develop in. Forty years ago, all the signs pointed to a renunciation of the traditions of Classical Modernism: sculpture was leaving the museum space and entering into everyday life. Away from the centrality of the work and the subject, and towards processes of public engagement with broad-based audience participation and, above all, extensive exploration of the city of Münster, which has never served merely as a temporary open-air gallery but—as is also the case in 2017—has established experimental areas in which reflection on art is just as much encouraged as the art of reflection: pondering, for example, the city's architectural constitution, the relationship between private and public, the specific temporality of natural spaces, digital communication, robots, garden allotments, tattoos, drones, and the totally unexpected encounter with performers, who might begin a brief conversation with a random passer-by in Münster with the question, 'May I show you a sculpture?'
You may. In fact, you should. Because even in this ephemeral form—as living action—sculpture recurs, if the performative can be counted as one of the specific properties characterizing the way sculptural processes are realized today. And, what is more, if this is a way to honour what Gustav Metzger—who participated in the Skulptur Projekte 2007—described, in an interview conducted shortly before his death, as the central task of art: 'To light, light up the world, light up issues facing the world.' The German Federal Cultural Foundation thanks all the artists taking part in the exhibition as well as curators Britta Peters and Marianne Wagner, artistic director Kasper König, and project director Imke Itzen for all their wide-ranging concern for the world, manifesting in 2017 in the Skulptur Projekte's continued contribution to this process of illumination.

Hortensia Völckers
Vorstand/Künstlerische Direktorin
Kulturstiftung des Bundes

Alexander Farenholtz
Vorstand/Verwaltungsdirektor
Kulturstiftung des Bundes

Hortensia Völckers
Executive Board/Artistic Director
Kulturstiftung des Bundes

Alexander Farenholtz
Executive Board/Administrative Director
Kulturstiftung des Bundes

Der öffentliche Raum mit seinen gesellschaftlichen wie politischen Ansprüchen zählt zu den schwierigsten Ausstellungsorten überhaupt. Die Kunst bewegt sich hier im Spannungsfeld von Ästhetik und Nutzen. Gleichwohl birgt sie großes Potenzial, den Stadtraum abseits raumplanerischer Konventionen zu gestalten.

Auch die Skulptur Projekte stehen im Kontext dieser kontroversen Debatte. Zu ihren Anfängen noch von teils hitzigen Diskussionen begleitet, haben sie sich längst als internationale Referenzadresse etabliert. Doch unabhängig von der Frage, was Kunst im öffentlichen Raum kann und soll, bleibt eines deutlich: Die Ausstellung ist ein Gewinn für unsere Stadt und ebenso für Westfalen. Denn mit jeder Ausgabe der Projekte rückt Münster ins Rampenlicht der weltweiten Kunstszene.

Als die Westfälische Provinzial bereits 1977 die Ausstellungspremiere unterstützte, leitete sie eine Unternehmenstradition ein, die noch immer Bestand hat. Damals wie heute ist es uns eine Freude, über die Provinzial Stiftung LWL-Museum für Kunst und Kultur einen Beitrag zu diesem kulturellen Highlight zu leisten. Gemeinsam mit der Sparkassen-Finanzgruppe treten wir als Hauptförderer auf und verleihen so unserer gelebten Nähe zu Kunst und Kultur Ausdruck.

Tatsächlich sind Kunst und Kultur Motor der gesellschaftlichen Entwicklung und prägen das soziale Leben. Auch für die Wirtschaftskraft einer Region können sie nicht hoch genug geschätzt werden. Als Regionalversicherer, der seit fast dreihundert Jahren in Westfalen verwurzelt ist, liegt uns ihre Förderung besonders am Herzen. Zusammen mit dem LWL-Museum für Kunst und Kultur begannen wir so Anfang der 1980er Jahre, eine Sammlung zeitgenössischer Werke westfälischer Künstler_innen aufzubauen – die wir ab Ende 2017 auch in einer Sonderausstellung im LWL-Museum zeigen. Mit der 1997 gegründeten Kulturstiftung der Westfälischen Provinzial Versicherung fördern wir zudem den künstlerischen Nachwuchs Westfalens. Es erfüllt mich mit Freude, aber auch einer guten Portion Stolz, dass für uns dieses Engagement – das über das klassische Versicherungsgeschäft hinausgeht und zur nachhaltigen Bereicherung Westfalens beiträgt – selbstverständlich ist. In diesem Sinne wünsche ich den Leser_innen des Katalogs viel Vergnügen bei der Lektüre und allen Ausstellungsbesucher_innen einen anregenden Aufenthalt in unserer Stadt.

The public space, complete with its social and political aspirations, is one of the most challenging exhibition sites of all. Art operates here in the dynamic interplay between aesthetics and utility. At the same time, it has great potential as a means to fashion the urban space away from the conventions of spatial planning.

The Skulptur Projekte are also part of this controversial debate. Initially the focus of sometimes heated discussion, they have long since established themselves as an international reference point. But quite apart from the question of what art in public space can and should be, one thing remains clear: the exhibition is a boon for our city and also for Westphalia, because with each new incarnation of the Projekte, Münster is thrust into the limelight of the global art scene.

When Westfälische Provinzial sponsored the inaugural exhibition in 1977, it introduced a corporate tradition that has endured to this day. As always, we are delighted to be able to contribute to this cultural highlight via the Provinzial Stiftung LWL-Museum für Kunst und Kultur. Together with the Savings Banks Finance Group, we are the event's main sponsor, and this is a way to express our close sense of connection to art and culture. In point of fact, art and culture are the drivers of social evolution and have a major influence on the life of a society. Moreover, their contribution to the economic strength of a region cannot be overemphasized. As a regional insurer, rooted in Westphalia for almost three hundred years, the funding of art and culture is something we feel strongly about. Accordingly, in the early 1980s we worked together with the LWL-Museum für Kunst und Kultur to begin the process of building up a collection of contemporary works by Westphalian artists, and we will be presenting this in a special exhibition at the LWL-Museum starting in late 2017. In 1997 we founded the Kulturstiftung der Westfälischen Provinzial Versicherung, which also supports the upcoming generation of artists in Westphalia.

I am delighted, and also rather proud, that for us this commitment—which goes beyond the classical business of providing insurance and contributes to the sustained and ongoing enrichment of the province—is axiomatic. With this in mind, I hope you will enjoy reading this catalogue and wish all the visitors to the exhibition a stimulating stay in our city.

Dr. Wolfgang Breuer
Vorstandsvorsitzender der Westfälischen
Provinzial Versicherung
Vorstandsvorsitzender der Provinzial Stiftung
LWL-Museum für Kunst und Kultur

Dr. Wolfgang Breuer
Chairman, Westfälische Provinzial Versicherung
Chairman, Provinzial Stiftung LWL-Museum für
Kunst und Kultur

Grußwort

Mit den Skulptur Projekten 2017 schaffen die Veranstalter_innen erneut ein unverwechselbares Kulturangebot für Münster und die Region. Die renommierte Open-Air-Ausstellung bringt Kunst mitten in unser Leben, in den öffentlichen Raum. Auf diese Weise sind die Werke für alle zugänglich und erlebbar, ohne dass dafür Schwellen überschritten werden müssen.

Jede der fünf Ausstellungen hat seit ihrem Ursprung im Jahr 1977 einen ganz speziellen Fokus und lädt die Besucher_innen immer wieder aufs Neue ein, Kunst für sich zu entdecken. Die bisherige Resonanz auf dieses mittlerweile vierzigjährige Kultur-Highlight zeigt: Kunst macht Lebensräume attraktiv – für diejenigen, die hier leben und arbeiten, ebenso wie für viele hunderttausend auswärtige Besucher_innen.

Als Sparkasse haben wir uns auf die Fahne geschrieben, Zukunft für die Menschen in der Region zu gestalten. Diese Zukunftsgestaltung findet für uns nicht nur statt, wenn's um Geld und Bankgeschäfte geht, sondern auch dann, wenn Menschen Unterstützung brauchen, um wertvolle Projekte zu realisieren. Die Bandbreite reicht da im kulturellen Bereich von der Förderung von Theaterprojekten über die Unterstützung von Kulturinitiativen bis hin zu einer inzwischen jahrzehntelangen Begleitung der Skulptur Projekte. Und jede einzelne realisierte Idee ist am Ende eine weitere Visitenkarte für ein lebenswertes Münsterland.

Kultur braucht auch Highlights mit Signalwirkung weit über den Ort ihrer Präsentation hinaus. Diese wirken vor Ort als Inspiration für alle, die sich für ihr Lebensumfeld engagieren und so zur Lebensqualität beitragen. Sie wirken zudem als Orientierungshilfe auf nationaler und sogar internationaler Ebene bei der Beantwortung der Frage, wo man seine Zeit verbringen, als Unternehmer_in investieren und möglicherweise auch seine Heimat haben will. Darum freuen wir uns, dass wir gemeinsam mit dem Sparkassen-Kulturfonds des Deutschen Sparkassen- und Giroverbandes, der Helaba Landesbank Hessen-Thüringen und dem Sparkassenverband Westfalen-Lippe dieses besondere kulturelle Highlight als Hauptförderer ermöglichen können.

In diesem Sinne wünsche ich den Skulptur Projekten 2017 vor allem eines: SIE – als begeisterte Besucher_innen und damit auch als Botschafter_innen für die Erlebnisvielfalt unserer schönen Region.

Foreword

The organizers of the Skulptur Projekte 2017 have once again produced a distinctive cultural event for Münster and the surrounding region. The prestigious open-air exhibition brings art into the midst of our lives and into the public space. This makes the works a tangible experience and accessible for everyone, without there being any barriers to overcome.

Each of the five exhibitions that have taken place since 1977, when the first event was staged, has had a particular focus, consistently inviting visitors to rediscover art for themselves. Previous feedback from this cultural highlight, which is now forty years old, shows that art helps create an attractive environment—both for those who live and work here and for the several hundred thousand visitors from outside the city who attend the event.

At the Sparkasse we have committed ourselves to helping shape the future for people in the region. For us, this process is not just about money and banking business but also about giving people the support they need to realize worthwhile projects. This covers a broad spectrum in the cultural realm, from funding theatre projects and supporting cultural initiatives to our decades-long support of the Skulptur Projekte. Moreover, every single idea that is realized is, in the end, another calling card advertising Münsterland's vibrant environment.

Culture also needs highlights that can send a strong signal far beyond the venue where they are presented. At the local level, these act as an inspiration for everyone who takes an active interest in their social environment and thus contribute to the quality of life. They also help to provide orientation at a national and even international level in determining where one wants to spend one's time, invest as an entrepreneur, and possibly even live. We are delighted that—acting in conjunction with the Sparkassen-Kulturfonds of the German Savings Banks Association, the Helaba Landesbank Hessen-Thüringen, and the Sparkassenverband Westfalen-Lippe—we are able to facilitate this special cultural highlight as its main sponsor.

With this in mind, I have one wish above all for the Skulptur Projekte 2017: YOU—as enthusiastic visitors and thus as ambassadors for the diversity of our beautiful region.

Markus Schabel
Vorstandsvorsitzender Sparkasse Münsterland Ost

Markus Schabel
Chairman, Sparkasse Münsterland Ost

Für die Skulptur Projekte 2017 haben wir einen Rat für Sie: Erleben ist einfach! Laufen Sie gleich drauf los, entdecken Sie die Kunstwerke in Münster und erfahren Sie alles rund um die mehr als dreißig neuen Arbeiten, die unsere lebenswerte Stadt bis zum 1. Oktober zu einem ganz besonderen Schauplatz machen. Um den Bürger_innen, die der Sparkasse schon seit vielen Generationen vertrauen, etwas zurückzugeben, unterstützt unsere Stiftung auch Projekte, die zur Attraktivität Münsters und des Kreises Warendorf beitragen. Diese Projekte sind so vielfältig wie die zahlreichen Facetten des Münsterlandes und seiner Bewohner_innen. Ein besonderes Augenmerk richtet unsere Stiftung übrigens auf Aktivitäten für Kinder und Jugendliche: Denn Kunst soll schließlich in jedem Alter Spaß machen!
Breit gefächert ist ebenfalls das gesamte Förderspektrum unserer Stiftung. Es reicht von Wissenschaft und Forschung über Jugend- und Altenhilfe bis hin zu Kunst und Kultur. Dabei stehen vor allem Projekte im Fokus, die mit der finanziellen Unterstützung Gutes für die Menschen vor Ort bewirken und als kulturelles Highlight über die Grenzen Westfalens hinaus strahlen können. Da liegt es quasi auf der Hand, dass wir als Förderer bei den Skulptur Projekten 2017 dabei sind!
Unser stifterisches Handeln ist besonders geprägt von der Verbundenheit zu den Menschen in unserem Geschäftsgebiet und von der Verantwortung, die wir für das Münsterland übernehmen. Um nah an den Münsterländer_innen und ihren Themen zu sein, beschließt unser Kuratorium, das unter anderem mit lokalen Fachexpert_innen besetzt ist, über die Verwendung der Stiftungserträge. So haben wir uns – ebenso die Kulturstiftung der Sparkasse Münster – wiederholt entschieden, die Skulptur Projekte zu unterstützen.
Wir wünschen allen Besucher_innen der Skulptur Projekte 2017 viele erlebnisreiche Stunden in dieser einzigartigen Open-Air-Ausstellung!

For the Skulptur Projekte 2017 our advice to you would be: Just do it! Get out there, discover the artworks in Münster, and find out all about the more than thirty new works that, up until 1 October, will turn our pleasant city into a very special venue. To give something back to the people of the city, who have put their trust in the Sparkasse for many generations, our foundation also supports projects that contribute to the attractiveness and appeal of Münster and the Warendorf district. These projects are as diverse as the many facets of Münsterland and its inhabitants. The foundation also pays special attention to activities for children and teenagers—art should be fun for all ages! Our foundation's funding activities are just as wide-ranging. They extend all the way from science and research to art and culture by way of support for the elderly and youth welfare. Here the primary focus is on projects that, with financial support, can benefit the local community and will shine as a cultural highlight beyond the bounds of Westphalia. It virtually goes without saying then that we are involved in funding the Skulptur Projekte 2017!
The work of the foundation is strongly influenced by our connection to the people in our business area and by our sense of responsibility for Münsterland. Our board of trustees, which also includes local experts in the field, decides on the use of the foundation's income in such a way as to stay close to the region's residents and their concerns. As a result, we have decided—as has the Kulturstiftung der Sparkasse Münster—to once again support the Skulptur Projekte.
We wish all visitors to the Skulptur Projekte 2017 many stimulating hours at this unique open-air exhibition!

Stiftung der Sparkasse Münsterland Ost

Stiftung der Sparkasse Münsterland Ost

Grußwort

Die einzigartige Beziehung von Kunst im öffentlichen Raum, Stadt und Museum und vor allem die internationale Öffentlichkeit, die nach Münster kommen wird, prägen, öffnen und verändern die Stadt und das LWL-Museum für Kunst und Kultur. Die Erwartungen sind groß! Ebenso groß sind daher die Herausforderung und die kuratorische Verantwortung, sich immer wieder freizuschwimmen und die Nase in den Wind zu halten auf der Suche nach vielversprechenden bekannten und unbekannten Künstler_innen. In enger Zusammenarbeit mit dem Museum, das die organisatorische Verantwortung hat, wuchs in den vergangenen zwei Jahren um Kasper König ein engagiertes Team zusammen. Zu den entscheidenden Erfolgsfaktoren gehören der seit 1977 eingehaltene Zehn-Jahres-Rhythmus sowie die Unabhängigkeit der künstlerischen Leitung bezüglich der Auswahl der Künstler_innen und deren frei und unabhängig vorgeschlagenen Kunstwerken. Auf der Landkarte der Ausgabe von 2017 befinden sich fünf Projektstandorte im beziehungsweise am Museum. Darin spiegelt sich das Interesse der Künstler_innen, sich mit dem Museum als Teil des städtischen Raumes sowie dem Nebeneinander von Innen- und Außenraum kritisch auseinanderzusetzen. Konkret geht es dabei immer auch um das Verhältnis von öffentlichem, privatem und institutionellem Raum sowie die Frage, welche Öffentlichkeit diese herstellen oder durch welche Kunstwerke diese erst ermöglicht wird. Im Rahmen eines durch die VolkswagenStiftung geförderten Forschungsprojekts haben wir in Zusammenarbeit mit dem Kunstgeschichtlichen Institut der Westfälischen Wilhelms-Universität begonnen, das seit den 1970er Jahren entstandene Konvolut an Dokumenten und Werken des Skulptur Projekte Archivs wissenschaftlich zu bearbeiten.

Ausdrücklich möchte ich neben den zahlreichen Förderern namentlich der Kulturstiftung des Bundes, dem Land Nordrhein-Westfalen, der Kunststiftung NRW und der Sparkassen-Finanzgruppe für ihr großzügiges Engagement danken, das viele Kunstwerke erst ermöglicht hat, die nun die aktuelle Ausgabe der Skulptur Projekte 2017 prägen. Der Stiftung Kunst³ für das LWL-Museum für Kunst und Kultur und dem Verein der Freunde des Museums gehört mein besonders herzlicher Dank für die Förderung einzelner Kunstwerke.

Schließlich gilt mein Dank dem künstlerischen Leiter der Skulptur Projekte 2017 Kasper König und den beiden Kuratorinnen Britta Peters und Marianne Wagner sowie dem ganzen Team der Skulptur Projekte. Die intensive Verbindung zwischen ihnen und dem Team des LWL-Museum für Kunst und Kultur war auch dieses Mal ein entscheidender Schlüssel zum Erfolg.

Kunst lebt von der Freiheit der Begegnung mit denjenigen, die sie wahrnehmen – als Freiraum, im Widerstreit unterschiedlicher Meinungen, als Identifikationsmöglichkeit – im besten Fall aber als Inspiration für das *Mehr* in unserem Leben. Diese Inspiration in der Begegnung mit den Skulptur Projekten 2017, mit dem Museum und der Stadt wünsche ich Ihnen.

Hermann Arnhold
Direktor des LWL-Museum für Kunst und Kultur

Foreword

The unique relationship between art in the public space, the urban environment, the museum, and, most importantly, the international audience that will come to Münster influences, opens up, and changes the city and the LWL-Museum für Kunst und Kultur. Expectations are high! Of equal magnitude, therefore, are the challenge and the curatorial responsibility involved in constantly heading out into open water and keeping one's nose to the wind in the search for promising artists, both known and unknown. In close collaboration with the museum, which is charged with organizing the event, a dedicated team has coalesced around Kasper König over the last two years. Our recipe for success includes the ten-year rhythm we have maintained since 1977 as well as the artistic director's independent choice of artists and the autonomous nature of their work, fostered by the freedom they are given to put forward their own proposals. For Skulptur Projekte 2017 there are five locations in and at the museum. This reflects the artists' interest in exploring the museum as a part of the urban space and critically examining the juxtaposition of interior and exterior. Specifically, what is also always at stake is the relationship between a public, private, and institutional space and the question of what kind of audience this will generate and what kind of artworks it will allow. As part of the research project funded by the Volkswagen Foundation, we have collaborated with the Institute of Art History at the University of Münster to initiate a scientific review of the collection of documents that have accrued since the 1970s as well as the works in the Skulptur Projekte archive.

Aside from our many sponsors, I would specifically like to thank the German Federal Cultural Foundation, the State of North Rhine-Westphalia, the Kunststiftung NRW, and the Savings Banks Finance Group for their generous involvement. Their support has facilitated the production of many of the artworks that are now making their mark on the current exhibition, Skulptur Projekte 2017. I am particularly grateful to the Stiftung Kunst³ für das LWL-Museum für Kunst und Kultur and the Friends of the Museum for their funding of individual artworks. Finally, I would like to thank Kasper König, the artistic director of Skulptur Projekte 2017, the exhibition's two curators, Britta Peters and Marianne Wagner, and all the members of the team involved in the project. The close relationship they had with the team at the LWL-Museum für Kunst und Kultur was once again vital to the exhibition's success.

Art thrives on free-spirited encounters with the people who see and appreciate it: as a free space, a place to relish the cut and thrust of different opinions, as an opportunity for identification, and, ideally, as an inspiration to aim for the 'more' in our own lives. I wish you a healthy dose of this inspiration in your encounters with the Skulptur Projekte 2017, with the museum, and with the city.

Hermann Arnhold
Director, LWL-Museum für Kunst und Kultur

Bruch und Kontinuität

2017 finden die Skulptur Projekte zum fünften Mal statt. Der Entstehungsprozess der internationalen Ausstellung ist seit 1977 nahezu unverändert: Künstler_innen werden nach Münster eingeladen und gebeten, nach ihren Besuchen Projektvorschläge zu entwickeln. Das Profil der jeweiligen Ausstellung bildet sich so erst mit den realisierten Arbeiten heraus. Eine Verstetigung der Skulptur Projekte im Zehn-Jahres-Rhythmus war dabei in den Jahren 1977 und 1987 noch nicht absehbar. Erst mit ihrer erneuten Veranstaltung 1997 – mit einem klaren Bekenntnis dazu seitens der Stadt und des Landschaftsverbandes Westfalen-Lippe (LWL) sowie mit einem deutlich höheren Budget ausgestattet – wurde der Grundstein für das periodische Format gelegt.[1]
Alle anderen Bedingungen jedoch haben sich seit den 1970er Jahren massiv verändert: Es gibt mehr Künstler_innen, mehr Ausstellungen und mehr Möglichkeiten, sich global und nahezu in Echtzeit über diese zu informieren. Der städtische Raum befindet sich immer weniger im Besitz der Kommunen und wird durch Werbung und kommerzialisierte Veranstaltungen dominiert, seine Nutzung unterliegt einem bis ins Kleinste ausgefeilten Regelwerk. Zudem besteht ein wesentlich breiteres Interesse an Kunst als einer Form von Freizeitgestaltung, seit den 1990er Jahren ergänzt durch ein immer ehrgeizigeres Stadtmarketing. Die Geschwindigkeit des Kommunizierens, Transportierens und Reisens ist allein im Vergleich zu den vergangenen Skulptur Projekten im Jahr 2007 rasant gestiegen – zwischen 1977 und 2017 liegen Welten. Reflexionen über die Frage, wie zunehmende Digitalisierung, Globalisierung und die dazugehörigen neuen Ökonomien die Kunstwelt, aber vor allem unsere Vorstellungen von Körper, Zeit und Ort verändern, haben die Entstehung der Skulptur Projekte 2017 grundlegend begleitet. Ihnen ist die im Vorfeld der Ausstellung erschienene dreiteilige Magazinreihe – *Out of Body, Out of Time, Out of Place* – gewidmet.[2]
Die vermeintliche Verfügbarkeit von allem und allen rund um die Uhr lässt die Zeit schrumpfen. Gegenüber dieser Entwicklung eine gewisse Unabhängigkeit zu bewahren, wird immer wichtiger – zumal Entschleunigung eine Qualität darstellt, die grundsätzlich eng mit dem Medium Skulptur verknüpft ist. Als umso entscheidender erweist sich deshalb das Beharren auf dem schwerfälligen zehnjährigen Veranstaltungsrhythmus, der Brigitte Franzen, Kuratorin der Ausgabe 2007, dazu veranlasste, im Bezug auf die Ausstellung von einer Langzeitstudie zu sprechen.[3] Zu den Konstanten gehört, neben der Stadt Münster, auch die Person von Kasper König, der seit 1977 alle Ausstellungen in unterschiedlichen Teamkonstellationen umgesetzt hat. Die Befürchtung, die Stadt und der LWL als Träger der Skulptur Projekte könnten das Intervall auf fünf Jahre verringern, war für ihn der ausschlaggebende Grund, 2017 erneut die künstlerische Leitung zu übernehmen, um auf diese Weise das bestehende Format im bisherigen Zeitrhythmus zu garantieren.
Die katholisch geprägte Stadt Münster, deren Hauptarbeitgeber Universität sowie Verwaltungsbehörden sind, erweist sich aufgrund ihrer vergleichsweise homogenen Sozialstruktur und ihres leicht zu lesenden städtebaulichen Aufbaus als ideales Testfeld für die Beobachtung synchroner und diachroner Entwicklungen. Synchrone Zustände, die Zeitgenossenschaft der Dinge, werden durch die Skulptur Projekte sichtbar. Sie gestatten den Blick auf die Stadt, die Gesellschaft und die vorhandene und tem-

porär ausgestellte Kunst als Schnitt in die Zeit. Die regelmäßige Wiederkehr der Ausstellung rückt diachrone Entwicklungen, Differenzen und Fortschreibungen ins Bewusstsein; die langsame Taktung ermöglicht Reflexionen über Skulptur als Medium und den distanzierten Rückblick auf die Themen einer Dekade. Das Format kommt einer Offenlegung der Befindlichkeiten der Stadt Münster gleich, es bietet Blicke hinter ihre Fassaden, untersucht ihr Eigenleben, ihre Eigenliebe.

Die Kulissenhaftigkeit der nach historischem Vorbild wiederaufgebauten Innenstadt ruft ein breites Assoziationsspektrum auf, von Heinrich Manns Roman *Die kleine Stadt* (1909) über Thornton Wilders Theaterstück *Unsere kleine Stadt* (1938) bis hin zu Peter Weirs Film *The Truman Show* (1998) – um nur einige Beispiele zu nennen. Gerhard Vinkens Essay *Skulpturen im Stadtraum: das Ende der Dialektik* [S. 405] analysiert, warum sich das Modell Altstadt bis heute so großer Beliebtheit erfreut. Das Künstlerduo Peles Empire wählte die Münsteraner Giebelkonstruktionen, gepaart mit Bildzitaten und Abstraktionen von dem für sie namensgebenden Schloss Peleș in den rumänischen Karpaten, als Vorlage für ihr begehbares Objekt *Sculpture*. Benjamin de Burca und Bárbara Wagner nutzen die versteckt in einer Passage gelegene Diskothek Elephant Lounge in der Innenstadt als Ausgangs- und Installationsort für ihr filmbasiertes Projekt *Bye Bye Deutschland! Eine Lebensmelodie,* das in Zusammenarbeit mit zwei ortsansässigen Musiker_innen entstand, die berühmte Schlagerstars covern.

2017, angesichts weitreichender Globalisierungsfolgen, auf der Stadt Münster als alleiniger Referenzgröße zu beharren, erscheint jedoch anachronistisch. In Auseinandersetzung mit diesem Dilemma hat sich das Skulpturenmuseum Glaskasten Marl als ein in vielerlei Hinsicht sprechender Kooperationspartner herauskristallisiert. In *The Hot Wire als Chance einer fokussierten Wahrnehmung* [S. 341] beschreibt Georg Elben, Direktor des Museums, die Verbindung aus Marler Perspektive. Ausführlich widmet er sich auch den im Rahmen der Zusammenarbeit realisierten gemeinsamen Projekten, darunter die Arbeit *Le Tag / 200 m* von Joëlle Tuerlinckx, die nur in Marl zu sehen ist. Aus Sicht der Skulptur Projekte erweitert die Kooperation den physischen und gedanklichen Anschauungsraum um eine andere deutsche Stadt mit einer gegenläufigen Geschichte. Marl fungiert in diesem Kontext als ein Satellit mit exemplarischen Eigenschaften: Die Stadt im Ruhrgebiet verfügt über eine reale und spezifische Gegenwart, genauso wie ihre Architektur beispielhaft für die Utopien einer globalen Moderne eintreten kann.

Grob vereinfacht lässt sich die Rolle von Kunst und der funktional ausgerichteten modernen Architektur in Marl bis in die 1970er Jahre hinein als integraler Bestandteil zur Vermittlung eines demokratischen, humanistischen Weltbildes begreifen, während die Skulptur Projekte in Münster im Konflikt mit der nach wie vor konservativen Stadtgesellschaft entstanden. Die nach dem Zweiten Weltkrieg von beiden Städten gewählten Identitäten – Wiederaufbau und Kontinuität in Münster, radikaler Neubeginn in Marl –, könnten verschiedener nicht sein. Die narrative Bedeutungsfunktion, die in Münster der historischen Architektur zugewiesen ist, übertrug man in Marl auf die Kunst, während die konzeptuell und minimalistisch geprägten Positionen der Skulptur Projekte 1977 der betulichen Beredsamkeit vor Ort Abstraktionen entgegenzusetzen suchten – dies lässt sich als These formulieren. Und auch die Gegenwart unterscheidet sich gewaltig. Während Münster wächst und einen überdurchschnittlichen Anteil wohlhabender Einwohner_innen aufweist, kämpft die ehemals prosperierende Stadt Marl seit den ersten Zechenschließungen in den 1970er Jahren mit hoher Arbeitslosigkeit, Leerstand und einer Vielzahl von sozialen Problemen, die sich aus dieser Strukturschwäche ergeben.

Die Kooperation zwischen Münster und Marl ist auch Thema des von Monika Rinck kuratierten Authors-in-Residence-Programms mit dem Titel *Münster: Kur und Kür* [S. 371]. Zehn Autor_innen verbringen jeweils zwei Wochen in Münster, auf Wunsch inklusive einer Übernachtungsreise nach Marl. Sie begleiten die Veränderungen in der Stadt auf literarischer Ebene, wobei die letzte Aufbauphase vor der Eröffnung und der Abbau bewusst eingeschlossen wurden. In der Wahl der Formate sind die

Autor_innen vollkommen frei, ein Kaleidoskop unterschiedlicher Wahrnehmungen und sprachlicher Annäherungen. Ergänzend zu den digitalen Veröffentlichungen der Texte findet alle zwei Wochen im Freihaus ms als Staffelübergabe zwischen dem gehenden und dem kommenden Gast eine gemeinsame Lesung statt.

Verschiedene Zeitkonstruktionen bestimmen nicht nur das Profil der Skulptur Projekte, die sich mit jeder Ausgabe in ein vorhandenes Feld aus seit 1977 angekauften, noch in der Stadt befindlichen Skulpturen sowie Erinnerungen an temporäre Setzungen einschreiben, sondern dienen auch vielen Künstler_innen als Material. Nairy Baghramians *Beliebte Stellen/Privileged Points* thematisiert durch die Platzierung vor dem barocken Adelspalais Erbdrostenhof (1753–1757), nach Plänen von Johann Conrad Schlaun erbaut, nicht nur retrospektiv einen im Rahmen der Ausstellung immer wieder genutzten Standort und dessen bisherige Besetzung durch männliche Künstler. Die Arbeit bezieht – mit Blick auf die Zukunft – die Möglichkeit eines Ankaufs und die Installation an anderer Stelle bereits mit ein. Implizit spielt der Faktor Zeit in nahezu allen künstlerischen Beiträgen eine Rolle: Offensichtlich ist seine konstituierende Bedeutung in den Projekten von Jeremy Deller, Xavier Le Roy und Scarlet Yu sowie in Lara Favarettos *Momentary Monument – The Stone*. Mit dem Projekt *NotQuite_Underground* offeriert Michael Smith eine dauerhafte Tätowierung insbesondere für Menschen über 65; die Motive dafür wurden unter anderem von Künstler_innen der Skulptur Projekte seit 1977 entworfen. Unter dem Titel *Hier war ich doch schon mal! Öffentliche Kunst und öffentliche Zeit* [S. 411] widmet sich Claire Dohertys Katalogtext diesem Aspekt.

Eine internationale Großausstellung wie die Skulptur Projekte, für die alle Arbeiten, mit Ausnahme des *Nuclear Temple* (2011) von Thomas Schütte, neu entstanden sind, besitzt ihre eigenen Gesetzmäßigkeiten und wird zugleich unter den Bedingungen einer globalen, zunehmend als verunsichernd wahrgenommenen Gegenwart entwickelt. Im Januar 2015 nahmen die ersten Mitarbeiter_innen des Teams ihre Arbeit auf und fanden die ersten Besuche von Künstler_innen statt – während der sogenannten Flüchtlingskrise und dem sichtbaren Erstarken rechter Parteien in ganz Europa, aber noch vor dem reaktionären Backlash, für den Stichworte wie Brexit, Trumps Wahl zum US-amerikanischen Präsidenten und der Umbau der Türkei zu einer Autokratie unter Erdoğans Herrschaft exemplarisch stehen können.

Die Projekte der Künstler_innen, aus denen sich die Ausstellung in ihrer finalen Form herauskristallisiert hat, sind unter diesen Vorzeichen entstanden. Einige davon adressieren sie direkt, ohne sie plakativ zu illustrieren. Mika Rottenberg beschäftigte sich schon vor der Diskussion um einen möglichen Mauerbau mit der US-amerikanisch-mexikanischen Grenze, und Lara Favaretto stellt über ihre Arbeit eine Verbindung zu einer Organisation her, die Flüchtlinge in Abschiebehaft betreut. Alexandra Pirici aktualisiert, ausgehend vom Westfälischen Friedensschluss 1648, das Themenfeld Identität, nationale Grenzziehungen und globale Kommunikation. In anderen Werken, wie in Oscar Tuazons als Feuerstelle und Aufenthaltsort nutzbarer Skulptur, manifestiert sich eine politische Haltung über das rund um die Uhr bestehende Angebot, sich dieser Infrastruktur auch zu bedienen.

Alle Positionen, wie auch die der Kunstvermittlung der Skulptur Projekte, lassen sich im Wunsch vereinen, mittels Kunst einen kritischen Erfahrungsraum zu schaffen, der sich nicht auf ein kunstimmanentes Verhältnis beschränkt, sondern sich auf vielfältige Art und Weise zu gesellschaftlichen, philosophischen und politischen Fragen in Beziehung setzen lässt.[4] Durch eine Abformung des sogenannten Nietzsche Felsen in Sils Maria in Originalgröße, als Skulptur dann allerdings auf Gehhilfen gestellt, durchdringt Justin Matherly in einem physischen Kraftakt dessen Aphorismus von der *ewigen Wiederkehr des Gleichen* und lädt darüber zu einer neuen Beschäftigung mit dem klassischen Stoff ein. Hervé Youmbi ließ in Kamerun hybride Masken fertigen, die popkulturelle westliche Einflüsse mit animistischen Traditionen vereinen und im Umland von Douala von hochqualifizierten Handwerker_innen gefertigt wurden. Ihre ortsspezifische Installation auf dem ehemaligen Überwasserfriedhof, in dessen unmittelbarer Nähe sich bereits Werke vergangener Skulptur Projekte befinden, erzeugt ein dichtes Netz aus kultischen und kulturellen Bezügen.

111

Im Idealfall unterscheidet sich eine solche Ausstellung von anderen Gesellschaftsbereichen dadurch, dass sie keine unmittelbare Zweck-Nutzen-Relation besitzt. Es handelt sich um kostenlos zugängliche, größtenteils mit öffentlichen Geldern finanzierte Projekte im Stadtraum. Das Erlebnis oder die zufällige Konfrontation mit ihnen unterliegt keinerlei Zwang, nichts muss verstanden, beurteilt oder auch nur bemerkt werden. Und schon gar nicht sofort. Mit der Ausstellung gehen für alle direkt und indirekt, aktiv und passiv Beteiligten Erfahrungen einher, die individuelle und damit auch gesellschaftliche Folgen haben können. Als geradezu paradigmatisch erweist sich in dieser Hinsicht On Kawaras Langzeitprojekt *Pure Consciousness*, das als erklärtermaßen nicht-pädagogische Maßnahme ausschließlich der Öffentlichkeit von Kindergartenkindern gewidmet ist, die sich später vielleicht an diese frühkindliche Erfahrung erinnern. Akiko Bernhöft hat die erste Realisierung nach Kawaras Tod in Münster betreut und führt im Katalog [S. 365] in das Projekt ein. Politisch bestehen die Skulptur Projekte auf den durch die ausgestellten Positionen aufgeworfenen Fragen – ästhetisch scharf gestellte Haltungen, die ihre eigene Zeit markieren.

2017 verteilen sich 35 Projekte in einem weiten Radius über das Stadtgebiet. Die Werke führen die Besucher_innen an Orte jenseits touristisch erschlossener Plätze: in den im Süden der Stadt gelegenen Sternbuschpark, Standort von Hreinn Friðfinnssons *fourth house of the house project since 1974*, zu Aram Bartholls Projekt *12 V* am Fernsehturm bis hin zu Pierre Huyghes biotechnischem Organismus in der ehemaligen Eissporthalle. Ausgehend von einem der wenigen modernen Gebäudekomplexe am Stadtrand, der gerade abgerissenen Oberfinanzdirektion, reflektiert Christian Odzuck das ästhetische Vokabular des modularen Bauens und rückt die künftige Stadtentwicklung in den Fokus. Ayşe Erkmen bezieht mit einer knapp unter der Wasseroberfläche gelegenen Querung erstmals das Hafengelände in die Skulptur Projekte mit ein. An dem kleinen Stichkanal ist im vergangenen Jahrzehnt eine Gemengelage aus Gastronomie und nach wie vor vorhandenem Gefahrengutlager entstanden, die Erkmen durch die prekäre Verbindung *On Water* zwischen den beiden unterschiedlichen Uferseiten hervorhebt.

Dem Wunsch nach sichtbarer Repräsentation, der den Skulptur Projekten seit 1997 anhaftet, finden sich ephemere Aktionen, komplexe Installationen und prozess- und teamorientierte Arbeitsweisen entgegengesetzt. Cerith Wyn Evans trug sich lange mit dem Gedanken, der Stadt lieber etwas wegzunehmen, als eine weitere Arbeit hinzuzufügen, woraus letztendlich sein Vorschlag für eine subtile Manipulation der Kirchenglocken der St. Stephanus-Gemeinde entstand. Künstler wie Ei Arakawa, der eine Gruppe grob gerasterter, singender LED-Panels auf einer Wiese am Aasee installiert, Michael Dean oder Samuel Nyholm arbeiten zum Teil, trotz vorhandener mechanischer Herstellungsmöglichkeiten, bewusst mit den eigenen Händen, um die Ästhetik ihrer Werke nicht den standardisierten Abläufen einer ausgelagerten Produktion zu überlassen. Hinsichtlich des mit einer Großausstellung einhergehenden Verwaltungsaufwands lässt sich das schon fast als eine subversive Haltung verstehen, die die Maschinerie an die Realität der künstlerischen Produktion zurückzukoppeln versucht. Auch die prozesshaft angelegte Gestaltung der Ausstellungskommunikation durch Urs Lehni und Lex Trüb steht der Idee einer strengen Corporate Identity zunächst entgegen – und besitzt dennoch einen hohen Wiedererkennungswert. Die Regisseurin Monika Gintersdorfer und der Künstler Knut Klaßen nutzen mit ihrem Netzwerk aus internationalen Performer_innen das Theater im Pumpenhaus während der gesamten Ausstellungslaufzeit als lebendige Produktionsstätte.

Die Projekte von Koki Tanaka und Xavier Le Roy gemeinsam mit Scarlet Yu, denen Workshops vorausgingen oder die während der Ausstellung durch zahlreiche Workshops begleitet werden, basieren auf der Zusammenarbeit mit unterschiedlichen Akteur_innen und verschiedenen Formen von Gemeinschaft. Kollektive Beziehungen stehen auch im Fokus der gemeinsam mit der Westfälischen Wilhelms-Universität veranstalteten *Blumenberg Lectures* [S. 375]. Der für 2017 gewählte Titel *Metaphern des Gemeinsinns – Contesting Common Grounds* greift Grundfragen der Ausstellung aus der Perspektive verschiedener Wissenschaftsdisziplinen auf. Gerard Byrne hebt

durch seine Standortwahl in der öffentlichen Stadtbücherei einen elementar am Gemeinwohl orientierten Ort hervor.

Der Körper, der eigene genauso wie die Körper der anderen, gewinnt im Zuge zunehmender Digitalisierung, aber auch innerhalb der damit verbundenen neuen Ökonomien, zunehmend an Bedeutung. Er verschwindet im Digitalen und wird durch digitale Geräte und hochtechnologisierte Prothesen ergänzt. Nur wer fit ist, vermag sich innerhalb einer flexibilisierten und projektbezogenen Berufswelt zu behaupten – um diesen komplexen Zusammenhang auf wenige Sätze herunterzubrechen. Die Auseinandersetzung damit spiegelt sich nicht nur in performativen Arbeiten wider, sondern auch in Skulpturen und Installationen. Das Brunnenensemble *Sketch for a Fountain* von Nicole Eisenman stellt in seiner Ansammlung von Gips- und Bronzefiguren gesellschaftlich und medial vermittelten Körperbildern das Ideal einer entspannten, weder geschlechtlich noch anderweitig normierten Selbst- und Fremdwahrnehmung entgegen. Emeka Ogboh interessiert sich in einer unbekannten Stadt vor allem für ihre Geräusche und ihren Geschmack. Statt der Dominanz des visuellen Sinns zu erliegen, stärkt er in seiner auf den epochalen Musiker Moondog – 1999 in Münster beerdigt – referierenden Sound-Installation unser Bewusstsein für andere Erfahrungsebenen. In ihrem Katalogbeitrag *Bodies Still Matter / Körper – noch immer von Bedeutung* stellt Raluca Voinea [S. 387] zwischen den Themen Körper, Performance und Politik eine Verbindung her. Mithu Sanyal beschäftigt sich in ihrem Text *Wem gehört der Common Ground?* [S. 381] mit Racial Profiling und der Frage, welche Rolle Geschlecht und Hautfarbe im öffentlichen Raum spielen.

Die Projekte von Hito Steyerl, Andreas Bunte und Aram Bartholl legen den Fokus stärker auf die Bedingungen und Möglichkeiten des Digitalen selbst: Wie verändert das Netz unsere Vorstellungen von öffentlicher und privater Sphäre? Wie verändern Roboter die Rolle des Menschen? Ähnliche Fragen reflektiert auch Inke Arns in ihrem Katalogbeitrag *Freiheit in Zeiten der Mustererkennung* [S. 393]. Shaina Anand und Ashok Sukumaran, Teil des interdisziplinären Netzwerks CAMP, installieren ein schwarzes Netz aus Kabeln im Innenhof der Städtischen Bühnen Münster, das die Ruine des alten Theaters mit der modernen Architektur des 1954 als erster Theaterneubau nach dem Krieg in der BRD entstandenen Gebäudes verbindet. Damit rufen sie das utopische Versprechen in Erinnerung, das in der Aufbruchsstimmung der modernen Architektur widerhallt und erweitern die aktuellen Überlegungen zum demokratischen Potenzial der digitalen Kommunikation durch einen Rückgriff auf die Basis: den Zugang zu Elektrizität und den grundlegenden Ressourcen des gesellschaftlichen und ökonomischen Lebens allgemein.

Das Westfälische Landesmuseum, heute LWL-Museum für Kunst und Kultur, ist als Veranstalter traditionell eng mit den Skulptur Projekten verknüpft. Es gewährt die Infrastruktur für das gut zwei Jahre vor Ort arbeitende Team, das in Zusammenarbeit mit den entsprechenden Stellen im Museum und der Stadt Münster die Ausstellung vorbereitet und realisiert. Die Institution hat dabei in jeder der bisherigen Ausgaben eine andere Rolle gespielt: 1977 fungierte das Museum durch die Initiative des dortigen Kurators und geistigen Vaters der Skulptur Projekte, Klaus Bußmann, als Ausgangspunkt für die Entwicklung des Ausstellungsformates. Aktuell stellt uns der Ende 2014 eröffnete Museumsneubau vor eine Herausforderung – wie jedes Gebäude ist er nicht frei von Ideologien, Erwartungen, Verhaltensregeln und Besitzansprüchen. Der Entwurf der Berliner Staab Architekten betont mit dem Konzept der Höfe und einem Wechsel von Innen- und Außenräumen den öffentlichen Charakter der Institution. Sie verfolgen ein Gesamtkonzept, das das Museum als Teil der Stadt proklamiert. In loser Korrespondenz dazu analysiert Angelika Schnell in ihrem Text *Der „polyvalente" öffentliche Raum* [S. 399] am Beispiel des Pariser Centre Pompidou die Bedeutung von Museumsbauten für die Herausbildung eines öffentlichen Raums auf allgemeinerer Ebene.

2017 sind fünf künstlerische Positionen im Museum angesiedelt. Es wird nicht als Abfolge von Ausstellungsräumen durch die Besucher_innen erschlossen, sondern durch einzelne Projektstandorte perforiert. Die Installationen von Nora Schultz im Foyer

und Michael Dean im Lichthof schreiben sich in den Gesamtkontext der Architektur ein und reflektieren das Selbstverständnis der Institution. Neben die Dichotomie von öffentlichem und privatem Raum, wie sie durch Gregor Schneiders im Wechselausstellungsbereich eingebaute Wohnung aufgegriffen wird, tritt der institutionelle Raum, dessen Niveau John Knight an der markanten Nordspitze des Baus durch eine große Wasserwaage auslotet. Das Projekt von Cosima von Bonin und Tom Burr auf dem Museumsvorplatz entstand in Kooperation mit dem Westfälischen Kunstverein, der zeitgleich zu den Skulptur Projekten mit *Surplus of Myself* Burr eine Einzelausstellung widmet. Auch die Installation von Ludger Gerdes' Leuchtschrift *Angst* (1998) am Aegidiihof gegenüber dem Museum, die im Zuge des Skulpturentauschs mit Marl nach Münster gewechselt ist, lässt sich als Kommentar zur Situation auf dem Vorplatz lesen: Seit der Eröffnung des Neubaus präsentiert sich der Landschaftsverband durch ein großes Logo in Otto Pienes Arbeit *Silberne Frequenz* (1970/1971, 2014) — eine Entscheidung, die nach wie vor zu Recht die Gemüter erhitzt.
Die Öffentliche Sammlung ist 2017 ebenfalls auf der Landkarte zu finden — 39 in der Stadt verbliebene Skulpturen der vergangenen Ausstellungen, mit Ausnahme der Skulptur *Ohne Titel (Fahrradständermonument B)* (1987) von Richard Artschwager, die wiederum im Zuge des Skulpturentauschs nach Marl versetzt wurde. Installationen wie Dan Grahams Pavillon *Oktogon für Münster* (1997) werden für die Ausstellungsdauer in der angrenzenden Allee zum Botanischen Garten wieder aufgestellt. Die aufgrund einer Baustelle in den vergangenen Jahren unzugängliche Arbeit *Ohne Titel* (Skulptur für die Chemischen Institute) (1987) von Matt Mullican lässt sich ab Juni wieder in der Nachbarschaft von Bruce Naumans *Square Depression* (1977/2007) besuchen. Für die Geschichte dieser Sammlung, die Entwicklung des Ausstellungsformats, Verschiebungen und Neubewertungen von Skulptur als Medium und viele andere kunsthistorische Themen liefert das Skulptur Projekte Archiv einen reichhaltigen Fundus. Seit 2016 werden, von den Archivalien ausgehend, regelmäßig künstlerische Positionen und ausgewählte Themen als Tiefenbohrungen sichtbar gemacht, wie aktuell mit *Double Check. Michael Ashers Installation Münster (Caravan) '77 '87 '97 '07* [S. 359]. Die Ausstellung umfasst historische Dokumente, aktuelles Material in Form von Interviews sowie eine eigenständige künstlerische Auseinandersetzung des Fotografen Alexander Rischer mit Ashers Werk in und für Münster.
Das Archiv ist Teil der Museumssammlung, Gegenstand und Mittel der wissenschaftlichen Forschung sowie Ausgangspunkt neuer künstlerischer Auseinandersetzungen. Seit Frühjahr 2017 fördert die VolkswagenStiftung das Projekt, das eine Metareflexion über die Ausstellungsgeschichte erlaubt.[5] Ziel ist es, das Archiv für Wissenschaft und Öffentlichkeit zugänglich zu machen sowie erste Forschungsergebnisse in Dissertationen zu präsentieren. 2018/2019 publiziert das Skulptur Projekte Archiv unter Mitarbeit der Forschungsgruppe eine umfangreiche wissenschaftliche Publikation, die alle fünf Ausgaben der Skulptur Projekte in den Blick nehmen wird.
Auch die Materialien zur Vorbereitung und Umsetzung der Ausstellung im Jahr 2017 werden schon bald Teil des Archivs sein. Neben vielen anderen interessanten, anregenden und kuriosen Dokumenten offenbaren sie auch die Schwierigkeiten, die das projektbezogene Arbeiten innerhalb eines auf Kontinuität angelegten Verwaltungsrahmens bedeutet, und das beständige Ringen um die Autonomie der Ausstellung. Aus dieser Erfahrung heraus möchten wir den Ausblick auf die aktuelle Ausstellung mit dem Appell beschließen, die Skulptur Projekte in Zukunft strukturell auf eigene Füße zu stellen. Aus einem Zusammenspiel von Stadt, Region und Land — sprich einer Förderung der Ausstellung durch die Stadt Münster, den Landschaftsverband Westfalen-Lippe, stellvertretend für die Region, und das Land Nordrhein-Westfalen — könnte sich eine ideale, unabhängige Konstellation für eine erweiterte Trägerschaft ergeben. An dieser Stelle möchten wir den Balanceakt zwischen Vergangenheit und Zukunft jedoch erst einmal an Mark von Schlegell übergeben, der in *Achte auf die Ecken (Münsterkristall)* [S. 417] sogar bis ins Jahr 2099 blickt…

Gemeinsam mit der Projektleiterin Imke Itzen sprechen wir allen Künstler_innen und vor allem dem großartigen Skulptur Projekte Team unseren herzlichen Dank aus. Jede /r einzelne hat entscheidend zum Gelingen der Ausstellung beigetragen: durch geniale eigene Ideen, einen Daniel-Düsentrieb-artigen Erfindergeist und musketier-haften Mut – und das trotz eines enorm großen Arbeitspensums.

Gedankt sei auch den Trägern der Ausstellung, dem Landschaftsverband West-falen-Lippe und der Stadt Münster für ihr von langer Hand geplantes Engagement sowie den vielen Förderern, ohne deren Unterstützung die Ausstellung nicht möglich gewesen wäre. Eine Vielzahl städtischer Ämter, Institutionen, wie die Westfälische Wilhelms-Universität, und Münsteraner Bürger_innen begleitete mit Rat und Tat Ent-stehungs- und Bewilligungsprozesse, genauso wie die Mitarbeiter_innen des LWL-Museum für Kunst und Kultur, deren Einsatz weit über das normale Maß hinausging. Praktische Unterstützung und eine fruchtbare inhaltliche Auseinandersetzung haben wir während der gesamten Vorbereitungsphase durch die enge Zusammenarbeit mit der Kunstakademie Münster und ihren Studierenden erfahren. Ihnen, dem Theater im Pumpenhaus, dem Skulpturenmuseum Glaskasten Marl und allen weiteren Koopera-tionspartnern gilt unser großer Dank. Nicht zuletzt danken wir Urs Lehni und Lex Trüb für ihre Unermüdlichkeit in Sachen Gestaltung, allen Katalogautor_innen, Überset-zer_innen und Lektor_innen sowie dem Verlag Spector Books für sein Vertrauen.

Kasper König, Britta Peters, Marianne Wagner

1 Internen Zahlen zufolge lag das Budget 1977 und 1987 unter einer halben Million DM, für 1997 war ein Anstieg auf sechs Millionen DM zu verzeichnen.
2 Herausgegeben durch die Skulptur Projekte, Redaktion John Beeson, Britta Peters und Luise Pilz (ab 2016), und distribuiert über das Kunstmagazin *frieze*. Online abrufbar unter www.skulptur-projekte.de.
3 Brigitte Franzen, „Am Beispiel Münster", in: Brigitte Franzen, Kasper König und Carina Plath (Hg.), *skulptur projekte münster 07*, Ausst.-Kat. LWL-Landesmuseum für Kunst und Kulturgeschichte, Münster, 2007, Verlag der Buchhandlung Walther König, Köln 2007, S. 13.
4 Die Kunstvermittlung schafft Situationen und stößt Prozesse an, in denen Veränderungen wahrgenommen und Wahrnehmungen verändert werden können. Das ausstellungsbegleitende Programm setzt den vielsprachigen Austausch unterschiedlicher Perspektiven fort, der mit Kooperationen wie *Mapping Skulptur Projekte*, bei der sich Schüler_innen mit Fluchterfahrung ästhetisch forschend mit dem Stadtraum auseinandersetzen, und dem medienpädagogischen Projekt *Mit unserem Blick* im Vorfeld begonnen wurde.
5 Basis für das Forschungsprojekt *Das Skulptur Projekte Archiv Münster. Eine Forschungseinrichtung für die Wissenschaft und die Öffentlichkeit* ist eine dreijährige Kooperation zwischen Museum und Universität unter der Leitung von Ursula Frohne und Marianne Wagner.

115

Disruption and Continuity

In 2017, the Skulptur Projekte will take place for the fifth time. The evolution of the international exhibition follows a process that, in essence, has hardly changed since 1977: artists are invited to Münster and asked to develop project proposals following their visits. Thus the profile of each exhibition emerges only as the works themselves take shape. In 1977 and 1987, no one could have foreseen that the Skulptur Projekte would eventually settle into a ten-year cycle. Its presentation again in 1997—with a clear commitment on the part of the city and the Landschaftsverband Westfalen-Lippe (LWL) as well as a significantly increased budget—is what laid the cornerstone for the periodic format.[1]

All the other conditions, however, have changed considerably since the 1970s: in the art world in general, there are more artists, more exhibitions, and more means of informing people about them globally and almost instantaneously. The urban space—of which an ever smaller percentage belongs to the municipality—is dominated by advertising and commercialized events, and its use is subject to a set of rules governing even minor details. There is far greater interest in art as a form of recreational activity, promoted since the 1990s by ever more ambitious city marketing endeavours. The speed of communication, transport, and travel has increased rapidly, already in comparison to 2007 alone, and in this respect 1977 and 2017 are poles apart. Reflection on the issue of how increasing digitalization, globalization, and the new economies associated with them are changing the art world—and, more especially, on our conceptions of body, time, and place—has been an integral part of developing the Skulptur Projekte 2017: the three-part magazine series *Out of Body*, *Out of Time*, *Out of Place*—published in the months preceding the exhibition—was devoted to these aspects.[2]

The purported 24/7 availability of everyone and everything has the effect of shrinking time. In view of this development, it has become ever more important to maintain a certain independence, especially considering the fact that deceleration is a quality inherent to the medium of sculpture. And the insistence on the ponderous ten-year interval has thus proven all the more crucial—prompting Brigitte Franzen, curator of the 2007 edition, to speak of the exhibition as a long-term study.[3] Among the constants are not only the city of Münster but also Kasper König, who has realized all the editions of the Skulptur Projekte since 1977 in various team constellations. The concern that the city and the LWL—the public entities backing the exhibition on the local and regional levels—might decrease the interval to five years was his main reason for once again taking on the artistic directorship in 2017, as it ensured that the existing format would continue in its accustomed rhythm.

The city of Münster is predominantly Catholic—its largest employers are the university and the municipal administration—its social structure is comparatively homogeneous, and its urban space easy to read. As such it has proven to be an ideal testing ground for the observation of synchronic and diachronic developments. The Skulptur Projekte make synchronic states, the contemporaneity of things, visible. They permit a view of the city, the society, and existing art, as well as pieces on temporary display, as a cross section of time. The regular recurrence of the exhibition exposes diachronic developments, differences, and perpetuations; the generous timing allows us to reflect

116

on sculpture as a medium and offers a detached perspective on the prevailing themes of a decade. The format amounts to a disclosure of Münster's 'state of mind'; it provides glimpses behind its façades, examining the life it leads and its self-absorption. The artificial quality of a city centre rebuilt to mimic its historical self sparks a wide spectrum of associations: Heinrich Mann's novel *The Little Town* (1909), Thornton Wilder's play *Our Town* (1938), and Peter Weir's movie *The Truman Show* (1998), to cite just a few examples. Gerhard Vinken's essay *Sculptures in the Urban Space: The End of Dialectics* [p. 408] analyses why the 'old town' enjoys such great popularity as a model these days. Peles Empire chose the city's gable constructions, coupled with pictorial quotations and abstractions from Peleş Castle—the edifice in the Carpathian Mountains in Romania that gave the artist duo its name—as a reference framework for their walk-on object entitled *Sculpture*. For Benjamin de Burca and Bárbara Wagner, the Elephant Lounge disco tucked away in a passage in the city centre serves as the point of departure and installation site for their film-based project *Bye Bye Deutschland! Eine Lebensmelodie*, which they developed in collaboration with the voice doubles—both locals—of two famous pop singers.

In view of the far-reaching consequences of globalization, however, in the year 2017 it would seem anachronistic to insist on Münster as a sole benchmark. In the process of grappling with this dilemma, the Skulpturenmuseum Glaskasten Marl emerged as a meaningful cooperation partner in many respects. In *The Hot Wire as an Opportunity for Focused Perception* [p. 350] the museum's director Georg Elben describes this connection from the Marl perspective. He also discusses the projects realized in the framework of the collaboration in detail, including *Le Tag / 200 m* by Joëlle Tuerlinckx, on display in Marl only. From the point of view of the Skulptur Projekte, the partnership broadens the exhibition space, both physically and conceptually, through the addition of a German town whose history took a course quite contrary to Münster's. In this context, Marl serves as a satellite with representative qualities: on the one hand, the town in the Ruhr district has a real and specific present; on the other, its architecture stands for the utopias of global modernism.

Broadly speaking, Marl's functionally oriented architecture and the role art played there until well into the 1970s can be regarded as integral elements of an endeavour to convey a democratic, humanist world view. The Skulptur Projekte, on the other hand, emerged in conflict with a town society that was still as staunchly conservative as ever. The identities chosen by the two cities after World War II—reconstruction and continuity in Münster, radical new beginning in Marl—could hardly be more different. One might venture the following thesis: whereas in Marl art was assigned the same function as historical architecture in Münster—that is, to serve as a vehicle of narrative meaning—the predominantly conceptual and minimalist works featured at the 1977 Münster Skulptur Projekte sought to counter the leisurely eloquence of those architectural surroundings with abstraction. The two cities also differ tremendously in the present. While Münster's population is growing and boasts an above-average proportion of affluent citizens, the once flourishing city of Marl has been struggling since the 1970s—when the first coal mines closed down—with a high unemployment rate, abandoned properties, and a range of social problems brought about by the resulting structural fragility.

The Münster–Marl connection is also the theme of the authors-in-residence programme entitled *Münster: Kur und Kür* curated by Monika Rinck. Ten authors are spending two weeks each in Münster, complete with an overnight stay in Marl if they so desire[p. 371]. Over a period that deliberately includes the final preparatory phase before the exhibition opens and its dismantling after 1 October, they are tracking the changes taking place in the city during the Skulptur Projekte on the literary level. As the choice of formats is entirely at their discretion, their contributions will form a kaleidoscope of different perceptions and linguistic explorations. In addition to the digital publication of their texts, a 'passing of the baton'—a joint reading at which one guest author takes leave of the SP17 and the next introduces him/herself—will take place every two weeks at the Freihaus ms.

Each edition of the exhibition 'inscribes' itself into an existing situation consisting of sculptures purchased since 1977 and still on display in the city and memories of past temporary projects. Various temporal constructions thus not only define the Skulptur Projekte's profile but also serve many of the artists as material. By virtue of their placement in front of the aristocratic Baroque Erbdrostenhof Palace built in 1753–1757 according to plans by Johann Conrad Schlaun, Nairy Baghramian's *Beliebte Stellen / Privileged Points* focuses on a site that has been used repeatedly in the exhibition framework—until now by male artists only. Yet the work is not just retrospective in nature: it also looks ahead to the future by allowing for its own possible purchase and installation at a different location. While the time factor plays an implicit role in nearly all of the artistic contributions, its constitutive significance is especially evident in the projects by Jeremy Deller and Xavier Le Roy with Scarlet Yu and in Lara Favaretto's *Momentary Monument—The Stone*. Michael Smith's project *NotQuite_Underground*, which is especially intended for people over the age of sixty-five, offers a permanent tattoo from a selection of motifs produced by, among others, artists who have participated in the Skulptur Projekte since 1977. Claire Doherty's essay elsewhere in the catalogue, *I've Been Here Before! Public Art and Public Time*, also addresses this aspect [p. 414].

A major international exhibition like the Skulptur Projekte, for which all the works except Thomas Schütte's *Nuclear Temple* (2011) have been newly created, is subject to its own laws. At the same time, it is developed under the conditions of a global present increasingly perceived as unsettling. The SP17 team began its work in January 2015 and was soon hosting the first artists' visits to Münster. It was a point in time when the so-called refugee crisis was already emerging and right-wing parties were visibly gaining momentum all over Europe—but before the reactionary backlash symbolized by such events as the Brexit vote, Trump's election to the office of US president, and Turkey's conversion into an autocracy under Erdoğan's rule.

These were the circumstances under which the artists developed the projects now constituting the exhibition in its final form. A number of the works address this situation directly, though without demonstratively illustrating it. Mika Rottenberg was already interested in the topic of the American–Mexican border before the discussion of a possible wall there got underway. Lara Favaretto's work forges a link to an organization that aids refugees in custody pending deportation. Alexandra Pirici takes the 1648 Peace of Westphalia as her starting point for a reflection on identity, national boundaries, and global communication. Other works manifest a political position, an example being the sculpture by Oscar Tuazon—which can be used as a fire pit as well as a place to spend time—in that it offers round-the-clock use of the 'infrastructure' it provides.

What all of the works—and the Skulptur Projekte art education programme—have in common is the wish to use the means of art to create a space of critical discernment and experience that is not limited to the realm of art but in many ways can also be seen in relation to social, philosophical, and political issues.[4] By producing a true-to-scale cast of the so-called Nietzsche Rock in Sils Maria but then propping it up on walkers, Justin Matherly has performed an act of physical exertion to penetrate the philosopher's aphorism of the 'eternal return of the ever-same', thus prompting us to revisit the classical text. Hervé Youmbi had highly qualified craftsmen in the vicinity of Douala make hybrid masks uniting Western pop-cultural influences with animistic traditions. Their site-specific installation at the former Überwasser cemetery—which already accommodates works from past Skulptur Projekte—spins a dense web of cultic and cultural references.

Ideally, an exhibition of this kind sets itself apart from other areas of society in that it implies no direct function–benefit relation. Its purpose, rather, is to organize projects in the urban space that are accessible free of charge and financed primarily by public funds. The experience of—or coincidental confrontation with—these works is in no way compulsory; there is no obligation to understand, judge, or even notice them, either now or at any time in the future. For all those involved, whether directly or indirectly,

actively or passively, the exhibition correlates with experiences that may have individual, and thus societal, consequences. In this respect, On Kawara's long-term project *Pure Concsciousness* proves absolutely paradigmatic. It is an explicitly non-educational measure devoted exclusively to a public made up of a group of kindergarten children who may or may not remember it later in life. In the framework of the SP17, Akiko Bernhöft organized the first realization of the project since Kawara's death and also introduces it in this catalogue [p. 369]. Politically, the Skulptur Projekte insist on the significance of the questions raised by the works on display—aesthetically honed attitudes that mirror their own time.

In 2017, thirty-five projects are scattered throughout the city in a wide radius. The works lure visitors to places off the well-trodden tourist paths: to Sternbuschpark in the south, the location of Hreinn Friðfinnsson's *fourth house of the house project since 1974*; to Aram Bartholl's project *12V* at the TV tower; to Pierre Huyghe's biotechnical organism in the former ice rink. Christian Odzuck took one of the few modern building complexes on the town periphery, the Oberfinanzdirektion (regional revenue office)—which has just been torn down—as an inspiration to reflect on the aesthetic vocabulary of modular construction with a focus on the future development of the urban space. With a crossing constructed slightly beneath the surface of the water, Ayşe Erkmen is the first artist to work with the harbour facilities. Her precarious link *On Water* between the two banks of a small branch canal accentuates the melange of old and new formed by a hazardous goods storehouse still in operation and a number of restaurants that have sprouted up in the area over the past decade.

Ephemeral actions, complex installations, and process-based or team-oriented working methods run counter to the wish for visible representation that has been an inherent aspect of the Skulptur Projekte since 1997. For a long time, Cerith Wyn Evans entertained the idea of taking something away from the city rather than adding yet another work to it, ultimately coming up with his proposal for a subtle manipulation of the church bells of St Stephanus. Despite the availability of mechanical means of production, artists like Michael Dean, Samuel Nyholm, or Ei Arakawa—who has installed a group of coarsely screened 'singing' LED panels on a meadow on Lake Aa—deliberately work in part with their hands so as not to leave the aesthetic of their art to the standardized processes of external production. In view of the administrative effort required for such a large-scale exhibition, this can almost be understood as a subversive approach and an endeavour to reconnect the machinery to the realities of artistic production. Much in the same vein, the process-oriented design of the SP17 communication media by Urs Lehni and Lex Trüb defies the idea of a strict corporate identity, while nevertheless ensuring high recognition value. Stage director Monika Gintersdorfer, artist Knut Klaßen, and their international network of performers are using the Theater im Pumpenhaus as a vibrant production venue for the duration of the exhibition.

The projects by Koki Tanaka and Xavier Le Roy and Scarlet Yu, both comprising workshops, are based on collaboration with various players and differing forms of community. Collective relationships are also the focus of the *Blumenberg Lectures* offered in cooperation with the University of Münster [p. 376]. As suggested by its title *Metaphern des Gemeinsinns – Contesting Common Grounds*, the series is addressing fundamental issues of the exhibition from the perspectives of different scholarly disciplines. The lectures will look at how various conceptions of publicness give pictorial expression to notions of community, and how society's attitudes towards community mirror present-day expectations, failures, and desires. Artist Gerard Byrne has chosen the public municipal library as the site of his work, thus drawing attention to a place whose fundamental purpose is to serve the common good.

To reduce a complex state of affairs to a few sentences: the body—one's own and that of others—is gaining importance in the context of increasing digitalization, and also within the new economies emerging as a result. In the digital realm it disappears; in reality it is enhanced with digital devices and high-tech prostheses. The only people capable of asserting themselves in the flexible, project-oriented world of work are

those in good physical shape. At the SP17, the artistic exploration of these matters is mirrored not only in performative works but also in sculptures and installations. Nicole Eisenman's fountain *Sketch for a Fountain*, an accumulation of plaster and bronze figures, juxtaposes images of the body conveyed by society and the media with the ideal of a relaxed self/other perception that defies standardization in terms of gender or any other category. When Emeka Ogboh encounters a city he is not familiar with, he is interested primarily in its sounds and taste. Rather than succumbing to the dominance of the sense of sight, he has created a sound installation that—referencing the epochal musician Moondog, who was buried in Münster in 1999—heightens our awareness of other levels of perception. While Raluca Voinea interlinks the themes of body, performance, and politics in her catalogue essay *Bodies Still Matter* [p. 390], Mithu Sanyal's text *Who Owns the Common Ground?* [p. 384] is concerned with racial profiling and the role played by gender and skin colour in the public space.

The projects by Hito Steyerl, Andreas Bunte, and Aram Bartholl focus more on the conditions and possibilities of digital technologies themselves. How does the Internet change our conceptions of the public and private spheres? How do robots affect the role of the human being? Inke Arns reflects on similar questions in her catalogue contribution *Freedom in an Age of Pattern Recognition* [p. 396]. Shaina Anand and Ashok Sukumaran, members of the interdisciplinary CAMP network, have installed a web of black cables in the inner courtyard of the Münster municipal theatre, connecting the ruins of the old theatre with the modern architecture of the first new theatre building (1954) to be erected in the Federal Republic of Germany after the war. They thus recall the utopian promise echoing in the spirit of optimism that informs the modern style. At the same time, they broaden present-day reflections on the democratic potential of digital communication by pointing back to its most essential prerequisite: access to electricity and the fundamental resources of social and economic life in general.

The Westfälisches Landesmuseum, now called the LWL-Museum für Kunst und Kultur, is the institution behind the Skulptur Projekte and as such has always been closely linked with them. It provides the infrastructure for the team working on site for a good two years before the opening to organize the exhibition in cooperation with various departments of the museum and the municipal administration. Yet the role played by the institution has evolved with every new edition. In 1977, owing to the initiative of its curator Klaus Bußmann—the Skulptur Projekte's originator—the museum served as the breeding ground for the development of the exhibition format. In the context of the SP17, the new museum building opened in late 2014 is posing a challenge. Like any building, it is not devoid of ideologies, expectations, rules of behaviour, claims of ownership, etc. Pursuing a concept that proclaims the museum as an integral part of the city, the design by Staab Architekten of Berlin makes use of courtyards and alternating interiors and exteriors to emphasize the institution's public character. In keeping with that idea, Angelika Schnell's text *The 'Polyvalent' Public Space* [p. 402] analyses the significance of museum buildings for the evolution of public space on a more general level, citing the Pompidou Centre in Paris by way of example.

In 2017, the museum is the venue for five of the exhibition's projects. Rather than offering the visitor access to them in a series of adjacent galleries, however, the building ensemble is perforated, as it were, by the individual project spaces. The installations by Nora Schultz in the foyer and Michael Dean in the atrium inscribe themselves into the overall architectural context and reflect the institution's self-conception. The theme of space is not confined to the public—private dichotomy addressed by Gregor Schneider's domestic interior installed in the temporary exhibition area but also encompasses institutional space, whose levelness John Knight measures with a large spirit level at the prominent northern tip of the building. In collaboration with Tom Burr—who at the invitation of Kristina Scepanski is showing his work in a solo exhibition at the Westfälischer Kunstverein, which is also located on the museum premises—Cosima von Bonin has devoted her work to the square in front of the museum.

Installed on the Aegidiihof opposite the museum complex, Ludger Gerdes's neon *Angst* of 1998—which has come to Münster in the context of the sculpture exchange with Marl—invites interpretation as a commentary on the square's spatial situation: since the new museum building opened, the Landschaftsverband has called attention to itself with a large logo installed literally *on* Otto Piene's *Silberne Frequenz* (1970/71, 2014)—a decision that is justifiably still causing a stir today.

The Public Collection—thirty-nine sculptures that have remained in the urban space from past Skulptur Projekte—also dots the map in 2017 (with the exception of Richard Artschwager's *Ohne Titel (Fahrradständermonument B)* on view in Marl as part of the sculpture exchange). A number of these older works, for example Dan Graham's 1997 pavilion *Octagon for Münster* (1997), have been re-erected in the tree-lined avenue adjoining the botanical garden for the duration of the exhibition. In June it will once again be possible to visit Matt Mullican's *Ohne Titel (Bodenrelief für die Chemischen Institute)* (1987) near Bruce Nauman's *Square Depression* (1977/2007): Mullican's work has been inaccessible in recent years because of a construction site. The Skulptur Projekte Archive offers a rich fund of documentary material on the history of this collection and the development of the exhibition format, as well as on the ongoing reappraisal of sculpture as a medium and other art-historical aspects. Since 2016, the archive has served as a point of departure for regular 'deep-drilling' endeavours—presentations on artists and other selected topics, for example *Double Check: Michael Asher's Installation Münster (Caravan) '77 '87 '97 '07* [p. 363]. This exhibition presents historical documents, current material in the form of interviews, and an independent artistic exploration of Asher's work in and for Münster by the photographer Alexander Rischer.

The archive is part of the museum collection, a subject and means of scholarly research, a basis for new artistic deliberations, and an opportunity for meta-reflection on the history of the exhibition.[5] A project sponsored by the Volkswagen Foundation since the spring of 2017 has set out to make the archive accessible to scholars and the public, and to present initial research results in dissertations. Within this context, an extensive scholarly publication slated for publication in 2018/19 will, moreover, take an in-depth look at all five editions of the Skulptur Projekte.

The material coming out of the preparations for the 2017 exhibition will also soon enter the archive. Among other things, this fund of interesting, inspiring, and unusual documents sheds light on the difficulties arising from project-oriented work within an administrative context based on continuity, and on the constant struggle to ensure the exhibition's autonomy. On the strength of this experience, we would like to close this overview of the current exhibition with an appeal for the Skulptur Projekte's structural autonomy in the future. Interplay between city, region, and state—that is, broad institutional backing of the exhibition by Münster, the Landschaftsverband Westfalen-Lippe, and North Rhine-Westphalia, respectively—would create the ideal conditions for the exhibition as an independent entity.

For now, let us leave the balancing act between past and future to Mark von Schlegell, who in *Watch the Corners (Münstercrystal)* [p. 423] looks ahead all the way to 2099 … But before doing this, we would like, in conjunction with the project manager Imke Itzen, to express our heartfelt thanks to all the artists and to the magnificent Skulptur Projekte team. Each and every one of them has made a crucial contribution to the success of the exhibition: with their inspired ideas, Musketeer-like valour, and a spirit of inventiveness worthy of Gyro Gearloose—and that in spite of a huge workload.

Our thanks too to the institutions behind the exhibition—the Landschaftsverband Westfalen-Lippe and the City of Münster—for their long-standing commitment, as well as to our many sponsors, without whose support the Skulptur Projekte would not have come to fruition. A wide range of municipal departments, institutions like the University of Münster, and many of the city's inhabitants were actively involved, in both word and deed, in the development and approval processes. The staff at the LWL-Museum für Kunst und Kultur also played an important role: their sense of dedication went far beyond what might ordinarily be expected. Throughout the pre-

paratory phase we enjoyed practical support and productive discussions about content with the students and staff at the University of Fine Arts Münster, with whom we worked in close collaboration. We are extremely grateful to them, to the Theater im Pumpenhaus, to the Skulpturenmuseum Glaskasten Marl, and to all our other cooperation partners. Finally, we would like to thank Urs Lehni and Lex Trüb for their tireless input in design-related matters, as well as all the catalogue authors, translators, and editors—and the publishing house Spector Books for the faith they placed in the project.

Kasper König, Britta Peters, Marianne Wagner

1 According to internal figures, the budget for 1977 and 1987 was less than 500,000 Deutschmarks in each case; by 1997 it had increased to 6 million Deutschmarks.
2 Published by the Skulptur Projekte, edited by John Beeson, Britta Peters, and Luise Pilz (from 2016), and distributed as a supplement to frieze art magazine. Available online at: www.skulptur-projekte.de.
3 Brigitte Franzen, 'Using the Example of Münster', in Brigitte Franzen, Kasper König, and Carina Plath (eds.), skulptur projekte münster 07 (exh. cat. LWL-Landesmuseum für Kunst und Kulturgeschichte, Münster; Cologne: Verlag der Buchhandlung Walther König, 2007), 13.
4 The mediation of art creates situations and initiates processes in which changes are perceived and perceptions changed. The programme accompanying the exhibition continues the multilingual exchange between different perspectives. This exchange began ahead of time with cooperations like Mapping Skulptur Projekte—in which students with refugee experience researched and explored the urban space in aesthetic terms—and Mit unserem Blick, a project focusing on media pedagogy.
5 A three-year partnership between the museum and the university, directed by Ursula Frohne and Marianne Wagner, forms the basis for the research project Das Skulptur Projekte Archiv Münster: Eine Forschungseinrichtung für die Wissenschaft und die Öffentlichkeit.

Projekte/Projects A–Z

Ei Arakawa

Die Arbeiten Ei Arakawas (* 1977 Fukushima, lebt in New York) sind meist performativ und schließen alltägliche Gegenstände, Kunstwerke oder Menschen als Akteur_innen gleichsam und gleichberechtigt ein. An künstlerische Strategien der Gutai-Gruppe und Fluxus anknüpfend, spielen Musik und Text in seinen Installationen und Aufführungen eine wichtige Rolle.

Harsh Citation, Harsh Pastoral, Harsh Münster

Für die Skulptur Projekte 2017 inszeniert Arakawa auf einer Wiese am südwestlichen Ende des Aasees ein Licht- und Klangspiel. Der Künstler gruppiert sieben grob gerasterte LED-Malereien, die er per Hand zusammengefügt hat, auf der Grünfläche. Als Bildvorlagen für diese Panels dienen Gemälde von Gustave Courbet, Nikolas Gambaroff, Jutta Koether, Joan Mitchell, Amy Sillman, Reena Spaulings und Atsuko Tanaka. In direkter Nachbarschaft zum Haus Kump, einer der ältesten Siedlungen in Münster und dem Sitz der Akademie der Gestaltung der Handwerkskammer, werden die leuchtenden und tönenden Bilder als ein audiovisueller Chor in der Landschaft arrangiert.

Wie häufig in Arakawas Werk wird Malerei mit einem performativen Potenzial ausgestattet. In seiner künstlerischen Praxis zeigt sich unter anderem ein zwiespältiges Verhältnis zur gängigen Rezeption von Gemälden als an der Wand hängenden Objekten. Arakawa trug schon in früheren Projekten Leinwände durch Museumsräume, um starre Verhältnisse aufzubrechen und ein gegenseitiges Aktivierungspotenzial von Bild und Rezipient_innen zu ermöglichen. Das gemeinsame Stehen oder Gehen, Singen oder Sprechen wird zu einem Akt kollektiver Kreativität. Häufig tritt dabei eine Handlungsmacht zutage, in der die Idee des Individuums durch gemeinschaftliche, partizipative Energie ersetzt wird. Deshalb zeichnen sich auch die von ihm hergestellten Objekte durch eine starke Do-it-yourself-Ästhetik aus: An der Perfektion eines maschinell und anonym hergestellten Ergebnisses ist Arakawa nicht interessiert. Für sein Projekt in Münster ist die Idee der Gemeinschaft in zweifacher Hinsicht wichtig: Er vereint eine Gruppe digitaler Tafelbilder, die in der Landschaft leuchten. Arakawa gibt ihnen – ganz wörtlich – eine Stimme, und räumt der digitalen Kopie die Interpretationshoheit über sich selbst und das entsprechende Original ein. Die Objektgemeinschaft generiert aus einer nur bedingt kontrollierbaren audiovisuellen Interaktion neue Formen ihrer selbst. Darüber hinaus entsteht an dem ruhigen und abgelegenen Ort eine temporäre Gemeinschaft der Besucher_innen. Das Spazieren und die Begegnung mit Arakawas LED-Malereien auf der grünen Wiese wird in der Wahl von Courbets Gemälde *Die Begegnung* (1854) reflektiert. Die Vorlage dieser Malerei zeigt die bedeutende Begegnung des wandernden Künstlers mit seinem Mäzen in einer flachen, grünen, pastoralen Landschaft. N.A.

[Grobes Zitat, schroffe Pastorale, ruppiges Münster]

Material
7 LED-Streifen auf handgefärbtem Textil, LED-Transmitter, Netzteile, SD-Karten, Energieumwandler, Karton, Verstärker, Mediaplayer

Maße
LED-Malereien:
130 × 150 cm (Gustave Courbet)
193 × 128 cm (Nikolas Gambaroff)
190 × 250 cm (Jutta Koether)
188 × 280 cm (Joan Mitchell)
115 × 110 cm (Amy Sillman)
147 × 279 cm (Reena Spaulings)
194 × 131 cm (Atsuko Tanaka)

Standort
Wiese vor Haus Kump
Mecklenbecker Straße 252,
48163 Münster

Credits
Musik: Christian Naujoks
Text: Ei Arakawa und Dan Poston
Metallrahmen: Gela Patashuri

Ei Arakawa

Ei Arakawa's (*1977 Fukushima; lives in New York) art is mostly performative and includes everyday objects, works of art, and people as his actors, as it were, with each accorded an equal footing. Music and lyrics play an important role in his installations and performances, as he draws on the artistic strategies of the Gutai group and Fluxus.

Harsh Citation, Harsh Pastoral, Harsh Münster

For Skulptur Projekte 2017, Arakawa has staged a light and sound show on the south-western end of Lake Aa. He has grouped seven pixelated LED paintings he assembled himself on the grassy space. Paintings by Gustave Courbet, Nikolas Gambaroff, Jutta Koether, Joan Mitchell, Amy Sillman, Reena Spaulings, and Atsuko Tanaka serve as source material for these panels. Situated adjacent to Haus Kump—one of the oldest settlements in Münster and the seat of the Academy of Design and Crafts under the aegis of the Chamber of Crafts and Skilled Trades—these illuminated pictures accompanied by sound are arranged like an audiovisual choir in the landscape.

As is often the case in Arakawa's work, painting is endowed with a performative potential. Arakawa's artistic approach mirrors, among other things, his ambivalent relationship to the contemporary reception of painting as an object hung on the wall. In earlier projects, for example, he carried canvases through the museum space to disrupt rigid gallery conditions and enable a mutual activation potential between image and recipient. Standing, walking, singing, or speaking together becomes an act of collective creativity. This frequently engenders an agency in which the idea of the individual is replaced by a communal, participatory energy. That is why the objects he produces are also characterized by a powerful Do-It-Yourself aesthetic: he is not interested in the perfection of a mechanically produced, anonymous result. The notion of the collective is important for Arakawa's Münster project in two respects. He combines a group of digital panels that illuminate a landscape and—quite literally—gives them a voice, while granting the digital copy an interpretative authority over itself and the corresponding original. The community of objects generates new forms of itself from an audiovisual interaction that can only be partially controlled. Furthermore, a temporary community of visitors is created at a peaceful and remote location. The walk and the encounter with Arakawa's LED paintings on the green field is reflected in the choice of Courbet's *The Meeting* (1854). The original source of this painting shows the important encounter of the wandering artist with his patron while walking through a flat, green, pastoral landscape. N.A.

Material
7 LED strips on hand-dyed fabric, LED transmitter, power supply units, SD cards, transducers, cardboard, amplifiers, media player

Dimensions
LED paintings:
130 × 150 cm (Gustave Courbet)
193 × 128 cm (Nikolas Gambaroff)
190 × 250 cm (Jutta Koether)
188 × 280 cm (Joan Mitchell)
115 × 110 cm (Amy Sillman)
147 × 279 cm (Reena Spaulings)
194 × 131 cm (Atsuko Tanaka)

Location
Meadow in front of Haus Kump
Mecklenbecker Straße 252,
48163 Münster

Credits
Music: Christian Naujoks
Lyrics: Ei Arakawa and Dan Poston
Metal frames: Gela Patashuri

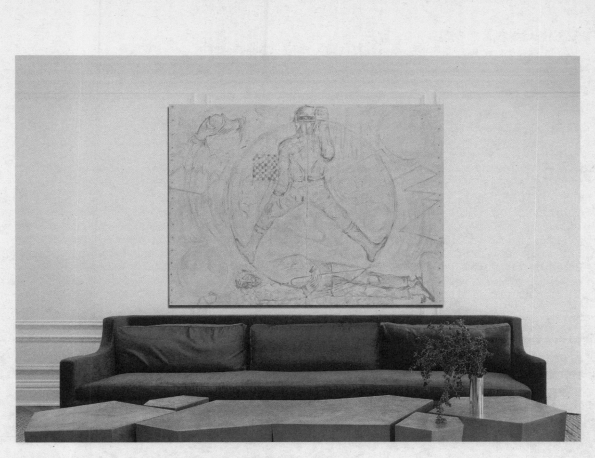

Ei Arakawa, Postkarte mit einem Bild von / postcard with an image by
Jutta Koether, *Formula Won Balthus, PdF #3*, 2016

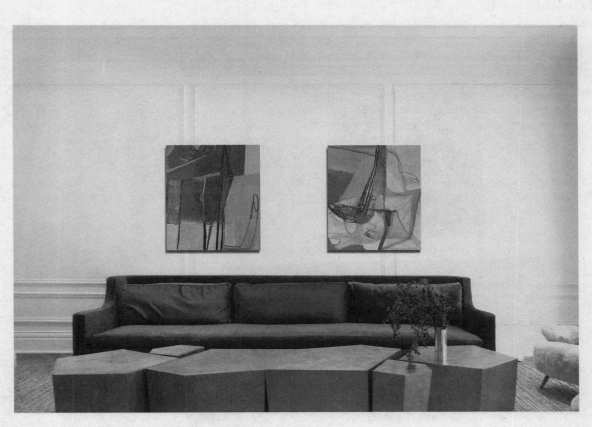

Ei Arakawa, Postkarte mit Bildern von / postcard with images by
Amy Sillman, *N*, 2007, und / and *B*, 2007

Ei Arakawa, Postkarte mit einem Bild von / postcard with an image by
Atsuko Tanaka, *Work 66–SA*, 1966

Ei Arakawa, Postkarte mit einem Bild von / postcard with an image by
Gustave Courbet, *Die Begegnung / The Meeting*, 1854

Ei Arakawa, Postkarte mit einem Bild von / postcard with an image by
Reena Spaulings, *Later Seascape 6*, 2014

Ei Arakawa, Postkarte mit einem Bild von / postcard with an image by
Nikolas Gambaroff, *Four Doors*, 2017

Ei Arakawa, Postkarte mit einem Bild von / postcard with an image by
Joan Mitchell, *Untitled*, 1992

Harsh Citation, Harsh Pastoral, Harsh Münster

Decennial. Painting like riding a bike with no hands.
Riding to harsh pastoral. Harshness of footing on the land.
Bonjour Monsieur!
You are greeted by bright LED one gloomy afternoon.

Time is brain. The 4-hour bodies. Tools for living. Performance.
We always begin with a circular motion.
Sensors on, spiraling outwards from the center
Attacking the canvas, and we are stuck. We are tough-eyed bitches.

A nipple and an arm. They become a polyhedron of dirty grey.
A beard. It becomes a patch of banana yellow.
Entwined legs become Itajime stripes.
Before scumbling off on jaunty diagonals
As we calculate the size and shape of the job.
Harsh bohemia. But also, harsh ausschreibung.
How are we doing today?

No one should ask the children about their reactions to the paintings.
Non-solo, but non-group. Irritation social networks.
Failed le prophète of Haus Kump. Sites and citation.
The bells travel in between. Cables winding.
Harsh citation of seven songs.

Bonjour Madame!
Her spirit will continue to spread through the pastoral!
Harsh Münster…
Münster LED Malerei Projekte 2017…

(For Jutta)

Innenaufnahmen / Interior photos: Reggie Shiobara; Ort / Location: Eleanor Cayre; Modell / model: Jacob King

Nairy Baghramian

In komplexen Installationen führt Nairy Baghramian (* 1971 Isfahan, lebt in Berlin) Objekte und Skulpturen zusammen, die unterschiedlichen Genres der Bildhauerei zugeordnet werden können. Ihre Formensprache umfasst fragile, wie aus Handgriffen oder einer zeichnerischen Geste heraus entwickelte Objekte genauso wie Arbeiten, die an Prothesen, Stützen, Brüstungen und Polster erinnern. Obwohl Baghramian sich jeweils präzise auf die architektonische, historische und institutionelle Rahmung der spezifischen Ausstellungssituation bezieht, besitzen ihre Werke eine konzeptuelle Wandelbarkeit und Anpassungsfähigkeit, mit der die Künstlerin bewusst arbeitet. So kommen beispielsweise bestimmte Werkgruppen häufiger zum Einsatz und laden sich darüber mit einer weiteren Geschichte auf.

Beliebte Stellen / Privileged Points

Als Standort für ihre Arbeit *Beliebte Stellen / Privileged Points* wählt Baghramian eine der ersten Adressen in Münster: den Erbdrostenhof (1757 von Johann Conrad Schlaun erbaut). Im Vorhof des Barockpalais platziert sie eine geschwungene Markierung, die sich aus drei aneinander anschließenden schlanken, dennoch schwergewichtigen, aus Bronze gegossenen Elementen zusammensetzt. Sie sind mit sichtbaren Klammern verbunden und an wenigen Stellen auf dem Kopfsteinpflaster des Innenhofes abgestützt. Die im Durchschnitt circa fünf Meter messende offene Kreisform ist genau von den Objektmaßen unterbrochen, mit denen im Bronzegussverfahren ein optimales Ergebnis zu erzielen ist. Auf dem rückwärtigen Hof des Palais (der vom Servatiikirchplatz aus zu erreichen ist) stapelt sich ein Konvolut aus sechs vergleichbaren Teilstücken, aus denen zwei weitere *Beliebte Stellen / Privileged Points* zusammengesetzt werden können.

Mit der Wahl des Standorts stellt sich die Künstlerin bewusst in die Tradition der skulpturalen Positionen von Richard Serra (*Trunk – Johann Conrad Schlaun recomposed*, 1987) und Andreas Siekmann (*Trickle Down. Der öffentliche Raum im Zeitalter seiner Privatisierung*, 2007), die sich anlässlich der Skulptur Projekte eine beziehungsweise drei Dekaden zuvor in den gleichen Ort eingeschrieben haben. Baghramian antizipiert mit ihrem Werk das kulturpolitische Davor und Danach sowie die behauptete Ortsspezifik der vorangegangenen Setzungen, die vor allem im Werk von Serra eine zentrale Rolle spielt. Erst nach der aktuellen Ausstellung, im Fall eines Ankaufs der Arbeit, sollen die Einzelteile der zunächst provisorischen und nur mit einer Vorlackierung versehenen Skulptur verschweißt und das Werk *vollendet* werden. Baghramian bezieht sich konkret auf die Geschichte von Kunst an diesem Ort, aber setzt bewusst keine ortsspezifische Beschränkung, die eine Installation des Werkes in einem anderen städtischen Kontext oder dem einer Sammlung ausschließen würde. Sie ist den Diskussionen und der Entscheidung über den Verbleib ihrer Skulptur in Münster einen Schritt voraus – diese sind ihrem Werk immanent. N.T.

Material
Lackierte Bronze, Metall, Zurrkette, Spindelspanner, Gummi

Standort
Vorplatz und Hinterhof
des Erbdrostenhofs
Salzstraße 38, 48143 Münster

Nairy Baghramian

Nairy Bagrahmian (*1971 Isfahan; lives in Berlin) brings together objects and sculptures that can be assigned to different sculptural genres. Their aesthetic vocabulary incorporates fragile objects that seem as if they were shaped by a flick of the wrist or a sketching gesture as well as works that resemble prosthetics, supports, parapets, and cushions. Although Baghramian always precisely alludes to the architectural, historical, and institutional framing of the specific exhibition environment, her works possess a conceptual mutability and adaptability that the artist consciously exploits. In this way, certain groups of works are deployed more frequently and recharged with further narratives.

Beliebte Stellen / Privileged Points

Baghramian chose one of the top locations in Münster for her work *Beliebte Stellen / Privileged Points*: the Erbdrostenhof (a baroque palace built by Johann Conrad Schlaun in 1757). In the palace forecourt she has placed an elegantly curved bronze landmark, consisting of three slender but heavy, interconnecting elements. They are held together by visible clamps and propped up in a few spots on the courtyard's cobblestones. The open circle, measuring a diameter of approximately five metres, is explicitly interrupted by the dimensions of the objects, whose bronze casting makes for an optimal result. In the palace's rear courtyard (which can be accessed from the St Servatii church square), six similar sculpture elements are piled up and can be used to assemble two more *Beliebte Stellen / Privileged Points*.

By choosing this particular location, the artist deliberately follows the tradition of sculptural positions by artists like Richard Serra (*Trunk: Johann Conrad Schlaun Recomposed*, 1987) and Andreas Siekmann (*Trickle Down: Der öffentliche Raum im Zeitalter seiner Privatisierung*, 2007) who left their mark on the same location—thirty and ten years ago respectively, both as contributions to the Skulptur Projekte. With her work, Baghramian anticipates the cultural-political *before and after* as well as the professed site-specificity of the previous sculptures located here, which plays a key role, especially with regard to Serra's work. Not until the exhibition is over, provided that the work has been sold, will the separate elements of the sculpture—which is initially provisional and only finished with a primer—actually be welded together and the work completed. Baghramian refers specifically to the history of art at this location, but she doesn't consciously impose any site-specific restrictions that would exclude the possibility of installing the work in another urban context or as part of a collection. She is one step ahead of the debates and the decision regarding the fate of her sculpture in Münster—they represent an immanent part of her work. N.T.

Material
Lacquered bronze, metal, lashing chain, tensioning devices, rubber

Location
Front and rear courtyard of Erbdrostenhof
Salzstraße 38, 48143 Münster

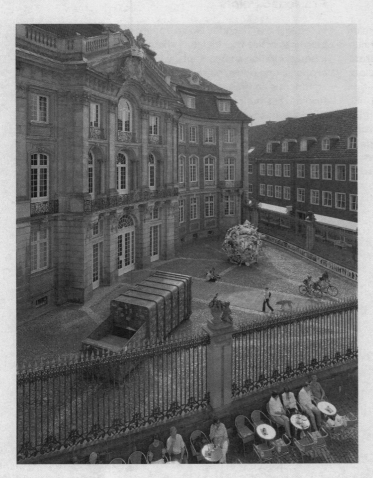

Andreas Siekmann, *Trickle Down. Der öffentliche Raum im Zeitalter seiner Privatisierung*, Skulptur Projekte 2007, Erbdrostenhof

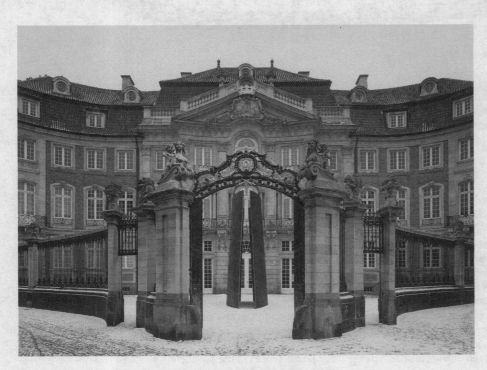

Richard Serra, *Trunk – Johann Conrad Schlaun Recomposed*, Skulptur Projekte 1987, Erbdrostenhof

Beliebte Stellen

In den vergangenen zwei Jahrzehnten hat Nairy Baghramian eine künstlerische Praxis entwickelt, die Fotografien, Zeichnungen, (kunst-)kritische Texte, Ausstellungssupplemente, kuratorische Konzepte und Kollaborationen, vor allem aber Skulpturen umfasst, die unablässig mit den Objektwelten von Design, Mode, Kosmetik und Kulinarik kommunizieren. Aufgrund (und nicht etwa trotz) des durchgängigen Prinzips einer Negation von Figuration, Gestalt, Masse und Volumen eignet Baghramians Skulpturen eine prekäre Körperlichkeit; umso prägnanter spiegeln sie indes die materiellen, diskursiven und kontextuellen Bedingungen künstlerischer Produktion und ästhetischer Erfahrung in sich wider und bringen sie zugleich auf Distanz.

Privileged Points

In the last two decades Nairy Baghramian has developed an artistic practice that includes photography, drawing, (art) criticism, exhibition supplements, curatorial concepts and collaborations, and above all sculpture. Her sculptural works are in continuous communication with the object worlds of design, fashion, cosmetics, and the culinary arts. It is not in spite but precisely because of the consistent principle of negating figuration, gestalt, mass, and volume that Baghramian's sculpture takes on a precarious corporeality; her works reflect the material, discursive, and contextual conditions of artistic production and aesthetic experience all the more incisively and at the same time manage to put them at a distance.

Nairy Baghramian, *Beliebte Stellen / Privileged Points*, 2014, Neuer Berliner Kunstverein

Mit ihrer fortlaufenden Serie *Beliebte Stellen*, die erstmals 2011 im Stedelijk Museum in Amsterdam gezeigt wurde, rückt Baghramian die Methoden und Modalitäten des Zeigens von Kunstwerken in den Fokus ihrer allegorischen Arbeit an der Geschichte und Gegenwart der avancierten Skulptur: Auf unterschiedlicher Höhe an den Wänden sowie an verschiedenen Positionen auf dem Boden des jeweiligen Ausstellungsraums installiert die Künstlerin variabel dimensionierte, offene Ringe aus massivem Metall, die mit mehreren Schichten Epoxidharz und Lackfarbe – beispielsweise in mintgrün, hellblau, maritim, rosa, petrol und ocker – überzogen worden sind. An den glänzenden Oberflächen der bogenförmigen Objekte bleiben Tropfen oder Farbnasen als haptische Spuren des Herstellungsprozesses erkennbar. Das beträchtliche Gewicht der in Struktur, Radius und Umfang unregelmäßigen Kringel wird lediglich an einem Punkt an der Wand gehalten; auch mit dem Boden besteht stets

In her ongoing series *Beliebte Stellen* (Privileged Points), which was shown for the first time in 2011 at the Stedelijk Museum in Amsterdam, Baghramian shifts the focus of her allegorical work on the history and present of advanced sculpture to the methods and modalities of the presentation of artworks. The artist installs variously sized open rings made of solid metal coated with multiple layers of epoxy resin and gloss paint (including such colours as mint green, light blue, teal, pink, sapphire blue, and ochre) at different heights on the wall and in different positions on the floor of the given exhibition space. Drips or runs remain on the shiny surfaces of the curved objects as haptic traces of the production process. The rings are irregular in their structure, radius, and size, and their considerable weight is supported at a single point on the wall. Even those placed on the floor are only partially in contact with the surface. The result is a tangible tension between the lightness suggested

Nairy Baghramian, *Beliebte Stellen / Privileged Points*, 2014, Neuer Berliner Kunstverein

nur partieller Kontakt. So ergibt sich eine greifbare Spannung zwischen der durch Form, Farbe, Hängung und Raumverteilung suggerierten Leichtigkeit und der tatsächlichen Materialität von Baghramians plastischen Propositionen. Obwohl sie wie bloße Markierungen wirken, die mit schneller Geste vorgenommen wurden (so wie etwa rasch per Hand vorgenommene Einkreisungen von Textstellen), handelt es sich keineswegs um lapidare Setzungen, sondern um geradezu gravitätische Gebilde, welche die zugewiesenen institutionellen Orte künstlerischer Sichtbarwerdung präzise besetzen.

Wiederholt lenkt Baghramians Werkkomplex die Blicke auf jene architektonischen Regionen, die bevorzugt zur Präsentation künstlerischer Arbeiten genutzt werden. Neben den Stellen, die konventionell für Gemälde und Skulpturen reserviert sind, setzen die bunten Ringe zudem an Ecken und Wandpartien kurz

by the form, colour, hanging, and spatial distribution and the actual materiality of Baghramian's sculptural propositions. Though they seem like mere markings rendered by means of rapid gestures (somewhat like a hastily drawn circle around a passage in a text), these are not tersely posited ideas but ponderous objects that precisely occupy the assigned institutional locations where artistic ventures are made visible.

Again and again Baghramian's work series draws attention to architectural zones that are typically utilized for the presentation of artistic works. In addition to the locations conventionally reserved for paintings and sculpture, the colourful rings are placed in corners or positioned on walls either just above the floor or just below the ceiling. In this way, her *Privileged Points* provides a new perspective on the margins and insular zones that have served since the late 1960s to suggest a critical atti-

oberhalb des Bodens oder in Deckennähe an. Damit eröffnen die *Beliebten Stellen* eine Perspektive auch auf jene Ränder und insularen Zonen, die seit den späten 1960er Jahren als Ausweis eines kritischen Umgangs mit den etablierten Standards des Ausstellens gelten. Baghramians skulpturale Indikatoren, die im buchstäblichen wie figurativen Sinn um eine Leerstelle kreisen und diese als Platzhalter farbig einfassen, forcieren so nicht zuletzt die Frage nach der zeitgenössischen Relevanz und Reichweite ortsspezifischer Strategien, wie sie auch ihre eigene Praxis – die seit den späten 1990er Jahren immer wieder die Schwellen, Übergänge und Rückseiten eines gegebenen Ausstellungsparcours betont und bespielt hat – maßgeblich informiert haben.

Mit seiner Arbeit *Locations* hatte Richard Artschwager im Zuge seines Langzeitprojekts der *blps* – tablettenförmige Markierungen [engl. *blips*], die der Künstler anonym in diversen Materialien an verschiedenen öffentlichen wie institutionellen Orten ausführte – bereits im Jahr 1969 in Reaktion auf die räumliche Orientierung der minimalistischen Skulptur spielerisch die Möglichkeiten aufgefächert, die Eckzone eines Ausstellungsraums mit abstrakten Elementen aus Metall, Glas, Spiegel, bemaltem Holz und gummiertem Pferdehaar zu interpunktieren. Mit seinem Werk *Ringe* hat Thomas Schütte seit 1981 den White Cube immer wieder in regelmäßigen Intervallen mit den titelgebenden Objekten aus farbig bemaltem Holz überzogen und damit angesichts der reduziert-repetitiven Verfahren einer sich als institutionskritisch begreifenden Malerei den Umschlag von analytischen Markierungen in Wandschmuck ironisch forciert. Mit ihren *Beliebten Stellen* nähert Baghramian die zeitgenössische Skulptur ebenfalls bewusst dem Terrain des Ornamentalen an, zielt dabei zugleich aber auf die in der künstlerischen Formation der kontextbezogenen Skulptur seither vollends durchgesetzte Norm der Abweichung: Das weit verbreitete Vertrauen in den Mehrwert, der mit der vermeintlich unerwarteten Betonung abseitiger Stellen von Ausstellungsorten einhergehen soll, konfrontiert die Werkserie mit der Einsicht, dass jede künstlerische Methode, die ihren Automatismen gegenüber blind bleibt, trotz bester Absichten als Lieferant von bloßem Design zu enden droht.

Baghramians *Beliebte Stellen* artikulieren eine Dialektik von Demarkation und Dekoration. Für die Skulptur Projekte Münster 2017 hat die Künstlerin ihre Auseinandersetzung mit den Prämissen und Prozeduren der zeitgenössischen Skulptur um eine Reflexion des Verhältnisses von temporärer Setzung und permanentem Werk erweitert: Nicht nur okkupiert und ornamentiert sie mit dem Platz vor dem Erbdrostenhof eine der beliebtesten Stellen des vier Jahrzehnte alten Ausstellungsformats; indem ein vergleichsweise monumentaler, in einem gräulichen Blauton kolorierter Ring aus dem Wert und Beständigkeit suggerierenden Material Bronze im zusätzliche Stützelemente bedürfenden Zustand einer unvollendeten Montage präsentiert und in dem zum Depot deklarierten Hinterhof des barocken Palais durch zwei noch vollständig in Einzelteile zerlegte Varianten komplementiert wird, lässt Baghramians Beitrag bewusst die Frage offen, ob weitere Manifestationen ihrer Serie für andere Orte in Vorbereitung sind beziehungsweise in Nachfrage stehen – oder aber selbst die annähernd vollendete Skulptur lediglich ihres Aufbaus und Abtransports nach Ende der Ausstellung harrt.

André Rottmann

tude towards the established norms of art exhibitions. Baghramian's sculptural indicators—which both literally and figuratively revolve around an empty space and curl colourfully around this space as placeholders—compel one to question the contemporary relevance and scope of site-specific strategies, which have also been critical in shaping the artist's own practice: since the late 1990s she has consistently emphasized and adorned the thresholds, transitional points, and rear sides of exhibition scenarios.

Back in 1969 Richard Artschwager playfully explored the possibilities of punctuating the corners of an exhibition space with abstract elements made of metal, glass, mirrors, painted wood, and rubberized horse hair. Entitled *Locations*, this work was part of the long-term project *blps*, which consisted of pill-shaped markings (or blips) that the artist executed anonymously in various public and institutional sites using different materials, as a reaction to the spatial orientation of minimalistic sculpture. For his work *Ringe* (Rings), which he began in 1981, Thomas Schütte has repeatedly covered the White Cube at regular intervals with ring-like objects made from colourfully painted wood, by means of which he ironically transforms analytical markings into wall decoration as a direct contrast to the reductionist, repetitive method of painting that considers itself an articulation of 'institutional critique'. With her *Privileged Points* Baghramian also consciously shifts contemporary sculpture towards the territory of the ornamental, while at the same time questioning the standard variance that has become generally accepted in the artistic development of context-related sculpture. The widespread faith in the surplus value that goes together with the supposedly unexpected emphasis on quirky areas of an exhibition venue is countered in the series by the insight that any artistic method that remains blind to its own automatisms runs the risk, despite its best intentions, of ultimately purveying mere design objects.

Baghramian's *Privileged Points* articulates a dialectic of demarcation and decoration. For Skulptur Projekte Münster 2017 the artist has extended her exploration of the premises and procedures of contemporary sculpture with a reflection on the relationship between temporary placement and permanent work. Not only does she occupy and adorn the square in front of the Erbdrostenhof palace, which is one of the favourite locations of the exhibition project now entering its fifth decade, but by presenting a comparatively monumental greyish-blue ring made from bronze (a material that suggests enduring value) in an incomplete state that requires additional supporting elements, and by placing two completely disassembled variations of the rings in the baroque palace's rear courtyard (thus converting the courtyard into a kind of depot), Baghramian's work intentionally leaves the question unanswered as to whether further manifestations of her series in other locations are being planned or are in demand—or whether the all-but-completed sculpture itself is merely waiting to be reassembled and carted away after the exhibition is over.

André Rottmann

Aram Bartholl

Aram Bartholl (* 1972 Bremen, lebt in Berlin) setzt sich als Installations- und Performancekünstler mit den Möglichkeiten und Folgen zunehmender Digitalisierung auseinander. Seit den frühen 2000er Jahren beteiligt er sich aktiv an der Produktion einer digitalen Öffentlichkeit – Anonymität, Open Source und Hacking sind die entscheidenden Stichworte dieser frühen Internetgeneration. In dem Projekt *Dead Drops* zeigte er 2010, wie sich herkömmliche USB-Sticks als *tote Briefkästen* einmauern lassen, und initiierte so eine bis heute andauernde, internationale Welle von entsprechenden Eingriffen. Im Stadtraum ermöglichen die Sticks den Austausch von Daten jenseits ihrer Speicherung und algorithmischen Auswertung im Internet. Obwohl es üblich ist, dass im Netz große Datenmengen hinterlegt und verschickt werden und im privaten Gebrauch USB-Sticks von Hand zu Hand weitergegeben werden, ruft ihre Installation im öffentlichen Stadtraum Irritationen und, gemessen an dem, was ohnehin schon täglich stattfindet und stattfinden kann, irrationale Ängste hervor.

12 V / 5 V / 3 V

Bartholls Installationen in Münster basieren alle auf thermoelektrischen Apparaturen, die Feuer – das erste Kommunikationsmedium überhaupt – direkt in elektrische Energie umwandeln. Gleichzeitig bezieht sich der Künstler damit auf drei Bauwerke, die in der Stadtentwicklung Münsters eine bedeutende Rolle gespielt haben: die Erbauung des Schlosses (1767), des Kanalwasserpumpenwerks (1901) und die Aufsetzung einer DVB-T-Antenne (2007) auf den Fernmeldeturm. In der Unterführung zum Schlossplatz bringt Bartholl fünf Kronleuchter an, die jeweils aus zehn thermoelektrischen, mit Teelichtern betriebenen LED-Leselampen bestehen und im Katastrophenfall einen Schutzraum beleuchten könnten. Am Kulturzentrum Pumpenhaus stellt Bartholl Werkzeuge zum Aufladen von Mobiltelefonen zur Verfügung: Besucher_innen können die mit Generatoren ausgestatteten Stöcke in ein Lagerfeuer halten, um ihre Handyakkus aufzuladen. Auf dem Spielplatz am Fernmeldeturm positioniert Bartholl einen kleinen Grill, der über einen Thermogenerator den am Turm befestigten Router ohne Internet mit Strom versorgt. Besucher_innen können sich per WLAN in eine Offline-Datenbank einloggen und dort Anleitungen für das Leben ohne Internet herunter- und eigene Dateien hochladen.

Bartholls spielerische und experimentelle Arbeiten tragen zur Entmystifizierung der Technologie bei. Sie forcieren einen kritischen, selbstbestimmten und unabhängigen Umgang mit den Möglichkeiten einer digitalen Vernetzung und beruhen auf einem Denken, das an den Begriff *technē* anknüpft: Die Künste sind vereint mit dem handwerklichen Tun, den Fertigkeiten sowie mit der Bedeutung und Reflexion ihres Gegenstands. N.T.

12 V

Material
Router, Grill, Thermogenerator, Kabel, Elektronik, Software, Datenbank

Standort
Fernmeldeturm
Spielplatz an der Mühlhäuser Straße, 48155 Münster

5 V

Material
Lagerfeuer, Holz, Stahl, Thermogenerator, Kabel, Elektronik

Standort:
Wiese neben dem Theater im Pumpenhaus
Gartenstraße 123, 48147 Münster

3 V

Material
Aluminium, Acrylglas, Thermogenerator, Elektronik, LEDs, Teelichter, Stahlkette

Standort
Unterführung am Schlossplatz
Schlossplatz 46, 48143 Münster

Aram Bartholl

Aram Bartholl (* 1972 Bremen; lives in Berlin) deals with the possibilities and effects of increasing digital-ization in his role as an installation and performance artist. Since the early 2000s he has been actively involved in the production of a digital public sphere—anonymity, open source, and hacking are the key buzzwords of this fledgling Internet generation. In 2010, as part of the project *Dead Drops*, he showed how conventional USB drives can be cemented into walls as *dead letterboxes*, thus initiating an ongo-ing international wave of similar interventions. The drives allow data to be exchanged in the urban space without being stored and evaluated by algorithms on the Internet. Although it is normal for large amounts of data to be stored and sent on the Internet and for USB drives to be passed from hand to hand on a private basis, by publicly installing them in an urban setting, he creates disturbing situations for people and—in light of what is already happening and what might happen on any given day—fuels people's anxieties.

12V / 5V / 3V

Bartholl's installations in Münster are all based on thermoelectric devices that directly transform fire—the primeval medium of com-munication—into electrical energy. At the same time, the artist al-ludes to three construction projects that have played a key role in Münster's urban development: the building of the palace (1767) and the canal-water pumping station (1901) and the installation of a DVB T-antenna (2007) on top of the telecommunications tower. In the un-derground passageway leading to the palace square, Bartholl has hung up five chandeliers, each consisting of ten thermoelectric LED reading lamps powered by tea candles. In the event of an emer-gency they could serve to illuminate a shelter. At Münster's Theater im Pumpenhaus, Bartholl has provided devices for charging mobile phones: visitors can hold sticks—equipped with generators—in a campfire to charge their phone batteries. On the playground at the base of the telecommunications tower Bartholl has set up a small barbecue, equipped with a thermoelectric generator that provides electricity to the router on the tower without using the Internet. Vis-itors can log into an offline database via Wi-Fi to download instruc-tions for living without the Internet and upload their own files.

Bartholl's playful and experimental work contributes to the demysti-fication of technology. It prompts critical, self-determined, and in-dependent interaction with the possibilities of digital networking and is based on an idea closely associated with *technē*: the arts are combined with craftsmanship, manual dexterity, and self-reflection.

N.T.

12V

Material
Router, grill, thermoelectric generator, cables, electronics, software, database

Location
Transmission tower playground on Mühlhäuser Straße, 48155 Münster

5V

Material
Campfire, wood, steel, thermoelectric generator, cables, electronics

Location
Meadow next to Theater im Pumpenhaus
Gartenstraße 123, 48147 Münster

3V

Material
Aluminium, acrylic glass, thermo-electric generator, electronics, LEDs, tea candles, steel chain

Location
Underpass at the palace square
Schlossplatz 46, 48143 Münster

Vlado Velkov

Wir können das Gespräch gleich mit dem Ende beginnen. Deine Arbeiten in Münster sind eine Art Survival-Kit für post-apokalyptische Zustände. Ist das das neue Ende: ein Tag ohne Internet?

Postdigitale Kunst bezieht sich oft auf technische Entwicklungen und ihre Auswirkungen. Bei Dir steht aber der Mensch im Vordergrund. Welche Begegnungen erwartest Du am Lagerfeuer?

Du bist einer der wenigen Künstler_innen, die aktiv und konsequent den digitalen Wandel im öffentlichen Raum erkunden. Woher kommt diese Leidenschaft für den öffentlichen Raum?

Ist das Internet öffentlicher Raum?

Dein erstes Kunstwerk hast Du auf einer Konferenz des Chaos Computer Club gezeigt. Jetzt bist Du Kunstprofessor, man vermutet etwas Anständiges, aber Du agierst inzwischen im Team des Hacker Congress. Welche Reize hat das noch zu bieten?

Findest Du es eine Frechheit, dass das Café, in dem wir jetzt sprechen, kein WLAN hat?

Aram Bartholl

Wenn das Internet mal ausfällt, ist die Lage für viele Betroffene dramatisch. Allein schon, wenn der Akku des Smartphones gegen null Prozent geht, macht sich Hektik bemerkbar. Wir sind in großem Maße von Geräten und Internet abhängig. Mit einem kompletten Internetausfall über längere Zeit wäre auch der Kollaps jeglicher Infrastruktur vorprogrammiert. Wie wäre das, wenn es keinen Strom gäbe und wir das Handy am Feuer aufladen müssten? Oder, wenn wir an einen bestimmten Ort in der Stadt fahren müssten, um an frische Daten zu kommen? In anderen Teilen der Welt sind solche Umstände Alltag.

Wie alt ist das Smartphone? Es ist erstaunlich, mit welcher Selbstverständlichkeit wir die technologische Entwicklung mit all ihren Nebenwirkungen als Status quo akzeptieren. Soziale Medien verändern die Gesellschaft, bringen Menschen einander näher, aber entfremden uns auch voneinander. Das Telefon am Lagerfeuer aufzuladen ist der Versuch, einen sehr alten, gar archaischen Begegnungsort mit unserer aktuellen Kommunikationswelt zu verbinden. Die Arbeit kann Geräte aktivieren, möchte aber vor allem Menschen zueinander führen – nicht über eine App, sondern ganz klassisch im direkten Kontakt. Ich erwarte einen spannenden Austausch, neue Freundschaften und vieles mehr.

Meine Neigung zum Public Space stammt aus meiner Kindheit in den 1970er Jahren, einer politisch bewegten Zeit mit vielen Demonstrationen, Straßenfesten etc. Später habe ich Architektur studiert und viel Zeit dem öffentlichen Raum in seiner Komplexität gewidmet. Für mich bietet der Außenraum viel mehr Emotionen, Reize und Möglichkeiten als der klassische White Cube. Der öffentliche Raum ist stets in Bewegung, da sind die Menschen, die Probleme, da tobt das Leben. Und ich bemühe mich, die Evolution des öffentlichen Raums durch die Vernetzung und Digitalisierung zu erkunden.

Das Internet ist kein öffentlicher Raum, obwohl wir das gerne glauben wollen. Die News- und Social-Media-Plattformen, auf denen wir unsere Meinung kundtun, sind zu hundert Prozent Privaträume von börsennotierten Unternehmen. Die kostenfreie Nutzung bezahlen wir mit unseren Daten, die schon lange von diversen Netzen und Filtern aufgefangen werden. Mein öffentlicher Raum ist weiterhin die Stadt, mit den realen Menschen, die sich mit der Digitalisierung auf viele Veränderungen vorbereiten müssen.

Ich bin mit meinen Arbeiten in unterschiedlichen Kontexten eingeladen worden. Dieser Crossover zwischen Kunst, Internet, Architektur, Design und Technik hat stets meine Arbeit geprägt. Seit Ende der 1990er Jahre bin ich auf CCC-Veranstaltungen regelmäßig aktiv und habe dort immer wieder mit neuen Werken und Projekten experimentiert. Es ist mir wichtig, die Kunst, die Realität und das Internet immer wieder zu verlassen und aus einer neuen Position zu hinterfragen.

Ist doch gut! Es gibt inzwischen viele Cafés, die nachdrücklich Werbung damit machen, dass sie eben kein Internet haben. It's time to go offline.

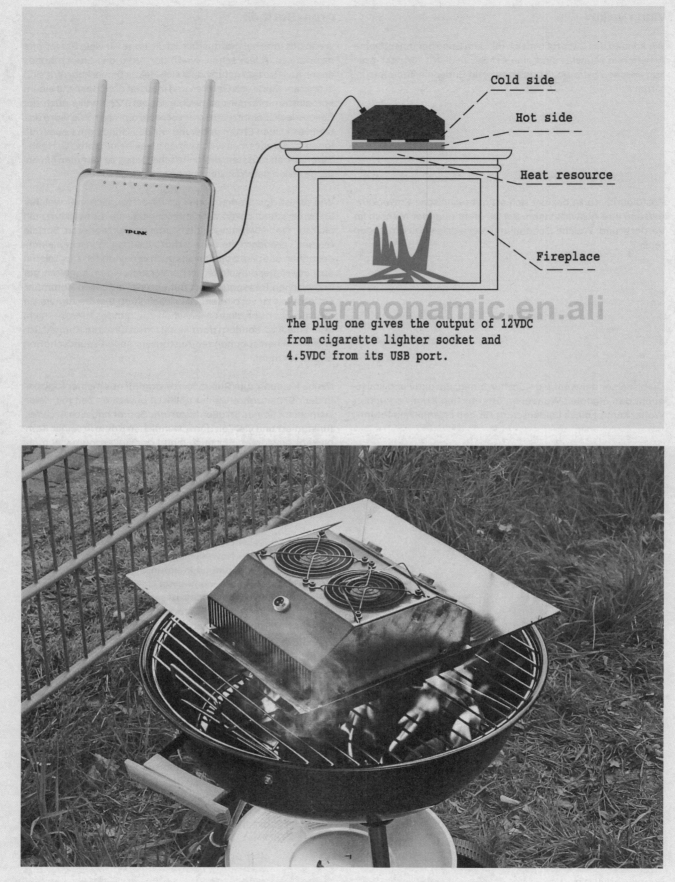

Cold side

Hot side

Heat resource

Fireplace

thermonamic.en.ali

The plug one gives the output of 12VDC
from cigarette lighter socket and
4.5VDC from its USB port.

12V Thermogenerator, mithilfe des Feuers wird Elektrizität erzeugt, um den Router zu betreiben /
12V thermoelectric generator producing electricity from fire to power a router

Aram Bartholl

Vlado Velkov

We can start the interview with the end. Your works in Münster are a kind of survival kit for post-apocalyptic conditions. Is this the new end: a day without Internet?

Post-digital art is frequently related to technical developments and their effects. But in your case, the focus is on people. What kinds of encounters do you expect around the campfire?

You are one of the few artists who are consistently and actively exploring the digital shift in public spaces. What is the origin of this passion for public space?

Is the internet a public space?

You displayed your first work of art at a Chaos Computer Club congress. Now you are an art professor, which people assume to be somewhat respectable, but you are now active in the team at the Hacker Congress. What attractions does this still have to offer?

Do you think it's bold that the café where we are talking right now doesn't have Wi-Fi?

Aram Bartholl

For many people, it's a big drama if the Internet goes down. Actually, it's enough for the smartphone battery to get down to zero for panic to break out. We are dependent on devices and the Internet to a great extent. If the Internet were to completely go out for an extended period of time, all our infrastructure would collapse. What would it be like if there was no electricity and we had to charge our phones at a fire? Or we had to drive to a specific place in the city to get fresh data? Conditions like these are part of everyday life in other parts of the world.

How old are smartphones? It's astonishing how natural it is for us to accept technological developments, along with all their side-effects, as the status quo. Social media change society and bring people closer, but they also estrange us. Charging a telephone at the campfire is an attempt to connect a very old, even archaic meeting place with our current world of communication. Work can activate devices, but, more importantly, it can reconnect people—not via an app, but through classic, direct contact. I expect exciting exchanges, new friendships, and much more.

My penchant for public space comes from my childhood in the 1970s, a politically dynamic period with many demonstrations, parties on the streets, etc. Later I studied architecture and devoted a great deal of time to public space in all its complexity. For me, outdoor space offers much more in the way of emotions, stimuli, and possibilities than the classic white cube. Public space is always in motion; there are people, problems, the pulse of life. And I make an effort to explore the evolution of public space through interconnectivity and digitalization.

The Internet isn't a public space, even though we would like to believe it is. The news and social media platforms where we make our opinions known are 100 per cent private spaces belonging to publicly listed companies. We pay for our free use of these platforms with our data, which has been harvested by various nets and filters for some time now. My public space continues to be the city, with real people who need to prepare for all sorts of changes related to digitalization.

I have been invited into a wide variety of contexts with my work. This crossover between art, Internet, architecture, design, and technology has always influenced my work. I have been active at CCC events since the late 1990s, and have repeatedly experimented with new work and projects there. For me it is important to keep leaving behind art, reality, and the Internet and question things from a new perspective.

It's great! Nowadays there are many cafes that expressly advertise that they don't have internet. It's time to go offline.

Post Snowden Nails, 2016, mit / with Nadja Buttendorf

Aram Bartholl

Cosima von Bonin / Tom Burr

Strategien der Zusammenarbeit, Aneignung und Kompilation prägen Cosima von Bonins (* 1962 Mombasa, lebt in Köln) multimediales Œuvre. Sie navigiert mit hintergründigem Humor durch ein Meer von Referenzen, zieht scheinbar mühelos Einflüsse an Land und bindet befreundete Künstler_innen und historische Positionen in ihre Ausstellungen ein. Ihr von Konzeptkunst und Pop gespeistes Werk rekurriert immer wieder auf zentrale Figuren wie Martin Kippenberger oder Mike Kelley und stellt zahllose Bezüge zu Film, Literatur, Musik, Mode, Design und Lifestyle her. So präsentiert sich ihre Arbeit weniger als originäre, individuelle künstlerische Geste denn als Resultat von Traditionslinien, Netzwerken und Wiederholungen. Häufig in Form tierischer Motivchiffren reflektieren die raumgreifend gruppierten Werke Konventionen und Spielregeln des Kunstbetriebs und thematisieren von Bonins künstlerische Identität in einem Geflecht von Beziehungen, Abhängigkeiten und Rollenmodellen.

Benz Bonin Burr

Weiche, textile Materialien sind die primäre Grundlage der patchworkartigen Bilder und skulpturalen Objekte, die ein der Warenwelt entstammendes Motivrepertoire transformieren. Anthropomorphisierte Tiergestalten bevölkern ihre bühnenhaften Ausstellungsszenarien, die an den Requisitenfundus eines Filmstudios oder an Fabelwelten denken lassen. Ihre überdimensionalen, plüschigen Protagonist_innen sind teils häuslich-domestizierter Natur, teils gehören sie dem maritimen Lebensraum an, dessen Metaphorik große Bedeutung zukommt. Meist pfeifen die dauermüden Wesen auf gesellschaftliche Produktivitätsimperative. In ihrer trägen Verweigerungshaltung deutet sich neben dem Recht auf Faulheit und Zigarettengenuss auch ein existenzieller Erschöpfungszustand an, der von Bonins Kosmos eine dunkle Unterströmung verleiht. Dieses Unwohlsein artikuliert sich auch in resignativen Ausstellungstiteln wie *Kapitulation* oder *The Fatigue Empire*. Autorität und Kontrolle sind latent präsente Themen in dieser anspielungsreichen Parallelwelt.

Auch für die Skulptur Projekte 2017 knüpft von Bonin an ihre Vorstellung von kollektiver Autorschaft an und arbeitet mit Tom Burr (* 1963 New Haven, lebt in New York) zusammen; beide verbindet eine langjährige Freundschaft. Das gemeinsame Projekt wird in Kooperation mit dem Westfälischen Kunstverein realisiert, der zeitgleich die Einzelausstellung *Surplus of Myself* von Burr zeigt. Burr setzt sich seit den späten 1980er Jahren mit Fragen des öffentlichen Raumes auseinander. Dabei nutzt er die Formensprache der Minimal Art, lädt diese jedoch (entgegen ihrer ureigenen Absicht) mit zahlreichen Konnotationen und Verweisen auf, die oftmals mit der Emanzipation von Subkulturen oder der Biografie des Künstlers verbunden sind. Für ihre Kooperation *Benz Bonin Burr* platzieren die Künstler auf dem gemeinsamen Vorplatz von LWL-Museum und Kunstverein einen Tieflader unweit der dort aufgestellten Skulptur von Henry Moore. Auf dessen Ladefläche befindet sich eine großformatige Black Box — ein wiederkehrendes Moment in Burrs Werk — deren Inhalt sich den Blicken entzieht. So entsteht eine ambivalente Situation, die zwischen Präsenz und Absenz, Ein- und Ausschluss, oszilliert und en passant die Infrastruktur des Ausstellungsbetriebs anhand eines potenziellen Verladevorgangs andeutet. A.P.

Material
Tieflader, Holzkiste, Sicherungsseile

Standort
Vorplatz des LWL-Museums
für Kunst und Kultur
Rothenburg 30, 48143 Münster

Cosima von Bonin / Tom Burr

Strategies of cooperation, appropriation, and compilation are characteristic of Cosima von Bonin's (*1962 Mombasa; lives in Cologne) mixed-media installations. She navigates the viewer through a sea of references with her subtle humour, bringing influences ashore without any apparent effort and involving artist friends and historical perspectives in her exhibitions. Energized by Conceptual Art and Pop Art, her work keeps touching on key figures like Martin Kippenberger or Mike Kelley and makes countless references to cinema, literature, music, fashion, design, and lifestyles. In this way, her artwork presents itself more as the result of traditional tendencies, networks, and recurrences than as an original, individual artistic gesture. The large-scale arrangements, often in the form of animal motifs, mirror the conventions and rules of the art world and address von Bonin's artistic identity within a network of relationships, dependencies, and role models.

Benz Bonin Burr

Soft textile materials serve as the primary basis for her patchwork-like pictures and sculptural objects, which transform a repertoire of motifs drawn from the world of consumerism. Anthropomorphized animal figures inhabit her theatrical exhibition scenarios, which are reminiscent of a film studio's prop room or a mythical setting. Von Bonin's oversized, fluffy protagonists are partly domesticated and partly associated with a maritime environment whose imagery is of great significance. Usually the permanently exhausted creatures don't give a damn about the societal imperatives of productivity. In their lazy mode of denial we recognize—in addition to the right to be lazy and enjoy a cigarette—an existential condition of fatigue that lends von Bonin's cosmos a dark undercurrent. This uneasiness also expresses itself in the submissive titles of her exhibitions, such as *Kapitulation* or *The Fatigue Empire*. Authority and control are latently present as themes in this parallel world abounding with allusions.

For Skulptur Projekte 2017, von Bonin also draws on her vision of collective authorship and joins forces with Tom Burr (*1963 New Haven; lives in New York)—the two have been friends for many years. The project is being produced in cooperation with the Westfälischer Kunstverein, which is showing Burr's solo exhibition *Surplus of Myself* at the same time. Burr has been grappling with questions relating to public space since the late 1980s. Although he makes use of the formal language of Minimal Art, it is charged (contrary to its intrinsic intention) with numerous connotations and references, frequently connected with the emancipation of subcultures and the artist's personal biography. For their cooperation *Benz Bonin Burr*, the artists intend to park a low-loader on the shared forecourt in front of the LWL-Museum and the Kunstverein, not far from where the Henry Moore sculpture is installed. A large-size black box is to be placed on the truck bed—a recurring feature of Burr's work. Its contents are hidden from sight, thus creating an ambivalent situation that oscillates between presence and absence, inclusion and exclusion, admiration and Oedipal fixation. It also incidentally alludes to the infrastructure of the exhibition world in general by bringing to mind a potential shipment process. A.P.

Material
Low-loader, wooden crate, safety ropes

Location
Forecourt LWL-Museum
für Kunst und Kultur
Rothenburg 30, 48143 Münster

Cosima von Bonin / Tom Burr

Cosima von Bonin / Tom Burr

Andreas Bunte

Andreas Buntes (*1970 Mettmann, lebt in Berlin) künstlerisches Interesse kreist um das Zusammenspiel von Technologie, menschlichem Körper und Architektur und die Frage, wie dieses unsere materielle und immaterielle Umgebung formt und bestimmt.

Laboratory Life

Seine für Münster realisierte Arbeit *Laboratory Life* hat ihren Ausgangspunkt in der Verschränkung von bewegtem Bild und wissenschaftlichem Versuchsaufbau. Bunte löst in diesen Filmen Vorgänge, zum Beispiel die Rotationsbewegung einer Autowaschanlagenbürste auf einer Windschutzscheibe, das Flattern einer Plastiktüte im Wind oder das Einsetzen einer Kontaktlinse, aus ihrem ursprünglichen Zusammenhang und stellt sie in einem laborähnlichen Raum unter die Beobachtung der Kamera. Die Filme ermöglichen den Betrachter_innen, bekannte Abläufe isoliert und neu zu sehen — insbesondere wenn durch sogenanntes *motion capture* die Aufführung des Alltäglichen zu einem abstrakten Punkt- und Linientanz vor schwarzem Hintergrund reduziert oder wenn menschliche Gliedmaßen durch Roboterarme ersetzt werden. Über in der Stadt plakatierte Poster mit QR-Codes sind diese Choreografien des Alltags auf den Telefonen der Besucher_innen abrufbar. Die Filme werden also nicht als Projektionen im Innenraum gezeigt, sondern sie aktivieren sich auf jedem gängigen Smartphone durch das Scannen der Codes. Die Filmposter sind direkt auf die architektonische Oberfläche der Stadt gekleistert. Somit entfalten sich die filmischen Laborbeobachtungen in direkter Konfrontation mit dem konkreten Münsteraner Alltag. Buntes *Laboratory Life* öffnet für die Besucher_innen innerhalb des Stadtraums kurzzeitig kineastische Fenster auf dem uns stetig begleitenden Portal namens Telefon.

Buntes Interesse für den wissenschaftlichen Film und das Labor als Produktionsort von Filmen lässt sich anhand seines dreijährigen Rechercheprojekts zum Göttinger Institut für Wissenschaft und Film nachvollziehen. Diese von 1957 bis ins Jahr 2010 aktive Forschungsstelle strebte an, zeitbasierte Phänomene aus ihrem Ursprungskontext zu lösen, um sie im neutralen Umfeld eines Labors im bewegten Bild zu konservieren. Buntes eigene Filme dokumentieren neben den Prozessen auch die Einbettung der Filmherstellung in die Laborrealität und hinterfragen so, inwieweit das Labor überhaupt ein Ort neutraler Beobachtung sein kann. Darüber hinaus versteht er die dort nachgestellten, alltäglichen Ereignisse und Prozesse als zeitbasierte Readymades, bei denen offen bleibt, wer eigentlich Protagonist_in eines bestimmten Vorgangs ist. Oft scheinen Objekte eigenartig belebt, menschliches Handeln dagegen durch eingeschränkte Interaktionsmöglichkeiten dominiert. Gleichzeitig stellen sich Fragen nach der *korrekten* Handhabe: Welche Handlungsoptionen legen eine Autotür oder ein Metalldetektor nahe, besonders wenn deren Handhabung allein für die Dokumentation durch die Kamera erfolgt? N.A.

[Laborbedingungen]

Material
16 mm Film, digitalisiert (Farbe, Ton), Dauer zwischen 2 und 3 Minuten, abrufbar über Poster mit QR-Codes

Standort
→ H1
Schlossplatz 46, 48143 Münster
→ VHS Münster
Aegidiistraße 3, 48143 Münster
→ Stadthaus I
Klemensstraße 10, 48143 Münster

Crew
Produktion: Florian Koerner von Gustorf und Michael Weber (Schramm Film Koerner & Weber) in Koproduktion mit Andreas Bunte ● Requisiten: Hagen Rissmann ● Ausstattung: Reinhild Blaschke ● Setbau: Mark Stolte ● Projektmanagement: Luisa Puschendorf ● Performer_innen: Chloe Pare-Anastasiadou, Jan Bockholt, Katja Brückner Declan Clarke, Johannes von Dassel, Michael Homann, Ele Krekeler ● Roboter Programmierung: Matthias Bartelt, Stefanie Spies ● Motion capture: Marc de Lussanet ● Fotos Poster: Florian Balze ● Originalton und Mischung: Adam Asnan ● Kamera- und Lichtequipment: FGV Schmidle, Berlin

App-Programmierung: Ivo Wessel

Zur Vorbereitung auf das Projekt von Andreas Bunte können Sie sich unter apps.skulptur-projekte.de eine App herunterladen.

Andreas Bunte

Andreas Bunte's (* 1970 Mettmann; lives in Berlin) artistic interests focus on the interaction between technology, the human body, and architecture and the question of how this interplay shapes and determines our material and immaterial environment.

Laboratory Life

His work *Laboratory Life*, which was created specifically for Münster, is based on the interplay between moving pictures and scientific experimental set-ups. In these films, Bunte removes everyday occurences—like the rotation of a car-wash brush on a windscreen, a plastic bag flapping in the wind, or someone putting in a contact lens—from their original context and places them in a laboratory-like setting under video surveillance. Bunte's films enable viewers to observe isolated processes in a new light, particularly when 'motion capture' is used to reduce the performance of an everyday activity to an abstract dance of points and lines in front of a black background or human limbs are replaced by robot arms. By means of QR codes that have been printed on posters and hung up around Münster, these everyday choreographies can be watched on viewers' phones. In other words, the films will not be screened in interior spaces but can be activated on any standard smartphone by scanning the QR codes. The film posters have been pasted straight onto the architectural surface of the city. In this way, the video surveillance under lab conditions unfolds in a direct encounter with actual everyday life in Münster. With the help of our constant companion, the portal we call the phone, Bunte's *Laboratory Life* opens a brief cinematic windows for us through which to view an urban environment.

Bunte's interest in scientific research films and the lab as a production site for films can be traced back to his three-year research project on Göttingen's Institute for Scientific Film. This research institute, which was active from 1957 to 2010, sought to disengage time-based phenomena from their original context and conserve them as moving pictures in the *neutral* environment of a laboratory. In addition to recording these processes, Bunte's films document the embedding of film production in the reality of a lab and examine the extent to which a lab can ever be a place of neutral observation. He also sees the everyday actions and processes reproduced there as time-based ready-mades, where it remains uncertain who is the actual protagonist of a particular event. Objects often seem strangely animated, whereas human actions are dominated by limited opportunities of interaction. At the same time, questions are raised about the *correct* way of performing the actions: What options are suggested by a car door or a metal detector, especially when these actions are only performed for the sake of video documentation? N.A.

Material
16 mm films transferred to digital video (colour, sound), between 2 and 3 min., accessed via posters with QR codes

Locations
→ H1
Schlossplatz 46, 48143 Münster
→ VHS Münster
Aegidiistraße 3, 48143 Münster
→ Stadthaus I
Klemensstraße 10, 48143 Münster

Crew
Production: Florian Koerner von Gustorf and Michael Weber (Schramm Film Koerner & Weber) in coproduction with Andreas Bunte ● Set design: Hagen Rissmann ● Equipment: Reinhild Blaschke ● Set construction: Mark Stolte ● Project management: Luisa Puschendorf ● Performers: Chloe Pare-Anastasiadou, Jan Bockholt, Katja Brückner, Declan Clarke, Johannes von Dassel, Michael Homann, Ele Krekeler ● Robot programming: Matthias Bartelt, Stefanie Spies ● Motion capture: Marc de Lussanet ● Poster photos: Florian Balze ● Sound and audio mix: Adam Asnan ● Camera and light equipment: FGV Schmidle, Berlin

App Programming: Ivo Wessel

An app is available to help you prepare for the project by Andreas Bunte. Download at: apps.skulptur-projekte.de.

Gerard Byrne

Gerard Byrne (* 1969 Dublin, lebt in Dublin) befragt mit seinen filmischen, auditiven und fotografischen Werken mediale Konstruktionen und Manipulationen, zum Beispiel von dokumentarischem Material, Fotografien, Interviews und Texten. Ihn interessiert, wie Geschichtsbegriffe und Mythen die Möglichkeiten von Verleumdung und das Aufkommen fiktiver Fakten konstituieren. Das schließt auch die Frage mit ein, wie sie eine Bewertung kultureller Produktion und Debatten über gegenwärtiges und künftiges gesellschaftspolitisches Geschehen bestimmen. Seine Filme erscheinen als High-End-Formate, sie brillieren durch exzellente Bildqualität, Kameraführung und Ausstattung, Darstellung, sprachliche Performanz und unterhaltsame Dialoge. Dennoch haben sie fragmentarischen Charakter. Byrne montiert Sequenzen aus dokumentarischem Material und reinszeniertem Schauspiel, das er mit Schwarzbild und räumlich-szenischen Wechseln, Close-ups von Gesichtern oder funktionalen Gegenständen unterbricht. Die Werke eröffnen sich in Installationen, die im Sinne des Narrativs, der filmischen Erzählung oder eines bildlichen oder musikalischen Themas inszeniert scheinen, und an denen die Besucher_innen performativ mitwirken. Byrne aktualisiert, sowohl mit bildlichen Verfremdungseffekten und Irritationen als auch in der zeiträumlichen Öffnung der Werke, Impulse des epischen Theaters Bertolt Brechts. Dieses markiert eine verspätete Aufklärung perzeptiver Anschauungsgewohnheiten und fordert die Besucher_innen dazu auf, sich selbst im Wirkungsprozess des Kunstwerkes und darüber hinaus, in gesellschaftlichen, kulturellen und ethischen Prozessen bewusst wahrzunehmen — Betrachter_innen und Akteur_innen zu werden.

In Our Time

Als Ort für sein Projekt *In Our Time* hat Byrne in der Stadtbücherei Münster einen Raum neben dem sogenannten Computerspielzimmer gewählt. Die strenge Inszenierung präsentiert die große Rückprojektion eines Bildes; nach und nach wird das Radiostudio einer vergangenen Ära erkennbar. Die Kamera bewegt sich kontinuierlich durch die Mise en Scène und baut die Szene auf, indem sie empirisch Einzelheiten zusammenträgt, die den Eindruck des Raums vermitteln, Mikroeindruck um Mikroeindruck. Während die Kamera pedantisch den Raum abfährt, wechselt der begleitende Soundtrack zwischen Popmusik, aktuellen Nachrichten, Wetterbericht und anderen Radioklängen. Hin und wieder ist die synchronisierte Stimme des Moderators zu hören, der auch im Bild zu sehen ist und von Zeit zu Zeit die abwesenden Zuhörer_innen anspricht. Zwischen den relativ vertrauten Klängen sind auf diese Weise Aktivitäten innerhalb eines Raumes zu sehen und zu hören, der sonst unsichtbar bleibt: das Studio.

Radiosendungen, ähnlich wie die populären Zeitschriften, auf die sich Byrne in seinen frühen Arbeiten immer wieder bezieht, sind besessen von dem Streben nach Aktualität, daher ist es keine Überraschung, dass der Radiomoderator wiederholt Tag und Uhrzeit ansagt. Zugleich scheinen diese Referenzen in Byrnes Film jedoch auf eine geradezu unheimliche Art und Weise mit der Echtzeit der Zuschauer_innen abgestimmt zu sein. *In Our Time* spielt mit dem Kontrast von Performativität und Verborgenheit, zwischen der extrovertierten Stimme und dem müden Körper des Moderators, der sich offenbar unbeobachtet fühlt. Konzepte von Skulptur und Theater, Gegenwart und Abwesenheit, der Jetztzeit und anderen Zeiten werden von Byrne im Kontext der Skulptur Projekte zusammengeführt und aufgelöst. N.T.

[In unserer Zeit]

Material
Video, ohne spezifische Dauer

Standort
Stadtbücherei
Alter Steinweg 11, 48143 Münster

Öffnungszeiten
Mo – Fr 10 – 19 Uhr
Sa und So 10 – 18 Uhr

Gerard Byrne

Gerard Byrne (* 1969 Dublin; lives in Dublin) uses his audio and video recordings and his photographs to scrutinize how media are constructed and manipulated, for example, in documentary footage, photographs, interviews, and writings. He examines how historical concepts and myths promote the possibilities of defamation and the rise of fictional facts, and how they dominate an evaluation of cultural production and debates about present and future sociopolitical events. His films appear in high-end formats, they steal the show with their excellent picture quality, their cinematography and decor, and the acting, speaking performances, and entertaining dialogues they contain. And yet they are fragmentary in nature. Byrne montages sequences from documentary footage and restaged scenes that he interrupts with black screens and spatially dramatic cuts, as well as close-ups of faces or functional objects. The works reveal themselves in installations that seem to be staged according to the particular narrative, the cinematic storytelling, or a visual or musical motif, allowing the audience to interact with the performance. Byrne updates the impulses of Bertolt Brecht's epic theatre, utilizing both visual alienation effects and disruptions as well as the temporal and spatial opening of the works themselves. This highlights a delayed clarification of perceptive viewing habits and invites the audience to consciously perceive themselves in the process of the artwork as well as in the social, cultural, and ethical processes and thus to become observers and actors.

In Our Time

In Münster, Byrne has selected a room adjacent to the gamer room at the municipal library as the site for his project *In Our Time*. Byrne's austere installation at the library presents a large back-projected image of what slowly reveals itself to be the control booth of a radio studio from another era. Byrne's camera continuously floats through this mise en scène, building up the scene through the detailed, empirical accumulation of an impression of the space, from one micro-impression to the next. Whilst the camera pedantically moves within the space, an accompanying soundtrack drifts between popular music, news, weather, and other pre-recorded sound for broadcast, which are interspersed with synchronized sound of the presenter we see, periodically addressing the absent audience via microphone. In and around these fairly archetypal sounds, we see and hear activities of an otherwise hidden space.

Radio shows, like the popular magazines Byrne often referenced in earlier works, are preoccupied with the threat of transience and the desire for currency, the imperative being to be of their time. The radio presenter in *In Our Time* rather unsurprisingly references the day and time of day routinely, and yet these references in Byrne's film appear to uncannily synchronize with our own 'real time' as viewers. In the hidden room in the basement of the library, *In Our Time* then contrives a challenging mix, contrasting the performativity of the extroverted broadcast voice with the introverted, jaded physicality of its host body, oblivious as it appears to be of itself as a spectacle for Byrne's floating camera. Conflations of presence and absence, sculpture and theatre, this time and other times—*In Our Time* brings these ideas together, and undoes them, in the context of Skulptur Projekte. N.T.

Material
Video, unspecified duration

Location
Public library
Alter Steinweg 11, 48143 Münster

Opening hours
Mon–Fri 10 am – 7 pm
Sat and Sun 10 am – 6 pm

Gerard Byrne

Gerard Byrne

CAMP

CAMP ist ein interdisziplinär arbeitendes Studio, derzeit bestehend aus Shaina Anand, Ashok Sukumaran, Zinnia Ambapardiwala, Simpreet Singh und weiteren Akteur_innen, das sich projektbezogen immer wieder neu zusammensetzt. In Langzeitprojekten entwickelt es unterschiedliche Varianten von investigativer, kultureller Arbeit im 21. Jahrhundert. CAMP nutzt verschiedene Medien — Chips, Kameraüberwachungsysteme (CCTV), Elektrizität, Archive; viele Projekte zeichnen sich durch eine Affinität zu technologischen Prozessen aus.

Matrix

Für die Skulptur Projekte 2017 realisieren Ashok Sukumaran (*1974 Hokkaido, lebt in Mumbai) und Shaina Anand (*1975 Bombay, lebt in Mumbai) als CAMP ein Werk im Theater Münster. Die Architekten dieses ersten Theaterneubaus in Deutschland nach dem Zweiten Weltkrieg (Harald Deilmann, Max von Hausen, Ortwin Rave und Werner Ruhnau) integrierten einen Teil der Fassade der vorherigen Spielstätte, des zerstörten Romberger Hofs, in das moderne Bauensemble. Zwischen der Ruine und der Glasfassade aus den 1950er Jahren spannt CAMP ein Netz aus Kabeln. Der Ausstellungsort wird in eine fiktive Erweiterung des Gebäudes verwandelt, die das bestehende Gefüge aus Zerstörung und Wiederaufbau, aus Außen- und Innenraum betont und verbindet. Das neue Bezugssystem erweitert die vorhandenen Zeitschichten, aus heutiger Sicht beide in der Vergangenheit angesiedelt, um die Frage nach dem Verhältnis zwischen den utopischen Verheißungen der Nachkriegsmoderne und der Gegenwart. Das von CAMP gespannte Netz steht sinnbildlich für eine globale Vernetzung und das bis heute nicht eingelöste Versprechen einer flächendeckenden, horizontalen, basisdemokratischen Partizipation. Mit an Stromkabeln herunterhängenden Schaltern können die Besucher_innen verschiedene *Veränderungen* in der unmittelbaren Umgebung auslösen und so aus einer Vertikalen in die Horizontale eingreifen.

CAMP metaphorisiert Systeme der Teilhabe: vom Zugang zu Strom — der sich heute nahezu überall in privater Hand befindet — bis hin zur digitalen Kommunikation und den Möglichkeiten der Manipulation, die darin liegen. Gleichzeitig erinnert das schwarze Netz auch konkret an jene Beleuchtungskabel und Seile, wie sie hinter der Theaterbühne und an der Bühnendecke Verwendung finden, um eine Illusion auf der Bühne zu gewährleisten. CAMP beschäftigt die kontingente, sich stetig verändernde Machtstruktur aktueller Gesellschaften. Moderne Architekturelemente und ihre Behauptungen, etwa der Transparenz und Durchlässigkeit versprechende Einsatz von Glasfassaden, werden im Hinblick auf ihre tatsächlichen und im Gebrauch zu Tage tretenden weiteren Qualitäten befragt: Wer befand sich historisch und befindet sich heute vor der Scheibe, wer dahinter? Woran sind die Ideale von basisdemokratischer, horizontaler Gleichberechtigung und Teilnahme gescheitert, und welche Wege und vertikalen Abkürzungen gibt es, sich trotz allem Zugang zum System zu verschaffen? N.A.

[Matrix: Lateinisch Mutter, Mutterleib. 2D-Anordnung, Environment, in dem ausdifferenzierte Strukturen wachsen können]

Material
Schwarzes Kabel, Monitore, Schalter, Lautsprecher, benutzerdefinierte Elektronik

Standort
Theater Münster
Neubrückenstraße 63, 48143 Münster

CAMP

CAMP is an interdisciplinary studio currently made up of Shaina Anand, Ashok Sukumaran, Zinnia Ambapardiwala, Simpreet Singh, and other actors. It was founded in 2007 and continuously regroups for specific projects. Within the context of long-term projects, the group has developed a range of investigative, cultural initiatives for the twenty-first century. CAMP makes use of various media—chips, CCTV, electricity, archives; many of its projects are characterized by an affinity for technological processes.

Matrix

Ashok Sukumaran (*1974 Hokkaido; lives in Mumbai) and Shaina Anand (*1975 Bombay; lives in Mumbai) are creating a piece in the Theater Münster as CAMP's contribution to Skulptur Projekte 2017. The architects of the first new theatre to be built in post-war Germany (Harald Deilmann, Max von Hausen, Ortwin Rave, and Werner Ruhnau) chose a section of the façade of the Romberger Hof, the theatre which was destroyed in World War II, and integrated it into the modern construction. CAMP has stretched a system of cables between the ruins and the glass façade from the 1950s. The exhibition site is transformed into a fictional extension of the building, which emphasizes and connects the existing assemblage of destruction and reconstruction, exterior and interior. The new system of reference expands on the existing temporal layers, which from today's perspective are both rooted in the past, to include the question of the relationship between the utopian promises of post-war modernism and the present. CAMP's system of cables symbolizes a global network and the still unfulfilled promise of comprehensive horizontal participation in grassroots democracy. By operating switches hanging from electrical wires, visitors can trigger various environmental changes, thus proposing a 'vertical' to impinge on the 'horizontal'.

CAMP creates a metaphor for systems of participation and support, from the access to electricity—which is now privately owned almost everywhere across the globe—to digital communication and the immanent possibilities of manipulation. At the same time, the black net specifically reminds us of the lighting wires and ropes that are used backstage and hung from the ceiling of a theatre to help create an illusion on stage. CAMP addresses the contingent and constantly changing power structures in today's societies. Modern architectural elements and the claims they make—for example, that glass façades ensure transparency—are questioned with regard to their actual qualities and other aspects that come to light in everyday usage: historically speaking, who was on which side of the glass, and what is the situation today? Why did the ideals of equality and participation in grassroots, horizontal democracy fizzle out? And, in spite of all this, what pathways and vertical shortcuts or incremental processes can provide systemic access? N.A.

[Matrix: Latin for mother, womb. 2-D array, environment in which more specialized structures can grow]

Material
Black cable, monitors, switches, speakers, electronics

Location
Theater Münster
Neubrückenstraße 63, 48143 Münster

Matrix

Beim Wiederaufbau der Neubrückenstraße nach dem Zweiten Weltkrieg wurden die Gebäude und die drei Kirchen rund um das Theater historisch wiederhergestellt. Ein finanzieller Engpass verzögerte die Rekonstruktion des Theaters in einem ähnlichen klassizistischen Stil, und nach Protesten von Architekten und Stadtplanern gegen dieses Vorhaben kam es zu einem Alternativvorschlag. In nur sechs Wochen erstellte das Protestkollektiv um Deilmann, Rave, von Hausen und Ruhnau einen Wettbewerbsbeitrag, der mit dem ersten Preis ausgezeichnet wurde. Dieser Entwurf war ein epochaler Einschnitt: ein Donnerschlag aus verstörenden rosanen und blauen Mosaiken und Glaspaneelen, die sich um das Fragment einer Hausruine legten. Dieser Bau prägte Münster so sehr, dass bald klar wurde: Ein so mutiges Vorgehen würde sich aller Wahrscheinlichkeit nach an keinem zweiten Ort der Stadt wiederholen.

Matrix

When Neubrückenstrasse was being rebuilt after the war, its buildings and the three churches surrounding the site of the theatre were constructed 'historically'. A financial delay stalled the rebuilding of the theatre in a similar neoclassical style, and a protest by architects and planners led to a counterproposal. Within six short weeks, the protesters' collective consisting of Deilmann, Rave, von Hausen, and Ruhnau had entered and won the competition. The result was epochal: a 'thunderclap' of bewildering pink and blue mosaic tiles and glass, wrapped around a fragment of ruin. It was such a special event in the city that it seemed unlikely to take place again.

Blick aus dem Foyer auf die Ruine des Romberger Hofs

View of the ruins of the Romberger Hof from the foyer

Was geschieht mit den Grundgedanken der Moderne, wenn sie ihrem eigenen Anspruch der permanenten Erneuerung ausgesetzt sind? Worin besteht ihre Aktualität? Werden sich dezidiert moderne Ideen immer weiter ausbreiten, bis sie die ganze Erde überziehen, oder hat die Moderne diesen Universalitätsanspruch inzwischen aufgegeben? Und falls ja: Welches Verständnis vom Raum kennzeichnet dann die Gegenwart? Um diesen Fragen nachzugehen, haben die Künstler_innen von CAMP einen historisch-materialistischen Vorschlag unterbreitet. Seine Entstehungsgeschichte erzählt man sich wie folgt:

The question is, how does modernism survive the continued assault of its own inventions? What is its plan for changing with time? Does it still want to grow to cover the entire Earth, or is that universality now abandoned? What, then, is its sense of space? To test these questions, the CAMP artists have made a historical-materialist proposal for this location, whose story goes as follows:

Blick vom Foyer des Theaters in Münster auf die Ruine des Romberger Hofs (*Die ZEIT*, 12. Juli 1956)

View of the ruins of the Romberger Hof from the foyer of the theatre in Münster (*Die ZEIT*, 12 July 1956)

16 Jahre nach der Eröffnungsgala des Stadttheaters und gerade zu der Zeit, als dieses um eine kleine Nebenbühne erweitert werden sollte, beschrieben zwei Damen in ihren Sechzigern einer Gruppe von Künstler_innen, welchen Eindruck es damals auf sie gemacht habe, aus dem verglasten Foyer auf die Überreste des Romberger Hofs draußen zu sehen. Eine vom Glas hervorgerufene Lichttäuschung, so erinnerten sie sich, habe den Eindruck erweckt, als ob (sie benutzten die theaterhafte Wendung *als ob*) die unzähligen Lichter des Foyers tatsächlich draußen von einer unsichtbaren Decke über der Stadt hingen. Dies habe sie an den Lichterhimmel aus 1200 Lampen im großen Theatersaal erinnert und das berückende Bild einer Agora, einer Öffentlichkeit als Versammlung, vor ihren Augen entstehen lassen – aber bestehend aus lauter einzelnen Personen. Die Künstler_innen waren vom Schlag der kritischen Zeitgenoss_innen und konnten zwar die Schönheit des Bildes nachvollziehen, wandten aber ein, dass eine Gesellschaft nicht nur aus einzelnen Menschen bestehe und dass es außerdem bekanntermaßen mühsam sei, all die durchgebrannten Glühbirnen im Großen Saal laufend zu ersetzen.

About sixteen years after the gala opening of the Stadt Theater, during the time of its expansion to include a small performance theatre, two women in their sixties described to an artists' group the experience of looking out from the glass lobby onto the ruins of the Romberger Hof outside. An optical illusion caused by the glass, they remembered, caused the multitude of lights in the lobby to appear as if (they used the theatrical phrase *als ob*) they were hanging over the city from an invisible ceiling. This reminded them among other things of the 'lamp sky' made of 1,200 household lamps in the main theatre hall, a beautiful image of the agora and the elevation of the public—but in the form of individuals. The artists, who belonged to a critical zeitgeist, responded 'yes' to beauty but said that society isn't just made up of individuals, and also that it was notoriously difficult to change the light bulbs when they blew out.

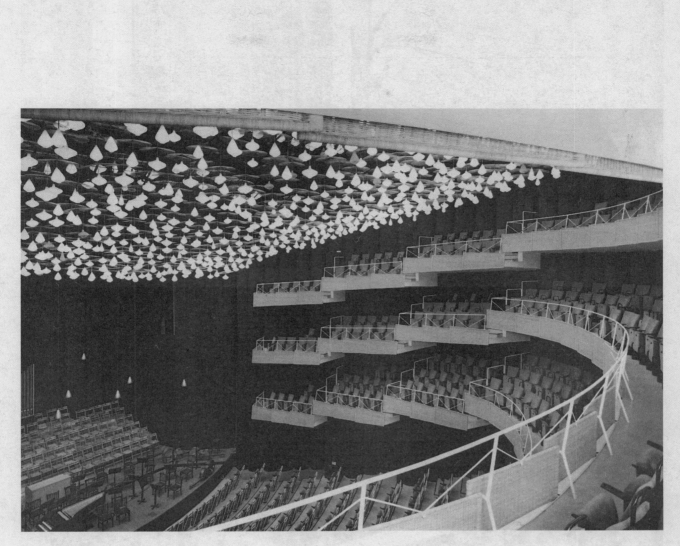

Theater Münster, Lampenhimmel / 'lamp sky'

Als Bestandteil der Erweiterungspläne schlugen sie daraufhin vor, im Außenraum eine Matrix oder einen dunklen *Mutterhimmel* aus Elektrodraht zu installieren – ausgehend von Lenins Formel *Elektrizität plus Sowjets gleich Kommunismus.* In der Habermas'schen Öffentlichkeit und ihrer zentralen Frage *Wie miteinander reden?* gerieten gerade diese notwendige Verdrahtung und die Mühen ihrer Wartung aus dem Blick. Die Künstler_innen ergriffen die losen Enden von Norbert Krickes *Raum-Zeit-Plastik* aus Eisenrohren an der Fassade der damaligen Städtischen Bühnen und verlängerten sie bis zu den benachbarten Institutionen der Volksbank und der *Münsterschen Zeitung*, umgingen dabei aber die Kirchen. Sie behaupteten zudem, der Drahtgitterhimmel sei eine Wiedereinführung der Vierten Wand aus dem Theater, ohne dies näher zu erläutern. Sie wiesen allerdings darauf hin, dass er in der Zukunft etwas mit Überwachungstätigkeiten zu tun haben würde. Um eine lange Haltbarkeit zu gewährleisten, flochten sie ihren Himmel aus einfach auszubesserndem Draht.

As part of the building expansion plan, these artists proposed an outdoor 'Matrix' or dark mother sky of wires, saying that although Lenin had said Electricity + Soviets = Communism, in the Habermasian public sphere it was exactly these wires, these material-energetic structures, and the efforts required to keep them up that disappeared, when the question became what to talk to each other about. Further, seizing the open ends of Norbert Kricke's *Raum-Zeit-Plastik* white bent-rod sculpture in front of the theatre, they extended black wires outward till they hit the neighbouring institutions, the Volksbank and *Münstersche Zeitung* buildings, while ignoring the churches. They also claimed that the mesh sky was a reintroduction of the fourth wall of the theatre, without ever clarifying further. Except to say that in the future, it would have something to do with surveillance. To anticipate this long life, they built the sky out of wires that could be easily replaced.

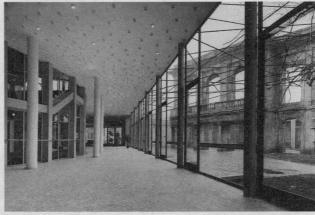

Norbert Kricke, *Raum-Zeit-Plastik*, 1955/1956, Eingangsbereich / foyer of the Theater Münster

Fotomontage von / Photomontage by CAMP, Blick ins Foyer / view into the foyer

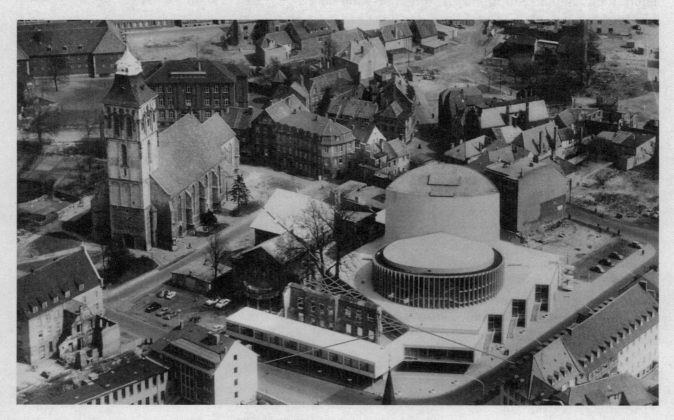

Fotomontage von / Photomontage by Camp, Theater Münster

Mitte der 1980er Jahre, vor dem Hintergrund von russischen Dorfbewohner_innen, die immer noch mit Öllampen auskommen mussten, schloss jemand in einer Aktion das Drahtnetz an einen elektrischen Schalter und verband es mit einem dritten Glied: der Kirche, die am nächsten stand. In diesem Moment wurde die Matrix in einer sehr elementaren Art und Weise nutzbar oder lebendig. Der Eingriff bereitete den Weg für weitere Funktionen, etwa als Anfang der 1990er Jahre ein Komponist aus Protest gegen die Undurchdringlichkeit des Glases in der modernen Architektur den Vorhof und das Foyer mit einer Animation verband, die man auch ohne Eintrittskarte sehen konnte. Änderungen der Drahtmatrix hat es seither immer wieder gegeben, und im Zuge der Skulptur Projekte 2017 kann man gleich mehrere davon als Überlebende oder Spekulierende der Zeit begutachten – vorausgesetzt, es gelingt, sich Zugang zum Erdgeschoss des Theaters zu verschaffen, denn dieses wird über die meiste Zeit des Sommers renoviert.

CAMP (Ashok Sukumaran und Shaina Anand)

In the mid-1980s, amidst stories of villagers in Russia still lighting oil lamps, an interventionist connected the grid with an electric switch to a third neighbour, the nearest church. At this moment, the matrix became, in a minimal / liminal way, functional or live. This act opened the door to other functions, such as in the early 1990s when, objecting to the non-transparency of glass in modern architecture, a composer connected the outside courtyard to the lobby inside with an animation that could be experienced without buying a ticket. Adaptations of the wire matrix have continued ever since, and in the Skulptur Projekte Münster 2017 you can see several of them together, as survivors or speculators of time. Of course, that is, only if you manage to navigate around the ground floor of the building, which for most of the summer will itself be under 'renovation'.

CAMP (Ashok Sukumaran and Shaina Anand)

Michael Dean

Michael Dean (*1977 Newcastle upon Tyne, lebt in London) entwickelt in vielen seiner Arbeiten eine Art skulpturale Schrift im Raum. Seine Objekte, häufig aus Materialien wie Zement, Sand und Erde gefertigt, stellen jedoch nicht unbedingt spezifische Buchstaben dar, sondern sind vielmehr als abstraktes Zeichensystem zu verstehen. Im Zusammenspiel – wie Wörter in einem Satz – generieren sie Bedeutung.

Tender Tender

Der Künstler installiert im Lichthof des LWL-Museum für Kunst und Kultur eine großflächige, transparente Plastikfolie, die von der Balustrade im ersten Stock bis zum Boden fällt, diesen bedeckt und einen Raum im Raum schafft. Bis auf einen Zugang, der sich am ehemaligen Haupteingang zum Domplatz orientiert, sind die Wege in den Lichthof durch die Folie verhängt. Dean stellt so die in den historischen Bauplänen des Museumsaltbaus festgelegte Laufrichtung durch den Säulenumgang wieder her. Durch Gucklöcher in Augenhöhe können die Besucher_innen einen Blick auf die Skulpturen im Inneren der Folie werfen. Die Körpergröße des Künstlers, die seiner Frau und seiner Kinder geben vor, in welcher Höhe die Löcher angebracht sind. Den Besucher_innen wird durch das Hineinschauen eine performative Rolle des Betrachtens und Betrachtet-Werdens zugewiesen. Zentral für die Installation ist ein aus Betonplatten gelegter, begehbarer Weg in Form des Buchstabens *f*, den Dean immer wieder in sein Werk einfügt: In Schreibschrift ist das *f* sowohl konkreter Buchstabe als auch eine kontinuierliche abstrakte Linie. Die Skulpturen im Innenraum erinnern an Straßenlaternen, öffentliche Mülleimer, Abfälle, an Objekte des urbanen Stadtraums. Die Folie ist mit Stickern beklebt. Im direkt angrenzenden Außenraum, auf dem Domplatz, befestigt Dean mit Fahrrad- und Vorhängeschlössern Objekte an den Laternenmasten. Er führt somit eine urbane Erzählung im musealen Kontext fort – und vice versa – eine Rückführung von Skulptur in den Stadtraum.

Die Verknüpfung von Museums- und Stadtraum spielte bereits im Rahmen der Skulptur Projekte 1977 eine Rolle: Joseph Beuys plante mit seiner Arbeit *Unschlitt/Tallow* einen Fettkeil im Stadtraum zu installieren; die Arbeit wurde allerdings in den Lichthof verlegt. Die thematische Ausrichtung einer Reflexion von urbanem Außen- und architektonischem Innenraum war in der Folge oft präsent an diesem Ort, der selbst wie eine nach innen gewendete Außenarchitektur erscheint. Ausgangspunkt für Deans skulpturales Werk ist sein Interesse an Buchstaben, Wörtern und Sätzen als Teile eines kontingenten Bedeutungsgefüges. Die exzessive Verwendung der von Dean in Anlehnung an bestehende Layouts gestalteten Sticker an verschiedenen Stellen und auf unterschiedlichen Untergründen zitiert Techniken der Street Art, die vermehrt als sogenanntes Guerilla-Marketing von Firmen vereinnahmt wird. Dean führt diese wieder in den Kunstkontext zurück. N.A.

[Sei zärtlich, sei zärtlich]

Material
Folie, Beton, Sticker, Metall, Papier

Maße
Installation im Lichthof auf einer
Fläche von ca. 215 m²;
Skulpturen vor dem Museum ca.
152 × 40 cm
107 × 35 cm
170 × 45 cm
175 × 45 cm

Standort
Lichthof im Altbau des
LWL-Museum für Kunst und Kultur
und Außenbereich vor dem Altbau
Domplatz 10, 48143 Münster

Michael Dean

In many of his works, Michael Dean(*1977 Newcastle upon Tyne; lives in London) develops a sculptural script within a space. However, his objects, which are frequently made of materials like cement, sand, and earth, don't necessarily depict specific letters. Rather, they are to be seen as an abstract semiotic system that generates meaning via a process of interaction—like words in a sentence.

Tender Tender

The artist has installed a large, transparent plastic sheet inside the atrium of the LWL-Museum für Kunst and Kultur, which is draped from the first-storey banister to the floor, covering it like a canopy and creating a space within a space. Apart from one entrance, which is aligned with what used to be the main entrance to the cathedral square, all the other ways into the atrium are covered with plastic sheeting. In this way, Dean re-establishes the original direction of movement through the arcade as designated in the historical construction plans of the old museum building. Using peepholes at eye level, visitors can take a look at the sculptures inside the plastic sheeting. The artist's height as well as that of his wife and children served to determine the height of the peepholes. By peering through the holes, visitors are assigned roles in the performance—both watching and being watched. An essential part of the installation is a walkway in the form of the letter 'f' and made of concrete slabs, an element he consistently includes in his work: written in cursive, an 'f' is both an identifiable letter as well as a continuous abstract line. The sculptures located within the plastic sheet are reminiscent of urban objects—street lamps, public rubbish bins, refuse. Stickers have been affixed to the transparent sheet. In the adjacent external space, Dean fastens objects to the street lamps on the cathedral square, using bicycle locks and padlocks. In so doing, he continues his urban tale in the museum context and, vice versa, returns sculptures to the city environment.

This link-up between the museum space and the urban space also played a role at the Skulptur Projekte 1977: Joseph Beuys had planned to install a wedge of tallow in the urban space as part of his project *Unschlitt / Tallow*, but the work was relocated inside the atrium. Since then, the conceptual orientation of linking the city's external space with internal architectural space has often been evident at this location, which itself seems to be an external architectural construction turned outside in. The source of Dean's sculptural work is his interest in letters, words, and sentences as part of a contingent framework of meaning. With his excessive use of stickers, which he designs based on existing layouts and affixes in various places and on diverse surfaces, Dean cites Street Art techniques that have been increasingly employed in the commercial sector for so-called guerrilla marketing. Dean now returns this procedure to an artistic context. N.A.

Material
Plastic sheeting, concrete, stickers, metal, paper

Dimensions
Installation in the atrium covering an area of ca. 215 m²
Sculptures in front of the building of the museum:
152 × 40 cm
107 × 35 cm
170 × 45 cm
175 × 45 cm

Location
Atrium in old building of LWL-Museum für Kunst und Kultur and outdoor area in front of the old building
Domplatz 10, 48143 Münster

Jeremy Deller

Jeremy Dellers (* 1966 London, lebt in London) Interesse gilt populär- und volkskulturellen Phänomenen, deren schöpferisches Potenzial und ästhetische Vielfalt er in zahlreichen, partizipatorisch-prozesshaften Arbeiten thematisiert. Ein Fokus liegt dabei auf der gruppenbasierten Produktion von Ereignissen, die so unterschiedliche Formen wie eine Stadtparade, ein Konzert, eine Ausstellung oder das Reenactment einer streikbedingten Konfrontation annehmen können.

Speak to the Earth and It Will Tell You (2007–2017)

Bei Dellers Arbeit für die Skulptur Projekte 2017 handelt es sich um eine naturwissenschaftliche und kulturanthropologische Langzeitstudie, die der Künstler bereits für die Ausgabe 2007 initiierte und in Zusammenarbeit mit Münsteraner Kleingärtnern realisierte. Er bat über fünfzig Vereine, für die nächsten zehn Jahre ein Tagebuch zu führen, das botanische und klimatische Daten protokolliert, aber auch als Chronik lokaler Vereinsaktivitäten und gesellschaftlicher wie politischer Ereignisse fungieren sollte. Die inhaltliche Gewichtung und Gestaltung blieb dabei den Vereinen überlassen. Um die Zeitspanne zu visualisieren, wurden Taschentuchbäume gepflanzt, die für ihre erste Blüte zehn Jahre benötigen.

Das 2017 präsentierte Resultat umfasst etwa dreißig Bände, die in einem der Schrebergärten ausgelegt sind und eingesehen werden können. Neben zyklischen Naturvorgängen und damit korrespondierenden Gartenroutinen dokumentieren die Bücher traditionsreiche Rituale, singuläre Ereignisse und Kuriositäten der Kleingärtnerkultur vor Ort in Münster. Zehn Jahre verdichten sich in objekthafter Gestalt, natürliche und soziale Strukturen, Wachstums- und Gestaltungsprozesse durchdringen sich in vielfältigen Relationen. Als Chroniken, die eine ganze Dekade umfassen, stellen die Bücher Wissensspeicher und kollektive Selbstporträts der Vereine dar. Sie bieten Einblick in einen teils klischeebehafteten Mikrokosmos. Zugleich sind sie Zeugnis einer alternativen Geschichtsschreibung, deren Aufmerksamkeit dem scheinbar Peripheren gilt. Indem Dellers Arbeit als Türöffner zu einer Alltagskultur fungiert, die in ihrer sozialen, ökologischen und ästhetischen Funktion das Münsteraner Stadtleben mitprägt, plädiert sie auch für ein erweitertes Umweltbewusstsein.

Vor allem in der zweiten Hälfte des 20. Jahrhunderts erfuhren Kleingärten einen Funktionswandel: Ursprünglich häufig als Nutzgärten für die Selbstversorgung von Arbeiter- und Kleinbürgermilieus angelegt und vor allem in Krisenzeiten arbeitsintensiv bewirtschaftet, verbinden sich mit ihnen heute primär Freizeit, Erholung und Naturerfahrung. Als Schnittstelle von privatem Refugium und öffentlich einsehbarem, gemeinschaftlich verwaltetem Raum vereinen sie zahlreiche Widersprüche: Einerseits dienen sie der Entspannung und dem Rückzug, andererseits fördern sie Produktivität und soziales Miteinander. Reglements und Ordnung treffen auf Autonomiestreben und den Wunsch nach individuellem Ausdruck, die sich an der teils eigenwilligen Gestaltung der Parzellen ablesen lassen. A.P.

[Sprich zur Erde, sie wird es dir sagen (2007–2017)]

Material
Holzregal mit Tagebüchern, 2007–2017 geführt, installiert und zugänglich gemacht in einem Gartenhaus

Standort
Kleingartenverein Mühlenfeld
Lublinring, 48147 Münster

Jeremy Deller

Jeremy Deller (* 1966 London; lives in London) is intrigued by the phenomena of pop and folk culture and explores their creative potential and aesthetic diversity in numerous participatory, process-oriented works. He has a particular interest in group-based productions of events that can take a variety of forms, such as a municipal parade, a concert, an exhibition, or the re-enactment of a strike-related confrontation.

Speak to the Earth and It Will Tell You (2007–2017)

Deller's contribution to Skulptur Projekte 2017 is based on a long-term scientific and cultural anthropological study, which the artist initiated for the edition 2007 and carried out in collaboration with Münster's allotment garden clubs. He contacted over fifty such clubs asking them to keep a diary for the next ten years and record botanical and climatic data. In addition, he suggested that they use the diary as a chronicle of local club activities as well as social and political events. The book's form and the weighting of the content were left to the discretion of the individual clubs. Dove trees, which take ten years to blossom, were planted as a visualization of the time span.

The result presented in 2017 encompasses about thirty volumes which have been placed on display in one of the allotment gardens. The books not only document natural cycles together with the corresponding garden routines, they also keep track of allotment garden culture in Münster: the traditional rituals, individual events, and peculiarities of the local clubs. Ten years are condensed and packed into a physically defined form; natural and social structures, and growth and design processes intersect in diverse relationships. As chronicles that cover an entire decade, the books become reservoirs of knowledge and collective self-portraits for the allotment garden clubs. They provide insight into a microcosm that is partly tainted by clichés. But, at the same time, they bear witness to an alternative historical record focused on the seemingly peripheral. By opening a window on an everyday folk culture that helps to shape city life in Münster in social, ecological, and aesthetic terms, Deller makes a strong case for increased environmental awareness.

Allotment gardens have experienced a functional transition, particularly in the second half of the twentieth century: while, in many cases, they were originally designed as fruit and vegetable gardens to help working- and lower-middle-class families provide for themselves, and were intensively cultivated, particularly in times of crisis, today people use them primarily for leisure, recreation, and experiencing nature. The gardens reconcile a number of contradictions as an interface between a private refuge and a publicly visible, communally managed space: on the one hand, they offer relaxation and retreat; on the other, they promote productivity and social cooperation. Regulations and organizational constraints clash with the desire for autonomy and the wish for individual expression, which can be seen in some of the highly original allotment designs. A.P.

Material
Wooden shelf with diaries (kept from 2007 to 2017), installed and made accessible in a garden shed

Location
Mühlenfeld allotment garden colony
Lublinring, 48147 Münster

Garten 1
Juli
Annette und Winfred Wulf

Garten 2
Liesel und Hubert Dürwald

11.2.2013

Rosenmontag im Vereins-
haus

mit
König

+

Glitzer

Karnevals-
musik
via Trompete
von Roger

Kleingartenverein / Garden shed Mühlenfeld e.V., Tagebuchführerin / Diarist: Cornelia Wächter (S. / pp. 171, 173)
Kleingartenverein Zur Linde, Tagebuchführer / Diarist: M. Buchwald (S. / pp. 172, 174)

Jeremy Deller

Oktober

Wir sind wirklich
spät dran,
aber lieber spät
und dicke Kartoffeln
als Früh, und kleine!!

Jeremy Deller

Gemeinsames Frühstück.

Pünktlich zum Frühlingsbeginn am 21. März lud der Vergnügungs Ausschuss alle Gartenmitglieder zu einem gemeinsamen Frühstück im Vereinshaus zur Gießkanne ein. Viele Gartenfreunde waren der Einladung gefolgt. Beim Betreten des Vereinshauses war jeder erfreut von der herrlichen frühlingshaften Dekoration und den hübsch gedeckten Tischen. Gertrud, Annette und Christian hatten wieder alles so schön hergerichtet.

Das Frühstücksbuffet war in der Küche aufgebaut. Es fehlte an nichts. Von Brötchen, Baguette, verschiedenen Brotsorten und selbstgebackenem Pflaumenbrot, ging es weiter zu Salatplatten, Käse- und Aufschnitt, gefüllte Tomaten, Fischplatte, Mett mit Zwiebeln, gekochten Eiern, Quark, Müsli und Cornflakes. Einen ganz besonderen Akzent setzte Annette mit ihren eigenhändig gestrickten Eierwärmer-Pudelmützen, die dann auch noch jeder mit nach Hause nehmen durfte. Die Stimmung war hervorragend und jeder konnte gut gestärkt den schönen sonnigen Frühlingstag genießen. Danke Gertrud und Annette für den gelungenen Vormittag.

Nachdem das Wasser weg war, ging's ans Aufräumen und Putzen. Vieles war nicht mehr zu gebrauchen und ging weg. Einen Tag habe ich gespült und geputzt.

Dann ging's in den Beeten weiter. Ob das Wasser die Ernte vernichtet hat? Die Kartoffeln waren hin.

Beeren und Äpfel haben die Flut überlebt.

Mit dem Wasser kam viel neues unbekanntes Unkraut und leider auch Ratten. Gott sei Dank blieben sie nicht lange. Nur Mäuse und Schnecken sowie die Kaninchen sind wohl auch gute Schwimmer!

Unser Elan für den Rest 2014 war nur noch mäßig.

Wenden wir uns schönen Dingen zu
— Grillen —

Echte Thüringer aus Mühlhausen

Grill leer

Grill voll

Tisch gedeckt

"Wir warten"

Nach dem Essen soll man ruhen
oder etwas im Garten tun!

Jeremy Deller

Nicole Eisenman

Nicole Eisenman (*1965 Verdun, lebt in New York) ist vor allem als Malerin und Zeichnerin bekannt. Spielerisch greift sie auf eine Palette an Stilen und Bildsprachen zurück, die von Renaissancemalerei bis zur Moderne reicht, und verknüpft sie mit Alltagsbeobachtungen und Referenzen auf Popkultur und Pornographie. Beziehungen, Rollenklischees, Körper und Sexualität kommt in ihren figurativen, melancholisch grundierten Bildern zentrale Bedeutung zu. Seit 2012 bedient sich Eisenman darüber hinaus vermehrt des Mediums Skulptur, dessen haptisch-sinnliche Qualitäten sie schätzt.

Sketch for a Fountain

In Münster installiert Eisenman eine mehrfigurige Brunnenanlage inmitten der Promenade. Das Ensemble aus fünf überlebensgroßen Figuren aus Bronze oder Gips ist locker um ein Wasserbecken gruppiert. Die unbekleideten Figuren mit voluminösen Proportionen, die nicht eindeutig einem Geschlecht zuzuordnen sind, nehmen unterschiedliche Haltungen ein. Erzählerische Momente begleiten die zwanglose Szenerie: Eine ihre Nacktheit selbstbewusst zur Schau stellende Figur streckt sich inmitten des Wassers dem Himmel entgegen, während die anderen um das Becken abhängen, ein Sonnenbad nehmen oder versunken ins spiegelnde Nass blicken. Aus drei Körpern rinnt Wasser, während kleinteilig modellierter Pilzbewuchs zu Füßen einer Figur sprießt. Wie der Farbauftrag in Eisenmans Bildern variiert die Textur der Figuren. Bemooste Steine aus Marl ergänzen die Szenerie.

Mit der Brunnengestaltung interpretiert die Künstlerin eines der ältesten Modelle von Kunst im öffentlichen Raum neu. Brunnen fungierten in der Antike als Treffpunkt kultischer Handlungen. Monumentale Brunnenanlagen mit figurenreichen Bildprogrammen prägen bis heute zahlreiche Gartenanlagen und Plätze. Auf solche opulenten Inszenierungen reagiert Eisenmans Arbeit mit zartem Sprinkeln, aus verschiedensten Körperteilen sprühenden Wasserstrahlen und einer nur sanft bewegten Wasserfläche, die verbunden mit der Inaktivität der Figuren, Ruhe vermittelt. Der ausgreifend-bedeutungsvollen Gestik der historischen Inszenierungen setzt sie eine klobig-träge, cartoonhafte Figuration entgegen, die Assoziationen an Cézanne, George Segal oder Tom Otterness aufruft und sich wenig um ästhetische oder gesellschaftliche Normen schert.

Die Szene erinnert an Zeichnungen Eisenmans, die ein queeres Arkadien entwerfen. Die Zeit scheint stillzustehen, lediglich die Getränkedose einer dösenden Figur verweist in die Gegenwart. Reduzierte Aktivität, sanftes Plätschern und die ebenerdige Aufstellung laden ein, es den Protagonist_innen gleichzutun und Teil der Szenerie zu werden. Alles steht als elementare Schöpfung in fluider Beziehung miteinander, Natur, Kultur und Identitäten gehen ineinander über. Wind und Wetter lassen die Gruppe im Laufe der Ausstellung ein wenig altern. A.P.

[Skizze für einen Brunnen]

Material
Bronze, Gips, Wasserbecken

Maße
Wasserbecken
ca. 500 × 700 cm
Liegende Bronze
ca. 70 × 165 × 280 cm
Stehende Bronze
ca. 260 × 80 × 120 cm
Sitzende Gipsfigur
ca. 100 × 120 × 100 cm
Liegende Gipsfigur
ca. 50 × 120 × 320 cm
Liegende Gipsfigur mit Wasser
ca. 150 × 110 × 240 cm

Standort
Wiese neben der Promenade
Am Kreuztor / Promenade,
48143 Münster

Nicole Eisenman

Nicole Eisenman is primarily known for her paintings and drawings. She makes playful use of a palette of styles and visual languages that ranges from Renaissance painting to modern art, combining them with everyday observations and references to pop culture and pornography. Relationships, stereotypes, the body, and sexuality are assigned a key role in her figurative pictures with their underlying sense of melancholy. Since 2012, Eisenman has been increasingly involved with sculpture, a medium she appreciates for its tactile and sensual qualities.

Sketch for a Fountain

In Münster Eisenmann has created a fountain installation with several figures in the middle of the Promenade. The ensemble of five larger-than-life figures, made of bronze or plaster, is casually grouped around a basin. The nude figures of voluminous proportions, which cannot readily be assigned to one gender, take various poses. The relaxed formation is accompanied by narrative moments: in the middle of the water, a self-assured nude extends its body skywards in exhibitionist fashion, while the other figures chill around the basin, sunbathing or lost in thought as they gaze into the reflections in the pool. Water trickles from three of the figures, as a culture of hand-made mushrooms sprouts at the feet of one figure. Similar to Eisenman's colour application in her paintings, the texture of the figures is varied. The entire setting is rounded off with moss-covered stones from Marl.

With her fountain design, the artist has interpreted one of the oldest examples of public art in a new way. In antiquity, fountains served as meeting places for cult rituals. And today monumental fountains with an abundance of figures still give distinction to numerous parks and squares. Eisenman's work responds to those opulent arrangements with a gentle sprinkle, streams of water coming from various body parts, and a placid water surface that—together with the inactivity of the figures—conveys calm. She counters these historical fountain arrangements, which are replete with a wide range of meaningful gestures, with lumpishly sluggish, cartoon-like figures that evoke associations with Cézanne, George Segal, or Tom Otterness and seem indifferent to aesthetic or societal norms.

The scene resembles those of the artist's drawings that bring forth a queer Arcadia. Time seems to stand still; only the can of soda held by a dozing figure alludes to the present. Reduced activity, gentle splashing, and the ground-level arrangement invite visitors to join the protagonists and become part of the setting. Everything stands together as an elementary creation in fluid correlation as Mother Nature, culture, and identities intertwine. Wind and weather cause the group to age slightly over the course of the exhibition. A.P.

Material
Bronze, plaster, basin

Dimensions
Basin
ca. 500 × 700 m
Reclining bronze
ca. 70 × 165 × 280 cm
Standing bronze
ca. 260 × 80 × 120 cm
Seated plaster figure
ca. 100 × 120 × 100 cm
Reclining plaster figure
ca. 50 × 120 × 320 cm
Reclining plaster figure with water
ca. 150 × 110 × 240 cm

Location
Meadow alongside Promenade
Am Kreuztor / Promenade,
48143 Münster

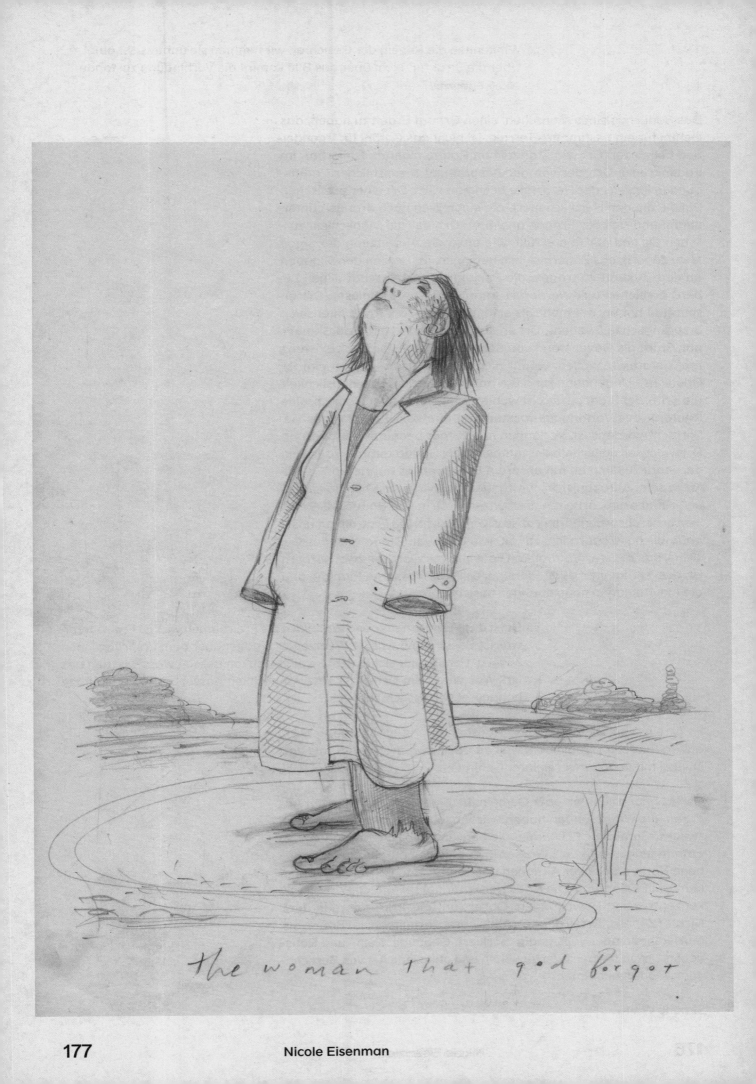

the woman that god forgot

Nicole Eisenman

> Wir kennen die Regeln der Gesichter, wir nehmen sie unbewusst auf.
> Über die Struktur, nicht über das Bild kommt die Verbindung zustande.
> (Nicole Eisenman)

Das Bedürfnis eines Menschen, einen Ort auf Erden zu haben, das Gefühl für ein bestimmtes Terrain, ist nicht das Gefühl für irgendeinen beliebigen Ort (ein Standort im Raum, planbar, isolierbar, im Fadenkreuz): Ort, der von der Ausbreitung menschlicher Empfindungen jenseits der Herdstelle bestimmt wird, Ort einer erotischen Politik, die den Herd scheuert, die einen Weg nach draußen unternimmt und sich der Fragen annimmt; Ort, der die Möglichkeit zwischen dir und mir übererfüllt, wie etwa die Aussetzung der *small love*; Zögern, das Zögern selbst, beginnen, im Herzen den Glauben an eine Zukunft zu tragen, die Perfektion gemeinschaftlichen Lebens erreichen (wir werden zusammengelebt und diesen Ort erschaffen haben) mit mehr als einem anderen, am Rand intensiven ursprünglichen Erlebens, Ort an der Schwelle zu Herd und Gemeingut. Stadt als Gegenstand von Sehnsucht, noch vor ihrer Existenz, mehr statt viel wollen, womit nicht Machtausübung gemeint ist. Deutliches Unbehagen rund um das Versprechen der Häuslichkeit, die Kritik der Stadt am *sex* ist wunderschön, anti-etymologisch, eine Rhetorik des Verlangens formulieren, die kein Postulat des Beherrschtwerdens ist. Verlangen nach Stadt bedeutet Verlagerung, Ortswechsel, außerhalb des Intimen in die Gänge kommen, das Sein der Stadt zusammen mit unserem Begehren, es figurieren, Co-Autor_in sein, Antagonist_in, wir fangen an. Wir gehen hinein, hinaus und rundherum, arbeiten uns konzentrisch in den Boden, als Reflexion unserer sprunghaften, obsessiven Absicht. Die Erde nimmt unser anfängliches Zögern in sich auf, wie auch wir. Die Regeln des Gesichts, das Zögern, das draußen beginnt, was zwischen zwei Körpern ist, das ist Planung; es ist Planung, es ist ambivalente Planung und die Akkumulation gegenläufiger Absichten.

Geist des Freiräumens des Stadtbildes als Freiräumen was ist Freiräumen was ist Beseitigung was ist Ersetzen was gegenüber dem ursprünglichen Zögern (Urteil) angesichts der Unzulänglichkeit dessen was zwischen uns ist? Was wird dem Urteil der Unzulänglichkeit dessen was als Erfüllung behauptet wird geschuldet sein?

Es ist ein wütendes Rein- und Rausgehen und ein Wiederkehren, außerstande, fortzubleiben, weil da mehr zwischen uns ist als das Dunkel miteinander vereinigter Genitalien.

Die Wohnung räumen oder Gemeingut. Eine Gruppe bilden mit Anderen, die wir gefunden haben werden, absichtliches Freiräumen zwecks räumlicher Erfindung, die begründete Transformation von Empfindung — Stein und Wasser und eine kleine Gruppe, die erhabene Kette glanzloser Aktionen gegen dreckige Gewalterfahrung, immerhin Erfahrung. Die Kritik der Stadt am *sex* und die Arbeit mit konzentrischen Bewegungen, Obsession und Pflanzen, aus dem Nichts / Zögern / Urteil neue Gefühle herausarbeitend, im Boden als befriedigend oder vollständig markiert. Gebäude. Rein- und Rausgehen, um zu bleiben oder zu gehen und ohne jede Art von Berechtigung wiederzukommen.

Simone White

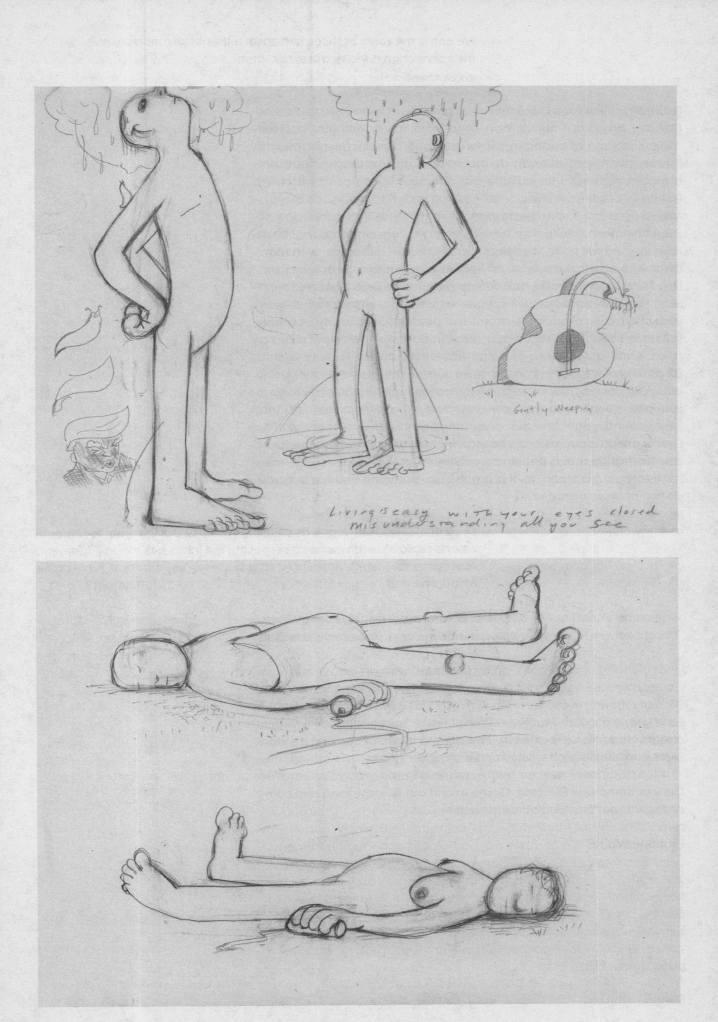

Gently Weeping

Living's easy with your eyes closed
Misunderstanding all you see

Nicole Eisenman

We know the rules of faces, we absorb them subconsciously/
the connection is via texture, not image.
(Nicole Eisenman)

Human feeling for a place on earth, emotion of terrain, is not feeling
for just any place (location in space, plot-able, isolable, in cross-
hairs): place constituted by sprawl of human feeling beyond hearth-
stone, location of an erotic politics that chafes the hearth, that com-
mences passage into outside and the questions passing attends,
place exceeding possibility between you and me, as such the sus-
pension of small love; hesitation, hesitation itself, commencing ac-
tion holding in the heart a future perfect achievement of collabora-
tive life (we will have lived together and made this place) with more
than one other at the edge of tight primordial experience, place at
the threshold of hearth and commons; 'city' as desire before found-
ing, to want more between many, which is not government; plain
dissatisfaction around the promise of domesticity, the city's critique
of sex is beautiful, anti-etymological, initiating a rhetoric of desiring
that is not a postulate of being governed, desire for city is shift,
changing place, getting on the move outside the intimate, city's being
with our desire, figuring it, co-maker, antagonist, we begin. We go in
out and around, wearing a concentrated or pacing concentricity into
the ground, reflecting our desultory and obsessive purpose. The
earth absorbs our initiating hesitation, with us, too, the rules of faces,
the hesitation that is beginning outside what is between two bodies
is planning; it is planning, it is ambivalent planning and the accumu-
lation of cross purposes.

spirit of clearing cityscape as clearing what is clearing what is removal
what is replacement what with respect to the initial hesitation (judgment)
regarding the insufficiency of what is between us? what will have come
of judgment of the insufficiency of what is given as fulfillment?

It is going in and out in a rage and returning, unable to stay away
because there is more between us than the dark of conjoined genitals.

Flat clearing or commons, going in a band with others we will have
found, purposeful clearing for topological invention, the transforma-
tion of emotion in cooperation with grounds, which is rock and water
and a little band, the sublime chain of flat actions against dirty violent
experience, also experience. The city's critique of sex and its work
with concentricity obsession and plants, carving out of nothing / hes-
itation / judgment new emotions, marked in the ground as satisfac-
tory or complete. Building. Going in and out to stay or go and come
back without any kind of authorization.

Simone White

Ayşe Erkmen

Ayşe Erkmens (* 1949 Istanbul, lebt in Berlin und Istanbul) ortsbezogene Interventionen lenken das Augenmerk auf Übersehenes und stellen aus, was sonst verdeckt bliebe. Sie greift in gegebene Strukturen ein und verändert Funktionen oder Abläufe, wodurch sich mindestens ein ungewohnter, wenn nicht ein gänzlich neuer Blick auf Bekanntes eröffnet.

On Water

Für die Skulptur Projekte 2017 wählt Erkmen den Binnenhafen als Standort. Zwischen dem stark frequentierten Nordkai und dem eher industriell geprägten Südkai installiert sie knapp unter der Wasseroberfläche einen Steg, der beide Ufer miteinander verbindet. Es entsteht der Eindruck, die Besucher_innen würden über das Wasser laufen. Sie werden dabei zu sichtbaren Akteur_innen auf einer von Erkmen inszenierten Bühne. Darüber hinaus beleuchtet die Künstlerin Probleme soziologischer und stadtplanerischer Art: Wie werden Grenzen auf Landkarten gezogen und soziokulturelle Zugänglichkeit auf dem Reißbrett geregelt? Wie können einmal gebaute Hürden physisch und metaphorisch überwunden werden?

Innerhalb des Werkes von Erkmen manifestiert sich das Transportieren, Relokalisieren und Verschieben immer wieder neu. So brachte sie während der Skulptur Projekte 1997 Sammlungsobjekte des Landesmuseums auf ungewöhnliche Weise in Bewegung, als sie diese mit einem Hubschrauber über der Stadt kreisen ließ. Damals waren Vorschläge für eine Intervention am St.-Paulus-Dom abgelehnt worden, und so nutzte Erkmen den genehmigungsfreien Luftraum. Für ihren diesjährigen Beitrag bietet sie einen im Gefüge der Stadt nicht vorgesehenen Weg an und beschäftigt sich ferner mit dem in ihren Arbeiten häufig auftauchenden Element Wasser. Für die 54. Biennale von Venedig ließ sie 2011 unter dem Titel *Plan B* eine Wasseraufbereitungsanlage in der italienischen Lagunenstadt installieren. Ihr Werk *Shipped Ships* hatte ebenfalls einen konkreten Bezug zu Wasserwegen: 2001 konnten die Bewohner_innen Frankfurts den Main mittels angemieteten Personenfähren aus Japan, Italien und der Türkei erstmals als Transportweg nutzen.

Flussläufe fungierten auf politischen Karten oft als Möglichkeit der Grenzziehung, Wasserwege und menschengemachte Kanäle dagegen als Ausgangspunkte und Katalysatoren für urbane Entwicklung. Wasserläufe zeichnen sich dementsprechend durch eine zivilisatorische Ambivalenz zwischen Möglichkeit und Beschränkung aus, die Erkmen in ihrem Beitrag für die Skulptur Projekte 2017 nicht nur spiegelt, sondern im Wortsinn überbrückt. Ihr Steg besteht zudem aus versenkten Cargo-Containern, jenen Behältern also, die normalerweise zum Transport von Gütern oberhalb der Wasseroberfläche auf Schiffen vorgesehen sind. Der von der Schifffahrt wenig benutzte Stadthafen des Donau-Ems-Kanals wird für die Bewohner_innen und Besucher_innen Münsters *per pedes* erschließbar, und Erkmen verbindet damit zwei zuvor durch das Hafenbecken getrennte urbane Räume – nicht durch eine Land-, sondern durch eine Wasserbrücke. N.A.

[Auf dem Wasser]

Material
Seefracht-Container, Stahlträger, Gitterroste

Maße
6400 × 640 cm Lauffläche

Standort
Stadthafen 1
→ Nordseite: Hafenweg 24
→ Südseite: Am Mittelhafen 20,
48155 Münster

Öffnungszeiten
Mo – So 12 – 20 Uhr

Ayşe Erkmen

Ayse Erkmen's (* 1949; Istanbul; lives in Berlin and Istanbul) site-specific interventions call our attention to things that are overlooked, presenting what would otherwise remain hidden. She interferes with pre-existing structures and alters their functions or operational processes, revealing, at the very least, an unusual if not completely new view of something familiar.

On Water

For Skulptur Projekte 2017, Erkmen selected Münster's inland harbour as her location. Just below the surface of the water between the bustling Nordkai (northern pier) and the industrialized Südkai (southern pier) she installed a jetty that links the two riverbanks. It creates the impression that visitors are walking on water. In that sense, they become visible actors on Erkmen's stage. In addition, the artist points out problems of a sociological and city-planning nature: How are borders drawn on maps, and how is sociocultural access achieved on the drawing board? How can existing hurdles be overcome, both physically and metaphorically?

Within Erkmen's oeuvre, the concepts of transportation, relocation, and displacement keep manifesting themselves anew. For example, during Skulptur Projekte 1997 she set objects from the collection at the Landesmuseum in motion in a very unusual manner when she had them circle above the city with a helicopter. Her plans for an intervention at St Paul's Cathedral had been rejected, so Erkmen made use of the airspace above it, which she was permitted to use. For her contribution this year she creates a pathway which wasn't intended as part of Münster's urban structure and deals once again with water, an element that frequently appears in her work. At the 54th Venice Biennale in 2011, she had a water treatment facility installed in the city, entitled *Plan B*. Her piece *Shipped Ships* was also specifically related to waterways: in 2001 she arranged for passenger ferries rented from Japan, Italy, and Turkey to carry local residents, turning the river Main in Frankfurt into a possible means of getting about in the city.

The courses of rivers have often been used on political maps as a possible place to draw borders, while waterways and man-made canals served as starting points and catalysts for urban development. Accordingly, waterways have had an ambiguous place in the processes of civilization, representing either possibility or restriction. Erkem not only mirrors this divide in her piece for Skulptur Projekte 2017, she literally bridges it. In addition to that, her jetty consists of sunken containers which are normally used to transport goods on ships on the surface of the water. The municipal harbour of the Danube-Ems Canal, which is rarely used by ships, now becomes accessible *on foot* to Münster's residents and visitors, thus linking two separate urban spaces that were previously separated by the harbour basin—using a water bridge rather than a land bridge. N.A.

Material
Ocean cargo containers, steel beams, steel grates

Dimensions
6400 × 640 cm walkway

Location
Stadthafen 1
→ North side: Hafenweg 24
→ South side: Am Mittelhafen 20, 48155 Münster

Opening hours
Mon – Sun 12 – 8 pm

The Walter is lazy today, it's stuck and greenish

Is Walter the canal in front of you. I have been to Bebek (baby/seaside in Istanbul) today to look at the sea and prepare for our talk.

I mean our chat!

road, tram and canal lying next to each other

at the place of the lantern, from time to time there is someone waiting for something, I never See him come or go, he's just there or not there

Walter is an unusual name as is Bebek ☺ for a neighborhood especially with water. That someone must be just gazing at the water as I've done this morning. It is so mesmerizing!

are you at the waters now

?

I am back at home now. No view of sea from here. You are lucky with your new flat! 😄

Not so sure, my drainage is stuck and I use a bucket to catch the water I use , which makes me so aware of the amount I am using, if I am in time to empty the bucket!

I just sat on a bench and looked. Someone was running with her dog, back and forth, between me and the sea.

This happened a lot back in the 80's in Istanbul, or we had to collect water to take a shower and cook. Therefore I am always stingy still when I use

Water became Walter

What's the name of the canal in Münster

By the way Walter is not the Name of the canal, this was the irritating autocorrection that I didn't succeed switching off yet

will call the canal Walter from now on

It is the name of the Belgian designer, Walter, he recently did kitchenware for ikea with eyes 👀 like this!

I like the time laps our writings create

It is also the name of a Belgian painter who eventually could use eyes like 👀

just harbor I call it. With lots of cafes, the Kunsthalle, Cinemas, many many young people, students… the good thing is that the water ends there, cannot move on…

like a dead Ende?

It is in the nature of chatting, it flows here and there and cannot wait! Yes a dead end!

walking over a dead end instead of walking towards it

🐟🐠no fish no boats

what are you doing with your collected water?

I throw it in the toilet

Instead of turning around it. Actually it is a futile effort.

Ayşe Erkmen

The boats pass by really slowly, you do not even see the water any more , the boats name yesterday was RAPIDE

To walk over water without getting wet, to walk over water without falling into it... big achievements although futile!

Falling into it, in german means cancelling the event, if something cannot take place

Means it is the end. such a strong statement on water.

Here is a boat from this morning. Water never stops moving...

Hidden waters as well, yesterday I opened a Zisterne, a room of water in the ground. A black box where it kept the water

We have a saying, " my dreams fell into water" which means the hopes and dreams of one person cannot be fulfilled.

I was always suspicious when they told me Jesus walked on water, never believed them, sounded like an ad

When and where did you get the idea for the work

None can walk on water. It is beautiful and dangerous. The sensation comes from that. Beauty and danger!

Sorry, falling into the trap of the Interview whereas we wanted it to be between views

no problem. What are you doing these days?

I don't think he did. I have been in venice by the seaside once when aqua alta happened. It was a wonderful experience, it felt like standing on the sea, I felt as if I was inside an endless space...all was open...

I am fascinated by water because it frightens me as well. But it was a more logical and pragmatic decision together with my fascination for Münster. I had made a work which was flying in the air before and I thought the second time around I can't go and sit on solid land. I should go under water...

This mark was already there I guess

this is the starting point of my bridge!

do you like swimming pools, controlled water

yes it was there, someone made a 😊

Not really, although I learned swimming in it, because someone pushed me in

someone threw me in deep water when I was 4 thinking this was a way to teach me to swim. My trauma became my fascination.

Ayşe Erkmen

Making coffee

Brown water

I love coffee

The film you have sent me just downloaded. It is beautiful how this ship occupies the whole waterway and how slow and gracefully it moves... I wish a film could be printed on paper.

There is this beautiful story I remember Bart told me, when he visited an artist in the studio, at a certain moment he took a spoon dived with it into the coffee and lifted a little sculpture out of it

this is my recent coffee maker. You pour water/ Walter very slowly

And back into the coffee

you mean a piece of solid coffee from down under the cup which sinks under water and tries to keep calm like the sandy surface under the sea?

I mean a sculpture that was kept in the coffee and then lifted to be shown and disappearing again

I thought of remains left in the coffee cup which looks like sculpture too.

coffee is ready

Not to forget, the sound of water

oh that's very artistic. like a treasure

They say one has to drink coffee together with water!

the variety is endless

while preparing I was watching water walk of John cage, a TV performance, he calls it water walk because it contains water and he is walking while performing

I love it in japan where they use water sound in public places...and the sound of boiling water; water hitting the shore, dripping water....all kinds of sounds,

a title?

Water, Walk, Walter...

title for what; maybe for my bridge... would be nice but I titled it already. Should I change??

what is the title

on Water! "walk the water Walter"??? but Walter is a man's name: politicly incorrect

Walter was a mistake. It can continue as mistake

it started with a mistake,remember?

BETWEEN
WATERS

between waters

Chat

between

Ayşe

and

Suchan

Ein Chat zwischen / Chat between Suchan Kinoshita und / and Ayşe Erkmen; Design: Suchan Kinoshita

Lara Favaretto

Die Objekte Lara Favarettos (*1973 Treviso, lebt in Turin) zeichnen sich durch eine minimalistische Formensprache aus, die jedoch anhand der bewusst gewählten ortspezifischen Einbettung eine starke soziale und politische Bedeutungsaufladung erfahren. Aus Stein und Metall gefertigt, vermitteln sie zunächst den Eindruck, als wären sie für eine längere Dauer entworfen. Die Arbeiten verschwinden durch Demontage oder vollständige Zerstörung jedoch zum Ende einer Ausstellung.

Momentary Monument – The Stone

Favaretto realisiert ihre fortlaufende Serie *Momentary Monuments* in verschiedenen Formen seit 2009. Für Münster wird diese Serie an der Promenade und in der benachbarten Stadt Marl jeweils mit einem von innen ausgehöhlten Granit-Monolithen fortgeführt. Der vier Meter hohe Stein erscheint wie ein Fremdkörper oder eiszeitlicher Findling. Zugleich ist er beim Umlaufen eindeutig als handwerklich bearbeitet erkennbar und wirft damit die Frage nach seiner Funktion auf. Durch einen kleinen Schlitz kann Geld eingeworfen werden. Zum Ende der Ausstellungszeit wird der Stein zerstört, der Schotter einer neuen Funktion zugeführt und das gesammelte Geld einem wohltätigen Zweck gespendet. Die Künstlerin hat sich dabei für die Hilfe für Menschen in Abschiebehaft Büren e. V. entschieden.

Favarettos Monument ist zu Beginn der Ausstellung leer und im besten Sinn bedeutungslos. Monumente oder Denkmale des öffentlichen Raums verweisen gewöhnlich entweder auf ein bestimmtes Ereignis oder eine Person der Vergangenheit, um sie in der Gegenwart präsent zu halten. Gelder für die Errichtung von Monumenten werden gewöhnlich vorab gesammelt, um sie als Auftragsarbeit von Künstler_innen ausführen zu lassen. Favaretto verschiebt diese übliche Genese und deutet Funktionen um. Insbesondere die kurze Lebensdauer des Objekts und seine Zerstörung unter Weiterverwendung der Bruchstücke und Überreste stehen einer institutionalisierten Denkmalpflege diametral entgegen.

Die symbolische Bedeutung des Objekts generiert sich nicht aus der Form selbst, sondern durch den ortsspezifischen Zusammenhang: Auf der Promenade tritt die Arbeit in Dialog mit dem *Train-Denkmal* aus den 1920er Jahren und der nahe gelegenen Ausländerbehörde, der in der Mitte gelegene Kreisverkehr verbindet die unterschiedlichen Zusammenhänge topografisch miteinander. Das *Train-Denkmal* ehrt das gleichnamige Bataillon sowie namentlich zwei in den Kolonialkriegen in ehemals Deutsch-Südwestafrika und beim Boxeraufstand in China gefallene höhere Militärs. Die gesammelten Spenden gehen an eine Stiftung, die seit 1996 Geflüchtete in einer sogenannten Unterbringungseinrichtung für Ausreisepflichtige betreut. Die in Nähe der Kleinstadt Büren auf dem Land gelegene Einrichtung ist für Geflüchtete in ganz Nordrhein-Westfalen zuständig, insofern ist auch der Spendenzweck des *Momentary Monument* in Marl der gleiche. Durch die Spendenfunktion entsteht ein starker Bezug zur Gegenwart, der im weiteren Sinne das Verhältnis zwischen Kunst und Politik kritisch reflektiert. N.A.

[Momenthaftes Monument – Der Stein]

Material
Tittlinger Grobkorn (Granit)

Maße
ca. 420 × 140 × 155 cm

Standort
→ Nordöstliche Wiese zwischen Ludgeriplatz und Promenade (hinter den Bushaltestellen), 48151 Münster
→ Zweiter Teil der Arbeit in Marl auf dem Rathausvorplatz Creiler Platz 1, 45768 Marl

Spenden gehen an Hilfe für Menschen in Abschiebehaft Büren e. V.

Lara Favaretto

Lara Favaretto's (* 1973 Treviso, lives in Turin) objects and installations are characterized by a minimalistic style, yet by conscientiously embedding her work in a carefully selected location, she gives it a strong social and political impact. By using materials such as stone or metal, her objects initially convey the sense that they are designed for a much longer space of time. However, Favaretto's art disappears at the end of an exhibition when it is either dismantled or completely destroyed.

Momentary Monument — The Stone

Favaretto's ongoing series of *Momentary Monuments* has been executed in various forms since 2009. For Skulptur Projekte 2017, this series will be continued on the Promenade and in the neighbouring town of Marl, in each case with a hollowed-out granite boulder. At first sight, the four-metre-high stone seems to be an alien object or a glacial erratic. And yet, when you circle the boulder, it is evident that it was wrought by hand, which raises questions as to its function. There is a little slot that money can be dropped into. At the end of the exhibition the stone will be destroyed, the resulting gravel reused, and the collected money donated to charity. The artist has decided to give the money to the organization Hilfe für Menschen in Abschiebehaft Büren e.V. (offering help to people facing deportation).

Favaretto's monument is empty at the beginning of the exhibition and meaningless in the best sense of the word. Normally public monuments or memorials refer to a particular event or a historical person to keep their memory alive in current discourse. Donations are usually collected before monuments are erected to pay the commissioned artists. Favaretto, however, changes the normal process and reinterprets certain functions. In particular, the object's temporary existence and its destruction, with the debris and remains being put to further use, are diametrically opposed to the concept of institutionalized monument conservation.

Nevertheless, the symbolic meaning of the object isn't derived from the form itself but rather emerges as a result of the site-specific interaction: on the Promenade, Favaretto's stone begins a dialogue with the *Train Monument* from the 1920s and the nearby immigration office. The roundabout in the middle (Ludgeriplatz) topographically connects the two contexts. The *Train Monument* honours the Train Battalion as well as two high-ranking German officers who died in battle, one in the former colony of German South West Africa and the other in the Boxer Rebellion in China. The donations collected inside the monument are also for a foundation that has been caring for refugees in a 'shelter for those scheduled for deportation' since 1996. The facility, located in a rural area near the town of Büren, is responsible for accommodating refugees from all over the state of North Rhine-Westphalia, thus corresponding to the fundraising aim of *Momentary Monuments* in Marl. The charitable aspect of Favaretto's work produces a strong sense of contemporary relevance, which, in a broader sense, critically reflects on the relationship between art and politics. N.A.

Material
Tittlinger coarse-grained granite

Dimensions
ca. 420 × 140 × 155 cm

Locations
→ North-eastern meadow between Ludgeriplatz Square and Promenade (behind bus stops), 48151 Münster
→ Part two of the work on the courtyard of the town hall in Marl
Creiler Platz 1, 45768 Marl

Donations to Hilfe für Menschen in Abschiebehaft Büren e.V.

„Unterschied – Wiederholung sind beides positive Kräfte mit unvorhersehbarer Wirkung. Ich mache das Konzept, ich erneuere es, und ich löse es entlang eines sich bewegenden Horizonts auf, aus einem stets dezentrierten Zentrum heraus, aus einer stets verschobenen Peripherie heraus, die sie wiederholt und differenziert." (G. Deleuze)

'Difference and Repetition are both positive forces with unpredictable effects. I make, remake and unmake my concepts along a moving horizon, from an always decentered center, from an always displaced periphery which repeats and differentiates them.' (G. Deleuze)

Momentary Monument – The Stone

Um sich einigen der Themen zu nähern, die für *Momentary Monuments – The Stone* von Bedeutung waren, werden hier Parallelen aufgezeigt: Schenkung – Zerstörung, Sichern – Vergessen, Wert – Kampf, Geschenk – Wagnis. Das Projekt ist in verschiedene Phasen unterteilt, die eng an diese Konzepte anschließen. Es fängt mit der Auswahl des Steins und der Wohltätigkeitsorganisation an, beide vor Ort, und endet mit der Zerstörung (der *Entformung*) des Steins sowie der Schenkung des übrig bleibenden Schotters an ein örtliches Bauunternehmen, das dieses Material beim Bau eines neues Gebäudes benutzen wird.

Momentary Monument – The Stone

To provide a better sense of some of the themes that helped shape *Momentary Monuments—The Stone*, they are shown briefly here as a series of parallels: Donation – Destruction; Save – Forget; Value – Battle; Gift – Risk. The project is divided into different phases that are closely related to these concepts. They go from choosing of stone and selecting the charity—both of them local—to the final demolition (de-sculpting) of the stone and the donation of the remaining gravel to a local construction company that will include this material in the making of a new building.

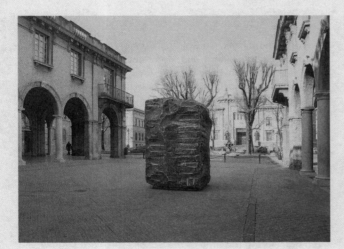

Momentary Monument – The Stone, 2009, Indischer Granit, 310 × 180 × 190 cm; Installationsansicht, Piazzetta Piave, Bergamo
Momentary Monument—The Stone, 2009, indian granite, 310 × 180 × 190 cm; installation view at Piazzetta Piave, Bergamo

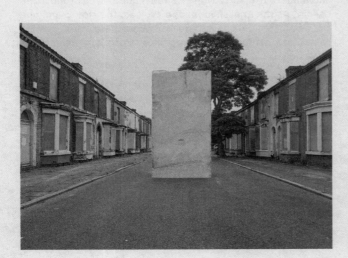

Momentary Monument – The Stone, 2016, Granit Tarn Silver Star, 400 × 155 × 195 cm; Installationsansicht, Rhiwlas Street, Liverpool
Momentary Monument—The Stone, 2016, Tarn Silverstar granite, 400 × 155 × 195 cm; installation view at Rhiwlas Street, Liverpool

Sparschwein, anonym, ca. 1300–1500;
Rijksmuseum, Amsterdam
Piggy bank, anonymous, ca. 1300–ca. 1500;
Rijksmuseum, Amsterdam

Der Westerham Hort, ein Goldmünzenhort aus der Eisenzeit,
1927 im Hohlraum eines Feuersteins gefunden;
The British Museum, London
The Westerham hoard, a hoard of gold Iron Age coins found
inside a hollow flint in 1927; The British Museum, London

Sparschweine gibt es seit fast sechshundert Jahren. Bevor sich Bankinstitute etablierten, war es üblich, sein Geld in gewöhnlichen Küchengefäßen aufzubewahren. Im Mittelalter wurden Geschirr und Töpfe aus einem günstigen Ton namens Pygg gefertigt. Sobald man ein paar Münzen zusammengespart hatte, steckte man sie in eine solche Tonbüchse, in einen *pygg pot*. Während der Zeit der Sachsen wurde das Wort *pygg* wie *pug* ausgesprochen. Als sich aber die Aussprache des *y* von einem *u* zu einem *i* änderte, wurde *pygg* schließlich wie *pig* (Schwein) ausgesprochen. Als sich die englische Sprache weiterentwickelte, wurden der Ton (*pygg*) und das Tier (*pigge*) gleich ausgesprochen, und die Europäer vergaßen allmählich, dass *pygg* sich einst auf die tönernen Töpfe bezogen hatte.

Die frühen Modelle hatten kein Loch an der Unterseite, sodass man das Schwein zerbrechen musste, um das Geld herauszubekommen. Manche behaupten, dass daher der Ausdruck *die Bank sprengen* stammt. Seriöse Akademiker_innen widersprechen dem aber. Die Redensart *breaking the bank* bedeutet, dass jemand finanziell ruiniert ist oder dass jemandes Budget überzogen ist. Der Begriff stammt wahrscheinlich aus dem Glücksspiel, wo er bedeutet, dass ein Spieler mehr gewonnen hat, als die Bank / das Haus auszahlen kann.

The origin of piggy banks dates back nearly six hundred years. Before the creation of modern-style banking institutions, people commonly stored their money at home in ordinary kitchen jars. During the Middle Ages, dishes and pots were made of an economical clay called pygg. Whenever people could save an extra coin or two, they dropped it into one of their clay jars—a pygg pot. During the time of the Saxons the word pygg would have been pronounced 'pug'. But as the pronunciation of 'y' changed from 'u' to 'i', pygg eventually came to be pronounced as 'pig'. As the English language evolved, the clay (pygg) and the animal (pigge) came to be pronounced the same, and Europeans slowly forgot that pygg once referred to the earthenware pots.

Early models had no hole in the bottom, so the pig had to be broken to get the money out. Some people say that's where we get the expression 'breaking the bank', but serious academics disagree. The idiom 'break the bank' means to bring financial ruin or to exhaust one's resources. The term is believed to have originated in gambling, where it means that a player has won more than the banker (the house) can pay.

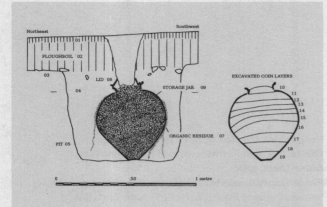

Querschnittszeichnung des Topfes in situ, die die Grube zeigt, in der er sich befand, den Deckel auf der Topfmündung, die organische Substanz und das kleine Loch, das von dem Sondengänger David Crisp gegraben wurde.
Section drawing of the pot in situ, showing the pit in which the pot was placed, the lid over the mouth of the pot, the organic matter, and the small hole dug by metal detectorist Dave Crisp.

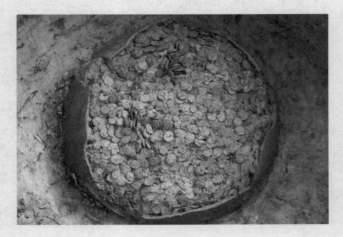

Der Frome Hort, der größte Münzhort, der jemals in England in einem einzelnen Gefäß entdeckt wurde. Er wurde 2010 von David Crisp gefunden und enthielt mehr als 52.503 Münzen aus der Zeit von 253 – 290.
The Frome hoard: the largest hoard of coins ever discovered in Britain in a single container. It was found by Dave Crisp in 2010 and contained 52,503 coins dating from AD 253 – 90.

Einer der Hauptgründe für das Vergraben von Münzen – und dementsprechend auch für Münzfunde – ist das Hamstern, daher sollte es auch ein paar Überlegungen wert sein. Die von Panik geplagten Menschen, die Geld horten wollten, verschwendeten nicht ihre Zeit, indem sie abgewertetes Papiergeld sparten, sondern legten Goldmünzen beiseite. Schätze wurden in verschiedenen Behältern versteckt und oft zerbrachen diese bei der Entdeckung, aber der ungewöhnliche Zustand mancher der antiken Münzen, an die wir so gelangen, ist dennoch dem Schutz zuzuschreiben, den sie gewährt haben. Bezüglich der Umstände, die zum Horten führen, wie auch den Gründen für das Vergraben der Horte, taucht eine interessante Frage auf: Wem gehört ein Hortfund nach der Entdeckung? Früher bekam immer der Finder den Schatz – ob er versteckt wurde, verloren war oder zurückgelassen wurde.

Since hoarding is one of the initial causes of coin burials and, consequently, of coin finds, it may be useful to consider it further. The panic-stricken people who wished to hoard money did not waste their time saving depreciated paper money but laid aside gold coins. Receptacles in which hoards are hidden vary widely and are often broken during the finding, but the protection they have afforded accounts for the unusual condition in which some of the ancient coins come down to us. In considering conditions that are conducive to hoarding, as well as the reasons for the burial of the hoards once they have been accumulated, an interesting question arises as to whose property such a hoard is when it is discovered. In the past, a treasure trove—whether hidden, lost, or abandoned—belonged to the finder.

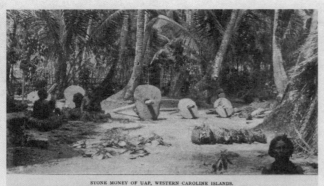

STONE MONEY OF UAP, WESTERN CAROLINE ISLANDS.
(From the paper by Dr. W. H. Furness, 3rd, in Transactions, Department of Archæology, University of Pennsylvania, Vol. I., No. 1, p. 51, Fig. 3, 1904.)

Rai aus Yap, mit Holzstangen für den Transport;
Quelle: Caroline Furness: *String Figures and How to
Make Them*, 1908
Rai of Yap, with logs for carrying the stones;
source: Caroline Furness, *String Figures and How to
Make Them*, 1908

Rai-Steine wurden und werden immer noch bei einigen wenigen gesellschaftlichen Transaktionen verwendet, etwa bei Hochzeiten, Erbschaften, politischen Geschäften, Bündnissen, als Lösegeld für im Kampf Gefallene, selten auch im Tausch für Nahrung. Es gibt mehrere Faktoren, die den Wert von Steingeld bestimmen. Der erste ist die Anzahl von Menschenleben, die geopfert wurden, als der Stein herbei geschafft wurde. Der Zweite ist die Qualität der Ausführung. Wenn man den Wert von Steingeld mit einer modernen Währung vergleicht, dann bezieht sich der Wert der modernen Währung auf Waren; Steingeld aber hat mit Rechten und mit Bräuchen zu tun, und als Teil der Tradition bleibt es bei den Menschen. John Tharngan, Denkmalschutzbeamter aus Yap, Föderierte Staaten von Mikronesien, erklärt die einzigartige Währung seiner Kultur.

Rai stones were, and still are, used in important social transactions, such as marriage, inheritance, and political deals, as tokens of an alliance, as ransom for the bodies of those who have died in battle, and, more rarely, in exchange for food. There are several factors that determine the value of stone money. The first is the number of human lives that were lost on the journey to bring the stone home. The second is the kind of workmanship. If you compare the value of stone money with modern currency, the value of modern currency is linked to commodities, while stone money deals with rights and customs and remains with the people as part of their traditions. John Tharngan, historical preservation officer of Yap, one of the Federated States of Micronesia explains his culture's unique currency.

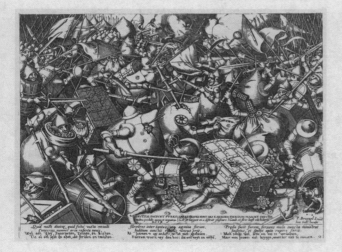

Die Schlacht um das Geld, nach 1570,
Pieter van der Heyden nach Pieter Bruegel d. Ä.;
The Metropolitan Museum of Art, New York
The Battle about Money, after 1570,
Pieter van der Heyden after Pieter Bruegel the Elder;
The Metropolitan Museum of Art, New York

Das Bild stammt von Pieter Bruegel dem Älteren. Geldkassetten, Sparschweine, Geldsäcke, Fässer voller Münzen und Schatzkisten – die meisten von ihnen schwerbewaffnet – attackieren sich in einer wilden Darstellung chaotischer, bis an das Äußerste gehender Kriegsführung. Die niederländischen Verse am unteren Rand informieren uns: „Es ist alles wegen Geld und Gütern, dieses Kämpfen und Streiten." Dem lateinischen Teil der Inschrift zufolge steht die Fahne mit dem *Barbaren-Enterhaken* im rechten Hintergrund für die Gier, das Übel an der Wurzel all dieser Unruhen.

This image derives from Pieter Bruegel the Elder. Strongboxes, piggy banks, money bags, barrels of coins, and treasure chests— most of them heavily armed—attack each other in a ferocious display of chaotic, all-out warfare. The Dutch verses inscribed in the lower margin inform us that 'it's all for money and goods, this fighting and quarrelling'. According to the Latin portion of the inscription, the banner with the 'savage grappling hook' in the right background exemplifies greed, the vice at the root of all this trouble.

Wert — Kampf

Value — Battle

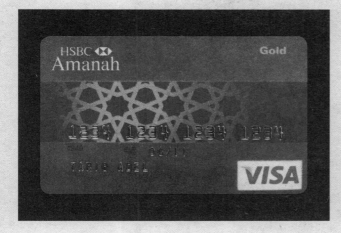

Wenn man die Menschen fragen würde, welche Erfindung des 20. Jahrhunderts heute den größten Einfluss auf ihren Alltag hat, dann würden die meisten wohl sofort antworten: ihr Mobiltelefon oder ihr PC. Nicht viele würden an die kleinen Plastikrechtecke denken, die ihre Brieftaschen und Portemonnaies füllen. Und doch sind Kreditkarten und ihresgleichen, seit sie in den späten 1950er Jahren erstmals in Erscheinung traten, Teil der Struktur des modernen Lebens geworden. Natürlich ist eine Kreditkarte selbst kein Geld – sie ist ein physisches Objekt, das es ermöglicht, auf eine bestimmte Art Geld auszugeben, es zu verschieben, es zu garantieren. Kredit- und Bankkarten führen uns täglich die Tatsache vor Augen, dass Geld seine essenzielle Materialität verloren hat. Während alle Münzen oder Scheine, die wir uns bisher angesehen haben, mit König und Land gekennzeichnet sind, erkennt der Entwurf unserer Karte keinen Anführer, keine Nation an und keine Begrenzung ihrer Reichweite, außer ihrem Gültigkeitsdatum. Wie Mervyn King betont: „Die Verbreitung eines großen Spektrums finanzieller Transaktionen, ob man Karten internationaler Banken nutzt oder die anderen Dienste, die sie anbieten, hat Institutionen geschaffen, die transnational sind, so groß, dass sie nicht von nationalen Aufsichtsbehörden kontrolliert werden können und die, wenn sie in finanzielle Schwierigkeiten geraten, enormes finanzielles Chaos verursachen können."

If you were to ask people which twentieth-century invention had the most impact on their daily lives today, their instant answers might be their mobile phone or their PC: not many people would think first of the little plastic rectangles that fill their wallets and purses. And yet, since they first emerged in the late 1950s, credit cards and the like have become part of the fabric of modern life. A credit card isn't itself money—it is a physical object that provides a way of spending money, moving it, and promising it. Credit and debit cards bring home to us on a daily basis the fact that money has now lost its essential materiality. Whereas all the coins or banknotes we have looked at so far had king and country marked on them, our card acknowledges no ruler or nation in its design and no limit to its reach, other than an expiry date. As Mervyn King emphasizes, 'the spread of a wide range of financial transactions, whether using cards used by international banks or the other services that they offer, has created institutions which are transnational, bigger than the ability of national regulators to control, and which, if they do get into financial difficulties, can cause enormous financial mayhem'.

Geschenk — Wagnis

Gift — Risk

Als zwei Generationen von Giganten zu den Gefilden der Götter vorzudringen drohten, wurde ein göttliches Konzil einberufen. Zeus entschied, die Menschheit mit der großen Flut auszulöschen, hatte aber Mitleid mit dem Paar Deukalion und Pyrrha, das er als fromm und gottesfürchtig erkannte. Er teilt die Wolken und beendet die Flut gezielt, um Deukalion und Pyrrha zu retten, die ziellos auf einem Floß dahintreiben. Ihnen ist klar, dass sie jetzt dafür verantwortlich sind, die Erde wieder zu bevölkern. Ratlos, wie sie ihr Schicksal erfüllen können, fragen sie die Göttin Themis um Rat. Themis antwortet, dass sie die Knochen ihrer Mutter werfen muss, um sich erfolgreich fortzupflanzen. Deukalion nimmt ganz richtig an, dass Themis sich auf die mächtige Mutter Erde bezieht. Sowohl Pyrrha als auch Deukalion werfen einen Stein über ihre Schulter: Der von Pyrrha verwandelt sich in eine Frau, der von Deukalion in einen Mann.

When two generations of giants threaten to reach the realm of the gods, a divine council is called. Zeus decides to destroy humankind via the deluge, but taking pity on Deucalion and Pyrrha, whom he recognizes as devout worshippers, he parts the clouds and ends the deluge specifically to save the couple, who are floating aimlessly on a raft. Understanding that they are now responsible for repopulating the earth, and confused about how to carry out their destiny, they go to see the goddess Themis. Themis tells Pyrrha that she must cast the bones of her mother to successfully reproduce. Deucalion correctly reasons that Themis is referring to great Mother Earth. Both Pyrrha and Deucalion throw a stone over their shoulder, Pyrrha's turning into a woman, and Deucalion's into a man.

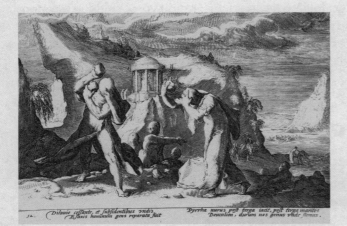

Deukalion und Pyrrha bevölkern die Erde wieder,
Hendrik Goltzius, 1558 – 1617
Deucalion and Pyrrha Repopulate the Earth,
Hendrik Goltzius, 1558 – 1617

***Pandora öffnet die Büchse,* Rosso Fiorentino,**
Giovanni Battista, 1494 – 1540; Bibliothèque de l'École des
Beaux-Arts, Paris
Pandora Opening the Box, Rosso Fiorentino aka
Giovanni Battista, 1494 – 1540; Bibliothèque de l'École des
Beaux-Arts, Paris

Der Mythos von Pandoras Büchse wird als einer der anschaulichsten griechischen Mythen über menschliches Verhalten verstanden. Die alten Griechen benutzten diesen Mythos nicht nur, um sich die Schwachheit der Menschen gegenwärtig zu halten, sondern auch, um Erklärungen für mehrere Unglücke des Menschengeschlechts zu finden. Dem Mythos zufolge war Pandora die erste Frau auf der Erde. Sie wurde von Göttern geschaffen, um die Menschen zu bestrafen. Alle beschenkten sie; ihr griechischer Name bedeutet daher auch *die mit allem Beschenkte*. Pandora bekam eine Büchse, ein Gefäß, auf Griechisch *pithos* genannt. Die Götter erzählten ihr, die Büchse enthalte besondere Geschenke von ihnen, aber sie dürfe sie niemals öffnen. Pandora bemühte sich, ihre Neugierde zu zügeln, aber am Ende konnte sie nicht mehr an sich halten: Sie öffnete die Büchse und die ganzen Krankheiten und Nöte, die die Götter in der Büchse versteckt hatten, begannen auszutreten. Pandora bekam Angst, als sie sah, wie die teuflischen Geister herauskamen. Sie versuchte, die Büchse so schnell wie möglich wieder zu schließen, und schloss so die Hoffnung mit ein.

The myth of Pandora's box is considered one of the most descriptive myths of human behaviour in Greek mythology. Ancient Greeks used this myth not only to instruct themselves about the weaknesses of humans but also to explain various misfortunes suffered by the human race. Pandora was, according to the myth, the first woman on Earth. She was created by the gods as a punishment to mankind; each one of them gave her a gift, and hence her name in Greek means 'the one who bears all gifts'. Pandora was given a box or a jar, called *pithos* in Greek. The gods told her that the box contained special gifts from them but she was never to open the box. Pandora tried to tame her curiosity but in the end she could not contain herself any longer; she opened the box and all the ills and hardships that the gods had hidden in the box started coming out. Pandora was scared when she saw all the evil spirits coming out and tried to close the box as quickly as possible, shutting Hope inside.

Hreinn Friðfinnsson

Das Werk von Hreinn Friðfinnsson (* 1943 Bær í Dölum, lebt in Amsterdam) gleicht verschachtelten Erzählsträngen, die von Inspiration, Entwurf und Herstellung handeln. Es enthält verschiedene Ebenen von Zeit und Natur und ent- wie verhüllt die Mysterien der Welt um uns. Friðfinnssons *House Project* (1974 – fortlaufend) durchzieht das gesamte Werk des Künstlers – getragen von seinem großen Narrativ. Die erste Wiederholung des Projekts ist in der Tat als ephemere Geste zu verstehen, die in den nachfolgenden Formen als Echo nachklingt.

fourth house of the house project since 1974

„Im Sommer 1974 wurde ein kleines Haus gebaut, genauso, wie es Sólon Guðmundsson vor einem halben Jahrhundert hatte tun wollen: ein *Inside-Out*-Haus. Es wurde am 21. Juli fertiggestellt. Es befindet sich in einer unbevölkerten Gegend von Island, an einem Ort, von dem aus man kein anderes menschengemachtes Objekt sieht. Ein Haus, das das ‚Außen' auf die Größe eines *geschlossenen Raumes*, der aus den Wänden und dem Dach des Hauses gebildet wurde, zusammenschrumpfen ließ. Das Übrige wurde zum ‚Innen'. Das Haus beherbergt die ganze Welt – außer sich selbst."[1]

Mit dem *House Project* verwandelt Friðfinnsson die Erzählung einer exzentrischen Anomalie in eine pointierte Auseinandersetzung mit den Grenzen des Raums: Das Kunstwerk umfasst heute neben der Konstruktion von *First House* (1974) den Umzug des *Second House* (2007) von Island in sein permanentes Zuhause in der Domaine de Kerguéhennec in Frankreich. Es schließt die Heimkehr des *Third House* ein, das 2011 am ursprünglichen Standort von *First House* (in einer abgelegenen Lavalandschaft außerhalb Reykjavíks) konstruiert wurde, sowie *Fourth House*, dem man nun in Münster begegnet.

Jedes neue Haus wurde mit der Innenseite nach außen, *inside out*, konstruiert, wobei jede Wiederholung, jedes Haus, sich durch diesen Prozess des Umstülpens oder Spiegelns mehr und mehr entmaterialisierte. Während *First House* und *Second House* aus traditionellen isländischen Materialien gebaut wurden – Holzkonstruktionen mit Metallverkleidungen, Tapeten, einer Tür und Fenster mit Vorhängen – wurde *Third House* als Zeichnung konzipiert: die einfache Skizze eines Stahlgerüsts, eine Art Echo des *First House*. Das ähnlich reduziert und doch invertiert angelegte *Fourth House*, das mit seiner Umgebung interagiert, vollendet das Projekt auf einer komplett gespiegelten Ebene – ein transformierendes Werk.

Da jede Heimkehr ein Wagnis ist, musste das Werk noch einmal auswandern. Es verließ seinen festen Wohnsitz und wurde in gewisser Weise nomadisch: Fünf Kilometer außerhalb der Münsteraner Innenstadt im Sternbuschpark geht Friðfinnssons Arbeit fast in seiner Umgebung auf, und doch materialisiert sich seine spiegelnde Qualität in der Begegnung mit den Besucher_innen. C.E.L./A.v.G.

[Viertes Haus der *house*-Serie seit 1974]

Material
Edelstahl, poliert

Maße
255 × 325 × 195 cm

Standort
Lichtung im Sternbuschpark
Sternbusch 24, 48153 Münster

1 Hreinn Friðfinnsson, *House Project: First House, Second House, Third House* (Crymogea, Reykjavík, 2012).

Hreinn Friðfinnsson

The work of Hreinn Friðfinnsson (* 1943 Bær í Dölum; lives in Amsterdam) often evokes intricate storylines of inspiration, conception, and creation, containing layerings of time and nature, both revealing and concealing the mysteries of the world around us. A work spanning the artist's career, *House Project* (1974 –), is sustained by its grand narrative. The first iteration of the project was, in fact, a far-flung ephemeral gesture, which would go on to echo in successive forms.

fourth house of the house project since 1974

'In the summer of 1974, a small house was built in the same fashion as Sólon Guðmundsson intended to do about half a century ago, that is to say an inside-out house. It was completed on the 21st of July. It is situated in an unpopulated area of Iceland, and in a place from which no other man-made objects can be seen. The existence of this house means that "outside" has shrunk to the size of a *closed space* formed by the walls and the roof of the house. The rest has become "inside". The house harbours the whole world except itself.'[1]

With *House Project* Friðfinnsson turned the tale of an eccentric anomaly into a pointed confrontation with the boundaries of space. The work's history has unfolded to include the 1974 construction, *Second House*'s migration from Iceland to its permanent home at Domaine de Kerguéhennec in France in 2007, the homecoming of *Third House*—constructed in 2011 on the original site of *First House* in the remote lava landscape outside of Reykjavík—and now *Fourth House* encountered within Skulptur Projekte Münster.

Every new 'house' was physically constructed inside out in turn, with each iteration successively dematerialized through this process of inversion or mirroring. Whereas *First House* and *Second House* were created with traditional Icelandic building materials—wooden constructions with metal siding, wallpaper, a door, and windows with curtains—*Third House* was conceived as a drawing, a simple steel outline of the frame, becoming a kind of echo of *First House*. Similarly devised in this reduced, yet inverted form, *Fourth House* culminates the project in a fully mirrored state—a transforming work—interacting with its surroundings.

In light of the fact that every homecoming requires further venturing, the work needed to migrate once more without a permanent home, becoming in a sense forever nomadic, forever in motion. Five kilometres outside the inner city of Münster in Sternbuschpark, Friðfinnsson's work nearly melts into its surroundings, and yet its reflective quality materializes in relation to each visitor, as the frame of a house surfaces and space is constructed. A reflected reality is mirrored and structured by its own form. C.E.L./A.v.G.

Material
Stainless steel, polished

Dimensions
255 × 325 × 195 cm

Location
Clearing in Sternbuschpark
Sternbusch 24, 48153 Münster

1 Hreinn Friðfinnsson, *House Project: First House, Second House, Third House* (Reykjavik: Crymogea, 2012).

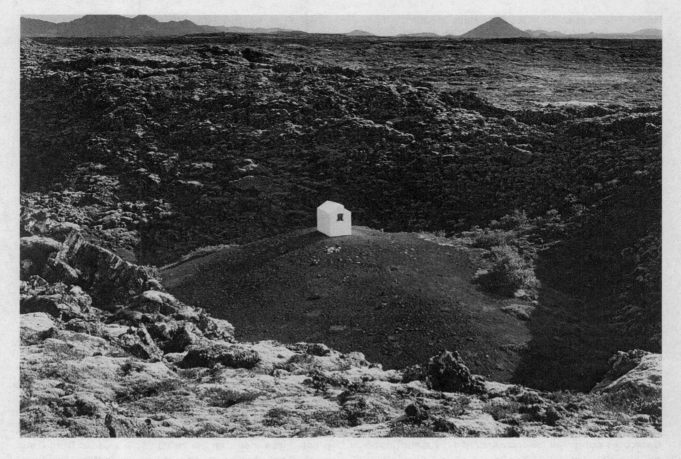

First House, 1974

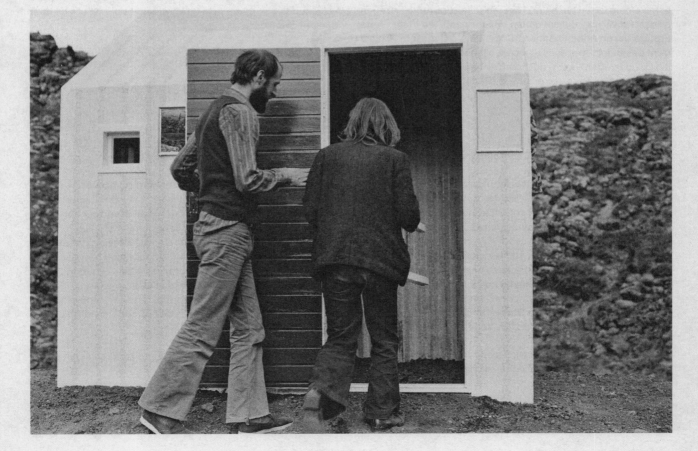

Hreinn Friðfinnsson

First House

Hreinn Friðfinnsson (HF): Das erste Haus begann als die Weiterführung einer Geschichte. In meinem Text *Der Ursprung*, der in dem Buch [Hreinn Friðfinnsson, *House Project*, Crymogea, Reykjavik, 2012] abgedruckt ist, wird erwähnt, dass es in dem Buch *Icelandic Aristocracy* eine kleine Anekdote über einen Mann gibt, von dem man sagt, dass er ein Haus mit der Tapete nach außen zu bauen anfing; das ist die einzige mir bekannte Quelle zu dieser Person, Sólon Guðmundsson. Er ist niemand Berühmtes, er spielt nur in diesem einen Buch eine Rolle. Es ist wichtig zu wissen, was *Icelandic Aristocracy* für den Autor Thórbergur Thórdarson, einen bedeutenden isländischen Schriftsteller des vergangenen Jahrhunderts, genau bedeutete. Es handelt sich überhaupt nicht um die Aristokratie im üblichen Sinn, sondern mehr um Menschen, die keine feste Adresse und keine Position in der Gesellschaft hatten und sich stattdessen dazu entschlossen hatten, frei im Land herum zu reisen, zu Fuß, und für Kost und Logis Gelegenheitsjobs anzunehmen. Das war um die Jahrhundertwende; das Land war arm und stand noch immer unter dänischer Herrschaft. Ich erinnere mich daran, dass es in meiner Kindheit Leute gab, die von Bauernhof zu Bauernhof zogen, und die gelegentlich für eine kurze Zeit bei uns blieben und dann weiterzogen. So lebte auch diese eine Person in einem der Dörfer in der nordwestlichen Ecke des Landes. Ob Thórdarson Sólon jemals getroffen hat, weiß ich nicht. Thórdarson interessierte sich sehr für Geschichten von Menschen, besonders, wenn es um exzentrische Charaktere ging, die sich ein wenig ungewöhnlich verhielten. Er sammelte detaillierte Beschreibungen solcher Leute – wo sie gewesen waren und was sie getan hatten. Einer dieser Charaktere war Sólon, ein Kuriosum, dessen Aktionen ein willkommenes Thema für Gespräche waren. Der *Icelandic Aristocracy* zufolge fing Sólon mit dem Bau einer Hütte für sich selbst erst an, als er schon ein älterer Mann war. Sólon begann mit einer hölzernen Konstruktion, die er auf die übliche Weise fertigte. Dann befestigte er Wellblech an den Innenseiten des Holzgerüstes und wollte zum Schluss noch Tapeten an den Außenseiten anbringen. Als Sólon gefragt wurde, warum er das Haus so bauen wolle, antwortete er mit einem leisen Lächeln: „Tapeten sollen das Auge erfreuen, also ist es vernünftig, sie außen anzubringen, wo mehr Leute Freude daran haben können." Sólon kam mit diesem Projekt nicht besonders weit, weil es wohlwollenden Menschen gelang, ihn zu überreden – kurz, nachdem er begonnen hatte –, in ein Altersheim zu ziehen, wo er später friedlich starb.

Second House

Cassandra Edlefsen Lasch (CEL): Was war der Anstoß zu *Second House*?

HF: Ein paarmal hatte ich überlegt, dass es doch schön sein müsste, Innen und Außen des *First House* zu vertauschen, aber es gab dann nie einen Grund dafür. Deshalb ist das Inside-Out-Haus perfekt, und es war mindestens 20 Jahre lang tadellos, bis es durch Vandalismus beschädigt wurde; eine ziemlich traurige Geschichte letztlich. Ich war einmal dort, und die Tapete war noch dran, wenn auch ein wenig beschädigt, weil man sie als Ziel für Schießübungen benutzt hatte. Dann wurde ich 2003 von Frédéric Paul, dem Direktor der Domaine de Kerguéhennec, eingeladen, ein permanentes Objekt für den Skulpturenpark zu machen, und ich stellte ihm drei Optionen vor; eine davon war *Second House*.

Annabelle von Girsewald (AvG): *Second House* hat jetzt seinen festen Platz gefunden, aber hat es nicht eine ziemliche Reise hinter sich?

HF: Ja, wir haben es in Island gebaut. Wenn man das Zuhause verlässt, um Erfahrungen zu sammeln, dann verlässt man die Vergangenheit und geht weit fort, oder man emigriert, was

First House

Hreinn Friðfinnsson (HF): The first house began as a continuation of a story. My text 'The Origin' [Hreinn Friðfinnsson, *House Project: First House, Second House, Third House*, 2012] states that in the book *Icelandic Aristocracy* there is a little anecdote about a man who is reputed to have started building a house with the wallpaper on the outside; that is the only source known to me about this person, Sólon Guðmundsson. He is not a known figure; he is only known within that particular book. It's important to know the nature of what *Icelandic Aristocracy* meant to the author, Thórbergur Thórdarson, an important writer in Icelandic literature of the last century. It's not at all aristocracy in the normal sense but rather people that didn't have a fixed address or position in society and chose instead to travel freely by foot around the country doing odd jobs in exchange for meals and lodging. This was taking place around the turn of the century; the country was poor and still under Danish rule. I remember in my childhood there were people on the move from farm to farm, and occasionally they would stay at our home for a short period of time and then move on. So it was that this particular person lived in one of the villages in the north-west corner of the country. Whether Thórdarson ever met Sólon I don't know. Thórdarson had a great interest in stories about people—in particular, eccentric characters who behaved a bit out of the ordinary. He gathered detailed descriptions of these people, where they had been, and what they had done. One of those characters was Sólon, a curiosity whose actions were a welcome source of conversation. According to *Icelandic Aristocracy*, Sólon started building a hut for himself to live in, at a time when he was already an elderly man. Sólon started by making a wooden construction in an ordinary way. Then he affixed corrugated iron sheets on the inside of the wooden frame and wanted to finish with wallpaper on the outside. When Sólon was asked why he planned to build the house in this way, he answered with a faint smile, 'Wallpaper is to please the eye, so it is reasonable to have it on the outside where more people can enjoy it.' Sólon did not get very far with this project because, shortly after starting, some well-intentioned people managed to persuade him to move to a retirement home where he later died peacefully.

Second House

Cassandra Edlefsen Lasch (CEL): What triggered *Second House*?

HF: Once in a while it crossed my mind that it might be nice to turn the first house inside out, but then I never had any reason for it. That was why the inside-out house is perfect and stood there intact for at least twenty years until it started to suffer vandalism, a very sad story in the end. I visited once and the wallpaper was still there, though a bit damaged because it had been used as a target for shooting practice. Then in 2003 I received an invitation from Frédéric Paul, the director of Domaine de Kerguéhennec, to create a permane nt piece for the sculpture park, and I gave him three options, one of which was *Second House*.

Annabelle von Girsewald (AvG): Even though *Second House* is now quite settled, didn't it start out on a quest?

HF: Yes, we built it in Iceland. When you leave home in order to gain experience, you leave the past and go far away, or you emigrate, which means you immigrate somewhere else. And that's what happened to this second house. It was put on board

Second House (second home), 2007

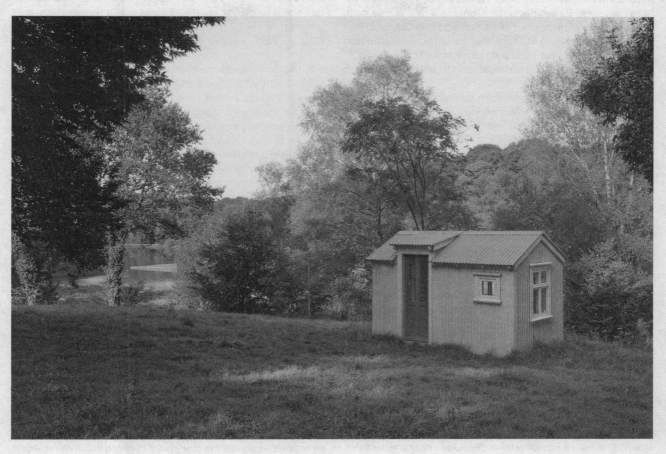

Third House, Illustration, 2014 (Detail)

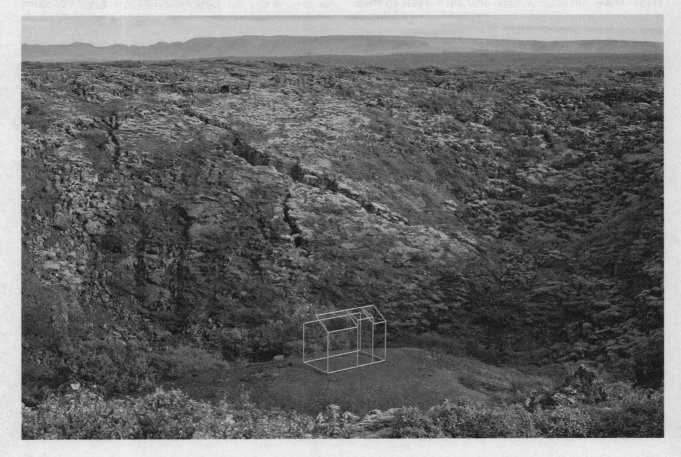

Hreinn Friðfinnsson

bedeutet, dass man woanders immigriert. Und das ist es, was mit diesem zweiten Haus passiert ist. Es wurde in Island auf ein Schiff geladen. Es segelte nach Frankreich und wurde nach Kerguéhennec transportiert und an einem sehr hübschen Platz abgesetzt, der gewisse Ähnlichkeiten mit dem Originalstandort hat, auch wenn es dort natürlich keine Lava gibt.

CEL: Wie haben Sie die ursprünglichen Strukturen und Dimensionen festgelegt?

HF: Die Dimensionen richteten sich danach, wie viel Platz eine Person mindestens brauchen würde, um dort zu leben, also Platz für ein Bett, einen kleinen Tisch und einen Stuhl. Das waren die Kriterien für die Maße.

AvG: Man kann das *Second House* zwar nicht wie das *First House* betreten, aber man kann durch die Fenster in ein fertiges Setting schauen. Was hat es mit dieser Inneneinrichtung auf sich?

HF: Sie enthält seine Geschichte: eine Tapete, deren Muster sehr ähnlich ist wie beim *First House*, und drei Fotos vom *First House*. Und etwas von einem Fremden, das ist der Meteorit. Der ist aus unserem Sonnensystem, aber von sehr weit weg; und er wurde auf dem Planeten Erde gefunden, verbrachte aber fast seine ganze Zeit irgendwo zwischen Jupiter und Mars. Und ein Drahtmodell des *Third House* befindet sich auf dem Meteoriten im *Second House*. Auf dem Boden unter dem hängenden Meteoriten befindet sich ein Spiegel.

Third House

CEL: Also arbeiteten Sie zu der Zeit schon an dem Modell für *Third House*, im Wissen um seine Realisierung?

HF: Ja, in der Bauphase von *Second House* entstand aus einer dreidimensionalen Zeichnung im Raum die Idee zu Third House. Das Modell wurde schließlich mit denselben Konturen und Proportionen und der gleichen Struktur wie *First House* und *Second House* realisiert, ohne die Wände und das Dach.

CEL: Also enthält *Second House* seine Geschichte, einen Fremden sowie eine mögliche Zukunft, die Idee des *Third House*?

HF: Im Gegensatz zu *First House*, das die ganze Welt beherbergt – außer sich selber –, behauptet *Third House* so etwas nicht, und sein Konzept von Innen / Außen ist mehrdeutig. Es stellt also mehr Fragen, als dass es Antworten gibt.

AvG: Ist *Third House* noch dort, an der Stelle, wo *First House* gestanden hat?

HF: Ja, das ist die Rückkehr in die Heimat. *Third House* ist eine Art Echo von *First House*. *Fourth House* wird dasselbe Material und dieselben Dimensionen haben wie *Third House*, eine Skizze von *First House*, sein Echo, abgesehen von der Behandlung seiner Oberfläche. Daher wird es weniger für sich selbst stehen und sich mehr in seine Umgebung einfügen. Das ist die Idee hinter dem, was schließlich das *Fourth House* werden wird.

a ship in Iceland. It sailed to France and was transported to Kerguéhennec and put down there in a very nice location that has some similarities to the original site, although there is of course no lava.

CEL: How did you determine the original structure and dimensions?

HF: The dimensions were based on what would be the minimum space required for one person to live there, and that means space for a bed, a small table, and a chair. Those were the criteria for the measurements.

AvG: Even though you cannot enter *Second House*, like the first, looking in the windows you can see a static setting. Can you say something about this interior?

HF: It contains its own history: wallpaper that comes close to the same pattern as the first, and three photos of the first house. And one thing from a stranger, which is the meteorite. It is from within the solar system but really far away and it is found on Planet Earth, but it has spent most of its time somewhere between Jupiter and Mars. And a wire model of the third house sits on the meteorite inside the second house. There is a mirror on the floor below the hanging meteorite.

Third House

CEL: So at this time you were already making the model for *Third House*, knowing you would realize it?

HF: Yes, at the point when *Second House* was being built, the idea of *Third House* was born as a three-dimensional drawing in space. Eventually the model was realized in the same shape, structure, and proportions as the first and second houses, minus the walls and the roof.

CEL: So *Second House* contains its history, a stranger, and a potential future, the idea of the third house?

HF: As opposed to *First House*, which harbours the whole world, excluding itself, *Third House* makes no such claim and its notion of inside / outside has become ambiguous. So it asks more questions than it answers.

AvG: Is *Third House* still there, at the location where *First House* once stood?

HF: Yes, that is the homecoming. *Third House* is a sort of echo of *First House*. *Fourth House* will be in exactly the same material and dimensions as *Third House*, an outline of the first house, its echo, except for the treatment of its surface. Because of this, it will become less a character in itself and rather merge with its surroundings. That is the idea behind what will eventually be *Fourth House*.

Auszüge eines Interviews mit Hreinn Friðfinnsson (2014), siehe Cassandra Edlefsen Lasch und Annabelle von Girsewald (Hg.), *homecomings*, Archive Books, Berlin, 2017.
Excerpts from an interview with Hreinn Friðfinnsson (2014), see Cassandra Edlefsen Lasch and Annabelle von Girsewald (eds.), *homecomings* (Berlin: Archive Books, 2017).

Gintersdorfer / Klaßen

Die Theaterregisseurin Monika Gintersdorfer (*1967 Lima, lebt in Berlin) und der bildende Künstler Knut Klaßen (*1967 Münster, lebt in Berlin) entwickeln seit 2005 transkulturelle Tanz- und Performance-Projekte. Dabei gelingt es ihnen, eine differenzielle, ethnische und kulturelle Vielheit, wie sie seit den 1990er Jahren von der Theorie der Dekolonisation gedacht wird, ins Werk zu setzen. Das Team realisiert seine Produktionen mit einem Netzwerk von internationalen Tänzer / Sänger / Künstler / Filmemacher / Charakterdarsteller_innen. Die Erfahrungen der Akteur_innen aus unterschiedlichen religiösen, politischen und gesellschaftlichen Zusammenhängen bilden die Grundlage von oft diskursiven, stets subversiven Stücken, die um existenzielle Fragestellungen wie Identitätssuche, Religion und Machtstrukturen kreisen. In der Aufführungspraxis treffen spezifische kulturelle Codes, durch die Performer_innen repräsentiert, aufeinander: Gesten, Mimik, Kostüm und Habitus werden gegeneinander und miteinander ausagiert. Die Akteur_innen konfrontieren die Zuschauer_innen mit eigenen zugespitzten Thesen über Politik, Versagensängste oder afrikanischen Gangsterstolz. Die Darsteller_innen übersetzen dabei simultan die Sprachbeiträge ihrer Kolleg_innen. In die Gestaltung der Kostüme fließen Referenzen auf afrikanische Kleidungskultur und auf plastisch-performative Kunst der europäischen Avantgarde sowie der 1970er Jahre ein.

Erniedrigung ist nicht das Ende der Welt

Während der Skulptur Projekte nutzen Gintersdorfer / Klaßen das Theater im Pumpenhaus als Produktionsstätte für neue Performances und fragmentarische Wiederaufführungen bestehender Stücke. Die Besucher_innen können dort an sechs Tagen in der Woche Proben, Aktionen und die Arbeit an der neuen Produktion mit dem Titel *Kabuki noir Münster* miterleben. Mit dem japanischen Kabukitänzer Toyohiko Fujima erarbeiten die Darsteller_innen eine Performance, in der sie sich den Kabuki-Codes annähern, um ein tieferes Verständnis dieser Darstellungsform zu erlangen. Das japanische Kabuki wurde seit dem 16. Jahrhundert als eine komplexe Theatersprache erschaffen, die Tanz, Gesang, Lautenmusik, Bühnenelemente und schauspielerischen Ausdruck zusammenbringt. Die Szenen eines Kabuki-Stücks sind im Gegensatz zur westlichen Aufführungspraxis keinen Veränderungen ausgesetzt – die dargestellten Situationen haben rituellen Charakter. Da die Texte im originalen Frühneujapanisch vorgetragen werden, erhalten im Kabuki-Theater selbst japanische Zuschauer_innen über Kopfhörer Hinweise zum Verlauf der Handlung. Gintersdorfer / Klaßen erhoffen sich durch die Entwicklung des neuen Stücks eine Reflexion ihrer eigenen Routinen und eine Integration von vorhandenen rituellen und spirituellen Dimensionen in eine neue Form von Ästhetik. N.T.

Standort
Theater im Pumpenhaus
Gartenstraße 123, 48147 Münster

Öffnungszeiten
Mo – So 10 – 22 Uhr
Performances
Di – So 17 Uhr

Gintersdorfer / Klaßen

Theatre director Monika Gintersdorfer (* 1967 Lima; lives in Berlin) and visual artist Knut Klaßen (* 1967 Münster; lives in Berlin) have been developing transcultural dance and performance projects since 2005. Together they have generated a differential ethnic and cultural diversity as conceived by decolonization theory in the 1990s. The team bring their productions to life with a network of international dancers, singers, artists, film-makers, and character actors. The theatrical performances, which are often discursive and always subversive, are based on the participants' own stories, an assortment of experiences defined by a variety of religious, political, and social contexts. The works focus on existential themes such as religion, power structures, and the search for identity. The performance is characterized by the clash of particular cultural codes, represented by the performers themselves: they act out their gestures, facial expressions, costumes, and attitudes, countering and supporting one other. The actors confront the audience with their own pointed remarks about politics, the fear of failure, or African gangster pride, while fellow performers simultaneously translate what has been said. The costume designs make reference to African clothing culture and to the sculptural performative art of the 1970s and Europe's avant-garde.

Erniedrigung ist nicht das Ende der Welt

During the Skulptur Projekte, Gintersdorfer/Klaßen are using the Theater im Pumpenhaus as a production site for new performances and fragmentary re-enactments of existing plays. Six days a week, visitors can come there to witness rehearsals, activities, and work on the new production, which is entitled *Kabuki noir Münster*. In collaboration with the Japanese kabuki dancer Toyohiko Fujima, the actors are developing a performance in which they try to come close to the kabuki codes to gain a deeper understanding of this form of presentation. Japanese kabuki was created in the sixteenth century as a complex theatrical form that unites dance, chants, shamisen playing, scenery, and the actors' dramatic expression. Unlike the Western conception of theatre, the scenes in a kabuki performance do not change—the depicted scenes have a ritual character. As the script is recited in the original Early Modern Japanese, even Japanese viewers are given information about the performance via headphones. Through the evolution of this new piece, Gintersdorfer/ Klassen hope to reflect on their own routines and incorporate existing ritual and spiritual dimensions into a new aesthetic form. N.T.

[Humiliation Is Not the End of the World]

Location
Theater im Pumpenhaus
Gartenstraße 123, 48147 Münster

Opening hours
Mon – Sun 10 am – 10 pm
Performances
Tue–Sun 5 pm

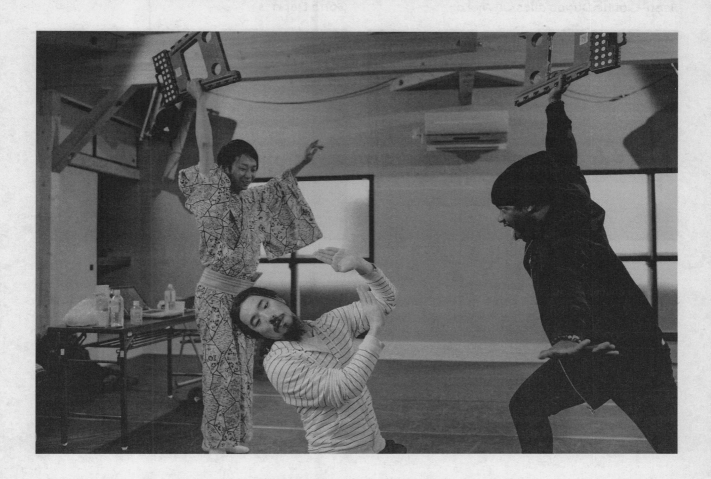

Annick Prisca Agbadou alias Annick Choco

Marc Aschenbrenner

Annick Prisca Agbadou alias Annick Choco (* Gagnoa) war von 2007 bis 2015 Tänzerin für Serge Beynaud und andere ivorische Couper-Decaler-Künstler_innen, seitdem Showbiz-Star und Choreografin mit den Hits *Simba Loketo* und *Téléguider*, performt im Gintersdorfer/Klaßen-Stück *Der Botschafter*.

Annick Prisca Agbadou alias Annick Choco (* Gagnoa) was a dancer for Serge Beynaud and other Ivorian Couper Decaler artists from 2007 to 2015; since then she has been a choreographer and showbiz star with the hit songs *Simba Loketo* and *Téléguider*; she performs in the Gintersdorfer/Klaßen piece *Der Botschafter*.

Marc Aschenbrenner (* Linz) studierte Malerei und Video an der Universität für künstlerische und industrielle Gestaltung Linz (1991–1999); Videoschnitt für John Bock (1999–2003). Seit 2008 ist er Performer und Co-Ausstatter bei Gintersdorfer/Klaßen. Zusammenarbeit mit Eva Carbó seit 2014. Mitglied Schokoladen, Berlin. Zahlreiche Ausstellungen im In- und Ausland.

Marc Aschenbrenner (* Linz) studied painting and video at the University of Art and Design Linz from 1991 to 1999; he was a video editor for John Bock from 1999 to 2003. He has been a performer and co-designer with Gintersdorfer/Klaßen since 2008. Cooperation with Eva Carbó since 2014. Member of Schokoladen, Berlin. Numerous exhibitions in Germany and abroad.

Jean-Claude Dagbo alias DJ Meko

Jean-Claude Dagbo alias DJ Meko (* Côte d'Ivoire) ist DJ und Tänzer der Couper-Decaler-Szene in den Pariser Clubs Ivoire und Platinium, 2013 Veröffentlichung von *Tonton Meko*. Performt in den Gintersdorfer/Klaßen-Stücken *La Jet Set*, *Am Ende des Western*s und *Dantons Tod*.

Jean-Claude Dagbo alias DJ Meko (* Côte d'Ivoire) works as a DJ and dancer on the Couper Decaler scene in the clubs Ivoire and Platinium in Paris. He released *Tonton Méko* in 2013 and has performed in *La Jet Set*, *Am Ende des Westerns*, and *Dantons Tod* by Gintersdorfer/Klaßen.

Gotta Depri

Gotta Depri (* Gagnoa) absolvierte eine Ausbildung an der Tanzschule EDEC in Abidjan, 2004 erhielt er den Preis für junge Choreografie. Gintersdorfer/Klaßen-Kernmitglied seit 2017. Spielte in Karin Beiers *Schiff der Träume* am Hamburger Schauspielhaus und in Alize Zandwijks *Golden Heart* am Theater Bremen.

Gotta Depri (* Gagnoa) completed training at the EDEC dance school in Abidjan, receiving the prize for young choreography in 2004. He has been a core member of Gintersdorfer/Klaßen since 2007. He played a role in Karin Beier's *Schiff der Träume* at the Deutsches Schauspielhaus in Hamburg and in Alize Zandwijk's *Golden Heart* at the Theater Bremen.

Jule Flierl

Jule Flierl (* Berlin) ist Tanzmacherin und Vokalakrobatin. Sie recherchiert die Geschichte von Stimmtänzen in ihrer Lecture *I INTEND TO SING*, zeigte die minimalistische Techno-Romanze *OPERATION ORPHEUS* in diversen Museen und arbeitete unter anderem mit Martin Nachbar, Ibrahim Quarishi, Christine Borch, Sergiu Matis und Tino Sehgal.

Jule Flierl (* Berlin) is a dance creator and vocal acrobat. She is researching the history of vocal dances in her lecture *I INTEND TO SING*, displayed the minimalistic techno romance *OPERATION ORPHEUS* in various museums, and has worked with a range of people including Martin Nachbar, Ibrahim Quarishi, Christine Borch, Sergiu Matis, and Tino Sehgal.

Ted Gaier

Ted Gaier (* Stuttgart) ist Musiker, Texter, Musikproduzent, Theaterschaffender und Regisseur für Musikvideos. Unter anderem Gründungsmitglied der Band Die Goldenen Zitronen (seit 1984), des interventionistischen Performancekollektives Schwabinggrad Ballett (seit 2000) und der Theatergruppe 400 ASA Nord (seit 2008). Seit 2009 Mitwirkung bei Projekten von Gintersdorfer/Klaßen.

Ted Gaier (* Stuttgart) is a musician, lyricist, music producer, theatre practitioner, and director of music videos. Among other things, he was a founding member of the band Die Goldenen Zitronen (since 1984), the interventionist performance collective Schwabinggrad Ballett (since 2000), and the theatre group 400 ASA Nord (since 2008). He has participated in projects by Gintersdorfer/Klaßen since 2009.

Nadine Geyersbach

Nadine Geyersbach (* Erfurt) absolvierte ihre Schauspiel-ausbildung an der Hochschule für Schauspielkunst „Ernst Busch" in Berlin. Sie ist Gründungsmitglied der freien Theatergruppe Candlelight Dynamite. Seit 2012/2013 festes Schauspielensemblemitglied am Theater Bremen; macht aber auch Bühnenbilder.

Nadine Geyersbach (* Erfurt) completed her training as an actress at the 'Ernst Busch' Academy of Dramatic Art in Berlin. She is a founder member of the independent theatre group Candlelight Dynamite. She has been a permanent member of the ensemble at Theater Bremen since 2012/13; she also creates stage designs.

Monika Gintersdorfer

Monika Gintersdorfer (* Lima) studierte Germanistik und Theater-, Film- und Fernsehwissenschaften in Köln und Regie in Hamburg; 2000—2004 Inszenierungen in Hamburg, München, Salzburg. 2004—2005 Rekolonisation mit Jochen Dehn. Seit 2005 Zusammenarbeit mit Knut Klaßen, 2017 Gründung La Fleur mit Franck Edmond Yao.

Monika Gintersdorfer (* Lima) did a degree in German studies and theatre, film, and television studies in Cologne and studied directing in Hamburg. From 2000 to 2004 she directed several productions in Hamburg, Munich, and Salzburg. From 2004 to 2005 Rekolonisation with Jochen Dehn. She has worked with Knut Klaßen since 2005, founding La Fleur with Franck Edmond Yao in 2017.

Hauke Heumann

Hauke Heumann (* Lübeck) studierte Germanistik und Genderstudies in Hamburg und Berlin. Schauspielstudium an der Universität der Künste, Berlin. 2005—2008 Engagement am Theater Aachen. Er arbeitet seit 2006 regelmäßig mit Gintersdorfer/Klaßen in fast jedem Stück und seit 2010 mit Johannes Müller.

Hauke Heumann (* Lübeck) did German studies and gender studies in Hamburg and Berlin. Studied acting at the Academy of Arts in Berlin. Involved with Aachen Theatre from 2005 to 2008. He has worked regularly with Gintersdorfer/Klaßen in almost every piece and with Johannes Müller since 2010.

Nadine Jessen

Nadine Jessen (* Flensburg) ist Dramaturgin und Kuratorin. Sie begann ihre Karriere am Stadttheater Kiel, gründete in Wien den Spiel:Platz für postdramatische Theaterpraxis, arbeitete neun Jahre auf Kampnagel und ist seit 2016 bei den Wiener Festwochen. Sie ist Teil des Migrantpolitan-Kollektivs und der Uschi-Geller-Experience. Seit 2007 immer wieder involviert in Gintersdorfer/Klaßen-Projekte.

Nadine Jessen (* Felnsburg) is a dramaturge and curator who began her career at the Stadttheater Kiel, founded Spiel: Platz, a platform for post-dramatic theatre practice in Vienna, worked at Kampnagel for nine years, and has been working for the Wiener Festwochen since 2016. She is part of the Migrantpolitan collective and the Uschi Geller Experience. She has been regularly involved in Gintersdorfer/Klaßen projects since 2007.

Knut Klaßen

Knut Klaßen (* Münster) studierte Freie Kunst an der Hochschule für bildende Künste Hamburg (1989–1995). Unter anderem Kamera für John Bock 1998–2003, schwarzwaldinstitut mit Martin G. Schmid 2005, Leitung Entwicklung Anselm Reyle 2007–2009, Architektenvideos mit Carsten Krohn seit 2008. Zusammenarbeit mit Monika Gintersdorfer seit 2005.

Knut Klaßen (* Münster) studied free art at the University of Fine Arts of Hamburg from 1989 to 1995. Camera for John Bock (1998–2003), schwarzwaldinstitut with Martin G. Schmid in 2005, and head of development at Anselm Reyle (2007–2009). Architecture videos with Carsten Krohn since 2008. Cooperation with Monika Gintersdorfer since 2005.

Spaguetty Mazantomo

Spaguetty Mazantomo (* Yopougon) ist Choreograf, Schauspieler, Chorist und Couper-Decaler-Animateur. Fing als Tänzer auf der Rue Princesse (Abidjan) an, dann Choreograf und Schauspieler. Unter anderem Hauptrolle im Film *Pieds magiques*, sein neuster Hit heißt *PAO PAO*.

Spaguetty Mazantomo (* Yopougon) is a choreographer, actor, chorister, and Couper Decaler animator. He started out as a dancer on Rue Princesse (Abidjan), before becoming a choreographer and actor. His film credits include the main role in *Pieds magiques*, and his latest hit is called *PAO PAO*.

Anne Müller

Anne Müller (* Rochlitz) absolvierte ihr Schauspielausbildung in Hannover; tätig als Schauspielerin in Frankfurt a. M., am Maxim Gorki Theater Berlin, Deutschen Schauspielhaus Hamburg sowie in Funk und Film. 2017 erste Zusammenarbeit mit Gintersdorfer/Klaßen am Deutschen Schauspielhaus Hamburg im Stück *Der Allmächtige Baumeister aller Welten*.

Anne Müller (* Rochlitz) completed her training as an actress in Hanover; she has worked as an actress in Frankfurt am Main, at the Maxim Gorki Theater Berlin, the Deutsches Schauspielhaus in Hamburg, and in radio and film. In 2017 she collaborated for the first time with Gintersdorfer/Klaßen at the Deutsches Schauspielhaus on the piece *Der Allmächtige Baumeister aller Welten*.

Jesseline Preach

Jesseline Preach (* Ghana) ist in Hamburg aufgewachsen und studiert dort Volkswirtschaftslehre. Seit 2009 performt sie unter anderem mit Chicks on Speed und Gintersdorfer/Klaßen. Sie ist zudem Sängerin bei Voodoo Chanel Köln und One Mother Hamburg.

Jesseline Preach (* Ghana) grew up in Hamburg, where she studies economics. She has been performing since 2009, including stints with Chicks on Speed and Gintersdorfer/Klaßen. She also sings on Voodoo Chanel Live in Cologne and at One Mother in Hamburg.

Tucké Royale

Tucké Royale (* Quedlinburg) studierte Puppenspielkunst an der Hochschule für Schauspielkunst „Ernst Busch". Er arbeitete mit Hans Unstern, Gintersdorfer/Klaßen, Lola Arias, Talking Straight und ist verantwortlich für die Gründung des Zentralrats der Asozialen in Deutschland und die BOIBAND.

Tucké Royale (* Quedlinburg) studied the art of puppetry at the 'Ernst Busch' Academy of Dramatic Art in Berlin. He has worked with Hans Unstern, Gintersdorfer/Klaßen, Lola Arias, and Talking Straight and founded the Zentralrat der Asozialen in Deutschland and BOIBAND.

Shaggy Sharoof

Shaggy Sharoof (* Abidjan) ist DJ und Sänger. Sein Hit *Sanguèbè* ist eines der erfolgreichsten Couper-Decaler-Konzepte 2009, seitdem weitere Hits wie *La Confirmation Du Boucan* und *Akpongbo*, performt seit dem Festival Abidjan Mouvement (2009) für Gintersdorfer/Klaßen.

Shaggy Sharoof (* Abidjan) is a DJ and singer. His hit *Sanguèbè* was one of the most successful Couper Decaler concepts in 2009, followed by other hits like *La Confirmation Du Boucan* and *Akpongbo*. He has been performing for Gintersdorfer/Klaßen since the Abidjan Mouvement festival in 2009.

Eric Parfait Francis Taregue alias SKelly

Eric Parfait Francis Taregue alias SKelly (* Bouaké) ist Sänger und Performer; veröffentlichte vier Alben, 1255 Featurings; seit 2002 Couper-Decaler-Sänger, seit 2010 Gintersdorfer/Klaßen Herzstück.

Eric Parfait Francis Taregue alias SKelly (* Bouaké) is a singer and performer; he has put out four albums, and has had 1,255 'featurings'; he has been a Couper Decaler singer since 2002 and part of Gintersdorfer/Klaßen's core group since 2010.

Anne Tismer

Anne Tismer (* Versailles) ist Performerin und gründete 2006 mit Freunden das Ballhaus Ost in Berlin. Seit 2008 arbeitet sie auch in Togo und ist seit 2016 Mitglied der dort ansässigen Hip-Hop-Gruppe New Star Dance Company. Seit 2015 arbeitet sie mit Gintersdorfer/Klaßen.

Anne Tismer (* Versailles) is a performer and, together with friends, she founded the Ballhaus Ost in Berlin in 2006. She has also been working in Togo since 2008 and has been a member of Togo-based hip-hop group New Star Dance Company since 2016. She has worked with Gintersdorfer/Klaßen since 2015.

Hans Unstern

Franck Edmond Yao alias Gadoukou la Star

Hans Unstern macht Songs, Texte, Musikinstrumente und Performance. 2010 erschien das Debütalbum *Kratz Dich Raus*, 2012 das Album *The Great Hans Unstern Swindle*. 2016 Gründung der BOIBAND mit Tucké Royale. Derzeit Bau neuer Harfen mit Simon Bauer, zudem entstehen neue Songs für das dritte Studioalbum.

Hans Unstern creates songs, texts, musical instruments, and performances. His debut album *Kratz Dich Raus* came out in 2010, followed in 2012 by *The Great Hans Unstern Swindle*. In 2016 he founded BOIBAND with Tucké Royale. He is currently building harps with Simon Bauer and writing new songs for his third studio album.

Franck Edmond Yao alias Gadoukou la Star (* Abidjan) studierte Tanz und Schauspiel an der Schule Kingbok, war Choreograf für Jet Set. Seit 2005 Zusammenarbeit mit Gintersdorfer/Klaßen, so gut wie in jedem Stück dabei. 2017 Gründung von La Fleur mit Monika Gintersdorfer.

Franck Edmond Yao alias Gadoukou la Star (* Abidjan) studied dance and acting at the Kingbok School in Abidjan and was choreographer for Jet Set. He has worked with Gintersdorfer/ Klaßen since 2005 and performed in almost every play. Founded La Fleur with Monika Gintersdorfer in 2017.

Plus weitere kurzfristig einspringende Darsteller_innen des Gintersdorfer/Klaßen-Teams sowie Schnellbekanntschaften.
Plus all the other actors and actresses who have joined the Gintersdorfer/Klaßen team, jumping in at short notice and taking part in one-nighters.

Pierre Huyghe

Pierre Huyghes (* 1962 Paris, lebt in New York) Arbeiten treten oft als komplexe Systeme auf, die sich durch ein breites Spektrum an Lebensformen, unbelebten Dingen und Technologien auszeichnen. Seine arrangierten Organismen verbinden nicht nur biologische, technologische und fiktionale Elemente, sondern es interagieren darin Menschen, Tiere und Nichtwesen genauso wie einzellige Organismen oder Viren. Huyghes konstruierte Situationen erinnern an Biosphären, innerhalb derer andere Gesetze gelten als in der Natur: Strukturelle Parameter für Veränderungen, Phänomene wie Schwarmverhalten und Clusterbildung werden genutzt, aber erweisen sich am Ende doch — wie jedes andere künstlerische Material auch — als letzte Grenzen des Gestaltungswillens.

After ALife Ahead

Für die Skulptur Projekte 2017 entwickelt Huyghe im früheren Eispalast, einer 2016 stillgelegten Schlittschuhbahn, nach einem umfassenden architektonischen Rück- und Umbau und mittels bio- und medientechnischen Eingriffen ein zeitbasiertes biologisch-technisches System. Alle Abläufe innerhalb der sehr großen Halle verhalten sich in wechselseitiger Abhängigkeit zueinander: Eine HeLa-Zelllinie, die sich in einem Inkubator im Prozess permanenter Teilung befindet, bestimmt einige davon. Das Wachstum der Zellen löst unter anderem die Entstehung von Augmented-Reality-Formen aus. Variationen in einem Weberkegel-Muster verändern die räumliche Struktur: zum Beispiel das Öffnen und Schließen eines pyramidenförmigen Fensters in der Hallendecke.

Durch Grabungen verwandelt Huyghe den Boden in eine flache Hügellandschaft. Beton und Erde, Ton-, Styropor-, Geröll- und eiszeitlich geformte Sandschichten sind stellenweise bis zu drei Meter unter die Erdoberfläche abgegraben, durchsetzt von kleinen Inseln, die stehen gelassen wurden. Unter anderem bewohnen Ameisen, Algen, Bakterien, Bienenstöcke und Pfaue das Gelände. Biologisches Leben, reale und symbolische Architektur und Landschaft, sichtbare und unsichtbare Prozesse, statische und dynamische Zustände verschmelzen miteinander zu einer unsicheren Symbiose. N.T.

[Nach einem K-Leben vor dem, was kommt]

Material
Betonboden der Eishalle, Logikspiel, Ammoniak, Sand, Ton, phreatisches Wasser, Bakterien, Algen, Bienen, Pfaue, Aquarium, schwarzes schaltbares Glas, Weberkegel (*Conus Textile*), GloFish, Inkubator, menschliche Krebszellen, genetischer Algorithmus, Augmented Reality, automatisierte Deckenstruktur, Regen

Standort
Ehemalige Eissporthalle
an der Steinfurterstraße 113–115,
48149 Münster

Zur Vorbereitung auf das Projekt von Pierre Huyghe können Sie sich unter apps.skulptur-projekte.de eine App herunterladen.

Pierre Huyghe

Pierre Huyghe's (*1962 Paris; lives in New York) works often present themselves as complex systems characterized by a wide range of life forms, inanimate things, and technologies. His arranged organisms combine not only biological, technological, and fictional elements, they also produce an environment for interaction between humans, animals, and non-beings as well as unicellular organisms or viruses. Huyghe's constructed situations are reminiscent of biospheres, where other laws apply than in nature: structural parameters for changes as well as phenomena like swarm behaviour and cluster development are used, but, in the end—as with any other artistic material—these prove to be the final limits of the will to make new possibilities happen.

After ALife Ahead

For Münster's Skulptur Projekte 2017, Huyghe has developed a time-based bio-technical system in a former ice rink that closed in 2016. This involved bio- and media-technological interventions and required extensive architectural de- and reconstruction. All the processes taking place within the very large hall are mutually interdependent: some of them are determined by the HeLa cell line, in a constant process of division in an incubator. Among its various effects, the cells' growth triggers the emergence of augmented reality shapes. Variations in a *Conus textile* pattern change the spatial configuration: for example, the opening and shutting of a pyramid-shaped window in the ceiling of the hall.

By digging into the earth, Huyghe transforms the ground into a low-level hilly landscape. In some spots, concrete and earth, layers of clay, styrofoam, gravel debris, and Ice Age sand are found as far as a few metres underground, interspersed with leftover surfaces. This space is inhabited, for instance, by algae, bacteria, beehives, and chimera peacocks. Biological life, real and symbolic architecture and landscapes, visible and invisible processes, and static and dynamic states are all fused into a precarious symbiosis. N.T.

Material
Concrete floor of ice rink, logic game, ammoniac, sand, clay, phreatic water, bacteria, algae, bees, chimera peacocks, aquarium, black switchable glass, *Conus textile*, GloFish, incubator, human cancer cells, genetic algorithm, augmented reality, automated ceiling structure, rain

Location
Former ice rink,
Steinfurterstraße 113–115,
48149 Münster

An app is available to help you prepare for the project by Pierre Huyghe.
Download at:
apps.skulptur-projekte.de

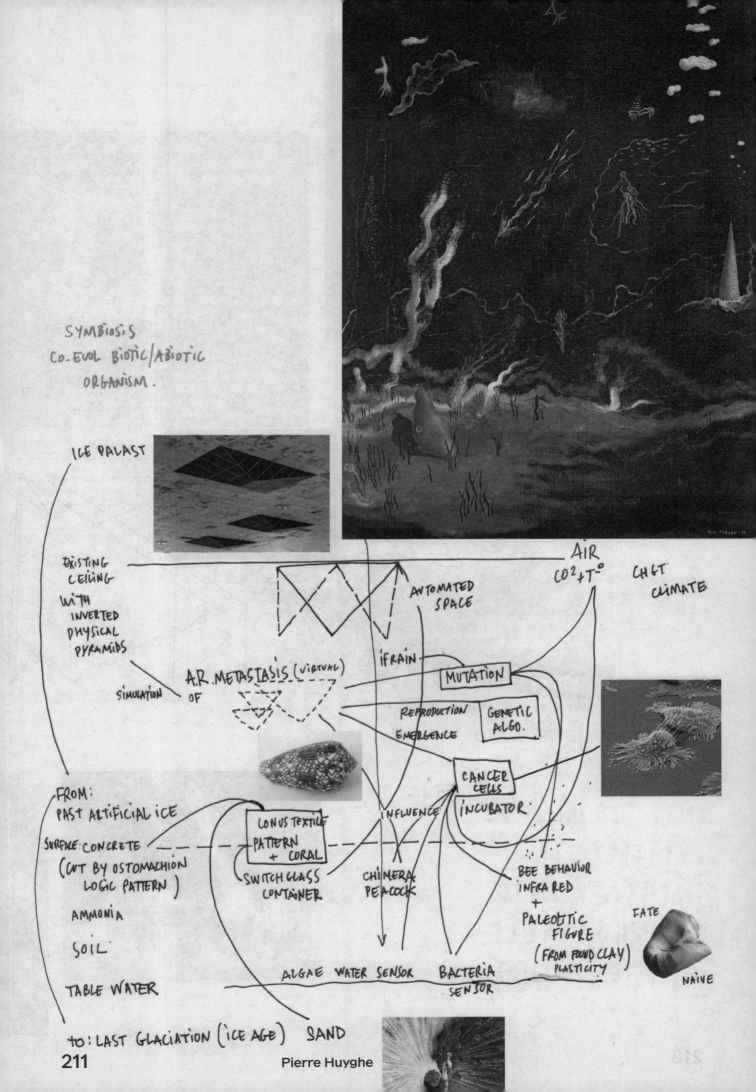

SYMBIOSIS
CO-EVOL BIOTIC/ABIOTIC
ORGANISM.

ICE PALAST

EXISTING
CEILING
WITH
INVERTED
PHYSICAL
PYRAMIDS

AIR
$CO_2 + T°$

CHGT
CLIMATE

AUTOMATED
SPACE

iRAIN

SIMULATION

A.R. METASTASIS (VIRTUAL)
OF

MUTATION

REPRODUCTION
EMERGENCE

GENETIC
ALGO.

CANCER
CELLS
INCUBATOR

INFLUENCE

FROM:
PAST ARTIFICIAL ICE

SURFACE: CONCRETE
(CUT BY OSTOMACHION
LOGIC PATTERN)

CONUS TEXTILE
PATTERN
+ CORAL

SWITCH GLASS
CONTAINER

CHIMERA
PEACOCK

BEE BEHAVIOR
INFRA RED
+
PALEOLITIC
FIGURE
(FROM POUND CLAY)
PLASTICITY

FATE

AMMONIA

SOIL

TABLE WATER

ALGAE WATER SENSOR BACTERIA
SENSOR

NAÏVE

TO: LAST GLACIATION (ICE AGE) SAND

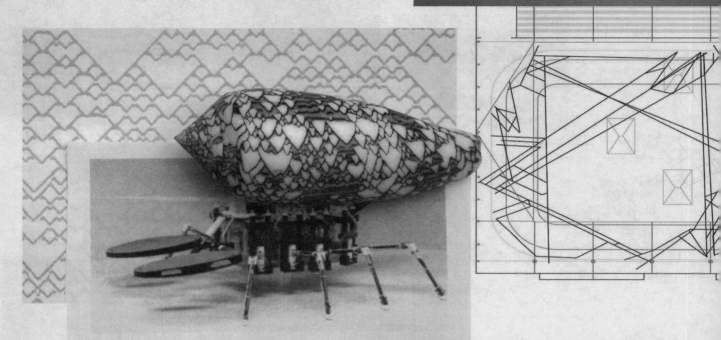

IN DE TER MI NATE
IN DI FFERENT
IN DISCERNIBLE
UN PREDICTA BLE
UN INTENTIONAL

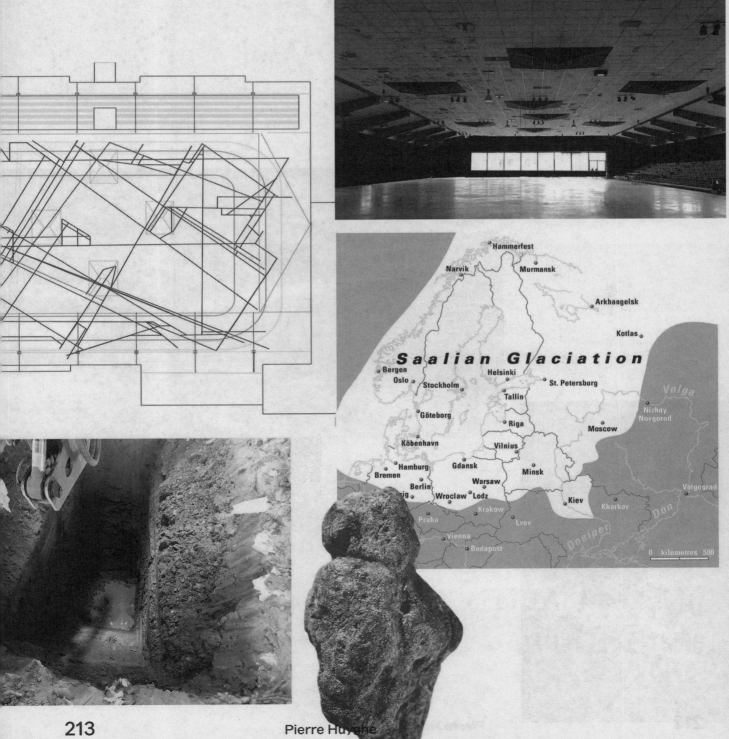

Saalian Glaciation

Hammerfest
Narvik Murmansk
 Arkhangelsk
 Kotlas
Bergen Helsinki
Oslo Stockholm St. Petersburg Volga
 Tallin Nizhny
 Göteborg Riga Novgorod
 Moscow
 Köbenhavn Vilnius
 Bremen Hamburg Gdansk Minsk
 Berlin Warsaw Volgograd
 ig Wroclaw Lodz Kiev Kharkov Don
 Praha Krakow Lvov Dneiper
 Vienna 0 kilometres 500
 Budapest

Pierre Huyghe

John Knight

Mit seinen Rauminstallationen, Signets, Schriftzügen und Objekten reagiert John Knight (* 1945 Los Angeles, lebt in Los Angeles) auf den institutionellen Rahmen und die wirtschaftlichen Belange von Museen und Galerien. Knights Werke führen die Wechselbeziehung zwischen dem spezifischen Kontext seiner Präsentation, der Materialität des Kunstwerkes und seiner Wahrnehmung durch die Betrachter_innen vor Augen, aus deren Zusammenwirken sich die Bedeutung eines Kunstwerkes generiert. In Distanznahme zur Selbstbezüglichkeit von Werken der Minimal Art konzipiert Knight seit den späten 1960er Jahren Projekte, die der unbedingten Zweckfreiheit von Kunst zu widersprechen scheinen. Es sind messerscharf formulierte Instrumente einer Institutionskritik, die ihre eigene Verortung innerhalb des politischen Mikrokosmos des Kunstbetriebs darstellen, und diesen zugleich zur gesellschaftspolitischen Realität zu öffnen suchen.

John Knight, A Work in situ

1969 startete Knight mit der Werkreihe *A Work in situ* eine Art Langzeitstudie über die Bedingungen von Kunstwahrnehmung. In einem Ausstellungsraum positionierte er mehrere Wasserwaagen, *Levels*, bei denen es sich um industriell hergestelltes Standardwerkzeug aus einem Baumarkt handelte. Das *Level* für Münster ließ Knight 2017 von einer kalifornischen Hightech-Manufaktur herstellen. In das schwarz lackierte Objekt sind drei mit Flüssigkeit und je einer Luftblase gefüllte Libellen eingelassen; die Richtwaage erfüllt alle Funktionen. Das *Level* ist an der Spitze des Neubaus auf der Nordseite des LWL-Museum für Kunst und Kultur parallel zur Vertikalen an der Sandsteinfassade angebracht. Der Grad der Neigung des montierten *Levels* ist an ihm selbst abzulesen. Am unteren Ende der Richtwaage befindet sich ein Signet mit den Initialen *JK*, das Knight in seinem gesamten Werk wie das Branding eines Corporate Designs verwendet.

Knight nimmt die Signalhaftigkeit der Architektur und die Verwendung von Kunstwerken im Interesse von institutionellen Vermarktungsstrategien ins Visier. Dem spektakulären Charakter des großen Schaufensters, das den Blick auf die gotische Skulpturengruppe *Der Einzug Christi in Jerusalem* (Heinrich Brabender, um 1516) inszeniert, begegnet er mit seinem eher beiläufig wirkenden Werk. Er verweist auf die Produktivität einer stets erschließenden Betrachtung – in der eine gotische Skulptur nicht bedeutender sein muss als eine Richtwaage. Der Künstler stellt die Vorstellung eines Wertes an sich infrage. Seine Signatur *JK* aktualisiert die Debatte über den Umgang mit dem Werk *Silberne Frequenz* (1970) von Otto Piene, das sich über zwei Fassadenseiten des Museums erstreckt. Bei der Neuinstallation der Arbeit wurde das Logo des Landschaftsverbandes Westfalen-Lippe (LWL) inmitten von Pienes Werk über dem Nordeingang angebracht. In dieser Entscheidung zeigt sich die Verschmelzung von öffentlichen und privatwirtschaftlichen Interessen, auf die Knights Werk aufmerksam macht. N.T.

[John Knight, eine Arbeit in situ]

Material
Carbonfaser-verstärkter Kunststoff

Maße
365 × 13 × 33 cm

Standort
Fassade Neubau LWL-Museum
für Kunst und Kultur
Domplatz 10, 48143 Münster

John Knight

John Knight's (* 1945 Los Angeles; lives in Los Angeles) space installations, logos, lettering, and objects are a response to the institutional framework and the commercial interests of museums and galleries. His works visualize the interaction between the specific context of his presentation, the materiality of his artwork, and the viewer's perception of it: the meaning of any given artwork is created by the interaction of these aspects. Distancing himself from the self-referentiality of Minimal Art, Knight has been conceiving projects since the late 1960s that seem to contradict the implicit purposelessness of art. They are instruments of institutional critique, formulated with razor-sharp precision, that map out their own place within the political microcosm of the art world and, at the same time, strive to open it up to socio-political reality.

John Knight, A Work in situ

In 1969, Knight's series of works entitled *A Work in situ* marked the beginning of a long-term study of the conditions of art perception. For his work *Levels*, he positioned several spirit levels in an exhibition space—standard industrially manufactured carpenter tools from a building supplies store. For Skulptur Projekte 2017, Knight had the *Level* produced by a high-tech manufacturer in California: the black-lacquered object contains three vials, filled with liquid and each containing one air bubble; the level is completely functional. It has been mounted, *parallel* to the vertical, at a slight distance from the sandstone façade at the pointed front of the new building on the northern side of the LWL-Museum für Kunst und Kultur. The mounted *Level* shows its own degree of inclination. At the bottom end of the object there is a logo with the initials *JK* which the artist adds to his works like the branding used in corporate design.

Knight focuses on architecture as a conveyor of signals and targets the way art is used to serve the interests of institutional marketing strategies. The spectacular nature of the large display window that frames our view of Heinrich Brabender's Gothic sculpture group *The Entry of Christ into Jerusalem* (ca. 1516) is contrasted with his own almost incidental piece. By pointing out the productivity of a view that is always exploratory—in which a Gothic sculpture need not be any more meaningful than a carpenter's level—Knight questions the idea of intrinsic value. His initials *JK* update the discussion about how to deal with Otto Piene's work *Silberne Frequenz* (1970), which spans two sides of the museum's façade. When *Silberne Frequenz* was reinstalled, the LWL logo was placed above the northern entrance right in the middle of Piene's work. This decision is a manifestation of the fusion of public and private commercial interests to which Knight's work calls attention. N.T.

Material
Carbon fibre

Dimensions
365 × 13 × 33 cm

Location
Façade of new building of
LWL-Museum für Kunst und Kultur
Domplatz 10, 48143 Münster

A wrinkle along the skin

Architecture as sculpture with a resented roof
Robert Venturi, *Iconography and Electronics [...]*

Skulptur Projekte Münster is a practice, not an exhibition that comes and goes over time, like other normative enterprises that are tethered to rhythms of fashion and spectacle. Its dedicated, singular focus on an ongoing field of inquiry makes it truly unique, less suscep-tible to the pangs of affect and novelty. As a practice, it is more concerned with a deeper investigation into the nature of production rather than the predisposition of the market. It is, even with its slips and foibles, a grand experiment in the accumulative production of curatorial and civic meaning.

A work *in situ* is also a practice, which is not dedicated to the refinement of a particular moment of history but rather the explicable nature of reception in a conjoined relationship with production. Which, by extension, calls into question both the means and place of production as custodial imperatives; in short, the production of history.

Both, by their very character and conduct, are deeply committed to the reclamation of a public realm.

Working from the premise of an economy of means, it is a pleasure to offer the following contribution to **Skulptur Projekte Münster 2017**, for your consideration: the introduction of a sly reprieve in the form of a variegated sign, to be installed ever so slightly off the surface of an inconsequential sliver of an overstated edge of real estate directed toward the central axis of the old city center, *as a structural nod to a long history...*

John Knight
Los Angeles 2016

Seit Ende der 1960er Jahre geht John Knight in seiner Praxis von architektonischen Bedingungen und Gegebenheiten aus. Der in Los Angeles lebende Künstler setzt sich mit dem gebauten Raum auseinander und stellt dabei kontextuelle Erwägungen über etablierte Vorstellungen von Medium und Genre. Dabei hat er eine originäre Methode entwickelt und konsequent verfolgt, die das Kunstobjekt in ein Verhältnis zum Ort stellt, den es einnimmt oder besetzt. Aus heutiger Sicht ließ die Arbeit *Levels* (1969) erstmals Knights Herangehen an Architektur nicht als bloßen Hintergrund oder Behälter, sondern als vorrangige Sphäre künstlerischer Reflexion und Intervention erkennen. Das Werk besteht aus einer variablen Anzahl handelsüblicher, aus diversen Quellen bezogener und gesammelter Wasserwaagen unterschiedlicher Farbe, Größe und Bauart, die vom Künstler in Kreisen oder geraden Linien direkt auf dem Boden des jeweiligen Raumes ausgelegt werden. Die einzelnen Elemente verweisen nicht nur auf den physischen Ort ihrer Platzierung, sondern vermessen ihn in konkreter Weise. Der deskriptive Titel spielt zugleich deutlich auf die 137 Ziegelsteine an, die Carl Andre in seiner Arbeit *Lever* (1966) zu einem schmalen, auf eine Galeriewand hinführenden Pfad arrangiert hatte. Der abstrakte Ortsbezug des Minimalismus wird in Knights Arbeit aufgehoben und in der buchstäblichen Vermessung des Raums sogar ausdrücklich verworfen.

Wenn *Levels* in programmatischer Weise den tatsächlichen Bezug des Kunstwerkes zu seiner räumlichen Umgebung jenseits der formalen (und phänomenologischen) Anliegen der zeitgenössischen Skulptur betont, so würde Knight in der Folge sein Modell der Ortsspezifik dahingehend erweitern, dass die gesamte Matrix der Architektur einbezogen und ausgelotet wird: jene materiellen, diskursiven, ökonomischen, sozialen und politischen Faktoren, die über die Grenzen und die Tektonik von Häusern, Plätzen und Straßen hinausgehen, diese aber nichtsdestotrotz bestimmen. Dieser Impuls wird insbesondere von den Logos verkörpert, die sich durch Knights Gesamtwerk ziehen. Erstmals treten sie 1981 im Rahmen eines nicht realisierten Vorschlags für die Ausstellung *The Museum as Site: Sixteen Projects* am Los Angeles County Museum of Art in Erscheinung. Aus einem Foto des Modells *in situ* wird ersichtlich, dass Knights Projekt das Zeichensystem im Eingangsbereich der zum Museum gehörenden Ahmanson Gallery verändern wollte. Ausgehend vom Motiv eines Sterns mit gekappten Zacken, das vom eigentlichen Designer des Gebäudes stammte und sich über dessen Wände, Säulen, Bodenfliesen und Teppiche zog, hätte Knight eben dieses Motiv in zwei Hälften geteilt, den vorhandenen Schriftzug mit diesen Fragmenten eingerahmt und ihn dadurch in eine Baubronze verändert, die an ein Firmenlogo erinnert. Auch in Knights *Museotypes* (1983) und *Autotypes* (2011) wird die Logik von Werbung und Marketing, die vorgeblich unabhängige Kunsteinrichtungen durchdringt, versinnbildlicht und in den Vordergrund gerückt. In beiden Arbeiten prangen die Grundrisse von Museen beziehungsweise deren Erweiterungsbauten in Form kobaltblauer Logos auf Gedenktellern aus Porzellan, wie um die Übergriffe der Unternehmenskultur auf die Sphäre des sogenannten Ästhetischen zugleich ins Extrem zu treiben und zu konterkarieren. Immer wieder hat sich Knights ortsspezifische Praxis den Supplementen und Rändern der Architektur zugewandt, um künstlerische Produktion dialektisch mit den Dispositiven der Konsumgesellschaft und der Medienkultur zu verschmelzen.

Für seinen Beitrag zu den Skulptur Projekten 2017 hat Knight erneut eine Wasserwaage geschaffen – diesmal allerdings in einem manipulierten Maßstab, wenn auch unter Beibehaltung ihrer referentiellen Funktion, und mit dem Zusatz der berühmten Ligatur der Initialen des Künstlers als Signatur. Sie ist vertikal auf die extrem schlanke, hoch aufragende Spitze des Erweiterungsbaus des LWL-Museum für Kunst und Kultur direkt gegenüber dem Domplatz montiert. Indem Knight die Register der (Pseudo-) Skulptur, der Dekoration und des Nutzwerts amalgamiert, setzt sein unaufdringliches Werk an dieser ausgewählten Stelle einerseits ein Zeichen, dass die Werbewirksamkeit der bürgerschaftlichen Architektur steigern soll, verankert andererseits aber die alle zehn Jahre stattfindende Ausstellung in der veränderten Topologie ihrer eigenen institutionellen Basis und ihres städtischen Umfelds.

André Rottmann

Unrealisierter Vorschlag für / Unrealized proposal for *The Museum as Site:*
Sixteen Projects, 1981, Los Angeles County Museum of Art

Levels, 1969, Installationsansicht, Atelier des Künstlers / installation view,
artist's studio, Inglewood, Los Angeles

John Knight

John Knight's work has been departing from the conditions of architecture since the late 1960s. Engaging built space and defying established notions of medium and genre in favour of contextual considerations, the Los Angeles–based artist has developed and sustained a persistent and distinct method of relating the object of art to the site it inhabits or occupies. With hindsight, Knight's work *Levels* (1969) indicates the emergence of his approach to architecture not as a mere backdrop or container but as a pre-eminent sphere of artistic reflection and intervention. It consists of a variable number of standard carpenter's levels that Knight collected from various sources; differing in size, colour, and materiality, these levels are arranged in circles or in straight lines directly on the floor of a designated space. These elements not only index but concretely measure the physical location of their own placement within a site. As signalled by the descriptive, yet allusive title—which clearly hints at the 137 firebricks that Carl Andre had aligned to build a path toward a gallery wall in his work *Lever* (1966)—Minimal Art's abstract address of place is superseded in Knight's work and even repudiated in terms of a literal survey of a given location.

If *Levels* programmatically stresses the actual rapport between the artwork and its spatial surroundings beyond the formal (and phenomenological) concerns of contemporary sculpture, Knight would subsequently expand his model of site-specificity to encompass and gauge the entire matrix of architecture: the material, discursive, economic, social, and political factors surpassing, but nonetheless determining, the confines and tectonics of proper buildings, squares, or streets. The impulse is epitomized by the logotypes that pervade Knight's oeuvre, which first gained prominence in 1981 when the artist submitted an ultimately unrealized proposal for the exhibition *The Museum as Site: Sixteen Projects* at the Los Angeles County Museum of Art. Evidenced by a photograph of the maquette in situ, Knight's project intended to alter the signage system at the entrance to the museum's Ahmanson Gallery. Based on a truncated star motif created by the museum's original designer and applied throughout the walls, columns, paving patterns, and interior carpets of that particular wing, Knight would have added a split version of the star to frame and transform the existing sign into an architectural bronze logotype. The logic of publicity and marketing that permeates allegedly independent art institutions is equally emblematized and brought to the fore in Knight's *Museotypes* (1983) and *Autotypes* (2011); in both works, the ground-floor plans of museums or their later annexes, respectively, are rendered as cobalt-blue logotypes that adorn bone china commemorative plates, as if to simultaneously exacerbate and contest the encroachments of corporate culture on the sphere of the so-called aesthetic. Time and again, Knight's site-specific practice has turned to the supplements and margins of architecture in order to dialectically conflate artistic production with the larger apparatus of consumer society and media culture.

For his contribution to Skulptur Projekte 2017 Knight has created another level—this time manipulated in scale, though still retaining its referential functionality, and sporting the artist's famous ligature of his own initials as signature—vertically mounted on the extremely narrow elevation of the 2014 extension to the LWL-Museum für Kunst und Kultur facing the old cathedral. Amalgamating the registers of (pseudo-)sculpture, decoration, and utility, Knight's unobtrusive work in situ offers a sign destined to enhance the promotional value of civic architecture, while anchoring the decennial exhibition to the changed topology of both its institutional basis and urban context.

André Rottmann

Justin Matherly

Die visuellen Vorlagen seiner Skulpturen findet Justin Matherly (* 1972 New York, lebt in New York) in Büchern und Texten, besonders in denen der klassischen Antike und der Philosophie. Auf sie nimmt er sowohl inhaltlich als auch formal Bezug, häufig sogar namentlich in den Werktiteln. Seine porösen, oft gebrochenen skulpturalen Interpretationen aus Beton, Gips und Plastik werden getragen von medizinischen Gehhilfen. Fotografien, die mit den Objekten eng verknüpft sind, ergänzen sein Werk.

Nietzsche's Rock

Wie vom Himmel gefallen wirkt Matherlys Skulptur auf der Grünfläche der Promenade. An mehreren Stellen sind Brüche und Löcher im Material zu sehen. Die Gehhilfen treten mal deutlich hervor, mal verschwinden sie ganz im grauen Material. Als Readymades, Objekte aus dem alltäglichen Leben, übernehmen sie die Funktion des Sockels und sind selbst Teil der Skulptur. Mit ihnen führt der Künstler ein Maß ein, das eng mit dem menschlichen Körper in Beziehung steht. Einige der Gehhilfen sind nicht neu und stammen aus der weiteren Umgebung von Münster. Trotz ihrer Massivität strahlt die Skulptur eine Leichtigkeit aus, scheint über der Erde zu schweben.

Die abstrakt wirkende Form hat einen sehr konkreten Ausgangspunkt: den sogenannten Nietzsche Felsen, benannt nach dem deutschen Philosophen. Der Fels am See von Silvaplana im Oberengadin hat ihn nach eigenen Angaben an einem Augusttag im Jahr 1881 zur Idee der *ewigen Wiederkehr des Gleichen* angeregt. Diese ist ein Gegenentwurf zur Vorstellung von einem Endzustand, wie sie vor allem die christliche Religion vertritt. Statt dass (Lebens-) Zeit abläuft, bedeutet die ewige Wiederkehr, dass „die ewige Sanduhr des Daseins […] immer wieder umgedreht [wird] – und du mit ihr".[1] In der Monumentalität des Felsens kann man ein Sinnbild für eine solche permanente Wiederholung sehen: Wenn jeder Moment des Lebens ewig von Neuem, wieder und wieder beginnt, dann liegt auf jeder noch so kleinen Handlung ein großes Gewicht. Der Mensch kann sich von diesem Gewicht niederdrücken lassen und jedes moralische Handeln als überflüssig erachten. Oder er bejaht diese permanente Wiederholung und sieht genau darin die Motivation für moralisches Handeln.

Wiederholtes Formen und Abformen, ausgehend von Fotografien des Felsens, prägten den dreiteiligen Entstehungsprozess der Skulptur Matherlys. „Ich spalte Formen in andere Formen auf", so der Künstler. „Nichts hört jemals wirklich auf." Keine Kopien von originalen Vorbildern entstehen so, sondern der Status quo einer sich als Objekt gestaltenden Interpretation. Matherly befragt über das Medium der Skulptur die Aktualität unserer philosophischen und ästhetischen Vergangenheit. Statt wie am Silvaplana fest mit dem Untergrund verbunden zu sein, wird das Schwergewicht in Matherlys Arbeit getragen von Stützen, die eigentlich Schwäche und den Verlust von Mobilität und Selbstständigkeit symbolisieren. s.t.

[Nietzsche Felsen]

Material
Beton, Glasfaser, medizinische Gehhilfen, Holz, Metall

Maße
ca. 350 × 700 × 300 cm

Standort
Wiese an der Promenade
Ecke Von Vincke-Straße / Salzstraße, 48143 Münster

1 Karl Schlechta (Hg.), *Friedrich Nietzsche: Werke in drei Bänden*, Band 2, Hanser, München, 1954. S. 202 f.

Justin Matherly

Justin Matherly (* 1972 New York; lives in New York) finds the visual prototypes for his sculptures in books and writings, especially in philosophical texts and the ancient classics, which he refers to both in form and content. In many cases, he even names them specifically in his titles. His porous and often fractured sculptural interpretations made of cement, plaster, and plastic are supported by medical walkers. His work is complemented by photographs that are closely linked to the objects.

Nietzsche's Rock

Matherly's sculpture on the grassy area along the Promenade looks as if it had fallen from the sky. The surface of the material exhibits cracks and holes in many places. The walkers clearly protrude in some spots and in others completely vanish inside the grey material. As ready-mades or everyday objects, they assume the function of a pedestal and also become part of the sculpture. In the artist's conception, these objects introduce a scale that is closely related to the human body. Some of the walkers used in this sculpture are no longer new and come from the wider Münster area. Despite its massive presence, the sculpture emanates a lightness, appearing to hover above the earth.

The seemingly abstract form has a very specific point of origin: the so-called Nietzsche Rock, named after the German philosopher. On an August day in 1881, according to his own records, the rock by Lake Silvaplana in Oberengadin inspired the idea of *eternal recurrence* which is an alternative to the concept of a finite state as preached by Christianity. Instead of (a life)time simply running out, eternal recurrence means that 'the eternal hourglass of existence is turned upside down again and again, and you with it'.[1] It is possible to see a symbol of permanent repetition in the monumental nature of the rock: if every moment in life eternally starts afresh again and again, then even the most trivial action is given tremendous weight. Man can allow himself to be crushed by this weight and view every moral act as superfluous. Or he can affirm eternal recurrence and see in it the real motivation for moral behaviour. Based on photographs of the rock, repeated shaping and moulding impacted the three-part creation process of Matherly's sculpture. 'I split up forms into other forms,' says the artist. 'Nothing ever really ceases to be.' No copies of original models are produced in this way; rather, it is the status quo of an interpretation that is in the process of becoming an object. Matherly investigates the relevance of our philosophical and aesthetic past by means of his sculpture. Instead of being anchored to the ground like the rock at Lake Silvaplana, the weight of Matherly's piece is held up by supports that actually symbolize weakness and the loss of mobility and independence. s.t.

Material:
Concrete, fibreglass, ambulatory equipment, wood, metal

Dimensions:
ca. 350 × 700 × 300 cm

Location:
Meadow on Promenade, corner of Von Vincke-Straße / Salzstraße, 48143 Münster

1 Friedrich Nietzsche, *The Gay Science: With a Prelude in Rhymes and an Appendix of Songs*, trans. Walter Kaufmann (New York: Vintage Books, 1974), 273.

„Alles geht, alles kommt zurück; ewig rollt das Rad des Seins. Alles stirbt, alles blüht wieder auf, ewig läuft das Jahr des Seins. Alles bricht, alles wird neu gefügt; ewig baut sich das gleiche Haus des Seins. Alles scheidet, alles grüßt sich wieder; ewig bleibt sich treu der Ring des Seins. In jedem Nu beginnt das Sein; um jedes Hier rollt sich die Kugel Dort. Die Mitte ist überall. Krumm ist der Pfad der Ewigkeit."

(Friedrich Nietzsche)

'Everything goeth, everything returneth; eternally rolleth the wheel of existence. Everything dieth, everything blossometh forth again; eternally runneth on the year of existence. Everything breaketh, everything is integrated anew; eternally buildeth itself the same house of existence. All things separate, all things again greet one another; eternally true to itself remaineth the ring of existence. Every moment beginneth existence, around every "Here" rolleth the ball "There." The middle is everywhere. Crooked is the path of eternity.'
(Friedrich Nietzsche)

Mein neuer Weg zu einer affirmativen Einstellung

Der Gedanke von der ewigen Wiederkehr des Gleichen kam Nietzsche 1800 Meter oberhalb von Mensch und Zeit, als er an den Ufern des Schweizer Silvaplanersees einem mächtigen, pyramidenförmigen Steinblock gegenüberstand. Nachdem ich mich des ungefähren Platzes des Steines vergewissert hatte, machte ich mich zur ersten Pilgerreise auf… als ich ihn fand, war ich enttäuscht. Er war unzugänglich, er brachte mir nichts, er hatte keine Geheimnisse – nicht, dass ich welche erwartet hatte, aber etwas in mir hatte an der Hoffnung festgehalten, dass er mich auf irgendetwas hinweisen würde. Es dauerte ein wenig, bis ich diese Hoffnung aufgab und den Stein als das ansah, was er war: nur ein Ding, ohne Absicht oder Bedeutung. Zwei Jahre später unternahm ich eine zweite Pilgerreise, um den Stein ausführlich zu dokumentieren, mit dem Ziel, ihn nachzubilden. Das schien eine angemessen absurde Weise, weitere Reflexionen über die Doktrin der ewigen Wiederkehr anzugehen. Die schwerste Last – diese niederschmetternde und schauerliche Idee – ist am Ende die stärkste Affirmation des Lebens, ein klares Ja zu allem im Leben (immer und immer wieder).

My new road to an affirmative attitude

The thought of eternal recurrence came to Nietzsche '6,000 feet beyond human beings and time in front of a powerful pyramidal block of stone' on the shores of Lake Silvaplana in Switzerland. After ascertaining the approximate location of the rock, I embarked on the first pilgrimage; upon finding it, I was underwhelmed. It was impenetrable and yielded nothing to me, no secrets, not that I was expecting it to exactly, but there was a part of me that held on to the hope that it might yield some clue. It was only later that I gave up on that hope and saw the rock for what it was: just a thing, without intention or meaning. Two years later I made a second pilgrimage to extensively document the rock with the intention of recreating it. This seemed an appropriately absurd way to approach further reflection of the doctrine of eternal recurrence. The heaviest weight—this crushing and gruesome idea—is, in the end, the highest affirmation of life, an unequivocal Yes to everything in life (over and over again).

Atelier / Studio Justin Matherly, Münster 2017

Justin Matherly

Christian Odzuck

Christian Odzucks (* 1978 Halle, lebt in Düsseldorf) künstlerisches Interesse gilt architektonischen Fragmenten sowie baulichen Prozessen in der Stadt. Grundlegende Methode seiner künstlerischen Praxis ist dabei die Weiterverwendung und -entwicklung bereits benutzter Bauteile, die er zu begehbaren Gefügen neu zusammensetzt. Die ursprünglichen Bauwerke sowie einzelne Elemente, Spolien oder Erinnerungen daran, werden so für die Besucher_innen sichtbar und ästhetisch erfahrbar.

OFF OFD

Ausgangspunkt seiner Arbeit für die Skulptur Projekte ist der 2016/2017 abgerissene Gebäudekomplex der Oberfinanzdirektion Münster (OFD), der in den 1960er Jahren nach Plänen der Architekten HPP Hentrich-Petschnigg & Partner errichtet wurde. Odzuck platziert sein Werk *OFF OFD* auf der Brachfläche und orientiert sich an der klaren, modernen Formensprache des abgerissenen Verwaltungsgebäudes sowie an dessen getreuen Maßen und der Raumaufteilung. Im Mittelpunkt der Arbeit steht die architektonisch auffällige Treppenanlage, die sich ursprünglich am Haupteingang der OFD befand. Odzuck rekonstruiert sie als Attrappe und erweitert sie konzeptuell wie baulich. Er recycelte das Material des abgerissenen Gebäudes als Schotterbett und ergänzte dieses um modulare Betonfertigsteine, die aus Restbetonmengen früherer Bauvorhaben gegossen wurden. Darüber hinaus verlagert und reaktiviert der Künstler die 23 Meter hohe Straßenlaterne vom Parkplatz der OFD.

In Anlehnung an die Spaziergangswissenschaft Lucius Burckhardts erkundet Odzuck in intensiven Streifzügen durch die Stadt Orte und ihre jeweiligen politischen, sozialen und historischen Subtexte und Funktionen, die er in fotografischen Essays, Studien und Recherchebüchern festhält. Seine Publikationen zeichnen diese fortlaufenden Suchbewegungen nach, kartografieren die Eindrücke seiner Spaziergänge und sind somit Arbeitsmedium, Dokumentation und Ereignis zugleich. Anschließend überführt der Künstler die Konzepte und Visionen aus dem zweidimensionalen in den dreidimensionalen, realen Raum. Bauprozesse begreift Odzuck als prozessuale, künstlerische Strategie, um die Möglichkeiten eines Raumes zu hinterfragen und sichtbar zu machen. Für die Skulptur Projekte hat sich der Künstler bewusst auf Bauwerke und Situationen in der Stadt konzentriert, deren Abriss oder Umnutzung kurz bevorstand. Mit der Platzierung seines Werkes vor das Anti-Panorama des brach liegenden Baufeldes verweist Odzuck auf diesen fragilen Schwebezustand zwischen Abriss und Neubau und die städteplanerischen und gesellschaftlichen Potenziale, die daraus entwachsen können. C.N.

Material
Beton, Stahl, Holz, Spolien

Maße
2300 × 1600 × 3600 cm

Standort
Andreas-Hofer-Straße 50,
48145 Münster

Christian Odzuck

Christian Odzuck (* 1978 Halle; lives in Düsseldorf) takes as his focus architectural fragments as well as urban building processes. His basic artistic approach is the reuse and further development of building materials, which he reassembles as accessible structures. The original buildings as well as individual elements, reused materials, or the memories thereof are made visible and aesthetically tangible for visitors.

OFF OFD

The point of departure for his Skulptur Projekte piece is Münster's former revenue office, the Oberfinanzdirektion (OFD) building complex, which was torn down in 2016/17. It was built in the 1960s from plans developed by the architecture firm HPP Heinrich-Petschnigg & Partner. Odzuck places his work *OFF OFD* in the now abandoned space, getting his bearings from the clear, modern use of form in the now demolished administrative building as well as from its former dimensions and floor plan. The centrepiece of the work is the stairway, which is conspicuous in an architectural sense. Originally, it was at the main entrance of the OFD, but Odzuck reconstructed it as a mock-up, imitating its function as a walkway yet expanding it from a conceptual and structural point of view. He recycled the demolished building's materials as a ballast bed and added on modular prefab concrete bricks made of leftover cement from previous building projects. In addition to this, the artist translocated and reactivated the 23-metre-long street light from the OFD car park.

In reference to Lucius Burckhardt's science of strollology, Odzuck investigates urban places on his strolls through town, exploring their political, social, and historical subtexts and functions, which he documents in essays, studies, and research books. His publications trace these continuing expeditions, mapping the impressions of his walks and, at the same moment, serving as his working medium, a documentation, and a true experience. Subsequently, the artist converts these concepts and visions from a two-dimensional surface to a real three-dimensional space. Odzuck understands construction phases as process-oriented, artistic strategies that challenge the possibilities of a space and render them visible. For Skulptur Projekte the artist consciously focused on urban structures and situations that were faced with impending demolition or repurposing. By placing his work in front of the anti-panorama of the abandoned construction site, Odzuck alludes to that fragile state of limbo between demolition and new construction and to the urban development potential and social opportunities that could emerge from it. C.N.

Material
Concrete, steel, wood, spolia

Dimensions
2300 × 1600 × 3600 cm

Location
Andreas-Hofer-Straße 50,
48145 Münster

Christian Odzuck

Christian Odzuck

231

Christian Odzuck

Christian Odzuck

Emeka Ogboh

Emeka Ogboh (* 1977 Enugu, lebt in Berlin und Lagos) arbeitet sowohl mit den Geräuschen einer Stadt, Stimmengewirr, Liedern, Rufen, Schreien, Rauschen, als auch mit eigenen Kompositionen aus bestehenden Liedern und öffentlichen Reden. Aus komplexem Soundmaterial filtert er spezifische klangliche und inhaltliche Ebenen heraus, die er in experimentelle Musikstücke und klangräumliche Installationen überführt, die in Ausstellungsräumen, aber auch, etwa in seiner Komposition für das neue Gebäude des Sicherheitsrats der Afrikanischen Union in Addis Abeba, im öffentlichen Raum zu hören sind. Es entstehen auditive Topografien von Urbanität und Politik, deren Schichtungen der Künstler als Ausschnitt aus der gesellschaftlichen und kulturellen Vielheit freilegt. Ogbohs Werk dreht sich um die Wahrnehmung mit allen Sinnen. Er hebt die Zubereitung von Speisen und Getränken als identitätsstiftende Praxis hervor, die über Generationen und in Migrationslinien weitergetragen wird.

Passage through Moondog / Quiet Storm

Für Münster entwickelte Ogboh, ausgehend von Kompositionen und Gedichten des legendären amerikanischen Musikers Moondog, ein Soundkonzept für den Hamburger Tunnel, eine Unterführung neben dem Hauptbahnhof. Er verwendet dafür unter anderem Aufnahmen, die der Musiker und Vertraute Moondogs, Stefan Lakatos, mit der Trimba eingespielt hat. Dieses Instrument ist eine Erfindung des erblindeten Moondog und charakteristisch für seine Stücke seit den späten 1940er Jahren. Moondog, geboren als Louis Thomas Hardin (1916–1999), war Straßenmusiker und, laut dem Nachruf seines ehemaligen New Yorker Mitbewohners Philip Glass, einer der einflussreichsten Nonkonformisten seiner Zeit, Dialogpartner von Leonard Bernstein und Inspirationsquelle für den Komponisten Artur Rodziński. Von seiner intensiven Beschäftigung mit Rhythmus, Melodie und Sprache zeugen neben den Musikstücken auch mehrere Hundert zweizeilige Gedichte (Couplets). Nachdem es ihn aus New York, wo er als Wikinger der 5th Avenue Berühmtheit erlangt hatte, ins westfälische Oer-Erkenschwick verschlagen hatte, lebte Moondog kurz vor seinem Tod in Münster, wo er heute auf dem Zentralfriedhof begraben liegt. Mit dem Konzept der Soundscapes teilen Moondog und Ogboh das Interesse am öffentlichen Raum als Quelle und Bühne für ihre Kompositionen: die Straße, die John Cage den „wahren Konzertsaal" nannte.

Ogboh trägt noch ein weiteres Projekt bei: Das Bier *Quiet Storm*, das er unter Zusatz von Lindenblütenhonig von der an der Promenade gelegenen Westerholtschen Wiese in Belgien brauen ließ. Während des circa zweiwöchigen Fermentierungsprozesses des Bieres wurden die großen Tanks der Brauerei mit speziellen Lautsprechern (Wandlern) ausgestattet, um das Bier mit Aufnahmen der Klangkulisse von Lagos, mit intensiven Vibrationen, zu beschallen und den Brauprozess zu beeinflussen: Die bevölkerungsreichste Stadt Afrikas, in der sich nigerianische Dialekte, Musik und Verkehrslärm überlagern, ist mit ihren *good vibes* im *Quiet Storm* anwesend. N. T.

[Passage zu Moondog]

Material
Soundinstallation (Soundscapes, Couplets von Moondog, Trimbaspiel, 16 Lautsprecher)

Standort
Hamburger Tunnel
Münster Hauptbahnhof, 48143 Münster

Credits
Text: Moondog ● Eingelesen von: Judith Frey, Wolfgang Gnida, Tineke Kaiser, Konstanze Klecha, Stefan Lakatos, Britta Peters, Tatjana Niederberghaus, Anna-Lena Treese, Sophia Trollmann, Jessi Tropp, Marianne Wagner, Doris Wermelt ● Trimbaspiel: Stefan Lakatos ● Soundscapes: Titus Maderlechner, Emeka Ogboh ● Beratend: Wolfgang Gnida ● Sounddesign: Titus Maderlechner

Mit freundlicher Genehmigung des Nachlasses von Louis Hardin (Moondog), vertreten durch den Testamentsvollstrecker Rechtsanwalt Alexander Duve, Berlin.

[Ruhiger Sturm]

Material
Honigbier mit Lindenblüten,
Braumenge: 60 HL, 7,5 % Alkohol

Zu erwerben
Café Lux, Theater im Pumpenhaus, Trafostation, Infopoint am Museum

In Zusammenarbeit mit Philipp Overberg (Guthaus-Brauerei) in der Anders Brauerei (Belgien) gebraut

Sounddesign: Thomas Bücker

Emeka Ogboh

Emeka Ogboh (*1977 Enugu; lives in Berlin and Lagos) deals with urban sounds, the babel of voices, songs, shouts, screams, and background noise, but he also works with his own compositions, consisting of existing songs and public speeches. He filters specific tonal and content-related layers from complex sound material and converts them into experimental musical pieces and spatial audio installations that can be heard in exhibition spaces and in compositions for public spaces like his arrangement for the African Union's new Peace and Security Building in Addis Ababa. He generates auditory topographies of urban and political sound textures, whose layers are exposed by the artist as an extract of social and cultural diversity. Ogboh's works focus on the use of all five senses for perception. He emphasizes the preparation of food and drink as a means of creating identity that is passed on from one generation to the next and along migratory routes.

Passage through Moondog / Quiet Storm

As his contribution to Sculpture Projects, Ogboh has developed a sound concept for the Hamburger Tunnel, an underground passageway next to Münster's main station. Based on the compositions and poems of the legendary American musician Moondog, he uses, among other things, material recorded on the Trimba by Moondog's close friend Stefan Lakatos. The instrument was invented by Moondog—a blind street musician, who was born Louis Thomas Hardin (1916–1999)—and it is characteristic of the pieces he began composing in the late 1940s. According to the obituary written by his old New York flatmate Philip Glass, he was one of the most influential nonconformists of his time, an associate of Leonard Bernstein, and a source of inspiration for the composer Artur Rodziński. Thanks to his intense involvement with rhythm, melody, and language, Moondog wrote several hundred two-line poems (Couplets) in addition to his music pieces. After leaving New York, where he had gained fame as the Viking of Fifth Avenue, Moondog ended up in the Westphalian town of Oer-Erkenschwick, moving just before he died to Münster, where he is buried at the main municipal cemetery. The concept of soundscapes shared by both Moondog and Ogboh reveals a common interest in the public space as a source and stage for their compositions: the *street*, which John Cage called 'the true concert hall'.

Ogboh has also contributed a second project: the beer called *Quiet Storm*, which he had brewed in Belgium and enhanced with lime-blossom honey from the Westerholt meadow along Münster's Promenade. During the two-week process of fermentation, the brewery's large beer tankers were equipped with special loudspeakers (transducers) to sonify the beer and influence the brewing process with intense vibrations from sound textures recorded in Lagos, Africa's most populous city, an overlapping mix of Nigerian dialects, music, and traffic noise. All the city's good vibes are present in *Quiet Storm*.
N.T.

Passage through Moondog

Material
Sound installation (soundscapes, *Couplets* by Moondog, Trimba music, 16 speakers)

Location
Hamburger Tunnel (underpass)
Münster central station, 48143 Münster

Credits
Lyrics: Moondog ● Read by: Judith Frey, Wolfgang Gnida, Tineke Kaiser, Konstanze Klecha, Stefan Lakatos, Britta Peters, Tatjana Niederberghaus, Anna-Lena Treese, Sophia Trollmann, Jessi Tropp, Marianne Wagner, Doris Wermelt ● Trimba music: Stefan Lakatos ● Soundscapes: Titus Maderlechner, Emeka Ogboh ● Consultant: Wolfgang Gnida ● Sound design: Titus Maderlechner

With kind permisson of the estate of Louis Hardin (Moondog), represented by executor Alexander Duve, Berlin.

Quiet Storm

Material
Honey beer with lime blossom; amount brewed: 60 hl, 7.5 % alcohol

Available at
Café Lux, Theater im Pumpenhaus, Trafostation, Museum infopoint

Brewed in collaboration with Philipp Overberg (Guthaus-Brauerei) at Anders Brewery (Belgium)

Sound design: Thomas Bücker

Moondog, 1974, vor dem / in front of St-Paulus–Dom, Münster

Emeka Ogboh

quiet storm

Inspired by Münster.
Fermented by Lagos.

Stadt, Klang und Bier.

quiet storm

Available this summer only.

Peles Empire

Das Künstlerinnenduo Peles Empire, bestehend aus Barbara Wolff (* 1980 Fogarasch, lebt in Berlin) und Katharina Stöver (* 1982 Gießen, lebt in Berlin), entnimmt sein Material und seinen Namen dem rumänischen Königsschloss Peleș aus dem Jahr 1883, in dessen Innerem ein chaotisches Nebeneinander von Möbelkopien und Raumgestaltung diverser Stilepochen herrscht. Diese historisierende Einrichtung greifen die beiden Künstlerinnen auf und machen ein postmodernes Reproduktions-, Sampling- und Zitierverfahren zur Grundlage ihrer künstlerischen Praxis.

Sculpture

Für die Skulptur Projekte errichtet Peles Empire in direkter Nähe zur Altstadt einen knapp acht Meter hohen Giebel, dessen gekachelte Fassade die marode Terrassenanlage des Schlosses abbildet sowie die Stützen, die diese Terrasse vor dem Einstürzen bewahren. Die Fassade wird mit Stangen auf ein hinteres, abgestuftes Volumen gestützt, dessen Oberfläche mit schwarz-weißen Schlieren, ähnlich einer Steinoberfläche, überzogen ist. Diese Oberfläche nimmt optisch bereits die aus Jesmonite gefertigte Bar im Innenraum vorweg. Beide sind in Schwarz-Weiß gehalten und erinnern so an Fotokopien. Die Besucher_innen können das Objekt, das auf einem Parkplatz steht, nicht nur betrachten, sondern auch betreten. Der äußere Eindruck suggeriert eine Wertigkeit, die so nicht existiert: Was von außen prachtvoll und massiv aussieht, entpuppt sich als Druck auf dünnem aluminiumbasierten Plattenmaterial. Die Größe der Kacheln sowie der hintere, getreppte Teil des Objekts orientieren sich an DIN A3-Papiermaßen. Die DIN-Maße sowie das Schwarz-Weiß verweisen auf die Technik des Fotokopierens, bei der jede weitere Reproduktion mit einer zunehmenden Abstraktion einhergeht.

Peles Empire bezieht sich mit *Sculpture* auf die historisierende Bauweise des Prinzipalmarktes. Dieser wurde nach seiner Zerstörung im Zweiten Weltkrieg wiederaufgebaut – und zwar nicht als exakte Rekonstruktion, sondern nach dem Vorbild der 1950er Jahre. Ausgehend von ursprünglichen, geplanten und gebauten Fassaden hat das Duo eine Art Durchschnittsgiebel entwickelt, der die Vorderfront der Skulptur definiert. Wie eine schwarz-weiße Bildstörung kommentiert das Objekt den pittoresken Charme und die homogenisierende Erzählung des scheinbar mittelalterlichen Stadtkerns. Zur Arbeit von Peles Empire gehört auch ein sozialer Aspekt: Zu Beginn ihrer Zusammenarbeit diente die Wohnung der beiden in Frankfurt a. M. als eine Art Salon, der später – mit dem Umzug nach London – zum Ausstellungsraum wurde. Als Ausstattung ihres wöchentlichen Salons im eigenen Wohnzimmer dienten Fototapeten mit Abbildungen der Räume von Schloss Peleș. Bereits hier wurde das dreidimensionale Interieur des Königssitzes mittels Kopien, Fotografien und Collagen in die Zweidimensionalität übersetzt – um schließlich durch die Nutzung des Bildmaterials als Tapete erneut in einen dreidimensionalen Raum überführt zu werden. Auch in Münster ist Peles Empire in der Rolle des Gastgebers: Die beiden laden zu Künstler_innengesprächen in der Bar ein. J.B.

[Skulptur]

Material
Dibond, Keramikfliesen, verzinkter Stahl und Jesmonite

Maße
755 × 622 × 638 cm

Standort
Parkplatz des Oberverwaltungsgerichts Ecke Aegidiistraße / Aegidiikirchplatz, 48143 Münster

Künstler_innengespräche, Beginn 19 Uhr
21.07.17 Alexandre da Cunha
22.07.17 Maria Loboda
11.08.17 Mariechen Danz
12.08.17 Anthea Hamilton / Julie Verhoeven
25.08.17 Nicolas Deshayes
22.09.17 Oliver Osborne
23.09.17 Daniel Sinsel

Peles Empire

The artist duo Peles Empire, consisting of Barbara Wolff (* 1980 Făgăraș, lives in Berlin) and Katharina Stöver (* 1982 Gießen, lives in Berlin), takes its material and name from the Romanian royal castle of Peleș, built in 1883. The interior is dominated by a chaotic hodgepodge of replica furniture and decors from various stylistic periods. The two artists pick up on the historical dimension of the furnishings and adopt a postmodern process of reproduction, sampling, and quotation as the basis for their artistic practice.

Sculpture

For the Skulptur Projekte, Peles Empire has erected a gable, nearly eight metres high, in the immediate vicinity of the city's historic centre. The gable's tiled façade shows an image of the castle's crumbling terrace as well as the supports that keep it from collapsing. The façade is braced by poles and propped against a stepped volume, whose surface is covered with black-and-white streaks, mimicking a stone surface. This surface visually anticipates the Jesmonite bar inside. Both are black and white and thus create the effect of a photocopy. The object, which is located in a car park, is not just for viewing from the outside—it can also be entered. The first impression suggests some intrinsic value, but this is misleading: what looks magnificent and solid from the outside turns out to be a print pasted on a sheet of thin aluminium-based material. The size of the tiles and the stepped element behind the façade were based on the size of standard A3 paper. This and the black-and-white imagery are a clear reference to the technology of photocopying, where every copy increasingly becomes an abstraction of the original.

Peles Empire uses its piece *Sculpture* to allude to the historicized architecture of Münster's historic market (the Prinzipalmarkt), which was rebuilt after being destroyed in World War II—not as an exact reconstruction but according to the prototype of the 1950s. Based on the original façade, the plans for the new façade, and what was actually built, the duo developed a kind of 'standard' gable from all three elements to define the front of the sculpture. Akin to black-and-white image interference, the object comments on the picturesque charm and homogenized narrative of the apparently medieval town centre. Peles Empire's work also includes a social dimension: at the beginning of their collaboration, the two artists used their flat in Frankfurt am Main as a kind of salon—after moving to London, it later became an exhibition space. Photo wallpaper served as the decor for their weekly gatherings in their own living room with depictions of the rooms in Peleș Castle. At that time they had already begun utilizing photocopies, photographs, and collages to transpose the three-dimensional interior of the castle into two dimensions—before finally returning it to a three-dimensional space by using the images as wallpaper. In Münster, Peles Empire has once again taken on the role of host: the artists have organized discussions with other artists in the bar. J.B.

Material
Dibond, ceramic tiles, galvanized steel, Jesmonite

Dimensions
755 × 622 × 638 cm

Location
Car park of Oberverwaltungsgericht, corner of Aegidiistrasse / Aegidiikirchplatz, 48143 Münster

Artist's talks, starting time 7 pm
21.07.17 Alexandre da Cunha
22.07.17 Maria Loboda
11.08.17 Mariechen Danz
12.08.17 Anthea Hamilton /
Julie Verhoeven
25.08.17 Nicolas Deshayes
22.09.17 Oliver Osborne
23.09.17 Daniel Sinsel

Durschnittslinie Fassaden Münster / Averaged outline of Münster façades
noroc, Frieze Projects, 2011 (S./p. 240)
Peles Empire space, 2010−2014 (S./p. 240)
3D Modell / 3D model *Sculpture*, 2015 (S./p. 241)
mutant, 2015, Salts, Biersfelden (S./p. 241)
remnant, Entwurf / draft, 2017 (S./p. 242)

Peles Empire

Peles Empire

Peles Empire

Alexandra Pirici

Alexandra Pirici (* 1982 Bukarest, lebt in Bukarest) verbindet in ihren Arbeiten Performance, Tanz und Skulptur. Häufig setzt sie sich mit der Geschichte und Bedeutung spezifischer Orte auseinander, um bestehende Hierarchien spielerisch zu befragen und zu transformieren. In ihren Interventionen stellt sie der Monumentalität öffentlicher Denkmäler und Institutionen lebendige Gesten entgegen, die eine grundlegende Skepsis gegenüber in Stein gemeißelten Formen von Vergangenheit und kanonischen Festschreibungen artikulieren. Ein weiterer Fokus ihrer Arbeit liegt auf der künstlerischen Reflexion von Informationssouveränität und Filtermechanismen im digitalen Raum.

Leaking Territories

Der Friedenssaal im Historischen Rathaus ist Ausgangspunkt einer mehrteiligen Arbeit, in der primär medial vermittelte Ereignisse reinszeniert werden. Während in einer Sequenz sechs Performer_innen einen Kollektivkörper formen, der den Raum dynamisch durchquert, stellen sie in einer anderen Situationen nach, die auf territoriale Konflikte und Momente der Infragestellung klarer Grenzziehungen verweisen. Ausgerufene Datums- und Entfernungsangaben verorten diese in Zeit und Raum. Stellenweise verkörpern die Performer_innen lebendige Suchmaschinen, die mit dem Publikum interagieren. Partiell überschneidet sich der touristische Besucherstrom mit der im Loop aufgeführten Aktion.

Pirici situiert ihre Arbeit an einem geschichtsträchtigen Ort. Heute dient die ehemalige Rats- und Gerichtskammer, in der 1648 der Friedensvertrag von Münster geschlossen wurde, als repräsentativer Empfangssaal und Touristenmagnet. Im Kontext des Westfälischen Friedens – der einen vordergründig religiösen, primär hegemonialen Krieg diplomatisch beendete und eine Fixierung territorialer Grenzen markierte – steht der Raum symbolisch für Dialog, Toleranz und die Geburtsstunde des Völkerrechts. Die Künstlerin begegnet dieser musealen Vergangenheitsinszenierung, indem sie den Raum für äußere Einflüsse öffnet und ihn in ein assoziatives, multiperspektivisches Netz von Referenzen einbindet. Die Körper dienen als Medium und Schnittstelle, über die reale, mediale und mentale Zeiträume, einem Hypertext vergleichbar, miteinander verknüpft werden. Durch Rückübersetzung von Bewegungen in dreidimensionale Ausdrucksformen wird Geschichte in dem Medium aktualisiert, in dem sie sich ereignet, aber auch in ihrer Konstruiertheit erfahrbar. Piricis Körpercollage wirft ein Bündel an Fragen auf, die um den Nationalstaat als statisches, identitätsstiftendes Konstrukt und die Ambivalenz digitaler Technologien kreisen. In Zeiten, in denen Nationalismus und Protektionismus die Idee Europas infrage stellen, plädiert Piricis Arbeit für eine Kultur des grenzüberschreitenden Dialogs und der Vielstimmigkeit. Damit lässt sie sich lose auch in Beziehung zu einem Rechtsgrundsatz setzen, der einen der Deckenbalken des Ratssaales ziert: *Audiatur et altera pars* – gehört werde auch der andere Teil. A.P.

[Undichte Territorien]

Standort
Friedenssaal im
Historischen Rathaus Münster
Prinzipalmarkt 10, 48143 Münster

Performer_innen
Beniamin Boar, Liliana Ferri De Guyenro, Montserrat Gardó Castillo, Susanne Grau, Susanne Griem, Jared Marks, Rolando Matsangos, Luísa Marinho Saraiva, Fang-Yu Shen, Tyshea Lashaune Suggs, Pia Alena Wagner, Andy Zondag

Öffnungszeiten
Di–So 16–20 Uhr
Mo geschlossen

Alexandra Pirici

In her works, Alexandra Pirici (* 1982 Bucharest; lives in Bucharest) fuses performance, dance, and sculpture. She frequently deals with the history and meaning of specific places in order to playfully tackle and transform existing hierarchies. She uses her interventions to confront the monumentality of public memorials and institutions with animated gestures that express a fundamental scepticism towards the chiselled stone forms of the past and canonical fixations. A further aspect of her work involves artistic reflections on data sovereignty and filter mechanisms within the digital space.

Leaking Territories

The Friedenssaal in Münster's historical town hall serves as the starting point for a work consisting of several parts: events which were primarily presented through media are restaged. In one sequence six performers form a collective body that dynamically cuts across the room, reconstructing an allusion to territorial conflicts and situations in which distinct lines of demarcation are challenged. This scene is strengthened by historical data and distances, giving the viewers a sense of orientation in time and space. Sporadically, the performers embody living search machines that interact with the audience. In part, the flow of visitors will overlap with the loop of ongoing action.

Pirici has situated her ongoing action in a historic location. Today, the former town council and court chambers where the Treaty of Münster was signed in 1648 serve as a prestigious reception hall and a magnet for tourists. Within the context of the Peace of Westphalia —an act of diplomacy that brought to an end a war that was ostensibly religious but primarily hegemonic and specified territorial borders—the space symbolically stands for dialogue, tolerance, and the birth of international law. Pirici confronts this historical, museum-like re-enactment of the past by opening up the space for external influences and incorporating it in an associative, multi-perspectival network of references. The bodies serve as a medium and interface through which real media-related and mental time frames are connected—similar to a hypertext. By translating the movements back to three-dimensional forms of expression, history is updated in the medium: it takes place but is also made tangible in its constructedness. Pirici's human-body collage raises a clutch of questions that revolve around the nation-state as a static, identity-establishing construct and the ambivalence of digital technologies. At a time when nationalism and protectionism are questioning the concept of Europe, Pirici's work makes an appeal for a culture of transnational dialogue and a diversity of voices. In this way she can be loosely associated with a legal tenet that adorns one of the ceiling beams in the council chambers: *Audiatur et altera pars*—Let the other side be heard too. A.P.

Location
Friedenssaal im Historischen Rathaus
(Historical Town Hall) Münster
Prinzipalmarkt 10, 48143 Münster

Performers
Beniamin Boar, Liliana Ferri De Guyenro, Montserrat Gardó Castillo, Susanne Grau, Susanne Griem, Jared Marks, Rolando Matsangos, Luísa Marinho Saraiva, Fang-Yu Shen, Tyshea Lashaune Suggs, Pia Alena Wagner, Andy Zondag

Opening hours
Tue–Sun: 4–8 pm
Mon closed

Spiel des Friedens / Game of Peace, LWL-Museum für Kunst und Kultur

Spiel des Friedens / Game of Peace, LWL-Museum für Kunst und Kultur

Datenumgebung der NYC-Bevölkerung, als hellblaues Blasenmodell dargestellt. Sofortige Wiedergabe von über 20.000 Datenpunkten. / Datascape of NYC's population, rendered in a light-blue bubble model representation. Over 20K datapoints rendered instantly. Datenquelle / Data source: UA census data; Quelle / Source: archinect.com

Tattoo von Kris Phillips, gestochen von Scotty-Potty, Exile Tattoo / Tattoo of Kris Phillips made by Scotty-Potty at Exile Tattoo Quelle / Source: geekytattoos.com

Leaking Territories

Es scheint angesichts der aktuellen globalen Situation ein guter Zeitpunkt, um aus der Perspektive eines der bedeutendsten historischen Ereignisse der vergangenen Jahrhunderte auf die Stadt Münster zu schauen: Dabei handelt es sich um den Westfälischen Frieden, die Unterzeichnung einer Reihe von Friedensverträgen im Jahr 1648, die eine Abfolge langer, verheerender Kriege in Europa beendeten. Die Abkommen wurden sowohl in Münster als auch in Osnabrück unterzeichnet und etablierten den Präzedenzfall des Friedens, den der Kongress der Diplomaten ausgehandelt hatte. Die meisten Wissenschaftler_innen, die sich mit internationalen Beziehungen beschäftigen, bescheinigen den Abkommen, dass sie das Fundament für das moderne Staatswesen legten, indem sie eine neue politische Ordnung einführten: das Westfälische Modell, das koexistierende, souveräne Staaten voraussetzt, die sich nicht in die inneren Angelegenheiten des jeweils anderen einmischen, in die territoriale Souveränität und die Machtverhältnisse. Diese Konzepte erwiesen sich als zentral für das Völkerrecht und die herrschende Weltordnung und sind heute noch in Kraft.

Bei den Überlegungen für einen ortsspezifischen Vorschlag für die Skulptur Projekte 2017 schienen die Westfälischen Abkommen, wenn man die aktuellen Spannungen zwischen dem Lokalen und dem Globalen, dem Speziellen und dem *Internationalen* oder *Universalen* (das aber immer eingebettet verstanden werden muss) in Betracht zieht, von höchster Relevanz zu sein. Dies ist eine Zeit, in der der moderne Nationalstaat und das Westfälische System sich in einer extremen Krise befinden, da sie angesichts globaler, vernetzter und sich überlappender Strukturen der Politik- und Finanzwelt sowie vertikaler, digitaler Geografien für obsolet erklärt werden. Überstaatliche Finanzunternehmen, globale Märkte, multinationale Kapitalgesellschaften, virtuelle Medienwelten und globale Medienplattformen fordern das traditionellere Verständnis, das vom Regieren über ein horizontales, genau begrenztes Territorium ausgeht, heraus. Dass ein Planet, der seiner Ressourcen beraubt wird, mit dem Klimawandel und der Flüchtlingskrise zu tun hat, verkompliziert die Dinge noch weiter, und es scheint, dass die einzige Antwort ein gewaltsamer Tribalismus ist, der sich im Wiedererstarken neuer Nationalismen, religiöser oder ethnischer Kriege und in einer Rückkehr zu fiktionalen, festgeschriebenen Identitäten sowie im Versprechen nach der *Greatness* des Vergangenen abermals wieder behauptet. Der neue Antikosmopolitismus manifestiert sich auf reichlich paradoxe Weise innerhalb des Internets, das mit seiner globalen, allgegenwärtigen Sozialität Territorien verbindet und in ein globales Dorf verwandelt, während er zur gleichen Zeit fragmentierte Gemeinschaften schafft, die kein Ortsgefühl kennen.

Manuel Castells paraphrasierend, könnte man sagen, dass der Raum der Orte zu einem Raum der Ströme geworden ist. An diesem Wendepunkt scheint der einzige Weg aus diesem reaktionären Prozess eine neue politische Fiktion zu sein: Es geht darum, einen Weg zu finden, miteinander zu verhandeln, diese Ströme zu entflechten und sie dann in einem Nicht-Nullsummenspiel zu arrangieren.

Der Ort, den ich für meine Arbeit vorschlage, ist der Friedenssaal im Historischen Rathaus. Jener Raum, in dem der Münsteraner Teil der Westfälischen Abkommen unterzeichnet wurde. Die Performer_innen, die den Friedenssaal okkupieren, die dort agieren und sich dort bewegen, sollen als Interface verstanden werden, als Verbindung zwischen dem historischen Moment des Westfälischen Friedens und dem gegenwärtigen Moment ihrer Präsenz. Sie funktionieren sowohl als skulpturale Elemente im Raum als auch als Live-Präsenzen, mit denen interagiert werden kann. Die Arbeit soll während der verlängerten

Gerard Terborch, *Westfälischer Friede in Münster*, 1648

Datascape. Quelle / Source: nedimah.eu

Internet der Dinge / Internet of Things; Quelle / Source: forbes.com

Satellitenbild der Erde, das Straßen, Luftverkehr, Städte (nachts) und Internetkabel zeigt / Satellite images of Earth show roads, air traffic, cities at night, and Internet cables; Bild / Image ©: Felix Pharand-Deschenes / SPL / Barcroft Media

Öffnungszeiten des Friedenssaals stattfinden. Sie markiert den Übergang von einem monumentalen Ort der Erinnerung zu einem öffentlichen Ort aktiver Reflexion über den gegenwärtigen Moment. Sie zielt darauf ab, räumliche und zeitliche Distanz zum Kollabieren zu bringen, Spannungen deutlich zu machen, das Ringen um Grenzen und klare Abgrenzungen, darauf, Territorien, Organe, Souveränität, Macht und Identität quer durch die Geschichte zu rekonfigurieren, Bilder und Fiktionen ferner Orte und Zeiten in den sauber abgegrenzten Erinnerungsraum des Friedenssaals sickern zu lassen – in einem Versuch, die Aktion gleichzeitig zu verwurzeln / zu verorten und zu entwurzeln / zu entorten. Auch die Verschränkung des Digitalen mit dem Körperlichen soll erkundet werden, wie auch neue Formen des Regierens, des Protokollierens und Arten der Regulierung der Welt, die mittels der digitalen Plattformen, die wir nutzen und die uns nutzen, entstehen – in einem Prozess ständigen Feedbacks zwischen unseren Körpern und anderen Technologien, mit denen wir interagieren. Online-Identität wird auch außerhalb unserer selbst konstruiert und verbreitet, unabhängig von uns; das kontinuierliche, zwanghafte Bedürfnis, zu verstehen und verstanden zu werden, das ewig durch Missverständnisse behindert wird, von Missachtung, von Vorhersagen trotzenden Verhaltensweisen und von Indiskretionen.

Der anfällige und von Hindernissen geprägte Weg des Menschen durch Raum und Zeit lehrt uns, dass in sich geschlossene, horizontale Territorien und stabile Identitäten Fiktionen sind. Mehr als je zuvor sollten wir uns zum jetzigen Zeitpunkt neue Fiktionen ausdenken und praktizieren, die nicht durch mehr Fragmentation wirken und auf mehr Fragmentation abzielen, sondern in denen es um mehr Zusammenhalt geht, die die Abhängigkeit voneinander verkörpern.

Alexandra Pirici

Anmerkungen

Es ist interessant, dass das Konzept der Infiltration, das eine natürliche Situation beschreibt, zum Beispiel Wasser, das durch ein Material hindurchgeht, es durchdringt, es durchfiltert – „(eine Flüssigkeit, beispielsweise) veranlassen, eine Substanz zu durchdringen, indem es durch ihre Zwischenräume oder Poren läuft" – als von Natur aus negative Situation auf die menschliche Kultur übertragen wird, wie in „Aktivisten hatten die Studentenbewegung infiltriert".

In·fil·trie·ren, tr. V.
1. a. Hinterrücks (zum Beispiel mit Truppen) in feindliches Gebiet eindringen.
 b. Mit feindlicher Absicht eindringen: feindliche Linien infiltrieren; Terroristen, die das Land infiltriert hatten.
2. Positionen einnehmen oder besetzen, schrittweise oder heimlich, zum Zweck der Spionage oder der Übernahme: infiltrierten Schlüsselposten in der Regierung mit Spionen.

„Wenn das lineare Zeitraster aufgelöst wird, ergeben sich andere Möglichkeiten für andere Entwicklungen und Bewegungen."
Randy Martin, Dance and Finance

„Eine Legende der Yurok besagt, dass weit draußen im Pazifik, aber nicht weiter, als ein Kanu hinauspaddeln kann, der Rand des Himmels Wellen erzeugt, indem er auf die Wasseroberfläche schlägt. Bei jedem zwölften Schlag bewegt der Himmel sich ein wenig langsamer, sodass ein geübter Seefahrer genug Zeit hat, um unter dem Rand durchzuschlüpfen, den äußeren Ozean zu erreichen und die ganze Nacht am Ufer einer anderen Welt zu tanzen."
Julie Phillips, The Fantastic Ursula K. Le Guin

Palindrom: ein Wort, eine Wendung, ein Satz oder eine Zahl, die sich vorwärts wie rückwärts gleich liest, griechisch *palindromos* – wieder zurückrennen, von *palin* zurück, wieder + *dramein* rennen, ähnlich wie griechisch *polos axis*, Polachse. Palindrome reichen bis mindestens 79 v. Chr. zurück. Das weiß man, weil in Herculaneum, einer Stadt, die in eben diesem Jahr von Asche begraben wurde, ein Palindrom als Graffito gefunden wurde. Dieses Palindrom, das man Sator-Quadrat nennt, besteht aus einem lateinischen Satz: *Sator Arepo Tenet Opera Rotas* [Der Sämann Arepo hält mit Mühe die Räder].

THE MAIN ROUTES

The Main Routes; Bild / Image: Tian Chi / China Daily

Credits: Jesus Blasco de Avellaneda / Reuters

Screenshot Datascape Videospiel /
Screenshot from Datascape video game

Credits: Associated Press

Leaking Territories

Considering the current global situation, it now seems to be a good time to look at the city of Münster through the lens of one of the most significant historical events of the past couple of centuries: the Peace of Westphalia—the signing in 1648 of a series of peace treaties that ended a sequence of long and devastating European wars. Treaties were signed both in Münster and Osnabrück and established the precedent of peace negotiated by diplomatic congress. Most scholars of international relations credit the treaties with providing a foundation for the modern state system by introducing a new political order, 'the Westphalian model', based on coexisting sovereign states, non-interference in their domestic affairs, territorial sovereignty, and the balance of power, concepts that became central to international law and the prevailing world order, and remain in effect today.

Thinking about a site-specific proposal for Skulptur Projekte Münster in 2017, the Westphalian treaties seemed to be very relevant in relation to current tensions between the local and the global, the particular and the 'international' or the 'universal' (which is, however, always situated), at a moment when the modern nation-state and the Westphalian system are experiencing a full-on crisis, made obsolete by the reality of global, interconnected, and overlapping political and financial structures and vertical, digital geographies. Supra-state financial entities, global markets, multinational corporate entities, virtual mediascapes, and global media platforms challenge more traditional modes of understanding governance over well-delimited, horizontal territory. Ongoing climate change and the crisis of migration on a planet in the process of being depleted of resources complicate matters even further and it seems the only response is violent tribalism reasserted in the resurgence of new nationalisms, religious or ethnic wars, and a return to fictional fixed identities and histories of 'greatness'. In a rather paradoxical manner, the new anti-cosmopolitanism manifests within and is also being amplified by the global, pervasive sociality of the Internet, which connects and turns vast territories into a global village, while at the same time creating fragmented communities with no sense of place.

To paraphrase Manuel Castells, the 'space of places' also became a 'space of flows'. At this turning point, the only way out of this spiralling reactionary process seems to be a new political fiction: finding a way to mutually negotiate, entangle these flows, and arrange them in a non-zero-sum game.

The site of the work I propose is the Friedenssaal in the historical town hall, the room in which the Münster part of the Westphalian treaty was signed. The group of performers that occupy, move, and act in the Friedenssaal is intended as an interface, a connection between the historical moment of the Peace of Westphalia and the contemporary moment of their presence there, functioning both as a sculptural insert in the space and live presences that one can interact with. The work should take place during the Friedensaal's extended opening hours and it marks a transition from a monumental place of remembrance to a public space of active reflection on the present moment. Its aim is to collapse spatial and temporal distance, to bring nearer the moments of tension, struggles to negotiate borders and clear delimitations, to configure and reconfigure territory, agency, sovereignty, power, and identity across history, and to leak memories, images and fictions of remote places and times into the well-delimited space of the Friedensaal, in an attempt to simultaneously ground/localize and uproot/de-localize the action. The entanglement of the digital and the corporeal is also meant to be explored, as new forms of governance, protocols, and ways of regulating the world emerge via the digital plat-

Alexandra Pirici

Proteste auf dem Platz der Unabhängigkeit, Ukraine / Protests in Independence Square in Ukraine; Quelle / Source: Reuters

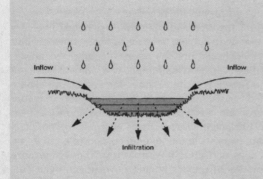

Wasserkreislauf-Diagramm / Diagram for water cycle; Quelle / Source: nibusinessinfo.co.uk

Filmstill / Film still *Storming Spain's Razor-Wire Fence: Europe or Die*; Quelle / Source: video on vice.com

Illustration des Musikstückes / Illustration for music piece *Ma fin est mon commencement* von / by Guillaume de Machaut; Quelle / Source: YouTube

forms we use and that use us, in an ongoing feedback between our bodies and other technologies we interact with. Online identity is also constructed and circulated outside ourselves and independent of ourselves, the ongoing and compulsive need to recognize and be recognized, which is forever thwarted by misunderstandings, misrecognitions, behaviour that escapes predictions, and leaks.

The frail and troubled movement of the human through space and time shows us that enclosed horizontal territories and stable identities are a fiction. At the present moment, more than at any other time, we might need to imagine and practice new fictions that work not through and towards greater fragmentation but through greater cohesion and embodied codependency.

Alexandra Pirici

Some notes

It is interesting that the concept of 'infiltration', which describes a natural situation, like water passing through a material, permeating, filtering through—'to cause (a liquid, for example) to permeate a substance by passing through its interstices or pores'—is transposed into human culture as an inherently negative situation, as in 'activists had infiltrated the student movement'.

in·fil·trate , v.tr.
1. a. To pass (troops, for example) surreptitiously into enemy-held territory.
 b. To penetrate with hostile intent: infiltrate enemy lines; terrorists that had infiltrated the country.
2. To enter or take up positions in gradually or surreptitiously, as for purposes of espionage or takeover: infiltrated key government agencies with spies.

'Breaking up the linear time grid leads to an opening up of different possibilities for different trajectories and movements.'
Randy Martin, Dance and Finance

'One legend of the Yurok people says that, far out in the Pacific Ocean but not farther than a canoe can paddle, the rim of the sky makes waves by beating on the surface of the water. On every twelfth upswing, the sky moves a little more slowly, so that a skilled navigator has enough time to slip beneath its rim, reach the outer ocean, and dance all night on the shore of another world.'
Julie Phillips, 'The Fantastic Ursula K. Le Guin'

Palindrome: a word, phrase, sentence, or number that reads the same backwards or forwards; Greek *palindromos*—running back again, from *palin* back, again + *dramein* to run; akin to Greek *polos* axis, pole. Palindromes date back at least to AD 79, as a palindrome was found as a graffito at Herculaneum, a city buried by ash in that year. This palindrome, called the Sator Square, consists of a sentence written in Latin: 'Sator Arepo Tenet Opera Rotas' (The sower Arepo holds with effort the wheels).

Mika Rottenberg

Mika Rottenbergs (* 1976 Buenos Aires, lebt in New York) Filminstallationen widmen sich der Verführung, Magie und Verzweiflung unserer hyperkapitalistischen, globalisierten Welt: In seltsamen Fabriken, die ausgeklügelten Fertigungslogiken folgen, produzieren Arbeiterinnen Güter. Der surreale Charakter der räumlich strukturierten Filme dient als Folie, vor der komplexe Zusammenhänge zwischen Arbeit, Wirtschaft und Wertzuschreibung verhandelt werden – auch im Hinblick auf die Ökonomisierung affektiver Beziehungen. Rottenberg verwebt dokumentarisches Material mit fiktiven Sequenzen zu einer Allegorie der Lebensbedingungen des Menschen innerhalb globaler Systeme.

Cosmic Generator (working title)

In Münster nutzt die Künstlerin einen ehemaligen Asialaden als Readymade-Setup für ihre Filminstallation. Den motivischen Ausgangspunkt für ihren neuen Film *Cosmic Generator* bildet ein Tunnelsystem, das verschiedene Orte und Akteur_innen via Handel miteinander verknüpft, darunter die mexikanische Stadt Mexicali und ihren durch einen Grenzzaun abgetrennten kalifornischen Teil Calexico. Gerüchten zufolge gelangt man über Läden und Lokale in Mexicali in das System. In ihrer filmischen Montage verknüpft die Künstlerin Aufnahmen vom dortigen Golden Dragon Restaurant mit einem 99 Cent Store in Calexico und dem Yiwu Market in China. Diesem Handelsort für Plastikartikel kommt im imaginären Netzwerk eine zentrale Rolle zu. In seiner artifiziellen Farbenpracht wirkt er selbst wie eine gigantische Inszenierung.

Im Verschleifen von Fakt und Fiktion, sozialen und psychologisch aufgeladenen Räumen knüpft Rottenberg an jüngere Arbeiten an, in die mit einer Kautschukplantage im indischen Kerala, einer Zuchtperlenfabrik im chinesischen Zhuji und leer stehenden Wohnsiedlungen nahe Shanghai zunehmend reale, als Bühnenbild appropierte Arbeitswelten Eingang fanden. Auch in *Cosmic Generator*, dessen Titel auf den Physiker und Elektroingenieur Nikola Tesla (1856–1943) zurückgeht, unter anderem Erfinder des als Zweiphasenwechselstrom bezeichneten Systems zur elektrischen Energieübertragung, verschwimmt die Zuordnung fiktiver und realer Arbeitsverhältnisse, während das im Studio gefilmte Tunnelsystem die geografischen Distanzen kollabieren lässt. Gleichzeitig knüpft er an Rottenbergs Auseinandersetzung mit der Kommodifizierung des Körpers an. Die Müdigkeit einiger Protagonistinnen verweist auf den Schlaf als temporären Rückzug und als eine der letzten, nicht verwertbaren körperlichen Ressourcen. Das installative Setting verstärkt den immersiven Charakter des Films und suggeriert eine Parallelwelt, die sich hinter der Ladenfront öffnet. Verband Martin Kippenberger Münster 1997 über sein imaginäres *Metro-Net* mit der Welt, verleiht Rottenberg der städtischen Infrastruktur eine weitere, im Wortsinn subversive Dimension. A.P.

Material
Asialaden, Video (ca. 20 Min.),
Kunststoffobjekte, Straßenschild

Standort
Gartenstraße 29, 48147 Münster

Mika Rottenberg

Mika Rottenberg's (*1976 Buenos Aires; lives in New York) film installations explore the seduction, magic, and desperation of our hyper-capitalistic, globally connected reality. Female workers produce goods in strange factories that follow elaborate manufacturing rationales. Rottenberg's cinematic works, which have a surrealistic aesthetic and are rigidly structured in a spatial sense, emphasize the interrelation between labour, economics, and the production of value, and how our affective relationships are increasingly monetized. The artist weaves documentary elements with fiction to create complex allegories for the living conditions experienced within our global systems.

Cosmic Generator (working title)

For her film installation in Münster the artist chooses a closed-down shop that used to sell Asian products as a ready-made installation set-up. The thematic starting point for her new work *Cosmic Generator* is a tunnel system that establishes a trading connection between various places and actors, among them the Mexican city of Mexicali and Calexico, the Californian town on the other side of the border fence. Rumour has it that the entrance to the tunnels can be accessed via shops and restaurants in La Chinesca, Mexicali's Chinatown. In her montage Rottenberg links footage from the local Golden Dragon Restaurant with a 99 Cent Store in Calexico and an enormous plastic commodities market in Yiwu, China. The Yiwu Market plays a pivotal role in this imaginary network. With its artificial blaze of colours it seems like a gigantic staged performance in itself.

Material
Asian shop, video (ca. 20 min.), plastic objects, street sign

Location
Gartenstraße 29, 48147 Münster

This mix of fact and fiction, of socially and psychologically charged spaces continues Rottenberg's recent works in which real working environments, like a rubber plantation in Kerala, India, a pearl farm in Zhuji, and empty housing developments near Shanghai, are 'appropriated' and used as stage sets for Rottenberg's film. *Cosmic Generator*—whose title is a reference to the engineer and physicist Nikola Tesla (1856–1943), who, among other things, invented today's two-phase AC—blurs the line between fictional and real working environments, just as the tunnels, shot in the studio, cause geographical distances between places to collapse. The work also touches on Rottenberg's concerns about the commodification of the human body. The weariness shown by some of the female protagonists is also a reference to sleep as a temporary means of withdrawal and as one of the few remaining bodily resources that cannot be exploited. The installation setting intensifies the immersive character of the film and implies a parallel world that opens up behind the shopfront. In 1997 Martin Kippenberger connected Münster with the world via his imaginary *Metro-Net*; Rottenberg, meanwhile, provides the city's infrastructure with another dimension that is literally subversive. A.P.

251 Mika Rottenberg

Mika Rottenberg

Der Tunnel – und seine Schwester, die Mauer

Es ist zu lesen, dass Mika Rottenberg sich zu ihrer hier in Münster ausgestellten Arbeit von dem Gerücht inspirieren ließ, es hätten die Chinesen, die in dem mexikanischen Teil der durch einen Zaun geteilten Grenzstadt Calexico / Mexicali leben, dort über Jahre ein weitläufiges unterirdisches Tunnelsystem angelegt, um so einen freien, von keiner Staatsmacht behelligten Personen- und Warenverkehr zwischen den beiden Stadthälften zu ermöglichen.

Da drängt sich natürlich sofort der Gedanke an die Mauer auf, mit deren Bau Donald Trump jeglichen Verkehr über diese Grenze zu Mexiko unter US-amerikanische Kontrolle bringen will. Und in dem Maße, wie sich da nun im Kopf alle möglichen mit den Worten *Tunnel* und *Mauer* verbundenen Vorstellungen und historische Reminiszenzen einstellen, tut sich unversehens ein verwirrender Verdacht auf: Könnten diese Institutionen *Tunnel* und *Mauer* womöglich gar nicht so verschieden sein wie sie es in bautechnischer und funktionaler Hinsicht sind … stehen sie einander nicht irgendwie doch sehr nah … irgendwie so wie zwei einander feindliche Geschwister?

Dass es bei diesen beiden, mal unterirdischen, mal oberirdischen Werken auf eine verdrehte Weise um ein und dasselbe geht, und sie dabei bezeugen, von welch widersprüchlicher Realität dieses ihnen Gemeinsame nicht allein in der Erfahrung der Menschen ist, sondern auch in ihrem Handeln, das soll im Folgenden aufgezeigt werden.

Was soll das denn sein, worum es – egal ob da ein Tunnel gegraben oder eine Mauer errichtet wird – gleichermaßen geht? Da geht es allemal um *Nähe*, – mal um den Wunsch danach, mal um die Angst davor. So steht der Tunnel dafür, dass und wie Menschen *Nähe* dort herzustellen trachten, wo die Welt ihrem Wunsch danach geografisch im Weg steht beziehungsweise sich ihm politisch in den Weg stellt (etwa die alpinen Tunnel oder die Flucht-Tunnel nach dem Berliner Mauerbau). Während die Mauer wiederum dafür steht, dass und wie der Mensch *Nähe* da abwehrt, wo er seine Welt von ihren möglichen Folgen existenziell bedroht beziehungsweise politisch gefährdet sieht (etwa die Deich-Mauern zur Sicherung einer Küste oder die Chinesische, die Berliner Mauer).

Soviel zu der menschlichen Not mit der Nähe, wie sie in Tunneln und Mauern Gestalt annimmt.

Es gibt allerdings diese Tunnel und Mauern – genauso wie auch die von ihnen bezeugte menschliche Not mit der Nähe – nicht nur in der physischen Welt. Die Leser_innen wenden sich doch bitte nur mal ihrer Innenwelt zu: Beweist sich hier nicht das Unbewusste unermüdlich in seinem tunnel-wühlerischen Elan, mit dem es sich an Ich-ferne Trieb-Ziele heranarbeitet … und zielt es nicht allemal auf das Unterminieren sittlicher Grenzen ab, um jenseits davon Erfüllung zu finden … genauso wie das Über-Ich sich da ständig im Diskriminieren übt, in diesem vernünftigen Unterscheiden und Selektieren dessen, worauf das Wünschen so fahrlässig total aus ist … und errichtet es nicht Mauern gegen alles, was mit seiner libidinösen Vehemenz das Ich überschwemmen würde?

Freud hat ja gern jenes Resümee zitiert, das Theodor Fontane aus den Erfahrungen seines Lebens zog: „Es geht nicht ohne ‚Hilfskonstruktionen'. Und als solche kann man wohl alle Tunnel und Mauern, egal ob die in der psychischen oder die in der materiellen Welt, verstehen. Aber ist mit der vernünftigen Einsicht, dass es ohne sie nicht geht, nicht schon genauso viel Unheil im Leben legitimiert worden wie der Wahn, es ginge im Leben ohne sie, darin angerichtet hat?!

Diesen Wahn mag man in seinen Folgen für die Welt beklagen … wie viel aber die Kunst der Idée fixe *Alles hänge mit Allem zusammen und verkehre frei miteinander* verdankt, ist nicht erst seit jenem den Surrealisten so teuren „zufälligen Zusammentreffen einer Nähmaschine mit einem Regenschirm auf einem Seziertisch" (Lautréamont) offenkundig. Lebt also der Aberwitz, wie ihn Rottenbergs globalisierungsbezogene Arbeiten in den von ihnen zusammengebrachten disparaten Lebens- und Arbeitsformen aufzeigen, nicht genauso von dieser Idée fixe wie ihre ästhetische Praxis? Mal wieder die Dialektik der Aufklärung.

Friedrich Wolfram Heubach

The Tunnel—and Its Sister, the Wall

One can read that Mika Rottenberg drew inspiration for the work that is on display here in Münster from the rumour about an extensive subterranean tunnel system that the Chinese living in the Mexican part of the border city of Calexico / Mexicali have set up over the years in order to facilitate the free flow of people and goods between the two halves of the city, circumventing the fence that divides it and evading interference from any state power.

Of course, this immediately brings to mind the wall that Donald Trump plans to build as a means to bring all the traffic across the Mexican border under US control. And to the extent that all the possible ideas and historical memories associated with the words *tunnel* and *wall* are now evoked, an unsettling suspicion raises its head unexpectedly: Is it possible that tunnels and walls are, in fact, not as different as they are from a constructional and functional perspective … are they not very close to each other after all … rather like two rival siblings?

The fact that these two constructions—one above and one below ground—are, in a skewed sense, focused on one and the same thing, and thus attest to the contradictory reality of what they share, not just in terms of human experience but also in their actions, will be illustrated in the following.

What might it be that is at stake—regardless of whether a tunnel is dug or a wall constructed? It certainly relates to *proximity*— on the one hand, the desire for proximity and, on the other, the fear of it. Thus the tunnel stands for the fact that, and the means by which, humans strive to generate proximity in places where the world stands in the way of this geographically, or bars it politically (for instance, the tunnels through the Alps or the escape tunnels dug after the construction of the Berlin Wall). While the wall, in turn, stands for the fact that, and the means by which, humans want to fend off proximity, where its potential consequences seems to represent an existential threat or political danger to their world (for instance, the walls of the dykes protecting a coastline, the Great Wall of China, or the Berlin Wall).

So much for the human need for proximity, as it manifests in tunnels and walls.

However, these tunnels and walls—just like the human need for proximity they attest to—do not only exist in the physical world. Readers should merely turn their attention to their interior world: Does not the subconscious show itself here, untiring in the rodent-like zest for tunnelling it exhibits as it works its way towards goals set not by the ego but by instinct? Does it not always aim to undermine ethical boundaries in order to find fulfilment beyond them—just as the superego constantly exercises discrimination in the process of making rational distinctions and selections of the things that one's wishes are so recklessly bent on—and does it not erect walls against everything that would overwhelm the ego with the libido's intensity?

Freund was fond of quoting the conclusion that Theodor Fontane drew from all that he had experienced in his life: 'We cannot do without auxiliary constructions.' And all the tunnels and walls can be understood as such, regardless of whether they manifest in the psychological or material world. But does not the rational sense that they cannot be dispensed with legitimize just as much calamity in life as that caused by the delusion that life would work without them?!

This delusion can be deplored in all the consequences it has for the world … it is not just since the 'chance meeting on a dissecting table of a sewing-machine and an umbrella' (Lautréamont), so treasured by the Surrealists, that it has been evident how much art owes to the idée fixe that *everything is connected and interacts freely with everything else*. So is not absurdity, as illustrated in Rottenberg's globalization-related work in the various forms of life and work it brings together, just as dependent on this idée fixe as her aesthetic practice is? Once again, the dialectic of Enlightenment.

Friedrich Wolfram Heubach

Mika Rottenberg

Mika Rottenberg

Mika Rottenberg

Xavier Le Roy mit Scarlet Yu

Das Spektrum von Xavier Le Roys (* 1963) künstlerischer Praxis reicht von Soloarbeiten bis zur Zusammenarbeit mit anderen Künstler_innen. Sein Projekt für Münster entwickelte er gemeinsam mit der Künstlerin Scarlet Yu (* 1978 Hong Kong, lebt in Berlin, Hong Kong und Paris).

Still Untitled

In ihrer Arbeit *Still Untitled* befragen sie Skulptur als eine statische und möglicherweise ortspezifische Einheit. Von den sogenannten lebenden oder darstellenden Künsten kommend, begreifen Le Roy und Yu Skulptur als eine spezifische zeitliche und räumliche Komposition, die Menschen miteinbezieht und sich über die Laufzeit der Ausstellung weiterentwickelt. Das Werk setzt sich aus einer Abfolge verschiedener Vorgänge zusammen, die sowohl Bewegungssequenzen als auch dialogische Situationen enthalten. In regelmäßigen Workshops, die ein von Le Roy und Yu angewiesenes Team leitet, hat jeder und jede die Möglichkeit, im Rahmen von *Still Untitled* seiner oder ihrer persönlichen Vorstellung von Skulptur entsprechende, eigene Formen zu suchen und zu komponieren. Künftig können die Teilnehmer_innen zu jeder Zeit, an jedem beliebigen Ort und so oft sie möchten ihre Skulpturen verkörpern und damit den Werkprozess fortschreiben. Die Skulpturen bergen das Potenzial, sich viral, wie ein Gerücht zu verbreiten.

Entgegen der Synchronisierung und Homogenisierung von Zeit, die unseren Alltag und das Weltgeschehen gleichermaßen bestimmen, gibt die Arbeit von Le Roy und Yu weder eine feste Aufführungszeit oder –dauer noch einen bestimmten Ort vor. Indem sie unvorhergesehen Zeit in Anspruch nimmt und durch die Art und Weise, wie sie das tut, sensibilisiert diese Arbeit das Bewusstsein für Zeit im Sinne einer Präsenz. Zeit wird als eigenständige Wirklichkeit jenseits der realen Weltzeit wahrnehmbar. In *Still Untitled* koexistieren die subjektiven Zeiten der Teilnehmer_innen und Betrachter_innen und die global gültige Zeit, die unser Leben taktet und Abläufe oder Verfügbarkeiten diktiert. *Still Untitled* stellt neben den verschiedenen Zeitstrukturen auch die vermeintlich eindeutige Unterscheidung in Betrachter_in und Kunstwerk zur Diskussion. Für Le Roy und Yu ist der Mensch immer eine Komposition aus Subjekt und Objekt — womit sie auch andere Dichotomien wie Arbeit und Freizeit oder öffentlich und privat befragen. Mit *Still Untitled* überwinden Le Roy und Yu diese Unterscheidungen auf subtile Art und unterbrechen alltägliche Abläufe in der Stadt. C.N.

[Noch / Standbild unbetitelt]

Entwickelt mit Scarlet Yu, in Zusammenarbeit mit Alexandre Achour, Susanne Griem, Zeina Hanna, Sabine Huzikiewiz, Laura Mareen Lagemann, Alexander Rütten, Imin Tsao mit Unterstützung von Le Kwatt

Standort
Zu jeder Zeit, an jedem Ort

Dank an alle, die *Still Untitled* verkörpert haben und verkörpern werden.

Xavier Le Roy with Scarlet Yu

The spectrum of Xavier Le Roy's (*1963) artistic endeavours ranges from solo performances to joint projects with other artists. In Münster, for example, he has developed a project in cooperation with the artist Scarlet Yu (*1978 Hong Kong; lives in Berlin, Hong Kong, and Paris).

Still Untitled

In their work *Still Untitled*, Le Roy and Yu explore sculpture as a static entity, conceived as a site-specific piece for Skulptur Projekte Münster. Through their involvement in the so-called living or performing arts, they approach sculpture as specific compositions of time and space involving human beings, developing the work during the course of the exhibition. This project consists of an arrangement of various procedures that include both movement sequences and situations in dialogue form. Everyone is welcome to participate in a series of workshops—run by a team of artists collaborating with Le Roy and Yu—to find their own sculptural forms and compose them in relation to a personal concept of sculpture within the context of the work *Still Untitled*. In the future, the participants will be able to present their embodied sculptures at any time and place, and as few or as many times as they wish, thus continuing the artistic process. The sculptures have the potential to go viral like a rumour.

Running counter to the process of synchronizing and homogenizing time, Le Roy and Yu's work cannot announce when the presentations will begin and how long they will last, nor can it be disclosed where they will take place. They sensitize the viewers' sense of time in terms of an awareness that penetrates the present and the past alternately. Time is perceived as an independent reality beyond real universal time. In this way, *Still Untitled* establishes several coexisting levels: on the one hand, the participants' and viewers' subjective sense of time and, on the other, the globally valid time that keeps our lives in sync and dictates processes and availability. *Still Untitled* raises questions about various temporal structures as well as the supposedly clear distinction between the viewer and the work of art. In their opinion, human beings are always composed of both subject and object—although they also deal with other dichotomies such as work and leisure or public and private. *Still Untitled* subtly transcends these distinctions, therefore interrupting everyday urban routines. C.N.

Developed with Scarlet Yu in collaboration with Alexandre Achour, Susanne Griem, Zeina Hanna, Sabine Huzikiewiz, Laura Mareen Lagemann, Alexander Rütten, and Imin Tsao with the support of Le Kwatt

Location
Anytime, anywhere

Thanks to all the people who have and will embody *Still Untitled*.

Dorothea von Hantelmann

Lass uns mit *low pieces* beginnen, einem Projekt, an dem Du zwischen 2009 und 2011 gearbeitet hast. Wir sehen eine Gruppe von Performer_innen, die sich durch Momente bewegt, die man als Darstellungen von Tieren, Maschinen oder Pflanzen wahrnehmen kann. Sie stehen niemals auf, gehen niemals, repräsentieren in keinem Moment die menschliche Figur. Dieses Konzept, eine Dekonstruktion des menschlichen Körpers durch das Nicht-Menschliche anzugehen, zieht sich als Thema und Methode durch Dein Werk. Hier arbeitest Du jedoch mit einer Gruppe von Darsteller_innen und, in diesem Stück auch ganz explizit, mit der Gruppe der Besucher_innen. Wie näherst Du Dich der Idee des *Sozialen* über diese Ansammlung von Nicht-Menschlichem?

Lass uns über die Ausstellungsversion von *low pieces* sprechen. Wie kam es zu dieser Verlagerung in den Ausstellungskontext?

Was interessiert Dich daran, im Ausstellungskontext zu arbeiten?

Was für eine Situation und was für eine Beziehung zu Besucher_innen oder dem Publikum stellen diese Formate her; wie würdest Du ihre Eigenheiten beschreiben?

Xavier Le Roy

Mein Antrieb, nach Wegen zu forschen, wie das Menschliche in etwas Nicht-Menschliches verwandelt werden kann, ist von der Notwendigkeit geleitet, den Prozessen der Identifikation, die die Menschen sich gerne aufbürden, zu entfliehen. Als wir an *low pieces* arbeiteten, ging es uns darum, wie man Bewegungen und Klänge von verschiedenen Maschinen und Tieren — und später von Dingen aus der pflanzlichen oder der mineralischen Welt — verkörpern könnte. Die Verkörperung dieser *nicht-menschlichen* Aktionen beeinflusst auch, wie wir uns sehen oder anschauen, wie wir anderen zuhören oder nicht zuhören können, und für die Darsteller_innen ziehen sie verschiedene Arten von Tätigkeiten nach sich. Die Leute, die diese Handlungen darstellen, bilden also bestimmte soziale Gruppen, die Resultate der Beziehungen sind, die von den jeweils spezifischen Verkörperungen kommen. Da Du nach der Interaktion mit den Zuschauer_innen fragtest — da wollten wir die Möglichkeiten des Theaters (im Gegensatz zu beispielsweise einer Filmvorführung) nutzen, ins Gespräch mit dem Publikum zu treten. Wir beschlossen also, dies am Anfang der Performance (im Licht) und am Ende (im Dunkeln) zu tun.

Das war ein Auftrag für das John Kaldor Public Art Project in Sydney. Es ging nicht darum, die Ausstellungsversion von *low pieces* zu produzieren, sondern eher darum, die Arbeit um den Begriff von Landschaft als Kompositionsverfahren zu erweitern. Ich hatte das in *low pieces* schon ansatzweise eingesetzt. Ich schlug vor, das Material dieses Stücks zu benutzen und eine sich ständig verwandelnde Landschaft zu formen, statt einer Reihe von Landschaften, von Blackouts unterbrochen. Es ging darum, etwas zu schaffen, was sich die ganze Zeit unmerklich verwandelt. Die Arbeit ist ein Ausstellungsstück, das sich entfaltet, während die Besucher_innen kommen, gehen und bleiben wie es ihnen beliebt, während die Darsteller_innen Gruppen bilden und wieder auflösen, die eine Landschaft in ständiger Verwandlung komponieren.

Mir wurde klar, dass ich im Theater zunehmend an Situationen arbeitete, deren Regeln ich benutzen und verändern konnte. Das wurde mir durch Tino Sehgal klar. Unsere intensiven und andauernden Diskussionen seit dem Projekt *E.X.T.E.N.S.I.O.N.S.* (1999) — zusammen mit seiner Arbeit, die ich seitdem aufmerksam verfolge, sowie Deinen Texten — haben mein Interesse daran, Arbeiten *in einer* oder *als eine* Ausstellung zu machen, bestärkt. Tino hat eine Arbeitspraxis im Ausstellungsformat etabliert, die die kontinuierliche Anwesenheit von Menschen, die für die gesamte Dauer der Ausstellung während der Öffnungszeiten die Arbeit herstellen, erfordert. Daraus ergeben sich neue Weisen, das Ausstellungsformat zu rekonfigurieren, die sehr produktiv sind. Es ist etwas radikal anderes, als einfach eine Performance in einem Museum zu machen. Die Einladung von Laurence Rassel, ein Stück für das ganze Gebäude der Fundació Antoni Tàpies in Barcelona zu komponieren — *Retrospective* —, übertraf meine Erwartungen an die Möglichkeiten dieses Formats.

In einem Theater müssen die Zuschauer_innen ihre Zeit miteinander und mit der Dauer der Arbeit synchronisieren. In einer Ausstellung haben die Besucher_innen eine unterschiedlich lange Beziehung zu dem Werk, und ihre Erlebnisdauer ist nicht an die Dauer der Arbeit geknüpft. Im Theater bleibt die Distanz zwischen dem Geschehen auf der Bühne und dem Publikum gleich. In einem Ausstellungsraum dagegen können die Darsteller_innen sich manchen Besucher_innen nähern oder sich weiter von ihnen entfernen. Ich versuche, Arbeiten zu machen, in denen sowohl die Künstler_innen als auch die Besucher_innen die Möglichkeit haben, über Nähe und Entfernung zu bestimmen. Und ich bemühe mich, Beziehungen zu produzieren, die variieren und nicht alle von vornherein festgelegt sind. Auch ermöglicht der individualisierte Aufbau der Ausstellung verschiedene Abstufungen von Ansprache und von Anonymität. Ein Werk, beziehungsweise seine Darsteller_innen, sprechen im Theater das Publikum normalerweise als anonyme Einheit an. In einer Ausstellung können die Darsteller_innen einer Arbeit die Besucher_innen auf ganz verschiedene Weisen und mit ganz verschiedenen Formen des Austausches adressieren — anonym oder persönlich, individuell oder in kleinen Gruppen. Darüber hinaus kann es zwischen diesen Modi Übergänge geben. Das bedeutet eine Pluralisierung der Möglichkeiten, Konnektivitäten und Bindungsformen herzustellen. Für mich ist es eine Art zusammen zu sein, die durch Überlagerungen oder Koexistenzen von Spezifika sowohl des Theaters als auch der Ausstellung entsteht.

Historisch gesehen ist allen bedeutenden kulturellen Ritualen oder ritualisierten Formen des Zusammenkommens (wie Theater oder Kathedrale) eine strukturelle Gemeinsamkeit eigen: der Eine, der zu den Vielen spricht – „ein Sender, viele Empfänger", wie Michel Serres es nennt. Das Ausstellungsformat funktioniert mit einer anderen Modalität. Hier kommunizieren die Vielen mit den Vielen – vermittelt durch materielle Objekte. Dabei entsteht eine im Vergleich zum Theater sehr viel individualisiertere, flexibilisiertere und in diesem Sinn liberalisiertere Form des Zusammenkommens. Viele Künstler_innen aus dem Bereich der bildenden Kunst verstehen das Theater heute als eine Art Werkzeugkasten: Es stellt Mittel oder Techniken bereit, um Aufmerksamkeit und Verbindung herzustellen, einen gemeinsam geteilten Fokus und eine kollektiv geteilte Erfahrung (alles Dinge, die heutige liberalisierte Gesellschaften schwer herstellen können). Uns geht es aber nicht um die Wiederherstellung eines vermeintlich verlorenen sozialen Bandes, sondern eher darum, neue Arten der Einbindung zu generieren, die für unsere Zeit adäquat oder relevant erscheinen. Ich finde Euer Projekt für Münster aus dieser Perspektive interessant, weil es mit Formen der Verbindung und Gemeinsamkeit operiert, die sich außerhalb beider Traditionen, des Theaters und der Ausstellung, situieren.

Die spezifischen Formen der Konnektivität, wie Du es nennst, ergeben sich aus der besonderen Situation, die die Skulptur Projekte Münster ermöglichen und festlegen. Die Arbeit *Still Untitled* resultiert aus der Einladung, etwas zu machen, bei dem menschliche Handlungen für andere aufgeführt werden. Diese Anfrage war verbunden mit der dringenden Bitte des Kurator_innen-Teams zu vermeiden, den Skulptur Projekten Münster einen Festivalcharakter zu verleihen – also einer Reihe von Veranstaltungen, die in einer bestimmten zeitlichen Abfolge angesetzt sind; im Gegensatz zu Arbeiten, die jederzeit während der gesamten Ausstellung erlebt werden können. Wir folgen dieser Vorgabe und versuchen, Skulpturen *in* der Stadt zu machen; Live-Performances, von Menschen präsentiert, rund um die Uhr hundert Tage lang, für Münsteraner_innen und Besucher_innen, die extra dafür kommen. Die andere Einschränkung war, dass das Budget nicht ausreichend sein würde, um den Darsteller_innen, die hundert Tage lang nonstop performt und die Arbeit sichtbar gemacht hätten, Honorar zu zahlen. Aufgrund dieser Gegebenheiten und aufgrund von Überlegungen zur Zeit wird *Still Untitled* die Form von Skulpturen annehmen, die von menschlichen Lebewesen verkörpert und anderen menschlichen Lebewesen präsentiert werden. Jede einzelne Skulptur wird in Workshops entwickelt werden, mit Menschen, die bereit sind, ihre Skulptur unseren Anforderungen gemäß zu entwickeln. Alle sind dann frei, ihre *Skulptur* der Person und zu der Zeit und an dem Ort ihrer Wahl zu präsentieren (oder nicht zu präsentieren). Diese Skulpturen werden zu etwas, das man miteinander teilt oder an andere weitergibt. Sie sind wie Begegnungen, und sie geschehen, wenn Besucher_innen auf eine dieser Skulpturen treffen oder wenn jemand, der eine Skulptur verkörpert, auf jemanden trifft, dem er sie zeigen will. Die Skulpturen werden sich während der drei Monate der Ausstellung vervielfachen. Viele werden nicht wahrnehmbar sein, viele können sich ausbreiten, wie ein Gerücht, wie ein Virus wachsen und zu jeder Zeit erscheinen – überall oder möglicherweise gleichzeitig an vielen Orten und zu vielen Zeiten. Die Arbeit wendet sich gegen den Imperativ der Synchronisation, der normalerweise Bedingung einer Performance ist, gerade bei Veranstaltungen, die eine sehr große Öffentlichkeit anziehen.

Deine Arbeit in Münster existiert gewissermaßen viral, setzt dabei aber auch das physische Aufeinandertreffen und die Verkörperung durch Menschen voraus.

In solchen Begriffen haben wir nicht gedacht, aber weil Verkörperung zu der Arbeit gehört, denke ich eher nicht, dass die Arbeit sofort verfügbar sein wird, wie auf Internetplattformen. Ein physischer Kontakt muss hergestellt werden. Es braucht die Konstruktion eines Moments, um Zeit zu teilen. Eine Person, die ihre/seine Skulptur anbietet – und damit auch eine Art, Zeit miteinander zu teilen –, unterbricht die Zeit einer anderen Person. Es liegt in der Entscheidung der einen Person, dies zu tun, sowie einer anderen, dies zu empfangen: Es handelt sich um eine Unterbrechung ihrer Zeit. Wenn wir die Beziehung zu anderen ändern wollen und die Art und Weise, wie wir Dinge gemeinsam und nicht ausschließlich als Einzelne/r erleben können, dann scheint es mir das Wichtigste, an der Zeit zu arbeiten und sie zu hinterfragen. Dieser Moment, wenn man das Gefühl hat, sich Zeit genommen zu haben, statt sie zu verbringen oder produktiv zu nutzen, ist interessant. Das ist nicht selbstverständlich. Vielleicht wie das Gefühl, das man hat, wenn man etwas anderes getan hat, als das, was die Zeit von einem verlangt hat. Ich versuche, Situationen herzustellen, in denen man ein anderes Gefühl für Zeit bekommen kann oder in denen verschiedene Zeiten gleichzeitig bestehen. Das Format der Ausstellung ermöglicht mir das.

Wie schwierig war es, für ein Projekt wie dieses ein eher unsichtbares Stück umzusetzen?

Mit am schwersten war es, die Vorstellung von der Arbeit als Performance zu überwinden, da weder ein bestimmter Zeitpunkt noch Ort zum Erleben der Arbeit kommuniziert werden kann. Wir bestehen darauf, *Still Untitled* als Skulpturen zu präsentieren, als etwas, das der Zeit und dem Raum als extrem veränderliche Materialien eine Form gibt und ihre nicht greifbaren Qualitäten in die Arbeit integriert. Wir müssen auch dem Wunsch widerstehen, die Arbeit als eine soziale performative Praxis zu beschreiben. Darum geht es in der Arbeit nicht, und sie will auch mehr als Kunstproduktion funktionieren denn als soziale Praxis. Auch war es schwierig, dem Team die Idee zu vermitteln, es dazu zu bringen, zu akzeptieren, dass wir die Leute nicht bitten, die Skulpturen, die sie mit uns entwickelt haben, zu zeigen. Es ist schwierig, das Kurator_innen-Team dazu zu bringen, zu begreifen und zu akzeptieren, dass die Arbeit für den Großteil des Publikums nicht wahrnehmbar sein könnte, da es jeder Person überlassen bleibt, sie zu zeigen. Da die Kurator_innen aber auch an einem unserer Workshops teilgenommen haben, können sie ihre Skulpturen so oft zeigen, wie sie sie sichtbar machen wollen. Eine Arbeit, die nicht auf den Ausstellungsplan

Xavier Le Roy / Scarlet Yu

gesetzt werden kann und der man keine Zeit, zu der sie geschieht, zuordnen kann, kann als Kritik verstanden werden. Aber es ist eine produktive Kritik, da wir diese Arbeit niemals hätten entwickeln und produzieren können, wenn wir nicht dazu eingeladen worden wären.

Dorothea von Hantelmann

Xavier Le Roy

Let's start with *low pieces*, a project you worked on between 2009 and 2011. We see a group of people that move through moments that are perceived as images of animals, machines, or plants. They never stand up, never walk, never represent the human figure. This idea of approaching a deconstruction of the human body through the non-human is an ongoing theme and method in your work. Here, however, you work with a group of performers, and, in this piece quite explicitly, also with a group of visitors, the audience. How do you approach the social through a gathering of non-humans, of stones, animals, or plants?

My motivation to look for ways of transforming the human into something non-human is guided by the necessity to escape the processes of identification that humans tend to throw back and forth at each other. When we worked on *low pieces*, we were looking for ways to embody movements and sounds from diverse machines and animals and later on from things that come from the vegetable or mineral worlds. The embodiment of each of these 'non-human' actions also conditions how we can see or look at each other, how we can or cannot listen to others, and they produce different kinds of agency for the performers. So the people performing these actions form certain 'social groups' resulting from the set of relations produced by each specific embodiment. As for the interaction with the audience that you asked about, we wanted to use the possibility that the theatre offers (unlike, for example, a movie screening) to have a conversation with the public. So we decided to do that at the beginning (in the light) and the end (in darkness) of the performance.

Let's talk about the exhibition version of *low pieces*. How did this shift to the exhibition context take place?

It took place in Sydney, as a commission of the John Kaldor Public Art Project. The idea wasn't to do 'the exhibition version of *low pieces*' but rather to extend the work with the notion of landscape as a mode of composition that I had started to use in *low pieces*. I proposed using the materials of that piece and making one landscape that continuously transforms instead of a series of landscapes interrupted by blackouts. The aim was to do something that transforms continuously in an imperceptible way. The work is an exhibition piece that unfolds as the visitors come, go, and stay at will, while performers form and unform assemblies that compose a landscape in perpetual transformation.

What prompted your interest in working with exhibitions?

I realized that increasingly I was working in the theatre in order to produce a situation by using and transforming its rules. Tino Sehgal made me understand this, and our intense and continuous discussions following the project E.X.T.E.N.S.I.O.N.S in 1999—in conjunction with his work, which I have followed closely since then, and your writings—have informed my interest in doing work in or as an exhibition. Tino has established a practice of working in the exhibition format that involves the continuous presence of people doing the work for the entire duration of the exhibition and its opening hours. This opened up ways of reconfiguring the format of the exhibition that are great to use and can produce many things. It is something radically different from simply doing a performance in the museum. The invitation by Laurence Rassel to do a piece for the whole building of the Fundació Antoni Tàpies in Barcelona, which became *Retrospective*, exceeded my expectations in terms of the potentials this format could offer.

How would you describe the specificities of each format in terms of the situation it creates and its relation to a visitor or an audience?

In a theatre the spectators have to synchronize their time with each other and with the duration of the work. In an exhibition, the relation to the work has a different duration for each visitor, and the time of their experience is not determined by the duration of the work. In the theatre, the distance between what happens on stage and the public stays the same, while in an exhibition space the performers can move closer or further away and back and forth between visitors, and vice versa. I try to do works where both the artists and the visitors have the agency to decide about proximity and distance, and I seek to produce sets of relations that vary and are not all predetermined. Also, the individualized set-up of the exhibition makes it possible to produce diverse degrees of address and anonymity. A work and performers in the theatre usually address the public as an anonymous entity. In an exhibition, a work and the performers can address the visitor in multiple ways and forms of exchange, which can be anonymous or personal, individual or in small groups. Moreover, there can be transitions in between these modalities. This is a plurality of connectivities and sociabilities. I see it as a way of being together produced by the superposition or coexistence of the social specificities of both the theatre and the exhibition.

Historically, all the significant cultural rituals or ritualized forms of gathering (such as the theatre or cathedral) were structured in the form of the one that speaks to the many: 'one sender, many receivers', as Michel Serres puts it. The exhibition format operates with a different modality, which does not involve the one speaking to the many but the many communicating with each other, transmitted and mediatized through material objects. This is a much more individualized, flexibilized, and in that sense liberalized form of gathering. Today, for many artists the theatre is something like a toolbox: it provides the means to solve some problems of liberalized contemporary societies by creating connectivity and focus. But we're not interested in rebuilding some presumably lost social bond but rather in creating new modes of connectivity that seem adequate or relevant to our time. In this regard, I think your Münster project is interesting, because it operates with forms of sociability and connectivity that are outside of both traditions, the theatre and the exhibition.

The specific 'connectivity', as you call it, results from the particular situation that Skulptur Projekte Münster offers and determines. The work *Still Untitled* has been developed to answer the invitation to make something with human actions performed for others. This request came together with a strong wish from the curatorial team to avoid transforming Skulptur Projekte Münster into a festival—meaning a series of events programmed one after the other at certain times, instead of works that can be experienced at any time during the whole exhibition. Following these instructions, we try to make 'sculpture(s), in the city of Münster, with live actions, presented by human beings, accessible round the clock for 100 days for the citizens of Münster and visitors coming specially for the occasion'. The other condition was a budget that would not be sufficient to pay the fee of performers who could have performed and make the work visible 24/7 for 100 days. Based on these conditions and on reflections about time, *Still Untitled* will take the form of sculptures that are embodied by human beings and presented to other human beings. Each individual sculpture will be developed during workshops with people who wish to make her/his sculpture according to our specifications. Each one is then free to present (or not present) their 'sculptures' at the time and in the space of their choice. These sculptures become something to share or to pass on to others. They are like encounters and occur when the visitor meets one of these sculptures or when one of the 'carriers' of these sculptures comes across someone they want to address. They will multiply and appear at any time, in any space, or eventually simultaneously at a multitude of spaces and times during the three months of the exhibition. Many may remain imperceptible, or they may spread and grow like a virus or develop into a rumour. The work wants to stay disconnected from the imperative of synchronization that a performance usually requires, specifically in events attracting a very large public.

Your work in Münster has a 'viral existence', so to speak, but also needs the physical encounter and embodiment of people.

We didn't think about it in these terms, but this requirement for embodiment makes me think that the work isn't readily available as it would be on Internet platforms. A physical connection needs to be produced. It requires the construction of a moment in order to share this time that is created through the interruption of the time of one person by another, who offers her/his sculpture as a way to share time. It depends on the decision of one person to do it and of another to receive it. It's an interruption of their time. If we want to change something in the relation to the other and how we can do things together, and not exclusively individually, I think questioning and working on time is the most important thing. I'm interested in this moment when you get the sense that you have made time rather then spent it or made it productive. It's not given. It's something different from consuming time or being consumed by it. Maybe a feeling you get when you have done something different from what the time wanted you to do. I try to produce situations where you can get a different sense of time or where different times coexist. The exhibition format allows me to do this.

How difficult was it to realize a rather invisible piece at a project like this?

One of the main difficulties was to get past the idea that the work should not be communicated as a performance, because there isn't any time and space that can be communicated to the public to experience the work. We insist on presenting *Still Untitled* as sculptures, something that gives form to time and space as extremely variable materials and extends their ungraspable qualities to the work. We also need to resist the desire to describe the work as a 'social performative practice'. The work isn't motivated by that and wants to work in relation to art production rather than as a social practice. It was also difficult to convey and get the team to accept the idea that we would not ask people to present the sculptures they have developed with us. It's difficult to make the curatorial team understand and accept that the work might stay imperceptible for most of the public as it depends on the desire of each person to present it or not. But as they also participated in one of our workshops, they can show their sculpture as many times as they wish to make it visible. A work that can't be put on the map of the exhibition and to which you can't assign a time when it happens can be seen as a critique, but it is a productive one as we would never have been able to develop and produce this work if we hadn't been invited to do so.

Xavier Le Roy / Scarlet Yu

Sany (Samuel Nyholm)

Samuel Nyholm (*1973 Lund, lebt in Stockholm und Bremen), der seine figurativen Zeichnungen unter dem Akronym Sany publiziert, arbeitet als Grafiker und Künstler. Häufig nehmen seine in wenigen Linien hingeworfenen Zeichnungen in Bildsprache und Motivwahl Anleihen bei dänischen Bier-Cartoons der 1960er und 1970er Jahre. Unter Bezug auf ein populärkulturelles, von Vorurteilen und stereotypen Simplifizierungen durchsetztes Genre des Slapstick-Humors variieren sie motivische Situationen, die von einer Handvoll fiktiver, immer wieder auftauchender Charaktere bevölkert werden. Ein Fokus der Cartoons, in denen gelegentlich auch der ferne Strich von Saul Steinberg nachhallt, liegt auf dem arbiträren Charakter von Sprach- und Zeichensystemen. Mit Humor entwerfen sie häufig im Kunstbetrieb angesiedelte Szenerien, die Missverständnisse und Fehlinterpretationen in den Blick nehmen und dabei auf jenen Raum, der sich zwischen einem Zeichen und seiner Bedeutung auftut, verweisen.

Marginal Frieze

Auch in Sanys Arbeit *Marginal Frieze* für die Skulptur Projekte verschränken sich zwei Bereiche. Zum einen ist er mit einer mehrteiligen Wandarbeit im Stadtraum vertreten, zum anderen in der begleitenden Kommunikation der Ausstellung präsent: Seine Motive zirkulieren als Filmtrailer, auf Bannern, Tragebeuteln, Flyern und Aufklebern als kleinteilige, unterschwellige Medien mit großer Reichweite im öffentlichen Raum. In Münster und Marl installiert Sany mit *Fallande ting* an mehreren Hauswänden großformatige Pyrographien, die einzelne, fallende Figuren zeigen. Er greift dabei auf bekanntes Personal seines Bildkosmos zurück: Mit Estrid, der Valkyrie, und Yggdrasil, dem Weltenbaum, interpretiert er zwei der nordischen Mythologie entstammende Figuren neu, denen der Affe Apis und der griechische Künstler Stavros zur Seite gestellt werden.

Sanys Beitrag nimmt in mehrfacher Hinsicht auf das Marginale, das Randständige Bezug. Das betrifft die Platzierung der Pyrographien, die an große Werbetafeln und -malereien erinnern, wie sie in den Nachkriegsjahrzehnten die Brandmauern städtebaulicher Zwischenräume bedeckten. Mit der Volkskunst der Brandmalerei bedient er sich einer alten, heute mit Hobbykeller und Spießigkeit assoziierten Technik, der die Aufnahme in den Kanon tradierter künstlerischer Medien verweigert blieb. Indem er sie auf Großformat aufbläst, spielt er auch auf das Gefälle an Wertzuschreibungen im Kunstsystem an, die ebenso auf Konvention beruhen wie die Beziehung zwischen Signifikant und Signifikat. Ihrem mythologischen, menschheits- und kulturgeschichtlichen Kontext entglitten, fallen Sanys Figuren vom Himmel. Die Zeichnungen bringen ein dynamisches, schnappschussartiges Moment in den primär von Werbung durchsetzten Stadtraum, durch das man Bildebene und Umraum, ähnlich wie bei der Betrachtung einer Skulptur, in Beziehung zueinander setzt. So scheinen die Figuren, als seien sie kurz vor dem Aufschlag auf den Bordstein begriffen – und wirken ebenso gefährdet wie die Passant_innen, die unter ihnen ahnungslos die Straße überqueren. A.P.

Fallande ting-Serie und Filmtrailer sowie Zeichnungen für Banner, Tragebeutel, Flyer, Aufkleber und Merchandise

Fallande ting
Serie von Pyrographien im Stadtraum
Münster/Marl

Untitled (Estrid)
333 × 340 cm
Schlossplatz 34, 48143 Münster

Untitled (Grazyna)
170 × 370 cm
Hüfferstraße 20, 48149 Münster

Untitled (Apisina)
117 × 247 cm
Bispinghof 20, 48143 Münster

Untitled (Yggdrasil)
370 × 340 cm
Kampstraße 8–10, 45768 Marl

Untitled (Norns)
280 × 235 cm
Kampstraße 8–10, 45768 Marl

Sany (Samuel Nyholm)

Samuel Nyholm (*1973 Lund; lives in Stockholm and Bremen), who publishes his figurative drawings under the acronym Sany, works as a graphic designer and artist. Frequently his sketchy drawings borrow from Danish Pilsner cartoons from the 1960s and 1970s in terms of both their visual language and choice of motif. They vary motivic situations, which are peopled by a handful of fictional characters who keep popping up again and again, as the drawings refer to popular culture's slapstick genre and play with prejudices and stereotypical simplifications. One particular focus of the cartoons, which some-times echo the distant style of Saul Steinberg, can be found in the arbitrary character of linguistic and symbolic systems. They often humorously depict scenarios from the world of art, highlighting misun-derstandings and misinterpretations and thus pointing to the gap between a symbol and its meaning.

Marginal Frieze

Sany's work *Marginal Frieze* for the Skulptur Projekte links two dif-ferent areas. On the one hand, a multi-part mural is being exhibited in the urban space, while, on the other, his cartoons are part of the exhibition's accompanying advertising campaign: his work is being circulated as film trailers, on banners, bags, flyers, and stickers—as a patchwork of subliminal media fragments with a wide range of influence in the public space. For his *Fallande ting* Sany is installing large-sized pyrographies on the walls of several buildings in Mün-ster and Marl, showing individual falling figures. For this project he turns to familiar characters from his cosmos of images: with Estrid, the Valkyrie, and Yggdrasil, the World Tree, he re-interprets two figures from Nordic mythology, who are joined by the monkey Apis and the Greek artist Stavros.

Sany's contribution alludes in many respects to the marginal, the fringe. And that applies specifically to the location of his pyrogra-phies, which are reminiscent of the large billboards and murals that covered the fireproof walls of vacant urban spaces during the post-war years. In his use of folk-art pyrography, he draws on an old technique associated with basement hobby rooms and stuffy bour-geois values that has been refused admission to the canon of ac-cepted artistic media. By blowing the figures up to a large-scale format, he refers to the disparities in value ascription within the art system, which are based not only on conventions but also on the relationship between the signified and the signifier. Having slipped from their mythological, human, and cultural-historical context, Sa-ny's figures fall from the sky. The drawings introduce a dynamic, snapshot-like element to an urban space that is otherwise domi-nated by advertising, thus promoting the interplay between the pic-torial surface and its surroundings, similar to viewing a sculpture. In this way, Sany's figures seem like they are just about to hit the kerb—and look just as endangered as the passers-by who unknowingly cross the street beneath them. A.P.

Fallande ting series and film trailer with drawings for banners, carrier bags, flyers, stickers, and merchandise

Fallande ting
Pyrographic series in the Münster / Marl urban space

Untitled (Estrid)
333 × 340 cm
Schlossplatz 34, 48143 Münster

Untitled (Grazyna)
170 × 370 cm
Hüfferstraße 20, 48149 Münster

Untitled (Apisina)
117 × 247 cm
Bispinghof 20, 48143 Münster

Untitled (Yggdrasil)
370 × 340 cm
Kampstraße 8–10, 45768 Marl

Untitled (Norns)
280 × 235 cm
Kampstraße 8–10, 45768 Marl

Von unten

Irgendwann muss jemand die Idee gehabt haben, es könnte witzig sein, heutige Musterwelten und Meinungen in die Steinzeit zu verlegen, um durch den Bruch einer radikalen Zeitverschiebung deutlich zu machen, dass der Prozess der Zivilisation noch kein Ende gefunden hat. Der Steinzeitwitz ist ein Genre, das sich dann mit der amerikanischen TV-Serie *Flintstones* ab 1960 auch animiert profilieren konnte. Wenn also die Errungenschaften unserer Kultur, unser Lebensstil und unsere Philosophie in die Steinzeit zurückversetzt werden, wenn sich also Steinzeitmenschen in ihrer komischen Fellkleidungen an Technologie, Politik, Emanzipation, Kunst, Design unserer Tage reiben, dann entsteht jene angenehme intellektuelle Stimmung, in der sich mit gewisser Leichtigkeit eine oder *die* Wahrheit sagen lässt.

Samuel Nyholm reanimiert dieses inzwischen seltsam gewordene Genre in seiner Serie *STONE-STEIN'S* (2013) und konkretisiert die geistige Dimension der Steinzeitwitze, indem er nun die Symbolsprachen des intellektuellen Diskurses in die Höhle Platons schickt, diese als *BULL-SHIT* und Platon selbst als *ASS-HOLE* diffamiert. Ein kleiner pfiffiger Steinzeitmensch ist es, der dem großen, etwas dämlichen Anverwandten die Welt des Diskurses, der Markennamen, der wissenschaftlichen Formeln oder der Kunst erklären will. Dieser Kleine hat so seine eigene, äußerst kritische, unorthodoxe, anarchische Art, mit den geistigen und anthropologischen Standards umzugehen. Die Wand

From Below

At one point, someone must have had the idea that it might be fun to take today's paradigms and notions and relocate them to the Stone Age, using the rift opened up by the radical shift in time to illustrate that the process of civilization has still not come to an end. The Stone Age joke is a genre that made a name for itself with the American animated TV series *The Flintstones*, starting in 1960. If, that is, all the achievements of our culture, our lifestyle, and our philosophy were transported back to the Stone Age, and Stone Age people in their strange fur-clothing were forced to cope with our world's technology, politics, emancipation, art, and design, then the kind of pleasant intellectual climate might emerge in which a truth or *the* truth could be uttered with relative ease.

With his series *STONE-STEIN'S* (2013), Samuel Nyholm reanimates this old genre, which has become quite outlandish over the years. And he substantiates the intellectual dimension of the Stone Age jokes by transferring the symbolism of the scholarly discourse to Plato's cave, defaming it as *BULL-SHIT* and berating Plato himself as an *ASS-HOLE*. It is a clever little Stone Age man who wants to explain the world of discourse, of brands, of scientific formulas, or the world of art to a somewhat stupid relative. This little character has his own extremely critical, unorthodox, anarchical way of dealing with intellectual and anthropological standards. After all, the wall of the cave is not the realm of shadows, it is a tangible visual aid for a lecture that

– I JUST WANT HER BACK!!!

–SHIT

der Höhle ist eben nicht das Schattenreich, sondern konkrete Schautafel für eine Lehrveranstaltung, welche die scheinbare Komplexität der Denksysteme und Begriffe analytisch wieder an den Ausgangspunkt der Frage zurückbeamt und damit gleichzeitig das zivilisierte und das politische Denken in eine Spannung versetzt, in der sich nicht entscheiden lässt, ob die Sache nun *nur* witzig ist oder ob der kleine Schlaumeier nicht doch letztendlich recht hat. Mit einer im Wesentlichen immer gleichen Figurenkonstellation erzielt Nyholm in wunderbarer Ökonomie eine Reflexionsdichte, die das Genre Steinzeitwitz und das Witzemachen selbst für uns große Doofe in eine *Meta-* Ebene überführt, damit das Lachen und das mit ihm verbundene Denken spektakulär und ausdauernd werden möge.

Die *STONE-STEIN'S* sind Kontrafakturen einer populären Cartoonwelt, die sich vor allem in den Zeitschriften und Zeitungen seit den 1950er Jahren verbreitete. Eine Welt, die international eigene Genres des Bilderwitzes entwickelt hatte und in ihnen vornehmlich Figuren- und Situationsstereotypen variierte. Neben den Steinzeitwitzen sind das etwa Inselwitze, Witze über betrogene Ehemänner, Hausfrauen-, Kannibalen- oder natürlich Künstler_innenwitze. Meist mit Kürzeln signiert, haben diese, auch vom Strich her, oft ähnlichen Zeichnungen, auf dem Feld des Cartoon jedoch keine Karriere gemacht, wie etwa zur gleichen Zeit Chas Addams, Siné, Topor, Loriot oder gar Saul Steinberg, denen teilweise – wie einigen Comiczeichnern – inzwischen die Museen offenstehen. Die Genrewitze dagegen verbleiben in der Publizistik des Gemischten von Kreuzworträtsel, Kurzcomic und Rebus, das nicht nur die

analytically projects the apparent complexity of our concepts and systems of thought back to the origin of the enquiry and, by so doing, dynamizes civilized and political thinking to the point that it is no longer possible to say whether the whole thing is *just* funny or if maybe that little wise guy is actually right. Essentially by using the same constellation of characters over and over again, Nyholm achieves a beautifully efficient density of reflection that shifts the jokes to a meta-level even for us big blockheads, potentially making the laughter and the intellectual processes associated with it both spectacular and sustained.

The *STONE-STEIN'S* are contrafacta of a popular cartoon world that has spread since the 1950s, above all in magazines and newspapers, a world that has developed its own international comic genres, with variations applied primarily to the stereotypes of characters and situations. In addition to the Stone Age jokes, there are jokes about islands, betrayed husbands, housewives, cannibals, and, of course, artists. These drawings, which are mostly signed with initials and are often similar in terms of their execution, never achieved commercial success in the world of comics, in the way that artists such as Chas Addams, Siné, Topor, or even Saul Steinberg did in the same period, with their work in some cases now showing in art museums and galleries, as is also the case with some comic illustrators. The genre jokes, on the other hand, continued to be an integral part of the miscellaneous section of newspaper and magazine publications—together with crossword puzzles, comic strips, and picture puzzles—something that was not restricted to the Saturday supplements. And analogous to the

Sany (Samuel Nyholm)

Samstagsausgaben fütterte. Und wie das immer neu Ange-
rührte des Gleichen, so anonymisierte sich auch diese Witzkul-
tur des kurzweilig Beiläufigen, bis der Zeitgeist seit den 1980er
Jahren dieser meist für ein Schmunzeln doch recht witzigen
Unschuld nach und nach den Garaus macht. Was bleibt, ist der
an Screwball und Situationskomik geschulte Geist dieser Zeich-
nungen mit dem Touch heiterster, listiger Anarchie und Subver-
sion des Alltags.

Unter anderem diese Witzkultur des „Marginalen" (Nyholm),
diese unendliche Permutation von zeichnerischen, situations-
abhängigen und mentalen Stereotypen reaktiviert Nyholm auf
seine empathische Weise in verschiedenen Serien, Einzelblät-
tern, in kleinen Booklets, speziellen Zeitschriften und in jüngster
Zeit auch als Installationen in Ausstellungen oder als Großfor-
mate im Stadtraum. Er entwirft zeichnerisch einen quirligen
Subkosmos, indem er nun selbst beginnt, die Stereotype zu
variieren, zu verändern, aus ihnen etwas zu entwickeln, das
zwar elementarer und komplexer erscheint, ohne jedoch die
zugrunde liegende Leichtigkeit und Subversion aufzugeben.
Nicht nur sein Lettering überführt die „Marginalität" in ein doch
sehr grundsätzliches Denken über heutige künstlerische, phi-
losophische, politische Positionierungen, das allerdings immer
wieder gebrochen wird durch die Anarchie des Ausgangsma-
terials; denn diese Anverwandlung wird und muss immer ein
Spaß bleiben, wird kaum die Geisteswelt verleugnen können,
aus der sie geboren wurde. Theoretisch können wir es uns in
diesem Fall also weder mit *Camp* (Susan Sontag) noch all den
anderen Aufwertungen des Trivialen von Roland Barthes bis

constant remix of the same material, the comic culture of casual
entertainment had an anonymous quality up until the 1980s
when this innocent type of chuckle-inducing humour was killed
off by the contemporary zeitgeist. What remains is the spirit of
these drawings, schooled in screwball and situational comedy,
enriched with a touch of clever, light-hearted anarchy and the
subversion of everyday life.

Nyholm empathically reactivates this comic culture of the 'mar-
ginal' (Nyholm), this never-ending permutation of graphic, sit-
uational, and mental stereotypes in various series, individual
pictures, small booklets, special magazines, and, more recently,
as installations in exhibitions or posted in large format in urban
spaces. He graphically develops a vibrant sub-cosmos by play-
ing with and changing the stereotypes and making something
out of them that seems more elemental and yet more complex,
without forfeiting the underlying lightness and subversion. His
lettering, amongst other things, shifts his 'marginality' towards
a much more basic way of thinking about today's artistic, phil-
osophical, and political positions, although this keeps being
disrupted by the anarchy of the original material. The adapta-
tion will and must always be funny and could scarcely disown
the intellectual world from which it sprang. In this case, we are
theoretically unable to feel at home either with 'camp' (Susan
Sontag) or with all the other positive assessments of the trivial
ranging from Roland Barthes to Jacques Derrida. Parodistic
elements are as irrelevant here as the appropriated jokes of
someone like Richard Prince. It is this thrilling 'delight in the
trivial' (Thomas Becker), whose prevalence was instigated by

–LOTS-OF-SHIT

Sany (Samuel Nyholm)

Jacques Derrida bequem machen. Auch das Parodistische spielt hier ebenso wenig eine Rolle wie die Witzappropriationen eines Richard Prince. Es ist gerade die seit der Pop Art verbreitete prickelnde „Lust am Unseriösen" (Thomas Becker) und der letztendlich damit verbundene Ernst der Kunst, der sich Nyholms Zeichnungen und Typentheater virtuos widersetzen und die er zum Zeichen seiner Solidarität mit den Archetypen ebenfalls mit einem Kürzel signiert: sany. Die Denker des *Rhizoms* hätten hier ihr diebisches Vergnügen.

Nyholms Kontrafakturen erweitern die Pathosformeln einer zeichnerischen „Lachkultur" (Michail Bachtin), um in einem Zwischenreich, einem Irgendwo zu landen: Der Stallgeruch des Marginalen und Anarchischen ist und bleibt seiner Kunst inhärent. Auf vielfältigste Weise und mit feinem Variationsreichtum beteiligt sich Sany so an Friedrich Nietzsches außergewöhnlichem Projekt des „Wahrlachens", ein „Wahrlachen", das die „Zeit der Tragödie, die Zeit der Moralen und Religionen" zu überwinden sucht und dessen Kraft notwendiger denn je erscheint, zumal Sanys Typen ziemlich oft von fallenden Gegenständen und stürzenden Personen bedroht werden, natürlich *VON OBEN*.

Michael Glasmeier

Pop Art—and the artistic seriousness ultimately associated with it—that is skilfully defied by Nyholm's drawings and character studies, which he also signs with 'sany', a shorthand form of his name, to demonstrate his solidarity with archetypes, something the 'rhizome' philosophers would take a mischievous pleasure in.

Nyholm's contrafactas expand the pathos formula of a graphic 'culture of popular laughter' (Mikhail Bakhtin) and end up somewhere in an in-between realm: the whiff of marginality and anarchy has always been inherent to his art. Sany uses diverse means and a wealth of subtle variations to take part in Friedrich Nietzsche's extraordinary project of *Wahrlachen* ('laughing into truth'), a laughter that strives to overcome 'the age of tragedy, the age of morals and religions' and whose strength seems more urgent than ever, because characters like Sany's are often threatened by falling objects and plunging people—of course, *FROM ABOVE*.

Michael Glasmeier

—Don't worry Sir, it's probably just a
site-specific performance!

Gregor Schneider

Gregor Schneider (* 1969 Rheydt, lebt in Mönchengladbach-Rheydt) entwickelt den Kanon seines Werkes aus den baulichen und atmosphärischen Interventionen, die er (seit 1985) in einem vormaligen Mietshaus in Mönchengladbach-Rheydt vornimmt. 2001 entkoppelte Schneider ganze Raumfolgen aus diesem *Haus u r* genannten Gesamtkunstwerk, um sie dem deutschen Pavillon auf der Biennale in Venedig als *Totes Haus u r* einzuverleiben. Indem Schneider das LWL-Museum für Kunst und Kultur hinter dem Einbau eines privaten Wohnraums zurücktreten lässt, unterwandert der Künstler die Grenzziehung zwischen privatem und öffentlichem Raum. Zugleich intensiviert sein Werk die Frage nach der existenziellen Befindlichkeit des Menschen in der nachmodernen Gesellschaft.

N. Schmidt
Pferdegasse 19
48143 Münster
Deutschland

N. Schmidt trat bereits in der Ausstellung *u r 54, N. SCHMIDT* (Bremerhaven, 2001) in Erscheinung. Der Titel verweist auf die Herkunft von *N. Schmidt* aus dem Raum 54 im *Haus u r*. Die Wohnung in Münster gibt nun Gelegenheit, der Persona *N. Schmidt* auf die Spur zu kommen. Ein separater Eingang an der Westseite des Museumsneubaus führt über eine Treppe in den ersten Stock zu einem Vorraum, von dem aus die Wohnung abzweigt. Im Durchschreiten von Flur, Wohnzimmer, Schlafzimmer und Bad gelangt der/die Besucher_in in einen Vorraum und eine wiederholte Einheit, deren räumliche Abfolge und Interieurs mit der ersten baulich identisch sind. In einer kreisförmigen Laufrichtung erreichen die Besucher_innen erneut den ersten Vorraum. Auf diese Weise wird die Wiederholung von Erfahrungen ermöglicht, die, nun von Erinnerungen modifiziert, einen anderen Raum eröffnen. Das Prinzip von Verdopplung und Differenz setzt sich auch im virtuellen Raum fort: Das Geschehen innerhalb der einen Wohnung scheint synchron auf Bildschirme in der jeweils anderen Wohnung übertragen zu werden. Durch dieses Szenario ist das Museum als institutioneller und architektonischer Rahmen ausgeblendet; das Werk ist der musealen Präsentation entzogen, wodurch es, aus der Sicht des Künstlers, *getötet* wird.

Seit Mitte der 1990er Jahre inszeniert Schneider in seinen Interieurs die An- beziehungsweise Abwesenheit möglicher Bewohner_innen: gedeckte Tische, Gerüche und Geräusche scheinen diese heraufzubeschwören. Schneiders Werk *Die Familie Schneider, 14 und 16 Walden Street* (London, 2004) stellte eine vorläufige Zuspitzung und Verschränkung dieser räumlichen und semantischen Werkaspekte dar: Die baugleichen und identisch ausgestatteten Doppelhaushälften wurden von je einem Zwillingspaar bewohnt, das, ungeachtet der Anwesenheit der Besucher_innen, alltägliche Handlungen verrichtete. Eine distanzierte Betrachtung der Umgebung und des Geschehens schien kaum möglich – der/die Besucher_in wirkte auch hier in einem zeiträumlichen emotionalen und mentalen Prozess an der Intensität von Schneiders Werk mit. N.T.

Material
Rheydt 2017, freistehende Räume in Räumen, Tischlerplatten und Sperrholzplatten auf Holzkonstruktionen, 16 Türen, 6 Fenster, 10 Leuchten, 8 Heizkörper, 2 Duschen, 2 Toiletten, 2 Waschbecken, weiteres Inventar, graue und weiße Bodenfliesen, brauner und grauer Teppich, weiße und beige Wände und Tapete, nicht sichtbare Aktion

Standort
LWL-Museum für Kunst und Kultur Domplatz 10, 48143 Münster Zugang über Pferdegasse 19

Gregor Schneider

Gregor Schneider (*1969 Rheydt; lives in Mönchengladbach-Rheydt) has developed the canon of his works from the architectural and atmospheric interventions he has been carrying out in a former block of flats in Mönchengladbach-Rheydt since 1985. In 2001, Schneider removed entire spatial sequences from *Haus u r*, which is what he called the artwork as a whole, and incorporated them into the German Pavilion at the Venice Biennale as *Totes Haus u r*. By having Münster's LWL–Museum für Kunst und Kultur recede behind the installation of a private living space, the artist subverts the border demarcation between private and public space. At the same time, his work intensifies the question about the existential state of man in postmodern society.

N. Schmidt
Pferdegasse 19
48143 Münster
Deutschland

N. Schmidt already made an appearance at the exhibition *u r 54, N. SCHMIDT* (Bremerhaven, 2001). The title refers to *N. Schmidt*'s origins in Room 54 of *Haus u r*. The flat in Münster now gives visitors the opportunity to start unravelling the persona of *N. Schmidt*. A separate entrance in the west wing of the museum's new building leads up a stairway to the first floor and to an anteroom where the flat branches off. By walking through the hallway, the living room, the bedroom, and the bathroom, the visitor comes to an anteroom and another flat whose room sequence and interiors are architecturally identical to the first unit. By following a circular route through the flat, the visitors once again reach the first anteroom. This offers an iterative experience, which, now modified by memories, opens up a new space. The principle of duplication and discrepancy is continued in virtual space: what happens in one flat seems to be relayed synchronously to screens in the other flat. All the while, the museum is masked out by this scenario, both as an institutional and an architectural framework; the work is stripped of any museum-style presentation, thus *killing* it from the artist's point of view.

Since the mid-1990s, Schneider has been staging the presence and absence of possible occupants of his interiors: laid tables, smells, and sounds seem to conjure them up. Schneider's work entitled *Die Familie Schneider, 14 and 16 Walden Street* (London, 2004) constituted a tentative accentuation and intertwining of the spatial and semantic aspects of his work: the semi-detached homes, identical in both structure and furnishings, were each lived in by one twin, who carried out everyday tasks despite the presence of visitors. It seemed almost impossible to objectively observe the surroundings and occurrences—here too every visitor played an active part in intensifying Schneider's work in an emotional and mental process in time and space. N.T.

Material
Rheydt 2017, free-standing rooms within rooms, blockboards and plywood panels on timber structures, 16 doors, 6 windows, 10 lamps, 8 radiators, 2 showers, 2 toilets, 2 washbasins, additional fixtures, grey and white floor tiles, brown and grey carpet, white and beige walls and wallpaper, invisible action

Location
LWL–Museum für Kunst und Kultur
Domplatz 10, 48143 Münster
Access via Pferdegasse 19

Gregor Schneider

Die totale Isolation und vollkommene Selbsttäuschung
Eine Wiederholung.

Vermutlich habe ich nur eine Arbeit verrichtet. Eine Wand vor die Wand gebaut. Ich habe versucht, einen bestehenden Raum in Form, Funktion und Aussehen in einem Raum zu wiederholen. Wobei sich diese Räume auch bewegen können. Decken fahren unmerklich einige Zentimeter rauf oder runter, und ganze Räume können sich komplett drehen.

Ich mache Räume transportfähig und baue diese Räume an anderen Orten wieder auf. Dabei war ich von Beginn an nicht an einem neuen Raum, sondern an der Auflösung des Raumes interessiert. Indem ich den bestehenden Raum baue, wird ein neuer Raum sichtbar und gleichzeitig der alte Raum unsichtbar. Der neue Raum wird von dem vorherigen Raum regelrecht geschluckt. Der neu errichtete Raum, der die Besucher_innen umgibt, muss nicht als Kunstwerk hervortreten.

Das Vorhandene oder das potenziell Vorhandene wird wiederholt – von Grund auf rekonstruiert. Nichts Neues. Ich habe gesagt: „Mich interessiert der Leerlauf von Handlung." So ist die Arbeit ein Zusatz, ein Mehr, überflüssig. Jedenfalls in dem Sinne, dass sie nicht didaktisch ist, nichts ausdrücken, auf nichts verweisen will. Die Verdopplung des Bestehenden legitimiert die Arbeit in der einfachsten möglichen Weise. Damit ist die Frage der Legitimation zum Beispiel durch Referenzialität geklärt, ohne dass diese von weiterer Bedeutung ist. Die Arbeit konzentriert sich in sich selbst.

Ich habe das Monster einen „nicht mehr zu wissenden Zeitraum" genannt ... Je länger ich daran arbeite, desto unbekannter wird diese unsichtbare Architektur für mich selbst.

Letztlich ist es nicht so wichtig, im Einzelnen zu identifizieren, welche Wand, welcher Raum, welches Detail hinzugefügt ist. Wichtiger ist zu beobachten, dass der neue Raum, derjenige, in dem man sich befindet, akzeptiert wird. Also keine Erfindung oder wenn Erfindung, eine, die sich der Kenntnisnahme entzieht – oder jedenfalls nicht hervortritt.

Verdopplung ist eine Geste, die das Vorhandene bestätigt.

Die Arbeit ist der Bau einer Wand vor eine Wand, eines Raumes in einen Raum. Die Arbeit ist da sichtbar, aber vielleicht wird sie vollkommen übersehen. Andere Arbeiten sind versteckt, also unsichtbar. Vielleicht aber beeinflussen sie doch die Wahrnehmung. Die Arbeit ist eine Arbeit, die sich selbst verschlingt. Zu dieser Vorgehensweise, die Arbeit unkenntlich zu machen, wird man nicht sagen, es handele sich um eine Negation des Gegenständlichen, um etwa das Erlebnis oder das Ereignis in den Vordergrund treten zu lassen. Doch ist es sicher so, dass sie der Verdinglichung oder Objektivierung des Werkes entgegenwirkt. Die Arbeit muss da sein, es muss sie geben, wenn von gewissen Arbeiten auch nicht bekannt ist, ob es sie wirklich gibt und was sie sind. Aber sie muss nicht fokussiert werden. Sie kann gespürt, empfunden, erinnert, vermutet, vorgestellt, aber auch gesehen, untersucht und reflektiert werden. Keine Wahrnehmungsweise ist ausgeschlossen.

Wir nehmen Räume bewusst nur als Ausschnitte wahr. Wir durchlaufen jedoch körperlich Räume, die unseren geistigen Raum nicht bewusst erreichen. Im Alltag geschieht das ständig. Dies ist der Grund, wieso wir uns nur schwer an Räume erinnern können und kaum Begriffe für Räume haben. Die Vernunft wird überschätzt, die Gefühle sind bestimmend. Für die Wahrnehnug einer stabilen Realität bedarf es großer Anstrengungen. Bei Verlust einer stabilen Wahrnehmung der Realität muss schon früh etwas kaputt gegangen sein. Ich glaube auch, dass man sich sehr häufig mit Dingen beschäftigt, um sie loszuwerden.

Die Arbeit ist, als wandere man durch die Schichtungen und Schalungen des eigenen Hirns und gehe dort den Mechanismen der Wahrnehmung und des Wissens nach.

Ich hatte die Vorstellung, in einer Mülltonne im Müllsack zu sitzen und von der Müllabfuhr abgeholt zu werden. In den Müllwagen geworfen zu werden, um spurlos zu verschwinden. Dieses sinnlose Sich-einfach-Wegwerfen taucht immer wieder auf.

In meinem Haus fühle ich mich zurzeit unwohl, es ist ein Einbrecher darin gewesen. Das empfand ich als eine sehr unangenehme Situation. Ich finde es faszinierend, dass man in einem Raum ist und nicht genau weiß, ob schon jemand da ist. Bisher war ich es immer, der anwesend war, und jetzt ist es jemand Fremdes. Es bringt mich wiederum zu einer neuen Arbeit. Ich habe eine Wohnung gebaut, wo jemand ist, den man aber nicht sieht, ein Fremder, der in der Wohnung ist, den ich aber nicht sehen kann. N. Schmidt ist einer der ersten Besucher, die im Haus waren. Er war regelmäßig dort, und so wurde er schließlich zu einem Teil des Hauses, quasi zu einem Bewohner. Er ist ein ständiger Begleiter, wie ein Schatten.

Vermutlich habe ich nur eine Arbeit verrichtet. Eine Wand vor die Wand gebaut. Ich habe versucht, einen bestehenden Raum in Form, Funktion und Aussehen in einem Raum zu wiederholen. Die Motivation war vermutlich Langeweile.

Gregor Schneider

Total Isolation and Complete Self-Deception
A reiteration.

I probably only achieved one task. Built a wall in front of the wall. I tried to reiterate an existing space in form, function, and appearance within a space. In fact, these spaces can also move. Ceilings indiscernably move up or down a few centimetres, and entire spaces can turn completely around.

I make spaces transportable and reconstruct them at other locations. From the outset, I wasn't interested in a new space but in dissolving the space. By constructing the existing space, a new space becomes visible, and, at the same time, the old space becomes invisible. The new space is simply swallowed by the previous space. The newly constructed space which surrounds the visitor needn't stand out as a work of art.

What exists or what potentially exists is reiterated—reconstructed from scratch. Nothing new. I said, 'I am interested in the neutral gear of action.' In that sense, the work itself is additional, extra, superfluous. At least in the sense that it is not didactic, it expresses nothing, it doesn't attempt to allude to anything. The duplication of the existing space legitimizes the work in the simplest way possible. The question of legitimation is thus resolved—by means, for example, of referentiality—without this being of further significance. The work is concentrated in itself.

I called the monster a 'no longer knowable time frame' … The longer I work on it, the more unfamiliar this invisible architecture becomes for me.

Ultimately, it isn't so important to specifically identify which wall, which room, which detail has been added. It is more important to observe that the new space, the one you are in, has been accepted. So, no invention, or if there is invention, one that escapes our notice—or at least doesn't stand out.

Duplication is a gesture that confirms what exists.

The job is to construct a wall in front of a wall, a space within a space. The work is visible, but perhaps it will be completely ignored. Other tasks are hidden, in other words invisible. But perhaps they influence our perception. The work is a work that entwines itself. With regard to this process of making the work unidentifiable, it will not be said that it involves a negation of the concrete as a means to let the experience or the event come to the fore. But it is certainly true that it counteracts the reification or objectification of the work. The work must exist, it must be there, even though with certain tasks we don't know if they actually exist and what they consist of. But there is no need to focus on the work. It can be perceived, sensed, remembered, assumed, and imagined, as well as seen, investigated, and reflected on. No means of perception is excluded.

We are only cognizantly aware of spaces as sections. Yet we physically walk through spaces that don't consciously penetrate our mental space. It happens constantly in everyday life. And that is the reason why it's so hard for us to remember rooms and why we have so few terms for rooms. Our faculty of reason is overestimated, our feelings are decisive. A great effort is required to perceive a stable reality. When we lose our stable perception of reality, then something must have gone wrong at an early stage. I also believe that we very often preoccupy ourselves with things in order to rid ourselves of them.

The work is as if we were moving through the layers and cortices of our own brains, pursuing the mechanisms of perception and knowledge.

I had a vision of sitting in a rubbish bag in a rubbish bin and being picked up by the rubbish collectors. Being thrown into the dustcart to vanish without a trace. This senseless idea of just throwing oneself away keeps popping up again and again.

I feel uneasy now at home; there's been a burglar in the house. It was a situation that greatly disturbed me. It's fascinating to be inside a room without exactly knowing if someone else is already there. Until now I was the one who was always there, but now it's a stranger. And that leads me to a new work. I've constructed a home where someone is present who can't be seen, a stranger who is in the flat, but I can't see him. N. Schmidt was one of the first visitors to the house. He came regularly, and so he finally became part of the house, essentially a resident. He is a constant companion, like a shadow.

I probably only achieved one task. Built a wall in front of the wall. I tried to reiterate an existing space in form, function, and appearance within a space. My motivation was presumably boredom.

Gregor Schneider

u 30, TREPPENHAUS, Rheydt 1989 – Venedig 2001, Mauer vor einer Mauer, Rigipsplatten auf einer Holzkonstruktion, hellgelb (197 × 313 cm (W × H), S 5 cm), TOTES HAUS u r, Deutscher Pavillon, 49. Biennale von Venedig, 10.06.2001–04.11.2001
u 30, TREPPENHAUS, Rheydt 1989 – Venedig 2001, wall in front of a wall, plaster boards on a wooden construction, light yellow (197 × 313 cm (W × H), S 5 cm), TOTES HAUS u r, German Pavilion, 49th Venice Biennale, la Biennale di Venezia, 10.06.2001–04.11.2001

u 30, TREPPENHAUS, Rheydt 1989–1993, Wand vor einer Wand, Rigipsplatten auf einer Holzkonstruktion, hellgelb (197 × 313 cm (W × H), S 5 cm), HAUS u r, Rheydt, 1985 – heute
u 30, TREPPENHAUS, Rheydt 1989–1993, wall in front of a wall, plaster boards on a wooden construction, light yellow (197 × 313 cm (W × H), S 5 cm), HAUS u r, Rheydt, 1985 – today

u r 3 B, VERDOPPELTER RAUM, Berlin 1994, Raum im Raum, Rigipsplatten und Holzkonstruktion, 2 Türen, 1 Fenster, 1 Lampe, grauer Boden, weiße Wände und Decke (247 × 332 × 249 cm (L × W × H), S 1,8–21 cm), Galerie Andreas Weiss, Berlin, 11.03.1994–11.04.1994
u r 3 B, VERDOPPELTER RAUM, Berlin 1994, room within a room plaster boards and a wooden construction, 2 doors, 1 window, 1 lamp, grey floor, white walls and ceiling (247 × 332 × 249 cm (L × W × H), S 1.8–21 cm), Galerie Andreas Weiss, Berlin, 11.03.1994–11.04.1994

u r 3 A, VERDOPPELTER RAUM, Rheydt 1988, Raum im Raum, Rigipsplatten und Holzkonstruktion, 2 Türen, 1 Fenster, 1 Lampe, grauer Boden, weiße Wände und Decke (245 × 263 × 243 cm (L × W × H), S 1,8–21 cm), HAUS u r, Rheydt, 1985 – heute
u r 3 A, VERDOPPELTER RAUM, Rheydt 1988, room within a room, plaster boards and a wooden construction, 2 doors, 1 window, 1 lamp, grey floor, white walls and ceiling (245 × 263 × 243 cm (L × W × H), S 1.8–21 cm), HAUS u r, Rheydt, 1985 – today

Gregor Schneider

Nora Schultz

Die künstlerischen Setzungen von Nora Schultz (*1975 Frankfurt a. M., lebt in Boston) beziehen ihre Spannung aus materialbezogenen Handlungen, Formungsprozessen und den Relationen zueinander. Alltägliche Materialien, Sprache, Schriftsysteme und kulturelle Verschiebungen spielen dabei ebenso eine Rolle wie der Rekurs auf den Postminimalismus. In jüngerer Zeit verlagerte sich ihr Fokus über die performative Arbeit mit selbstkonstruierten Druckmaschinen auf die Auseinandersetzung mit den Strukturen des Ausstellungsraumes, auf die sie mit raumgreifenden Installationen reagiert. Mit der Reflexion des architektonischen Rahmens, der die Wahrnehmung von Kunst formatiert, reiht sich ihre Arbeit auch in eine Traditionslinie institutionskritischer Praktiken ein.

Pointing their fingers at an unidentified event out of frame

In Münster bildet die architektonische Inszenierung des Museumsfoyers den Ausgangspunkt von Nora Schultz' multimedialer Intervention. Der dominante Raumkörper mit seinem repräsentativen Charakter erfährt in visueller, akustischer und taktiler Hinsicht eine Transformation. Durch die Abdeckung des Oberlichtes mit Folien moduliert sie die Intensität des Lichteinfalls, der verlegten Teppichboden wirkt schallschluckend. Am Treppenaufgang integrierte sie die Stahlplastik *YZI* des Künstlers Olle Bærtling (1911–1981) aus Marl. Zwei Projektionen zeigen Filmaufnahmen, die mithilfe von GoPro-Kameras und Drohnen vor Ort entstanden sind. Zudem eignet sich Schultz infrastrukturelle Elemente wie die Infoscreens an, auf denen unvermittelt Filmausschnitte aufflackern. Irritierende, von Soundaufnahmen der unbemannten Fluggeräte stammende Tonspuren durchhallen das Foyer.

Der Eingangsbereich, dem als Rahmungselement des Museumsbesuches zentrale Funktion zukommt, erfährt durch die Eingriffe eine atmosphärische Umcodierung. Der aufgrund seiner Helligkeit schwer erfassbare, gebäudehohe Raum, der fast virtuell wirkt, wird in seiner Gestalt zurückhaltender, seine Konturen werden greifbarer. In den Filmen driften die für den Einsatz im Außenraum konstruierten Fluggeräte in hektischen, instabilen Bewegungen durch dieses Raumgefüge und eröffnen im Wechsel von Mikro- und Makroperspektive alternative Blickwinkel auf seine dominante Struktur. Wie die Drohnen die Schwerkraft temporär außer Kraft setzen, wird sie auch in Bærtlings Werk modellhaft suspendiert. Die 1969 entstandene Plastik, die wie eine Zeichnung im Raum wirkt, artikuliert in ihrer abstrakten Geste ein dynamisches Kraftfeld. Im transitiven, auf eine räumliche Ferne jenseits von Begrenzungen hindeutenden Moment liegen Bedeutung und Potenzial von Bærtlings Arbeiten, für die der Begriff der „offenen Form" zentral ist.

Schultz thematisiert das Museumsfoyer als vielseitigen, skulpturalen Körper – ein negativer Raum, dessen Ränder, aber auch scheinbare Leere modelliert und (um)geformt werden können. Indem der Außenraum in das makellose Foyer getragen wird, fungiert es auch als eine Art Druckmaschine: Sukzessive prägen die Besucher_innen dem Boden ihre Spuren ein, ein Zufallsmuster entsteht. A.P.

[Deuten mit ihren Fingern auf ein unbekanntes Ereignis außerhalb des Rahmens]

Material
Folie, Teppich, 2-Kanal-Videoinstallation mit Ton, Störung in der Anzeigentafel

Integriert in die Installation:
Olle Bærtling, *YZI*, 1969, Leihgabe vom Skulpturenmuseum Glaskasten Marl

Standort
Foyer des LWL-Museum für Kunst und Kultur
Domplatz 10, 48143 Münster

Nora Schultz

Nora Schultz's (*1975 Frankfurt am Main; lives in Boston) artistic interventions develop their tension from material-related actions, formative processes, and their relationship to one another. Everyday materials, language, writing systems, and cultural displacements play just as much a role as the recourse to Post-Minimalism. More recently, her focus has shifted, going via performative work with self-constructed printing presses to an engagement with the structures of the exhibition space, which she responds to with expansive installations. By reflecting on the architectural framework that shapes the way we perceive art, her work aligns itself with the tradition of institutional critique.

Pointing their fingers at an unidentified event out of frame

In Münster, the architectural arrangement of the museum's foyer represents the starting point for Nora Schultz's multimedia intervention. The dominant space, which is calculated to impress, is visually, acoustically, and tactually transformed. By covering the skylight with clear plastic sheeting, she modulates the intensity of the incident light entering the room. The carpet is sound-absorbent. Olle Bærtling's (1911–1981) steel sculpture *YZI* from Marl has been integrated into the stairway setting. Two projections show footage that was made on location using GoPro cameras and drones. In addition to that, Schultz employs infrastructural elements like info-screens that suddenly flash up film clips. Confusing sounds recorded by the unmanned flying objects echo through the foyer.

The interventions serve to recode the entrance area, which has a central function as a framing element for the visit to the museum. The brightness of the room, with its almost virtual effect, makes it difficult to get a clear sense of the space, which extends to the full height of the building. Schultz's work makes its design seem more restrained, and its contours more tangible. The flying devices in the films, which were constructed for external use, drift in hectic, unstable patterns through this space, offering alternative views of the room's dominant structure as the perspective varies back and forth from micro to macro. The drones temporarily suspend the force of gravity, and this same suspension happens in Bærtling's work in model form. The sculpture, which was made in 1969 and seems like a drawing in the space, expresses a dynamic force field with its abstract gesture. The meaning and potential of Bærtling's works lie in the transitive aspect suggestive of an unbounded spatial distance—the concept of 'open form' is inherent to his oeuvre.

Schultz treats the museum's foyer as a diverse sculptural body—a negative space whose edges and apparent void can be modelled and (re-)shaped. By relocating the external form and placing it in the pristine foyer, it also works as a kind of printer: visitors successively imprint vestiges of their presence onto the floor of the museum, creating a random pattern. A.P.

Material
Plastic sheeting, carpet, 2 videos, sound, interference in the display panel

Integrated in the installation
Olle Bærtling, *YZI*, 1969, on loan from the Skulpturenmuseum Glaskasten Marl

Location
Foyer of the LWL-Museum für Kunst und Kultur, Domplatz 10, 48143 Münster

Es ist das Jahr 1, denn es ist immer Jahr 1 hier, wo die Menschen die Jahre nicht mehr ansteigend zählen, sondern immer in Beziehung zu einem anderen Punkt in der Zeit, wie… ein paar Jahre früher als jetzt, Jahr 1, oder ein paar Jahre von jetzt in der Zukunft.

It is Year 1 several years from now, as it is always Year 1 at this place where people now count the years not in a cumulative way but always from now in relation to another point in time, like some years from now in the past, or some years ahead of now in the future.

Im Jahr 1 jetzt, wenn die Erderwärmung endlich unerträglich wird, werden zwei neue Technologien erfunden, die den Planeten radikal umgestalten. Die eine ermöglicht eine starke Verringerung der Schwerkraft, dadurch wird nicht nur die Materie leichter und es wird einfacher, sie auf verschiedene Arten zusammenzusetzen, sondern so geht es auch Orten, Städten, Kontinenten, der Hitze und der Luft, Ozeanen und Parks. Sie steigen alle auf und zirkulieren im Raum wie ein großer Schwarm in atmosphärischen Blasen, die sich organisch miteinander verbinden und wieder voneinander trennen können. Die zweite Technologie, die entdeckt wird, kann die Umgebung und alles darin, auch alle Lebewesen, auf Minimalgröße schrumpfen lassen. Häuser werden so groß wie ihre architektonischen Modelle, so ist es viel einfacher, sie zusammenzusetzen und umzustellen. Sie benötigen nur noch ein Minimum der Energie, die sie zuvor benötigt haben, und riesige Waldgebiete werden in Originalgröße belassen, und sie fliegen in der Atmosphäre herum und füttern den schwebenden Schwarm mit Sauerstoff.

In Year 1 now, when global warming finally becomes unbearable, two new technologies are invented, to radically reshape the planet. One allows an intense reduction of gravity, as a result of which not only does material become much lighter and easier to assemble in different ways but so do places, cities, and continents, the heat and air, oceans and parks: they all lift up and fluently circle around as a big swarm in space in atmospheric bubbles that can connect and disconnect organically. The second technology that is discovered can shrink the environment and everything in it, including all living beings, to minimal proportions: houses become the size of their own architectural model so it is much easier to assemble and shift them— they need a minimum of the energy they needed before—and huge areas of forest retain their original size and fly around the atmosphere, feeding the floating swarm with oxygen.

Nora Schultz

Aber der Prozess des Schrumpfens ist immer noch schwierig und teuer, und die geschrumpfte Existenz sieht nie ganz so aus wie das Original. In Anbetracht der Frage, was von der alten Welt in die neue transformiert werden soll, werden daher die meisten Kunstwerke, die es auf der Welt gibt, natürlich aussortiert. Die Werke, die die Menschen weiterhin betrachten wollen, werden in ihrer eigenen großen Blase gelagert, die im Raum umherschwebt und die manchmal wie ein Mond am Himmel erscheint … Museum und Lager in einem, eine Ausstellung in Form einer Blase, in der die Werke sich frei bewegen, sodass verschiedene Kunstwerke gleichzeitig sichtbar sind. Obwohl die Kunstblase ein ziemlich chaotisches Durcheinander ist, ist es doch unterhaltsam zu sehen, wie sie am Horizont auftaucht und wieder verschwindet. Sie wirkt wie weit, weit weg … und doch auch so, so nah.

Auch auf Planet Münster wird im Jahr 1 das Modell zur neuen Realität. Während Gebäude zuvor wie Renderings aussehen sollten, wie ein virtueller Raum, ein Ort für reine Normalität oder Spiritualität, wirkt sich das Fehlen der Schwerkraft jetzt auf eine kuriose Art negativ auf sie aus … sie wirken irgendwie wie fadenscheinige Behauptungen, so, als ob sie nicht mehr ernst genommen werden müssen.

But the process of shrinking is still difficult and expensive, and the shrunken existence never quite looks the same as the original. Therefore, in determining what to transform from the old world to the new, most of the artworks that exist on earth are naturally sorted out. Those works that people like to keep looking at are stored in their own big bubble, which floats around in space and sometimes appears like a moon in the sky—museum and storage all at once, an exhibition in the form of a bubble in which the works fluidly move around so that different artworks are visible at one time. Even though the artbubble is a pretty chaotic mess, it is still entertaining to see it appear and disappear on the horizon; it seems far, far away, but also so, so close.

On planet Münster, in Year 1, the model becomes the new reality. Where buildings before were intended to look like a rendering, a virtual space, a place for pure normality or spirituality, now the lack of gravity has a funnily negative effect on them—they appear somehow like flimsy assertions, not to be taken seriously any more.

Nora Schultz

XYO 1967 H. 450 cm

Nora Schultz

Die Menschen fangen an, hier und da kleine Verschmutzungen einzufügen, damit die Gebäude lebendiger und geerdeter wirken. Sie fügen die Stadt neu zusammen und bauen verschiedene, riesige Lichtschalter ein, die sie von dem Recyclingplaneten der alten Welt holen, für atmosphärische Lichtverlagerungen in größerem Maßstab. Wie üblich brauchen sie lange, lange Zeit, um sich an die neue Situation zu gewöhnen. Einige Jahre später, im Jahr 1, erscheint wieder der Kunstmond am Horizont, und Olle Bærtlings Skulptur *Xyya* aus dem Jahr 1, von vor mehreren Jahren, ist gut zu sehen. Jetzt endlich kann sein Plan, sie als 73 Meter hohe Version auf dem Dach eines Hochhauses zu realisieren, umgesetzt werden. Und seine Aussage, dass die Skulptur nur als Modell für diese gigantische Realisierung gedacht ist, leuchtet den Münsteraner_innen plötzlich ein. Für die Umsetzung seines 525 Meter hohen *Yayao*, aus dem Meer aufsteigend, sind sie noch nicht ganz bereit, aber *Xyya* wird aus der Blase abgeholt und mitten in die Stadt gestellt, von wo aus es seinen langen Schatten auf Straßen, Häuser und mehrere Sky Lobbys der Stadt wirft.

People start to insert small spots of dirt here and there, to make the buildings seem more lively and grounded. They reassemble the city and build in various gigantic light switches that they take from the recycling planet of the old world to create atmospheric light shifts on a bigger scale. As usual, the process of assimilation to the new situation takes them a long, long time. In Year 1, several years from then, the artmoon appears on the horizon again and Olle Bærtling's sculpture *Xyya* from Year 1, several years from now, is well visible. Now, his plan to realize it as a 73-metre version on top of a skyscraper can finally be realized, and his statement that his sculpture is meant as a mere model for this gigantic realization suddenly makes a lot of sense to the people of Münster. They are not quite ready yet for the realization of his 525-metre *Yayao*, rising from the sea, but *Xyya* is picked up from the bubble and placed right into the city, where it casts its long shadow over the streets, houses, and several sky lobbies in town.

Es wird geplant, weitere Kunstwerke auf spektakuläre Art und Weise in die neue Welt zu integrieren: Landschaftsgemälde werden zu Landschaften aus Gemälden, kleine Projektionen werden groß, Kurzfilme lang, lang, usw.

Nora Schultz

More artworks are planned to be integrated into the world in spectacular new ways: paintings of landscapes become landscapes of paintings, small projections turn big, short films long, long, etc.

Nora Schultz

Die Abbildungen beinhalten Fotos und Bildausschnitte von Olle Bærtlings Skulpturen *Xyya* (1949) und *Asamk* (1961), dem LWL-Museumskatalog *Architektur als Sequenz* und der LWL-Museumslobby.
The images include photographs and details of Olle Bærtling's sculptures *Xyya* (1949) and *Asamk* (1961), and from the LWL-Museum catalogue *Architektur als Sequenz* (Architecture as a Sequence) and the LWL-Museum Lobby.

Nora Schultz

Thomas Schütte

Thomas Schütte (*1954 Oldenburg, lebt in Düsseldorf) nimmt mit der Setzung seiner figürlichen und architektonischen Skulpturen auch unscheinbare Plätze oder in Vergessenheit geratene Orte in den Blick. In die Entwicklung seiner Werke spielen Bezugnahmen auf Architektur, Geschichte und Geschichten hinein. Zugleich wirken die Referenzen irritierend, seltsam umgedeutet oder von überraschenden und nachdenklich stimmenden Motiven unterbrochen. Auf diese Weise sensibilisiert sich die Aufmerksamkeit für den Stadtraum und für die Vielfalt des öffentlichen Lebens. Urbanität ist ein zentrales Thema im Werk von Schütte, der mit seinen Werken seit den 1980er Jahren zu den Diskursen von Kunst im öffentlichen Raum beiträgt. Zu konzeptuellen Fragestellungen bewahrt er eher Distanz, und seine Werke können sich den Betrachter_innen auch ohne entsprechendes Kontextwissen erschließen.

Nuclear Temple

Schütte platziert die drei Meter hohe, 2,5 Tonnen schwere, malerisch oxidierte Stahlskulptur auf dem Gelände des alten Zoos: in die Mitte eines überschaubaren, teils von flachen Mauern gerahmten Areals, direkt auf dem sandigen Boden. Der architektonische Körper ist an seinen acht Seiten von je einem Torbogen geöffnet, über welchem sich, im oberen Drittel der acht Flächen, je drei rückseitig geschlossene Fensternischen befinden. Der Maßstab von Toren und Nischen verweist auf den Modellcharakter des Werkes, das Vorbild für einen oktogonalen Kuppelbau sein könnte. Den Innenraum teilen 16, zwischen die acht Tore gesetzte Stahlwände, die sich auf das Zentrum der im Prinzip kreisrunden Grundfläche ausrichten. Je zwei Wände schließen sich alsbald und gemäß eines 45°-Winkels zu einer Kammer. Zwischen den Kammern führen acht Gänge auf das Zentrum der Architektur zu einer gemeinsam eröffneten Leerstelle, die von einem Opaion oder Auge in der Kuppel ins Licht gesetzt ist.

Mit dem *Nuclear Temple* stehen zwei weitere, im Gelände auf Sichtachse befindliche Rundbauten in Beziehung: die befestigte Ruine des *Eulenturms*, als solcher ein Relikt des ehemaligen Zoos, und die *Wasserbär* genannte Bemauerung eines Wasserwehrs. In dieser Konstellation aktualisiert sich der Blick auf Stadtgeschichte, die immer auch eine technologische und militärische ist, auf Kolonialgeschichte, die in Münster zum Beispiel in den sogenannten Völkerschauen im alten Zoologischem Garten präsent war – es aktualisiert sich Kulturgeschichte aus den historischen Bauwerksresten, mit welchen der *Nuclear Temple* in ein Spannungsverhältnis tritt. Das Werk gibt Anlass, über ein Verständnis von Geschichte nachzudenken, das mit abgeschlossenen zeiträumlichen Einheiten hantiert. Der *Nuclear Temple* verweist auf die Fluchtlinien der Zivilisation und ihre Vernichtungen, den Gang der Zivilisierung und ihrer Wirkung auf die Verfasstheit des Gemeinwesens und auf diejenige des Subjekts. N.T.

Material
Hohlform, 8 mm Stahlblech, Lasercut, geschweißt

Maße
Durchmesser ca. 250 cm,
Höhe ca. 300 cm

Standort
Altes Zoogelände, hinter der Musikschule
Himmelreichallee 50, 48149 Münster
(Zugang über Promenade)

Thomas Schütte

Thomas Schütte's (*1954 Oldenburg; lives and works in Düsseldorf) placement of his figural and architectural sculptures spotlights inconspicuous places or sites that have been forgotten. The development of his works is also influenced by references to architecture, history, and stories. At the same time, the references have a disturbing effect: they are strangely reinterpreted or interrupted by the surprising and thought-provoking motifs. In this way, the viewers' awareness of urban space and the diversity of public life is sensitized. Urbanity is a key theme in Schütte's artwork—he has been contributing to the discussion of art in public spaces since the 1980s. Yet he prefers to keep his distance to conceptual matters. In fact, his works are accessible to viewers even without contextual knowledge.

Nuclear Temple

Schütte has placed the artistically oxidized, 3-metre-high, 2.5-ton steel sculpture in the grounds of the former Zoo, the old zoo: on sandy ground in the middle of a clearly defined area partly surrounded by low stone walls. Each of the architectural structure's eight sides has an open archway, above which—in the upper third of the surface—there are three window recesses that are closed at the back. The scale of the doors and recesses points to the model-like quality of the work, which could be the prototype for a domed octagonal building. Situated between the eight archways, sixteen steel walls partition the interior and are aligned towards the centre of the essentially circular base. In each case two walls quickly come together at a 45-degree angle to form a chamber. Between the chambers there are eight corridors leading to the heart of the structure, creating a shared empty space at the centre that is lit by an oculus or eye in the dome.

There are also two other related round structures on the grounds located along a visual axis with the *Nuclear Temple*: the fortified ruins of the Owl Tower (*Eulenturm*), a relic of the former zoo, and the batardeau, constituted by the walls of a weir. This constellation updates our view of urban history (which always has its technological and militaristic side too), colonial history (which, for example, was present in Münster in the 'Völkerschauen', the ethnological displays at the former Zoologischer Garten), and cultural history, derived from the historic architectural remains, which have a dynamic relationship with the *Nuclear Temple*. The work gives rise to speculations about an understanding of history that makes use of closed units of time and space. The *Nuclear Temple* alludes to the vanishing lines of civilization and its periods of destruction, to the course of the civilizing process and its effect on the constitution of the community and of the subject. N.T.

Material
Mould, 8 mm steel sheeting, laser cut, welded

Dimensions
Diameter ca. 250 cm
height, ca. 300 cm

Location
Former zoo grounds, behind music school
Himmelreichallee 50, 48149 Münster
(access via Promenade)

Innen und Außen als Modell

Der *Nuclear Temple* ist eines der seltenen Architekturmodelle im Außenraum von Thomas Schütte, das weder begehbar ist, noch Einblick in einen Innenraum gewährt. Es ist ausgerüstet wie ein Denkmal, das Jahrhunderte überdauern kann. Seit seinem Entstehen vor fünf Jahren arbeitet der Regen an der Oberfläche des Tempels und überzieht den Stahl mit flächigen Schlieren von Rost – vor denen meditiert werden könnte. Ob man den *Nuclear Temple* eine Skulptur, ein Modell oder eine Architektur nennen möchte, führt gleichermaßen zur Geschichte des Werkes.

2011.

Der *Nuclear Temple* hat ein Vormodell (*Tempel I*, 2011), das gemeinsam mit einem weiteren Werk Schüttes (*Tempel II*, 2011) im Rahmen der Ausstellung *Thomas Schütte. Houses* im Musée National de Monaco 2012 und im Kunstmuseum Luzern 2014 präsentiert wurde. *Tempel I* zitiert die Gestalt einer Versammlungshalle, vielleicht ein Pantheon oder eine Architektur von Rudolf Steiner. *Tempel II* erinnert an ein Ei oder an eine Bombe, vielleicht auch an den Behälter einer Biogasanlage, jedenfalls handelt es sich um eine vollkommen in sich geschlossene Form. Die Gegenüberstellung der Skulpturen wirft Fragen nach dem Einfluss des technologischen Denkens auf die Kultur, nach dem

Inside and Outside as a Model

The *Nuclear Temple* is one of Thomas Schütte's rare architectural models in the outdoor space that can neither be entered nor peered into. It resembles a monument built to withstand the test of time. Ever since it was erected five years ago, the rain has worked on the temple's surface, covering the steel with streaky areas of rust that might serve as an object of contemplation. Regardless of whether you prefer to see the *Nuclear Temple* as a sculpture, a model, or an architectural structure, you come in any case to the history of the object.

2011

The *Nuclear Temple* has a prototype (*Temple I*, 2011), which was presented together with another one of Schütte's works (*Temple II*, 2011) as part of the exhibition *Thomas Schütte: Houses* at the Musée National de Monaco in 2012 and at the Museum of Art Lucerne in 2014. *Temple I* makes reference to the shape of an assembly hall, perhaps a pantheon or an architectural design by Rudolf Steiner. *Temple II* is reminiscent of an egg or a bomb—it may even evoke the gasometer of a biogas plant. In any case, it is an absolutely self-contained form. The comparison of these sculptures raises questions about the influence of technological ideas on culture, about human beings in a work-

Thomas Schütte, *Tempel I + II*, 2010

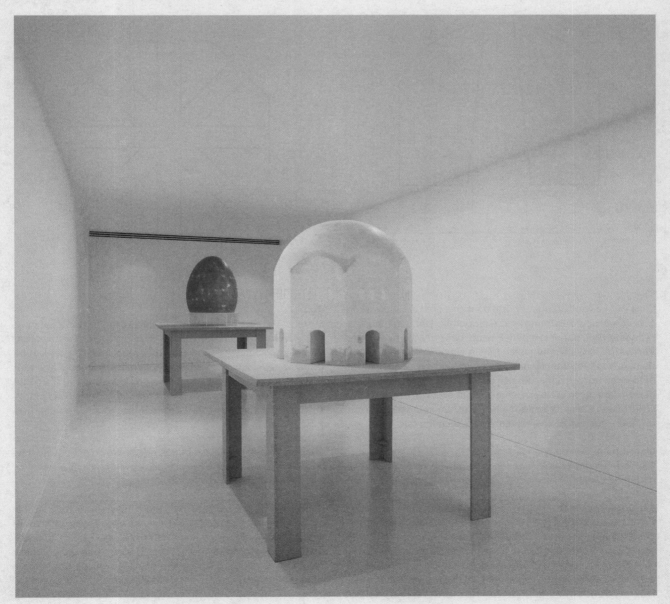

Menschen in der technologisch bestimmten Arbeitswelt und der ethischen Verantwortung für ein von Machbarkeit geleitetes Handeln auf. Es sind Fragen nach der Sehnsucht des nachmodernen Menschen, in einer sich unentwegt erneuernden technischen Utopie nicht Teil der Maschine zu sein, sondern sich als Subjekt in die Unverfügtheit der Transzendenz zu öffnen. Die Sehnsüchtigen finden möglicherweise ihren Weg in eine religiöse Gemeinschaft, für die der Tempel Sinnbild ist.

2012.

Interessenten aus dem arabischen Emirat Katar entdecken den *Tempel I* als mögliches Architekturprojekt für sich. Schütte denkt an ein Bauwerk, das wie ein anderes Werk[1] aus Naturstein oder aus farbig glasierten Ziegeln gemauert werden könnte. Er lässt ein Präsentationsmodell herstellen, den *Nuclear Temple*. Das aus einem Styroporblock gesägte skulpturale Vormodell *Tempel I* wird in erheblicher Vergrößerung aus Stahlelementen rekonstruiert. Acht Millimeter dicke Platten und eine Kugelhaube werden verschweißt und an deren höchstem Punkt eine kreisrunde Öffnung ausgeschnitten. Schütte überdenkt den Grundriss und versieht den Innenraum mit acht Kammern. Das Bild eines gesprengten Kerns entsteht. Die Gestalt eines Tempels verfügt sich mit dem einer Bombe zu einer Figur. Wirklichkeit.

ing environment dominated by technology, and about where the ethical responsibility lies for actions dictated by feasibility. These are questions that probe postmodern man's yearning not to be a part of the machine in a technological utopia that is constantly being renewed, his endeavour to open himself up as a subject to the unavailability of transcendence. A person with these aspirations will possibly seek out a religious community as symbolized by the temple.

2012

Interested persons from the State of Qatar are to discover *Temple I* as a potential architectural project in its own right. Schütte has in mind a structure that could be built of coloured glazed bricks or natural stone like another of his works.[1] He has had a model made for presentation purposes, the *Nuclear Temple*. The sculptural prototype *Temple I*, which is cut from a block of styrofoam, is reconstructed from steel elements at a much larger scale. Steel plates with a thickness of 8 mm are welded with a spherical cap, and a circular opening is cut out at the apex. Schütte has rethought the floor plan and added eight chambers to the interior, creating an image of an exploded nucleus. Temple and bomb are melded to create a figure.

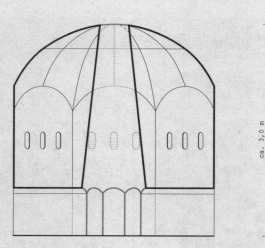

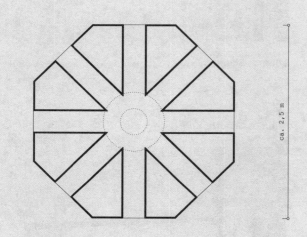

Viele Werke von Thomas Schütte thematisieren die Auswirkungen von Machtausübung und Geldpolitik. Der Titel *Nuclear Temple* könnte daher mit dem Einsatz der *Fat Man* genannten Kernwaffe in Verbindung stehen, die ein amerikanisches Militärflugzeug 1945 über Nagasaki abwarf, und mit einer weiteren nuklearen Katastrophe, die sich am 11. März 2011 ereignete. An diesem Tag lösen die Kernschmelzen in drei von Erdbeben erschütterten Kernkraftanlagen in Fukushima eine globale und bis heute nachwirkende nukleare Verseuchung aus.

Innen und Außen als Modell.

Die Tore des Modells *Nuclear Temple* gewähren nicht den Eintritt in das Architekturmodell oder den Weg zu seinem Innenraum. Sie laden vielmehr zu einem Eintreten in die Vorstellung ein. Das Modell kann erlebt werden, weil es sich auf bestehende Erfahrungen bezieht, auf Erinnerungen an Geborgenheit, Abgeschiedenheit, Eingeschlossenheit. In die Neugier, wie und welche Räume sich in der Vorstellung noch eröffnen mögen, fließt vielleicht auch Furcht und Abwehr. Auf diese Weise ist ein Modell auch eines der inneren Verfasstheit, das Tagesbewusstsein und Träume, Bewusstes und Unbewusstes in sich vereint. Zugleich

Reality

Many of Thomas Schütte's works deal with the impact of political power and monetary policy. The title *Nuclear Temple* could thus be associated with the use of *Fat Man*, the nuclear weapon dropped on Nagasaki by a US military aircraft in 1945, and with another nuclear disaster that occurred on 11 March 2011. On that day, in Fukushima, meltdowns in three nuclear power plants struck by earthquakes triggered ongoing global contamination.

Inside and Outside as a Model

The doorways of the model *Nuclear Temple* do not permit anyone to enter the architectural model and access its interior. In fact, the only conceivable way in is through the imagination. The model can be experienced, because it alludes to existing experiences, to feelings of security, seclusion, enclosure. Fear and resistance may also feed into the sense of curiosity about how and what spaces may open up in the mind. In this way, a model is also a model of one's internal constitution, combining waking consciousness and dreams and one's conscious and unconscious mind. At the same time, it creates a distance to real experiences and gives one the ability to analyse, reorganize, and

Thomas Schütte

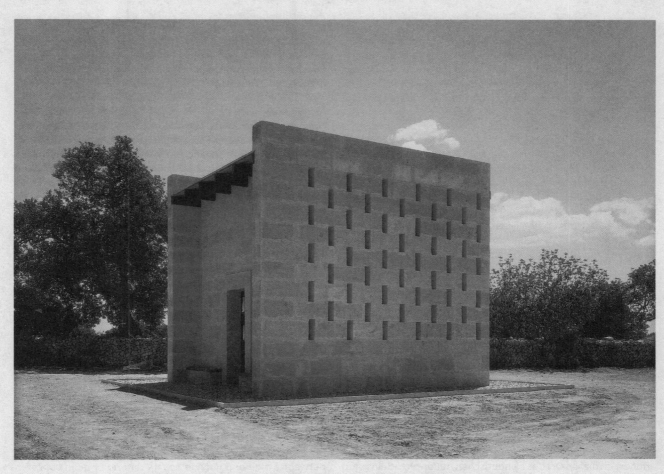

Thomas Schütte, *Ackermans Tempel*, 2012, Marès Stein / Marès stone, 560 × 540 × 650 cm, Mallorca

Thomas Schütte, *One Man House II*, 2007–2009, Stahl, Holz, Glas, Farbe / steel, wood, glass, paint, 500 × 800 × 800 cm

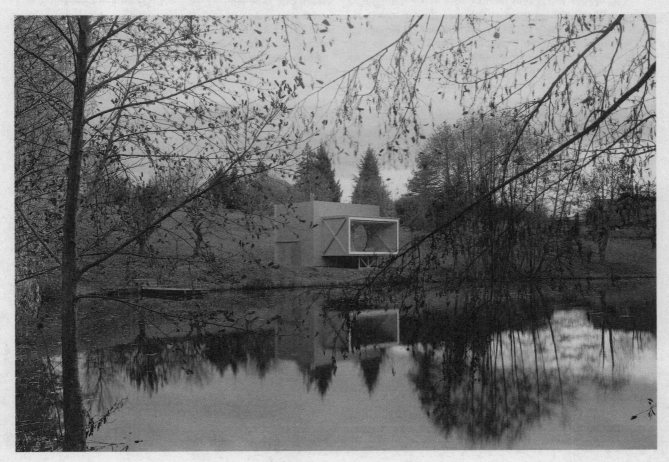

schafft es eine Distanznahme zu realen Erfahrungen, ermöglicht Analysen, Umstellungen und Versuchsanordnungen, in denen Veränderungen erprobt werden können. Die Gestaltung eines Modells definiert die Beziehung von innen und außen oder ist Ausdruck des spezifischen Verhältnisses von Subjekt und Welt. In den Architekturmodellen von Thomas Schütte ist es ein zentrales Thema.

Ein Beispiel.
Mit den Architekturmodellen *One Man Houses* entstehen Baukörper, die wie räumliche Metaphern der Verfasstheit des modernen Subjekts erscheinen. Das Modell *One Man House II* [2] wird 2009 auf dem idyllischen, an einem Gewässer gelegenen Grundstück eines Kunstsammlers im französischen Roanne realisiert. Das Haus enthält einen einzigen Raum mit zwei Fenstern, die wie Objektive einer alten Kamera auskragen, aus denen sich der Blick in das Gelände auftut.

Romantik.
Ein derartiger Blick aus der bergenden Kammer findet sich auch – als ein Setting der Romantik – in Caspar David Friedrichs Bild *Das Eismeer. Die gescheiterte Hoffnung*. [3] Das Werk berichtet von der Gewahrwerdung der Risse, die sich im romantischen Bewusstsein eröffnen. Die Grundstimmung des romantischen Subjekts ist deshalb eine melancholische, die im Zeichen des Vormärz auch vom Verlust der Einflussnahme auf das politische Geschehen geprägt ist. Georg Friedrich Kerstings Bild *Caspar David Friedrich in seinem Atelier* [4] zeigt den Maler in der Abgeschiedenheit seiner Kammer vor einer Staffelei, versunken in den Prozess der Innenschau. „Er fing das Bild nicht an, bis es lebendig vor seiner Seele stand." [5] Das *One Man House* erinnert an diesen Ort des romantischen Außer-sich-Seins und an eine Verfassheit, die ihren Bezugspunkt in einem absoluten Außen fand. Das Verhältnis von innen und außen entbehrt in der Konstitution des gegenwärtigen Subjekts seiner Bezugs- oder Anhaltspunkte. Innen und außen scheinen zu kollabieren, eine Zone der Ununterscheidbarkeit zu bilden, wie zum Beispiel im Aufgehen von Natur und Technik oder in der digitalen Arbeitswelt. Wir sind auf ein Selbst verwiesen, dessen Interpretation sich im Außen verliert, uns jedoch zugleich anheimgestellt ist. Die Verlassenheit, die Thomas Schüttes Werk *One Man House II* vermittelt, hat wenig gemein mit einem romantischen Rückzug oder einer Eremitage, mit Orten, an denen das Unbegrenzte zu denken versucht wurde. Im *Nuclear Temple* könnte es von dem Opaion [6] angedeutet sein, das sich über dem leeren Platz in der Mitte des Modells öffnet.

Nicola Torke

create experimental set-ups in which variations can be tested. A model's design defines the relationship between inside and outside, or it is the expression of the specific relationship between the subject and the world. It is a central theme in Schütte's architectural models.

An Example
The architectural models *One Man Houses* are structures that materialized as spatial metaphors for the inner constitution of the modern subject. The model *One Man House II* [2] was built in 2009 on an art collector's property in the French town of Roanne, an idyllic plot of land on a stretch of water. The house consists of one room with two windows that protrude like the lenses of an old camera, opening up a view of the landscape.

Romanticism
A similar view from a concealed chamber can be found—as a Romantic setting—in Caspar David Friedrich's picture *The Sea of Ice, or The Wreck of Hope*. [3] The painting refers to an awareness of the cracks that are revealed in the Romantic consciousness. Consequently, the prevailing mood of the Romantic subject is melancholic, characterized by the loss of influence on political events as experienced in the pre-revolutionary period prior to 1848. Georg Friedrich Kersting's portrait *Caspar David Friedrich in His Studio* [4] shows the painter standing in the seclusion of his chamber, in front of his easel, lost in the process of introspection. *He did not begin to paint an image until it stood, living, in the presence of his soul.* [5] The *One Man House* evokes this place where the Romantic subject is outside itself, recalling a disposition that found its point of reference in absolute exteriority. In the constitution of the contemporary subject, the relationship between inside and outside has no criteria or points of reference. Inside and outside seem to collapse, creating a zone of indistinguishability, as in the merger of nature and technology or in the digital work environment. We are referred to a self whose interpretation loses itself in the exterior world but is left to our discretion at the same time. The forlornness that Schütte's work *One Man House II* conveys has little in common with a retreat or a hermitage, with places where one seeks to ponder the limitless. In the *Nuclear Temple*, it might be suggested by the oculus [6] that opens up above the empty space in the middle of the model.

Nicola Torke

1 *Ackermans Tempel I*, 2012, Palma de Mallorca, Spanien.
2 *One Man House II*, 2007–2009, Roanne, Frankreich.
3 Caspar David Friedrich, *Das Eismeer. Die gescheiterte Hoffnung*, 1823/24, Hamburger Kunsthalle.
4 Georg Friedrich Kersting, *Caspar David Friedrich in seinem Atelier*, um 1812, Alte Nationalgalerie, Berlin.
5 Carl Gustav Carus über Caspar David Friedrich, Zitat aus: Wieland Schmied, *Caspar David Friedrich*, DuMont Buchverlag, Köln 1992, S. 50.
6 Ein Opaion (griechisch ὀπαῖον für *Rauchloch*) ist eine runde Öffnung am höchsten Punkt einer Kuppel. Andere Bezeichnungen sind Kuppelauge oder schlicht Auge.

1 *Ackermans Tempel I*, 2012, Palma de Mallorca, Spain.
2 *One Man House II*, 2007–2009, Roanne, France.
3 Caspar David Friedrich, *Das Eismeer: Die gescheiterte Hoffnung*, 1823/4, Hamburger Kunsthalle.
4 Georg Friedrich Kersting, *Caspar David Friedrich in seinem Atelier*, ca. 1812, Alte Nationalgalerie, Berlin.
5 Carl Gustav Carus on Caspar David Friedrich, cited in Wieland Schmied, *Caspar David Friedrich* (Cologne: DuMont, 1992), 50.
6 An oculus (Greek ὀπαῖον, meaning 'a hole in the roof') is a circular opening at the apex of a dome.

Michael Smith

Michael Smiths (* 1951 Chicago, lebt in New York und Austin) künstlerische Praxis umfasst Performances, Videos und Installationen, die häufig mit der Adaption populärkultureller Medienformate und Trends operieren. Seit den 1970er Jahren bevölkern die Charaktere Mike und Baby Ikki seinen multimedialen, von Tragikomik durchzogenen künstlerischen Kosmos. In jüngerer Zeit diente Smith vor allem der naive Durchschnittsamerikaner Mike als Alter Ego für die Auseinandersetzung mit Themen wie Alter, Jugendkult, Trends und Rollenbildern.

Not Quite Under_Ground

Mit der Installation eines Tattoostudios in Münster, in dem Personen ab 65 Jahren Sonderkonditionen erhalten, verschränkt Smith diesen Themenstrang mit Aspekten des Städte- und Kulturtourismus. Besucher_innen können Motive aus einem Bilderpool wählen, zu dem aktuelle und ehemalige Teilnehmer_innen der Ausstellung ebenso wie befreundete Künstler_innen und die Tätowierer_innen Zeichnungen beigesteuert haben. Die Bandbreite reicht von miniaturisierten Visualisierungen von Ausstellungsbeiträgen bis zu autonomen Entwürfen. Ein vom Künstler produzierter Werbeclip läuft an Infoständen und bei Stadtrundfahrten durch Münster im Bus. Der Clip zeigt eine Reisegruppe im besten Alter auf ihrem Trip in die Welt des Tätowierens.

Smiths Projekt resultiert aus einer Verknüpfung lokaler und einfacher Alltagsbeobachtungen. Mit Interesse registrierte er sowohl die große Zahl an kulturaffinen Senior_innen, denen Münster als Ausflugsziel dient, als auch — unabhängig davon — die gesellschaftliche Akzeptanz, die Tätowierungen als Form symbolischer Körperkommunikation seit den 1990er Jahren erfahren haben. Lange mit Vorurteilen behaftet, sind sie als Lifestylephänomen und Selbstinszenierung, die ihr provokatives Potenzial weitgehend verloren hat, vor allem in einer jüngeren Generation stark präsent. Als schmerzhafte Umgestaltungen jener Membran, die Äußeres und Inneres trennt, fungieren Tattoos nicht nur als Körperschmuck, ihnen kommt als individuell gewählter Ausdruck auch identitätsstiftende Funktion zu. Smiths Arbeit knüpft an dieses dem Medium inhärente Transformationsmoment an und propagiert, nicht ohne Augenzwinkern, eine Verjüngung mittels Anpassung an das jugendlichere Erscheinungsbild. Zudem nimmt sie Bezug auf die Geschichte und das Format der Skulptur Projekte. Im Gegensatz zum temporären Charakter der Ausstellung zeugen die tätowierten Souvenirs von einer Kunsterfahrung, die dem Speichermedium der Haut über das Ausstellungsende hinaus physisch eingeprägt bleibt. Die Zusammenarbeit mit Künstler_innen und Tätowierer_innen löst nicht nur die singuläre künstlerische Geste zugunsten einer kollektiven Autorschaft auf, sondern verschleift auch die Grenzen von Ausstellungskunst und populärkulturellen Bildmedien. Der mehrdeutige Titel spielt dabei sowohl auf die Tatsache an, dass Tätowierungen längst im Mainstream angekommen sind, als auch auf die gewachsene Popularität der Münsteraner Ausstellung. Zudem lässt er sich in abgründiger Weise auf das fortgeschrittene Lebensalter der Zielgruppe beziehen, das auch Smiths eigenem entspricht. A.P.

Material
Installation, verschiedene Medien und Aktivitäten

Standort
Tätowierstudio
Hansaring 38, 48155 Münster

Projekt Credits
Crew Tätowiersucht: Sascha Achilles, Elli Beike, Tanina Palazollo, Frank Zimmermann
Recherche: Kate Scherer
Design: Jesse Cline
3D-Visualisierung: Bill Haddad, Blue House Design
Poster: James Scheuren
Produktionssupport: Dan Gunn

Darsteller_innen
Sascha Achilles, Annegret Diehle, Heiner Diehle, Gerda Esser, Uschi Kniewel, Manfred Krukenkamp, Gilla Pitz, Tanina Palazollo, Michael Smith, Friedel Werner

Filmteam
Drehbuch: Michael Smith • Produziert von: jae kunst und medien • Regisseurin: Leila Aliev • Kameramann: Jan Enste • Koordination: Julia Jung • Soundtrack: Kevin Bewersdorf • Schnitt: Leila Aliev, Jan Enste • Beleuchter / Kameraassistent: Gunar Peters • Visuelle Effekte: Adnan Alorbeni • Set-Runner: Anna Viehoff • Equipment: cineOne Dortmund, Kunstakademie Münster, Filmwerkstatt Münster e. V.

Dank an alle Künstler_innen, die Tattoos für *Not Quite UNder_Ground* designt haben.

Michael Smith

Michael Smith (* 1951 Chicago; lives in New York and Austin) is a performance, video, and installation artist who often adapts media formats and trends from popular culture. Since the 1970s, his performance personae, Mike and Baby Ikki, have inhabited familiar landscapes infused with tragicomic elements. Most recently, Smith has used Mike, the average naive American, to address time-worn themes such as aging and the cult of youth.

Not Quite Under_Ground

Setting up Not Quite Under_Ground (the official tattoo studio of Skulptur Projekte Münster 2017), as both an installation and a fully operational tattoo shop offering deep discounts to seniors aged 65 and older, Smith links this particular thread with aspects of urban and cultural tourism. Visitors are invited to get tattoos, designed by past and present participants of Skulptur Projekte Münster, as well as Smith's personal friends and local tattooists. The spectrum of tattoos ranges from miniature visualizations of Skulptur Projekte Münster projects to stand-alone motifs. In addition, a video is embedded at various tourist attractions and on sightseeing buses, dramatizing a spirited elder group's journey into a brand new world bonded by tattoos.

Smith's project is the result of combining local and general observations of everyday life. It not only caught his eye that a large number of culturally interested senior citizens are heading for Münster, but also—irrespective of this realization—that tattoos, as a form of symbolic body language, have become increasingly socially acceptable since the 1990s. Long tainted by prejudice, tattoos have now become prevalent lifestyle brands and means of self-expression that have lost their provocative potential, especially for younger generations. Tattoos, as a painful remodelling of the membrane separating the internal from the external, not only serve as physical decorations but also confer a certain identification with the selected design. Smith's work underscores this moment of transformation, which is inherent to the medium, and touts rejuvenation—not without a touch of irony—by helping people conform to a more youthful appearance. Not Quite Under_Ground is also linked to the history and format of Skulptur Projekte: in contrast to the temporary character of the exhibition, tattoos can provide permanent souvenirs of an art experience, leaving physical marks in the storage medium of the skin, long past the closing date of the show. The cooperation between artists and tattooists does not merely eliminate singular artistic gestures in favor of a collective authorship; it also blurs the boundaries between exhibition art and the visual media of popular culture. The ambiguously humorous title refers not only to the fact that tattoos have been part of the mainstream for some time but also to the growing popularity of the exhibition in Münster and the advancing age of the target demographic to which Smith himself belongs. A.P.

Material
Installation with mixed media and activities

Location
Tattoo studio
Hansaring 38, 48155 Münster

Project Credits
Tattoo crew Tätowiersucht: Sascha Achilles, Elli Beike, Tanina Palazollo, Frank Zimmermann
Research: Kate Scherer
Design: Jesse Cline
3D visualization: Bill Haddad, Blue House Design
Poster: James Scheuren
Production support : Dan Gunn

Film Cast
Sascha Achilles, Annegret Diehle, Heiner Diehle, Gerda Esser, Uschi Kniewel, Manfred Krukenkamp, Gilla Pitz, Tanina Palazollo, Michael Smith, Friedel Werner

Film Crew
Script: Michael Smith • Produced by: jae kunst und medien • Director: Leila Aliev • Director of photography: Jan Enste • Coordinator: Julia Jung • Soundtrack: Kevin Bewersdorf • Editor: Leila Aliev, Jan Enste • Gaffer / camera assistant: Gunar Peters • Visual effects: Adnan Alorbeni • Set-runner: Anna Viehoff • Equipment: cineOne Dortmund, Kunstakademie Münster, Filmwerkstatt Münster e.V.

Special thanks to all the artists who designed tattoos for Not Quite Under_Ground.

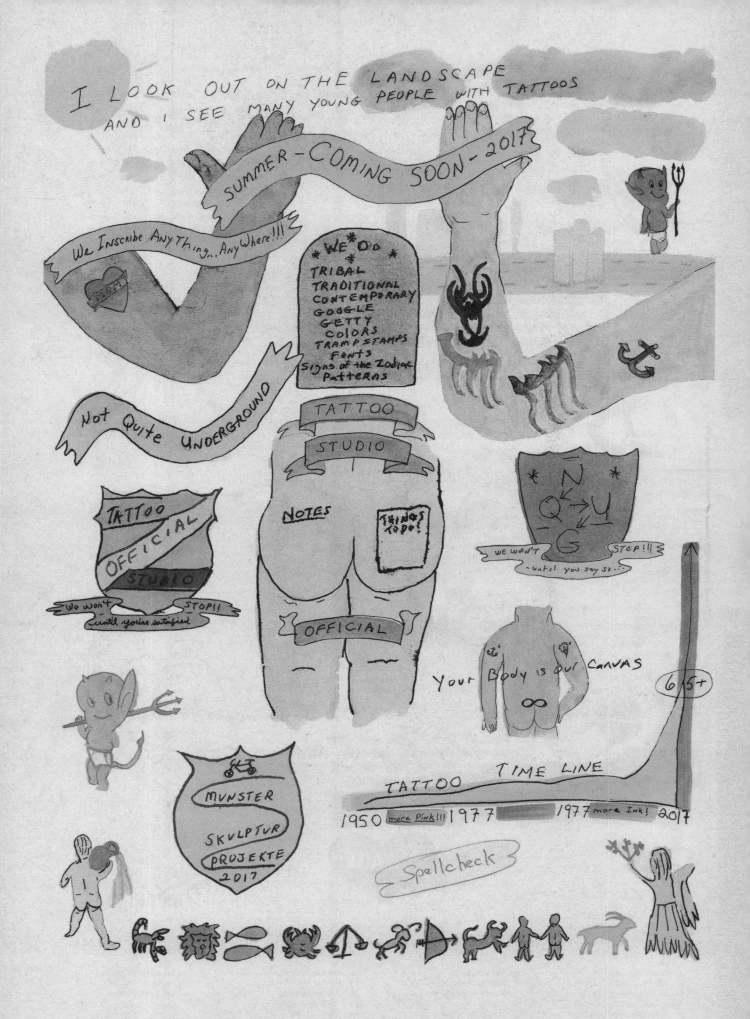

Michael Smith

FOREVER & A DAY

1.

2.

HOME SWEET HOME

3.

4.

5.

6.

7.

8.

9.

10.

11. HELL YEAH

12.

13.

STILL HERE

14.

15.

LOVE ME BETTER

16.

1 Lawrence Weiner
2 Tobias Rehberger
3 Jordan Rathus
4 Ellie Beike

5 Jake Borndal
6 Clemens von Wedemeyer
7 Michel Sauer
8 Jen Hitchings

9 Leslie Mutchler
10 Valesca Gutzeit
11 Sascha Achilles
12 Wade Guyton

13 Robert Fones
14 Andrea Blum
15 Martha Edelheit
16 Ali Fitzgerald

Michael Smith

nicht reanimieren

BEAUTIFUL CLEAR SKIN

I'VE BEEN AGAIN

BE SAFE CLOSE COVER BEFORE STRIKING

OLDER LADY

1.
2.
3.
4.
5.
6.
7.
8.
9.
10.
11.
12.
13.
14.
15.
16.
17.
18.

Hito Steyerl

Die Filme, Installationen und Schriften von Hito Steyerl (* 1966 München, lebt in Berlin) gehen aus einer systemischen Denk- und Arbeitsweise hervor, in der künstlerisches Schaffen und die theoretische Durchdringung von globalen gesellschaftlichen Fragestellungen aufs Engste verbunden sind. Steyerl analysiert die Wechselwirkungen und Synthesen von technologischen und künstlerischen Bildsprachen, zum Beispiel auf der Ebene der visuellen Massenkultur – und deren Funktion im Gesamtdispositiv von Technokratie, Geldpolitik, Machtmissbrauch, Gewalt.

HellYeahWeFuckDie

Ort für ihre Installation ist das Gebäude der Westdeutschen Landesbausparkasse (LBS), eine futuristisch-technokratische Architektur, die 1975 auf dem nördlichen Gelände des alten Zoos durch den Bankier Ludwig Poullain erbaut wurde. Im ehemaligen Kassenschalterraum und Foyer befinden sich Werke kinetischer Kunst von Heinz Mack, Günther Uecker, Otto Piene etc. aus der LBS-Sammlung, die im Rahmen der Skulptur Projekte der Öffentlichkeit wieder zugänglich gemacht werden. In das Foyer des modernistischen Gebäudes werden raumgliedernde Absperrelemente (Stahlrohr) und Wände (Stahlprofilbleche) eingepasst. Auf drei Monitoren sind kompilierte Video-Audio-Sequenzen zu sehen: Dokumentationsmaterial aus Laboren über konkrete physische oder am Rechner simulierte Krafteinwirkungen auf humanoide Roboter, mit denen das Balanceverhalten getestet wird. Die Videos beginnen mit der Animation eines losen Satzes: HELL YEAH WE FUCK DIE – die laut dem Online-Magazin *Billboard* am häufigsten gebrauchten fünf Worte in den englischsprachigen Musikcharts der vergangenen Dekade. Sie liefern die Basis für die musikalische Komposition und tauchen auch in Form von leuchtenden Schriftzügen, eingefasst in Beton, wieder auf. Im hinteren Raum befindet sich ein weiterer Aufbau mit den gleichen Elementen, zudem ist ein weiteres Video zu sehen: Aufnahmen aus der kurdischen Stadt Diyarbakır im Südosten der Türkei, deren Innenstadt 2016 weitgehend im Rahmen eines neuangefachten Bürgerkriegs in den kurdischen Gebieten durch das türkische Militär zerstört wurde. Dort wirkte der Wissenschaftler und Ingenieur al-Dschazarī, der 1205 ein Werk über mechanische Apparaturen verfasste, das Buch des Wissens von sinnreichen mechanischen Vorrichtungen, als *Automata* im westlichen Kulturbereich bekannt. Steyerl kombiniert die Aufnahmen aus der Stadt mit Fragen an die auf dem Mobiltelefon installierte Software SIRI: Welche Rolle spielen Computertechnologien im Krieg? N.T.

HellYeahWeFuckDie [1]

Material
3-Kanal-Videoinstallation, Environment, 4 Min., HD Video (2016)

Standort
LBS West
Himmelreichallee 40, 48149 Münster
Zugang via Promenade, Foyer A

Credits
Soundtrack: Kassem Mosse ● Postproduktion: Christoph Manz, Maximilian Schmoetzer ● Produktionsleiterin: Lawren Joyce ● Produzent / Regisseur: MIT DARPA Robotics Challenge Team, Kevan Jenson ● Assistent: Milos Trakilović

Dank an: Dr. Imad Elhajj (Vision & Robotics Laboratory, American University of Beirut), Siyuan Feng (The Robotics Institute, Carnegie Mellon University), Thomas Geijtenbeek, Noel Maalouf (Vision & Robotics Laboratory, American University of Beirut), Natural Motion, MIT DARPA Robotics Challenge Team, Michiel van de Panne, Frank van der Stappe, Seedwell Media, Benjamin Stephens (Robotics Challenge Team, Carnegie Mellon University), WPI-CMU DARPA Robotics Challenge Team, Zhibin (Alex) LI (University of Edinburgh School of Informatics) sowie ATRIAS ROBOT (Oregon State University Terrestrial Robotics Engineering & Controls Lab, Virginia Tech)

Robots Today

Material
HD Video, 8 Min. (2016)

Credits
Protagonisten: Nevin Soyukaya (Archäologin, Wissenschaftlerin und Autorin, Leiterin des Departments kulturelles Erbe und Tourismus; Diyarbakır), Abdullah Yaşin (Wissenschaftler, Autor; Cizre) ● Tänzer: Ibrahim Halil Saka, Vedat Bilir, Sezer Kılıç ● Musik: Kassem Mosse ● Postproduktion: Christoph Manz, Maximilian Schmoetzer ● Assistent: Milos Trakilović ● Kamera: Savaş Boyraz ● Übersetzung: Rojda Tugrul, Övül Durmosoğlu ● Produktion: Misal Adnan Yıldız, Şener Özmen ● Unterstützt von: Barış Şehitvan, Zelal Özmen, Sümer Kültür Merkezi Diyarbakır

1 Basierend auf Recherchen von David Taylor, der die fünf populärsten Wörter in englischsprachigen Songtiteln seit 2010 ermittelt hat.

Hito Steyerl

Hito Steyerl's (* 1966 Munich; lives in Berlin) films, installations, and writings come out of a systemic way of thinking and working, in which artistic production and the theoretical analysis of global social issues are closely linked. Steyerl investigates the interaction and synthesis of technological and artistic imagery, for example, at the level of visual mass culture—and its function within the overall dispositif of technocracy, monetary policy, the abuse of power, and violence.

HellYeahWeFuckDie

The location for Steyerl's installation is the Westdeutsche Landesbausparkasse (LBS savings bank) with its futuristic technocratic architectural style. It was built in 1975 at the northern end of the old zoo by the banker Ludwig Poullain. In what used to be the cashier's hall and lobby there are kinetic works by Heinz Mack, Günther Uecker, Otto Piene, etc., from the LBS collection, which has been made accessible to the public again within the framework of Münster's Skulptur Projekte. Steyerl has installed tubular steel barriers and corrugated steel partitions in the lobby of the modernistic building. Compiled audiovisual sequences can be seen on three monitors: documentary lab footage showing computer-simulated or actual physical force applied to humanoid robots to test their balance behaviour. The videos begin with the animation of a fragmented sentence: HELL YEAH WE FUCK DIE—which according to the online magazine *Billboard* are the five most frequently used words in the English language music charts of the past decade. They provide the basis for the musical compositions and also appear in neon lettering encased in concrete. In the room at the back there is a further installation with the same elements and an additional video: footage of the Kurdish city of Diyarbakır in south-eastern Turkey, the centre of which was largely destroyed in 2016 by the Turkish military in a flare-up of the civil war in the country's Kurdish regions. The scientist and engineer Al-Jazarī worked there, writing a book about mechanical apparatuses in 1205 to convey knowledge about ingenious devices, a work known as *Automata* in Western culture. Steyerl combines the pictures of the city with questions addressed to SIRI, the software installed on the mobile phone: What role does computer technology play in war? N.T.

1 Based on research by David Taylor, who identified the five most popular words in English song titles since 2010.

HellYeahWeFuckDie [1]

Material
3-channel-video installation, environment, 4 min., HD video (2016)

Location
LBS West
Himmelreichallee 40, 48149 Münster
access via Promenande, Foyer A

Credits
Original soundtrack: Kassem Mosse ● Post-production: Christoph Manz, Maximilian Schmoetzer ● Line producer: Lawren Joyce ● Producer / Director of photography: California Robotic Challenge Kevan Jenson ● Assistant: Milos Trakilović

Special thanks to: Dr. Imad Elhaji (Vision & Robotics Laboratory, American University of Beirut), Siyuan Feng (The Robotics Institute, Carnegie Mellon University), Thomas Geijtenbeek, Noel Maalouf (Vision & Robotics Laboratory, American University of Beirut), Natural Motion, MIT DARPA Robotics Challenge Team, Michiel van de Panne, Frank van der Stappe, Seedwell Media, Benjamin Stephens (Robotics Challenge Team, Carnegie Mellon University), WPI-CMU DARPA Robotics Challenge Team, Zhibin (Alex) LI (University of Edinburgh School of Informatics) and ATRIAS ROBOT (Oregon State University Terrestrial Robotics Engineering & Controls Lab, Virginia Tech)

Robots Today

Material
HD video, 8 min. (2016)

Credits
Protagonists: Nevin Soyukaya (archaeologist, researcher, writer, Head of the Department Cultural Heritage and Tourism; Diyarbakır), Abdullah Yaşin, (researcher and writer; Cizre) ● Dancers: Ibrahim Halil Saka, Vedat Bilir, Sezer Kılıç ● Music: Kassem Mosse ● Post-production: Christoph Manz, Maximilian Schmoetzer ● Assistant: Milos Trakilović ● Camera: Savaş Boyraz ● Translation: Rojda Tugrul, Övül Durmosoğlu ● Production: Misal Adnan Yıldız, Şener Özmen ● Support: Bariş Şehitvan, Zelal Özmen, Sümer Kültür Merkezi Diyarbakır

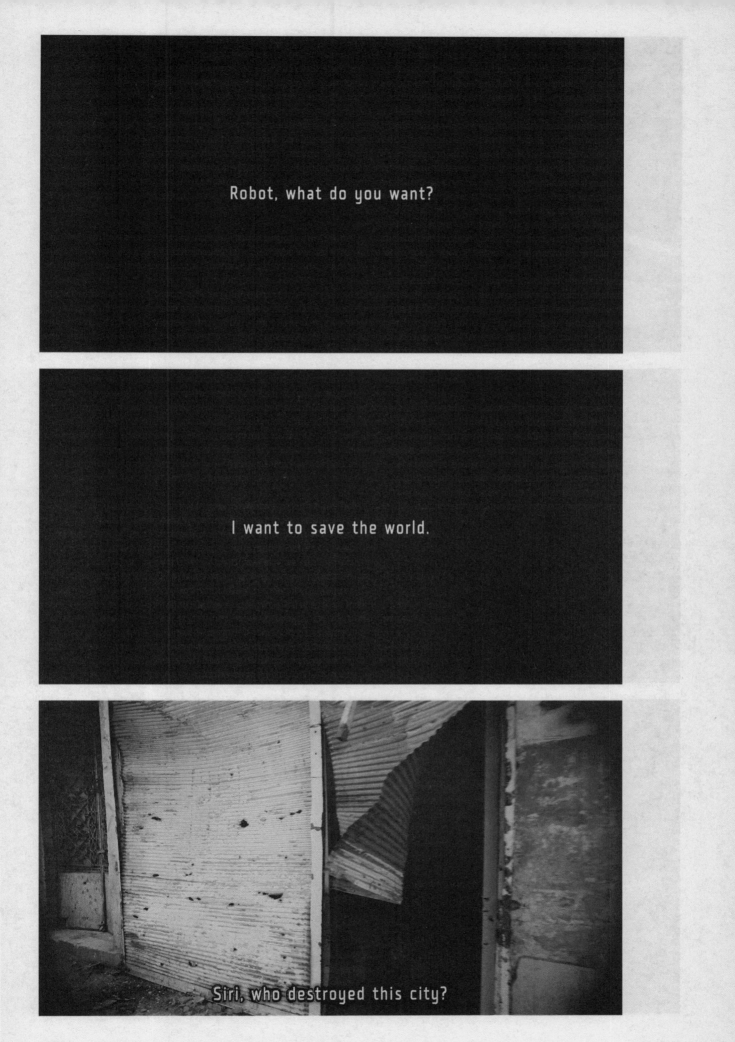

Hito Steyerl

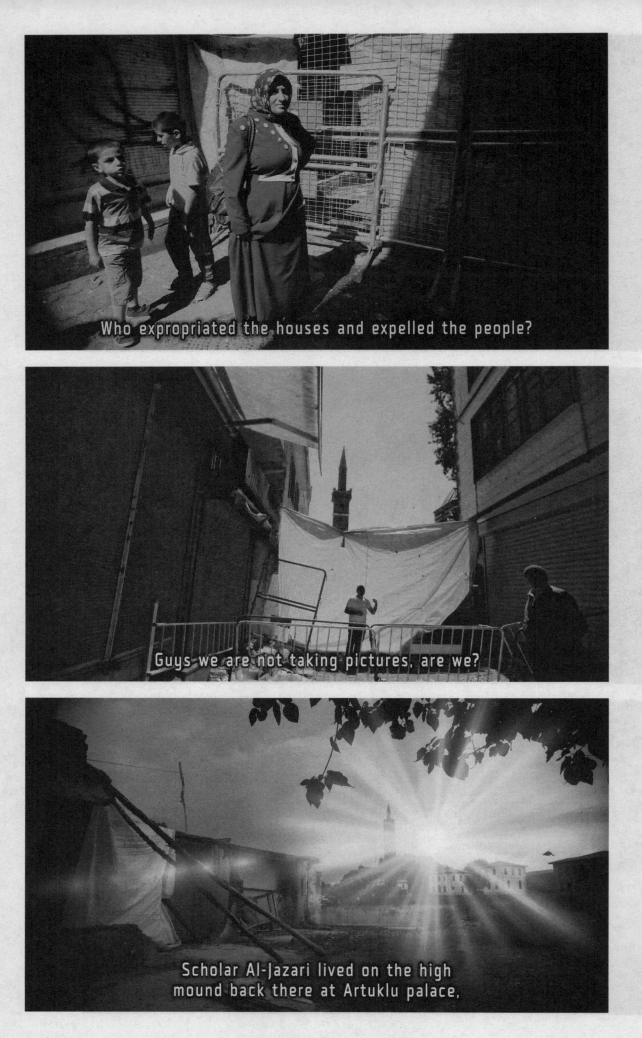

Hito Steyerl

where he also produced his robots.

He produced a robot that could play different kinds of music.

He invented over 60 machines, hydraulic machines, encrypted
locks and safes, thermometers, and toy automats.

He established the foundations of computer technology.

Physicist, artist, calligrapher, sculptor...

So he is both a technician and an artist.

Koki Tanaka

Spätestens seit Fukushima spielen in den Arbeiten von Koki Tanaka (* 1975 Tochigi, lebt in Kyoto) Krisen und temporär entstehende Gemeinschaften eine wichtige Rolle. Tanaka bringt Menschen in ungewöhnlichen Situationen zusammen, die oft verunsichernd wirken. Er erprobt in diesen besonderen, kollektiven Momenten die Möglichkeit des Widerstands gegen bestehende Routinen. Das dokumentarische Filmmaterial, das in diesen Situationen und in Workshops entsteht, bildet in unterschiedlicher Form die Grundlage für seine Videoinstallationen.

Provisional Studies: Workshop #7
How to Live Together and Sharing the Unknown

Für die Skulptur Projekte bat Koki Tanaka acht Münsteraner_innen unterschiedlicher Generationen und unterschiedlicher kultureller Herkunft, für neun Tage an Workshops teilzunehmen. In Anlehnung an den gleichnamigen Buchtitel von Roland Barthes lautete die zentrale Frage: *Wie zusammen leben?* Dazu lud Tanaka sogenannte „Faciliators" als temporäre Gäste und Impulsgeber für Beiträge ein.

Insgesamt neun Videosequenzen dokumentieren die gemeinsam verbrachte Zeit: die Übernachtung in der Turnhalle, das Kochen eines Rezeptes aus Kriegszeiten, das von den Teilnehmer_innen geführte wie gefilmte Interview mit einem syrischen Globalisierungsexperten sowie Bewegungsübungen in einem ehemaligen Atombunker. Das Kamerateam war angewiesen, auch Pausen und Unterbrechungen einzufangen. In diesen werden Erschöpfungszustände der Akteur_innen sowie das Entstehen oder Aufbrechen von Rollen- und Argumentationsmustern ebenso sichtbar wie Momente der Irritation oder des Missfallens. Die Präsenz der Filmcrew macht die Partizipierenden vom ersten Moment des Zusammentreffens an zu Subjekten vor der Kamera und damit zu einer ausgewiesenen, temporären und definierten Gruppe von Performer_innen. Tanaka selbst sieht sich während der Aufnahmen in der Rolle des Beobachters und überlässt den Teilnehmenden die Gestaltung des Prozesses bis hin zur Entscheidung, eine Übung abzubrechen. Die Notizen des Künstlers sind, wie die Alltagsobjekte des Workshops, wichtiger Bestandteil der Arbeit und werden als eigenständige Publikationen konzipiert.

Inhaltlicher Ausgangspunkt des Projekts sowie Austragungsort der Workshops war das Aegidiimarkt-Areal gegenüber dem LWL-Museum für Kunst und Kultur. Ende der 1970er Jahren erbaut, vereint das Gebäude Wohnen, Einkaufen, Arbeiten und Freizeit. Neben der Volkshochschule ist ein Parkhaus der am meisten genutzte Bereich des Areals. Dieser wurde zur Zeit des Kalten Krieges gebaut und sollte bis 2015 im Krisenfall als ABC-Bunker dreitausend Menschen Schutz bieten. Ein Blick zurück verrät, dass dort zu allen Zeiten unterschiedliche Gemeinschaften zusammenkamen oder gemeinsam lebten: Vor 1819 befand sich am selben Ort ein Kloster, das ab 1830 als Kaserne genutzt wurde. Nach dessen Zerstörung im Zweiten Weltkrieg lag das Gelände lange Zeit brach. Vom Standort der Installation aus können die Besucher_innen auf den gegenüberliegenden Aegidiimarkt blicken. s.t.

[Provisorische Studien: Workshop #7 Wie zusammen leben und das Unbekannte teilen]

Material
Aktion und Workshops, Installation der Videodokumentation in vier Räumen

Standort
Johannisstraße 18/20, 48143 Münster
Zugang über den Durchgang zwischen Johannisstraße 18/20 und 21, gegenüber dem Aegidiimarkt

Begleitendes Booklet verfügbar vor Ort

Teilnehmer_innen Workshops: Tasnim Baghdadi, Stephan Biermann, Isa Selçuk Dilmen, Annette Hinricher, Anna Mondain-Monval, JoAnn Osborne, Rolf Tiemann, Lina Zaher

Moderatoren_innen Workshops: Ahmad Alajlan, Kai van Eikels, Andrew Maerkle, Hendrik Meyer, Tami Tanagisawa

Filmteam
Bildregisseur: Hikaru Fujii
Ton: Ryota Fujiguchi
Schnitt: Koki Tanaka
Kameramann: Shinya Aoyama
Tonassistent: Kadoaki Izuta
Assistenten: Leila Aliev, Jakob Reuter
Koordination Workshop/Film: Sophia Trollmann
Assistentin: Alexandra Südkamp
Logistik: Jan Enste/kunst und Medien
Unterstützung Textilien: Kvadrat
Equipment: Kunstakademie Münster, Filmwerkstatt Münster e. V., Atelier Screen TV, ARTISTS' GUILD, C-RENT, CAMCAR, cineOne
Untertitel: Eurotape – Media Services GmbH

Zusätzliche Videos während des Ausstellungszeitraums:
https://vimeo-pro.com/kktnk/ps7

Koki Tanaka

Since Fukushima, if not before, Koki Tanaka's (* 1975 Tochigi; lives in Kyoto) art has been centred around crises and the temporary communities that they produce. Tanaka brings people together in unaccustomed situations that are often unsettling. In these unusual collective moments, he tests the possibility of defying existing routines. The documentary footage that was produced in these situations and workshops serves in various forms as the basis for his video installations.

Provisional Studies: Workshop #7
How to Live Together and Sharing the Unknown

For Skulptur Projekte, Tanaka asked eight residents of Münster from various generations and different cultural backgrounds to participate in workshops for nine days. Based on Roland Barthes's book of the same title, the central question was, how to live together? Tanaka invited contributions from 'facilitators' acting as temporary guests and sources of inspiration.

A total of eleven video sequences document things such as the night spent together on mats in the gymnasium, cooking a wartime recipe, the interview and shoot with a globalization expert from Syria, and physical exercises in an old nuclear bunker. The camera crew was also told to capture all the breaks and interruptions. So we witness moments of exhaustion as well as the moments when stereotypical roles and argument patterns are initiated or set off. And we also see moments of irritation or displeasure. From the very beginning, the presence of a film crew transforms the participants into subjects in front of the camera and, as such, into a designated, temporary, and defined group of performers. During the shoot, Tanaka sees himself as the viewer and leaves it up to the participants to guide the process, including the decision to stop an exercise. Like the everyday objects in the workshop, the artist's notes are an important part of the work and are designed as independent publications.

The contextual starting point of the project was also the location where it took place: the Aegidiimarkt complex across from the LWL-Museum für Kunst und Kultur. Built in the late 1970s, the building incorporates space for living, shopping, work, and leisure. Next to the adult education centre there is a car park for the section of the building frequented most. It was erected during the Cold War and until 2015 designated as a WMD shelter which could house three thousand people in the event of an emergency. Researching the history of the place, we discover how various communities gathered or lived together there: prior to 1819, there was a monastery on the same site that had been used as a military barracks since 1830. After being destroyed in World War II, the property remained vacant for quite some time. The lines of sight that visitors are offered from the standpoint of the installation are directly connected to the Aegidiimarkt across from it. S.T.

Material
Action and workshops, installation of the video documentation in four rooms

Location
Johannisstraße 18/20, 48143 Münster access via the passage between Johannisstraße 18/20 and 21, opposite Aegidiimarkt

Accompanying booklet available on-site

Participants' workshops
Tasnim Baghdadi, Stephan Biermann, Isa Selçuk Dilmen, Annette Hinricher, Anna Mondain-Monval, JoAnn Osborne, Rolf Tiemann, Lina Zaher

Facilitators' workshops
Ahmad Alailan, Kai van Eikels, Andrew Maerkle, Hendrik Meyer, Tami Tanagisawa

Crew
Director of photography: Hikaru Fujii
Sound: Ryota Fujiguchi
Editor: Koki Tanaka
Camera operator: Shinya Aoyama
Boom operator: Kadoaki Izuta
Assistants: Leila Aliev, Jakob Reuter
Workshop/filming coordination:
Sophia Trollmann
Assistant: Alexandra Südkamp
Logistics: Jan Enste/jae kunst und medien
Textiles support: Kvadrat
Equipment rental and support:
Kunstakademie Münster,
Filmwerkstatt Münster e.V., Atelier Screen TV, ARTISTS' GUILD, C-RENT, CAMCAR, cineOne
Subtitles: Eurotape—Media Services GmbH

Additional videos online during the exhibition period:
https://vimeopro.com/kktnk/ps7

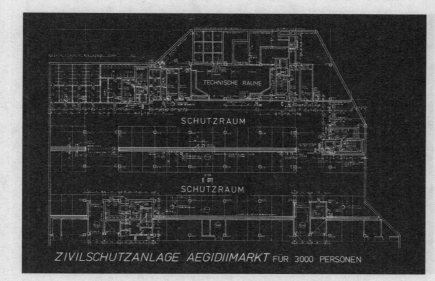

Aegidiimarkt: Zivilschutzanlage für 3 000 Personen /
3,000-person civil protection shelter

Die Angst vor dem Fremden ist unser größtes und eigentliches Problem. Unsere Welt teilt sich zunehmend in zwei Lager – dem einen sind Migrant_innen und Flüchtlinge willkommen, dem anderen nicht. Toleranz scheint nicht mehr auszureichen, um unterschiedliche Menschen in einer multikulturellen Gesellschaft zu vereinen. Kann man dennoch einen Weg finden, mit jemandem zusammenzuleben, der anders ist?

Xenophobia is the central issue. Our world is getting divided into two camps—one accepts immigrants and refugees, and the other doesn't. Tolerance is probably not enough to bind different people together as a multicultural society. However, can you still make an effort to live together with someone different?

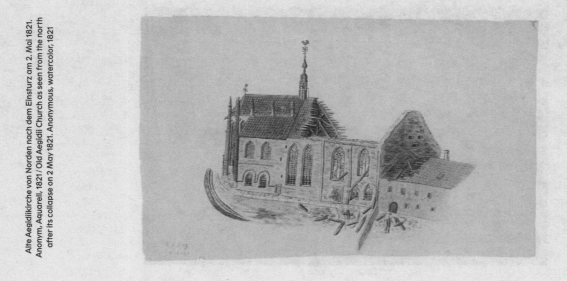

Alte Aegidiikirche von Norden nach dem Einsturz am 2. Mai 1821. Anonym, Aquarell, 1821 / Old Aegidii Church as seen from the north after its collapse on 2 May 1821. Anonymous, watercolor, 1821

Im Zentrum von Münster befindet sich ein Atombunker, 1979 erbaut, in dem dreitausend Menschen überleben könnten. Soweit ich weiß, gingen die Erbauer davon aus, dass die Geretteten nach einer atomaren Apokalypse erneut eine Gemeinschaft aufbauen könnten. Wie viel schöner und besser ist unsere Welt heute als die von den Menschen damals ins Auge gefasste, schlimmste anzunehmende Katastrophe?

There is a nuclear bunker in the centre of Münster that would allow three thousand people to survive. It was built in 1979. I believe that the people who designed the place expected to be able to rebuild humanity afterwards in a post-apocalyptic situation. How much better is our present world than the worst-case scenario envisaged by people in the past?

Wenn jetzt Krieg herrschen würde, wovon würden wir uns ernähren?

What if a war happens here? What would you eat?

Ich fühle mich während gemeinsamer Abendessen eher unwohl. Mit engen Freunden geht es, aber wenn ich die anderen nicht wirklich gut kenne, werde ich nervös. Irgendwann fangen alle an, die Runde mit Anekdoten zu unterhalten. Ich habe allerdings nichts zu sagen. Ich kann diesem Verhalten nicht viel abgewinnen. Ich bin beim Essen eher schweigsam. Meine Strategie ist es, mich so lange wie möglich zurückzuhalten, möglichst nicht reden zu müssen. Lieber höre ich den anderen beim Erzählen zu. Mögen Sie solche Situationen bei Tisch? Welche Geschichten erzählen Sie?

I am not very comfortable being out at a group dinner. If it's with close friends, it's fine, but if it's with someone I don't know very well, I get nervous. At some point everyone at table starts telling appropriate stories to entertain the group. I have nothing to say. I don't much like this custom. I'm rather quiet at table. My strategy is to try to dodge my turn and avoid speaking for as long as possible. I like to remain quiet but enjoy listening to someone else's story. Do you like these kinds of moments at a social dinner? What story do you tell?

Wie würde man sich verhalten, wenn man eine Nacht mit voll-kommen fremden Menschen verbringen müsste? Wie würde man sich mit den anderen verständigen?

What if you spend a night together with total strangers—how do you communicate with them?

Man würde sich wahrscheinlich mithilfe recht simpler Fragen kennenlernen: Wie geht es Ihnen? Woher kommen Sie? Was hat Sie hierher verschlagen? Und dann könnten wir aus unserem Leben erzählen oder von Dingen sprechen, die uns gerade be-schäftigen. In diesem Moment würde uns vielleicht aufgehen, dass unsere persönlichen Belange mit gesellschaftlichen Pro-blemen oder historischen Konflikten verknüpft sind. Wie also könnte Ihre erste Frage lauten?

The process of getting to know one another would start with a simple question: How are you? Where do you come from? How did you end up here? And then we might share something about our personal issues or histories. We may even realize that such personal matters are related to social problems or historical conflicts. So what question do you start with?

Während eines einwöchigen sozialen Experiments fanden sich Menschen unterschiedlicher Herkunft zusammen. Alle berichteten von ihrer Vergangenheit und von ihren Familien und diskutierten über die Möglichkeiten gesellschaftlichen Zusammenlebens: Wie können wir miteinander leben? Wenn Sie die Gelegenheit hätten, an so einer Begegnung teilzunehmen, würden Sie sie ergreifen? Und welche Erwartungen hätten Sie?

As a week-long social experiment, people with different backgrounds participated in a group. They all shared their past and their family history and then also discussed the possibilities of social coexistence—how to live together. If there was an opportunity for you to take part, would you do so? And what would you expect?

Als ich in Los Angeles lebte, fuhr ich fast jeden Tag mit dem Auto. Diese Art zu leben war mir ganz neu, aber ich mochte das Autofahren sehr. Im Auto fühle ich mich meiner Partnerin und meinen Freund_innen in einer Weise nahe, die ich so von keiner anderen Situation her kenne. Haben Sie etwas Ähnliches erlebt? Welche Rolle spielen Autos in Ihrem Leben?

When I lived in LA, I drove almost every day. I'd never lived like that before, but I enjoyed driving a lot. In a car I share an intimate feeling with my partner and friends that is different from any other situation. Have you had a similar experience? What do cars mean to you?

Oscar Tuazon

Oscar Tuazons (* 1975 Seattle, lebt in Los Angeles) skulpturale Arbeiten bewegen sich an der Schnittstelle zur Architektur und entstehen in Auseinandersetzung mit den Bedingungen des Ausstellungskontextes. Die Konstruktionen aus Holz, Beton oder Stahl charakterisiert eine raue Materialität, an der sich Produktionsspuren und konstruktionsbedingte Ermüdungserscheinungen ablesen lassen. Die Arbeiten rekurrieren auf das Vokabular des Minimalismus, begegnen dessen steriler Ästhetik aber mit einem handlungsorientierten Skulpturbegriff, dem Tuazons Aussage „Ich denke mit den Händen" greifbare Dimension verleiht.

Burn the Formwork

In Münster installiert der Künstler auf einer Industriebrache am Kanal — einem undefinierten Areal, das von verschiedenen Personengruppen genutzt wird — ein Betonobjekt, das als öffentliche Feuerstelle dient. Die zylinderförmige Skulptur ermöglicht Nutzungen als Grill, Aufwärmplatz und Aussichtsturm. Das Zentrum der Arbeit, deren reduzierte Form aus ihrer Funktion resultiert, bildet eine schornsteinartige Säule mit zwei integrierten Feuerstellen. Eine in großen Stufen spiralförmig aufsteigende Treppe, die eine seitliche Mauer umschließt, umgibt den Kamin zu etwa zwei Dritteln. Durch ein Rohrsystem wird die Abluft unterhalb der Stufen zum Kamin transportiert. Die kleinteilige Holzverschalung, die zur Herstellung benötigt wurde, lässt sich ablösen und als Brennstoff verwenden.

Die Arbeit führt Tuazons Beschäftigung mit provisorischen Konstruktionen im Freien fort, wie er sie bereits auf der Biennale in Venedig 2011 oder dauerhaft im Brooklyn Bridge Park installierte. Steht bei diesen Betonpavillons die Funktion als elementare Schutzhütte und Treffpunkt im Mittelpunkt, tritt in Münster durch die aktive Benutzung der Arbeit ein formveränderndes Moment hinzu. Ebenso, wie bei der Herstellung die körperliche Erfahrung von zentraler Bedeutung für Tuazon ist, zielt die Arbeit in ihrer offenen Dynamik auch auf eine unmittelbare, lebensnahe Rezeption durch Gebrauch, die — im Gegensatz zur künstlerischen Praxis der Relational Aesthetics — nicht in erster Linie an ein Kunstpublikum adressiert ist. Der wärmespendenden Skulptur, die als offizielle Architektur im regulierten städtischen Raum kaum denkbar wäre, kommt eine soziale Dimension zu. Sie impliziert eine Form von Partizipation, die sich der Kontrolle entzieht und dadurch Reibungspotenzial aufweist. Über das archaische Motiv der Feuerstelle verweist sie auf eine gemeinschaftsstiftende Aktivität. Zugleich mutet sie wie ein skulpturaler Nachhall auf selbstgeschaffene, mit Gegenkultur und Aussteigertum verbundene Basisarchitekturen an, die von pragmatischer Improvisation gekennzeichnet sind. Sich selbst überlassen entwickelt die Arbeit, die in ihrer rohen Gestalt inmitten des peripheren Terrains Züge von Verfall und Entropie hat, ein Eigenleben. A.P.

[Verbrennt die Verschalung]

Material
Beton, Holz, Feuer

Maße
ca. 370 × 530 × 530 cm

Standort
Wiese zwischen Hafengrenzweg /
Alsbersloher Weg, 48155 Münster

Oscar Tuazon

Oscar Tuazon's (*1975 Seattle, lives in Los Angeles) sculptural works have overlaps with architecture and evolve through their encounter with the exhibition's context. His constructions of wood, concrete, or steel are characterized by a rough materiality: one can see traces of the manufacturing process and visible signs of material fatigue. His artwork refers back to the vocabulary of Minimalism, but it confronts the sterile aesthetics of this style with an action-based concept of sculpture made tangible by the artist's statement, 'I think with my hands.'

Burn the Formwork

In Münster, Tuazon has installed an object made of concrete in an industrial wasteland along a canal—an undefined plot of land which is used by various groups of people. The object serves as a public fireplace. The cylindrically shaped sculpture can be used for barbecuing, warming up, and as a look-out. The work's focal point is the chimney-like pillar with its two integrated fireplaces—its reduced form is the consequence of its function. A spiral stairway with large steps rises around the hearth, encircling two-thirds of it. In turn, the stairway is bounded by a lateral wall. The vitiated air from the separate fireplaces is conveyed to the chimney through a system of pipes beneath the stairway. The small sections of wooden boarding that were used in the construction can be removed and burned as well.

This object represents a continuation of Tuazon's work with temporary exterior structures such as his contribution to the 2011 Biennale in Venice or his permanent installation at Brooklyn Bridge Park. The focus in both of these concrete pavilions is on their function as rudimentary shelters and meeting places. In Münster, however, the form is recast by the active use to which the work is put. Just as physical experience plays a key role for Tuazon in the production process, his contribution to Skulptur Projekte with its accessible dynamics is intended for immediate reception as a utilitarian object with a close relationship to everyday life: in contrast to the artistic practice of relational aesthetics, the art crowd is not the main recipient to whom the work is addressed. This heat-radiating sculpture, which is almost unthinkable as an official architectural structure within a regulated urban space, has a social dimension. It connotes a form of participation that eludes regulation and thus also has an inherent potential for friction. Using the archaic motif of the fireplace, it points to a communal activity. It also has a sculptural resonance with the basic home-made architecture associated with the counterculture and dropping out and characterized by pragmatic improvisation. Left to itself, the work—which emanates an element of ruinous entropy as an unwrought object in the peripheral terrain—develops a life of its own. A.P.

Material
Concrete, wood, fire

Dimension
ca. 370 × 530 × 530 cm

Location
Meadow between Hafengrenzweg /
Albersloher Weg, 48155 Münster

Oscar Tuazons künstlerische Projekte sind auf eine zeitliche Begrenzung angelegt: Das Ende einer Ausstellung bedeutet meistens auch das Ende einer Arbeit. In seiner Arbeitsweise verwischen die Grenzen zwischen dem skulpturalen oder architektonischen Objekt und dem künstlerischen Prozess, den er als Möglichkeit zum Experiment, ohne festgelegte Regeln, begreift. Die doppelte Rolle der Arbeiten als provisorische Architektur und Skulptur verdeutlicht Tuazons spezifisches Interesse an Skulptur im Spannungsverhältnis zu ihrem Kontext – in einer bestehenden Architektur, im urbanen Raum, für eine Ausstellung oder im Rahmen eines bestimmten Ereignisses. „For me, what's interesting is to bring a new function or a new possibility to the space…"

Tuazon studierte Architektur und Stadtplanung an der Cooper Union in New York und lernte bei Vito Acconci. Seine Idee von Skulptur ist geprägt durch die Minimal und Post-Minimal Art; Werke von Künstlern wie Sol LeWitt, Gordon Matta-Clark, Richard Serra und Robert Smithson dienten ihm bereits als Inspirationsquelle. So bezog sich seine Installation in der Kunsthalle Bern 2010 – mit einem radikalen Eingriff in die bestehende Architektur – auf LeWitts Ausstellung ebendort im Jahr 1972. LeWitt stellte weiße Kuben von circa einem Meter sechzig Höhe aus, die auf verschiedene Arten miteinander verbunden waren. Tuazon wiederum durchbrach die Wände der Ausstellungsräume, um diese durch eine übergeordnete modulare Struktur aus massiven Holzbalken einzunehmen. In Fällen wie diesen bewohnt Tuazon regelrecht eine künstlerische Idee und interpretiert sie neu. Seine Praxis zirkuliert dabei trotz ihrer Bezüge weniger um eine konzeptuelle Verortung in der Geschichte als vielmehr um die Erzeugung einer räumlichen Erfahrung und eines unmittelbaren ästhetischen Erlebnisses.

Seine Skulpturen sind stark von ihrem Entstehungsprozess geprägt: dem Austesten von Materialkombinationen sowie Produktionsverfahren. Manchmal passen Konstruktion und Material nicht so zusammen, dass sie auf Dauer ein stabiles Ganzes ergeben. Das Scheitern dieser Skulpturen ist von Tuazon einkalkuliert und Teil des Experiments, es bedeutet ein eigenständiges Weiterleben der Skulptur während der Ausstellungslaufzeit, jenseits seiner Kontrolle. Dieses improvisierte Moment in Tuazons Werk rührt auch her von seinem Interesse an sogenannter Outsider- und Do-it-yourself-Architektur sowie der Aussteiger-Kultur, die sich insbesondere seit den 1960er Jahren in den Wüsten des Südwestens der USA und in den Wäldern Oregons entwickelt hat. Ihren Ursprung hat diese Kultur im Gedankengut von Henry David Thoreaus Buch *Walden* (1845), in dem er von seiner Erfahrung berichtet, zwei Jahre zurückgezogen am Walden Pond in Massachusetts in einer selbstgebauten Hütte, nahe der Natur zu leben.

In seinem Katalog *I Can't See* (2011) druckte Tuazon Auszüge aus der Zeitschrift *Dwelling Portably* (April 2010) ab, die praktische Tipps für ein unabhängiges Leben in den Wäldern liefert. In der Publikation *Leave Me Be* (2012) schreibt er über das Leben im Wald aus der Sicht des Aussteigers Rayo. Der fiktionale Text handelt von dem Bedürfnis nach dem Alleinsein, dem Rückzug aus der Gesellschaft und der Loslösung aus sozialen Zwängen. Während Tuazon mit seinen Texten Erzählungen schafft, versucht er als Bildhauer eine Narration auszublenden. Das Publizieren begreift er als Möglichkeit, über die Bildhauerei hinaus bestimmte Interessen durch eigene Texte und Fotografien zu vertiefen.

Mit der Ausstellung *Shelters* (2016) in der Galerie Chantal Crousel und der Skulptur *Zome Alloy* (2016), die er auf dem Messeplatz vor der Art Basel installierte, setzte sich Tuazon innerhalb seiner skulpturalen Praxis mit alternativen Lebensräumen, die ein Leben in wirtschaftlicher und sozialer Unabhängigkeit hervorbringen können, auseinander. *Zome Alloy* ist eine Rekonstruktion der Zome-House-Architektur des amerikanischen Erfinders und Zomeworks-Gründers Steve Baer. Baer entwickelte den *Zome* in den 1960er Jahren, ein Hybrid aus einem Zonoeder und einem *Dome* und somit eine Struktur, die sich in verschiedene Richtungen beliebig erweitern lässt. Erste Experimente mit der Zome-Architektur machte Baer in Drop City, einer der ersten ländlichen Hippie-Kommunen, die 1965 von einer Gruppe Kunststudent_innen in der Nähe von Trinidad, Colorado, gegründet wurde. Bei der Bebauung des Landes entschieden sie sich für eine architektonische Form, den geodätischen Dom, einen Kuppelbau, der auf den Plänen von Richard Buckminster Fuller und Baer basiert. Aus alten Autoteilen und recyceltem Material bauten sie nach und nach mehrere *Domes*, die als Wohnhäuser, Gemeinschaftsräume und Konzerthallen genutzt wurden. Tuazon selbst wurde in einem von seinen Eltern gebauten *Dome* geboren.

In der Ausstellung *Shelters* zeigte Tuazon metallische Konstruktionen, deren direkte Vorbilder aus der Outsider-Architektur stammen. Auf kleinen Bänken in den ausgestellten Schutzhütten lag das 1970er-Jahre-Fanzine *Vonulife* aus, mit politischen Artikeln, Tipps und Anzeigen für die Aussteiger-Community. Ohne zu romantisieren thematisiert Tuazon mit seinen Skulpturen dieses neothoreausche Phänomen des unabhängigen Lebens in den Wäldern.

Seine raumgreifenden, institutionellen Projekte distanzieren sich durch ihre Nähe zur Architektur zunehmend vom bloßen Objekt. Material und Maßstäblichkeit ermöglichen eine Verbindung dieser Arbeiten zum Raum, der uns umgibt. In ihrer Einfachheit, Unmittelbarkeit und Nutzbarkeit bringen die Skulpturen die Komplexität der uns vertrauten Strukturen und Formen zum Vorschein und definieren Skulptur als einen sozialen Ort, der von andauernder Veränderung geprägt ist.

Anna Brohm

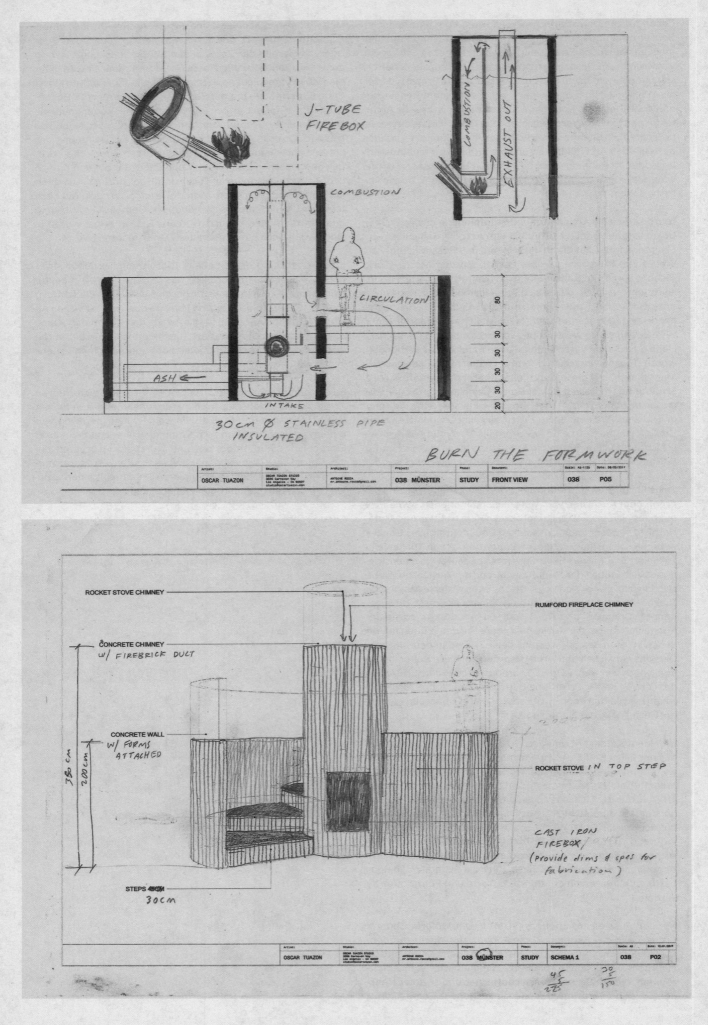

J-TUBE
FIREBOX

COMBUSTION

COMBUSTION

EXHAUST OUT

CIRCULATION

80

30

30

30

30

20

ASH

INTAKE

30cm Ø STAINLESS PIPE
INSULATED

BURN THE FORMWORK

Artist:	Studio:	Architect:	Project:	Phase:	Document:	Scale: A3-1:25	Date: 08/03/2017
OSCAR TUAZON	OSCAR TUAZON STUDIO	ANTOINE ROCCA	038 MÜNSTER	STUDY	FRONT VIEW	038	P05

ROCKET STOVE CHIMNEY

RUMFORD FIREPLACE CHIMNEY

CONCRETE CHIMNEY
w/ FIREBRICK DUCT

CONCRETE WALL
w/ FORMS
ATTACHED

380 cm
200 cm

ROCKET STOVE IN TOP STEP

CAST IRON
FIREBOX/
(provide dims & spes for
fabrication)

STEPS 45CM
30CM

Artist:	Studio:	Architect:	Project:	Phase:	Document:	Scale: A3	Date: 10/01/2017
OSCAR TUAZON	OSCAR TUAZON STUDIO	ANTOINE ROCCA	038 MÜNSTER	STUDY	SCHEMA 1	038	P02

45
5
225

30
5
150

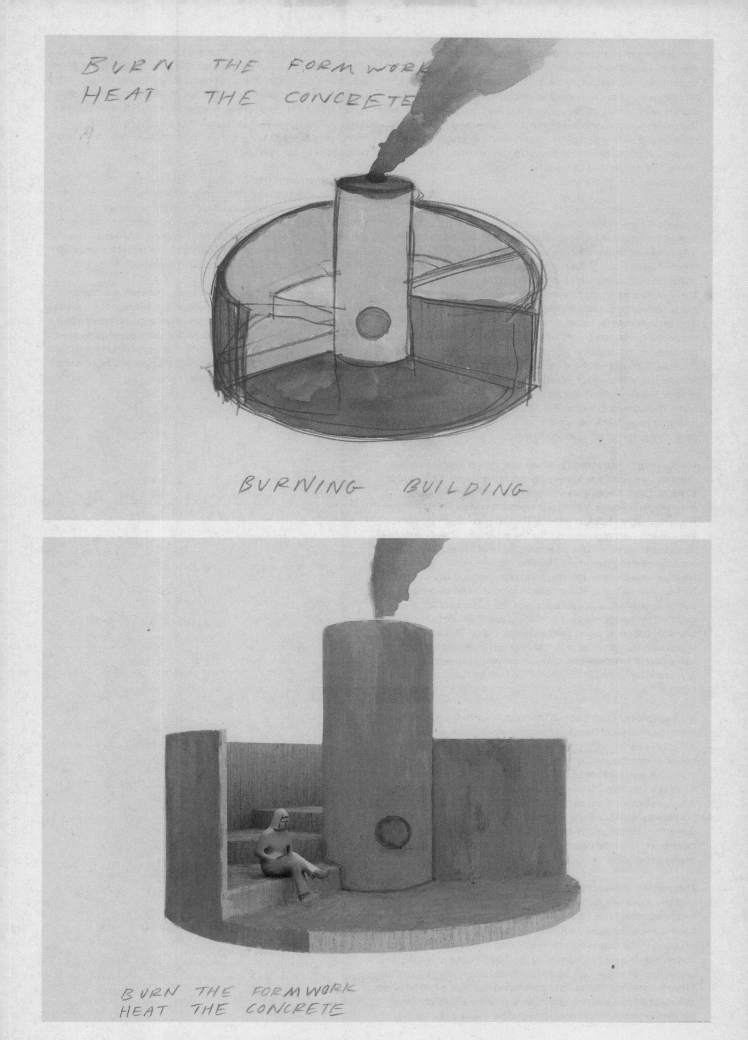

BURN THE FORMWORK
HEAT THE CONCRETE

BURNING BUILDING

BURN THE FORMWORK
HEAT THE CONCRETE

Oscar Tuazon's artistic projects are geared to a limited time frame: the end of an exhibition usually also means the end of a piece. His working methods blur the boundaries between the sculptural or architectural object and the artistic process, which he sees as a chance to experiment without fixed rules. The works' double role as provisional architecture and sculpture illustrates Tuazon's specific interest in sculpture in the charged relationship with its context—in an existing architecture, in urban space, for an exhibition, or in the context of a specific event. 'For me, what's interesting is to bring a new function or a new possibility to the space.'

Tuazon studied architecture and urban planning at Cooper Union in New York and studied under Vito Acconci. His conception of sculpture is influenced by Minimal and Post-Minimal Art; works by artists such as Sol LeWitt, Gordon Matta-Clark, Richard Serra, and Robert Smithson served as sources of inspiration. Accordingly, his installation at the Kunsthalle Bern in 2010—with a radical intervention in the existing architecture—made reference to LeWitt's exhibition staged there in 1972. LeWitt exhibited white cubes, approximately 1.6 metres in height, that were connected in various ways. For his part, Tuazon broke through the walls of the exhibition rooms in order to occupy them with an overarching modular structure made of sturdy wooden beams. In cases like these, Tuazon literally inhabits an artistic idea and reinterprets it. In so doing, his practice—despite the references it contains—circles around the creation of a spatial experience and an immediate aesthetic event rather than a conceptual localization in history.

His sculptures are strongly influenced by the process of their creation: the testing of material combinations and the methods of production. Sometimes construction and material do not fit together to produce a permanent stable whole. The failure of these sculptures is factored in by Tuazon and constitute part of the experiment; this means that the sculpture takes on an independent life of its own over the course of the exhibition, beyond his control. This improvised aspect of Tuazon's work also touches on his interest in so-called outsider and DIY architecture as well as the dropout culture, whose main development began in the 1960s in the deserts of the American Southwest and the forests of Oregon. This culture has its origin in the philosophical concepts expressed in Henry David Thoreau's book *Walden* (1845), where he reports his experience of spending two years next to Walden Pond in Massachusetts, living as a recluse in a cabin he had built for himself so that he could be close to nature.

In his catalogue *I Can't See* (2011), Tuazon reproduced clippings from the periodical *Dwelling Portably* (April 2010), which offers practical tips for an autonomous life in the woods. In the publication *Leave Me Be* (2012), he writes about living in the woods from the perspective of the dropout Rayo. The fictional text focuses on the need to be alone, retreating from society, and the disengagement from social pressures. While Tuazon creates narratives with his texts, as a sculptor he attempts to avoid narration. He understands publication as a possible means to deepen certain interests beyond sculpture, using his own texts and photographs.

Through the *Shelters* (2016) show in the Chantal Crousel gallery and the sculpture *Zome Alloy* (2016), which he installed on the exhibition square in front of Art Basel, Tuazon uses his sculptural work to engage with alternative living spaces that can produce a life that is economically and socially autonomous. *Zome Alloy* is a reconstruction of the Zome house architecture originated by the American inventor and Zomeworks founder Steve Baer. In the 1960s Baer developed *Zome* as a hybrid of a zonohedron and a dome, and thus a structure that can be expanded in various directions at will. Baer carried out his initial experiments with Zome architecture in Drop City, one of the first rural hippie communes, founded by a group of art students close to Trinidad, Colorado, in 1965. When building on the property, they decided on an architectonic form, the geodesic dome based on Baer's designs and those of Richard Buckminster Fuller. Using old car parts and recycled material, they successively built multiple domes, which were used as dwellings, communal spaces, and concert halls. Tuazon himself was born in a dome built by his parents.

In the *Shelters* exhibition, Tuazon displays metallic constructions whose direct models originate from outsider architecture. The 1970s' fanzine *Vonulife* was laid out on small benches in the shelters on display, with political articles, tips, and advertisements for the dropout community. Without romanticizing the subject, Tuazon uses his sculptures to address this neo-Thoreauvian phenomenon of an independent life in the woods.

His large-scale, institutional projects increasingly distance themselves from the status of mere object through their proximity to architecture. Material and scale foster a connection between these works and the space that surrounds us. In their simplicity, immediacy, and usability, the sculptures reveal familiar structures and forms and define sculpture as a social place that is influenced by constant change.

Anna Brohm

Joëlle Tuerlinckx

Joëlle Tuerlinckx' (* 1958 Brüssel, lebt in Brüssel) konzeptuelle Arbeiten entstehen häufig an der Grenze des Sichtbaren. Ihre Installationen aus gefundenen Objekten, Zeichnungen, Vitrinen und Fotografien sind eher räumliche Erfahrungen als bloße Artefakte. Jeder Ausstellung liegt eine genaue Beobachtung des Raumes und der jeweiligen Institution zugrunde, der sie ihr Werk ortsspezifisch anpasst und neu betrachtet. Dabei gilt ihr Interesse besonders der Frage nach der gesellschaftlichen Rolle von Museen.

Le Tag / 200 m

Mit ihrer Arbeit für die Skulptur Projekte Münster, die als Teil der Kooperation *The Hot Wire* mit dem Skulpturenmuseum Glaskasten Marl realisiert wird, verlässt Tuerlinckx den musealen Innenraum und arbeitet mit dem Gelände des alten Sickingmühler Friedhofs in Marl. Dieser wurde nach und nach in einen öffentlichen Park umgestaltet und wird vom Museum Glaskasten bereits als Skulpturengarten genutzt. In einem ähnlichen Prozess der Umwandlung befindet sich auch das Museum selbst, das in den nächsten Jahren in die ehemalige Schule in der Kampstraße auf der anderen Seite des Friedhofparks umziehen möchte. Ausgehend von Überlegungen zur Linie als Skulptur oder Form und dabei anknüpfend an den Formalismus der Minimal Art, realisiert Tuerlinckx eine ephemere Skulptur in Form einer 200 Meter langen Linie. In einer performativen Aktion wird die Linie Tag für Tag, jeden Morgen 10 Uhr, neu gezogen, und die Spur, die sie im öffentlichen Raum hinterlässt, mit einem Kreidespray, wie es auch für Spielfeldmarkierungen auf Sportplätzen eingesetzt wird, nachgezeichnet. Nach der Laufzeit der Ausstellung verschwindet die Arbeit allmählich, sie löst sich buchstäblich in nichts auf.

In seiner schieren Dimension rekurriert *Le Tag* auf monumentale Werke der Land Art der 1960er Jahre. Es steckt ein Gebiet ab und definiert einen Raum, gleichzeitig ist sie ein grafisches Element und eine bewusste Setzung der Künstlerin: eine Signatur ähnlich einem *Tag*, dem persönlichen Kürzel, das Graffiti-Sprayer als Markierung einsetzen. *Le Tag* spielt aber auch mit dem deutschen Wort Tag und der täglichen Wiederholung der Aktion des Zeichnens. Wie nehmen wir Zeit wahr, wie stellt man sie dar, und was sind die Spuren, die das 20. Jahrhundert hinterlässt, sind Fragen, die Tuerlinckx immer wieder stellt.

Das Prinzip, bestehende Arbeiten neu zu denken, zu wiederholen, zu kopieren, zu überschreiben und eine Idee dadurch immer weiterzuentwickeln, durchzieht ihr gesamtes Werk. Linien, Punkte und Kreise und deren multiple Bedeutungsebenen als formale Körper, aber auch als Symbole, Zeichen- oder Ordnungssysteme finden sich sowohl als zweidimensionale gezeichnete Formen wie auch als physische Objekte darin wieder. Das Eingreifen in den Ort und seine Manipulation ist Ausgangspunkt jeder ihrer Auseinandersetzungen mit einer Ausstellungssituation. L.P.

Material
Kreidespray

Maße
200 m

Restaurierung
jeden Morgen 10 Uhr

Standort
Skulpturenpark Marl
Alter Friedhof Brassert, 45768 Marl

Joëlle Tuerlinckx

Joëlle Tuerlinckx's (*1958 Brussels; lives in Brussels) conceptual works are frequently conceived at the edge of the visible. Her installations, which consist of found objects, drawings, display cases, and photos are more like spatial experiences than actual artefacts. Every exhibition is based on a precise study of the room and the particular institution where the work will appear. She then re-evaluates her idea and adapts it to the site in question. She has a special interest here in examining the role of museums in society.

Le Tag / 200 m

With her work for the Skulptur Projekte Münster, which is being carried out as part of the collaborative project *The Hot Wire* together with the Skulpturenmuseum Glaskasten Marl, Tuerlinckx abandons the museum's interior and focuses on the old Sickingmühler Cemetery in Marl. The terrain has been gradually transformed into a public park and is now being used as a sculpture garden by the Museum Glaskasten. The museum itself is experiencing a similar process of transformation, as it plans to move to the former school in Kampstraße on the other side of the cemetery park in the next few years. Based on the concept of a line as a sculpture or form—and tying in with the formalism of Minimal Art—Tuerlinckx has created an ephemeral sculpture in the form a 200-metre line. As part of a performance, the line is redrawn every morning at 10 o'clock, and the imprint it leaves in the public space is retraced with the kind of chalk spray used to mark out playing fields and sports grounds. When the exhibition is over, the work will disappear bit by bit, literally vanishing into thin air.

In terms of sheer size, *Le Tag* invokes the monumental land art of the 1960s. It stakes off a piece of land and defines a space. At the same time, it is a graphic element and a conscious designation by the artist: a signature similar to a tag, the personal initials used by a graffiti sprayer to brand his work. But *Le Tag* also plays with the German word *Tag* (day) and the daily repetition of the action of drawing a line. How do we perceive time? How can it be depicted? And what are the traces that the twentieth century leaves behind? These are the questions Tuerlinckx keeps on asking.

The principle of rethinking existing works, repeating them, copying them, and transcribing them—and, in so doing, further developing an idea—runs through her entire oeuvre. Lines, points, and circles and their multiple levels of meaning—not only as formal bodies but also as symbols, systems of signs, and organizational systems—are to be found both as forms drawn in two dimensions and as physical objects. Site intervention and manipulation: these are her starting points as she sets out to tackle an exhibition situation. L.P.

Material
Chalk spray

Dimension
200 m

Restoration
Every morning 10 am

Location
Sculpture park Marl
Alter Friedhof Brassert, 45768 Marl

Joëlle Tuerlinckx

Benjamin de Burca und Bárbara Wagner

Benjamin de Burca (*1975 München, lebt in Recife) und Bárbara Wagner (*1980 Brasília, lebt in Recife) untersuchen gesellschaftlich-ökonomische Zusammenhänge, etwa anhand von großen Stadtentwicklungsprojekten oder ausgehend von bestimmten popkulturellen Phänomenen. Nach investigativen Recherchen am jeweiligen Ort produzieren sie gemeinsam mit den Protagonist_innen des porträtierten Mikrokosmos fotografische und filmische Werke über Realität und Wunschdenken.

Bye Bye Deutschland! Eine Lebensmelodie

Für ihr Projekt in Münster nehmen Wagner und de Burca den deutschen Schlager in den Blick und untersuchen historische und strukturelle Prinzipien dieses Genres mittels vor Ort produzierter Musikvideos. Die Diskothek Elephant Lounge in der Münsteraner Altstadt fungiert dabei sowohl als investigativer Ausgangspunkt wie auch als Präsentationsort ihrer Videoinstallation. Die versteckt in einer Passage gelegene Diskothek bedient seit 1974 ein breites, generationenübergreifendes Publikum. Nach dem Schlagerboom der 1950er Jahre führte die Schlagerindustrie jahrzehntelang ein erfolgreiches Nischendasein. Nach einer ersten Renaissance in den 1990er Jahren erlebt der deutsche Pop momentan eine weitere Welle neuer, stärker elektronisch gefärbter deutschsprachiger Musik, deren Inhalte und Ästhetik an Schlagermuster anknüpfen. Die Außenperspektive ermöglicht dem in Brasilien lebenden Künstlerduo einen Blick auf diese Entwicklung und ihren gesellschaftlich-kulturellen Gesamtkontext.

Dem Projekt in Münster ist eine Beschäftigung mit der Brega-Szene und -Industrie in der im Norden Brasiliens gelegenen Stadt Recife vorausgegangen. Der in den vergangenen Jahren sehr erfolgreiche Tecno-Brega orientiert sich musikalisch an der elektronischen Popkultur der 1980er Jahre, wobei die Liedtexte theatralische Bilder von Liebe, Leben, Träumen und Traurigkeit entwerfen, die durchaus mit denen des deutschen Schlagers vergleichbar sind. Ihr Film *Estas vendo coisas* aus dem Jahr 2016 porträtiert einige Sänger_innen, Tänzer_innen und Produzent_innen der Szene in Aufnahmesituationen; formal bedient und dekonstruiert er das Genre Musikvideo im selben Zug.

In einer Stadt, deren Wahrnehmung oft über sogenannte Hochkultur befördert wird, trifft das Musikgenre Schlager offensichtlich einen bestimmten Nerv, der sich in den eskapistischen Qualitäten, eingängigen Motiven und der leicht verständlichen Sprache der Musik spiegelt. Die Musikvideos wurden vor Ort in Münster und in Zusammenarbeit mit ansässigen Produzent_innen und Akteur_innen der Schlagerszene gedreht. N.A.

Material
1-Kanal-Videoinstallation, 20 Min.

Standort
Elephant Lounge
Roggenmarkt 15, 48153 Münster

Öffnungszeiten
Mo – So 10 – 20 Uhr

Darsteller
Mike Förster, Sebastiano Lo Medico, Petra Schwar, Markus Sparfeldt, Makiko Tanaka, Leonardo Teumner, Stefani Teumner

Statisten
Ulla Bockhorn, Dorothée Degenhardt, Stephanie Heinrich, Jochen Hohmann, Hannelore Quick

Filmteam
Regie: Benjamin de Burca, Bárbara Wagner ● Ausführender Produzent: Michel Balagué ● Produktionsleitung: Leila Aliev, Jan Enste ● Postproduktion: Unai Rosende ● Recherche-Assistentin: Hannah Zipfel ● Kinematograf: Pedro Sotero ● Erste Kamera-Assistentin: Maíra IabrudiZweiter ● Kamera-/Licht-Assistent: Jakob Reuter ● Oberbeleuchter: Gunar Peters Schnitt: Eric Ménard ● Schnitt-Assistent: Mustafa Khalaf ● Ton: Gábor Ripli ● Musik-Produktion: Jochen Hohmann (Starstreet Studio) ● Piano: Jürgen Bleibel ● Assistenz Aufnahmeleitung: Sabine Huzikiewiz ● Make-up, Kostüm, künstlerische Assistentin: Jana-Kerima Stolzer ● Licht-, Grip-, künstlerischer Assistent: Alexander Rütten ● Drohnen-Operatoren: Dirk Lüttke-Harmann, Christopher Müller

Drehorte
Botanischer Garten, Clemenskirche, Theater Münster, Preußenstadium, Grille Nachtclub und WDR Studio Münster

Benjamin de Burca and Bárbara Wagner

Benjamin de Burca (* 1975 Munich; lives in Recife) and Bárbara Wagner (* 1980 Brasília; lives in Recife) analyse socio-economic relationships, on the basis, for example, of large urban development projects or specific phenomena from pop culture. After doing investigative research on site, they produce photographic and film works together with the protagonists of the performances they portray, addressing their movements between reality and aspirational ideals.

Bye Bye Deutschland! Eine Lebensmelodie

For their project in Münster, Wagner and de Burca have focused on schlager, a particular style of German pop music, and examined the historical and structural principles of this genre by means of music videos produced on location. Elephant Lounge discotheque in Münster's historical old town is the starting point for the investigation as well as the venue for the presentation of their video installation. Since 1974, the disco, which is tucked away in a passageway, has been catering to a broad group of people that spans the generations. Following the schlager boom of the 1950s, Germany's Tin Pan Alley spent decades leading a successful niche existence. After its first renaissance in the 1990s, German pop music is currently experiencing another wave of new, more electronically tinged German-language music, whose lyrics and aesthetic tastes are closely associated with the schlager model. Their external perspective enables the artist duo, who live in Brazil, to view this development and its overall sociocultural context.

Prior to the project in Münster, Wagner and de Burca took a close look at the brega scene and music industry in the city of Recife in northern Brazil. Tecno brega, which has become very successful in recent years, can be linked musically to the electronic pop culture of the 1980s, although the lyrics describe similarly theatrical visions of love, life, dreams, and sadness, strongly resembling those found in German schlager. Their 2016 film *Estas vendo coisas* portrays a few of the genre's singers, dancers, and producers during recording sessions; in formal terms, it makes use of the music video genre, while at the same time deconstructing it.

In a city where cultural perception is often advanced through so-called 'highbrow' culture, music genre of the schlager obviously strikes a certain nerve, which is mirrored in the music's escapist qualities, catchy motifs, and easily understandable lyrics. The music videos were made on location in Münster and shot with local producers and professionals from the schlager music scene. N.A.

[Bye Bye Germany! A Life Melody]

Material
1-channel video projection, 20 min.

Location
Elephant Lounge
Roggenmarkt 15, 48153 Münster

Opening hours
Mon – Sun 10 am – 8 pm

Cast
Mike Förster, Sebastiano Lo Medico, Petra Schwar, Markus Sparfeldt, Makiko Tanaka, Leonardo Teumner, Stefani Teumner

Extras
Ulla Bockhorn, Dorothée Degenhardt, Stephanie Heinrich, Jochen Hohmann, Hannelore Quick

Crew
Directed by: Benjamin de Burca, Bárbara Wagner • Executive producer: Michel Balagué • Production managers: Leila Aliev, Jan Enste • Postproduction coordinator: Unai Rosende • Research assistant: Hannah Zipfel • Cinematographer: Pedro Sotero • 1st camera assistant: Maíra Iabrudi • 2nd camera assistant, lightning assistant: Jakob Reuter • Gaffer: Gunar Peters • Editor: Eric Ménard • Assistant editor: Mustafa Khalaf • Sound recording, design, and mixing: Gábor Ripli • Music producer: Jochen Hohmann (Starstreet Studio) • Piano: Jürgen Bleibel • Set assistant producer: Sabine Huzikiewiz • Art assistant, make-up, wardrobe: Jana-Kerima Stolzer • Lighting, grip, art assistant: Alexander Rütten • Drone operators: Dirk Lüttke-Harmann, Christopher Müller

Film locations
Botanical Gardens, St Clement Church, Theater Münster, Preussen Stadium, Grille Nightclub and WDR TV Studio Münster

Filmstill, Petra Schwar singt Helene Fischers *Ich will immer wieder dieses Fieber spür'n* im Nachtclub Grille
Film still, Petra Schwar sings *Ich will immer wieder dieses Fieber spür'n* (I will always want to feel this fever again) by Helene Fischer at the Grille nightclub

Benjamin de Burca und Bárbara Wagner wagen sich an einen Zankapfel der deutschen Popkultur: den Schlager. Mittel ihrer Wahl ist das dokumentarische Musical.

Hannah Zipfel: In Eurer gemeinsamen Arbeit geht es um populäre Formen der Kulturproduktion im Verhältnis zum Markt. Der Schlager ist seit seinen Anfängen eine Ware und Bestandteil der Massen- und Konsumkultur. Wie verhandelt Ihr diese Zusammenhänge in Eurem Film *Bye Bye Deutschland! Eine Lebensmelodie*?

Bárbara Wagner: Nach allgemeiner Ansicht ist eine Vorliebe für Schlager oft mit kollektiven Tagträumereien von fernen Ländern verbunden, außerdem mit einer gewissen Schwäche für schlichte Texte voll nationalistischer Klischees und für eine Rührseligkeit, die schwere Geschütze auffährt. Wer Schlager mag, beweist sowohl ästhetisch als auch sozioökonomisch einen Mangel an Klasse. Fairerweise muss man aber zugeben, dass sich der Schlager als Musikgattung einer eindeutigen Definition entzieht, weil es uns nicht weiterbringt, die vielen verschiedenen Kontexte, in denen er seit fünfzig Jahren produziert wird, über einen Kamm zu scheren.

Benjamin de Burca: Tatsächlich ist der Schlager kein einzelnes Untergenre, und so lässt sich auch kaum sagen, was einen Schlager genau ausmacht. Er kann verschiedene Musikstile von Folk und Rock bis Techno und Pop beinhalten. Dennoch haben viele Menschen einen festen Begriff vom Schlager, und er wird im Rahmen einer mit großem Ernst geführten Kulturdebatte besonders in akademischen Kreisen oft scharf kritisiert. Die Hartnäckigkeit, mit der er seiner Form treu bleibt, gilt als eine Art konservative Rebellion, eine Weigerung, Neues zu akzeptieren und die herrschende liberale Vorliebe für die bessere Musik zu teilen. Wer Schlager hört, so die Unterstellung, schwelgt lieber in einfach gestrickten Texten und Rhythmen. Als kommerzielle Musik polarisiert der Schlager einerseits, andererseits

wird er von der Kunst vermutlich aufgrund seiner Durchschnittlichkeit und Banalität ganz ignoriert. Für uns ist klar, dass die permanente Wiedergeburt des Schlagers in den vergangenen Jahrzehnten bei allen einen Nerv trifft – ob sie ihn nun lieben oder hassen.

BW: Nicht zufällig singt das Paar aus Münster, dessen Leben in *Bye Bye Deutschland! Eine Lebensmelodie* erzählt wird, Lieder von Udo Jürgens und Helene Fischer, zwei ganz großen Nummern aus verschiedenen Bereichen des Schlagers. Udo Jürgens wurde berühmt für seine Einführung des französischen Chansons in den deutschen Schlager der 1960er und -70er Jahre (oft mit einem politischen oder gesellschaftskritischen Unterton). Helene Fischer ist ein Star unserer Zeit, der das Genre für eine Art Pop-Weltstandard geöffnet hat.

HZ: Wenn man ein Konzert von Helene Fischer oder Florian Silbereisen besucht, fällt auf, dass sich die Show eng an die großen Broadway- oder Cabaret-Produktionen anlehnt. Sie zelebrieren das Können und den Ruhm des Schlagerstars. Das hat mit der eher persönlichen Beziehung zwischen Sänger und Publikum, wie sie in alten Schlagersendungen wie *Hitparade* bestand, kaum noch etwas zu tun. Sind solche unterschiedlichen Formen und Formate Thema in Eurer Arbeit?

BW: Wir sollten nicht vergessen, dass der Schlager von Anfang an für die Kamera und für ein großes Fernsehpublikum gemacht wurde. In den Sendungen der 1970er Jahre stand der Körper der Sängerin oder des Sängers noch in direktem Bezug zur Kamera. Er oder sie trat in einem Studio vor einem Publikum auf, das in die Show einbezogen wurde. Demgegenüber inszenieren heutige High-End-Produktionen den Star in einer großen Arena,

oft sogar an Seilen in der Luft schwebend, beim Singen und Tanzen für eine ganze Batterie von Kameras. Dadurch geht zugleich viel von der körperlichen Nähe zum Star verloren.

HZ: Seht Ihr einen Zusammenhang zwischen der Stadt Münster, vielleicht auch in rein filmischer Hinsicht, und dem Thema Schlager? Wie erscheint die Stadt in Eurem Film, und warum habt Ihr Euch für die Elephant Lounge als Ort Eurer Installation entschieden?

BdB: Münster passt zum Thema, weil es – als Kulissenstadt, die nach dem Zweiten Weltkrieg als Kopie ihrer selbst wiederaufgebaut wurde – insgesamt einen szenografischen Hintergrund bildet. Auch der Schlager war Mittel und Medium des Wiederaufbaus, indem er ein Gefühl gemeinsamer Identität jenseits der unmittelbaren, finsteren Vergangenheit bestärkte und gelegentlich die Nostalgie der Heimat mit Träumereien von Heimweh und Fernweh bediente. Daraus gingen auch neue Formen der Selbstreflexivität wie Drag und Exotismus ferner Länder hervor, die ebenso mit der Rekonstruktion oder Kopie eines früheren Selbstbildes zu tun hatten.

BW: Als Diskothek, die seit fast fünfzig Jahren im Zentrum von Münster angesiedelt ist, entzieht sich die Elephant Lounge in gewisser Weise der Künstlichkeit rundherum. Man gelangt in den Club nur über einen langen Gang, der ganz im Gegensatz zum Gepränge der Häuser steht. Es ist, als beträte man die Hinterbühne einer Stadt. Die Elephant Lounge unterhält enge Verbindungen zur Schlagerwirtschaft in der Region (und ihren Produzent_innen, Sänger_innen, DJs, Konsument_innen). Sie war ein wichtiger Ausgangspunkt unserer Recherche. Daher sprach vieles dafür, unsere Arbeit hier zu zeigen. An diesem Ort können die Besucher_innen die Stadt erneut als Inszenierung erfahren, diesmal aber innerhalb eines Films.

HZ: Der Titel Eurer Arbeit ist offensichtlich an die deutsche Doku-Soap *Goodbye Deutschland! Die Auswanderer* angelehnt. Inwiefern nimmt Eure Arbeit Bezug auf dieses Fernsehformat, in dem Menschen im Ausland ein neues Leben beginnen?

BW: Schon thematisch gehören Deutsche, die im Ausland ihr Glück versuchen, zum Kernrepertoire des Schlagers. Auch dass diese beliebte Fernsehserie Beschreibungen des Alltagslebens mit Elementen dramatischer Spannung verbindet, schien uns eine interessante Parallele zu unserer Recherche. Wir erzählen von zwei Menschen, die mit dem Nachsingen von Schlagern ihr Leben verändert haben, und wir haben uns entschieden, dabei mit den Konventionen von Direct Cinema und Musical zu experimentieren. Während wir an den dokumentarischen Aspekten arbeiteten, ließen wir uns mehr auf den Alltag der beiden und ihr Einstudieren der Lieder ein. Erst danach konnten wir das Drehbuch für den Musical-Teil des Films erstellen.

BdB: Wenn Figuren sich selbst darstellen, kann man kaum noch eine Grenze zwischen echtem Leben und Inszenierung ziehen, und darin liegt auch die Komplexität des Films. Einen beobachtenden Zugang zu wählen, bedeutet nämlich nicht, dass alles, was man sieht, auch wahr ist. Umgekehrt ist auch im Musical nicht alles inszeniert. Aus dieser Dynamik entsteht ein Dreiecksverhältnis auf Augenhöhe zwischen uns als Filmemacher_innen, Sängerin und Sänger als Hauptdarsteller_innen und dem Publikum in der Elephant Lounge.

Filmstill, Stefani Teumner und Markus Sparfeldt performen das Duett *Ich will, ich kann* von Udo Jürgens im WDR TV Studio
Film still, Stefani Teumner and Markus Sparfeldt perform a duet of *Ich will, ich kann* (I can I will) by Udo Jürgens at the WDR TV Studio

Benjamin de Burca / Bárbara Wagner

Filmstill, Stefani Teumner singt *Mitten im Paradies* von Helene Fischer im Botanischen Garten
Film still, Stefani Teumner sings *Mitten im Paradies* (In the middle of paradise) by Helene Fischer at the Botanical Gardens

Benjamin de Burca and Bárbara Wagner are handling a hot potato of German pop culture—the schlager—in the form of a documentary musical.

Hannah Zipfel: In your collaborative work, you investigate popular forms of cultural production and how they are connected to the economy. Schlager music is a commodity from its origin and is strongly connected to the consumption of mass culture in general. How is this treated in your film *Bye Bye Deutschland! Eine Lebensmelodie*?

Bárbara Wagner: In the public imagination, a fondness for schlager is often associated with a collective daydream of foreign lands, simple texts with a nationalist imaginary or heavy-duty sentimentalism. It's also connected with a certain lack of class, in both socio-economic and aesthetic terms. In fairness, schlager as a music genre is as hard to define as it is unproductive to simplify the contexts in which it has been produced over the last fifty years.

Benjamin de Burca: Yes, it's not a sub-genre, so defining what makes a schlager can be tricky. It can incorporate different musical styles from folk and rock to techno and pop. But it is still fixed as a concept in people's minds and in academic circles it has long been the topic of serious cultural debate—one that is often treated in highly critical terms. It's stubbornness in staying true to its form is thought to represent a kind of conservative rebellion, a refusal to accept change and embrace the dominant liberal taste for newer or better, opting instead to revel in simplistic lyrics and rhythms. It's an industry that divides opinion strongly and, perhaps because of its mainstream quality, the topic is avoided by the art field. What is clear for us is that the constant rebirth of schlager over the past decades repeatedly touches a nerve both for those who love it and for those who don't.

BW: It's not by coincidence that the couple portrayed in *Bye Bye Deutschland! Eine Lebensmelodie* are singers from Münster who cover Udo Jürgens and Helene Fischer, two very prominent schlager celebrities from distinct eras. While Udo is known for introducing French chanson into sixties' and seventies' schlager (often with a political or critical edge), Helene is the contemporary icon who opened the genre to a type of global pop standard.

HZ: If you watch a Helene Fischer or Florian Silbereisen show, it's very linked to huge Broadway productions or cabaret, with its celebrations of a person's skills and fame. This differs a lot from a more intimate relation between singer and audience in old TV shows like *Hitparade*. How do you reflect on these different forms of production?

BW: We think it's really important to remember that the schlager has always been a form produced for the camera and broadcast to big audiences. In seventies' TV shows, the body of the singer relates to the camera inside a studio and in close proximity to an audience that is present and included as part of the scenario. This differs from contemporary high-end productions, where the star is often seen in a large arena, even flying overhead on ropes, and performs to a multi-camera apparatus. In such scenarios, the singer is less physically accessible.

HZ: Do you see a connection between the city of Münster, even from a cinematographic point of view, and the topic of schlager? How is the city represented in your film and why is the Elephant Lounge chosen as the site for the installation?

BdB: Münster suits the topic since it is a scenographic background in itself—a staged city reconstructed after World War II—and literally a replica of its former self. The schlager was also a tool in a post-war rebuilding effort, only this time for recreating a sense of collective identity that looked beyond its recent dark past, sometimes returning to a nostalgia for *Heimat*, loaded with fantasies of *Heimweh* and *Fernweh* (homesickness and wanderlust). This produced new forms of self-reflexivity through drag and the exoticism of other places, processes that also have to do with reconstructing an image or replica of a former self.

BW: As a nightclub that has been in the centre of Münster for nearly fifty years, the Elephant Lounge somehow sits behind the artifice: in order to reach its door, you have to walk through a long passageway that is somehow at odds with the ostentation of the edifices, as if entering the backstage of the city. Closely related to the schlager economy in the region (musical producers, singers, DJs, and consumers), it was a fundamental departure point for our research. For us, it makes a lot of sense to show the work there, where the audience again experiences the city as a scenario, but this time inside the film.

HZ: The title of your work seems to be influenced by the German docu-soap *Goodbye Deutschland! Die Auswanderer*. How does your work relate to this TV format, in which people start a new life in a foreign country?

BW: As a subject, Germans who try their luck in a foreign country are already at the very heart of schlager. The fact that this popular TV programme combines depictions of daily life with elements of drama also seemed to have an interesting connection to our research. Following two singers who changed their lives by performing well-known hits of this musical genre, we decided to experiment with the conventions of both Direct Cinema and musicals. While developing the more documentary

side of the work, we got close to their routine and practice, and only then were we able to put together the actual script of what became the musical part of the film.

BdB: When characters represent themselves, it becomes hard to define the limit of what is real and what is staged, and therein lies the complexity of it. When we make use of an observational approach, it does not mean that everything we are looking at is true. The same happens in the musical, where not everything is arranged. This dynamic creates a triangularity based on a horizontal view between us as filmmakers, the singers as subjects, and the audience watching it in the Elephant Lounge.

Sebastiano Lo Medico singt *Von hier bis unendlich* von Helene Fischer in der Clemenskirche
Sebastiano Lo Medico sings *Von hier bis unendlich* (From here to infinity) by Helene Fischer at the St Clement Church

　　Benjamin de Burca / Bárbara Wagner

Cerith Wyn Evans

Eine Mischung aus konzeptionellen, philosophischen und poetischen Gedanken bildet den Ausgangspunkt für die Arbeiten von Cerith Wyn Evans (* 1958 Llanelli, lebt in London). Die Gleichzeitigkeit dieser zum Teil widersprüchlichen Lesarten wird ermöglicht durch den Einsatz reduzierter Mittel wie Licht, Ton und geschriebenes Wort, und eine insgesamt eher kühle, minimale Ästhetik. Eine prägende Bedeutung kommt darüber hinaus dem jeweiligen Installations- und Ausstellungskontext zu, der weitere inhaltliche und formale Bezugssysteme anbietet. Einige Arbeiten von Wyn Evans bewegen sich dabei buchstäblich zwischen den Extremen alles oder nichts: Sie eignen sich ohne jede Opulenz – daher die Nähe des Nichts – als Projektionsfläche für tiefgreifende und allumfassende Gedanken.

A Modified Threshold … (for Münster)
Existing church bells made to ring at a (slightly) higher pitch
Intervals // Leaning Horizons

Im Glockenstuhl der im Stil des Brutalismus erbauten St. Stephanus Kirche im Stadtviertel Aaseestadt installiert Wyn Evans ein Klimagerät, das die Kirchenglocken kühlt. Durch die veränderte Temperatur klingen die Glocken ein wenig höher – wenn auch für das menschliche Ohr kaum wahrnehmbar. Ergänzend dazu lehnen im geschützten Kirchhof zwei Neonröhren an der Außenmauer der Kirche. Die beiden auf den ersten Blick identischen Leuchtelemente unterscheiden sich minimal in ihrer Farbigkeit. Die *Leaning Horizons* bilden den sichtbaren Konterpart zur unsichtbaren Modifikation der Kirchenglocken und sind ein wiederkehrendes Moment im Werk von Wyn Evans. Die Benennung der vertikalen Neonröhren als Horizont widerspricht der damit verbundenen räumlichen Dimension als Trennlinie zwischen Himmel und Erde, Ausgangspunkt zur Orientierung, Navigation und Grundlage perspektivischer Raumdarstellung. Gleichzeitig lassen sich die Neonröhren als vorsichtige Ergänzung des Gebäudes verstehen: Statt über eine vermeintlich neutrale Neonbeleuchtung als Merkmal der Moderne wird der hermetische Baukörper über farbige Oberlichter gespeist.

Münster besitzt eine sehr hohe Kirchendichte, und das Zusammenspiel der läutenden Glocken überzieht das gesamte Stadtgebiet. Wyn Evans verfolgte von Anfang an die Idee, der Stadt keine weitere Skulptur hinzuzufügen. Er sah sein Projekt darin, lieber etwas wegzunehmen. Nach der Entscheidung, das allgegenwärtige Glockengeläut subtil zu manipulieren, fiel seine Ortswahl auf den Kirchhof von St. Stephanus. Vom Kölner Architekten Hans Schilling 1965 erbaut, ist diese Kirche der erste Kirchenneubau in Münster nach dem Zweiten Vatikanischen Konzil. Die Aufbruchsstimmung der damaligen Zeit manifestiert sich in der kühnen Architektur des Ensembles. Die besondere Qualität der Gebäude und die sichtbaren Spuren des aktiven Gemeindelebens machen die Kirche zu einem lebendigen Ort, der durch die reduzierten Mittel der Installationen als wichtiger Parameter hervortritt. Die manipulierte Glocke befindet sich im Dialog mit dem verschobenen räumlichen Gefüge der *Leaning Horizons*. Gemeinsam reflektieren sie an einem Ort, dem der Glaube an Transzendenz innewohnt, die messbaren Koordinaten Raum und Zeit. J.B.

[Kirchenglocken, leicht verändert, in höherer Tonlage erklingend]

Material
Kirche St. Stephanus, Kühlgerät

[Intervalle // angelehnte Horizonte]

Material
Kirche St. Stephanus, zwei Neonröhren (Farbtemperatur variabel)

Maße
300 cm Höhe

Standort
Kirche St. Stephanus
Stephanuskirchplatz 4, 48151 Münster

Cerith Wyn Evans

A mixture of conceptual, philosophical, and poetic ideas serves as the basis for Cerith Wyn Evans's (*1958 Llanelli, Wales; lives in London) works. The concurrence of these somewhat contradictory readings is made possible by the use of reduced means, such as light, sound, and the written word, and a minimalist aesthetic whose overall timbre is rather cool. In addition to that, great importance is attached to the particular context of each installation and exhibition which offers further frames of reference in terms of form and content. Some of Wyn Evans's works literally deal with the extremes of all or nothing: they lend themselves as a projection screen for profound and all-encompassing ideas devoid of any opulence—thus approximating nothing.

A Modified Threshold … (for Münster)
Existing church bells made to ring at a (slightly) higher pitch
Intervals // Leaning Horizons

In the belfry of the Brutalist-style St Stephanus Church in the Aaseestadt district of Münster, Wyn Evans has installed an air-conditioning unit that cools the bells. With the change in temperature, the bells ring at a higher pitch—although this is hardly perceptible to the human ear. In addition, there are two neon light tubes leaning against the outer wall of the church inside the sheltered churchyard. The two lights, which look identical at first glance, have a slightly different colour. The *Leaning Horizons* form the visible counterpart to the invisible modification of the church bells and are a recurring feature in Wyn Evans's work. By calling the neon tubes the horizon, he contradicts the spatial dimension associated with it as a dividing line between heaven and earth, a starting point for orientation, a means of navigation, and the basis for depicting perspectival space. At the same time, the neon tubes can be understood as a tentative addition to the building: instead of using supposedly neutral neon lighting as a characteristic of modernism, the hermetic building is illuminated by coloured overhead lights.

Münster has a high density of churches, and the interplay of ringing bells resounds across the entire city. From the beginning, Wyn Evans pursued the idea of not adding another sculpture to the cityscape. Instead, he saw his project as a means rather to remove something. After deciding to subtly manipulate the omnipresent sound of the bells, he selected the churchyard of St Stephanus's. Built by the Cologne architect Hans Schilling in 1965, this was the first new church to be built in Münster after the Second Vatican Council. The spirit of optimism that prevailed at the time manifested itself in the ensemble's daring architecture. The building's specific quality and the visible traces of active congregational life make the church a lively place, which emerges as an important dimension of the work owing to the installations' reduced means. The manipulated bells 'converse' with the displaced spatial arrangement of the *Leaning Horizons*. Together they contemplate the measurable coordinates of space and time in a place where the belief in transcendence is immanent.

J.B.

A Modified Threshold … (for Münster)
Existing church bells made to ring at a (slightly) higher pitch

Material
Bells of the St Stephanus Church, refrigeration unit

Intervals // Leaning Horizons

Material
Two neon lights (colour temperatures variable)

Dimensions
Height 300 cm

Location
St Stephanus Church
Stephanuskirchplatz 4, 48151 Münster

Leaning horizons (after site/cite/sight)

....some thoughts about presence and absence and the wilful dissolution of dialectic apparatus and it's role in the mimetic stranglehold (tyranny of representation) and condition of the illusion...

Agency dismissed.
...and with the dismissal, comes a departure from the stable paradigm of orientation,
 which has situated concepts of subject and object, of time and space...

A horizon at repose
at rest...

Liminal point lifted and excised from space/time representation...
Let us take a step back and consider the role of the horizon... Our traditional sense of orientation - and, with it, modern concepts
of space/time are based on a stable line:
th itareareareareare, modern concepts of time and space
– are based on a stable line:

the horizon line.

The illuminating gas.

......
Its stability hinges on the stability of an observer, who is thought to be located on a ground of sorts, a shoreline,

a boat – a ground that can be imagined as stable, of this earth. The horizon line was an extremely important element in navigation. It defined the limits of communication and understanding.

Temporary pause from the work of the horizon's role in representation standing for the boundary marking the meeting point of the land and the sky…

Temporary cessation…
a designated dissolution of a boundary.
(time out, a break, interlude, interstice, suspension of duties…)

Beyond the horizon, there was imagined muteness and silence. Within it, things could be made visible. It could also be
used for determining one's location and relation to one's surroundings, bearings, destinations and ambitions.
Early navigation consisted of gestures and poses relating to the horizon.

….Star/Steer

"In early days [Arab navigators] used one or two fingers width, a thumb and a little finger on an outstretched arm, or an arrow held at arms length to the sight of the horizon at the lower end and Polaris at the upper."
The angle between the horizon and the Pole star gave information about the altitude of one's position.
This measurement method was known as sighting the object, shooting the object, or taking a sight…
In this way, one's location could at least roughly be determined.
Citation as Sight specific…
bearings, frequencies, numerable and innumerable…

("you've searched babe at any cost, but how long babe can you search for what's not lost?")

"…Instruments, such as the astrolabe, quadrant, and sextant refined the way

of gaining orientation [Mirror travels]

by using the horizon and the stars.

The use of the horizon…became an important tool for the construction of
the optical paradigms that came to
define modernity, numerous experiments in visual production culminated in
the development of linear perspective.
… The perspective is aligned to
culminate in one single vanishing point,
located on a virtual horizon defined by the eye line." *

Designated (casually) temporal coordinates.

The horizon has 'taken a break' and is mindlessly 'hanging out' leaning against any available wall to, take the
weight off it's feet…
It's 'off duty'…

Retracted, withheld, disavowed, untitled/unentitled…

Not exactly to be anthropomorphised…
Not strictly a body…
More a frequency, a monad, a singularity

Issued…'In the wings'… off set… an elapsure of
space… through time. (Notes on Neon - dusk through
dawn and on bracing amidst the solar glare).

Linear perspective is based on several decisive negations. First, the curvature of the earth is typically disregarded.
The horizon is conceived as an abstract flat line upon which the points on any horizontal plane converge.
Additionally, the construction of linear perspective declares the view of a
one-eyed (monocular) and immobile
spectator as a norm.

Cerith Wyn Evans

Linear perspective is based on an abstraction, and does not correspond to 'subjective' perception…
It computes a mathematical, flattened, infinite, continuous and homogenous space,
and declares it a reality…
Linear perspective creates the illusion of a quasi-natural view to the 'outside',
as if the image plane was a window opening on to ethereal' world.
This is the meaning of the Latin Perspectiva: to see through. This space

Yet, here (hic et nunc), - Issued with a different frequency or issued with the same frequency…

Here as manifest gas glass electricity illumination and shadow. That which has provided the means to produce an absence.
Limbo incarnate.

This space……defined by linear perspective is calculable, navigable and predictable.
It allows the calculation of future risk, which can be anticipated and therefore
managed. As a consequence, linear perspective not only transforms space, but also introduces
the idea of linear time… … … … … …
which allows mathematical prediction and, with it, linear progress.

This is the second, temporal meaning of perspective: a view on to a calculable future.

("I sometimes play in the future.")

So, time, you say, just as homogenous and empty as space…

Empty how?

The horizons here are apt to congregate together, together 'shooting the

breeze… **. . . Contre jour'**

Something like - A picture, liminal, sequestered, and in suspense…

for all these calculations to operate, we must necessarily assume an observer standing on stable ground looking
out toward a vanishing point on a flat and artificial horizon.

However, linear perspective further performs an ambivalent operation concerning the viewer.

As the whole paradigm converges in one of the viewer's eyes, the viewer becomes central to the worldview
established by it.

Seemingly…the viewer is mirrored in the vanishing point, and thus constructed by it…yet here, something unlike a picture, more a frequency in the shade…

Cerith Wyn Evans

calling Supernatural *Shift*

and a change of mind… that which exceeds the actual "natured nature"
…equiped with the prosthesis of an abstract machine -

an *inhuman eye*

subtracted, at any cost, from the 'visual atlas' of common perception.

The perceiving subject is *stripped* of its flesh
to reveal a hallucinating automaton which
promptly takes leave of the space of
representation and its
perspectival - subjective - mimetic
"point of view"

meaning that the

conditions of the pictorial as such
MIGHT be rethought in the light of
the visual……

Cerith Wyn Evans

Hervé Youmbi

Hervé Youmbi (* 1973 Bangui, lebt in Douala) reflektiert in verschiedensten Medien die (post-)koloniale Situation des afrikanischen Kontinents. Mit Objekten und einer ikonografisch hybriden Formsprache, gespeist aus westlicher Popkultur sowie der vorkolonialen und kolonialen Kunstproduktion in West- und Zentralafrika, widerspricht er der Idee von einer singulären kulturellen Identität.

Les masques célèstes

Youmbis Installation befindet sich auf dem stillgelegten Überwasserfriedhof. In unmittelbarer Nähe zum Grab des Generals Ludwig Roth von Schreckenstein sind in circa zehn Metern Höhe vier Masken angebracht. Vier weitere kleinere Masken hängen direkt in den Bäumen. *Les masques célèstes* zitieren Elemente der westlich-kapitalistischen Popkultur – klar erkennbar ist die Referenz zur Maske aus dem US-amerikanischen Horrorfilm *Scream* (1996), deren Gestaltung wiederum durch Edvard Munchs Gemälde *Der Schrei* (1893) inspiriert wurde. Neben diesem ikonischen Motiv für Angst und Schrecken stehen animistische Zeichen verschiedener afrikanischer Kulturen. Sie fungieren laut Youmbi als Einladung an die Geister der Toten, während feierlicher Zeremonien in die Masken zu fahren und sie zu besetzen. Youmbis Objekte wurden in Maskenwerkstätten in Kamerun gefertigt. Seine Intervention an einem Ort christlicher Begräbniskultur, der dem Gedenken an die Toten gewidmet ist, wirft Fragen nach Religiosität, Spiritualität und Aberglaube auf. Seine Arbeit beleuchtet die Objekte und Plätze anhand derer wir Verbindungen zwischen Diesseits und Jenseits herstellen, und reflektiert, anhand welcher Parameter diese kulturellen Praktiken als gültig, wirkmächtig oder authentisch erachtet werden.

Die westliche Moderne und die Masken des afrikanischen Kontinents verbindet eine lange wie problematische Geschichte. Masken wurden seit jeher aus dem rituellen Gebrauchskontext herausgelöst, als rein formale, ästhetische Inspirationsquellen genommen und als Trophäen an die Wand gehängt. Das Interesse und die kommerzielle Nachfrage des Westens lösten einen Produktionsboom von Masken aus, der bis heute Gutachter_innen in Auktionshäusern beschäftigt. Diese Geschichte steht unter den Vorzeichen von Mystifizierung und Fetischisierung und thematisiert die rituelle Authentizität. Bekannt ist auch, dass viele der Objekte, die außerhalb des afrikanischen Kontinents als genuin afrikanisch verstanden werden, in Wirklichkeit koloniale und kulturelle Hybride sind. Auch in diesen Masken finden sich Perlen, die in Italien produziert wurden und seit Jahrhunderten in den rituellen Objekten Kameruns verarbeitet werden. Youmbi verdeutlicht durch den ortsspezifischen Zusammenhang des Grabmals Von Schreckenstein eine besondere Dringlichkeit: Von Schreckenstein ist als Gisant, als just entschlafene Liegefigur mit geschlossenen Augen dargestellt. Über der Plastik schweben nun die himmlischen Masken, auf denen sich auch die Darstellung eines Vogels findet, der eine Eidechse auf dem Rücken trägt. Beide Tiere fungieren als Boten zwischen Diesseits und Jenseits. Youmbi verbindet einen europäischen, christlichen Totenkult mit einer Serie von (pseudo-) animistischen Hybridobjekten und fragt, unter welchen Bedingungen uns ein Glaubenssystem als authentisch erscheint. N.A.

[Himmlische Masken]

Material
Holz, Glasperlen, Holzleim,
Baumwollfäden, Silikon

Maße
Große Masken
200 × 40 × 45 cm
184 × 46 × 42 cm
193 × 41 × 41 cm
200 × 35 × 31 cm
Kleine Masken
103 × 35 × 27 cm
84 × 37 × 32 cm
82 × 37 × 33 cm
100 × 33 × 27 cm

Standort:
Überwasserfriedhof
Wilhelmstraße / Schlosspark,
48149 Münster

Hervé Youmbi

Hervé Youmbi (* 1973 Bangui; lives in Douala) deals with the African continent's (post)colonial situation using various media. He contradicts the idea of a singular cultural identity, using objects and an iconographic, hybrid system of forms taken from Western pop culture as well as from precolonial and colonial art production in West and Central Africa.

Les masques célèstes

Youmbi's installation is located in the disused Überwasser cemetery north of Münster's palace gardens, near General Ludwig Roth von Schreckenstein's grave. Suspended among the trees, four massive masks appear to hover some ten metres from the ground. Another four, smaller masks are mounted directly on the trees. *Les masques célèstes* incorporates iconography from popular Western capitalist culture: immediately apparent is the Ghostface mask—from the American horror film *Scream* (1996)—which was in turn inspired by Edvard Munch's 1893 painting. This icon of fear is juxtaposed with animistic tokens from many traditional African cultures. According to Youmbi, these animate the spirits of the dead by inviting them to enter and possess the masks during celebratory ceremonies. Youmbi commissioned the masks from workshops in Cameroon. His intervention at a Christian burial site, a location for the commemoration of the dead, raises questions about religion, spirituality, and superstition. Youmbi's work highlights the objects and the sites where we make connections between this world and the hereafter and examines what parameters are used to decide whether these customs are valid, effective, or authentic.

A long and problematic history links Western modernity with masks from the African continent. Masks have always been removed from the ritual context in which they were used; they have been seen in purely formal terms as aesthetic sources of inspiration and hung on walls as trophies. The West's interest in masks and the commercial demand for them led to a boom in the production of masks that still keeps auction-house appraisers in business. It is a history characterized by mystification and fetishism that deals with the authenticity of rituals. It is also well known that many of the objects which are considered genuinely 'African' outside of the African continent are really colonial and cultural hybrids. For example, in *Les masques célèstes* you will find beads produced in Italy that have been used for centuries in the ritual objects of Cameroon. By using the site-specific context of von Schreckenstein's grave, Youmbi brings out a particular immediacy: von Schreckenstein is depicted as a tomb effigy—a recumbent figure, asleep with his eyes closed. Above this sculpted figure are Youmbi's hovering heavenly masks, which also include the depiction of a bird carrying a lizard on its back. Both animals serve as messengers between this world and the next. Youmbi thus links a European Christian death cult with (pseudo-) animistic hybrid objects and raises the question, What conditions are needed to make a belief system seem authentic to us? N.A.

[Celestial Masks]

Material
Wood, glass beads, wood glue, cotton thread, silicone

Dimensions
Large masks
200 × 40 × 45 cm
184 × 46 × 42 cm
193 × 41 × 41 cm
200 × 35 × 31 cm
Small masks
103 × 35 × 27 cm
 84 × 37 × 32 cm
 82 × 37 × 33 cm
100 × 33 × 27 cm

Location
Überwasser cemetery
Wilhelmstraße / Schlosspark,
48149 Münster

Legen Sie den Kopf in den Nacken und stellen Sie sich vor, der Äquator verliefe unter Ihren Zehen. Wir sind in Douala, der großen Hafenstadt von Kamerun, wo einst die fatalen Verträge mit der deutschen Schutzmacht besiegelt wurden. Es ist schwül. Um uns lärmender Verkehr, Hafenkräne, bröckelnde Mauern, Benzingeruch und dann und wann der Duft blühender Bäume. Man spürt hier noch das Joch der Kolonialherrschaft auf den Schultern, aber das Leben ist weitergegangen.

Heute finden sich im öffentlichen Raum dieser tropischen Stadt Dutzende ortsspezifische Skulpturen und Interventionen. Die Werke von Künstler_innen verschiedenster Herkunft zieren das alte Verwaltungsviertel und begleiten den Alltag in den einfachen Wohnquartieren mit ihren betonierten Wasserstellen. Sie ziehen sich durch die vielsprachig lärmenden Geschäftsstraßen voller chinesischer Waren bis hin zu den beschaulichen Wohngegenden am Ufer des Wouri-Flusses. Sie polarisieren; mehr als einmal haben sie Skandale ausgelöst; ihre Instandhaltung ist prekär.

Hervé Youmbi ist ein Kind dieser Stadt am Golf von Guinea. Er wurde 1973 geboren. Als Heranwachsender besucht er das einzige Kunstgymnasium von Zentralafrika – eine italienische Gründung – ergattert Ausschnitte aus französischen Zeitungen, um sich die Bildsprache der französischen Moderne anzueignen, und verkehrt in den Ateliers seiner *grands frères*, den älteren Kollegen.[1] Er wird Maler, sein bevorzugtes Sujet sind Porträts. Die künstlerische Eroberung des Stadtraums von Douala begleitet seine Karriere, denn als junger Mann wird er von der umtriebigen NGO *Doual'art*[2] in Gruppenprojekte einbezogen. Später wird er Mitglied eines Künstlerkollektivs, gemeinsam gründen sie einen Kunstraum, der in den Stadtteil New Bell ausstrahlt. Bildung, Umweltschutz, Bürgerrechte und zivilgesellschaftliches Engagement sind die Reizworte dieser Jahre, die von politischen Unruhen geprägt sind. Kontakte mit Gästen aus dem Okzident sind an der Tagesordnung, Mobilfunk und Internet lassen die (Kunst-)Welt näher rücken.

Mit Blick auf die Kunstszene von Douala mag es überraschen, dass Youmbis Beitrag zu den Skulptur Projekten ausgerechnet Masken bemüht, das Klischee alter afrikanischer Kunst. Tatsächlich war hier das städtische Leben und dessen globale Einbindung für lange Zeit der wichtigste Bezugsrahmen. Entsprechend neu und urban waren die Medien der Wahl. Die vielfältigen ländlichen Lebensweisen, zu denen die Maskentraditionen gehören, blieben außen vor – vielleicht, um sich von den Authentizitätsdebatten der Unabhängigkeitsgeneration abzugrenzen; vielleicht, um der Spaltung durch die verheerenden Tribalismen entgegenzuwirken; oder schlicht als Reaktion auf die Maßgaben der alles dominierenden europäischen Projektförderung. Seit einigen Jahren lässt sich eine gegenläufige Entwicklung beobachten: Bildende Künstler wie Youmbi entdecken die einheimischen Bildtraditionen für sich. Dass dies erst im Zuge ihrer Auslandsreisen möglich wurde, ist einer von vielen postkolonialen Widersprüchen. Aber schließlich verbleibt das kulturelle Erbe von Ländern wie Kamerun weiterhin in den ethnologischen Museen des Nordens, in denselben Metropolen, wo auch die Karrieren von Künstler_innen des globalen Südens gemacht werden.[3] Dass Youmbi in Münster Masken ins Spiel bringt, ist Teil seiner Auseinandersetzung mit diesen Widersprüchen und mit seiner kulturellen Hybridität.

Ein Ausgangspunkt dieser Auseinandersetzung war ein Erlebnis in der Region seiner Vorfahren, im sogenannten Grassland. Bei einem der folkloristischen Events, die die Tradition der Ahnenverehrung mehr schlecht als recht in Erinnerung rufen, stechen einzelne Tänzer heraus. Sie tragen die Maske des Serienkillers Ghostface aus dem amerikanischen Blockbuster *Scream*. Die Tänzer haben dieses Stück Plastik billig ergattert, als Totenkopf identifiziert und für hinreichend ausdrucksstark befunden. Nicht umsonst hat Edvard Munchs expressionistischer *Schrei* dafür Pate gestanden. Youmbi ist verblüfft. Seither widmet er sich der Aktualisierung der Tanzmasken des Grasslands.[4] Er ist davon überzeugt, dass Afrikas Masken „ein neues Gesicht brauchen",[5] um die modernen Toten verkörpern zu können, die die Lebenden unterstützen sollen. Um dabei die Würde der alten Religionen des Kontinents zu wahren, spricht er mit den verschworenen Tänzerbünden, unterbreitet den Holzschnitzern seine Skizzen und erörtert mit den Perlenhandwerkerinnen neue Gestaltungsideen, wie die Melierung der starkfarbigen Flächen des Perlenüberzugs.

Stellen Sie jetzt Ihre Füße auf westfälischen Boden. Der Kopf bleibt im Nacken. Sie werden bemerken, dass die Masken, die Youmbi für den alten Friedhof im Land der Kolonisatoren entworfen hat, keines Tänzers bedürfen. Sie führen ein Eigenleben zwischen Himmel und Erde, es sind *himmlische Masken*. Verschiedene kulturelle Einflüsse verbinden sich in ihnen, auch die Screammaske taucht wieder auf. Würden Sie deswegen diesen Skulpturen eine spirituelle Dimension absprechen? Können sie hier, über den Gräbern preußischer Adeliger ihre Mittlerrolle zwischen dem Diesseits und dem Jenseits spielen? Und wie ist das mit dem öffentlichen Raum des Jenseits? Ist er nach Religionen unterteilt?

Annette Schemmel

1 Frauen sind unter den Kunstschaffenden in Kamerun eine winzige Minderheit. Vgl. dazu und zum Phänomen der *grands frères* Annette Schemmel, *Visual Arts in Cameroon. A Genealogy of Non-formal Training*. 1976–2014, Langaa R&P CIG, Bamenda, 2016, S. 117–148.
2 Die NGO wurde 1991 gegründet von Marilyn Douala-Bell und Didier Schaub; siehe online: www.doualart.org [02.05.2017].
3 Vgl. Larissa Buchholz, *The Global Rules of Art*, Columbia University Academic Commons 2013; siehe online: http://hdl.handle.net/10022/AC:P:18794 [01.05.2017]. Zu Youmbis gewitztem Umgang mit den Funktionsmechanismen des Markts für die boomende, zeitgenössische afrikanische Kunst vgl. Dominique Malaquais (2016), *Playing (in) the Market*, Cahiers d'Études africaines, LVI (3), 223, S. 559–580.
4 Genaueres zu Youmbis Projekt *Visages de Masques* (2010–2015) bzw. zu seiner Wechselwirkung mit der Ökonomie des Maskenhandels und der Maskentänze vgl. Silvia Forni, *Masks on the Move. Defying Genres, Styles, and Traditions in the Cameroonian Grassfields*, african arts, Bd. 49, Nr. 2, Sommer 2016, S. 38–53.
5 Youmbi im Telefoninterview am 21.04.2017.

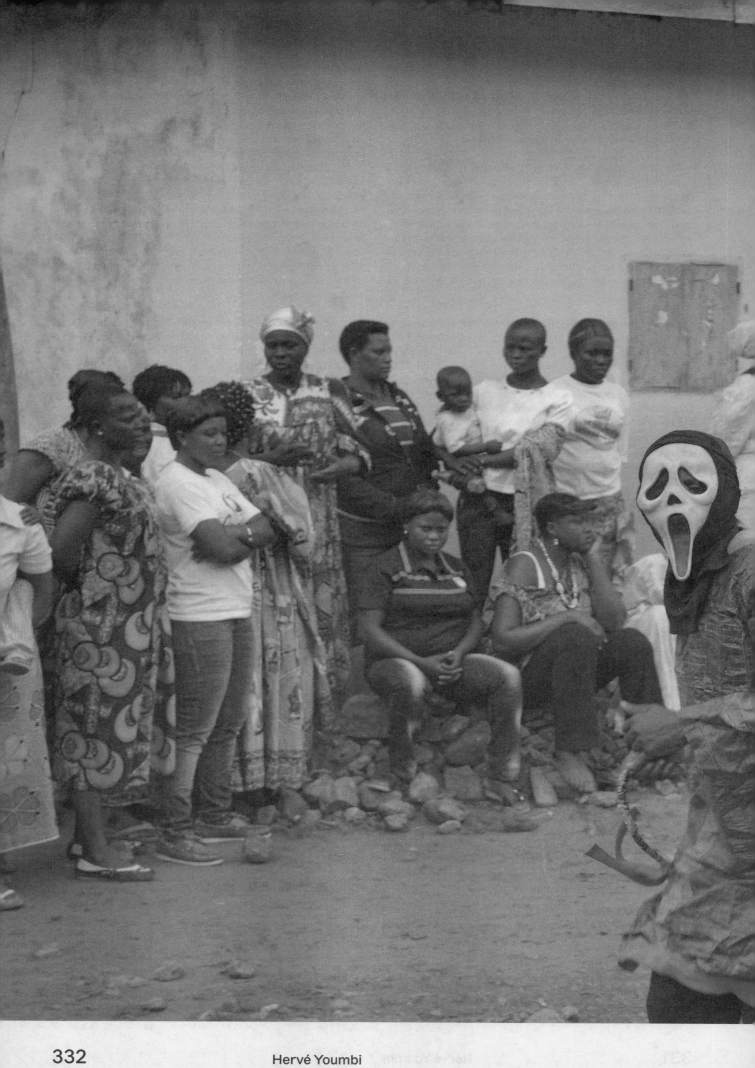

Hervé Youmbi

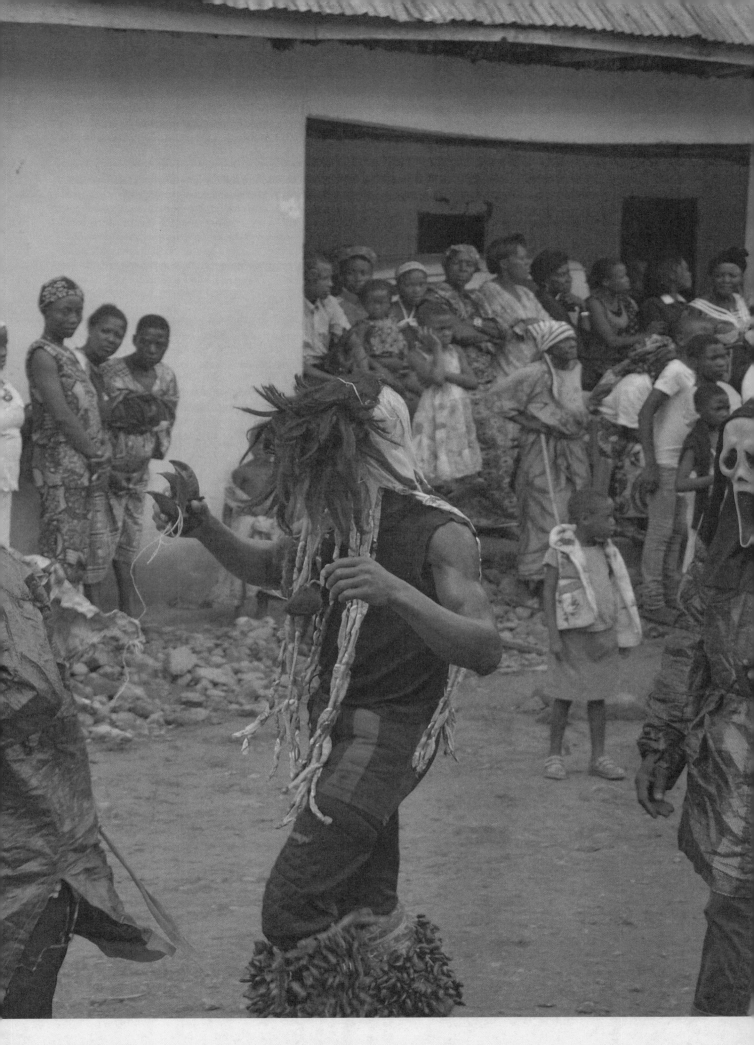

Hervé Youmbi

Tilt your head back and imagine the equator is running under your toes. We are in Douala, the largest port city in Cameroon, where the fatal treaty with the German Empire was once sealed, turning the country into a protectorate. It is humid. We are surrounded by noisy traffic, harbour cranes, crumbling walls, the stench of petrol, and, once in a while, the scent of blossoming trees. The yoke of colonial rule can still be felt on the shoulders, but life has moved on.

Today in the public spaces of this tropical city there are dozens of site-specific sculptures and interventions. Works by artists of various origins decorate the old administrative district and accompany everyday life in the simple residential areas with their concrete-enclosed watering places. They run through the boisterous polyglot business streets that are full of Chinese goods, all the way to the placid residential neighbourhoods on the banks of the river Wouri. They have a polarizing effect; they have caused scandals more than once; their maintenance is precarious.

Hervé Youmbi is a child of this city on the Gulf of Guinea. He was born in 1973. As a teenager, he attended the only art high school in Central Africa, which had been established by Italians. He gathered clippings from French newspapers to teach himself the visual languages of the French modernists, and walked to and fro between the studios of his *grands frères*, his older colleagues.[1] He became a painter, his preferred subject portraits. The artistic conquest of Douala's urban space has marked his career: as a young man he was included in group projects run by Doual'art, a very active NGO.[2] Later he became a member of an artists' collective, and together they founded an art space that had a great influence in the city's New Bell neighbourhood. Education, environmentalism, civil rights, and civic engagement were the buzzwords of these years, which were characterized by political unrest. Contact with guests from the Occident became a daily event, and mobile communication and the Internet brought the (art) world closer.

In view of the art scene in Douala, it might be surprising that Youmbi's contribution to the Skulptur Projekte makes use of masks, of all things—an old cliché of African art. In fact, urban life and its integration into the global context were for a long time the most important frame of reference for local artists. Their media of choice were correspondingly new and urban. The diverse rural ways of life, which include the mask traditions, fell by the wayside—perhaps to distance themselves from the authenticity debates of the independence generation; perhaps to counteract the disastrous divisions caused by tribalism; or simply as a reaction to the stipulations laid down by the all-pervasive European project funding. A different development can be observed over the last few years: visual artists like Youmbi have discovered the vernacular visual tradition for themselves. It is one of the many postcolonial paradoxes that this only became possible in the course of their travels abroad. But, after all, the cultural heritage of countries like Cameroon continues to be stored in the ethnological museums of the North, in the same metropolises where artists from the Global South are making their careers.[3] The fact that Youmbi uses masks in Münster is a part of his engagement with this paradox and with his cultural hybridity.

One starting point for this engagement was an experience Youmbi had in his ancestral region, the Grassfields. A few individual dancers stood out at one of the folkloric events that recall, after a fashion, the traditions of ancestor worship. They were wearing the mask belonging to the serial killer Ghostface from the American blockbuster *Scream*. The dancers had inexpensively acquired this piece of plastic, identified it as a skull, and considered it sufficiently expressive. It is not for nothing that this mask took its inspiration from Edvard Munch's expressionistic painting *The Scream*. Youmbi was astounded. Since then, he has devoted himself to the contemporizing of dance masks from the Grassfields.[4] He is convinced that Africa's masks 'need a new face'[5] to be able to embody the modern dead, who should support the living. In order to preserve the dignity of the continent's ancient religions in the process, he speaks with the dedicated associations of dancers, shares his sketches with woodcarvers, and explains new design ideas to the pearl craftswomen, like the veining of the intensely coloured surfaces of the pearl overlay.

Now set your feet on Westphalian soil. Your head remains tilted back. You will notice that the masks that Youmbi created for the old cemetery in the land of the colonizers do not require dancers. They have an independent life between heaven and earth, they are *divine masks*. They unify various cultural influences; even the *Scream* mask reappears. Would you deny these sculptures a spiritual dimension because of this? Can they play their mediating role between this world and the next, here above the graves of Prussian nobility? And what about the public space of the great beyond? Is it divided up along religious lines?

Annette Schemmel

1 Women represent a tiny minority in Cameroon's artistic community. For more on this and the phenomenon of the *grands frères*, see Annette Schemmel, *Visual Arts in Cameroon: A Genealogy of Non-formal Training; 1976–2014* (Bamenda: Langaa Research & Publishing: 2016), 117–48.
2 The NGO was founded by Marilyn Douala-Bell and Didier Schaub in 1991; see <http://doualart.org/> accessed 2 May 2017.
3 See Larissa Buchholz, *The Global Rules of Art*, PhD thesis (Columbia University Academic Commons, 2013) <http://hdl.handle.net/10022/AC:P:18794> accessed 1 May 2017. On Youmbi's shrewd handling of the functional mechanisms of the booming market for contemporary African art, see Dominique Malaquais, 'Playing (in) the Market: Hervé Youmbi and the Art World Maze', *Cahiers d'Études africaines* 223 (2016), 559–80.
4 For more details on Youmbi's project *Visages de Masques* (2010–2015) and his interaction with the economics of the mask trade and mask dances, see Silvia Forni, 'Masks on the Move: Defying Genres, Styles, and Traditions in the Cameroonian Grassfields', *african arts* 49, no. 2 (Summer 2016), 38–53.
5 Youmbi, in a telephone interview with the author, 21 April 2017.

Satelliten / Satellites

Eine Kooperation der Skulptur Projekte Münster mit dem Skulpturenmuseum Glaskasten Marl

Rathausplatz Marl/Town hall square Marl

Ausstellung/Exhibition *Stadt und Skulptur*, 1970

The Hot Wire als Chance einer fokussierten Wahrnehmung

Die Stadt Marl besitzt keine lange Tradition: Im Zuge der zunehmenden Industriali-
sierung seit Beginn des 20. Jahrhunderts wuchsen die unter dem Namen Marl zusam-
mengefassten Dörfer rasant, und der Ort bekam schließlich 1936 unter den National-
sozialisten die Stadtrechte zugesprochen. Durch die Steinkohleförderung und die
chemische Industrie vor Ort wurde Marl in den 1950er und 1960er Jahren zum Inbe-
griff des westdeutschen Wirtschaftswunders. Zu dieser Zeit war die Stadt eine der
reichsten Kommunen Deutschlands mit einem vielfältigen kulturellen Angebot. Impulse
gingen unter anderem von der innovativen Volkshochschule die insel unter der Leitung
von Bert Donnepp, der Philharmonia Hungarica sowie dem Fernsehpreis für kritische
Formate, der als Grimme-Preis noch heute einmal im Jahr die Aufmerksamkeit der
Medien auf Marl lenkt, aus.
Das beherrschende Thema nach dem Zweiten Weltkrieg war jedoch die städtebau-
liche Entwicklung. So wurde versucht, die noch dörflich geprägten Ortsteile Marls
durch eine neue Stadtmitte zu einem Ganzen zusammenzuschließen. Mit dem Ziel der
Errichtung einer Stadtkrone wurde 1957 ein internationaler Wettbewerb[1] für einen
Rathauskomplex ausgerichtet, den die niederländischen Architekten Jacob Berend
van den Broek und Johannes Hendrik Bakema gewannen. Das 1967 fertiggestellte
Rathaus mit den zwei Verwaltungstürmen[2] und der dazugehörenden Platzanlage ist
eines der wichtigsten Beispiele der mittlerweile unter dem Begriff Ruhrmoderne zu-
sammengefassten Epoche (1950–1970) und steht seit 2015 unter Denkmalschutz.[3]
Rückblickend zeichnen sich die Bauwerke dieser Epoche durch einen Fortschritts-
glauben und eine Experimentierfreude aus, die heute undenkbar erscheinen und die
sich zu einem weiteren Mythos über das Ruhrgebiet entwickeln könnten – wenn die
Architektur der Nachkriegszeit in der öffentlichen Wahrnehmung aus dem Schatten
der Siedlungen und Industriebauwerke der Vorkriegszeit heraustritt. In Teilen kenn-
zeichnet diesen umfangreichen Bestand eine innovative und bisweilen radikale Archi-
tektur, aber viele der Gebäude sehen heute dem Ende ihres Lebenszyklus entgegen,
und es stellt sich immer häufiger die Frage, wie damit umzugehen ist. Seit einiger Zeit
ist zu beobachten, dass insbesondere junge Architekt_innen, Künstler_innen und Wis-
senschaftler_innen das bauliche Erbe der Nachkriegszeit wiederentdecken, neue Im-
pulse für dessen Erhalt und Weiterentwicklung geben und sie zum Gegenstand ihrer
Arbeit machen.
Welche Rolle spielte die bildende Kunst in diesen Aufbruchsjahren und vor allem vor
Ort in Marl? Auf der Ebene der Vermittlung war sie durch die Angebote der Volks-
hochschule bereits früh präsent, die in Marl schon 1955 als erste Institution dieser Art
in der Bundesrepublik ein eigenes Gebäude bekam. Aber auch durch den bereits
1948 gegründeten sogenannten Kunstring, der für seine Mitglieder mehrmals im
Jahr Fahrten zu Ausstellungen im Umland organisierte.[4] Von einigen historischen
Denkmälern abgesehen gab es vor 1945 keine Skulpturen im Stadtraum von Marl. Im
Zuge des Rathausprojekts begann man, Kunst in großem Stil und für den öffentlichen
Raum zu kaufen. Teilweise wurden Werke mit Bezug auf die industrielle Gegenwart
(Constantin Meunier, *Bergmann*, vor 1899, erworben 1956) angekauft, teilweise auch
zeitgenössische Werke mit metaphorischem Bezug (Bernhard Heiliger, *Nike*, 1956;
Ossip Zadkine, *Großer Orpheus*, 1956, beide Ankauf 1965). Auch für die Ausstattung
der Amtsstuben wurde auf sehr hohem Niveau Kunst erworben: etwa Wilhelm Lehm-
brucks *Mädchenkopf, sich umwendend* (1913/1914) und Auguste Rodins *Bürger mit
Schlüssel (Jean d'Aire)* in der kleinen Fassung (circa 1895), beide seit 1956 in städti-
schem Besitz, oder der in vielen Museumssammlungen ausgestellte *Kopf in Messing*

von Rudolf Belling (1925, Ankauf 1965). Ein weiteres herausragendes Beispiel für den Anspruch und das Qualitätsbewusstsein in Marl in dieser Zeit ist das in einem Kunst-am-Bau-Wettbewerb ausgewählte Kunstwerk *Der Heilende – der Geheilte – der Kranke*. Diese Figurengruppe schuf Karl Hartung 1955/1956 als eine Art Triptychon aus Bronze für die Wand am Haupteingang der Paracelsus-Klinik, ein damals revolutionär neuartiger Krankenhaustyp.

Veranlasst durch Bürgermeister Rudolf Heiland, wurde also dem hohen ästhetischen, qualitativen und demokratischen Anspruch der Rathausarchitektur entsprechend Kunst mit einem engen Bezug zu – nach den katastrophalen und traumatischen Erfahrungen des Zweiten Weltkrieges – akuten gesellschaftlichen Fragen gekauft. 1982 wurde durch einen Ratsbeschluss das Skulpturenmuseum Glaskasten gegründet. Als Gründungsdirektor konnte Uwe Rüth den städtischen Kunstbesitz um spektakuläre Werke erweitern – es seien nur einige wenige Beispiele genannt: Wolf Vostells *Tortuga* (1987, aufgestellt in Marl 1993), Alberto Giacomettis *Frauentorso* (1928/29, Bronzeguss 1/6) oder das Fernsehgerät *TV* mit Nägeln von Günther Uecker (1963); letztere wurden (1988 und 1990) mithilfe des Landes Nordrhein-Westfalen angekauft.

Einen wichtigen Anknüpfungspunkt für die aktuelle Kooperation zwischen Marl und Münster bilden die Ausstellungen *Stadt und Skulptur*, die 1970 und 1972 – also noch vor den ersten Skulptur Projekten – als temporäre Freiluftausstellungen neben deutschen einmal Schweizer und dann niederländische Bildhauer auf der großen Wiese vor dem Rathaus zeigten. Diese bundesweit wahrgenommenen Präsentationen trugen sehr zum frühen Bild von Marl als Stadt der Skulpturen bei, und sie legten den konzeptionellen Grundstein, das Museum spezifisch den dreidimensionalen Künsten zu widmen – ein Profil, das bald durch Video- und Klangkunst vervollständigt werden sollte.[5]

Ludger Gerdes, *Angst*, 1989,
Skulpturenmuseum Glaskasten Marl

Reiner Ruthenbeck, *Begegnung Schwarz/Weiß*, 1997,
Promenade Münster, Skulptur Projekte 1997

Impulsgebend für das Kooperationsprojekt *The Hot Wire* war die Idee von Britta Peters, Skulpturen zwischen den beiden benachbarten Städten buchstäblich zu tauschen, um die Werke an einem anderen Standort und unter komplett anderen sozialen und städtebaulichen Bedingungen neu zu befragen. So wird Olle Bærtlings filigrane Eisenskulptur *YZI* (1969), die sonst auf einem hohen schwarz gestrichenen Eisenpfeiler am Ufer des Marler Citysees steht, von Nora Schultz in ihre Installation im Foyer des LWL-Museum für Kunst und Kultur integriert. Ludger Gerdes Installation *Angst* (1989) findet sich an der Fassade des Aegidiimarktes wieder, gegenüber dem LWL-Museum für Kunst und Kultur, und nicht mehr über den Räumen des Ordnungsamtes am Marler Rathaus.

Aus Marler Sicht ging es darum, aus den noch heute im Münsteraner Stadtraum präsenten Objekten Werke auszuwählen und für die Dauer der Ausstellung nach Marl zu holen, die einen guten Einblick in die vergangenen Ausgaben der Skulptur Projekte seit 1977 geben und deren neuer Standort auf Zeit auch einen Mehrwert für die jeweilige Werkbiografie durch die Kontextverschiebung in den Marler Stadtraum ermöglicht. Bei vielen Werken ist Ortsbezug jedoch ein derart integraler Bestandteil, dass sich eine Umsetzung nach Marl schon aus diesem Grund verbot. Der einleuchtende Gedanke, Skulpturen zwischen Marl und Münster zu tauschen, ließ sich nicht so einfach umsetzen – hinter jedem Vorhaben steckt eine eigene abenteuerliche Geschichte.

Thomas Schütte, *Kirschensäule*, 1987, Harsewinkelplatz Münster

Thomas Schütte mit Melonen/with melons, 1987

Thomas Schütte, Gussform für/casting for *Melonensäule*

Jeder Standort hat Auswirkungen auf die Ästhetik einer Skulptur. Wenn sie nicht explizit mit einem speziellen Ort verwoben ist, entstehen mit einem Ortswechsel neue Lesarten, können neue Bezüge aufgezeigt werden. Das gilt im Besonderen für die als *drop sculptures*[6] heute im kunsthistorischen Diskurs meist negativ konnotierten autonomen Skulpturen. Nach Marl wurde Richard Artschwagers Betonmonument *Ohne Titel (Fahrradständermonument B)* (1987) versetzt, das zusammen mit den flankierenden Fahrradständern in unmittelbarem räumlichen wie auch materiellen Bezug zum Rathaus und dem Prototyp für die Rathaustürme, dem sogenannten Türmchen, steht. Die Skulptur hatte in Münster schon vor Jahren ihren ursprünglichen Ort verlassen und stand nun unter der Obhut der Universität an einem exponierten Standort neben dem Sitz des ASTA auf dem großen Schlossplatz. Sie war also bereits schon einmal bewegt worden. In Marl wirkt die Skulptur nicht wie ein ironisches Zitat, sondern wie ein Objekt, das trotz seiner Bepflanzung in lichter Höhe (die sicher auch den Marler Sommer nicht überleben wird – noch nie hat eine Pflanze in den vergangenen dreißig Jahren überlebt) aus dem gleichen Geist zu stammen scheint wie das benachbarte Rathaus, obwohl dieses noch einmal zwanzig Jahre älter ist: ein komplexes Spiel der Bezüge.

Die *Kirschsäule* (1987) von Thomas Schütte hätte theoretisch nach Marl kommen können, doch in den Diskussionen um die technische Umsetzung des Umzugs konnte vor allem die Befürchtung nicht ausgeräumt werden, dass der empfindliche Sandstein des Münsteraner Säulenschaftes den zweifachen Transport sowie Ab- und Wiederaufbau nicht unbeschadet übersteht. Schüttes neuer Vorschlag, mit den 1987 in Münster zugunsten des Kirschenentwurfs nicht realisierten Wassermelonen-Schnitzen dreißig Jahre später eine Zwillingssäule zu realisieren, und zwar auf einem Parkplatz, also an einem ähnlichen Standort wie in Münster, fand sofort Zustimmung. Die Realisierung war jedoch nicht einfach, was nicht an der Formfindung lag (es sind die Proportionen der Münsteraner Säule, zehn Prozent vergrößert und damit fast fünf Meter hoch), sondern am vom Künstler gewählten Material. In diesen Dimensionen ist formgenauer Betonguss ein hochspezialisiertes Handwerk – das Marler Baumaterial der 1960er und 1970er Jahre, der Zeit der Ruhrmoderne mit ihrer brutalistischen Baukultur, liefert nur bei absolut präziser Verarbeitung überzeugende Ergebnisse.

Ist Schüttes Entscheidung, den in Münster genutzten Sandstein gegen Sichtbeton auszutauschen, eine zwingende Entscheidung? Kasper König liest die unterschiedliche Entwicklung der Nachbarstädte an ihren Rathäusern ab: Das Münsteraner Rathaus habe Butzenscheiben, im Sitzungssaal des Marler Rathauses gebe es rotes, gelbes und blaues Glas – in den De-Stijl-Farben.[7] Dieser Vergleich ist in seiner Pars-pro-toto-haften Zuspitzung der Entwicklungskonzepte beider Städte nach dem Zweiten Weltkrieg sehr treffend, und Schüttes Materialwahl für Marl thematisiert genau diesen Befund. Wobei die Frage bleibt, wie ironisch die zehnprozentige Vergrößerung zu verstehen ist. Es liegt sicherlich nicht nur konstruktionsbedingt daran, dass die drei Wassermelonenstücke eine größere Auflagefläche benötigen.

Es gibt jedoch durchaus auch Parallelen zwischen Marl und Münster, die nicht auf den ersten Blick ins Auge springen. Partiell ist Marl immer noch sehr ländlich, eben fast schon Münsterland, und da ist die Wiederauflage der Performance *Begegnung Schwarz/Weiß* von Reiner Ruthenbeck, die als temporäre Aktion während der Skulptur Projekte 1997 über die vier Kilometer lange Promenade führte, in Marl ein echtes Re-enactment an einem strukturell ähnlichen Ort. Ein Schimmel und ein Rappe werden sich (samt Reiter) zufällig auf ihrer gegenläufigen Bahn um den Citysee, durch den Skulpturenpark und um das Rathaus herum an immer anderen Stellen begegnen. Die Begegnung von Schwarz und Weiß, wie beim Schachspiel, erzeugt einen unwirklich-märchenhaften Moment für die zufällig vorbeikommenden Spaziergänger_innen wie für die gezielt die Kunst im Marler Stadtgebiet suchenden Kunstkenner_innen gleichermaßen.

Ein weiteres Projekt ist kein Austausch, sondern eine Art Klammer: ein skulpturales Objekt aus zwei gleichen, aber nicht identischen Teilen, die sowohl in Münster als auch in Marl ihren Platz gefunden haben. Lara Favarettos doppeltes Granitmonument mit dem Titel *The Momentary Monument – The Stone* sind zwei von Bearbeitungsspuren aus dem Steinbruch gezeichnete monolithische Blöcke, aus denen nicht sichtbar der Kern herausgeschnitten wurde. Durch einen kleinen Schlitz kann Geld eingeworfen werden – wie in eine überdimensionierte Spardose oder einen ungewöhnlichen Opferstock. Nach Ausstellungsende werden beide Steine zerstört und der Schutt für Bauvorhaben anderer Art weiterverwendet. Der Marler Stein kann durchaus noch eine Zeit nach Ende der Ausstellung auf dem Creiler Platz vor dem Rathaus stehen, aber schließlich wird auch er komplett geschottert werden und als Kies im Fundament einer neuen Straße oder eines anderen Bauprojekts in Marl seine letzte Bestimmung finden – das Kunstwerk ist dann rückstandsfrei verschwunden und hat seine Funktion als nur vorübergehend existierendes Monument erfüllt. Das in beiden Monolithen gesammelte Geld wird dem Hilfe für Menschen in Abschiebehaft Büren e. V. übergeben, einem Verein, der seit 1994 in der ländlich gelegenen und für ganz NRW zuständigen Abschiebeeinrichtung Flüchtlinge betreut. Allerdings ist bis zur finalen Zerstörung der Steine nicht bekannt, wie viel Geld sich angesammelt hat.

Eine weitere sichtbare Klammer bilden die in dünne Holzplatten gebrannten Zeichnungen von Samuel Nyholm, die das Münsteraner und Marler Publikum zugleich erheitern und verwirren. Innerhalb der Auseinandersetzung mit Ortsspezifik haben wir es hier mit einer Arbeit zu tun, deren Wahrnehmung zwar von ihrem Installationsort beeinflusst wird, die als figurative Zeichnung jedoch stärker noch ihren eigenen Ort als Erzählung in sich trägt. Den unterschiedlichen Darstellungen, darunter ein großer Eichenbaum, ist gemeinsam, dass sie alle von oben fallen.

Eine völlig neue und ortsspezifisch für die Marler Stadtmitte entwickelte Intervention hat Joëlle Tuerlinckx für den Skulpturenpark entworfen, der hinter dem Rathaus an dem Parkplatz beginnt, auf dem Schüttes Melonensäule steht. Das Kunstwerk besteht aus einer ungefähr 200 Meter langen weißen Linie: ein Spiel mit der Idee von Anfang und Ende, mit Grenzen. Ein surreal und zugleich materialisierter gedanklicher Transit zwischen zwei Bauwerken: dem jetzigen Museum im Rathaus und dem Ort, in den das Museum möglicherweise in ein paar Jahren umziehen wird, eine seit Jahren leer stehende Schule aus dem Jahr 1967. Die Linie ist eine offensichtliche Verbindung, die erst durch ihre Materialisierung vor Ort greifbar wird – aus der Vogelperspektive

oder in Google Earth ist die Verbindung sofort ersichtlich und direkt nachvollziehbar. Die Kreidelinie geht quer durch den Park, kreuzt Gehwege, Beete und zerschneidet die Rasenflächen. Sie wird in einem performativen Akt jeden Morgen für die Dauer der Ausstellung nachgezogen, um sich dann ab Oktober 2017 wieder langsam zu verflüchtigen.

Im Rahmen von *The Hot Wire* werden in den beiden von Tuerlinckx verbundenen Museumsorten zwei Ausstellungen zu sehen sein. In der ehemaligen Schule an der Kampstraße werden zwölf Videoarbeiten präsentiert – unter anderem von Manuel Graf, Charlotte Moth, Corinna Schnitt und Nico Joana Weber –, die thematisch zwischen den Bereichen Skulptur und Architektur stehen. Die Klassenräume der schön gegliederten einstöckigen Schule, die als zeittypische Betonarchitektur von Günther Marschall geplant wurde, aber nicht unter Denkmalschutz steht, sind von Atmosphäre und Dimensionen her ein perfekter Ort, um Videokunst zu zeigen. Diese Präsentation soll die Schule auch bei der Marler Bevölkerung bekannter machen und das ganze Gebäude zugleich auf seine Museumstauglichkeit testen: Im Eingangsbereich empfängt die Besucher_innen ein von Studierenden der Fachhochschule Münster und der Universität Kassel anlässlich der Ruhrmoderne Sommerakademie konzipierter und gebauter Infocounter, im Hof der ehemaligen Hausmeisterwohnung entsteht ein Freiluftcafé, das die Milchbar des ehemals benachbarten, nun abgerissenen Hallenbads wiederauferstehen lässt.

Im Skulpturenmuseum Glaskasten Marl, im Rathaus, werden 23 Modelle aus allen bisherigen Skulptur Projekten aus dem Besitz des LWL-Museum für Kunst und Kultur ausgestellt. Damit werden Projekte der vergangenen Ausgaben im speziellen sowie

Mike Kelley, *Petting Zoo*, 2007, Modell/model

Isa Genzken, *ABC*, 1987, Modell/model

die Verbindung von Modell und anschließender Realisierung im Außenraum im Allgemeinen in den Blick genommen. Zu sehen sind Modelle für ausgeführte Projekte wie etwa Claes Oldenburgs *Drei Kugeln für das Projekt für Münster II* (1977), Ludger Gerdes *Schiff für Münster* (1987) oder Sol LeWitts *White Pyramid* (1987). Im Eingangsbereich des Skulpturenmuseum ist eine Auswahl von modellhaften Skulpturen installiert, die Dominique Gonzalez-Foerster 2007 in Münster auf eine Wiese an der Wallanlage gestellt hatte. Diese Skulpturengruppe ist eine wichtige inhaltliche Verbindung zwischen den Skulpturen im Außenraum und der Modell-Ausstellung im Untergeschoss des Museums. Beide Ausstellungsbereiche waren nur möglich durch die enge Zusammenarbeit mit Marianne Wagner, die als Kuratorin der Skulptur Projekte und dem LWL-Museum kurze Wege bei der Auswahl aus dem Münsteraner Museumsbesitz und aus dem Skulptur Projekte Archiv möglich machte.

Die Ausstellung *The Hot Wire – Eine Kooperation der Skulptur Projekte Münster mit dem Skulpturenmuseum Glaskasten Marl* dokumentiert den künstlerischen Umgang mit Themen wie Stadtraum und Kunst im öffentlichen Raum, die in Münster in den vergangenen Jahrzehnten beispielhaft untersucht wurden, aber auch in Marl mit seinen rund hundert Skulpturen im Außenraum ständig präsent sind und nun anhand neuer Beiträge diskutiert werden können. Die Kooperation zwischen Marl und Münster mit einigen neuen Skulpturenprojekten im Marler Stadtraum und die dazu gehörenden Ausstellungen sind ein perfekter Anlass, diese für Marl so wichtigen Themen mit breiter öffentlicher Beteiligung weiterzuführen. Sicher werden auch die Fragen nach der weiteren Entwicklung des Skulpturenparks und die Neuaufstellung der Skulpturen auf dem Creiler Platz nach der Rathaussanierung neue Impulse bekommen.

Georg Elben
Direktor des Skulpturenmuseum Glaskasten Marl

1 Unter anderem nahmen Arne Jacobsen, Alvar Aalto und Hans Scharoun am Wettbewerb teil. Scharoun realisierte wenig später im Auftrag der Stadt eine Grund- und Hauptschule (1960–1964) im damaligen Neubaugebiet Drewer, die nach ihrer 2015 abgeschlossenen Restaurierung heute sowohl als Grund- als auch als Musikschule genutzt wird.
2 Ursprünglich waren vier Türme geplant, zwei davon blieben jedoch wegen der nicht wie vorhergesagt steigenden Einwohnerzahl unausgeführt.
3 2015 hat sich in Marl die Initiative RUHRMODERNE mit dem Ziel gegründet, auf die Bedeutung und die Potenziale von Bauwerken der Nachkriegszeit aufmerksam zu machen und deren Erhalt und Weiterentwicklung zu fördern. Das Rathaus-Ensemble wird im Laufe der nächsten Jahre einer Komplettsanierung unterzogen, die ersten seit fünfzig Jahren.
4 Ein Angebot, für das sich in den ersten Jahrzehnten für die Anmeldung lange Schlangen bildeten, das in diesem Jahr aber mangels Nachfrage nach fast siebzig Jahren aufgelöst wurde.
5 Der Marler Videokunst-Preis wurde 1984 ins Leben gerufen, Klangkunst kam 2002 hinzu. Seit 2013 sind nun Video- und Klangkunst – weiterhin in getrennten Wettbewerben ausgelobt – als Marler Medienkunst-Preise in einer Ausstellung vereint.
6 Als *drop sculptures* werden seit den 1980er Jahren Skulpturen im öffentlichen Raum bezeichnet, die wirken, als hätte man sie von oben abgeworfen. Das trifft auf viele in den 1950er und 1960er Jahren entstandene Werke zu, die sich als autonome künstlerische Setzungen erst einmal selbst zu genügen scheinen und keine direkte Beziehung zu ihrer Umgebung suchen.
7 Vgl. Kasper König, „Nur 60 Kilometer zu den Proletariern", in: *Süddeutsche Zeitung*, 14.12.2016.

André Volten, *Zylindrische Konstruktion*, 1969, Skulpturenmuseum Glaskasten Marl

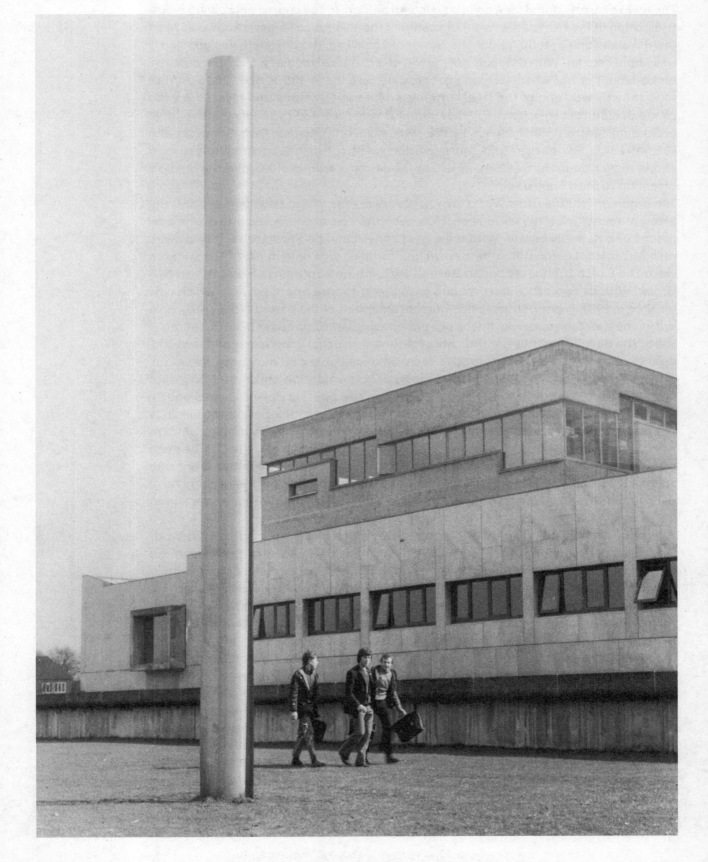

The Hot Wire as an Opportunity
for Focused Perception

The town of Marl cannot look back on a long tradition: in the course of growing indus-trialization at the start of the twentieth century, the villages collectively known as Marl grew rapidly and in 1936, under the National Socialists, the borough was granted a municipal charter. With its local coal mining and chemical industry, Marl became the embodiment of the West German economic miracle in the 1950s and 1960s. At that time the city was one of the richest municipalities in Germany and offered a wide range of cultural attractions. Further stimulus was provided by the innovative adult education centre (Volkshochschule die insel) under its director Bert Donnepp, the Philharmonia Hungarica, and the television prize for news, documentaries, and shows that critique the medium, which, as the Grimme Award, still draws the media's attention to Marl once a year.

The dominant theme after World War II, however, was urban development and the attempt to integrate the various districts, with their rural character, into a whole by means of a new city centre. With the aim of constructing a *Stadtkrone* ('city crown'), an international competition for a town hall complex was held in 1957.[1] The winners were the Dutch architects Jacob Berend Bakema and Johannes Hendrik van den Broek. With its two office towers[2] and associated square, the town hall, which was finished in 1967, is one of the most important examples of the period 1950–1970, now known as the Ruhrmoderne. It was put under a preservation order in 2015.[3] In retro-spect, the buildings of this era are characterized by a belief in progress and a willing-ness to experiment, which nowadays seem inconceivable and may become yet an-other legend about the Ruhr area—once public perception shifts and post-war architecture steps out from under the shadow of the housing developments and in-dustrial constructions of the pre-war era. In part, the large number of extant buildings are marked by an innovative and sometimes radical architecture, but many of them are approaching the end of their life cycle, and the question of how this can be dealt with crops up more and more frequently. For some time it has been apparent that young architects, artists, and academics have begun to discover the architectural heritage of the post-war era and are providing new inspiration for its preservation and development by making it the subject of their work.

What role did the fine arts play in this period of transformation, in particular in Marl? On an educational level, they were already a factor at an early date through the courses offered by Marl's Volkshochschule, which in 1955 became the first institution of its kind in West Germany to be given its own building. The Art Society (Kunstring), which was founded in 1948, also played a part by organizing trips to exhibitions in the surrounding area for its members several times a year.[4] Apart from several historical monuments, there were no sculptures in Marl's urban spaces before 1945. As part of the town hall project, the large-scale purchasing of art for the municipality's public spaces was begun. Works that referred to contemporary industry were purchased (Constantin Meunier's *Le Mineur*, pre-1899, purchased 1956), as well as contemporary works with metaphorical references (Bernhard Heiliger, *Nike*, 1956; Ossip Zadkine, *Orpheus*, 1956, both purchased in 1965). High-quality art was also acquired for the administrative offices: for example, Wilhelm Lehmbruck's *Mädchenkopf, sich um-wendend* (1913/14), and Auguste Rodin's *Jean d'Aire* ('the man with the key') in the small version (ca. 1895), both owned by the city since 1956, and Rudolf Belling's *Kopf in Messing* (1925, purchased 1965), which had been exhibited in a number of different museum collections. A further outstanding example of Marl's standards and aware-ness of quality at that time is Karl Hartung's work *Der Heilende – der Geheilte – der*

Kranke, which had won a *Kunst am Bau* competition for public art. Hartung created this group of figures as a form of triptych in bronze in 1955/56. It was intended for the wall above the main entry to the Paracelsus Clinic, a revolutionary new type of hospital at that time.

Thus, prompted by Marl's mayor Rudolf-Ernst Heiland, art was purchased that met the high aesthetic, qualitative, and democratic requirements of the town hall architecture and also had a close relationship to urgent social questions that had their origins in the catastrophic and traumatic experiences of World War II. In 1982 a decision of the town council led to the foundation of the Skulpturenmuseum Glaskasten. Founding director Uwe Rüth was able to enlarge the town's art collection with several spectacular works, among them Wolf Vostell's *Tortuga* (1987, installed in Marl 1993), Alberto Giacometti's *Female Torso* (1928/29, bronze casting 1/6), and Günther Uecker's *TV 1963* (1963)—a television set riddled with nails; the works by Vostell, Giacometti, and Uecker were purchased with the assistance of the State of North Rhine-Westphalia in 1988 and 1990.

The exhibitions *Stadt und Skulptur* (City and Sculpture) are an important factor in the current cooperation between Marl and Münster. They took place in 1970 and 1972—before the very first Skulptur Projekte—and were temporary open-air exhibitions on the large lawn in front of the town hall. In addition to the works of German sculptors, pieces by Swiss sculptors were displayed in 1970 and by Dutch sculptors in 1972. The nationwide awareness of these presentations contributed to Marl's early image as a city of sculpture and launched the concept of dedicating the museum specifically to three-dimensional arts—a profile that was soon to be complemented by video and sound art.[5]

Ludger Gerdes, *Angst*, 1989, Skulpturenmuseum Glaskasten Marl

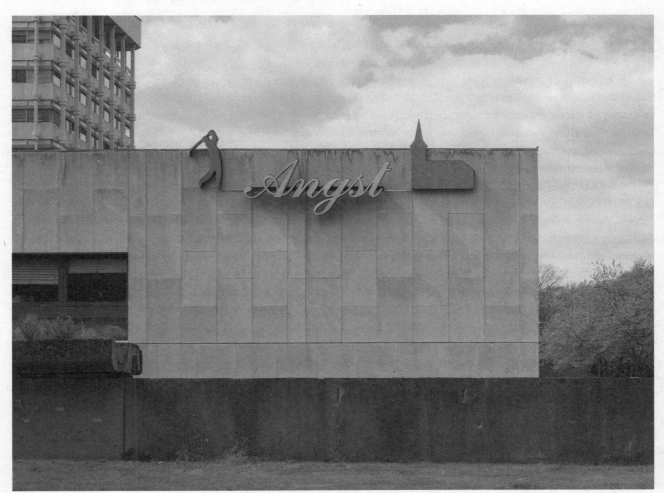

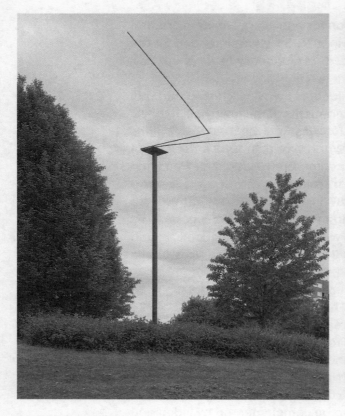

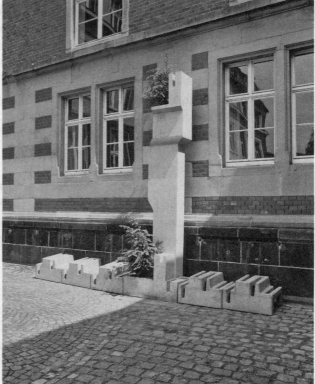

Olle Bœrtling, *YZI*, 1969,
Skulpturenmuseum Glaskasten Marl

Richard Artschwager, *Ohne Titel (Fahrradständermonument B)*,
1987, Skulptur Projekte 1987

The impulse for the joint project *The Hot Wire* was Britta Peters's idea to literally swap sculptures between the two neighbouring municipalities, in order to examine the works at another location and under totally different social and urban conditions. Olle Bœrtling's filigree iron sculpture *YZI* (1969), for example, which normally stands on top of a tall, black-painted iron pillar on the shore of Marl's city lake, will be incorporated in Nora Schulz's installation in the foyer of the LWL-Museum für Kunst und Kultur. And Ludger Gerdes's installation *Angst* (1989) is once more to be found on the façade of the Aegidiimarkt opposite the LWL-Museum, having been relocated from its position above the offices of the Ordnungsamt, the office of public order at Marl's town hall.

From Marl's point of view, the aim was to select works from those now present in the Münster urban area and bring them to Marl for the duration of the exhibition. The works selected should provide a good insight into previous Skulptur Projekte since 1977, and the temporary location was intended to augment their individual histories by putting them in a new context in Marl's urban area. An integral component of many works is their relationship to their location, and this prohibited any transfer to Marl. For every object, the obvious and simple idea of swapping sculptures between Marl and Münster became an adventure.

The aesthetic of a sculpture is always influenced by its location. If it is not explicitly bound up with a particular place, a change of location generates new interpretations and can reveal new relationships. This is especially true of the 'drop sculptures',[6] autonomous sculptures that nowadays generally have negative connotations in art-historical discourse. Richard Artschwager's concrete monument *Ohne Titel (Fahrradständermonument B)* (1987) was moved to Marl and, together with the bike racks that flank it, stands in a close spatial and material relationship with the town hall and the prototype for its towers (the so-called *Türmchen*). The sculpture had already been

moved from its original location in Münster some years previously and was in the care of the university in an exposed location on the Schlossplatz (palace square) next to the Students Union building. So it had already been relocated once. In Marl the sculpture does not seem to be an ironic quotation but an object which, despite the plants on its top (they will not survive the summer in Marl—no plant has lived that long in the past thirty years), seems to have been conceived in the same spirit as the neighbouring town hall, a building that is, however, twenty years older: a complex game of relationships. Thomas Schütte's *Kirschsäule* (1987) could, in theory, have been brought to Marl. However, the discussions about the technical aspects of the move could not dispel the misgivings that the sensitive sandstone elements of the column would not survive being transported back and forth and being dismantled and reinstalled without suffering damage in the process. Schütte's new idea of implementing his proposal for 'watermelon carvings', which had been rejected in favour of the *Kirschsäule* thirty years earlier, as a twin column situated on a parking area—a location similar to that in Münster—was immediately accepted. Realizing this was, however, not simple: not because of the form (this has the same proportions as the column in Münster, enlarged by 10 per cent and now almost five metres tall) but due to the material which the artist had chosen. In such dimensions the precision casting of concrete is a highly specialized craft. This material, used in Marl in the 1960s and 1970s and a trademark of the Ruhrmoderne with its Brutalist building culture, only provides convincing results when the workmanship is absolutely precise.

Is Schütte's decision to replace the sandstone used in Münster with fair-faced concrete a compelling one? Kasper König reads the different developments of the neighbouring municipalities by looking at their town halls: Münster's town hall has crown-glass

Thomas Schütte, *Kirschensäule*, 1987, Harsewinkelplatz Münster, Skulptur Projekte 1987

The Hot Wire

Reiner Ruthenbeck, *Begegnung Schwarz/Weiß*, Schlossplatz / palace square Münster, Skulptur Projekte 1997

window panes; in Marl's town hall the glass of the assembly hall is red, yellow, and blue—the colours of the De Stijl movement.[7] In its *pars pro toto* highlighting of the development concepts of the two municipalities after World War II, this comparison is an apt one, and Schütte's choice of material for Marl turns this feature into a thematic focus, although it is unclear how ironic the 10 per cent enlargement is meant to be. It is certainly not merely for structural reasons that the three pieces of watermelon require a larger supporting surface.

There are parallels between Marl and Münster, however, that are not apparent at first glance. In part Marl is still very rural and the revival of Reiner Ruthenbeck's performance *Begegnung Schwarz/Weiß*, a temporary action which took place in Münster on the four-kilometre-long promenade during the 1997 Skulptur Projekte, is an authentic re-enactment in Marl at a location with a similar structure. Two riders, one on a black horse, the other on a grey, will ride in opposite directions round the city lake, through the sculpture park, and around the town hall, encountering one another at a different place each time. The meeting of black and white, just as in a game of chess, will generate an unreal and magical moment both for strollers who happen to be passing and for the art connoisseurs who are deliberately searching for art in Marl's municipal area.

Another of the projects is not an exchange but rather a kind of bracketing: a sculptural object composed of two similar but not identical parts, located in both Münster and Marl. Lara Favaretto's two-part granite monument titled *The Momentary Monument—The Stone* comprises two monolithic blocks that still bear the marks of their excavation in the quarry and whose cores have been invisibly extracted. A small slot makes it possible to throw coins inside—like an oversized piggy bank or an unusual offertory box. After the exhibition has ended, both stones will be destroyed and the rubble will be used for different building projects. The Marl stone may well remain standing in front of the town hall on Creiler Platz for a time, but in the end it will be reduced to gravel and only discover its final destiny when used for the foundations of

a new road or in another construction project in Marl—the work of art will have disappeared without trace and fulfilled its function as a temporary monument. The money that is collected in the two monoliths will be donated to the association Hilfe für Menschen in Abschiebehaft Büren e. V. which, since 1994, has been looking after refugees held in deportation facilities, both locally and in the whole state of North Rhine-Westphalia. How much money has been collected will, however, only be known after the stones have finally been broken up.

Another obvious bracketing are the drawings, burnt by Samuel Nyholm into thin wooden tiles, which will both amuse and bewilder viewers in Münster and Marl. As part of our examination of site-specificity, here we are confronted with a work our perception of which is certainly influenced by where it is installed, even if, as a series of figurative drawings, it is more heavily imprinted with its own siting as a narrative. Common to the various illustrations, among them a large oak tree, is the fact that they are all falling from the sky.

Joëlle Tuerlinckx has created a completely new, site-specific intervention for the sculpture park in Marl's city centre. It begins behind the town hall at the parking area where Schütte's melon pillar is located. The work is a white line some 200 metres long: a play on the idea of beginning and end, of limits. A surreal and yet materialized conceptual transition between two buildings: the current museum in the town hall and the place to which the museum may be moved in a couple of years—a school built in 1967 that has been standing empty for several years. The line is obviously a connection that can only become obvious once it has materialized. From a bird's-eye view or in Google Earth the connection is immediately visible and directly comprehensible. The chalk line runs straight through the park, crosses paths and planting beds, and dissects the grass areas. Every morning, for the duration of the exhibition, it will be drawn afresh in a performative act, until in October 2017 it will start slowly fading away.

Within the framework of *The Hot Wire*, two exhibitions will be held in the museum locations joined together by Tuerlinckx. Twelve video works will be presented in the old school in Kampfstraße—among them works by Manuel Graf, Charlotte Moth, Corinna Schnitt, and Nico Joana Weber—thematically placed between the sculpture and architecture areas. In terms of their atmosphere and dimensions, the attractively laid-out classrooms of the single-storey school, planned by Günther Marschall in the concrete architecture typical of its time—although not listed as a heritage building—are a perfect location for displaying video art. This presentation is intended not only to make Marl's citizens more aware of the school but also to test the building's suitability as a museum: in the entry area the visitors will find an information counter, designed and constructed by students of the Münster University of Applied Sciences and Kassel University during the Ruhrmoderne Summer Academy. In the courtyard of the caretaker's apartment, an open-air café will be set up as a revival of the 'milk bar' in the indoor swimming bath, which previously stood next to the school before it was torn down.

Twenty-three models from all the previous Skulptur Projekte that are part of the holdings of the LWL-Museum für Kunst und Kultur will be on display in the town hall in the Skulpturenmuseum Glaskasten Marl. These will focus specific attention on projects from earlier incarnations of the exhibition, while also looking more generally at the connection between each model and its realization in the outside space. Models for projects that were actually carried out can be seen, including Claes Oldenburg's *Giant Pool Balls* (1977), Ludger Gerdes's *Schiff für Münster* (1987), and Sol LeWitt's *White Pyramid* (1987). In 2007 Dominique Gonzalez-Foerster installed a series of scale models of sculptures on the lawn of Münster's ramparts, and a selection of these is on display in the entry area of the Skulpturenmuseum. This group of sculptures constitutes an important conceptual connection between the sculptures in the outside area and the exhibition of models in the museum's basement. These two parts of the exhibition were only possible because of the close involvement of Marianne Wagner, who, as curator of the Skulptur Projekte and the LWL-Museum, simplified the process of selecting exhibits from the museum's holdings and the Skulptur Projekte Archive.

Hans Arp, *Feuille se reposant*, 1959, Skulpturenmuseum Glaskasten Marl

The exhibition *The Hot Wire – A Cooperation between the Skulptur Projekte Münster and the Skulpturenmuseum Glaskasten Marl* documents the artistic handling of themes such as the urban environment and art in public spaces. These themes have been investigated in Münster in exemplary fashion in past decades, as well as in Marl, whose approximately one hundred sculptures are permanently installed outdoors and can now, on the basis of the new additions, become the subject of discussion. The cooperation between Marl and Münster, with several new sculpture projects in Marl's municipal space, and the associated exhibitions are an ideal reason for Marl to pursue such important themes with the involvement of a broad cross section of the public. We can also assume that questions about the further development of the sculpture park and the repositioning of the sculptures on Creiler Platz following the renovation of the town hall will be given new momentum.

Georg Elben
Director Skulpturenmuseum Glaskasten Marl

1 Arne Jacobsen, Alvar Aalto, and Hans Scharoun were among those who took part in the competition. Shortly afterwards, the city commissioned Scharoun to realize a primary and secondary school (1960–1964) in Drewer, then a new development area. Since 2015, following its restoration, the school has been used both as a primary school and as a music school.
2 Four towers were originally planned, but two of them were not built because the predicted growth in the population did not take place.
3 In 2015 the RUHRMODERNE initiative was founded in Marl. Its aim is to increase the awareness of the significance and potential of post-war construction and to support its preservation and development. The town hall complex will be completely refurbished for the first time in fifty years.
4 During its first decades, applicants had to wait in long queues to register for the trips. This year, due to insufficient demand, the tradition was discontinued after almost seventy years.
5 The Marl Video Art Prize was founded in 1984 and was supplemented by audio art in 2002. Since 2013 video and sound art have been exhibited together as the Marl Media Art Prize, although the two competitions are still separate.
6 Since the 1980s, sculptures in public spaces, which look as if they have dropped down from above, have been known as 'drop sculptures'. This is the case with many works that had their origins in the 1950s and 1960s. They seem to be autonomous artistic compositions and make no attempt to directly reference their surroundings.
7 See Kasper König, 'Nur 60 Kilometer zu den Proletariern', *Süddeutsche Zeitung*, 14 December 2016.

Double Check

Michael Ashers Installation Münster (Caravan) '77 '87 '97 '07

Michael Asher (1943–2012) war an allen vier Editionen der Skulptur Projekte zwischen 1977 und 2007 beteiligt. Auf jede erneute Einladung nach Münster erfolgte eine intensive Auseinandersetzung des Künstlers mit der Stadt, dem Ausstellungsformat und seiner eigenen Arbeit – ein „double check" in zehnjährigen Intervallen, wie Asher es selbst formulierte.[1] Der Entscheidung, sein Wohnwagenprojekt noch einmal zu realisieren, gingen immer ein kritisches Abwägen und später auch Recherchen im Archiv voraus. Die Präsentation 2017 in der Sammlung des LWL-Museum für Kunst und Kultur umfasst historische Dokumente, aktuelles Material in Form von Interviews sowie eine eigenständige künstlerische Auseinandersetzung des Fotografen Alexander Rischer (* 1968) mit Ashers Beiträgen.

1977 erhielt Asher eine Einladung zum Projektbereich der Skulptur Ausstellung in Münster vonseiten Kasper Königs, der den Künstler 1970 in Los Angeles kennengelernt hatte. Ashers Vorschläge für Münster sahen zuerst diskrete Veränderungen des gegebenen Ortes vor, beispielsweise das Anpflanzen von Bäumen an mehreren Orten oder die Grabung eines Tunnels. Letztlich entschied sich der Künstler jedoch für die Installation eines Wohnwagens des Typs Hymer-Eriba Familia, den er im wöchentlichen Rhythmus an verschiedenen Standorten in und um Münster parkte. Abreißzettel im Museumsfoyer sowie der Katalogeintrag wiesen die Besucher_innen auf die jeweilige Parkposition hin.

Nachdem Klaus Bußmann 1985 als Direktor an das Westfälische Landesmuseum[2] zurückgekehrt war, beschlossen er und König, 1987 eine weitere Skulpturausstellung zu veranstalten. Auch dieses Mal legte Asher im Vorfeld der Ausstellung mehrere Entwürfe vor. Parallel zu neuen Ideen faszinierte ihn jedoch die Möglichkeit, eine Reinstallation der Caravan-Arbeit durchzuführen. Voraussetzung hierfür war, dass ein identisches Wohnwagenmodell wie das von 1977 angemietet und die zuvor festgelegten Parkpositionen angefahren werden konnten. Und so beschloss Asher, einem wissenschaftlichen Experiment gleich, das Projekt unter veränderten Bedingungen zu wiederholen. Durch den zehnjährigen Abstand wurden die Veränderungen des Münsteraner Stadtbildes sichtbar und anhand derselben Standorte nachvollziehbar: War die Aufstellung an einem Standort aus logistischen Gründen nicht mehr möglich, stationierte Asher den Wohnwagen in dieser Woche in einer Garage und das Projekt blieb bis auf den aktuellen Standortzettel im Museum für kurze Zeit unsichtbar.

Neben Asher waren auch andere Künstler_innen mehrmals zu den Skulptur Projekten eingeladen. Er war jedoch der einzige, der sich immer wieder aufs Neue und nach eingehender Überlegung entschied, seine Arbeit weiterzudenken. Ab 1997 entwickelte die Caravan-Installation ein weitgreifendes, kritisches Potenzial: Asher unterwanderte durch die erneute Wiederholung die Mechanismen eines nach unerschöpflicher Kreativität und Innovation verlangenden Kunstmarktsystems. In den Archivdokumenten zeichnen sich zunehmend die Schwierigkeiten und der erhebliche Verwaltungsaufwand bei der Realisierung der Arbeit ab, da der Wohnwagen Eriba Familia mittlerweile ein Oldtimer-Modell und nur schwer auffindbar war. Der Wohnwagen als offensichtlicher Anachronismus im Stadtbild erzeugte aufgrund seiner Kontinuität einerseits, des Bekanntheitsgrad der Skulptur Projekte andererseits einen hohen Wiedererkennungseffekt. Er wurde dadurch gewissermaßen unfreiwillig als Marketingsymbol vereinnahmt und tauchte vermehrt in der Berichterstattung über die Ausstellung auf.

Die vierte Ausgabe der Skulptur Projekte stand unter dem Stern des Generationenwechsels, da sich das Kuratorenteam – erstmals ohne Bußmann – aus König und mit Brigitte Franzen und Carina Plath, zwei jüngeren Kuratorinnen, zusammensetzte. Gleichzeitig reflektierten einige der eingeladenen Künstler_innen das Ausstellungsformat als Langzeitstudie über urbane Transformationsprozesse. In den Dokumenten

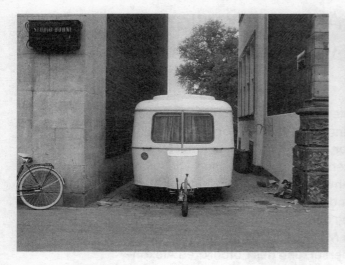

1977	Parkposition der 1. Woche, 04.–11. Juli Siegelkammer und Pferdegasse	1987	Parkposition der 1. Woche, 08.–15. Juni Siegelkammer und Pferdegasse
1977	Parking position, 1st week, 4–11 July Siegelkammer and Pferdegasse	1987	Parking position, 1st week, 8–15 June Siegelkammer and Pferdegasse

lässt sich die Zusammenarbeit zwischen dem kuratorischen Team und Asher beson-
ders deutlich nachvollziehen: Nachdem fest stand, dass das Wohnwagenprojekt ein
viertes Mal realisiert würde, dienten die Unterlagen der vorangegangenen Editionen
als Referenz und ganz selbstverständlich als Arbeitsgrundlage für die Vorbereitungen.
Hierdurch manifestiert sich in den immer wieder reproduzierten und überarbeiteten
Archivdokumenten eine dekadenübergreifende Ästhetik der Kopie. Der Wohnwagen
war nun seltener im öffentlichen Raum präsent, wohingegen die Fotodokumentation
einen umso umfangreicheren Teil im Ausstellungskatalog einnahm. In diesem Layout
erlauben die Fotografien der Standorte aus den Jahren 1977, 1987, 1997 und 2007
eine vergleichende Perspektive. Vor allem zeigen sich in der Gegenüberstellung die
Veränderungen der jeweiligen Orte über eine Zeit von drei Jahrzehnten. Damit sind
die Fotografien auch Dokumente der Münsteraner Stadtgeschichte.
Mit prüfendem Blick näherte sich der Fotograf Alexander Rischer fast zehn Jahre
nach der letzten Ausstellung den jeweiligen Standorten des Wohnwagens. Für *Münster.
19 Orte* hat er sich intensiv mit Ashers Arbeiten beschäftigt und dessen Wohnwagen-
installation in Münster als Ausgangspunkt für seine Fotoserie genommen. Es entstand
eine Serie von 19 Fotografien, die nicht nur die Veränderungen und Besonderheiten
der städtischen Räume in den Fokus nimmt, sondern das Caravan-Projekt aus einem
persönlichen Blickwinkel reflektiert. Rischers fotografierte Wirklichkeit evoziert – mit
den sachlichen Bildern der jeweiligen vorangegangenen Ausstellungen von Ashers
Installation vor dem inneren Auge – eine Leerstelle im Bild.[3] In der seriellen Anord-
nung wird ein individuelles Betrachten möglich, das sowohl ein geisterhaftes Erschei-
nen des Caravans imaginieren lässt als auch ein eigenständiges Erinnern oder eine
Reflexion über den urbanen Raum anregt.

Die Präsentation wurde zusammengestellt von Maria Engelskirchen (Forschungsprojekt Skulptur
Projekte Archiv, Universität Münster), Marijke Lukowicz (LWL-Museum für Kunst und Kultur) und
Marianne Wagner (Skulptur Projekte 2017 / Skulptur Projekte Archiv). Sammlung des LWL-Museum für
Kunst und Kultur, 1. OG, Lichthof

1 Siehe Brigitte Franzen im Gespräch mit Maria Engelskirchen und Marianne Wagner, 07.12.2016, Abschrift S. 1, Skulptur Projekte Archiv /
 LWL-Museum für Kunst und Kultur.
2 2008 umbenannt in LWL-Museum für Kunst und Kultur.
3 1977 und 1987 fotografierte Rudolf Wakonigg die Standorte, 1997 und 2007 wurden sie von Roman Mensing dokumentiert.

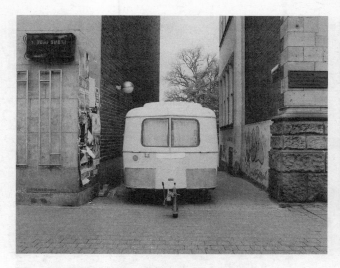 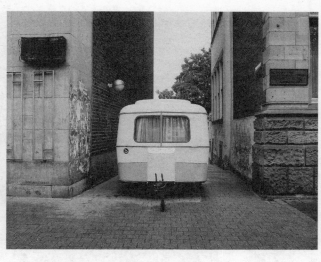

1997 **Parkposition der 1. Woche, 23. – 30. Juni**
 Siegelkammer und Pferdegasse

1997 Parking position, 1st week, 23 – 30 June
 Siegelkammer and Pferdegasse

2007 **Parkposition der 1. Woche, 16. – 24. Juni**
 Siegelkammer und Pferdegasse

2007 Parking position, 1st week, 16 – 24 June
 Siegelkammer and Pferdegasse

2016 **Alexander Rischer**
 Woche 1 (Pferdegasse)
 aus der Serie *Münster. 19 Orte*

2016 Alexander Rischer
 1st week (Pferdegasse)
 from the series *Münster. 19 Orte*

 Double Check

2016 Alexander Rischer
 Woche 4 (Alter Steinweg/Kiffe-Pavillon)
 aus der Serie *Münster. 19 Orte*

2016 Alexander Rischer
 4th week (Alter Steinweg/Kiffe-Pavillon)
 from the series *Münster. 19 Orte*

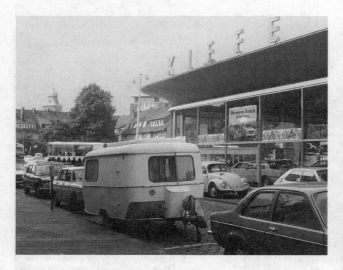

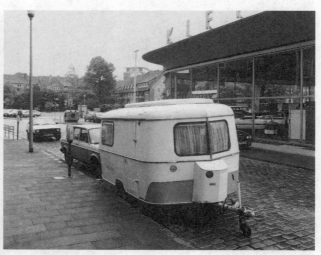

1977 **Parkposition der 4. Woche, 25. Juli – 01. August**
 Alter Steinweg, gegenüber vom Kiffe-Pavillon,
 vor der Parkuhr Nr. 275 oder 274

1977 Parking position, 4th week, 25 July–1 August
 Alter Steinweg, across from Kiffe-Pavillon,
 parking metre no. 275 or 274

1987 **Parkposition der 4. Woche, 29. Juni – 06. Juli**
 Alter Steinweg, gegenüber vom Kiffe-Pavillon,
 vor der Parkuhr Nr. 2200

1987 Parking position, 4th week, 29 June–6 July
 Alter Steinweg, across from Kiffe-Pavillon,
 parking metre no. 2200

Double Check Michael Asher's Installation Münster (Caravan) '77 '87 '97 '07

Michael Asher (1943–2012) participated in all four editions of Skulptur Projekte between 1977 and 2007. Each new invitation to Münster was followed by the artist's intense examination of the city, the exhibition format, and his own work—a 'double check' at ten-year intervals, as Asher himself described it.[1] The decision to once again realize his caravan project for Münster was always preceded by a process of critical appraisal, followed by research in the archive. The 2017 presentation in the permanent collection at the LWL-Museum für Kunst und Kultur includes historical documents, current material in the form of interviews, and an independent artistic examination of Asher's contributions by photographer Alexander Rischer (* 1968).

In 1977, Asher was invited by Kasper König himself—who had met the artist in Los Angeles in 1970—to participate in the project section of the exhibition *Skulptur Ausstellung in Münster 1977*. Asher's proposals for Münster initially envisaged discreet changes to the given site: for example, planting trees in various locations or excavating a tunnel. Ultimately, however, the artist decided to install Hymer's Eriba Familia caravan, which he parked at locations in and around Münster that changed weekly. Tear-off stubs, available in the museum foyer, as well as the catalogue entry provided visitors with directions to the respective parking locations.

Following Klaus Bußmann's return as director to the Westfälisches Landesmuseum in 1985,[2] he and Kasper König decided to organize the sculpture exhibition for a second time in 1987. Asher also once again submitted several proposals during the run-up to the exhibition. Although he considered new ideas, he was equally fascinated by the prospect of carrying out a reinstallation of the caravan work. The preconditions for such an undertaking were that an identical model of caravan to the 1977 one could still be rented and that the parking locations previously used were still accessible. Since these conditions could be fulfilled, Asher then proceeded, in a manner similar to a scientific experiment, to repeat the project under modified conditions. Changes to Münster's cityscape had become visible during the ten-year interval, and the project

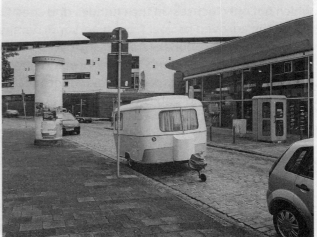

1997 Parkposition der 4. Woche, 14.–21. Juli
 Alter Steinweg, gegenüber vom Kiffe-Pavillon,
 vor der Parkuhr Nr. 2560

1997 Parking position, 4th week, 14–21 July
 Alter Steinweg, across from Kiffe-Pavillon,
 parking metre no. 2560

2007 Parkposition der 4. Woche, 09.–15. Juli
 Alter Steinweg, gegenüber vom Kiffe-Pavillon

2007 Parking position, 4th week, 9–15 July
 Alter Steinweg, across from Kiffe-Pavillon

made it possible to follow this process using the same sites: if one of the sites was in-accessible due to logistical reasons, Asher stationed the caravan in a garage for that week, the project remaining invisible for a short period, except for the stubs in the museum providing information on its current location.

In addition to Asher, other artists have also been invited to participate in the Skulptur Projekte several times. He was nevertheless the only one who decided repeatedly, after careful consideration, to reconceive the same work. From 1997 onwards the caravan installation began developing a wide-ranging critical potential. Asher's renewed repetition undermined the mechanisms of an art market system demanding inexhaustible creativity and innovation. The archival documents reveal both increas-ing difficulties and the considerable administrative effort required in realizing the work, as the Eriba Familia caravan was now a vintage model and difficult to locate. The obvious anachronism of the caravan within the cityscape created a high level of recognition, not only through its own continuity but also due to the high profile of the Skulptur Projekte. It thus involuntarily became a kind of marketing symbol, appear-ing more and more frequently in reports on the exhibition.

The fourth edition of the Skulptur Projekte took place at a time of generational change, since the curatorial team—for the first time without Bußmann—now comprised Kasper König together with Brigitte Franzen and Carina Plath, two younger curators. At the same time, some of the invited artists began considering the exhibition format as a long-term study of the processes of urban transformation. Documents from the ar-chive enable the cooperation between the curatorial team and Michael Asher to be clearly followed. After it had become apparent that the caravan project was to be realized for a fourth time, the documents from the preceding editions were then used as reference material and very naturally became the basis for preparatory work. The result is that the aesthetics of the copy across the decades have manifested in archi-val documents that have continually been reproduced and revised. Whilst the cara-van itself was less and less present in public space, the photographic documentation in the exhibition catalogue became increasingly expansive. The layout of photographs of the sites from 1977, 1987, 1997, and 2007 enable a comparative overview. The jux-tapositions illustrate, above all, transformations in the respective locations over a period of three decades, the photographs thus also becoming documents of Mün-ster's urban history.

The photographer Alexander Rischer approached the caravan's various locations with an interrogative gaze almost ten years after the last exhibition. For *Münster: 19 Orte* he deeply immersed himself in Asher's works, employing the caravan instal-lation in Münster as the point of departure for his series of nineteen photographs, which not only focuses on the changes and specifics of the urban sites but also recon-siders the caravan project from a personal perspective. With the impersonal images of the various iterations of Asher's installation in mind, Rischer's photographic reality evokes a void in the image.[3] The serial arrangement enables an individual perspective, which imagines both a spectral (re)appearance of the caravan, while also prompting individual memories and considerations of the urban space.

The presentation has been compiled by Maria Engelskirchen (Skulptur Projekte Archiv Research Project, Münster University), Marijke Lukowicz (LWL-Museum für Kunst und Kultur) and Marianne Wagner (Skulptur Projekte 2017/Skulptur Projekte Archiv).

1 See Brigitte Franzen in conversation with Maria Engelskirchen and Marianne Wagner, 07.12.2016, transcript p.1, Skulptur Projekte Archiv/
 LWL-Museum für Kunst und Kultur.
2 The museum was renamed LWL-Museum für Kunst und Kultur in 2008.
3 In 1977 and 1987 Rudolf Wakonigg photographed the locations; in 1997 and 2007 they were documented by Roman Mensing.

On Kawara: *Pure Consciousness*

On Kawaras Arbeit *Pure Consciousness* ist besonderen Betrachter_innen vorbehalten: Kindern im Alter von vier bis sechs Jahren. 1998 verließ der Künstler im Rahmen der Sydney Biennale bewusst den Museumsraum und installierte sieben seiner Datumsbilder, der sogenannten *Date Paintings*, in einem Kindergarten. Nach der ersten Station in Sydney reiste die Bildergruppe mit den Daten vom 1. bis 7. Januar 1997 in zwanzig weitere Kindergärten quer durch die Welt. Sie hingen unter anderem in Reykjavik, Abidjan, Shanghai, in Leticia im kolumbianischen Regenwald und auf der Insel Bequia in der Karibik.

Kawara malte sein erstes *Date Painting* am 4. Januar 1966. Über einen Zeitraum von 48 Jahren setzte er die Arbeit an den monochromen Gemälden kontinuierlich fort und vermerkte auf diesen nichts weiter als ihr jeweiliges Entstehungsdatum. Anhand der wechselnden Notationsform der Daten zeigt sich Kawaras beständiges Reisen als Teil seiner künstlerischen Strategie, denn die Datumsangabe entsprach immer den Standards des aktuellen Aufenthaltsorts des Künstlers. Bis Mitternacht musste der aufwändige manuelle Herstellungsvorgang, der bis zu zehn Stunden dauerte, vollendet sein. Ansonsten wurden die Bilder zerstört. Dieses Regelwerk bewirkte, dass die Entstehungsvoraussetzung selbst — nämlich die aktuelle Gültigkeit der auf den Bildern angezeigten Raum-Zeit-Konstellation — das alleinige Motiv generierte. Damit widmen sich die *Date Paintings* der Darstellung des Nicht-Sichtbaren, nämlich Kawaras stetiger mentaler künstlerischer Bewusstmachung der Kategorien Raum und Zeit.

Bei *Pure Consciousness* begegnen die Bilder Kindern in einer Lebensphase, bei der die Wahrnehmung noch wenig vorgeprägt ist und Erlebtes unmittelbar empfunden wird. *Pure Consciousness* verschränkt die kindliche (Selbst-)Wahrnehmung mit der vom Künstler einst kontinuierlich betriebenen Untersuchung des menschlichen Bewusstseins innerhalb der unaufhörlich fortschreitenden Zeit.

In Münster haben 24 Kinder der städtischen Kindertageseinrichtung in Berg Fidel mehrere Wochen mit den *Pure Consciousness*-Bildern verbracht. Von einem auf den anderen Tag hingen die Gemälde plötzlich in ihrem Gruppenraum, um drei Wochen später wieder zu verschwinden. Die Kinder sollten beim Betrachten der Bilder nicht beeinflusst werden, weder durch Fragen oder Erläuterungen der Erzieher_innen noch durch anderweitige Vermittlung der Entstehungszusammenhänge der Bilder. So legte es der Künstler in seinen knappen „Instructions" zu *Pure Consciousness* fest: „This exhibition is not educational."[1] Der für die Ausstellungen in den Kindergärten wesentliche Ansatz des Nicht-Vermittelns passt zu Kawaras grundsätzlicher Verschwiegenheit dem Kunstbetrieb gegenüber, denn der Künstler kommentierte seine Kunst nicht. Er gab keine Interviews, ließ sich nicht fotografieren und war bei seinen Ausstellungseröffnungen nicht anwesend. Angesichts dieser nach außen hinterlassenen Leerstelle zu seinen Lebzeiten ist umso bedeutsamer, dass der Künstler sich wünschte, dass *Pure Consciousness* auch über seinen Tod hinaus fortgesetzt wird. So, wie er selbst stets unterwegs war, so reisen nun die Bilder beständig weiter und begegnen Kindern an unterschiedlichen Orten der Welt.

On Kawara

Anlässlich der Skulptur Projekte 2017 wird die erste Station nach Kawaras Tod im Jahr 2014 realisiert, wodurch für *Pure Consciousness* ein neues Kapitel beginnt. Die Ausstellung war allein den Kindern vorbehalten und fand schon vor den Skulptur Projekten im Frühjahr statt. Während der Laufzeit der Skulptur Projekte informiert eine Dokumentation im Foyer des Kunstmuseum Pablo Picasso sowohl über die Ausstellung in der Münsteraner Kindertageseinrichtung als auch über die vorangegangenen Stationen von *Pure Consciousness*. Das Museum zeigt zeitgleich eine Präsentation mit Werken aus der Sammlung Yvon Lamberts, Kawaras langjährigen Galeristen, der 2002 selbst eine Station von *Pure Consciousness* in Avignon organisierte.

Die Skulptur Projekte Münster sind seit jeher ein Kunstprojekt, das die Grenzen zwischen öffentlichem und privatem Raum zur Disposition stellt. Ihr Veranstaltungsrhythmus im Intervall von zehn Jahren stellt per se eine besondere Zeitlichkeit her, die – anders als die schnelle Taktung von Biennalen oder Triennalen – sich eher dem Abstand von Generationen annähert. Die Kinder, die in diesem Jahr wochenlang Zeit mit Kawaras Datumsbildern verbracht haben, werden bei den darauf folgenden Skulptur Projekten 2027 bereits Teenager sein. Kawara formulierte in seinen „Instructions": „Some children may form a memory in their minds, some may not."[2] Und tatsächlich werden sich manche der Kinder aus der Kita in Berg Fidel als Jugendliche im Jahr 2027 nicht erinnern, dass sie Kawaras Bildern einst begegnet sind – aber manche vielleicht doch. Denn so, wie Kawaras *Date Paintings* Zeitzeugen sind, tragen nun auch die beteiligten Kinder die Erfahrung mit *Pure Consciousness* in sich – ob unbewusst oder bewusst.

Akiko Bernhöft

Biografie von On Kawara 29.771 Tage

1 On Kawara, *Instructions for „Pure Consciousness" Exhibition*, o.J., abgedruckt in den vom Künstler gefertigten Boxen, in denen er die jeweils zu den einzelnen Stationen von *Pure Consciousness* veröffentlichten Heften zusammenfasste. Eine Neuauflage der *Pure Consciousness*-Hefte erscheint im Sommer 2017 im Verlag der Buchhandlung Walther König.
2 Ebd.

On Kawara

Münster: Kur und Kür
Treatments and Treats

Eine textuelle Neubegehung des städtischen Raumes
A Textual Revisiting of Urban Space

Die Skulptur Projekte Münster 2017 laden über die gesamte Dauer der Ausstellung einige Autor_innen und Performer_innen dazu ein, jeweils zwei Wochen in Münster zu verbringen. Sie beziehen hierfür eine Wohnung im Freihaus ms in der Hüfferstraße in unmittelbarer Nähe zum Schlosspark. Das Residency-Programm firmiert unter dem Titel *Münster: Kur und Kür*, ausgesucht wurden die Teilnehmer_innen von der Berliner Autorin Monika Rinck.

Over the course of the Skulptur Projekte Münster 2017 exhibition a number of authors and performers will be invited to spend a fortnight in Münster. They will reside in a flat in the Freihaus ms on Hüfferstraße right beside the Schlosspark. The residency programme is entitled *Münster: Kur und Kür*, and the participating artists were chosen by the Berlin-based author Monika Rinck.

Postkarte / Postcard, 1906, Botanischer Garten Münster, Weg zur Orangerie / path to the Orangerie

„Die klassische Kur verspricht Linderung durch einen Ortswechsel, durch die Anwendung ortsspezifischer Heilmittel. Der Körper muss sich bewegen, wird neuen Anwendungen unterzogen, probiert sich wieder aus. Es handelt sich um eine Lücke im Ablauf, die nicht Urlaub ist, sondern Gesundung sein soll, in einer fremden Umgebung, mit Menschen, auf die man zum ersten Mal trifft. Dem botanischen Garten in Münster kommt dabei die Rolle des Kurparks zu. Eine solche Kur könnte ebenso die Züge einer Kür annehmen: der freien Zusammenstellung von artistischen Bewegungsformen im Raum. ‚Es gab den Passanten, welcher sich in die Menge einkeilt; doch gab es auch noch den Flaneur, welcher Spielraum braucht und sein Privatisieren

'The classic spa treatment promises symptom relief through a change of location and the application of geographically specific remedies. The body needs to move; it is treated with new applications and rediscovers itself. It is hiatus from the daily routine that is not a holiday but meant to be recuperation, in a strange environment, among people one meets for the first time. The Botanical Gardens in Münster will assume the role of the spa gardens. This kind of health resort cure (*Kur*) could also take the form of a *Kür*: the free combination of artistic forms of movement in the space. "There was the pedestrian who wedged himself into the crowd, but there was also the flâneur who demanded elbow room and was unwilling to forgo the life of a

nicht missen will. Müßig geht er als eine Persönlichkeit; so protestiert er gegen die Arbeitsteilung, die die Leute zu Spezialisten macht. Ebenso protestiert er gegen die Betriebsamkeit. Um 1840 gehörte es vorübergehend zum guten Ton, Schildkröten in den Passagen spazieren zu führen. Der Flaneur ließ sich sein Tempo von ihnen vorschreiben.' So beschrieb Walter Benjamin 1937 in seinem Buch über Charles Baudelaire den neuen Typus des großstädtischen Flaneurs, seinen *Noctambulisme*, die phantasmagorische Wegführung. Auch während einer Kur soll sich die rege Betriebsamkeit des Alltags verringern und die Wahrnehmung erneuern."

Auf der Internetpräsenz www.kur-und-kuer.de sind die Teilnehmer_innen dazu aufgerufen, ihre während des Aufenthalts entstehenden Texte und Fotos zu veröffentlichen. Welche Ausdrucksformen die Teilnehmenden dabei bevorzugen, ist ihnen gänzlich freigestellt. Außerdem haben sie die Gelegenheit, einige Tage in Marl, dem diesjährigen Kooperationspartner der Skulptur Projekte Münster, zu verbringen. Alle zwei Wochen, jeweils am Sonntagabend um 19 Uhr, verabschiedet sich der aktuelle Gast im Freihaus ms und präsentiert die in Münster entstandenen Texte, Fotos oder Bewegungsformen. Zudem stellt der neue Gast seine künstlerische Arbeit vor.

gentleman of leisure. He goes his leisurely way as a personality; in this manner, he protests against the division of labour which makes people into specialists. He protests no less against their industriousness. Around 1840 it was briefly fashionable to take turtles for a walk in the arcades. The flâneurs liked to have the turtles set the pace for them." This is how Walter Benjamin, in his 1937 book on Charles Baudelaire, described the new type of metropolitan ambler, his noctambulism, the phantasmagoric traffic pattern. A spa treatment is also meant to reduce the hustle and bustle of the daily routine and to renew mindfulness.'

On the website <www.kur-und-kuer.de>, the participating artists will be encouraged to share texts and photos they created during their stay. It is up to the participants to choose the artistic forms they prefer. They also have the opportunity to spend a few days in Marl, which is cooperating this year with Skulptur Projekte Münster. Every second Saturday at 7 pm, the current resident in the Freihaus ms will take their leave and present the texts, photos, or movement forms they created in Münster. At the same time, the new guest will introduce their artistic work.

● Shane Anderson (* 1982 San José, lebt/lives in Berlin)
Anderson ist Autor von *Soft Passer* (Mindmade Books) und *Études des Gottnarrenmaschinen* (Broken Dimanche Press). Seine Gedichte, Prosatexte und Übersetzungen erscheinen u.a. in *6x6, Asymptote, Edit, Plinth*, in der *Il pleut*-Reihe von Natalie Czech und in Matthew Barneys *River of Fundament* (Skira Rizzoli). 2016 kuratierte er das Festival *HERE! HERE! THERE! @ the ilb* im Rahmen der Berliner Festspiele. 2017 erscheint seine Übersetzung von Ulf Stolterfohts Gedichtband *Ammengespräche* bei Triple Canopy. www.shane-anderson.blogspot.de/
Anderson is the author of *Soft Passer* (Mindmade Books) and *Études des Gottnarrenmaschinen* (Broken Dimanche Press). Amongst other places, his poems, texts, and translations can be found in *6x6, Asymptote, Edit, Plinth*, Natalie Czech's *Il pleut* series, and Matthew Barney's *River of Fundament* (Skira Rizzoli). In 2016, he curated the festival *HERE! HERE! THERE! @ the ilb* at the Berliner Festspiele, and in 2017 his translation of Ulf Stolterfoht's *The Amme Talks* will be published by Triple Canopy. www.shane-anderson.blogspot.de/

● Daniel Falb (* 1977 Kassel, lebt/lives in Berlin)
Falb ist Dichter und Philosoph, studierte Philosophie in Berlin und promovierte 2012 mit einer Arbeit zum Begriff der Kollektivität. Falb veröffentlichte die Gedichtbände die *räumung dieser parks* (2003), *BANCOR* (2009) und *CEK* (2015) – alle im Verlag kookbooks. Zuletzt erschienen sind der Essay *Anthropozän. Dichtung in der Gegenwartsgeologie* (Verlagshaus Berlin, 2015) sowie das Langgedicht *CHICXULUB PAEM* (zweisprachig deutsch-niederländisch, Druksel, 2016). Falbs Arbeiten wurden mit Stipendien und Preisen gefördert, 2016 erhielt er den Kurt Sigel-Lyrikpreis des PEN Zentrum Deutschland.

Falb is a poet and philosopher. He studied philosophy in Berlin and received a doctoral degree in 2012, writing his dissertation on the concept of collectivity. Falb has had three collections of poetry published by kookbooks: *die räumung dieser parks* (2003), *BANCOR* (2009), and *CEK* (2015). His latest publication was the essay *Anthropozän: Dichtung in der Gegenwartsgeologie* (Verlagshaus Berlin, 2015) and the long poem *CHICXULUB PAEM* (Druksel, 2016), which was published in German and Dutch. Falb's work has won him scholarships and prizes and in 2016 he received the German PEN Centre's Kurt Sigel Award for Poetry.

● Philipp Gehmacher (* 1975 Salzburg, lebt/lives in Wien)
Gehmachers künstlerische Arbeiten verwenden Körper und Sprache als Formen der Äußerung, den gebauten wie institutionellen Raum, wie das Ding, das Objekt und die Skulptur. Mit diesen Arbeiten zwischen Black Box und White Cube ist Philipp Gehmacher international auf Theaterfestivals und in Ausstellungsinstitutionen vertreten. Zuletzt 2016 u.a. im Museum der Moderne Salzburg, beim steirischen herbst (Graz), der Biennale of Sydney und dem Baltic Circle International Theatre Festival (Helsinki). www.philippgehmacher.net
Gehmacher's artistic work harnesses the body and language as forms of expression and makes use of built and institutional environments, as well as things, objects, and sculpture. Gehmacher shows these works at international theatre festivals and art institutions in both black box and white cube settings. In 2016 he participated in events at the Museum der Moderne Salzburg, the steirischer herbst festival in Graz, the Biennale of Sydney, and the Baltic Circle International Theatre Festival in Helsinki. www.philippgehmacher.net

● Martina Hefter (* 1965 Pfronten, lebt/lives in Leipzig)
Hefter ist Autorin und Performancekünstlerin. Sie ist Mitglied des Leipziger Performancekollektivs Pik 7 und verknüpft in ihren Arbeiten darstellende/szenische und textliche Verfahrensweisen. Sie veröffentlichte zuletzt den Gedichtband *Ungeheuer. Stücke/Gedichte* (kookbooks, 2016) und zeigte in diesem Jahr mit dem Kollektiv Pik 7 die Performance *Stellen Sie sich vor, Sie haben Hühner, wollen aber Rosen* in Chemnitz, Leipzig, Dresden, Berlin und Frankfurt a. M.

Hefter is an author and performance artist. She is a member of the Leipzig performance collective Pik7 and combines performative/theatrical and textual practices in her work. Her latest publication is the poetry collection *Ungeheuer: Stücke/Gedichte* (kookbooks, 2016); in early 2017, as part of the collective Pik7, she presented the performance *Stellen Sie sich vor, Sie haben Hühner, wollen aber Rosen* in Chemnitz, Leipzig, Dresden, Berlin, and Frankfurt am Main.

● Hendrik Jackson (* 1971 Düsseldorf, lebt/lives in Berlin)
Jackson studierte Theaterwissenschaft, Slawistik und Philosophie, arbeitete bei Filmen und Hörspielen mit und ist als Lyriker, Übersetzer aus dem Russischen, Herausgeber und Lesungsveranstalter tätig (http://parlandopark.wordpress.com, www.lyrikkritik.de, http://summbo.wordpress.com.). Seine Gedichte wurden in mehrere Sprachen übersetzt und mehrfach ausgezeichnet. Zuletzt erschienen *sein gelassen* (kookbooks, 2016) und die Übersetzung *Flügel des Lebens* des russischen Klassikers Venevitinov (Ripperger & Kremers, 2016)

Jackson read theatre studies, Slavic studies, and philosophy at university. He has contributed to films and radio plays and works as a poet, translator of Russian, editor, and organizer of literary readings (parlandopark, lyrikkritik, summmbo). His poems have been translated into multiple languages and won a series of awards. His latest publications are *sein gelassen* (kookbooks, 2016) and *Flügel des Lebens* (Ripperger & Kremers, 2016), a translation of works by the classic Russian poet Venevitinov.

● Orsolya Kalász (* 1964 Dunaújváros, lebt/lives in Berlin)
Kalász ist Autorin und Übersetzerin. Gemeinsam mit Monika Rinck übersetzt sie ungarische Gegenwartsliteratur. Die eigene Lyrik schreibt sie mal in der ungarischen, mal in der deutschen Sprache. Sie überträgt die eigenen Texte selbst in die zweite Sprache, was ihr eher zu einer Variation gerät. Ihrem Gedichtband *Das Eine* (Brueterich Press, 2016) wurde 2017 der Peter-Huchel-Preis zugesprochen.

Kalász is an author and translator. Together with Monika Rinck she translates contemporary Hungarian literature. She writes her own poetry, sometimes in Hungarian and sometimes in German. She translates her texts between the two languages, with the result that they turn out as variations rather than reproductions. In 2017 her poetry collection *Das Eine* (Brueterich Press, 2016) was awarded the Peter Huchel Prize.

● Valentinas Klimašauskas (* 1977 Kaunas, lebt/lives in Münster)
Klimašauskas erforscht in seiner Arbeit als Kurator und Autor, wie die neuen Vielheiten in der gegenwärtigen Geopolitik der post-westfälischen politischen Geografie sich zurzeit selbstquantifizieren oder quantifiziert werden. Zu seinen neueren Schriften und Lektüren gehören *Everybody Reads!*, die Nächte des horizontalen Lesens, sowie *How To Clone A Mammoth (In Three Voices And With A Fisherman's Exaggeration)*, ein Lesenachmittag zur Poetik der Ent-Ausrottung in der Klickwirtschaft.

Klimašauskas is a curator and writer investigating how the new multitudes are being (self-)quantified in the new geopolitics of the post-Westphalian political geography. Recent writings and readings include *Everybody Reads!*, the nights of horizontal readings, and *How to Clone a Mammoth (In Three Voices and with a Fisherman's Exaggeration)*, a reading afternoon on the poetics of de-extinction in the economy of clicks.

● Katharina Merten (*1987 Rudolstadt, lebt/lives in Leipzig)
Merten studierte bildende Kunst an der Akademie der bildenden Künste Wien und an der Hochschule für Grafik und Buchkunst Leipzig, wo sie 2012 ihr Diplom und 2015 ihre Auszeichnung als Meisterschülerin erhielt. Neben ihrer künstlerischen Arbeit in den Bereichen Installation, Audio, Video und Performance initiierte sie verschiedene Projekte an der Schnittstelle von Literatur und bildender Kunst; u.a. ANACONDA, *Heroes (Rework)*, *Initiative Wort und Bild* und *Volte Studio*. www.katharinamerten.de

Merten studied fine arts at the Academy of Fine Arts Vienna and the Academy of Fine Arts in Leipzig, where she received her diploma in 2012 and her distinction as a master-class student in 2015. Besides her artistic work in the areas of installation, audio, video, and performance, she has initiated several projects at the interface between literature and visual arts, such as ANACONDA, *Heroes (Rework)*, *Initiative Wort und Bild*, and *Volte Studio*. www.katharinamerten.de

● Monika Rinck (* 1969 Zweibrücken, lebt/lives in Berlin)
Seit 1989 diverse Veröffentlichungen in vielen Verlagen. 2012 erschien ihr Lyrikband *Honigprotokolle* bei kookbooks, 2015 folgte *Risiko und Idiotie* im selben Verlag. Rinck ist Mitglied im PEN-Club, der Akademie der Künste in Berlin und der Deutschen Akademie für Sprache und Dichtung in Darmstadt. 2015 erhielt sie den Kleist-Preis, 2017 kuratierte sie die Poetica III in Köln. Sie übersetzt mit Orsolya Kalász aus dem Ungarischen, kooperiert mit Musiker_innen und Komponist_innen und lehrt von Zeit zu Zeit. Zuletzt: *Hypno-Homullus*, Hypnose-Übersetzungen von Gedichten von Magnus William-Olsson aus dem Schwedischen.

Since 1989 Rinck has authored a variety of publications with numerous publishers. Her poetry collection *Honigprotokolle* was published by kookbooks in 2012, followed in 2015 by *Risiko und Idiotie* (also kookbooks). Rinck is a member of the PEN Club, the Academy of Arts in Berlin, and the German Academy for Language and Literature in Darmstadt. She received the Kleist Prize in 2015 and curated Poetica III in Cologne in 2017. Together with Orsolya Kalász she translates Hungarian literature and also collaborates with musicians and composers and teaches from time to time. Her latest publication is *Homullus absconditus [Hypno-Homullus]* (Urs Engeler, 2016), a collection of poems by the Swedish writer Magnus William-Olsson that she translated under hypnosis.

● Sabine Scho (* 1970 Ochtrup, lebt/lives in Berlin)
Scho lebt nach längeren Aufenthalten in Münster, Hamburg und São Paulo heute in Berlin. Nahezu alle ihre Texte sind im Grenzbereich zu Fotografie und Bild angesiedelt. Zwei Gedichtbände und ein Band mit Prosaminiaturen sind bei kookbooks erschienen: *Album* und *farben*, beide 2008, sowie *Tiere in Architektur*, 2013. Das Magazin *The Origin of Senses* erschien 2015 im Rahmen einer künstlerischen Intervention im Museum für Naturkunde in Berlin mit Zeichnungen von Andreas Töpfer. Zuletzt wurde sie 2012 mit dem Anke Bennholdt-Thomsen-Lyrikpreis der Deutschen Schillerstiftung ausgezeichnet.

After extended stays in Münster, Hamburg, and São Paulo, Scho now lives in Berlin. Almost all of her texts occupy a crossover zone that borders on the realms of photography and the image. She has had two poetry collections and a volume of prose miniatures published by kookbooks: *Album* and *farben*, both in 2008, and *Tiere in Architektur* in 2013. The magazine *The Origin of Senses* was published in 2015 as part of an artistic intervention at the Museum für Naturkunde in Berlin with drawings by Andreas Töpfer. In 2012 she was awarded the German Schiller Foundation's Anke Bennholdt-Thomsen Poetry Prize.

Blumenberg Lectures 2017

Metaphern des Gemeinsinns – Contesting Common Grounds

Der Aspekt der Gemeinschaft steht im Fokus einer Kooperation zwischen der Westfälischen Wilhelms-Universität Münster und den Skulptur Projekten. Wie schon 2007 werden in der Vortragsreihe Blumenberg Lectures Grundfragen der Ausstellung aufgegriffen und aus der Perspektive verschiedener Wissenschaftsdisziplinen zur Diskussion gestellt. Der für 2017 gewählte Titel *Metaphern des Gemeinsinns – Contesting Common Grounds* nimmt Bezug auf die These des Münsteraner Philosophen Hans Blumenberg, dass dem Menschen bei seiner Suche nach Orientierung in der Welt Definitionen nicht ausreichen. Es sind Metaphern, die dem Menschen dabei helfen, die Welt und ihre Phänomene zu ordnen und sein Denken und Handeln darin zu bestimmen.

Damit nehmen die Blumenberg Lectures in den Blick, wie in verschiedenen Konzeptionen von Öffentlichkeit Vorstellungen von Gemeinschaft bildhaft aufscheinen, und wie sich in den gesellschaftlichen Haltungen zu Gemeinschaft gegenwärtige Erwartungen, Fehlschläge und Wünsche widerspiegeln. Viele der 2017 eingeladenen Künstler_innen thematisieren in je unterschiedlicher Weise Formen von Gemeinschaft oder inkorporieren sie als Praxis direkt ins Werk. Die Blumenberg Lectures erweitern mit Beiträgen aus Soziologie, Kunstgeschichte, Philosophie und anderen Wissenschaften die von den Künstler_innen eröffneten Diskursfelder. Wie diese befassen sie sich kritisch mit aktuellen Herausforderungen wie sozialen Konflikten, Wirtschaftskrisen, Privatisierungsprozessen oder antidemokratisch-nationalistischen Tendenzen und fragen nach zukünftigen Formen für gesellschaftliche Aushandlungs- und Veränderungsprozesse.

- Laura Kurgan, Columbia University, New York
 Conflict Urbanism, Recent Projects at the Center for Spatial Research
 12.06.2017, Fürstenberg-Haus

- Thomas Keenan, Bard College, New York
 No Common Ground Without Contest: Human Rights and Images of Migration
 19.06.2017, Fürstenberg-Haus

- Oliver Marchart, Universität Wien
 Pre-enacting Public Space. Zur Herstellung von Öffentlichkeit durch Praktiken des Pre-enactments
 30.06.2017, Juridicum

- Gesa Ziemer, HafenCity Universität, Hamburg
 Vom Dialog zum Doing? Öffentliche Räume im Fokus der Interessen Vieler
 10.07.2017, Fürstenberg-Haus

- Alexander Alberro, Columbia University, New York
 Contemporary Art between the Regional and the Global
 21.07.2017, Juridicum

- Philipp Oswalt, Universität Kassel und Theo Deutinger, Amsterdam
 Kann Gestaltung Gesellschaft verändern?
 26.07.2017, Fürstenberg-Haus

- Juliane Rebentisch, Hochschule für Gestaltung, Offenbach
 Die Performanz der Potenzialität. Über das Erscheinen im digitalen Netz
 31.08.2017, Juridicum

- Erhard Schüttpelz, Universität Siegen
 Die Öffentlichkeit und ihre Veröffentlichungen. Einige Vergleiche von der Steinzeit bis heute
 13.09.2017, Juridicum

- Claus Leggewie, Kulturwissenschaftliches Institut Essen
 Wahrheit und Lüge in der Politik. Zur HyperNormalisation bei Hannah Arendt, Adam Curtis und anderen
 21.09.2017, Juridicum

- Chantal Mouffe, University of Westminster, London
 The Affects of Democracy
 29.09.2017, Juridicum

Beginn: 18 Uhr
Fürstenberg-Haus, Domplatz 20–22 oder Juridicum, Universitätsstraße 14–16

Vortragssprachen sind Deutsch und Englisch.
Der Eintritt ist frei.

Aktuelle Informationen zu den Blumenberg Lectures unter www.go.wwu.de/blumenberg oder unter www.skulptur-projekte.de

Die Blumenberg Lectures finden in Kooperation mit der Westfälischen Wilhelms-Universität Münster statt.

Blumenberg Lectures 2017

Metaphors of Community Spirit – Contesting Common Grounds

The issue of community is the focus of a cooperation between the University of Münster and the Skulptur Projekte. As was the case in 2007, the Blumenberg Lectures series addresses fundamental questions from the exhibition and puts them up for discussion from the perspectives of various academic disciplines. The title selected for the series in 2017, *Metaphors of Public Spirit—Contesting Common Grounds*, refers to the thesis put forward by the Münster-based philosopher Hans Blumenberg that definitions are not sufficient for humans in their search for orientation in the world. Metaphors are what help people to order the world and its phenomena, determining their thoughts and actions.

The Blumenberg Lectures focus on how ideas of community figure metaphorically in various conceptions of the public sphere, and how our current expectations, failures, and desires are reflected in societal attitudes to community. Many of the artists invited in 2017 tackle forms of community in one way or another, or incorporate them as praxis directly into their work. The Blumenberg Lectures will expand the areas of discourse broached by the artists with contributions from sociology, art history, philosophy, and other disciplines. Like the artists, the lectures critically engage with current challenges, such as social conflicts, economic crises, processes of privatization, or anti-democratic nationalist tendencies, and pose questions about the future forms that societal processes of negotiation and change may take.

- Laura Kurgan, Columbia University, New York
 Conflict Urbanism: Recent Projects at the Center for Spatial Research
 12 June 2017, Fürstenberg Haus

- Thomas Keenan, Bard College, New York
 No Common Ground without Contest: Human Rights and Images of Migration
 19 June 2017, Fürstenberg Haus

- Oliver Marchart, University of Vienna
 Pre-enacting Public Space: On the Production of the Public through Practices of Pre-enactments
 30 June 2017, Juridicum

- Gesa Ziemer, HafenCity University, Hamburg
 From Dialogue to Doing? Public Spaces at the Centre of the Interests of the Many
 10 July 2017, Fürstenberg Haus

- Alexander Alberro, Columbia University, New York
 Contemporary Art between the Regional and the Global
 21 July 2017, Juridicum

- Philipp Oswalt, University of Kassel, and Theo Deutinger, Amsterdam
 Can Design Change Society?
 26 July 2017, Fürstenberg Haus

- Juliane Rebentisch, University of Art and Design, Offenbach
 The Performance of Potentiality: On Appearance in the Digital Web
 31 August 2017, Juridicum

- Erhard Schüttpelz, Siegen University
 The Public and its Publications: Some Comparisons from the Stone Age to the Present
 13 September 2017, Juridicum

- Claus Leggewie, Institute for Advanced Study in the Humanities, Essen
 Truth and Lies in Politics: On Hypernormalization in the work of Hannah Arendt, Adam Curtis, and Others
 21 September 2017, Juridicum

- Chantal Mouffe, University of Westminster, London
 The Affects of Democracy
 29 September 2017, Juridicum

Starting time: 6 pm
Fürstenberg Haus, Domplatz 20–22 or Juridicum, Universitätsstraße 14–16

The lectures will be held in German and English.
Free admission.

For the latest information on the Blumenberg Lectures, please visit
www.go.wwu.de/blumenberg or
www.skulptur-projekte.de

The Blumenberg Lectures are a cooperation with the University of Münster.

Texte / Texts

Mithu Sanyal

Wem gehört der Common Ground?

September 2016 fuhr ich nach Hamburg, um mich mit Susanne Mayer von *DIE ZEIT* und mit der Autorin Margarete Stokowski zu einem Interview zu treffen. Der Hamburger Hauptbahnhof sah in alle Richtungen gleich aus, also fragte ich einen Schaffner nach dem Hauptausgang, doch der ignorierte mich eisern. In der Annahme, er habe mich nicht gehört, wiederholte ich meine Frage, woraufhin er mich anblaffte: „Ich habe zu tun." In dieser Sekunde kamen zwei Frauen auf ihn zu, die so aussahen wie die Ergebnisse einer Google-Bildersuche nach „deutsche Frau", und er erklärte ihnen ausführlich alles, was sie wissen wollten. Anstatt mir daraufhin peinlich berührt ebenfalls den Weg zu weisen, drehte er sich um und marschierte davon.

Meine Fantasie dazu ist, dass das an meiner Hautfarbe lag, an der Decke, die ich an meinen Rucksack geschnallt hatte, weshalb ich so aussah wie das Resultat einer Google-Suche nach „geflüchtete Frau". Vielleicht hatte seine Reaktion überhaupt nichts mit Rassismus zu tun. Vielleicht hatte ihn an jenem Morgen seine Freundin verlassen, die mir zufällig wie aus dem Gesicht geschnitten ist. Wer weiß das schon? Das Einzige, was ich weiß, ist, dass diese Begegnung mein Verhältnis zum Hamburger Hauptbahnhof grundlegend veränderte. Es verwandelte mich von einer Person, die einen Platz in diesem verheißungsvollen Gedränge von Menschen hatte, in — nein, keinen Störfaktor, diese Macht hatte er nicht — eine Person ohne jene magische soziale Haut, die es uns erlaubt, gleichzeitig Teil einer Menge und wir selbst zu sein — unverletzbar, weil eine Verletzung von uns gleichzeitig eine Verletzung der Gemeinschaft wäre. Ich trat unwillkürlich einen Schritt von den Gleisen zurück, nur zur Sicherheit.

Was mir am Hamburger Hauptbahnhof passiert war, geschah wenige Monate darauf rund tausend jungen Männern am Kölner Hauptbahnhof: Sie wurden explizit anders behandelt als Personen eines anderen Phänotyps. Es war das Silvester nach *dem* Silvester in Köln. Aus Angst, dass sich die Übergriffe des Vorjahres wiederholen könnten, hatte die Polizei den Bahnhof bis auf zwei Ausgänge abgeriegelt und *selektierte* die Karnevalist_innen: die Guten ins Töpfchen, respektive auf die Domplatte, die Schlechten in den Polizeikessel. Und *schlecht* waren natürlich diejenigen, die das Pech hatten, so auszusehen wie ich, wenn ich ein Mann wäre. Dieses Vorgehen hieß früher Gesichtskontrolle und heißt heute Racial Profiling. Als die Grünen-Chefin Simone Peter fragte, ob das verhältnismäßig gewesen sei, erntete sie einen Shitstorm. „Ich bin sprachlos über so viel Dummheit, Naivität und Staatsverachtung", kommentierten Trolle auf ihrer facebook-Seite und echoten damit die *BILD*, die online getitelt hatte „Dumm, dümmer, GRÜFRI". GRÜFRI ist das Akronym für GRÜn-Fundamentalistisch-Realitätsfremde-Intensivschwätzerin. Es ist immer interessant, wenn Beleidigungen so kryptisch sind, dass sie eine Übersetzung brauchen. Das Ergebnis war, dass Peter sich entschuldigen musste.

Allerdings hatte es noch ein anderes Akronym gegeben, und zwar von der Polizei selbst in ihrem berüchtigten Tweet aus der Silvesternacht: „#PolizeiNRW #Silvester2016 #SicherIn-Köln: Am HBF werden derzeit mehrere Hundert Nafris überprüft. Infos folgen." Die Info, die hätte folgen müssen, ist, dass Nafri eine herabwürdigende Gruppenbezeichnung ist. Abgesehen davon war der Tweet schlicht falsch: Kontrolliert wurden nicht mehrere Hundert Naf-

ris, sondern mehrere Hundert Menschen mit dunklen Haaren. Ziemlich schnell stellte sich heraus, dass die Profiler keineswegs wussten, wer genau ihrem Profil entsprach. Die „rund 2.000 Nordafrikaner", die an Silvester nach Köln geströmt sein sollten, entpuppten sich als Iraker, Syrer und… Deutsche. Doch sogar, wenn es Marokkaner oder Algerier gewesen wären, wären sie noch lange keine Nafris gewesen. Denn das ist keineswegs die Abkürzung für Nordafrikaner, sondern steht für Nordafrikanischer Intensivtäter. Und alle Menschen, die kontrolliert wurden, als Intensivtäter zu bezeichnen, zeigt, dass die Polizei eben nicht unvoreingenommen war, sondern dass es in der Tat Vorverurteilungen gab. Peter spricht mit ihrer Kritik also durchaus einen relevanten Punkt an. Und es muss möglich sein, darüber öffentlich nachzudenken. Denn Racial Profiling – oder auch schlicht Menschen in besonderer und besonders gefährlicher Form wahrzunehmen, weil sie nun einmal aussehen, wie sie aussehen – macht ja nicht nur die Polizei. Allein die Frage „Warum kamen an Silvester wieder viele Nordafrikaner nach Köln?" (*Süddeutsche Zeitung*) zeigt, dass es hier nicht um *Verhalten* geht, sondern um *Sein*. Carolin Emcke, die 2016 mit dem Friedenspreis des Deutschen Buchhandels ausgezeichnet wurde, schreibt: „Wer zum ersten Mal von der Polizei ohne erkennbaren Grund kontrolliert wird, dem mag das unbequem sein, aber der oder die nimmt das hin ohne Unmut. Wer aber wieder und wieder grundlos behelligt wird, wer sich wieder und wieder ausweisen muss, wer wieder und wieder Körperkontrollen über sich ergehen lassen muss, für den oder die wird aus einer zufälligen Unannehmlichkeit systematische Kränkung."[1] Wann immer ich aus meinem Fenster schaue, sehe ich das Ordnungsamt einen Mann mit dunklen Haaren anhalten und durchsuchen. Direkt nach dem ersten Silvester in Köln, als der Januar 2016 noch jung und so roh war wie eine offene Wunde, befragten mein Mann und ich die Herren vom Ordnungsamt nach ihrem Handeln. „TRETEN SIE ZURÜCK", blafften sie uns in Großbuchstaben an. Wir traten zurück. „Was machen Sie mit dem Mann?", fragte mein Liebster und zeigte auf den schmalen arabisch oder nordafrikanisch aussehenden Mann™ – wie meine Kollegin Nadia Shehadeh diese neu geschaffene Identität getauft hat.[2] Damit hatte mein Mann seine Hand erhoben, die ihm sofort von den Ordnungshütern auf den Rücken gedreht und mit einer Plastikfessel gesichert wurde. Das Traumatische dieser Erfahrung ist nicht, dass er daraufhin eine Anzeige bekam – interessanterweise für das Vergehen, den Ordnungsdienern nicht schnell genug seinen Ausweis gezeigt zu haben (er erklärte ihnen, sie müssten ihn selbst aus seiner Hosentasche holen, da er mit gefesselten Händen nicht an ihn heran kam) –, sondern, dass ich seitdem eben nicht mehr hinausgehe, wenn eine Gruppe Uniformierter einen Menschen fremden Aussehens kontrolliert.

Emcke fährt fort: „Regelmäßige Demütigungen dieser Art zu erfahren, führt mit der Zeit zu einer Melancholie, die alle kennen, die sich irgendwo in dem Raster zwischen unsichtbar und monströs bewegen."[3] Denn das ist die gegenwärtige Großerzählung, dass bestimmte Menschen eine Bedrohung darstellen. Und zwar dort draußen, in dem Raum, den wir uns alle teilen, sodass die reflexartige Reaktion darauf ist, sie aus diesem Raum entfernen zu wollen. Dabei ist der öffentliche Raum zurzeit so sicher wie schon lange nicht mehr. Die Kriminologin Sandra Bucerius hat sogar eine Studie vorgelegt, nach der Immigration die nationale Kriminalitätsrate tendenziell senkt. Warum wachsen unsere Ängste dann aber umgekehrt proportional? Das Max-Planck-Institut für ausländisches und internationales Strafrecht erklärt das mit der Generalisierungsthese,[4] die, knapp zusammengefasst, besagt: Je mehr soziale Zukunfts- und Existenzängste es in einer Gesellschaft gibt, desto mehr Angst vor Kriminalität gibt es auch. Es ist nun einmal deutlich einfacher, sich einen Menschen vorzustellen, der einem etwas – Geld/Wohnraum/Sicherheit – entwendet, als ein gesichtsloses Staatsgebilde. Und zurzeit stellen wir uns diesen Menschen wieder einmal mit dunklen Haaren und dunklen Absichten vor. Genährt wird dies durch Nachrichten und andere Narrative über Muslime als Bedrohung für *unsere* Werte. Allerdings ist unklar, was genau diese Werte sind. Die Forderung in Großbritannien, britische Werte an Schulen zu unterrichten, führte zu vagen Formulierungen wie „Toleranz" und „Fairness" (sowie zu amüsanten Vorschlägen wie „Trunksucht" und „die Neigung, sich über sich selbst lustig zu machen"). Leider fehlte es in der Debatte an Toleranz und Fairness. Doch ist diese Idee nicht neu. Sie basiert auf der Vorstellung, dass die westliche Zivilisation in der Antike von den Griechen begründet und deren Wissen dann an die Römer weitergegeben wurde und von diesen an die Europäer. Oder kürzer: „Von Plato zur Nato", wie der Philosoph Kwame Anthony Appiah die Theorie nennt.[5] Der Haken daran

Mithu Sanyal

ist, dass diese Kultur von der muslimischen Welt geteilt wird. Die klassischen antiken Texte, auf denen unsere Renaissance basiert, wären für immer verloren gewesen, wenn sie nicht ins Arabische übersetzt und während des gesamten Mittelalters dort aufbewahrt worden wären.

Aber was ist dann mit den Frauen? Ja, was ist mit den Frauen? War es wirklich so viel sicherer für sie Silvester 2016/2017, weil keine Dunkelhaarigen/Dunkeläugigen/irgendwie dunkel Aussehenden auf der Domplatte herumliefen? Das würde ja bedeuten, dass wirklich nur oder hauptsächlich diese Gruppe Übergriffe begehen würde, was mit den Polizeistatistiken nicht zu belegen ist. Trotzdem gab es Silvester 2015/2016 und gibt es nach wie vor mehr Gruppen junger Männer, die im öffentlichen Raum herumhängen – weil sie häufig keinen anderen Platz haben – und vorbeigehenden Frauen und anderen Menschen blöde Sprüche hinterhergrölen. Die Antwort darauf ist in der Regel der Ruf nach mehr Überwachungskameras, die Übergriffe, wie wir wissen, nicht verhindern, sondern nur verlagern, und außerdem etwas mit Menschen machen – mit allen Menschen: Überwachung bringt uns dazu, uns selbst zu überwachen, den liebenden Blick auf uns selbst in einen misstrauischen zu verwandeln. Überwachung macht uns zu Objekten und nicht mehr zu Subjekten von Gemeinschaft. Im Gegensatz dazu stellt Sophie Roznblatt in *DIE ZEIT* das beste Best-Practice-Modell vor, das ich bisher gefunden habe: Aufklärung. Sie berichtet unaufgeregt und freundlich von den Sexualsprechstunden, die sie (nicht nur) für Geflüchtete anbietet. In einen extra dafür eingerichteten Briefkasten können Menschen Fragen einwerfen und sie beantwortet diese dann einmal im Monat – und zwar vorbehaltlos, egal, ob es darum geht, dass der Penis des besten Freundes zwei Meter lang ist und warum der eigene so klein sei oder ob Masturbation zum übermäßigen Verzehr von Gurken führen kann. In dem Text schreibt sie so kluge Sätze wie: „Diejenigen, die am lautesten Fikki-Fikki schreien, schämen sich bald am meisten und bringen irgendwann Blumen."[6] Damit schafft sie im wahrsten Sinne des Wortes *common ground*. Das englische *commons* bezieht sich auf zwischenmenschliche Gemeinsamkeiten ebenso wie auf Land, das der Gemeinschaft gehört und von *Common(ern)* bewirtschaftet wird. Die deutsche Übersetzung ist *Allmende* vom mittelhochdeutschen *allgemeinde*. Eigentlich wollte ich diesen Text *Mehr Allmenden* nennen, nur sind Allmenden hierzulande so selten geworden, dass kaum jemand mehr Allmenden kennt. Was der Grund ist, warum wir mehr von ihnen brauchen. Zum Glück ist Common Ground inzwischen in die deutsche Sprache eingegangen. Es bezeichnet ein Kommunikationsmodell, bei dem die Teilnehmer_innen miteinander kooperieren, um ein gemeinsames Ziel zu erreichen – sprich: die anderen zu verstehen und selbst verstanden zu werden. Der Diskurs wird dadurch zu einem kollektiven Akt, in dem neues gemeinsames Wissen entsteht. Es ist daher kein Zufall, dass das andere Best-Practice-Modell schlicht öffentliche Bibliotheken sind. Weil sie nach dem Motto „Zugang für alle" tatsächlich öffentlicher Raum im Sinne von gemeinsamer Raum sind. Und wie wir unsere öffentlichen Räume gestalten, bestimmt nun einmal, wie wir zusammenleben.

Als ich zurück in den Stadtteil zog, in dem ich aufgewachsen war, erlebte ich zum ersten Mal, dass jeder Stromkasten und jede Straßenecke in meinem Kopf in allen Zeiten gleichzeitig existierten. Geschäfte hatten zwei oder mehr Namen, und die Straßenlaternen flüsterten mir Geschichten in zischendem Gas zu. Der britische Autor Iain Sinclair bezeichnet das als Psychogeografie: die Erfahrung, dass der öffentliche Raum nicht einfach nur draußen ist, sondern die Erweiterung des eigenen Körpers, des Seelenraums, dessen, was ich in Ermangelung anderer Begriffe Heimat nenne. Die Philosophin bell hooks geht noch einen Schritt weiter: „Wahre Heimat ist der Ort – jeder Ort – an dem emotionales und intellektuelles Wachstum gefördert wird."[7] Das wäre doch mal ein Motto für den öffentlichen Raum.

1 Carolin Emcke, *Gegen den Hass*, S. Fischer Verlag, Frankfurt a. M., 2016, S. 98.
2 Vgl. Nadia Shehadeh, „arabisch oder nordafrikanisch aussehende Menschen™"; siehe online: https://shehadistan.com/2016/01/08/arabisch-und-nordafrikanisch-aussehende-menschen/ [23.03.2017].
3 Carolin Emcke 2016, S. 100.
4 Vgl. Dr. Dina Hummelsheim und Priv.-Doz. Dr. Dietrich Oberwittler, *Schützt soziale Sicherheit vor Kriminalitätsfurcht? Eine ländervergleichende Untersuchung zum Einfluss nationaler Wohlfahrtspolitiken auf kriminalitätsbezogene Unsicherheitsgefühle Max Planck Institut für ausländisches und internationales Strafrecht"*; siehe online: www.sifo-dialog.de/images/pdf/fachworkshop-sicherheitswahrnehmungen/workshop_sicherheit09_hummelsheim-1-.pdf [23.03.2016].
5 Vgl. Kwame Anthony Appiah, „Mistaken Identities", in: *The Reith Lectures*, BBC Radio 4; siehe online: www.bbc.co.uk/programmes/b081lkki [23.03.2017].
6 Sophie Roznblatt, „Sexuelle Aufklärung. Das Problem mit dem Penis", in: *DIE ZEIT*, 13.02.2017; siehe online: www.zeit.de/zeit-magazin/leben/2017–02/sexuelle-aufklaerung-fluechtlinge-deutschland [23.03.2017].
7 bell hooks, *Belonging. A Culture of Place*, Routledge, New York, 2009, S. 203.

Mithu Sanyal

Who Owns the Common Ground?

In September 2016 I went to Hamburg for an interview with Susanne Mayer from *DIE ZEIT* and author Margarete Stokowski. Hamburg's central railway station looked the same to me in every direction, so I asked a guard to point me to the main exit but he resolutely ignored me. Assuming he hadn't heard me, I repeated my question, at which point he snapped at me, 'I'm busy.' At this very moment, he was approached by two women who looked like the results of a Google image search for 'German woman', and he gave them detailed information about everything they wanted to know. Instead of then feeling embarrassed and giving me directions too, he turned on his heel and marched off.

My fantasy about this is that it had to do with the colour of my skin and with the blanket I had strapped to my rucksack, which made me look like the result of a Google search for 'refugee woman'. Maybe his reaction had nothing to do with racism at all. Maybe his girlfriend had left him that morning and I happened to be the spitting image of her. Who's to know? All I know is that this encounter fundamentally changed my relationship with the station. It transformed me from a person who belonged to this promising throng of people into … no, not a disruptive element—he didn't have that kind of power—but into someone without that magical social skin that allows us to be part of a crowd and to be ourselves at the same time: invulnerable, because any injury we suffer is at once an injury to the community. I instinctively took a step back from the tracks, just for safety.

What happened to me in Hamburg happened a few months later to around a thousand young men at Cologne's main station: they were explicitly given separate treatment from that given to people with a different phenotype. It was the New Year's Eve after *the* New Year's Eve in Cologne. Fearful that the assaults from the previous year might be repeated, the police had cordoned off the station apart from two exits and *selected* the carnival-goers: the good guys got the green light and were allowed onto the Domplatte, the area around the cathedral; the bad guys got kettled. And the 'bad' guys were of course the ones who had the misfortune to look like me, if I were a man, that is. This process used to be called face control and is now known as racial profiling. When the leader of the Greens, Simone Peter, asked whether this had been proportional, she got caught in a shitstorm. On her Facebook page she got comments from trolls like 'I'm dumbstruck at so much stupidity, naivety, and contempt for the state'—thus echoing *Bild,* who had run the online headline: 'Dumm, dümmer, GRÜFRI' (Dumb, dumber, GRÜFRI). GRÜFRI is an acronym for GRÜn-Fundamentalis-tisch-Realitätsfremde-Intensivschwätzerin (Green Fundamentalist Reality-averse Imbecile). It is always interesting when insults are so cryptic that they need translating. The result was that Peter was obliged to apologize.

There'd been another acronym, however, and that had come from the police themselves in their notorious New Year's Eve tweet: '#PolizeiNRW #Silvester2016 #SicherInKöln: Am HBF werden derzeit mehrere Hundert Nafris überprüft. Infos folgen.' (Several hundred Nafris are currently being checked at the main station. Information to follow.) The information that should have followed is that Nafri is a derogatory group label. Quite apart from this, the tweet was plain wrong: it wasn't several hundred Nafris who were controlled but rather

several hundred people with dark hair. It quickly emerged that the profilers had no idea who actually fitted their profile. The 'around two thousand North Africans' who were meant to have flooded into Cologne on New Year's Eve turned out to be Iraqis, Syrians… and Germans. But even if they had been Moroccans or Algerians, they still wouldn't have been Nafris. Not by a long chalk. Because it is not actually an abbreviation for North African but stands rather for North African serial offender (*Intensivtäter*). And to classify all the people who were checked as serial offenders shows that the police were not impartial but were in effect operating on the basis of prejudices. Peter was thus bringing up a thoroughly relevant point with her criticism. And it ought to be possible to air it in public. Because racial profiling—or even simply seeing people in a particular way, or considering them particularly dangerous, just because they look the way they look—is something that is by no means confined to the police. The very question asked by the *Süddeutsche Zeitung*—'Why did so many North Africans come to Cologne again for New Year's Eve?'—shows that this is not about *behaviour* but about *being*. Carolin Emcke, who was awarded the 2016 Peace Prize of the German Book Trade, writes, 'Anyone checked by the police for the first time without any apparent reason may find it uncomfortable, but he or she will put up with it without feeling aggrieved. But if you are accosted over and over again for no reason, if you have to keep showing your identity card, if you have to endure repeated physical checks, a random inconvenience turns into a systematic disease.'[1]

Whenever I look out of my window, I see bylaw enforcement officers from the Ordnungsamt stopping and searching a man with dark hair. Directly after the first New Year's Eve incident in Cologne, right at the start of January 2016, when the year was still young and as raw as an open wound, my husband and I questioned the guys from the Ordnungsamt about their actions. 'STEP BACK,' they snapped at us in capital letters. We stepped back. 'What are you doing with the man?' my husband asked and pointed to the slim Arab- or North African–looking man™, as my colleague Nadia Shehadeh has dubbed this newly created identity.[2] My husband raised his hand to point, and the officers immediately twisted it behind his back and secured it with a plastic handcuff. What was traumatic about this experience was not that he was charged—interestingly enough for the offence of not having shown his ID quickly enough to the officers (he explained that they would have to get it out of his trouser pocket themselves, as he couldn't reach it with his hands cuffed)—but that since then I don't go out any more when a group of uniformed men are checking a foreign-looking person.

Emcke continues: 'Over time, experiencing regular humiliations of this kind with depressing regularity brings on a melancholy familiar to anyone who walks the line between the invisible and the monstrous.'[3] Because this is a grand narrative of our day and age, that certain people represent a threat—out there, in the space that we all share, so that the reflex reaction to it is to want to remove them from this space. The public space is now as safe as it has ever been. The criminologist Sandra Bucerius has even presented a study that shows that immigration tends to lower the national crime rate. Why then do our fears grow in inverse proportion to this? The Max Planck Institute for Foreign and International Law explains this with the generalizing proposition that says, in a nutshell, that the more social anxieties, concerns about the future, and existential fears there are in a society, the more fear there is of criminality.[4] It is now much easier to imagine a person who steals something from you—money/living space/security—as a faceless state entity. And at this point in time we imagine this person to have dark hair and dark intentions. This is fed by the news and other narratives about Muslims as a threat to *our* values. However, it is unclear what exactly these values are. The call in the UK to teach British values in schools led to vague formulations like 'tolerance' and 'fairness' (as well as amusing suggestions like 'alcoholism' and 'the propensity to make fun of oneself'). Unfortunately, there has been a lack of tolerance and fairness in the debate. But this idea is nothing new. It is based on the notion that Western civilization was founded in antiquity by the Greeks and their knowledge was then passed on to the Romans and from them to the Europeans. Or put more concisely, 'From Plato to NATO'. Philosopher Kwame Anthony Appiah is critical of this theory,[5] because the snag is that this culture is shared by the Muslim world. The classical texts of antiquity on which our Renaissance is based would have been lost forever if they had not been translated into Arabic and preserved in the Arab world throughout the Middle Ages.

Who Owns the Common Ground?

But what about the women? What's the story with the women? Was it really so much safer for them on New Year's Eve 2016/17 because no dark-haired/dark-eyed/somehow-dark-looking people were walking about on the Domplatte? That would mean that only (or mainly) this group actually commit assaults, which is not borne out by police statistics. Nevertheless, New Year's Eve 2015/16 took place and there continue to be more groups of young men hanging around in public spaces—because they often have no other place to go—and bawling out dumb jibes at passing women and other men. In general, the response to this is to call for more surveillance cameras, which, as we know, don't hinder attacks but only displace them and also do something to people—to all people: surveillance causes us to police ourselves, to transform our loving view of ourselves into one that is mistrustful. Surveillance turns us from subjects of a community into objects.

As a contrast to this, Sophie Roznblatt in the German magazine *ZEIT* presents the best Best Practice Model that I have come across so far: education. She reports in a composed and genial manner on a sex education course that she offered for refugees (and others). In a special post box set up for the purpose, people can mail in questions, which she then answers once a month—unconditionally, regardless of whether they are about how your best friend's penis is two metres long and how come yours is so small, or whether masturbation can lead to excessive consumption of cucumbers. In the text she writes astute sentences like, 'Those who yell "Frau Fucky-Fucky" the loudest are usually the ones who are most ashamed later and will ultimately bring me flowers.'[6] That's how she creates common ground in the most literal sense. The English word 'commons' relates to interpersonal commonalities as well as to land that belongs to the community and is cultivated by commoners. The German translation is *Allmende*, from Middle High German *allgemeinde*. I actually wanted to call this text 'Mehr Allmenden' (More Commons), but commons have become so rare in this country that few people know what they are any more. Which is the reason why we need more of them. Luckily, the expression 'common ground' has now entered the German language. It denotes a model of communication in which participants cooperate with one another to achieve a common goal—that is, to understand others and be understood themselves. The discourse thus turns into a collective act in which new common knowledge is generated. It is therefore no accident that the other Best Practice Model is common or garden public libraries. Because, based on the idea of 'access for all', they are actually public space in the sense of common space. And how we design our public spaces determines how we live together.

When I moved back to the neighbourhood where I grew up, I experienced for the first time that every junction box and every street corner existed in my head in every moment simultaneously. Businesses had two or more names and the street lights whispered stories to me in hissing gas. British author Iain Sinclair calls this psychogeography: the experience that the public space is not simply outside but is an extension of our own bodies, of our psychic space, of what I call *Heimat* (home) for want of another term. The philosopher bell hooks goes a step further: 'A true home is the place—any place—where growth is nurtured.'[7] Now that would be a motto for the public space.

1 Carolin Emcke, *Gegen den Hass* (Frankfurt a. M.: S. Fischer, 2016), 98.
2 Nadia Shehadeh, 'Arabisch oder nordafrikanisch aussehende Menschen™', *Shehadistan*
 <https://shehadistan.com/2016/01/08/arabisch-und-nordafrikanisch-aussehende-menschen/> accessed 23 March 2017
3 Emcke, *Gegen den Hass* (see n. 1), 100.
4 See Dr Dina Hummelsheim and Dr. Dietrich Oberwittler, 'Schützt soziale Sicherheit vor Kriminalitätsfurcht? Eine ländervergleichende Untersuchung zum Einfluss nationaler Wohlfahrtspolitiken auf kriminalitätsbezogene Unsicherheitsgefühle', Max Planck Institut für ausländisches und internationales Strafrecht
 <www.sifo-dialog.de/images/pdf/fachworkshop-sicherheitswahrnehmungen/workshop_sicherheit09_hummelsheim-1-.pdf> accessed 23 March 2016
5 'Culture', part 4 of *Kwame Anthony Appiah: Mistaken Identities, The Reith Lectures* (BBC Radio 4, 12 November 2016) <www.bbc.co.uk/programmes/b081lkki> accessed 23 March 2017
6 Sophie Roznblatt, 'Sex Education: The Problem with the Penis', trans. Charles Hawley *ZEIT MAGAZIN*, 19 February 2017
 <http://www.zeit.de/zeit-magazin/leben/2017-02/sex-education-refugees-germany> accessed 23 March 2017
7 bell hooks, *Belonging: A Culture of Place* (New York: Routledge, 2009), 203.

Raluca Voinea Körper – noch immer von Bedeutung

Wir mögen staunen über neu entdeckte Planeten und uns vorstellen, Lichtjahre in Sekunden zurückzulegen. Wir kommunizieren vielleicht von Bildschirm zu Bildschirm über stetig flimmernde Wellen, und wir ersetzen unsere Organe durch immer raffiniertere technische Wunderwerke. Doch sind wir noch immer keinen Schritt weiter, gefangen in unseren gebrechlichen Körpern, wir altern mit ihnen, verfallen und sterben.

Wir sind *diese* Körper, die der Schwerkraft trotzen – paradoxerweise mithilfe von Schwermetallen –, an Staatsgrenzen aber aufgehalten und wie Wegwerfprodukte behandelt werden. Wir sind *diese* Körper, die geschmückt werden und im Scheinwerferlicht stehen – auf verschiedenen Bühnen, in gläsernen Büros und blitzblanken Aufzügen, auf den Laufstegen unseres Alltags, allnächtlich auf Tanzflächen, in schillernden Bars und in der digitalen Welt, in der täglich Milliarden Selfies gepostet werden.

Es sind unsere Körper, die, Robotern ähnlich, immer mehr arbeiten, obwohl uns die *echten* Roboter tatsächlich immer mehr eintönige Arbeiten abnehmen. Unsere Körper leben länger, und dennoch fürchten wir zugleich, dass uns die Zeit immer schneller davonläuft. Unsere Körper träumen davon, Bewusstsein auf virtuelle Foren auszulagern, und unterstehen zugleich dem ständigen Zwang, gesund, leistungsstark und glücklich zu sein – einfach nur um zu beweisen, dass sie ihren Platz in der Gesellschaft auch verdienen. Umgekehrt sind es auch unsere Körper – wenngleich das in unserer bequemen westlichen Welt seltener vorkommt –, die geschmuggelt und unsichtbar gemacht werden, die niedergeschlagen, gedemütigt, gequält, zerfetzt, vergessen, nicht beachtet werden. Vor allem aber, überall auf diesem Planeten, sind wir eben *diese* Körper, die zunehmend im täglichen Strom der umherirrenden, eilenden Körper untergehen.

Je mehr wir unseres kollektiven, globalen Leibs gewahr werden, desto eindrücklicher empfinden wir die Grenzen und die Präsenz des eigenen Körpers. Zugleich haben wir auch gelernt, dass wir uns diesen Grenzen nur stellen können, indem wir zur Handlungsmacht vereinter „Körper im Bunde", wie Judith Butler das in einem Aufsatz von 2011 nennt, zurückfinden.[1] Im Zusammenhang mit den gesellschaftlichen Umwälzungen des Arabischen Frühlings hat Butler gezeigt, dass die von den herrschenden Verhältnissen ausgeschlossenen Körper ihr Recht, in der Öffentlichkeit in Erscheinung zu treten, für sich beanspruchen müssen. Sie sind ausgeschlossen aus einer von diesen Verhältnissen selbst legitimierten Sphäre, deren Definition von Öffentlichkeit darauf beruht, dass bestimmte, von der Norm des Realen abweichende Kategorien darin keinen Platz haben. Sie müssen ihr Arendtsches „Recht, Rechte zu haben", einfordern und kraft vereinten Handelns und Sich-Verlautens die Materialität ihrer Präsenz behaupten, und zwar durchaus nicht nur als Mittel zu einem jeweiligen politischen Zweck, sondern mit dem Ziel, die Polis und ihre Öffentlichkeit neu zu definieren und dafür zunächst einmal, als unbedingte Voraussetzung, das eigene Überleben und Gedeihen zu sichern.

Seit 2011 haben wir miterlebt, wie sich Dutzende Plätze (im Frühling oder im tiefsten Winter) mit politischen Körpern füllten, die ihre Unsicherheit und Unsichtbarkeit überwanden und ihre Forderungen in einstimmigen Chören hinausriefen. Wir haben die langen Züge der

Flüchtlingskörper endlos über Felder und über Stacheldrahtzäune hinweggehen sehen. Und wir waren Zeug_innen, als Körper am Atmen gehindert und Menschenleben, die als nicht wichtig genug erachtet wurden, zum Schweigen gebracht wurden. Wir waren stolz, wenn kollektive Leiber einzelnen Körpern oder den Körpern der *Anderen* Zuflucht boten, und wir konnten anhand der Äußerungen eines einzelnen Körpers die Bedürfnisse und Wünsche ganzer Gemeinschaften verstehen lernen.

Durch jede Bewegung, die auf den Erfolgen und Fehlern vorangegangener aufbaute, mit jeder Aktion, die gleichzeitig weltweit stattfand, und jeder spezifisch lokalen Reaktion darauf, die zum leuchtenden Vorbild für andere werden konnte, haben wir eines gelernt: Wir können erst vom öffentlichen Raum sprechen, wenn wir das Recht jedes Körpers anerkennen, in diesem Raum zu existieren und präsent zu sein, sich als Teil dieses Raumes zu behaupten und ihn dadurch eigentlich erst zu dem zu machen, was er ist. All das mussten wir lernen, um mit der langen Tradition eines öffentlichen Raumes, der nur bestimmten Körpern Sichtbarkeit einräumt und eine Stimme verleiht, brechen zu können – nämlich immer dieselben weißen, gesunden, sauberen, männlichen, voll tauglichen Körper.

Als gemeinsame Manifestationen der Wut und der Sehnsucht nach Gerechtigkeit zeichnen sich solche Proteste genau wie die vom Ausdruck der Freude und Selbstaffirmation geprägten *Pride*-Paraden dadurch aus, dass sie den Raum zwischen den Körpern sichtbar machen. Sie vergegenwärtigen ein inneres Kräftespiel, schaffen Raum für Körper, für das Erscheinen jedes einzelnen Körpers in all seiner Zerbrechlichkeit und Eigentümlichkeit. Darin bilden diese Proteste den äußersten Gegensatz zu staatlich organisierten Aufmärschen und choreografierter Propaganda sowie zu den Versammlungen extremistischer Gruppen mit ihren einförmigen Rufen nach Gleichheit und Exklusion.

In der Kunst der vergangenen Jahrzehnte wurde der Körper in all seinen Funktionen wie Bewegungen benutzt und thematisiert: physisch und intellektuell, in Performances, Aktionen und Nicht-Aktionen, für Interventionen, in Kompositionen und Narrationen, als lebende Skulptur, im *tableau vivant* und anderen Spielarten der Live Art. Man konnte verschiedenen Körpern begegnen… dem berührenden und dem berührten Körper; dem Körper als Maßeinheit und dem Körper, der begafft wird; dem Körper, mit dem gemalt oder der selbst bemalt und tätowiert wird; dem schreienden, auslaufenden, blutbeschmierten, kriechenden, Wildfremde küssenden, grell nackten oder aufgetakelten, dem schönheitsoperativ veränderten, leistungsoptimierten, aggressiven oder aufdringlichen Körper. Dem Körper, der gegen Zensur aufbegehrt, und jener Unzahl von Körpern, die sich der Polizei entgegenstellen; dem Körper, der einen auf der Straße verfolgt oder einem den Weg versperrt; dem diskreten oder gespenstischen Körper, der sich in die Natur flüchtet oder hinter Schleiern verbirgt. In Käfigen zur Schau gestellten oder auf den Asphalt genagelten Körpern, und Körpern hoch oben auf Sockeln; Körpern, die Berge versetzen und anderen, die Ozeane beanspruchen; den Körpern von Künstler_innen oder diesen delegierten Körpern,[2] die ausharren oder zusammenbrechen, bezeugt von Tausenden oder keinem, fotografiert, gefilmt oder gar nicht dokumentiert. Yves Klein, Valie Export, Santiago Sierra, Carolee Schneemann, Petr Armyanovsky, das Invisible Theatre, Orlan, die Wiener Aktionisten, Jiři Kovanda, Sophie Calle, Dan Perjovschi, Abramović & Ulay, Rassim Krastev, Collective Actions, Guillermo Gómez-Peña und Coco Fusco, Petr Pavlensky, Antony Gormley, Francis Alÿs, Tania El Khoury – für jede der genannten Aktionen kann man sich seine eigene Liste aus Künstler_innen zusammenstellen.

Die Performance gehört traditionell zu den Kunstformen, die man am einfachsten aus der schützenden Hülle der Institutionen heraus in den öffentlichen Raum führen kann. Kaum eine ist provozierender und zugleich unauffälliger, verwundbarer und flüchtiger. Mittels ihrer wurde die gewaltige Regulierung des Körpers im öffentlichen Raum häufig verdeutlicht. Durch sie wurde uns vor Augen geführt, wie wenige unserer Handlungen tatsächlich legal sind und wie gefährlich und zugleich bedeutungslos wir für die Mechanismen der Macht sind – wie Normierung, Disziplinierung und Überwachung mit immer größerem Druck durchgesetzt werden. Gerade hierin beschreiben Performancekunst und die oben erwähnten gesellschaftlichen Bewegungen *Common Ground*: Beide beanspruchen den öffentlichen Raum als ein Terrain, das von unseren verschiedenartigen Körpern gemeinsam eingenommen und erzeugt, hinterfragt und umgestaltet werden muss. Beide sind in der Lage, dem

Raluca Voinea

starr einheitlichen Verständnis von Subjektivität zu begegnen und tatsächliche, konkrete Körper zum Beweis der unbezweifelbaren Existenz eines breiten Spektrums anderer, ebenfalls zu berücksichtigender, unverzichtbarer Subjektivitäten in den Vordergrund zu rücken. Die eindringliche Gegenwart des Körpers im öffentlichen Raum in Form von Demonstrationen und Krawallen ist ebenso wie die umfassende Rückkehr der Performance – und das Wiederaufleben östlicher spiritueller Praktiken – Symptom eines Zeitalters, in dem der Körper sowohl heftiger Aggression als auch radikalem Wandel in Richtung eines erweiterten Menschheitsbegriffs ausgesetzt ist. Indem man die Gefährdung des Körpers sowie sein Existenzrecht offenbart, wird man sich außerdem der Gewalt bewusst, die Menschen über andere ausüben. Es beginnt damit also ein Prozess, der von einfacher Identitätspolitik über horizontale Bewegungen hin zum Posthumanen in der optimistischen, affirmativen Bedeutung von Rosi Braidotti führt.[3] Sich von den Normen freizumachen, die dem gesellschaftlichen Konstrukt der „menschlichen Natur" zugrunde liegen, ist ein erster Schritt zum Aushebeln des Anthropozentrismus und zur Ausbildung einer „nomadischen Subjektivität", die das Bedürfnis nach Solidarität und Verbundenheit mit anderen, auch nichtmenschlichen Wesen anerkennt. Braidotti beschreibt drei Stadien dieser neuen post-humanen Subjektivität: Tier werden, Erde werden, Maschine werden. Sie wollen mehr als *nur* überleben, auch wenn sie davon bestimmt sind. Sie wollen überleben, um eines besseren, komplexeren, fantasievolleren Selbstes willen, dem es gelingt, sich einem nicht destruktiven Lebensentwurf zu verpflichten.

Performancekunst lenkt unsere Aufmerksamkeit auf die Unmittelbarkeit anderer und auf unser aller Nähe zueinander – uabhängig davon, ob sie unser direktes Mitwirken oder Nachdenken darüber einfordert, ob sie technologisch vermittelt ist oder auf Präsenz beruht. Sie verankert uns an einem bestimmten Ort und verknüpft uns zugleich mit unsichtbaren oder diffusen Netzwerken. Sie verkörpert Erinnerungen sowie Sehnsüchte, und sie erweitert die Grenzen dessen, was Körper tun und darstellen dürfen. Lange Zeit wurden Performances vor allem im Rahmen von Ausstellungen und Kunstereignissen ohne große Budgets realisiert, wohl aus der Überlegung heraus, dass *der* Körper ein billiges und leicht formbares Material darstelle.[4] In Osteuropa spielten Performances in den 1990er Jahren eine wichtige Rolle, als man sich neue Medien noch nicht leisten konnte, Malerei aber zu gestrig schien. Diese hatte sich bereits in den Jahren des Sozialismus als Form des Experimentierens bewährt – fernab von offizieller Kunst und Zensur. Da Performances darauf angewiesen sind, dokumentiert und bezeugt zu werden, sind sie keineswegs selbstgenügsam, sondern hängen ab von der jeweiligen Institution, dem Wetter oder dem Publikum. Doch gerade aus ihrer Flüchtigkeit und Abhängigkeit beziehen sie ihr Potenzial als zeitgenössische künstlerische Ausdrucksform. Mehr als jedes andere Genre läuft Performancekunst Gefahr, zum Spektakel zu verkommen, Körper zu objektivieren oder gar zu konsumieren. Dennoch hat sie sich als widerstandsfähig erwiesen, kann nicht auf schmückendes Beiwerk, auf einen Programmpunkt reduziert werden, sondern vermag ausgesprochen scharf auf politische Umstände zu reagieren. Obgleich sie den traditionellen Daseinsformen des Menschen verpflichtet ist, hat sie das Potenzial – in ihrer Prozesshaftigkeit und Aufmerksamkeitsökonomie – uns in eine posthumane Zukunft zu führen. Sie ist prädestiniert dazu (im Bereich der bildenden Kunst und kraft ihrer Öffentlichkeit), mit Braidotti gesprochen, uns daran zu erinnern: „Wir durchleben diese Zeiten gemeinsam und sind dennoch verschieden."

1 Judith Butler, „Bodies in Alliance and the Politics of the Street", Europäisches Institut für Progressive Kulturpolitik, September 2011; siehe online: http://eipcp.net/transversal/1011/butler/en [20.04.2017].
2 Claire Bishop, „Delegated Performance: Outsourcing Authenticity", *October* 140, Frühling 2012, CUNY Academic Works; siehe online: http://academicworks.cuny.edu/gc_pubs/45 [20.04.2017].
3 Rosi Braidotti, *The Posthuman*, Polity Press, Oxford, 2013.
4 Inzwischen haben sich viele Künstler_innen im Bereich der Performance, darunter auch einige sehr bekannte wie Alexandra Pirici und Xavier Le Roy, die eher von der Choreografie oder aus dem Theater als aus der bildenden Kunst kommen, von der Selbstausbeutung und Selbstgefährdung verabschiedet und sind zu einem anderen Verständnis ihrer Arbeit gelangt. Sie haben auch zu einem anderen Arbeitspensum und Umgang mit den Kräften ihrer Körper gefunden. Das hat umgekehrt dazu geführt, dass sie in Ausstellungen einen größeren Stellenwert einnehmen (statt wie früher nur im Anhang oder als Eröffnungsunterhaltung aufzutreten), außerdem zu neuen Leitlinien für den Ankauf von Performancekunst (und sogar eigenen Ausstellungsräumen nur für die Live Art).

Raluca Voinea Bodies Still Matter

While we may gaze at new planets being discovered and imagine travelling light years in seconds, communicate with each other through screens and fluctuating waves, or replace our organs with ever more sophisticated pieces of technology, we are still in the same very old place where our bodies remain frail throughout our lives, only to age, decay, and die.

We are those bodies that defy gravity—paradoxically, with the help of heavy metals—but are then stopped at borders and treated as disposable. We are the bodies that are embellished and spotlighted on various stages, catwalks of the everyday, with glass offices and shining elevators, of the every-night, with dance platforms and clinking bars, and of the digital, with billions of selfies per second sent out into the world.

It is our bodies too that are working more and more like robots, despite real robots taking over endlessly repetitive tasks; our bodies are living longer, despite our anxiety over time flowing faster; they dream of transferring consciousness to virtual platforms, while faced with the constant imperative to be healthy, fit, and happy, simply to prove themselves worthy of a place in society. Conversely—though this is more seldom in the comfort of our Western world—we are also bodies that are trafficked and made invisible, that are knocked down, humiliated, tormented, smashed to pieces, forgotten, never taken into account. Most of all, across the planet, we are those bodies that are disappearing in the daily swarm of bodies rushing from one point to another.

The more aware we learn to be of our collective, global body, the more acute our sentience of the limits and presence of our own body becomes. At the same time, we have also learned that the only way to confront these limits is by returning to the power of bodies that come together, of bodies-in-alliance, as Judith Butler terms them. In an essay from 2011,[1] reflecting on the social upheavals of the Arab Spring, she underlines the need for the bodies usually barred from the sphere legitimated by the powers that be (a sphere whose definition as public is based on excluding certain categories that do not fit the norms of 'realness' set 'by those who seek to monopolize the terms of reality') to reclaim their right to appear in public, their Arendtian 'right to have rights', and, through their coming and acting and voicing together, to make the materiality of their presence not only the means of achieving a political objective but also an end in itself, for which their own survival is essential in order to redefine the polis and its publicness.

Since 2011 we have seen dozens of other squares (in spring or in the depths of winter) filled with political bodies that have decided to step out of their precariousness and invisibility and chant their claims as one voice; we have seen the long lines of refugee bodies walking vondlessly through fields and crossing barbed-wire fences, and we have witnessed the silencing of bodies that can't breathe and of lives that don't matter. We took pride when collective bodies sheltered individual bodies or the bodies of *others*, and we have read beyond one particular body's statement to understand the

needs and desires of entire communities. What we have learned—with every movement building on the achievements and mistakes of previous ones, with actions happening simultaneously across the globe, and with very specific, local responses becoming iconic and inspirational—is that we cannot speak of a public space today unless we take into account the legitimacy of *every body* to exist and appear in it, to affirm itself as a part of this space, and to constitute it. We have learned all this in response to, and as a means of interrupting, the long tradition of a public space that accepts only certain bodies in its sphere of visibility and speech—always the same, white, sane, clean, male, straight, fully abled bodies.

These protests, as collective manifestations of anger and a desire for justice, and certain parades, with their expression of joy and affirmation, are also characterized by the way in which they make visible the space between bodies, the inner dynamics through which these bodies occupy the space, and the way in which they make place for the appearance of the individual body, in all its fragility and difference. They are in this respect at the opposite end of the spectrum from state-organized marches and choreographed propaganda festivities, and from the gatherings of extremist groups, in their uniformed calls for sameness and exclusion.

In the recent history of art, the body was used and addressed in all its functions and exercises, physical and intellectual, in performances, actions, non-actions, interventions, compositions, narrations, living sculptures, tableaux vivants, and other forms of live art. One could encounter the body that touches and is touched upon; that is a measuring unit and that is stared at; that is painted with and is painted or tattooed on; the screaming, leaking, bloodied, crawling, stranger-kissing, over-naked or over-dressed body; the aesthetically altered, enhanced, aggressive, or intrusive body; the body that confronts censorship and the endless number of bodies that confront the police; the body that stalks you in the street or blocks the way; the discreet or ghostly body that disappears into nature or hides under veils; bodies displayed in cages or nailed to the asphalt and bodies raised on plinths; bodies that move mountains and others that claim seas; the bodies of artists or delegated bodies,[2] enduring or falling down, witnessed by thousands of people or by none, photographed, filmed, or completely undocumented. Yves Klein, Valie Export, Santiago Sierra, Carolee Schneemann, Petr Armyanovsky, invisible theatre, Orlan, Viennese Actionists, Jiři Kovanda, Sophie Calle, Dan Perjovschi, Abramovic & Ulay, Rassim Krastev, Collective Actions, Guillermo Gómez-Peña and Coco Fusco, Petr Pavlensky, Antony Gormley, Francis Alÿs, Tania El Khoury—for each of these actions you can make your own list of artists.

Performance has traditionally been one of the easiest media to take out of the institutions' protective environment and insert in public space, one of the most provocative and most inconspicuous, most exposed and also most ephemeral. It has often underlined the excessive regulation of the body in public space; it has made us aware of how few of our actions are actually legal, how dangerous and at the same time unimportant we are for the mechanisms of power, how the enforcement of norms, disciplining, and surveillance are exercised with increasing pressure. And it is here that performance art finds itself on common ground with the social movements described above, as both are reclaiming public space as a territory to be shared and produced, questioned and reconfigured by our different bodies. Both have the capacity to challenge the unitary and rigid understanding of subjectivity and to foreground actual, physical bodies as proof of the unquestionable existence of this wide spectrum of other subjectivities that need to be taken into account and to become indispensable. The acute presence of the body in public space, through protests and riots, and the extensive return of performance art and of Eastern spiritual practices are symptoms of our current age, when the human body is subjected to both severe aggression and radical transformation towards an expanded notion of humanity. By exposing the body's precarity and its right to exist, one is also made aware of the violence exercised by humans upon other species. A process thus takes place, going from simple identity politics to transversal movements and to the posthuman, understood in the optimistic, affirmative sense in which Rosi Braidotti uses it.[3] Moving out-

Bodies Still Matter

side the norms that have defined the social construct of 'human nature' is a first step in dislocating anthropocentrism and creating a 'nomadic subjectivity', able to recognize the need for solidarity and interconnection with others, including the non-human. The three stances of this new, posthuman subjectivity (as described by Braidotti), becoming-animal, becoming-earth, and becoming-machine, aspire to more than mere survival and yet they are conditioned by it, by the survival of humanity's better, complex, and imaginative self, which is capable of committing to a non-destructive course. Performance art, whether it requires our participation or just our contemplation, whether mediated by technology or relying on presence, draws our attention to the immediacy of others and our proximity to one another. It embeds us in a particular locality, while connecting us to invisible or diffuse networks. It embodies memories and desires, and it stretches the limits of what bodies are allowed to do and to represent. For a long time, it was used in exhibitions and art events that did not have big budgets, which considered 'the body' to be a cheaper and more malleable material.[4] In Eastern Europe it was used extensively in the 1990s, when new media were still unaffordable and painting too obsolete (following the Socialist era, when it was used as a form of experimentation away from official art and the eye of the censors). Highly dependent on documentation and the memory of witnesses, performance is hardly self-sufficient; it mostly relies on context, be it institutional, meteorological, or audience-related. However, its very ephemerality and dependency are what make it so suitable for contemporary expressions. It has always been in danger of being spectacularized more than other artistic genres, of objectifying bodies and offering them for consumption, yet it is also adept at avoiding being turned into mere decoration and at responding to political urgencies. Although it may seem to be dedicated to traditional forms of humanity, performance—in its processuality and situatedness in an economy of attention to the other—also appears perfectly suited to the task of accustoming us to the posthuman future. It is one of the privileged forms (of art and of being public) whose job it is to remind us that, to quote Braidotti again, 'we are in this together but we are not all the same'.

1 Judith Butler, 'Bodies in Alliance and the Politics of the Street', *European Institute for Progressive Cultural Policies* (September 2011) <http://eipcp.net/transversal/1011/butler/en> accessed 9 March 2017
2 Claire Bishop, 'Delegated Performance: Outsourcing Authenticity', *October* 140 (Spring 2012). See *CUNY Academic Works* <http://academicworks.cuny.edu/gc_pubs/45> accessed 9 March 2017
3 Rosi Braidotti, *The Posthuman* (Oxford: Polity Press, 2013).
4 Today, many artists working with performance—some of the most prominent with a background in choreography and theatre rather than visual arts, among them Alexandra Pirici and Xavier Le Roy, who are participating in this edition of Skulptur Projekte Münster—have shifted from self-exploitation and self-precarization to a different understanding of their practice, their working hours, and the economy of the body, resulting in more central places in exhibitions (rather than that of appendices or accessories for the opening), new policies for acquiring performance works (even new wings of museums especially dedicated to live arts), and so on.

Inke Arns Freiheit in Zeiten der Mustererkennung

In den 1990er Jahren geisterte eine – nicht nur aus heutiger Sicht naive – Vorstellung durch die Weiten des Internet: Das Internet als Raum der Freiheit, den es gegen die Interessen feindlicher Mächte zu verteidigen gelte. John Perry Barlow, US-amerikanischer Autor, Mitbegründer der Electronic Frontier Foundation (EFF) und ehemaliges Mitglied der legendären Band The Grateful Dead, war einer derjenigen, der diese Forderung in seiner wütenden *Declaration of the Independence of Cyberspace* (1996) auf den Punkt brachte: „Regierungen der industriellen Welt, ihr müden Giganten aus Fleisch und Stahl, ich komme aus dem Cyberspace, der neuen Heimat des Geistes. Im Namen der Zukunft bitte ich euch, Vertreter einer vergangenen Zeit: Laßt uns in Ruhe! Wo wir uns versammeln, habt ihr keine Macht mehr."[1] Anlass für Barlows Unabhängigkeitserklärung war die Verabschiedung des Communications Decency Act – ein Versuch des US-amerikanischen Senates, Inhalte im Internet zu regulieren. Barlow erklärt in seinem Manifest das Internet zu einem Raum außerhalb der Souveränität der „Regierungen der industriellen Welt" und proklamiert die „Zivilisation des Geistes im Cyberspace".

Was Barlows Manifest verschweigt: Schon 1996 war das Internet kein Hafen der Freiheit – ein solcher ist es eigentlich noch nie gewesen. 1969 als ARPANET entstanden, diente es ursprünglich vor allem dem Time-Sharing zwischen Großrechnern, um die damals knappe, kostspielige Ressource Prozessor optimal auszulasten. Bezahlt wurde es von der Advanced Research Projects Agency (ARPA), die mit der Entstehung einer dezentralen Netzstruktur gleichzeitig dem Bedürfnis des US-amerikanischen Militärs nach Schaffung einer unverwundbaren Kommunikationsstruktur im Falle eines nuklearen Angriffes entsprechen konnte. Auch wenn in der akademischen beziehungsweise der wilden Grassroots-Phase des Internets in den 1980er und frühen 1990er Jahren dann utopische Vorstellungen hinsichtlich einer demokratischen Kommunikation (zum Beispiel in Form von Digitalen oder Internationalen Städten[2]) ins Kraut schossen – Regierungen, insbesondere die US-amerikanische, waren von Anfang an Teil des Internet.

War das ursprüngliche Internet textbasiert, begann es mit dem World Wide Web und seinen grafischen Oberflächen ab 1993 prinzipiell auch kommerziell interessant zu werden. Trotzdem brauchten das Web 2.0 und die sogenannten Sozialen Medien noch zehn Jahre, bis sie online gingen: Facebook startete im Jahr 2004, YouTube 2005 und Twitter 2006. In der Social-Media-losen Zwischenzeit (1993–2004) stellte sich die frühe Netz- beziehungsweise Softwarekunst mit ihrem scharfen analytischen Blick gegen die zunehmende Verdeckung der maßgeblichen (Macht-)Strukturen durch (grafische Benutzer-) Oberflächen. Ein gutes Beispiel ist der *WebStalker* (1997) von der Künstlergruppe I/O/D: Dieser Browser stellt die grafische Oberfläche einer Website als Text (HTML-Code) dar, während die Hyperlinks als Grafik visualisiert werden. Er kehrt quasi das Innerste des Webs nach außen, indem er Strukturen sichtbar macht, die normalerweise durch Software (herkömmliche Web-Browser) unsichtbar gemacht werden.[3]

393

Vor spätestens zehn Jahren bildete sich das Internet dann zu dem aus, was es heute ist. Einige wenige Konzerne betreiben Plattformen wie Facebook oder YouTube, die viele für öffentlichen Raum halten. Aber genau so, wie der physische öffentliche Raum in den Städten zunehmend privatisiert wurde (zum Beispiel im Form von Shopping Malls), so wurde auch die digitale Kommunikation privatisiert. Das bedeutet, dass das, was im öffentlichen Raum rechtlich möglich war, heute durch das Hausrecht außer Kraft gesetzt wird (beispielsweise durch das Demonstrations- und Versammlungsrecht). Auf Facebook bestimmt Mark Zuckerberg die Regeln, nicht irgendein gewähltes Parlament.

In den digitalen Medien, in denen sich viele von uns heute so selbstverständlich bewegen wie im öffentlichen Raum, ist außerdem der Begriff der Transparenz von zentraler, weil ambivalenter Bedeutung. Transparenz bedeutet im positiven Sinne Kontrollierbarkeit durch Einsehbarkeit – man denke etwa an Antikorruptionsorganisationen wie Transparency International, die das Wort im Namen führen. In der Informatik hat der Begriff jedoch eine andere Bedeutung: Hier steht Transparenz für das *Verstecken* oder *Unsichtbarmachen* von Informationen als Komplexitätsreduktion. Ist ein Interface transparent, bedeutet das, dass es für die Nutzer_innen nicht wahrnehmbar ist. Während dieses Verstecken von (überschüssigen, exzessiven) Informationen in vielen Fällen sinnvoll ist, kann es die Benutzer_innen jedoch auch in einer falschen Sicherheit wiegen, denn es suggeriert durch seine Unsichtbarkeit eine direkte Sicht auf etwas, eine durch nichts gestörte Transparenz, an die zu glauben natürlich Unsinn wäre.

In dem Maße, wie die uns umgebenden Strukturen transparent werden, wie die Maschinen, Computer, Algorithmen zum Teil unserer Umgebungen werden[4] und sich uns so entziehen, werden wir als Individuen durchleuchtet – und zwar im Sinne einer viel weitergehenden Durchschaubarkeit, als sie durch Videoüberwachung bislang möglich war. Big Data ist das neue Zauberwort. Riesige Datenmengen werden gespeichert, in denen sich dann mithilfe von Algorithmen Muster erkennen lassen. Besonders anschaulich wurde diese Art der digitalen Extrapolation am Beispiel der US-amerikanischen Supermarktkette Target, die im Jahr 2012 anhand des Kaufverhaltens einer Kundin auf deren Schwangerschaft schloss und ihr Werbung für Babykleidung und -ausstattung zuschickte. Peinlicherweise war die Kundin minderjährig, ging noch zur Schule, und der Vater der Schülerin war nicht sehr erfreut.[5] Das Verhalten der Firma verstößt nicht nur eklatant gegen das Recht auf informationelle Selbstbestimmung, sondern auch gegen den Grundsatz einer digitalen Ethik, der da lautet: „Öffentliche Daten nützen, private Daten schützen."[6]

Vor zehn bis 15 Jahren war die Digitalisierung noch kein breites Thema. Inzwischen hat sich die Situation grundlegend geändert: In allen Geräten, egal ob klein (zum Beispiel Smartphones) oder groß (zum Beispiel Autos) steckt Software. Schätzungen zufolge sind heute bereits fünfzig Milliarden Geräte miteinander verbunden – bei nur sechs Milliarden Menschen.[7] Unsere Umgebungen werden so zu Instrumenten permanenter Datenerhebung. Wir hinterlassen Spuren in diesen Umgebungen, die nur für deren Betreiber_innen lesbar sind. In diesem Sinne beschrieb Frank Schirrmacher das iPad als zynisches Gerät, einer Fernbedienung gleich, mittels dessen Apple über die Apps im Begriff ist, unsere bisherige Kultur digitaler Kommunikation tiefgreifend zu verändern. Um diesen Wandel zu beschreiben, wäre es zwingend, „dass die in Vodafonegoogleapple und sogar in Microsoft verliebte Teilwelt der deutschen Medien ihren Blick darauf richtet, dass Giganten entstehen, während sie immer noch von der Partizipation aller redet. Die Dimension der neuen Bewusstseinsindustrie ist noch kaum verstanden."[8]

Die Digitalisierung ist nicht nur ein kurzes Zwischenspiel an der Schwelle vom 20. zum 21. Jahrhundert, nach dessen Ende alles wieder so (analog) sein wird wie vorher. Die Digitalisierung bedeutet vielmehr einen tiefgreifenden und im besten Sinne des Wortes *radikalen*, also *an die Wurzel gehenden* Wandel in der Art und Weise, wie die Welt zu uns kommt und wir zur Welt – eben abhängig davon, welcher *contrat social* in Technologie eingeschrieben ist. Neue Technologien, digitale Medien und globale Vernetzung eröffnen eine Vielzahl an Möglichkeiten; gleichzeitig hat es wohl noch nie ein

so großes Potenzial für Schließungen und Kontrolle gegeben. Mustererkennung ist eine solche potenzielle Schließung. Plattformen schlagen Nutzer_innen auf der Grundlage von Big Data zum Beispiel Musik oder Bücher vor oder stellen News zusammen: Andere Kund_innen hörten auch diese Musik, andere Leser_innen kauften auch dieses und jenes Buch, andere Nutzer_innen lasen auch diese Nachricht. Mustererkennung zeigt uns immer mehr desgleichen – und sie führt zur Bildung einer Filterblase. Wir sehen und hören immer mehr desselben und vergessen darüber, dass es auch anderes gibt. Freiheit in Zeiten der Mustererkennung ist, in Abwandlung des Zitates von Rosa Luxemburg, immer die Freiheit zum statistisch Unwahrscheinlichen; Freiheit in Zeiten der Transparenz ist immer die Freiheit zur Opazität, Intransparenz und Unsichtbarkeit des Einzelnen. Auch wenn das aus einer zukünftigen Perspektive sicherlich naiv klingt.

1 John Perry Barlow, „Unabhängigkeitserklärung des Cyberspace", in: *Telepolis*, 29.02.1996; siehe online: www.heise.de/tp/features/Unabhaengigkeitserklaerung-des-Cyberspace-3410887.html [16.03.2017].
2 De digitale stad (DDS) hatte sich Anfang 1994 unter dem Slogan „access for all" (Zugang für alle, kurz: xs4all) in Amsterdam gegründet. Die Internationale Stadt (IS) war ein unabhängiger Berliner Internetprovider, der Ende 1994 aus der Künstlergruppe Handshake entstanden war und bis 1997 existierte. Vgl. Inke Arns, „Interaktion, Partizipation, Vernetzung: Kunst und Telekommunikation", in: Dieter Daniels und Rudolf Frieling (Hg.), *Medien Kunst Netz 1: Medienkunst im Überblick*, Springer, Wien, New York, 2004; siehe online: www.medienkunstnetz.de/themen/medienkunst_im_ueberblick/kommunikation/ [16.03.2017].
3 Vgl. online: https://anthology.rhizome.org/the-web-stalker oder die Originalseite http://bak.spc.org/iod/ [16.03.2017].
4 Vgl. Inke Arns und transmediale e. V. (Hg.), *alien matter*, transmediale, Berlin, 2017.
5 Kashmir Hill, „How Target Figured Out A Teen Girl Was Pregnant Before Her Father Did", in: *Forbes*, 16.02.2012; siehe online: www.forbes.com/sites/kashmirhill/2012/02/16/how-target-figured-out-a-teen-girl-was-pregnant-before-her-father-did/ [16.03.2017].
6 Achter Grundsatz der Hackerethik, in den 1980er Jahren formuliert durch Wau Holland und Steffen Werbery; siehe online: www.wauland.de/de/projekte/HackerEthik2.0.html [16.03.2017].
7 Vgl. Sabina Jeschke, „Wenn Roboter Steuern zahlen", in: Philipp Otto (Hg.), *Das Netz – Jahresrückblick 2015–16*, iRights.media, Berlin, 2015; siehe online: http://dasnetz.online/wenn-roboter-steuern-zahlen/ [16.03.2017].
8 Frank Schirrmacher, „Die Politik des iPad", in: *Frankfurter Allgemeine Zeitung*, 01.02.2010; siehe online: www.faz.net/aktuell/feuilleton/debatten/digitales-denken/apples-macht-die-politik-des-ipad-1229376.html [16.03.2017].

Inke Arns

Freedom in an Age of Pattern Recognition

In the 1990s an idea—one that was naive, and not only from our contemporary perspective—circulated through the expanses of the Internet: it saw this interconnected network as a space of freedom, which it was necessary to defend against the interests of hostile forces. US author John Perry Barlow, co-founder of the Electronic Frontier Foundation (EFF) and former member of the legendary band The Grateful Dead, was one of those who got to the heart of this challenge in his angry *Declaration of the Independence of Cyberspace* (1996): 'Governments of the Industrial World, you weary giants of flesh and steel, I come from Cyberspace, the new home of Mind. On behalf of the future, I ask you of the past to leave us alone. You are not welcome among us. You have no sovereignty where we gather.'[1]

Barlow's declaration of independence was occasioned by the passage of the Communications Decency Act—an attempt by the US Senate to regulate content on the Internet. In his manifesto Barlow described the Internet as a space outside the sovereignty of the 'Governments of the Industrial World' and proclaimed 'a civilization of the Mind in Cyberspace'.

What Barlow's manifesto fails to mention is that by 1996 the Internet had already ceased to be a haven of liberty—in fact, it had never been any such thing. When it first appeared in 1969 as ARPANET, the primary function it served was as a means of timesharing between mainframe computers so that optimal use could be made of the processor, a costly resource that was in short supply at the time. It was funded by the Advanced Research Projects Agency (ARPA), which, by creating a decentralized network, was able to satisfy the US military's need to establish an invulnerable communications structure in the event of a nuclear attack. Even if in the academic, or grassroots phase of the Internet in the 1980s and early 1990s utopian ideas about a democratic mode of communication (for example, in the form of digital and international cities[2]) were rife, governments—and the US administration, in particular—were part of the Internet from the start.

While the original Internet was text based, the World Wide Web and its graphical interfaces started, generally speaking, to make it commercially interesting from 1993 onwards. Nevertheless, it still took ten years for Web 2.0 and what came to be called social media to go online: Facebook was launched in 2004, YouTube in 2005, and Twitter in 2006. In the intervening, social-medialess period (1993–2004), the early Internet and software art with its sharp analytical eye opposed the increasing tendency to mask the prevailing (power) structures with (graphical user) interfaces. A good example here is *WebStalker* (1997) by the artist group I/O/D: this browser presents the graphical interface of a website as text (HTML code), while the hyperlinks are visualized as graphics. It turns the Web inside out, so to speak, by giving visible form to structures that software—in a conventional browser—normally renders invisible.[3]

Ten years ago, at the latest, the Internet developed into what it is today. A few corporate groups operate platforms like Facebook or YouTube, which many people think of

as public space. But in just the same way as the physical public space in cities has become increasingly privatized (for example, in the form of shopping malls), digital communication has also been privatized. This means that what was legally possible in the public realm is now invalidated by rights of access (for example, the right to protest and the right of assembly). On Facebook Mark Zuckerberg determines the rules, not some elected parliament.

In the realm of digital media in which many of us now move as naturally as in public space, the term transparency is also of key importance, precisely because it is ambiguous. Transparency in the positive sense means controllability through visibility—think, for example, of anti-corruption organizations like Transparency International, which includes the word in its name. However, in informatics the term has a different implication: here transparency means *hiding* information or rendering it *invisible* in the sense of reducing its complexity. If an interface is transparent, it means that it is not perceptible to the user. But while this concealment of (surplus, excessive) information makes sense in many cases, it can also lull users into a false sense of security, as this invisibility suggests that one has a direct view of something, an entirely undisrupted transparency—although believing in this would, of course, be folly.

Insofar as the structures that surround us are becoming transparent, and machines, computers, and algorithms are becoming part of our environment[4] and in the process turning into an elusive phenomenon, we as individuals are coming under examination—in the sense of being subject to a transparency that goes much further than was hitherto possible with video surveillance. Big Data is the new catchword. Huge quantities of data are stored and algorithms can then be used to recognize patterns in them. A very clear example of this kind of digital extrapolation was provided by the US supermarket chain Target, when in 2012 it concluded that a customer was pregnant based on her shopping behaviour and sent her advertising for baby clothing and accessories. Embarrassingly, it turned out that the customer was a minor and still at school, and the girl's father was none too pleased.[5] The company's behaviour was not only in blatant violation of the right to informational self-determination but also contravened one of the fundamental principles of digital ethics which says, 'Use public data, protect private data.'[6]

Ten to fifteen years ago, digitalization was still not a major issue. In the meantime the situation has fundamentally changed. All the equipment we use—both small (e.g. smartphones) and large (e.g. cars)—have software in them. It is estimated that today fifty billion devices are already connected to one another, in a global population of only six billion people.[7] Our environments have thus become instruments of permanent data collection. We leave traces in these environments that can only be read by the companies running them. With this in mind Frank Schirrmacher described the iPad as a cynical device, equivalent to a remote control, by means of which Apple can use its apps to radically change our present culture of digital communication. To map this change, it is imperative that 'the German media, which is so enamoured of Vodafonegoogleapple and indeed Microsoft, focuses on the fact that while they are still talking about universal participation, behemoths are being created. The dimensions of the new consciousness industry are still barely understood.'[8]

Digitalization is not only a brief interlude at the transition from the twentieth to the twenty-first century, after which things will go back to the way they used to be (i.e. analogue). Rather digitalization means far-reaching change—change that is *radical* in the best sense of the word, i.e. it *goes to the root*—in how the world comes to us and how we access the world, depending on what social contract is written into technology. New technologies, digital media, and global networking are opening up a multitude of possibilities; at the same time there has probably never been such a great potential for closure and control. Pattern recognition is one such potential source of closure. Platforms suggest things like music and books to users or compile news, all based on Big Data: other customers also listened to this music; other readers also bought this or that book; other users also read this news. Pattern recognition shows us more and more in the same vein—and it leads to the creation of a filter bubble. We see and hear

more and more of the same and forget that there is anything else out there. Freedom in an age of pattern recognition is, to paraphrase Rosa Luxemburg's words, always the freedom to be statistically improbable; freedom in an age of transparency is always the individual freedom to be opaque, non-transparent, and invisible. Even if that may sound naive from a future perspective.

1 John Perry Barlow, 'A Declaration of the Independence of Cyberspace', Electronic Frontier Foundation (8 February 1996) <https://www.eff.org/cyberspace-independence> accessed 28 March 2017

2 De digitale stad (DDS) was founded in Amsterdam in early 1994 with the slogan 'access for all' (xs4all for short). The Internationale Stadt (International City Federation—IS) was an independent Internet provider in Berlin that was originated by the artist group Handshake in the latter part of 1994 and was in existence until 1997. See Inke Arns, 'Interaction, Participation, Networking: Art and Telecommunication', in Dieter Daniels and Rudolf Frieling (eds.), Media Art Net 1: Survey of Media Art (Vienna: Springer, 2004). Also available online: 'Overview of Media Art', Medien Kunst Netz | Media Art Net <http://www.medienkunstnetz.de/themes/overview_of_media_art/communication/> accessed 16 March 2017

3 See 'The Web Stalker', Rhizome (16 February 2017) <https://anthology.rhizome.org/the-web-stalker> or the original site, 'Software is mind control—get some', I/O/D <http://bak.spc.org/iod/> accessed 28 March 2017

4 See Inke Arns and transmediale (eds.), Alien Matter (Berlin: transmediale, 2017).

5 Kashmir Hill, 'How Target Figured Out a Teen Girl Was Pregnant Before Her Father Did', Forbes (16 February 2012) <www.forbes.com/sites/kashmir-hill/2012/02/16/how-target-figured-out-a-teen-girl-was-pregnant-before-her-father-did/> accessed 16 March 2017

6 'Öffentliche Daten nützen, private Daten schützen': the eighth principle of the hacker ethics formulated in the 1980s by Wau Holland and Steffen Werbery. See 'Die bisherige Hackerethik', Wau Holland Stiftung <www.wauland.de/de/projekte/HackerEthik2.0.html> accessed 16 March 2017

7 See Sabina Jeschke, 'Wenn Roboter Steuern zahlen', in Philipp Otto (ed.), Das Netz 2015/2016: Jahresrückblick Netzpolitik (Berlin: iRights.media, 2015). Also available online: Das Netz (10 December 2015) <http://dasnetz.online/wenn-roboter-steuern-zahlen/> accessed 16 March 2017

8 Frank Schirrmacher, 'Die Politik des iPad', Frankfurter Allgemeine Zeitung (1 February 2010) <www.faz.net/aktuell/feuilleton/debatten/digitales-denken/apples-macht-die-politik-des-ipad-1229376.html> accessed 16 March 2017

Angelika Schnell Der „polyvalente" öffentliche Raum

Einen „polyvalenten" Raum nannte Jean Baudrillard einst das Innere des Centre national d'art et de culture Georges-Pompidou im vierten Arrondissement von Paris. Und er meinte es nicht positiv. Dass der Raum so offen und *mehrdeutig* ist, dass unklar ist, wie, wann und von wem er genutzt werden kann oder nicht, schien ihn gerade bei einem öffentlichen Kulturbau zu stören. Hier werden die Widersprüche einer spät-kapitalistischen Gesellschaft offenbar, die sich mit dem Centre Pompidou ein „mobiles, vertauschbares Äußeres, cool und modern", aber zugleich „ein über den alten Werten verkrampftes Inneres" gegeben hatte.[1]

Heute, im Jahr 2017, feiert das Centre Pompidou seinen vierzigsten Geburtstag – und die Skulptur Projekte finden zum fünften Mal statt. Und man möchte die These auf-stellen, dass es gerade dieses Freilegen und Austragen jener Probleme und Wider-sprüche ist, von denen Baudrillard spricht, die das Centre Pompidou als tatsächlich offenes Kulturzentrum – offen für jede Art von kulturellem Ereignis, aber auch für gesellschaftspolitische Anliegen –, zu jener „fröhlichen Stadtmaschine" gemacht haben, als die es von seinen Architekten Renzo Piano und Richard Rogers einst be-zeichnet wurde. In den ersten Jahren war es vor allem die ästhetische Rhetorik seiner scheinbar industriell hergestellten Konstruktion, die zugleich als Bestätigung sowie als Kritik der sich zunehmend abzeichnenden transnationalen neoliberalen wirtschaft-lichen Prozesse erschien, die nicht nur Baudrillard zu seiner galligen Kritik brachte. Sanford Kwinter verweist in seinem Rückblick auf das Centre Pompidou auf die nicht immer leicht zu sehende Verflechtung von gesellschaftspolitischen mit ästhetischen Fragen, die in öffentlichen Projekten, in öffentlichen Räumen besondere Signifikanz entfalten können.[2] Deshalb ist der vielleicht wichtigste Beitrag des Centre Pompidou die aktive Bewerkstelligung eines Begriffs von öffentlichem Raum, wie er davor nicht existiert hat. Als Alternative zum herkömmlichen weißen Galerieraum und zum eli-tären Kunstbetrieb hat der polyvalente Innenraum des Centre Pompidou nicht den Kunsttempel, sondern die Fabrikhalle zum Vorbild, ermöglicht durch eine konsequente Umkehrung von Innen und Außen. Alles, was sich sonst im Inneren des Gebäudes befindet – Erschließung, Installation, Tragwerk – wurde nach außen verlegt, um einen großen stützenfreien Innenraum für vielfältige Aktivitäten zu schaffen, mit der Folge, dass der Innenraum polyvalent und tatsächlich schwierig zu nutzen war und ist – jeder „seiner Inhalte ein Wider-Sinn", wie Baudrillard ätzt, weil die „topische Unterschei-dung von Innen und Außen nicht mehr einzusetzen ist".[3] Was Baudrillard aber nicht sehen will, ist, dass auch der Außenraum des Centre Pompidou polyvalent geworden ist, weil sich auch hier Innen und Außen sowie *privat* und *öffentlich* überschneiden. Die Fassade aus transparenten Rolltreppen, bunten Röhren und Stahlstäben ist weni-ger Kulisse als vielmehr eine offene vertikale Bühne. Dazu gehört auch der große ge-neigte Platz vor dem Gebäude, der aufgrund der Tatsache, dass das, was sonst innen ist, nun außen zu sehen ist, zugleich zum Innenraum sowie zum Foyer des ganzen Baukomplexes wird. Sobald man den Platz betritt, ist man bereits *im* Centre Pompidou,

ohne dass man Eintritt hätte zahlen müssen; niederschwelliger und zugleich großzügiger kann man den Eingang in ein öffentliches Kulturzentrum kaum machen. Heute machen verschärfte Sicherheitsvorkehrungen überall in Paris diese Niederschwelligkeit zunichte, aber vor gut vierzig Jahren gab es eine Zeit, wo neue Verbindungen zwischen öffentlichem Raum und Kunst zugelassen wurden,[4] aus denen auch Initiativen wie die Skulptur Projekte in Münster hervorgegangen sind. Was freilich in der Folge auf die Kunstszene große Wirkung entfaltet hat, gilt jedoch kaum für die Architektur. Erstaunen muss, dass das Centre Pompidou und sein Beitrag zum Museumsbau und zum öffentlichen Raum kaum Einfluss auf die Architektur- und Städtebaudebatte der folgenden Jahre und Jahrzehnte genommen haben. Im Gegenteil. Zur selben Zeit, da es errichtet wurde, segelte die Architektur bereits unter der Flagge der Postmoderne und erträumte sich einen öffentlichen Raum, der sich viel eher an der geschlossenen Stadtmorphologie der Piazza San Marco in Venedig orientierte. Diese Bewegung war international, ist jedoch in der Bundesrepublik Deutschland auf besonders fruchtbaren Boden gefallen, weil in der Zeit der Nachkriegsmoderne in den Städten trotz vieler Kriegszerstörungen ohne Skrupel historische Bauten und Stadtkomplexe durch Neubauten ersetzt wurden. Was als verständliche und sinnvolle ästhetische Kritik begann, endete nicht selten in zu idealistischen Vorstellungen von Stadt und öffentlichem Raum, die die Widersprüche der Gesellschaft, auch der vergangenen, auf deren Zeit man sich berief, zumeist ausblendeten. Der Architektursoziologe Werner Sewing hat dieser „am öffentlichen Raum fixierten Stadtphänomenologie" immer wieder vorgeworfen, dass ihr „ein politischer und gesellschaftlicher Begriff von Stadt" fehle.[5] Stattdessen orientierte sie sich an der vermeintlichen Klarheit der Blockrandbebauung des 19. Jahrhunderts, mit dem Argument, dass diese die alte bürgerliche Trennung zwischen öffentlich (Straße und Platz) und privat (Haus) wieder herstelle. Diese naive Formel, nach der draußen gleich öffentlich und drinnen gleich privat bedeute, führe nach Sewing zu einem „Stadttheater" aus bloßen Kulissen, das den politischen öffentlichen Raum missverstehe, denn für diesen sei „der Zugang zu den Medien […] viel wesentlicher als der Zugang zum Bahnhofsvorplatz." Zudem wurde politische Öffentlichkeit auch im 19. Jahrhundert nicht auf der Straße hergestellt, sondern „in halbprivaten Szenen, in Salons, auf Empfängen und Veranstaltungen, die einen Zugang zu den Entscheidungszentren eröffnen".[6] Der öffentliche Raum ist nicht nur selbst polyvalent, vielmehr gibt es verschiedene öffentliche Räume, die sich überlagern und überschneiden können, die sich teils widersprechen und die – wie der Philosoph Vilém Flusser in zahlreichen Publikationen analysiert hat – auch selbst die Sphäre des Privaten durchdringen können.[7]

Der polyvalente öffentliche Raum definiert sich aber nicht nur durch die Verflechtung von physisch-ästhetischen mit politischen Phänomenen. Heute gilt für jedes öffentliche Bau- und Kulturvorhaben, was sich bei der Errichtung des Centre Pompidou in den 1970er Jahren erst abzuzeichnen begann: die „systematische Unterordnung des sozialen und kulturellen Kapitals unter die Rationalität der Geldwirtschaft".[8] Kein Museumsbau, keine Ausstellung in Europa, wo nicht irgendwo das obligatorische „Sponsored by" verschämt bis offen angebracht ist, den Bankrott der öffentlichen Hand bestätigend. Umgekehrt befleißigen sich die sich selbst Stadtmanager_innen nennenden politischen Vertreter_innen zunehmend, jedes größere öffentliche Kunstereignis, seien es die Skulptur Projekte, die Venedig-Biennale, die documenta, für ihr sogenanntes Stadtmarketing zu vereinnahmen. Aber ist damit auch der öffentliche Raum in der Krise, wie es inzwischen vielfach behauptet wird?

Hannah Arendt hat in ihrem politischen Hauptwerk *Vita activa* die These vertreten, dass der Einbruch des Ökonomischen in den Bereich des politischen öffentlichen Raums typisch für die Neuzeit ist. Die radikale Unterscheidung zwischen öffentlichen und privaten Räumen galt für die antike Polis. Dort standen sich die Polis, der Stadt-Staat und seine öffentlichen Einrichtungen, wo freie politische Entscheidungen getroffen wurden, dem Oikos, dem privaten Haus, wo die „Notwendigkeiten" des Lebens verwaltet wurden, gegenüber. In der Neuzeit, so Arendt, tritt noch ein zusätzliches Phänomen auf, nämlich die Gesellschaft, welche ein „merkwürdiges Zwischenreich"

zwischen öffentlich und privat darstellt, weil dort zum einen sich die Politik die Ökonomie und die private Hauswirtschaft erobert und zum anderen private Interessen und Notwendigkeiten in die Öffentlichkeit getragen werden.[9] Wenn zum Beispiel jemand der Musik im neuen Konzerthaus der Elbphilharmonie lauscht, die Aussicht von der Plaza auf den Hamburger Welthafen genießt oder durch die Straßen der Stadt flaniert und sich in den Auslagen der Schaufenster verliert, dann bewegen sich diese neuzeitlichen Individuen – so müsste man mit Arendt sagen – weniger im öffentlichen Raum als vielmehr im Raum der Gesellschaft. Ein Raum, in dem die Gesellschaft die soziale Interaktion erprobt und dabei auch – anders als in der antiken Polis – private Angelegenheiten austauscht (zu denen auch große Teile der Geldwirtschaft gehören), aber auch ein Raum, in dem politische Handlungen möglich sind. Für Architektur und Kunst, die sich für und in diesem „merkwürdigen Zwischenreich", dem polyvalenten öffentlichen Raum, engagieren wollen, bedeutet das gleichwohl, die Polyvalenz nicht zu unterdrücken, sondern sie sichtbar und erlebbar zu machen.

1 Jean Baudrillard, „Der Beaubourg-Effekt. Implosion und Dissuasion", in: ders., *Kool Killer*, Merve Verlag, Berlin, 1978, S. 59–82.
2 Sanford Kwinter, „Beaubourg, or the Planes of Immanence", in: ders., Requiem for the City at the End of the Millennium, Actar, Barcelona, New York, o. J.
3 Baudrillard 1978, S. 66.
4 Eine der bekanntesten kritischen öffentlichen künstlerischen Interventionen an der Baustelle des Centre Pompidou war Gordon Matta-Clarks *Conical Intersect* von 1975, bei der der Künstler zwei kegelförmige Öffnungen schräg durch zwei Altbauten geschnitten hat, die für den Bau des Centre Pompidou zum Abriss freigegeben waren.
5 Viele seiner Aufsätze zielen besonders auf die Berliner Architektur- und Stadtbaupolitik, die es nicht geschafft hat, nach der Wende einen prononcierten Begriff von städtischer Öffentlichkeit zu etablieren.
6 Werner Sewing, „Über das Verschwinden der Öffentlichkeit aus dem städtischen Raum", Gespräch mit Peter Neitzke, in: Peter Neitzke, Reinhart Wustlich und Carl Steckeweh (Hg.), *CENTRUM Jahrbuch Architektur und Stadt 2001.2002*, Verlag Das Beispiel, Darmstadt, 2002, S. 86–89.
7 Ein amerikanischer Präsident, der per Twitter mit seinen Followern direkt kommuniziert, ohne sich um die anderen Repräsentant_innen des demokratischen Systems – vor allem die Judikative – auch nur zu scheren, ist nur die vorläufig letzte Stufe dieser Entwicklung.
8 Kwinter, S. 17.
9 Hannah Arendt, *Vita activa, oder: Vom tätigen Leben* (The Human Condition, University of Chicago Press 1958), Piper, München, Zürich, 1999 (1981), S. 45.

Angelika Schnell The 'Polyvalent' Public Space

Jean Baudrillard once spoke of the interior of the Pompidou Centre in Paris's 4th arrondissement as a 'polyvalent' space. And he didn't mean it in a positive way. The fact that the space—particularly a public building devoted to culture—should be so open and *ambiguous*, the fact that it's not clear how, when, and by whom it can or can't be used, seemed to trouble him. What becomes evident here are the paradoxes of a late-capitalist society that gave the Pompidou Centre its 'mobile exterior, commuting, cool and modern' but at the same time 'an interior shriveled by the same old values'.[1] This year, in 2017, both the Skulptur Projekte and the Pompidou Centre are celebrating their fortieth birthdays. And we're tempted to postulate that it is precisely this readiness to expose and work through the problems and paradoxes cited by Baudrillard that has turned the Pompidou Centre—as a culture centre truly open to every kind of cultural event as well as to sociopolitical issues—into the 'joyful urban machine' its architects Renzo Piano and Richard Rogers once referred to it as. In its initial years, what prompted the caustic criticism of Baudrillard and others was, more than anything, the aesthetic rhetoric of its seemingly industrial construction, which appeared as both a confirmation and a criticism of increasingly evident transnational neo-liberal economic processes.

In his retrospect of the Pompidou Centre, Sanford Kwinter calls attention to the often rather subtle intertwinement of sociopolitical and aesthetic questions that can take on particular significance in public projects in the public space.[2] The Pompidou Centre's most important contribution may therefore be that it actively effected a previously non-existent conception of public space. As an alternative to the traditional white gallery space and the elitist art scene, the polyvalent interior of the Pompidou Centre takes its orientation not from the art temple but from the factory hall in that it systematically inverts inside and outside. Everything otherwise found in a building's interior—circulation, installation, supporting structure—was moved to the outside to create a large open interior, uninterrupted by pillars and capable of accommodating a wide range of activities. The consequence was an interior that was and is polyvalent and, as it happens, difficult to utilize. As Baudrillard grumbles, 'The question: "What should have been placed in Beaubourg?" is absurd because the topical distinction between interior and exterior should no longer be posed.'[3] What he refuses to acknowledge, however, is that the space surrounding the Pompidou Centre has likewise become polyvalent because, there as well, interior and exterior as well as *private* and *public* overlap. The façade of transparent escalators, colourful ducts, and steel poles is less a backdrop than an open vertical stage that also encompasses the large inclined square in front of the building. The fact that what is otherwise on the inside is now seen on the outside renders that exterior space an interior, a foyer for the entire building complex. As soon as you enter the square, you're already *in* the Pompidou Centre, without even having had to pay admission. As an entrance to a public cultural centre it could hardly be more accessible or more generous.

The heightened security precautions in effect throughout Paris these days have done away with that easy accessibility. A good forty years ago, however, there was a time when new connections between public space and art were allowed,[4] and gave rise—among other things—to initiatives such as the Skulptur Projekte in Münster. Yet even if that phenomenon came to have a major impact on the art scene, it hardly caused a ripple in architecture. As astonishing as it may seem, the Pompidou Centre and its contribution to museum construction and public space scarcely made itself felt in the architecture and urban-planning debates of the following years and decades. On the contrary, by the time it was built, architecture was already sailing under the 'post-modernism' flag and envisaging a public space far closer in character to the self-contained urban morphology of the Piazza San Marco in Venice. This movement was international but fell on particularly fertile soil in the Federal Republic of Germany. That was because, in the era of post-war modernism, there were no scruples about replacing historical buildings and entire urban complexes with new construction—even though so much had already been destroyed during the war.

What began as understandable and sensible aesthetic criticism frequently ended in drastically over-idealized conceptions of the city and public space, usually failing to take into account the contradictions of society—including those of the past eras that were seen as exemplary. The architectural sociologist Werner Sewing considered this state of affairs an 'urban phenomenology fixated on the public space', and repeatedly accused it of lacking 'a political and social concept of the city'.[5] For orientation, it looked instead to the supposed clarity of a nineteenth-century urban fabric consisting of perimeter blocks, arguing that this approach would restore the old bourgeois separation of public (street and square) and private (house). In Sewing's view, this naive formula, which equates the outdoors with the public and the indoors with the private, leads to an 'urban theatre' of mere stage settings that misunderstands the political public space because, for this space, 'access to the media … is far more essential than access to the station square.' And, he argues, even in the nineteenth century, political publicness was not created on the street, but 'in semi-private milieus, in salons, at receptions and events that provided access to the decision-making centres.'[6] Not only is the public space itself polyvalent but there are different public spaces that can overlap and intersect, that contradict one another to an extent, and that—as analysed by the philosopher Vilém Flusser in his numerous publications—can even penetrate the private sphere.[7]

Yet the polyvalent public space defines itself not only by the intertwinement of physical-aesthetic and political phenomena. Today, every public building and cultural project is subject to a process that was only just emerging when the Pompidou Centre was under construction in the 1970s: the 'systematic subsumption of social and cultural capital by financial rationality'.[8] There's no museum building or exhibition in Europe where the obligatory 'sponsored by' isn't posted somewhere—now more bashfully, now more openly—declaring the bankruptcy of the public sector. Conversely, political representatives calling themselves 'city managers' have taken to co-opting every major public art event—from the Skulptur Projekte to the Venice Biennale to the documenta—for their so-called city marketing activities. But does that mean the public space is in a crisis, as is now so frequently claimed?

In her political magnum opus *The Human Condition*, Hannah Arendt argues that the invasion of the political public space by the economical is typical of the modern age. The radical segregation of public and private spaces applied only to the ancient *polis*. There the *polis*—the city-state and its public institutions, where free political decisions were made—distinguished itself from the *oikos*, the private house where the 'necessities' of life were managed. In the modern era, Arendt points out, a new phenomenon has emerged, namely society, which represents a 'curiously hybrid realm' between public and private because in it, on the one hand, economics—and thus private house-keeping—becomes a political issue, and, on the other, private interests and necessities are carried into the public realm.[9] When, for example, a person listens to music in the new Elbphilharmonie concert hall, enjoys the view of Hamburg harbour from its Plaza,

or saunters along the city streets and becomes absorbed in the shop window displays, this latter-day individual—to follow Arendt's train of thought—is moving not so much in the public space as in the space of society. It is a space where society practises social interaction while at the same time—unlike the ancient *polis*—exchanging private matters (which include a major proportion of the money economy), as well as a space in which political action is possible. For architecture and art, actively involved in and committed to this 'curiously hybrid realm'—the polyvalent public space—this nevertheless means not repressing its polyvalence but making that quality perceivable with all the senses.

1 Jean Baudrillard, 'The Beaubourg Effect: Implosion and Deterrence', in Steve Redhead (ed.), *The Jean Baudrillard Reader* (Edinburgh: Edinburgh University Press, 2008), 57−70.
2 Sanford Kwinter, 'Beaubourg, or the Planes of Immanence', in *Requiem for the City at the End of the Millennium* (Barcelona: Actar, 2010).
3 Baudrillard, 'The Beaubourg Effect' (see n. 1), 61.
4 One of the best-known critical public art interventions at the Pompidou Centre construction site was Gordon Matta Clark's *Conical Intersect* of 1975, for which the artist cut two conical openings diagonally through two old buildings that were slated for demolition to make way for the centre.
5 Werner Sewing, 'Über das Verschwinden der Öffentlichkeit aus dem städtischen Raum', conversation with Peter Neitzke, in Peter Neitzke, Reinhart Wustlich, and Carl Steckeweh (eds.), *Centrum: Jahrbuch Architektur und Stadt 2001/2002* (Darmstadt: Verlag Das Beispiel, 2002), 86−89. Many of Sewing's essays take aim at the architectural and urban-planning policies of Berlin which, after German reunification, did not succeed in establishing a pronounced concept of urban publicness.
6 Ibid.
7 An American president who communicates directly with his followers on Twitter without bothering in the least about the other representatives of the democratic system—especially the judiciary—merely represents the latest stage in this development.
8 Kwinter, 'Beaubourg, or the Planes of Immanence' (see n. 2), 17.
9 Hannah Arendt, *The Human Condition* (Chicago, IL: University of Chicago Press, 1958), 35.

Angelika Schnell

Gerhard Vinken

Skulpturen im Stadtraum: das Ende der Dialektik

Die vor über vierzig Jahren geborene Idee, moderne Skulpturen in Münster auszustellen oder vielmehr sie in situ erarbeiten zu lassen, versprach Störung und Kontrast, Kritik und Aufbruch. Entsprechend groß war die Begeisterung – und noch größer die Ablehnung. Man kann also sagen, es funktionierte gut. Was da gut funktionierte, war eine Kunst, die sich seit den 1960er Jahren und der Minimal Art oft als ortsspezifisch definierte und ihre Interventionen als kritisch verstand. In Münster arbeiteten die eingeladenen Künstler_innen von Anfang an ortsbezogen, alle zehn Jahre intervenieren sie mit den Mitteln der Kunst an einem von ihnen ausgewählten Ort; Kunstobjekt und öffentlicher Stadtraum sind so im Rezeptionsprozess eng aufeinander bezogen. Insofern lohnt es sich, den Blick von den Objekten auf die Räume der Stadt zu richten. Hier lassen sich in den vergangenen Jahrzehnten Veränderungen nachzeichnen, die die Konstellation Kunst/Stadtraum neu definieren. Es ist nicht so, dass sich Münster, stadträumlich gesehen, in diesen Dekaden dramatisch gewandelt hätte. Münster war und ist eine Stadt, die in ihrem Zentrum zuverlässig das viel beschworene Modell der europäischen Stadt aufruft: dicht, zentriert, bestimmt von Korridorstraßen und eng umbauten Plätzen, insgesamt von mittelständisch-vorindustrieller Anmutung. Was sich geändert hat, ist die Besetzung und Bewertung dieser Räume und das Verhältnis der Gesellschaft zum *Historischen* und damit auch zum Projekt der Moderne, mit seinem avantgardistischen, anti-traditionellen Impetus.

Moderne Skulptur in Münster, das war ein dialektisches Vorhaben. Es brachte nicht nur Positionen und Konzepte in das *schwarze* Münster, wie sie zur selben Zeit auch im *roten* Kassel vorgestellt wurden; seine geschlossenen traditionellen Stadträume ließen das Innovations- und Aufbruchspotenzial der Kunst auch als einen gesellschaftlichen Gegenentwurf voll zur Entfaltung kommen. Die *traditionsbezogen* wiederaufgebaute Stadt mit ihrem Prinzipalmarkt und umrundet von der Promenade entlang der ehemaligen Stadtbefestigungsgrenzen bot dem kritischen Potenzial der Kunst eine zuverlässige Kontrastfolie. Anders Kassel mit seinen modernistischen und oft anti-urbanen Wiederaufbaukonzepten, wo heterogene und vielfach gebrochene Stadträume moderne Erfahrungen der Entfremdung, der Ortlosigkeit und des Verlustes gleichermaßen zu reflektieren schienen. In Münster musste jede zeitgenössische Intervention nicht nur als Bruch und Aufbruch wirken, sondern auch als ein Implantat, als ein kritisches Gegenmodell. Heute ist der Status der Ausstellung fast unumstritten. Sie ist für die Stadt ein wichtiges Marketingelement. Vom Schandfleck zum Event, von der Provokation zum Konsum, von der Kritik zur Affirmation? Die dialektische Konzeption der Moderne (und der modernen Kunst) scheint an ein Ende gekommen.

Es ist tatsächlich eine dialektische Konstellation, die die Stadt und die Rezeption ihrer Räume für zwei Jahrhunderte geprägt hat. Die Stoßrichtung modernistischer Stadtprojekte richtet sich gegen die alte Stadt, die als hässlich, ungesund, eng empfunden wird. Schon der barocke Städtebau mit seinen geometrischen Stadterweiterungen und der regelmäßigen *Neuordnung* der mittelalterlichen Zentren erfolgte im Namen

von Fortschritt und Ordnung. Erst recht der radikale Stadtumbau von Paris unter Baron Haussmann schneidet den Stadtkörper für Licht und Luft, für Kontrolle und Ordnung auf – mit einem Wort für *modernité*. In einer Gegenbewegung zu einer Moderne, die zunehmend auch als Entfremdung und Zerstörung empfunden wird, wird das Alte und das historisch Gewachsene, werden *Vieux Paris* und Alt-Wien zu Chiffren von Heimat, zu Seelengefäßen, wird Altstadt zum identitätsstiftenden Ort schlechthin.[1] Im 20. Jahrhundert spitzt sich der dialektische Kontrast Altstadt/*modernité* zu. Auf der einen Seite die funktionalistischen *fordistischen* Stadtutopien: Le Corbusier zeigt von seiner „Zeitgenössische Stadt" (1922) bis zur „industriellen Bandstadt" (1935), wo die Reise hingehen soll. Auf der anderen Seite wird die gute alte Zeit endgültig in der Altstadt heimisch: als ein erfolgreiches Produkt der Tourismusindustrie, wie in Rothenburg ob der Tauber, Alt-Nürnberg et cetera. Die hier mehr hergestellten als bewahrten Heimatinseln lassen sich durchaus auch als Orte des Widerstands und der Modernekritik lesen, jenseits deren enger Grenzen der Zeitgeist herrscht und sich als Zerstörer hergebrachter Stadt- und Lebensräume profiliert. Sogar die Kriegszerstörung und Auslöschung vieler deutscher Städte wird von den meisten Planer_innen als eine einzigartige Chance begriffen. Der Wiederaufbau wird zumeist – und hier war Münster eine bemerkenswerte Ausnahme – als Auftrag genutzt, der *Moderne* zu ihrem Recht zu verhelfen. Die durchgrünte und aufgelockerte Stadt als das herrschende Leitbild ließ suburbane Einöden entstehen, deren Unwirtlichkeit und Entfremdung alsbald beklagt werden sollten.[2]

Die Exzesse des modernen Städtebaus mit seiner einseitigen Ausrichtung auf technische Modernisierung, auf Infrastruktur und Verkehr, haben in den 1960er Jahren eine Renaissance der historischen Stadt eingeleitet.[3] Zuerst gingen die Bürger_innen in New York auf die Straße, um ihre Stadt vor den zerstörerischen Großplanungen zu retten: Im Rahmen einer verkehrstechnischen Modernisierung und *Slum-Clearance* sollte eine Stadtautobahn durch Greenwich Village getrieben werden und die heterogene Vielfalt der gewachsenen Bebauung monotonen Großblocks weichen. Jane Jacobs hat die heterogene Lebendigkeit und die Lebensqualität der historisch gewachsenen *Neighbourhoods* eindrücklich in die Debatte um die Stadt und das Städtische zurückgebracht.[4] Eine kritische Bürgergesellschaft trat dem kapitalistisch-technoiden Staat und seinen lebensfeindlichen Planungen zunehmend selbstbewusst entgegen. In den 1970er Jahren fand auch in Deutschland eine Wiederaneignung innerstädtischer Quartiere durch die Bürger_innen statt. Davon zeugen neue Veranstaltungsformen wie Straßenfeste oder Flohmärkte. In Hannover, einer Stadt, die programmatisch *verkehrsgerecht* und im Bruch zur Tradition aufgebaut worden war, wurde 1970 im Zuge der Bemühungen um eine städtische *Revitalisierung* das erste Altstadtfest veranstaltet, begleitet von einem Straßenkunstprogramm. 1975 wurde hier zugleich der erste Flohmarkt in Deutschland abgehalten, und zwar bezeichnenderweise vor der historischen Stadtmauer und rund um die feministisch-bunten *Nanas* von Niki de Saint Phalle, die erst im Jahr zuvor aufgestellt worden waren. Für einen Moment leuchtet hier eine neue Utopie auf, in der eine emanzipationswillige Bürgergesellschaft Traditionsbewusstsein und Weltoffenheit nicht mehr als Gegensatz begreift. Dieser heute schon nostalgische Moment der bundesrepublikanischen Protestkultur findet sein Emblem in der Versöhnung von öffentlichem Stadtraum und moderner Kunst.

Diese Konstellation ist Geschichte. Die Altstädte sind nicht mehr bürgergesellschaftliche Rückzugsorte und Gegenbilder zu einer technoiden Planungskultur. Architektur und Immobilienindustrie haben sich das Thema auf eine Art zu eigen gemacht, die nicht vorhersehbar war. Zunächst hat eine postmodern gestimmte Theorie einen Wechsel in Bezug auf die gewachsene Stadt eingeleitet und begleitet. Nach der Verengung der Architektur auf funktionalistische Ziele sollte die Stadt wieder Lebensraum sein, und das Gewachsene und Bestehende Ausgangspunkt für ortsspezifische Planung. Stichworte wie Stadtreparatur, „behutsame Stadterneuerung" und „kritische Rekonstruktion", wie sie die von Joseph Kleihues geleitete IBA Berlin (1977–87) ausgab,[5] ließen auf eine Versöhnung von Moderne und Tradition hoffen. Doch schlug das Pendel bald in eine andere Richtung aus: hin zu der ganz unkritischen Rekonst-

Gerhard Vinken

ruktion historischer Bauwerke und ganzer Plätze, wie zuerst in Hildesheim oder Frankfurt am Main. Inzwischen ist das *Historische* ein erfolgreicher Brand auf dem Immobiliensektor geworden. Überall leisten sich Städte jetzt *historische* Viertel: von Dresden (Neumarkt) bis Potsdam (Alter Markt), von Frankfurt am Main (Dom-Römer-Quartier) bis Lübeck (Gründerviertel).[6]

Diese Projekte werden oft als wie Wiedergutmachung oder verspäteter Wiederaufbau verkauft, sie fügen sich jedoch ein in eine internationale Strömung historischer Themenarchitektur. Erfolgreich war diese Themenarchitektur, die die Ästhetik kleinstädtisch-vorindustrieller Stadträume reaktivierte, vor allem auf dem gehobenen Immobiliensektor, etwa mit Seaside in Florida, das bezeichnenderweise auch als Kulisse für den Film *The Truman Show* diente, sowie mit der von der Disney Company errichteten Stadt Celebration. Das vielleicht spektakulärste Beispiel in Europa ist Poundbury bei Dorchester, eine großflächige Vorstadtsiedlung in gediegen-altenglischen Formen.[7]

Als eine Art *Citytainment*[8] werden heute altstädtische Wohlfühlviertel geschaffen, mit vorindustriell-kleinstädtischem Flair, überschaubaren Ausmaßen und Dimensionen, vertrauten Angeboten; aufgerüstet mit nostalgischen Architekturklonen, die sich praktischerweise bruchlos in die renditestarke, saubere, heimelige Welt einfügen. Altstadt wird hier vollends zum Produkt, ein jederzeit und überall aufrufbares Architekturpattern, das bestimmte Stimmungswerte reproduziert, hoch konsensfähig scheint und erfolgreich vermarktet werden kann.

Was macht, was kann die Kunst in diesen altstädtischen Konsum- und Wohlfühlräumen? Der Schritt der Skulptur Projekte nach Marl scheint aus dieser Perspektive fast zwangsläufig. Mit ihren am Reißbrett entstandenen Räumen kündet Marl von den Selbstgewissheiten und der Utopiefähigkeit einer Moderne, die in ihrem Verblassen durchaus nostalgische Züge zeigt. War einst der mit Bedeutung übervolle Raum der Altstadt eine dichte Folie, vor der eine ortsspezifisch und kritisch arbeitende Kunst ihre utopischen Potenziale entwickeln konnte, könnte Marl mit seinen bedeutungsarmen Funktionsräumen neue Reibungsflächen entfalten helfen.

1 Siehe Gerhard Vinken, *Zone Heimat. Altstadt im modernen Städtebau*, Deutscher Kunstverlag, München, Berlin 2010.
2 Siehe Alexander Mitscherlich, „Die Unwirtlichkeit unserer Städte" (1965), in: Alexander Mitscherlich, *Die Unwirtlichkeit unserer Städte. Anstiftung zum Unfrieden*, Suhrkamp Verlag, Frankfurt a. M., 2008.
3 Siehe Gerhard Vinken, „Escaping Modernity? Civic Protest, the Preservation Movement and the Reinvention of the Old Town in Germany since the 1960s", in: Martin Baumeister, Bruno Bonomo und Dieter Schott (Hg.), *Cities Contested. Urban Politics, Heritage, and Social Movements in Italy and West Germany in the 1970s*, Campus Verlag, Frankfurt a. M., 2017, S. 169–191.
4 Siehe Jane Jacobs, *The Death and Life of Great American Cities*, Random House, New York, 1961.
5 Siehe Bauausstellung Berlin GmbH (Hg.), *Internationale Bauausstellung Berlin 1987, Projektübersicht*, Offizieller Katalog Berlin 1987.
6 Siehe Gerhard Vinken, „Im Namen der Altstadt. Stadtplanung zwischen Modernisierung und Identitätspolitik. Einführung in eine wechselhafte Geschichte", in: Carmen M. Enss und Gerhard Vinken (Hg.), *Produkt Altstadt. Historische Stadtzentren in Städtebau und Denkmalpflege*, Bielefeld 2016, 9–26.
7 Siehe HRH Prince of Wales, *A Vision of Britain. A Personal View of Architecture*, Doubleday, 1989 .
8 Siehe Dieter Hassenpflug, „Citytainment oder die Zukunft des öffentlichen Raums", in: Dirk Matejovski (Hg.), *Metropolen, Laboratorien der Moderne*, Campus Verlag, Frankfurt a. M., New York 2000, S. 308–320.

Gerhard Vinken Sculpture in the Urban Space: The End of Dialectics

The idea that was born more than forty years ago of exhibiting modern sculptures in Münster—or rather of having them developed in situ—promised disturbance and contrast, a critical stance and new departure. There was great enthusiasm to match, and even greater hostility. So one might say it worked—the 'it' being an art that, since the 1960s and the emergence of Minimal Art, has often been defined as site-specific, an art that saw its interventions as critique. In Münster, the artists invited to participate have always produced site-specific work: every ten years, they use art to intervene in places they choose themselves. As a result, the art object and the public urban space are closely interrelated in the reception process.

In view of this, it is a worthwhile exercise to shift our focus from the objects themselves to the city's spaces. Over the past decades, we can detect changes in these spaces that have redefined the art–urban space constellation. It is not that the Münster cityscape has undergone dramatic changes during that time. Münster was and is a municipality whose centre authentically invokes the much-vaunted model of the European city: dense, centred, dominated by streets laid out like corridors and squares tightly enclosed on all sides by buildings, characterized overall by the aura of a medium-sized pre-industrial town. What has changed is what or who occupies these spaces and what value is assigned them, as well as society's relationship to the *historical* and thus also to the modernist project with its anti-traditional, avant-gardist impetus.

The idea of putting modern sculpture in Münster was a dialectical undertaking. It did not merely bring to *black* (that is, centre-right-governed) Münster positions and concepts of the kind being presented at the same time in *red* (centre-left-governed) Kassel; its traditional, self-contained urban spaces also provided a setting in which art's potential to innovate and break new ground could be realized to the fullest as an alternative social concept. The city's reconstruction had been carried out with *tradition* as its main reference point: its historic marketplace, the Prinzipalmarkt, had been restored, and the town centre encircled by a promenade along the former fortification boundaries. As such it offered a sure foil for the critical potential of art. Not so in Kassel, with its modernist and often anti-urban reconstruction concepts, where heterogeneous and multiply fractured urban spaces seemed to reflect the modern experience of alienation, disorientation, and loss to equal degrees. In Münster, any contemporary intervention inevitably came across not only as a break with the past and a new departure into the future but also as an implant, a critical counter-model. Today the exhibition's status is virtually undisputed and an important marketing tool for the city. From eyesore to event, from provocation to consumption, from critique to affirmation? The dialectical conception of modernism (and modern art) appears to have come to an end.

It is indeed a dialectical constellation that has shaped the city and the reception of its spaces for two centuries. The main thrust of modernist urban projects was directed against the Old Town areas, which were considered ugly, unhealthy, and claustro-

phobic. Baroque-era urban planning, with its geometric town expansions and regularized *reorganization* of medieval city centres, had been carried out in the name of progress and order. Above all, the radical restructuring of Paris under Baron Haussmann cut open the city's body to introduce light and air, control and order, or, in a word, *modernité*. Meanwhile, however, in a counter-movement to a modernism increasingly considered alienating and destructive, the old parts of town which had evolved historically—*Vieux Paris* and *Alt-Wien*—became cyphers for homeland, vessels of the soul. Old Towns became the quintessential places for conferring a sense of identity.[1]

The dialectical contrast between Old Town and *modernité* came to a head in the twentieth century. On the one hand, there were the functionalist *Fordist* urban utopias. Le Corbusier pointed the way, from his 'Contemporary City' (1922) to his 'linear industrial city' (1935). On the other hand, the good old days found a home in the Old Towns once and for all: as a successful product of the tourism industry, for example in Rothenburg ob der Tauber, Old Nuremberg, etc. These little pockets of 'home'—more constructed than preserved—can certainly also be understood as sites of resistance to and a critique of modernism, as islands beyond whose confines the zeitgeist marches on, leaving its mark as a destroyer of traditional urban spaces and habitats. In fact, the majority of urban planners even went so far as to conceive of the ravages of war and the obliteration of many German cities as a golden opportunity. In most cases—and in this respect Münster was a notable exception—reconstruction was understood as a mandate to see justice done to modernism. The prevailing principle of the generously greened and de-densified town led to the emergence of suburban wastelands, whose inhospitable and alienating character was soon to be lamented.[2]

In the 1960s, the excesses of modern urban planning, with its one-sided concentration on technical modernization, infrastructure, and traffic, ushered in a renaissance of the historical city.[3] The people of New York were the first to take to the streets in a bid to save their city from destructive urban development projects. As part of a traffic modernization and slum clearance plan, an urban motorway was to cut straight through Greenwich Village, and the heterogeneous diversity of districts that had evolved over centuries was to make way for huge, monotone apartment blocks. Jane Jacobs made a convincing case for reintroducing the heterogeneous vitality and liveability of 'neighborhoods' with their patterns of historical development into the debate over the city and urban culture.[4] With growing self-confidence, a critical civil society stood up to the technology-enamoured capitalist state and its pernicious development projects. In the 1970s, inner-city districts were also reappropriated by citizens in different parts of Germany. New forms of event such as street festivals and flea markets testify to this trend. In Hanover—a city that had broken entirely with tradition and systematically reconstructed itself around the needs of traffic—the first Old Town festival, complete with a street art programme, was organized in 1970 in the context of efforts towards urban *revitalization*. And it was also there that, in 1975, Germany's first flea market was held—set, revealingly, against the backdrop of the *historical* town wall and around Niki de Saint Phalle's colourful feminist Nana sculptures, which had been installed just the previous year. A new utopia flashed briefly into view, in which a civil society striving towards emancipation no longer saw cosmopolitanism and a consciousness of tradition as opposites. Now preserved as a nostalgic memory, this instance of West German protest culture is symbolized by the reconciliation of public urban space and modern art.

That constellation is history. The Old Towns no longer serve as refuges for civil society and counter-models to a technology-oriented planning culture. Architecture and the property industry have appropriated the issues in a way that could not have been foreseen. To begin with, a postmodernist-tempered theory introduced and accompanied a shift with regard to the historical city. After a period in which architecture had been confined to functionalist goals, the city was now once again to be a living space, and what remained of its past was to serve as a point of departure for site-specific

planning. Terms such as urban repair, 'cautious urban renewal', and 'critical reconstruction', as propagated by the International Building Exhibition (IBA) Berlin (1977–1987) under the direction of Joseph Kleihues,[5] nurtured hopes of a reconciliation of modernism and tradition. Soon, however, the pendulum swung in a different direction: to the entirely uncritical reconstruction of historical buildings and whole squares, with Hildesheim and Frankfurt among the earliest examples. The historical has accordingly taken on the character of a successful brand in the property sector. Cities everywhere are treating themselves to historic districts: from Dresden (Neumarkt) to Potsdam (Alter Markt) and from Frankfurt am Main (Dom-Römer-Quartier) to Lübeck (Gründerviertel).[6]

These projects are often billed as a form of compensation or belated reconstruction; actually, however, they are quite in keeping with an international current of historically themed architecture. With its capacity to reactivate the aesthetic of small-town pre-industrial urban spaces, architecture of this genre has been very successful at the luxury end of the property sector, as seen, for instance, in Seaside, Florida, which tellingly formed the setting for the film *The Truman Show*, or in Celebration, a city put up by the Disney Company. Poundbury near Dorchester, a large suburban development in tasteful Olde English style, is perhaps the most spectacular example in Europe.[7]

A kind of *citytainment*[8] industry is now creating entire Old Towns as feel-good districts with pre-industrial small-town atmosphere, manageable dimensions, and familiar goods and services on offer, as well as an assortment of nostalgic architectural clones conveniently designed to fit in seamlessly with the clean, cosy, high-yield surroundings.

What does art do—what can it do—in these consumption-oriented feel-good spaces replete with Old Town flair? From this perspective, the Skulptur Projekte's expansion to Marl seems virtually inevitable. Its spaces conceived on the drawing board, Marl bears witness to the self-assurance and utopian aspirations of a modernism that has taken on a nostalgic quality as its freshness fades. Münster's Old Town area with all its overbrimming significance once formed a dense background against which critically oriented site-specific art could develop its utopian potentials. By contrast, Marl's functional spaces are almost bereft of meaning, and this may prove to be a new source of productive friction.

1 See Gerhard Vinken, *Zone Heimat: Altstadt im modernen Städtebau* (Munich and Berlin: Deutscher Kunstverlag, 2010).
2 See Alexander Mitscherlich, 'Die Unwirtlichkeit unserer Städte' (1965), in *Die Unwirtlichkeit unserer Städte: Anstiftung zum Unfrieden* (Frankfurt a. M.: Suhrkamp Verlag, 2008).
3 See Gerhard Vinken, 'Escaping Modernity' Civic Protest, the Preservation Movement and the Reinvention of the Old Town in Germany since the 1960s', in Martin Baumeister, Bruno Bonomo, and Dieter Schott (eds.), *Cities Contested: Urban Politics, Heritage, and Social Movements in Italy and West Germany in the 1970s* (Frankfurt am Main: Campus Verlag, 2017), 169–91.
4 See Jane Jacobs, *The Death and Life of Great American Cities* (New York: Random House, 1961).
5 See Bauausstellung Berlin GmbH (ed.), *Internationale Bauausstellung Berlin 1987: Project Report*, official catalogue (Berlin: Bauausstellung Berlin, 1987).
6 See Gerhard Vinken, 'Im Namen der Altstadt: Stadtplanung zwischen Modernisierung und Identitätspolitik; Einführung in eine wechselhafte Geschichte', in Carmen M. Enss and Gerhard Vinken (eds.), *Produkt Altstadt: Historische Stadtzentren in Städtebau und Denkmalpflege* (Bielefeld: transcript, 2016), 9–26.
7 See HRH Prince of Wales, *A Vision of Britain: A Personal View of Architecture* (London: Doubleday, 1989).
8 See Dieter Hassenpflug, 'Citytainment oder die Zukunft des öffentlichen Raums', in Dirk Matejovski (ed.), *Metropolen: Laboratorien der Moderne* (Frankfurt a. M.: Campus Verlag, 2000), 308–20.

Claire Doherty
Hier war ich doch schon mal!
Öffentliche Kunst und öffentliche Zeit

Alle zehn Jahre finden, wie in diesem Sommer, drei der wichtigsten europäischen Kunstereignisse parallel statt. Das ist (zumindest für diejenigen, die im Bereich der zeitgenössischen Kunst arbeiten) ein Anlass, sich neu zu orientieren – neue Begegnungen an vertrauten Orten, durch Augen, die bereits viel gesehen haben, vor dem Hintergrund geopolitischer Veränderungen, wie sie ein Jahrzehnt unweigerlich mit sich bringt. Während Kassel und Venedig alle fünf beziehungsweise zwei Jahre eine Plattform bieten, globale Belange künstlerisch neu zu verhandeln, betrachtet die kleine Stadt Münster das Weltgeschehen eher wie unter einem Brennglas: teils Wiedersehen, teils Déjà-vu, markieren die Skulptur Projekte das Fortschreiten der Zeit – in Münster sowie für unser eigenes Leben.

Ein zeitbezogener Kontext ist in den Künsten sicherlich nicht mehr ungewöhnlich. Die meisten Institutionen haben erkannt, wie wichtig es für den eigenen gesellschaftlichen Stellenwert ist, ortsspezifische Geschichte beziehungsweise Geschichten zu sammeln und festzuhalten. Traditionell wird *Dauer* in Bezug auf Kunst im öffentlichen Raum mit der materiellen Langlebigkeit eines Kunstwerkes – in seiner endgültigen Form an einem spezifischen Ort – in Verbindung gebracht. In den vergangenen Jahren hat sich dies allerdings zugunsten der Vorstellung, dass sich ein Kunstwerk im öffentlichen Raum allmählich mit der Zeit entfalten kann, gewandelt. Den Künstler_innen kommt dabei die Rolle der charismatischen Akteur_innen zu, die das Projekt initiieren, das Potenzial der Arbeit aufzeigen, ein Werk innerhalb der Zeit, in der das Projekt seinen Lauf nimmt, erlebbar machen und Unvorhergesehenem Raum geben.[1] Zu beobachten ist seit einigen Jahren außerdem ein expliziter Umgang mit Zeit als grundlegendem Material bei der Realisierung von Kunst im öffentlichen Raum. Dabei dient ein bestimmter Zeitabschnitt als konzeptuelle Struktur eines Werkes, das darauf angelegt ist, sich über einen längeren Zeitraum hinweg zu entwickeln. So kündigte Sophie Calle vor Kurzem eine auf 25 Jahre angelegte Arbeit auf dem Green-Wood Cemetery in Brooklyn an; Mark Storor sieht für sein Projekt *Baa Baa Baric: Have You Any Pull? A Quiet Revolution* im britischen St. Helens zwölf Jahre vor, Katie Patersons *Future Library* in Oslo sogar hundert Jahre. Dies sind Beispiele für ein Verständnis von Zeit beziehungsweise Dauer als künstlerisches Mittel, um das Mitwirken der Öffentlichkeit an einem Kunstwerk über Jahre und Generationen hinweg zu ermöglichen und das Werk in verschiedene gesellschaftliche Kontexte zu stellen. Die Arbeit kann aufgrund der zeitlichen Ausdehnung nicht in ihrer Gesamtheit wahrgenommen werden (darin kommt auch eine bewusste Abkehr von der Idee der Langzeit-Performance zur Geltung, indem hier die Künstler_innen ausdrücklich den Mitwirkenden und Besucher_innen einen Teil der Verantwortung zuweisen).[2] In Münster sprengen Maria Nordman mit *De Civitate* und Jeremy Deller mit *Speak to the Earth and It Will Tell You* den zeitlichen Rahmen der Skulptur Projekte; ihre Arbeiten werden erst im Laufe der Jahre im Münsteraner Alltag wirksam.

Bleibt zu fragen, wie dieses *Dehnen* der Zeit – dieses Sich-Entfalten von Akteur_innen und Handlungen an einem bestimmten Ort – von einem Publikum erfahren werden kann, das an dem Projekt nicht unmittelbar teilhat. Diese Frage führt uns auch zurück nach Münster: Wie können Projekte, wie sie alle zehn Jahre vor Ort in Münster realisiert werden, eine Resonanz entwickeln? Und zwar nicht nur für die, die in ein Projekt eingebunden sind oder den Werkprozess direkt miterleben – nicht nur für die Einwohner_innen Münsters.

Zunächst einmal ist das Postulat der Dauer grundlegend für die Begegnung mit Kunst. Das heißt, das Publikum verzichtet darauf, das Kunstwerk in seiner Gesamtheit beziehungsweise über die gesamte Zeitspanne zu erfahren. Allerdings setzen Projekte, die auf einen längeren Zeitraum angelegt sind, voraus, dass sie weitergedacht und ergänzt, als Ganzes imaginiert werden. So wussten die Besucher_innen der Skulptur Projekte 2007 von Jeremy Dellers Arbeit *Speak to the Earth And It Will Tell You* in einer Münsteraner Kleingartenanlage nur, dass sich die Gärtner_innen und Vereinsmitglieder zum Führen von Tagebüchern, die die Jahre zwischen der Ausgabe 2007 und 2017 dokumentieren sollten, verpflichtet hatten. Sie bezeugten somit den Beginn des Projekts, das in die Zukunft wies.[3] Die *Future Library* von Katie Paterson beruht ebenso auf einem Versprechen – das sich in diesem Fall sogar erst nach Ablauf unserer Lebenszeit einlösen wird. Seit 2014 übergibt jedes Jahr ein/e Autor_in ein Manuskript, das in der Deichmanske bibliotek in Oslo unter Verschluss gehalten und bis zum Jahr 2114 dort unveröffentlicht aufbewahrt wird. Unterdessen wachsen im Nordmarka-Wald, außerhalb der norwegischen Hauptstadt gelegen, tausend Bäume, aus denen das Papier für die Anthologie der in den hundert Jahren zusammengekommenen Texte hergestellt werden wird. Hier ist es die Zeit selbst, die ein Erleben des Werkes in seinem vollen Umfang in unserer Gegenwart verhindert. Zugleich wird sich die *Future Library* im Laufe der Zeit von einem Zukunftsversprechen in ein Archiv verwandeln. Ab 2064 können einige Autor_innen noch damit rechnen, die Publikation ihrer Beiträge zu erleben, und auch die Besucher_innen der Bibliothek werden die Texte zunehmend als etwas wahrnehmen, das auf die Publikation wartet, nicht als ein Geheimnis, das weggesperrt ist, ihren Blicken entzogen.

Andere Projekte im öffentlichen Raum verstehen Zeit vor allem als Material, um das Publikum zu aktivieren beziehungsweise das Mitwirken der Öffentlichkeit zu erzielen. Theaster Gates definierte für seine Arbeit *Sanctum* (2015) in Bristol zeitliche Parameter, um eine Beziehung zwischen dem Publikum und einem antiken Monument, der Kirchenruine Temple Church, herzustellen und – vielleicht noch wichtiger – die Beziehung unter den Besucher_innen neu zu gestalten. Gates sammelte für dieses Projekt überall in der Stadt ausrangierte und ungenutzte Materialien von früheren Arbeitsstätten und Orten religiöser Andacht ein. Darunter Dachbalken eines Speichers aus dem 18. Jahrhundert, Backsteine aus der Kirche Bristol Citadel der Heilsarmee im Osten der Stadt und Holztüren aus einer verlassenen Schokoladenfabrik. Daraus errichtete er im Mittelschiff der Kirchenruine einen temporären Bau. Konstruktion und Gestaltung waren beispielhaft für ein durchdachtes und visionäres *Umnutzen* von Ressourcen aus verschiedenen Zeitabschnitten. Im Vordergrund stand allerdings die zeitliche Struktur des Baus, denn die Temple Church wurde zum Schauplatz eines 24 Tage, rund um die Uhr, Tag und Nacht andauernden Musik- und Performanceprogramms. Vom Tag der Eröffnung am 29. Oktober bis sich die Türen am 21. November 2015 wieder schlossen, performten mehr als 700 Musiker_innen. Die Zugangsbeschränkung auf fünfzig Besucher_innen sorgte für eine intime Atmosphäre innerhalb des *Sanctum* – Tag wie Nacht. Das Programm wurde nicht kommuniziert, sodass das Publikum nie wusste, was es erwartete. Diese Struktur gab dem Werk *Sanctum* seinen Sinn und Zweck und verwischte die Grenze zwischen Performer_innen und Besucher_innen. Beide Gruppen bezeugten gegenseitig die Ausdauer des jeweils anderen. Auch das machte einen Teil der über 552 Stunden aufrecht erhaltenen Lebendigkeit von *Sanctum* aus.

Projekte wie dieses konkretisieren unsere Vorstellung von der Teilhabe am öffentlichen Raum – weg vom kollektiv erlebten Event – als fortlaufend, individuell erfahrbar,

Claire Doherty I've Been Here Before! Public Art and Public Time

The decennial alignment of three significant European art events in the summer of 2017 provides (for those engaged in the contemporary art field at least) a moment to take bearings—to experience new encounters in familiar places through older eyes, against the backdrop of the inevitable seismic geopolitical shifts that a decade brings. Whilst Kassel and Venice perform as the artistic platforms for global concerns every five and two years respectively, the small city of Münster offers a more focused lens through which to take bearings: the Skulptur Projekte event operating as part reunion, part déjà vu, marking the unfolding of time in the city of Münster and in ourselves. A durational relationship to context is not unusual for the arts, of course: after all, most arts institutions recognize the importance of their cumulative histories in specific places for their civic role. Whilst, conventionally, duration in public art was conceived in relation to its durability in a fixed form on a stable site, in recent years, it has emerged as a means by which to allow a public artwork to unfold over time, whereby artists act as charismatic agents to realize a project's potential, enabling the artwork to be lived through and allowing space for the unplanned as the project unfolds.[1] In recent years, we can also discern an explicit use of time as a constituent material in the making of public projects, where a specified time period provides the conceptual structure for the unfolding nature of the work. Sophie Calle's recently announced twenty-five-year work at Brooklyn's Green-Wood Cemetery, Mark Storor's twelve-year *Baa Baa Baric: Have You Any Pull? A Quiet Revolution* in St Helens, UK, and Katie Paterson's hundred-year *Future Library* in Oslo demonstrate the use of duration as a means to layer public contributions to a work over time and over generations, exposing the work to changing conditions, and rendering it impossible to experience in its entirety due to its dispersal across time (with a marked departure from durational performance through the artist's explicit assigning of responsibility to participants, visitors, and co-owners).[2] In Münster itself, Maria Nordman's *De Civitate* and Jeremy Deller's *Speak to the Earth and It Will Tell You* stretch the limits of the exhibition frame of the Skulptur Projekte so that the work itself bleeds into the everyday experience of Münster in the intervening years.

The question remains, how is that stretching of time—that unfolding of actors and actions in a specific place—experienced by an audience beyond a project's immediate participants? And this brings us back to the moment at which we are called to attend to the decennial event of Münster. How can such projects resonate for those not engaged in the 'living through' of the process over time, for those not resident in Münster?

In the first instance, the proposition of duration is fundamental to an audience's encounter: they surrender a 'complete experience' for a partial view, but the concept of a project's extended timescale still resides in the social imagination. In 2007, for example, visitors to *Speak to the Earth and It Will Tell You* at one of the garden allotments in Münster knew only that the gardeners and members had committed to keep diaries

durchaus widersprüchlich und mit der Möglichkeit, aktiv den Verlauf des Projekts mitzugestalten. Auf Dauer angelegte künstlerische Ansätze begünstigen die Entstehung eines Publikums *zweiter Ordnung*, das heißt, über den Kreis der ursprünglichen Teilnehmer_innen hinaus wird das entsprechende Narrativ von Mund zu Mund, über digitale Netzwerke und persönliche Anekdoten weitergetragen. In diesem Sinn kann Zeit einem Kunstwerk, das von Anfang an unbegrenzt, unquantifizierbar und unabsehbar ist, etwas Wesentliches hinzufügen. Das Mitwirken daran ist dann keine Begegnung mit einem Kunstwerk, sondern ein eigener, für dessen Produktion zwingend notwendiger gesellschaftlicher Prozess, der folglich nicht nur im öffentlichen Raum stattfindet, sondern sich auch durch ein Verständnis von öffentlicher Zeit äußert. Projekte im öffentlichen Raum wie die hier angeführten setzen nicht in erster Linie auf den Moment des Zeigens oder das Ereignis der Ausstellung. Sie ermöglichen stattdessen einen unabgeschlossenen, kumulierenden Prozess des Sich-Einbringens. Die Skulptur Projekte haben sich von jeher als eine solche kumulierende Auseinandersetzung zwischen Künstler_innen und der Stadt verstanden. Der Ort ist in diesem Fall ein *event in progress* und der Stadt Münster wird die Kunst nicht übergestülpt. Der Ort selbst befindet sich, in den Worten der Geografin Doreen Massey, in „einem beständigen Zustand des Werdens".

Aus Sicht der Münsteraner_innen bietet sich mit der Entwicklung der im Stadtraum realisierten Werke beziehungsweise mit der Entwicklung der einzelnen Projekte an einem Ort, der ständigem Wandel unterliegt, eine besondere Gelegenheit: Sie haben die Möglichkeit, das Kunstwerk als Ereignis zu *durchleben* – egal, ob es sich um sichtbare, physisch präsente, noch erhaltene Arbeiten vergangener Ausgaben der Skulptur Projekte handelt oder um immaterielle, sich mit der Zeit entwickelnde Projekte. Ganz anders dagegen das Erlebnis der Besucher_innen von auswärts – insbesondere für diejenigen, die nur alle zehn Jahre kommen. Die über viele Standorte verstreute Ausstellung kann für sie nur als Momentaufnahme wahrgenommen werden und sich nicht in ihrer Dauer entfalten. Wie sich unsere Sicht auf ein Kind mit dessen zunehmendem Alter verändert – je größer es wird, desto kleiner scheint es früher gewesen zu sein –, so erscheinen auch die Skulptur Projekte nicht einfach als Repräsentation einer Gegenwart, sondern fügen Wiederholungen zusammen, um das Gleichgewicht zu stören, das sich zwischen Vergangenem, Gegenwärtigem und dem Künftigen einspielt. Betrachter_innen, die gekommen sind, um etwas zu sehen und zu erleben, gestalten zugleich das Ereignis mit, das soeben entsteht. So wirkt Michael Ashers berühmter Eriba-Familia-Wohnwagen aus den 1970er Jahren zunehmend aus der Zeit gefallen. Er ist eher ein Objekt, das historische Erinnerungen weckt, als alltägliche Intervention.[4]

„Die Zukunft", schreibt Boris Groys, „wird fortwährend neu geplant – der andauernde Wechsel kultureller Trends und Moden macht jedes Versprechen einer festen Zukunft für ein Kunstwerk oder ein politisches Projekt unglaubwürdig. Ebenso wird die Vergangenheit andauernd umgeschrieben – Namen und Ereignisse erscheinen und verschwinden, erscheinen und verschwinden von Neuem. Die Gegenwart ist nicht länger ein Zeitpunkt des Übergangs von der Vergangenheit zur Zukunft, sondern wird zum Ort eines andauernden Umschreibens sowohl der Vergangenheit als auch der Zukunft – ein Ort unablässig wuchernder Geschichtserzählungen, die kein einzelner Mensch mehr erfassen oder beherrschen kann."[5]

1 Vgl. Paul O'Neill und Claire Doherty (Hrsg.), *Locating the Producers: Durational Approaches to Public Art*, Valiz, Amsterdam 2011.
2 Siehe Akiko Bernhöft zu Maria Nordmans *De Civitate* in der Zeitschrift *Out of Time*; siehe online: www.skulpturprojekte.de; zu Sophie Calle: www.creativetime.org und zu Katie Paterson: www.futurelibrary.no [21.04.2017].
3 Außerdem hatten sie Gelegenheit, Samen des nur alle zehn Jahre blühenden Taschentuchbaums zu kaufen.
4 Siehe Alexander Alberro zu Michael Asher in *Out of Time*; siehe online: www.skulpturprojekte.de [21.4.2017]. Während der Laufzeit der Skulptur Projekte 2017 ist zudem die Ausstellung *Double Check. Michael Ashers Installation Münster (Caravan) '77 '87 '97 '07* im Lichthof des LWL-Museum für Kunst und Kultur zu sehen.
5 Boris Groys, siehe online: www.e-flux.com/journal/11/61345/comrades-of-time/ [21.04.2017].

over the period between the decennial exhibitions: this was a moment of beginning in which the project itself was a promise to the future.³ Katie Paterson's *Future Library* for Oslo, similarly turns on a promise—in this case to be realized beyond our lifetime. Every year, from 2014 onwards, a writer presents a manuscript to be held in trust in Oslo, unpublished, until the year 2114. Meanwhile, 1,000 trees grow in Nordmarka, a forest outside the capital, and will eventually supply the paper for the special anthology of all the texts published in one hundred years' time. Here, time itself withholds the 'total' experience of the work in our present, but, as time unfolds, *Future Library* will turn from a prospect to an archive—by 2064, contributing writers may see their texts published in their lifetime, and visitors to the Deichmanske Bibliotek will increasingly come to see the texts in a state of readiness for publication, rather than a secret locked away from view.

Other recent public projects use time as material more directly as the means by which to activate public agency. Theaster Gates's *Sanctum* in 2015, for example, used a set of temporal parameters to reconfigure the audience's engagement with an ancient monument, Temple Church in Bristol, UK, and perhaps more importantly, with each other. Gates sought out discarded and dormant materials from former places of labour and religious devotion across the city, such as roof joists from an eighteenth-century warehouse, bricks from the Salvation Army's citadel in the east of the city, and wooden doors from a now-defunct chocolate factory, to fabricate a temporary structure within the main architectural frame of the church. Essentially, though *Sanctum*'s visual and structural elements operated as an example of the thoughtful and visionary 'repurposing' of resources from different time periods across the city, the true agency of the project was realized through a temporal structure—a non-stop, continuous programme of sound and performance over twenty-four days, night and day. From the moment *Sanctum* opened its doors on 29 October to its close on 21 November 2015, the sound was sustained by over seven hundred performers. The audience capacity of *Sanctum* was limited to fifty people at a time, creating an intimate atmosphere day and night. The programme was kept secret so that visitors never knew who they were going to hear. This structure gave *Sanctum* its purpose and levelled the status of performers, with the audience cast as witnesses to the endurance test of sustaining *Sanctum*'s 'liveness' over 552 hours.

Such works offer us the opportunity to move away from an abstracted idea of participation in public space—as event-based and experienced collectively—towards something ongoing, experienced individually, sometimes discordantly, which is enacted by us as active participants in the unfolding of the work. Such a durational approach works by encouraging subsidiary audiences to form, beyond the initial participants, permitting others to receive the project anecdotally through the dispersion of the narrative of the project through word-of-mouth, viral, and digital networks. In this sense, time can contribute something to the artwork that is immeasurable, unquantifiable, and unknowable from the outset. Participation is not then an encounter with artistic production but a social process necessary for art's production, which occurs through public time, not just in public space. Public projects such as these do not prioritize the moment of display or the event of exhibition; they allow instead for open-ended, cumulative processes of engagement. Münster's Skulptur Projekte has always recognized its exhibition form as a cumulative engagement between artists and the city. Place here is an 'event in progress'. The city is not a static site onto which public art is grafted; rather, it is, as geographer Doreen Massey proposed, in 'a constant state of becoming'.

For the residents of Münster, the unfolding of these works in a place which is in a constant state of becoming, in their home town, establishes the possibility of living through the event of the artwork—whether in the physically present public artworks that have remained or in the immaterial, unfolding durational projects. But for the visitor, and particularly the decennial visitor, the experience is entirely different. The scattered-site exhibition is a moment in this unfolding—and must therefore perform for the visitor—but just as our view of a child changes as they grow older, their past

selves becoming smaller in relation to their present size, the Skulptur Projekte does not occur simply as a representation of the present but rather gathers a confluence of repetitions to 'retroactively change the balance' between the actual past, the present, and the anticipated future. The spectator who has come 'to see and experience' becomes a participant in the forming of this event, this moment of becoming. Michael Asher's 1970s' Eriba Familia caravan becomes increasingly anachronistic, therefore, an object of historical resonance rather than everyday intervention.[4]

As Boris Groys has suggested, 'The future is ever newly planned—the permanent change of cultural trends and fashions makes any promise of a stable future for an artwork or a political project improbable. And the past is also permanently rewritten—names and events appear, disappear, reappear, and disappear again. The present has ceased to be a point of transition from the past to the future, becoming instead a site of the permanent rewriting of both past and future—of constant proliferations of historical narratives beyond any individual grasp or control.'

1 See Paul O'Neill and Claire Doherty (eds.), *Locating the Producers: Durational Approaches to Public Art* (Amsterdam: Valiz, 2011).
2 See Akiko Bernhöft, 'Nothing Ever Truly Repeats: Maria Nordman's De Civitate', *Out of Time* magazine <www.skulpturprojekte.de/#/>;
 Sophie Calle <www.creativetime.org>; and Katie Paterson <www.futurelibrary.no> accessed 21 April 2017.
3 And also the opportunity to buy seeds for the *Davidia Involucrata* tree, which flowers ever ten years.
4 See Alexander Alberro; 'Sculpture Palimpsests: Michael Asher in Münster', *Out of Time* magazine <www.skulpturprojekte.de/#/> accessed 21 April 2017.
5 Boris Groys, 'Comrades of Time', *e-flux Journal* 11 (December 2009), <www.e-flux.com/journal/11/61345/comrades-of-time/> accessed 21 April 2017.

Mark von Schlegell

Achte auf die Ecken (Münsterkristall)

> Drum poche sacht, du weißt es nicht
> Was dir mag überm Haupte schwanken;
> Drum drücke sacht, der Augen Licht
> Wohl siehst du, doch nicht der Gedanken.
>
> (Anna Elisabeth Franzisca Adolphina Wilhelmina Ludovica Freiin von Droste zu Hülshoff)

Seit den 2050ern ist von den Originalpublikationen, die irgendetwas mit Kunst und linksgerichteter Literatur der präaugmentierten Gesellschaften zu tun hatten, nichts mehr übrig – neuartige Schimmelpilze und eine Reihe systematischer faschistischer Bücherverbrennungen hatten ihnen den Garaus gemacht. Die Datenplagen um die Jahrhundertmitte haben die meisten übrigen Aufzeichnungen vernichtet; tatsächlich sind fast alle Textdokumente, die die sogenannte Unsichtbare Kunst zu ihrer Blütezeit kommentierten, verloren gegangen. Für die Künstler dieser faszinierenden Zeit waren ihre Arbeiten nicht unsichtbar. Das ist unser Begriff, jetzt, in den 2090ern, und er bezeichnet bloß unsere eigene Unfähigkeit, zu erkennen, was diese Kunst bedeutete.

Sicher ist aber, dass die Stadt Münster von 1977 bis 2017 alle zehn Jahre die Skulptur Projekte veranstaltete, die bedeutende internationale Ausstellung, die Violet Reeves und ihr Co-Kulturator Phoenix Klaus König in der hyperzeitgenössischen Ära wiederbeleben wollten.

Unter der konvertierbaren und geheimnisvoll schönen westfälischen Geokuppel regnete es jeden Tag im Münsterland. Stolz bot die Stadt eine fast makellose prädigitale urbane Realität. Man lief ebenerdig im Freien. Die Augmentation war stark eingeschränkt.

Ich duckte mich. Drei große Flugräder, beladen mit älteren Damen, verfehlten meinen Kopf nur um wenige Zentimeter. In der Nähe bemerkte ich Menschen, die *unter* die Oberfläche hinabstiegen, als wäre das hier eine normale Stadt. Die Treppen waren nach Geschlecht unterteilt. Ich bin altmodisch, wie jedermann, und halte mich stets streng an die örtlichen Gepflogenheiten. Allerdings stellte ich schnell fest, dass ich keine unterirdische Stadt betreten hatte, sondern die ausschließlich Männern zugedachte Seite eines öffentlichen Urinals. Dem Geruch nach war es keineswegs *nur* ein Urinal. Ein breitschultriger Mann stand dort Wache – meinetwegen? Ich spürte, dass man mir misstraute. Eine surreale Szene. Ich musste tatsächlich die Treppen nehmen, um rauszukommen!

Nach dieser Realitätserfahrung fühlte ich mich bereit für etwas Kunst. Das erste Beispiel, dem ich begegnete, war ortsparasitär. Der tote Bildhauer Henry Moore hatte eine Fantasie hinterlassen, die seinem eigenen Kopf entsprungen war, und er hatte darauf bestanden, sie groß und unverrückbar zu präsentieren, *hier, als ob in alle Ewigkeit*. Man bekam schon eine Ahnung, warum manche Kunst zur Unsichtbarkeit tendieren mochte.[1]

Hinter diesem Zerberus ging man weiter und betrat das prädigitale LWLL[2] Museum wie durch das Ärmelende eines sehr steifen Hemdes. Die forcierte Rechtwinkligkeit streckte sich noch, wenn man die Anlage betrat, die zum größten Teil aus einer riesigen leeren Lobby bestand,

drei Stockwerke hoch und weiter als jede der Galerien mit ihren niedri-
gen Decken. Ich erfuhr später, dass diese Leere eine Arbeit der Bostonerin
Nora Schultz war.

An einem Tisch, der mehr Platz einnahm als KLM beim Eintritt in die
Umlaufbahn des Mondes, erklärte ich meine Situation einem Komitee.
Schließlich wurde mir ein Horn gereicht.

Es war Violet Reeves.

 „Ickles. Du wirst jetzt genau tun, was ich dir sage…"

 „Hier spricht nicht Ickles. Ich bin mit Selbst hier."

 „Archie? Bei allen außerplanmäßigen…"

 „Ich fürchte, es ist ein Notfall. Eine Steuergeschichte. Vertrau mir, es ist
 für alle Beteiligten wichtig, dass ich jetzt zu dir hoch komme. Nur in den
 Raum. Als Teil der Abmachung."

Ich bin Mathematiker und regle normalerweise die Steuerkampagnen
von Ickles, Etc. In Wahrheit mache ich bei diesem ganzen kranken Plan nur
wegen V. R. mit. Ich bin nicht immun gegen weibliche Reize. Meine Part-
nerinnen kommen und gehen (Ickles nennt mich „Die Drehtür"), aber *sie*
tut das bisher nicht, auch wenn ihr das nicht aufgefallen wäre.

Ich konnte fast hören, wie sie auf ihre Unterlippe biss.

 „Also, dann", sagte ich, „bis gleich", und gab das Horn zurück.

Ich wurde freigegeben. Meine Uhr führte mich die endlose steile Treppe
hinauf. Jeder Wachmann, an dem ich vorbei musste, ließ sich meinen
Ausweis zeigen, und als ich das Zimmer endlich gefunden hatte, war ich
mehrere Minuten zu spät. Drinnen war die Präsentation bereits in vollem
Gange. Die Silhouette eines großen jungen Mannes zeichnete sich vor
einer undurchdringlichen Reihe Holo-Lichter ab. Es schien, als sähe mich
der Kerl an. Ich verbeugte mich. Ich war immer glücklich, wenn ich auf
irgendeiner Art Bühne stand. Er war ein großes, extrem jugendliches
Exemplar, mit hämischen Augen und Schlupflidern. Er trug tatsächlich
Hosenträger und spannte sie mit seinen Daumen in meine Richtung.

 „A. R. James, Mathematiker", vermeldete ich. „Direkt hergekommen
 von Ickles, Etc. Info-Architekten. Heute beratend tätig, das ist alles."

Noch nie zuvor hatte jemand derart humorlos geblickt wie dieser junge
Kerl mit seinen kaum sichtbaren Augen. Es war klar, dass dieser Jüngling
Ickles genau kannte.

 „Ich hatte gerade Ser Reeves vorgestellt."

Vi Reeves erhob sich von einer nahe gelegenen Bank in einem grauen
Kostüm, das ihr charmantes Kastanienbraun perfekt akzentuierte. Ihre
Farbe, unaugmentiert, war die von Granatäpfeln. Sie lief kühl an mir vorbei.

 „Danke, Ser König", sagte sie.

 Phönix Klaus König, das Wunderkind der derzeitigen hyperzeitgenössi-
 schen Kunstszene, packte mich grob und führte mich zu der Bank. V. R.
 blickte direkt ins Licht. „Ich möchte dem Handelskomitee dafür danken,
 dass wir heute zumindest rudimentäre Augmentation verwenden dürfen.
 Ich werde jetzt einen Holo-Screen in all unseren Kortexen öffnen."

Ich machte mir keine großen Sorgen, dass mein Eindringen negative
Auswirkungen auf Violets Pläne haben könnte. Wenn die Dinge schief
liefen, dann zugunsten der wahren Arithmetik. Ich kannte ihren geheimen
Kern besser als die meisten anderen. Ickles hatte recht … V. R. war Kalku-
latorin, nicht Kulturatorin.

 „Kunst hat keinen rechtlichen Anspruch auf die Vergangenheit", fing sie
 an. „Menschen schon, sofern sie verfügbar ist. Mit diesen Rechten geht
 Verantwortung einher, und aus diesem Grund bin ich hier. Ich bin nicht
 nur Info-Architektin und experimentelle Mathematikerin. Ich bin auch
 Kunstfan. Insbesondere der Unsichtbaren Kunst. Das Münsterland – als
 nahezu einziger Ort in Europa – hat die wichtige Entscheidung getroffen,

die Feier seiner überlebenden Kunst in Zukunft fortzuführen. Heute bitten wir Sie, Verantwortung zu übernehmen und die Rückkehr der Skulptur Projekte Münster zu unterstützen, eigens konzipiert für das Jahr 2107."

Es war erst 2099. Sie schlugen hier ein acht Jahre dauerndes gemeinsames Projekt vor? Das schien mir in der Tat eine sehr ernsthafte Beziehung zu sein.

„Mit einer kurzen Einführung dazu, wie und warum wir an die Rückkehr der SPM glauben, genau neunzig Jahre nach ihrer letzten Inkarnation, möchte ich Sie zunächst daran erinnern, dass uns äußerst wenige wirkliche Informationen darüber vorliegen, welche Künstler welche Werke geschaffen haben und wo diese Werke sich befanden oder noch befinden. Mit Ausnahme von Lawrence Weiner, dessen signierte sichtbare Werke unanzweifelbar sind, sind die meisten Arbeiten, die die Skulptur Projekte in Ihre Stadt gebracht haben, wie ein Eisberg von Bedeutung, dem die Spitze fehlt und den wir niemals wahrnehmen werden. Doch wie viel gewährt uns diese Unsichtbarkeit, wie großzügig lehrt sie uns, die Welt um uns herum als Kunst zu lesen?"

„Superintelligente Drucker und AugCiv waren bereits in der Entwicklung, als die unsichtbaren Künstler, die früher hierher kamen, ein Verständnis für die Endlichkeit der Biosphäre und den wahren Preis der Erinnerungskultur bekamen. Wie Arakawa, vielleicht der erste AI-Künstler überhaupt, schufen sie flüchtige Werke, die der chaotischen und zerfallenden Realität offen gegenüberstanden und die Welt um sie herum einluden, sich selbst zu Kunst zu machen."

„Münster hat gewissermaßen immer schon seinen eigenen Kortex kontrolliert. Im 16. Jahrhundert implementierten die Wiedertäufer hier eine Utopie, die nichts mit dem umliegenden Europa gemein hatte. Es gab keine Entität Deutschland, als Karl Marx eine Bäuerin namens Jenny heiratete, von der Historiker glauben, dass sie aus Westfalen stammte. Es gab auch kein Deutschland, als die Skulptur Projekte 1977 hierher kamen. Die BRD Noir verhalf dieser Ausstellung zur Geburt. Und wir alle stimmen darin überein, dass die Superkorruption des späten 20. Jahrhunderts der hyperzeitgenössischen Kultur auch heute noch Signale der Supermöglichkeit bietet. Wir schlagen eine Art BRD Science Fiction vor, die es den Menschen ermöglicht, den Ausblick auf die Zukunft zu vergessen und an der jugendlichen, törichten Vergangenheit teilzuhaben. Entlang der, Aah…"

„Tja", sagte eine Stimme hinter den Lichtern. „Nette Rede. Aber Augmentation ist hier verboten, außer unter ganz besonderen Umständen."

In diesem Moment öffnete sich nahe dem Boden die Wand hinter mir und ein kleiner Hyperbot näherte sich diskret meinen Knien.

„Aber die nicht."

P. K. K. stieß mich an und reichte mir eine billig hergestellte 3D-Brille.

„Eine Brille!"

Seit den 70ern hatte kein Mensch solche Brillen getragen. Ich setzte sie unsinnigerweise auf. Ich trug magnetische Schuhe, also war mein Kortex gesperrt.

„Lassen Sie uns einen Spaziergang durch die Vergangenheit und die Zukunft dieser möglichen Ausstellung machen. Am Ufer des Flusses, Aah…"

Es war ein Tick. Offenbar konnte sie den Namen dieses Flusses beim besten Willen nicht aussprechen.

„Sehen Sie einen seltsamen Friedhof." In Ickles' Plan war ganz bestimmt nichts von dieser Brille erwähnt. Aber weil sich die anderen jetzt in der erweiterten Realität befanden, entschied ich mich, direkt zum Plan überzugehen.

Der Hyperbot entfaltete sich und reichte mir das zusammengerollte

Zwenster, um sich dann in einen passenden Demolator umzuformen.

„Wir haben Glück", fuhr Vi fort. „Ein früherer Museumswärter hat ein
paar Skizzen für ein Projektvorhaben von einem Künstlertrio zurück-
gelassen, dessen Arbeiten sich mit dem digitalen Zeitalter ausreichend
überschnitten, um uns ein erstes Signal zu übertragen. Damals, im Jahr
2007 hatten Dominique, Foerster und Gonzalez die Idee, sich humorvoll
von der Kunst der Vergangenheit zu verabschieden. Sie arrangierten
verkleinerte Modelle von vielen vorherigen Werken der Skulptur Projekte
wie auf einem Friedhof. Durch die Entdeckung dieser Miniaturmodelle
waren wir tatsächlich in der Lage, einige der alten Arbeiten aufzufinden,
die noch heute in der Stadt existieren."

Der Bot verwandelte sich in eine Stange. Ich ließ mich durch das Loch im
Boden hinab in die darunterliegende Galerie mit spätmittelalterlicher
Kunst. Während der Bot die Decke reparierte, folgte ich dem Weg, den
meine Uhr anzeigte. Im Nullkommanichts stand ich vor dem einzigen ver-
bliebenen Teil von Giovanni di Paolos Altargemälde *Johannes der Täufer*.
Das entfaltete Zwenster flog aus meinen Händen zum Gemälde und
passte sich exakt an die Form des Subjektils an.

„Hallihallo! Willkommen in Münster. Das dürfen Sie nicht."

Ich drehte mich um, nur um mich dem ironischen Blick eines der edelsten
Männer Münsters ausgesetzt zu sehen. Ein menschlicher Wachmann,
nicht maschinell.

„Zieh die Schuhe aus, A. R."

„Was?" Die Augen des Wachmanns weiteten sich. Meine auch, denn die
Stimme war aus dem gezwensterten Gemälde gekommen.

Während wir auf das außergewöhnliche Bildnis blickten, streifte ich
meine Schuhe ab. Wenn man für Deutsche arbeitete, war es vielleicht
sicherer, keine klare Meinung in Taufangelegenheiten zu haben, weshalb
dieser Italiener so etwas wie einen frühen Blick auf das Multiversum ent-
worfen hatte. Die verschiedensten Dinge spielten sich im Innern einer
komplexen Architektur gleichzeitig ab, die diese eigentlich unmöglich
hätte beherbergen können. Aber das tat sie. Es schien mir, als ob ich
selbst im Vordergrund als Angeklagter dastand, während Menschen in
einer Meute frustriert aneinander zerrten. Ich fühlte, dass ich ohnmächtig
wurde. Schon bald legte ich mich offen auf einem Bett nieder, das an-
scheinend schon immer genau hier gestanden hatte. Mysteriöser- und
unmöglicherweise kam ich mir schwanger vor.

„Achte auf die Ecken, A. R.!"

Welche Ecken? Ich sah keine. Um jede Säule herum nur Öffnungen und
Dunkelheit, Bögen und andere Rundungen.

„Mach die Ecken heller!", rief ich angstvoll zurück. „Alles ist dunkel."

Ich zitterte. Niemand in dieser Komposition trug Schuhe. Auch ich nicht.

Als wäre ich im Büro in New L. A., ertönte 90er-Jahre-Indierock (*Guiding
Star* von Teenage Fanclub, in Dauerschleife). Die eigenartige Säulenwild-
nis lief steif um mich herum. Wendeltreppen zeigten ihre Hinterteile, und
aus der Ferne starrte mich ein vertrautes fischähnliches bebrilltes Auge
an. Bin ich Ickles?, dachte ich entsetzt.

„A. R., konzentrier dich hierauf!"

„A. R.?", sagte das Gesicht. In diesem Moment trat eine Reihe von Wir-
kungen ein, die schwer zu beschreiben sind, außer in ihrer Abfolge.

Das Selbstkonzept war flüchtig.

V. R. stand nahe bei mir, wir hatten die Größe von Insekten. Neben uns
lag ein riesiger Spaceball und noch zwei andere gleich dahinter; was
nahelegte, dass sich irgendwo ein gravitationsloses Spielfeld in einer
Umlaufbahn befand.

Vi sagte: „Claes Oldenburg hat eine Skulptur gebaut, um uns daran zu

Mark von Schlegell

erinnern, dass wir in den Stadtmuseen unserer eigenen Zukunft durch
ein Ensemble von Miniaturen laufen."

Die Sicht auf ein eher mittelalterliches Setting wurde freigegeben. Ich war
nicht nur im Inneren eines Wirrwarrs an Farben und Gerüchen, die ich
nicht verstand, sondern in einem riesigen Kochtopf. Neben mir trat Ickles,
in ein Narrenkostüm gekleidet, den Blasebalg.

"Ach", sagte ich, "Ickles gesehen". Mein Gesicht verzerrte sich, es war
gleichzeitig mit sich selbst und Ickles verwischt.

"Archie, bleib ruhig. Du stehst nur in Dan Grahams Fun House, das 1997
gebaut wurde."

"Jetzt erst verstehen wir, dass diese runde Arbeit von Donald Judd nicht
nur als Leinwand für diejenigen gedacht war, die die Stadt mit ihrer eigenen
Kunst besprühen wollten, sondern auch als eine Rampe für Gravboarder."

"A. R.", bellte Ickles durch den Spiegel. "Wer hat dir diese Brille gegeben?"

"Vor einem Gebäude, das der Naturwissenschaft gewidmet ist, entschied
sich der Invisibildhauer Bruce Nauman, nichts darzustellen", sagte König.
"Stattdessen grub er ein Loch, wo die Leute rauchten, und bedeckte es
mit Beton, so als ob er sie alle in einen riesigen Aschenbecher stürzte. Na?
Das gefällt uns."

Ein dunkelhäutiger nackter König hatte einen Arm um mich herum gelegt;
mit dem anderen fasste er meinen Apfel an. Ich war nicht nur schuhlos,
ich war vollkommen nackt, und nahm einen Ast, der zuhanden war, um
uns vor den Blicken des Komitees zu schützen.

"Ickles? Wo bist du?"

"Ich liege nackt auf einer Bank", antwortete mein Arbeitgeber. "Der Kor-
pus fühlt sich wohl. Aus einem kleinen niedlichen Loch im Bauch kommt
ein glänzendes rotes Band heraus, das stramm gespannt nach oben zu
einem Spieß läuft, den sie oben drüber drehen. Bald wird es aufgerollt sein."

"Malerei klappt den Raum zusammen; Architektur verdichtet ihn", sagte
König. "Skulptur *erschafft* ihn."

"Ja", sagte Vi. "Stimmen Sie jetzt für *ja*, für 2107! Wir haben keine Zeit
zu verlieren."

"Was?", fragte ich, denn die ohne Selbst tun stets das, was ihnen gesagt
wird.

Ickles antwortete, aber an der Frage vorbei.

"Unglücklicherweise ist diese Brille Zwenster, A. R. Zwenster auf Zwenster?
Selbst ist gefährdet. Seit dein Blick einen traf, sind nun unsere überein-
andergelegten Blickwinkel für alle Absichten und Zwecke (imaginativ
gesprochen) mit der komplexen sichtbaren Oberfläche des überdimensi-
onierten *Münsterkristalls* verschmolzen, der Lebewesen, die du dir nicht
einmal vorstellen kannst, in ganz Westfalen verwirrt. Wenn das Zwenster
hier entfernt würde, wärst du dazu verdammt, für alle Zeit die sichtbare
mögliche Oberfläche des großen Münsterkristalls einzunehmen. Ein Trost:
Ickles, Etc. ist es vor zehn Jahren gelungen, einen Deal mit örtlichen
Glasern zu machen. Die 72 Tonnen Quasikristall, die für die Steuerbots in
Neukalifornien so fatal sind, laufen jetzt schwarz."

"Was hast du als Gegenleistung bekommen?"

"Die andere Hälfte des Diptychons, auf dem du dich gerade befindest."

Diese Worte wurden von einem unerfreulichen Geruch begleitet.

Ickles und ich standen Hand in Hand da, elfengleich unter zwei hoch
emporragenden Hecken. Violet erklärte: "In dieser sichtbar unsichtbaren
Arbeit persifliert R. Trockel eine gewisse Neigung männlicher Karnevalis-
ten im Grün münsterländischer Parklandschaften. Sie pflanzte Hecken,
die hoch genug dafür sind, dass Frauen eintreten, sich erleichtern und
dabei sicher fühlen können."

Köstliche Kirschen, wie ich sie aus meiner Jugend kannte, standen jetzt

groß wie eine Kirche vor mir. Die Welt war jung. Ickles hatte ganz Münster
zu einer neuen Auffassung der angemessenen Taufzeit bekehrt.

Ickles schrie: „A. R.! BLOSS NICHT DAS ZWENSTER ENTFERNEN!"
Selbst schnappte sofort zurück. Der Wachmann hatte das Zwenster vom
Gemälde abgerollt. Er reichte es herüber. Ich fand mich selbst neben
Violet Reeves stehend wieder, als wäre ich von den Toten zurückgekehrt.
Violet nahm mir die Brille ab.

„Was ist gerade passiert?", fragte ich sie.

„Fürs Erste hast du gerade ein Loch in den Boden gefräst und ein unbe-
zahlbares Gemälde gestört."

„Hör mal, ich tue nur, was mir gesagt wird. Aber eigentlich bin ich hier, um
dich nach Hause zu bringen. Du bist keine Kulturatorin. Du bist eine…"

„Ko-Kulturatorin. Ihr postamerikanischen Männer seid doch alle gleich.
Weißt du was? Ich brauche von niemandem Hilfe, Ratschläge oder irgend-
welche Einmischungen in meine Angelegenheiten. Oh, Archie, du bist ge-
nauso berechenbar wie Ickles."

„Das geht jetzt aber unter die Gürtellinie."

„Aber ich bin gar nicht wirklich böse", flüsterte sie.
Im Zimmer nebenan gab es Unruhe. „Ich habe ein Zwenster auf Hermann
tom Rings *Weltgericht* platziert. Übrigens haben alle mit *ja* gestimmt.
Einstimmig. Sogar mit Selbst will jetzt niemand draußen vor bleiben."

„Und *sein* Selbstkonzept?" Ich deutete auf den jungen großen König. Als er
uns durch seine Brille ansah, bemerkte ich einen „UNKEL WILLY"-Anste-
cker an seiner Brust.

„Phoenix ist dabei, ein Selbstkonzept zu *erlangen*. Tatsächlich war er ein-
mal ein gedrucktes Baby, zusammengeschmolzen aus der DNA der beiden
Gründer der Skulptur Projekte Münster, Kasper König und Klaus Buß-
mann. Ist das nicht seltsam? Noch ungefähr eine Stunde Münsterkristall
zwenstern, und er wird ein funktionierendes Unbewusstes haben."

„Nun ja, er wirkt ziemlich… jung."

„Ich weiß, ist er nicht ganz entzückend? Wir sind Fibonaccis! Er glaubt,
das erklärt den *unglaublichen* Sex."

Ich suchte nach Zuspruch. „Ist Ickles zufällig in diesem Gemälde gefangen?"

„Ickles muss den Korpus in ein Stück des nahegelegenen Münsterkristalls
einschließen, das so alt ist wie dieses Gemälde. Dann kann er das Zwens-
ter entfernen und schauen, was passiert."[3]

„Du wusstest die ganze Zeit über von Ickles' Plan, den Quasikristall zu
entladen? Du hast doppelt gezwenstert, um die Selbstkonzepte der Mit-
glieder des Komitees zu gefährden!"
Sie legte einen Finger an ihre Lippen.

„Aber wie hat Ickles das ganze Q abgeladen?"
Sie machte eine Geste nach oben.

„Wie, glaubst du, haben sie Westfalen abgedeckt?", zwinkerte sie. Oder
blinzelte sie lediglich mit diesen bewimperten, jedoch lidlosen Augen?
Sie lehnte sich aromatisch nach vorne, sodass mein einzelnes Herz eine
zweischrittige Quadrille tanzte.

„Ist das ein Schreibfehler?"

„Was bitte?"

„Auf deine Stirn sind jetzt die Wörter MACH DIE ECKEN HÖLLE tätowiert."
Irgendwo tönte ein Horn, wie von einer Kirche hoch oben.

1 Heute gilt es als klassische Geste der Unsichtbaren Kunst, dass die Künstlerin Cosima von Bonin 2017 vorschlug, in einer Art Performance den Moore zu entfernen.
 Das Handelskomitee, stets gewillt, Käse zu bewerben, lehnte diesen Vorschlag allerdings ab.
2 Die Bedeutung des zweiten Ls konnte ich nicht ergründen.
3 Ickles wurde schließlich im Knipperdolling-Käfig entdeckt, der noch immer am Turm der Lamberti-Kirche hängt – lebendig, aber ohne Implantate, Zahnersatz und
 den geringsten Fetzen Kleidung.

Mark von Schlegell

Watch the Corners (Münstercrystal)

Drum poche sacht, du weißt es nicht
Was dir mag überm Haupte schwanken;
Drum drücke sacht, der Augen Licht
Wohl siehst du, doch nicht der Gedanken.

(Anna Elisabeth Franziska Adolphine Wilhelmine Louise Maria Freiin von Droste zu Hülshoff)

By the 2050s new moulds and various concentrated fascist book burnings had done away with all the original published material having anything to do with the art and leftist-leaning literature of the pre-augmented societies. The data plagues of the mid-century did away with most other records; and the fact is almost all textual accompaniment that actually explained so-called Invisible Art in its heyday was lost. Artists of that fascinating moment didn't see their work as invisible. It's our 2090s' term, signifying our own inability to know what that art meant.

But it's for certain that every ten years from 1977 to 2017 the city hosted the Skulptur Projekte Münster, the important international exhibition that Violet Reeves and her co-kulturator Phoenix Klaus König meant to revive for the hyper-contemporary age.

With the convertible and mysteriously beautiful Westphalian geodome overhead, they had rain every day in Münsterland. The city proudly constituted a nearly intact pre-digital urban reality. One walked at surface level, out of doors. Augmentation was highly limited.

I ducked. Three large fly-cycles, bearing matrons, missed my head by mere centimetres.

Nearby, I spied people descending *below* surface as in a normal city. The stairways were divided by gender. I am as old-fashioned as the next and follow local customs to the T. However, I soon discovered I had not entered a subsurface urbs, but the male-only side of a public urinal! And not *only* a urinal by the scent of things.

One broad-shouldered man stood there on guard—against me? I felt I was suspected. A surreal scene. I had to climb the actual stairs out!

With that reality experience behind me, I deemed myself ready for some art. The first specimen I came upon was site-parasitic. Dead sculptor Henry Moore had left behind a fantasy from out of his own mind, insisting on presenting it large and immovable, *here as if for all time*. One already began to understand why some art might tend towards invisibility.[1]

Beyond this Cerberus, one proceeded to enter the pre-digital LWLL[2] Museum as through the sleeve end of a very stiff shirt. This enforced rectangularism only lengthened upon entering the structure which was mostly taken up by its own enormous empty lobby, three storeys tall and wider than any of the low-ceilinged galleries. I found out later that emptiness was a piece by Bostonian Nora Schultz.

At a desk taking up more length of wall than KLM at Lunar Entry, I explained my situation to a committee. Eventually a horn was passed to me. It was Violet Reeves.

'Ickles. *You will now do exactly what I say—*'
'It's not Ickles. I am with self.'
'Archie? What in all the irregularities—'

'It's an emergency, I'm afraid. A tax matter. Trust me, we all need me to
get up there with you. Just in the room. As part of the deal.'
I am a mathematician and normally employed on the tax campaigns of
Ickles, Etc. The truth is I went along with this whole sick plan because of
V. R. I am not impervious to female charms. My various partners come
and go (Ickles calls me *The Revolving Door*); by now, though she wouldn't
have realized it, *she* does not.
I could almost hear her bite that lower lip.

'OK then,' I said. 'See you in a jiffy,' and handed back the horn.
I was cleared. Watchlet led the way up interminable sloping stairs. Each
guard I passed demanded ID, so by the time I'd found the room, I was
minutes late.
Inside, I found the presentation was already going. A tall young man
stood silhouetted in front of an impenetrable bank of holo-lights.
Apparently the fellow was looking at me. I bowed, always happy to be on
any sort of stage. He was a tall, extremely young specimen, with hooded
sardonic eyes. He actually wore suspenders and thumbed them my way.

'A. R. James, Mathematician,' I beamed. 'Directly here from Ickles, Etc.
Info-architects. Consulting, today, that's all.'
Never was a glance quite so without humour as that which this youngster
delivered to me through those barely visible eyes. This was a boy-man,
one felt, who knew his Ickles.

'I've just finished introducing Ser *Reeves*.'
Vi Reeves rose from a nearby bench, attired in a grey crewskirt suit that
perfectly accented her charming chestnuts. Her colour was unaugmented
pomegranate. She passed me coldly.

'Thank you, Ser König,' said she.
Phoenix Klaus König, boy-wonder of the current hyper-contemporary
art scene, took me rudely by the buff and chuffs and led me to the bench.
V. R. faced the light. 'I thank the Merchants Committee for allowing us to
employ rudimentary augmentation today. I am now drawing open a holo-
screen in all of our cortexes …'
I wasn't particularly worried about any ill effects of my intrusion on Violet's
plans. If things went wrong, it would only be for the sake of true arithmetic.
I knew her mysterious core better than most. Ickles was correct; V. R. was
calculator, not kulturator.

'Art has no rights,' she began. 'People do, to the past when it's available.
With those rights come responsibility, and that's why I'm here. I'm not
merely an info-architect and experimental mathematician. I'm a fan of art.
Invisible art, in particular. Münsterland, almost alone in Europe, has made
the important decision to continue the celebration of its surviving art into
the future—and today we ask you to take responsibility and support a
return of Skulptur Projekte Münster, specially conceived for 2107.'
It was only 2099 now. They were proposing an eight-year project to-
gether? This seemed a very serious relationship indeed.

'By way of a short introduction as to how and why we believe in the return
of SPM, exactly ninety years since its last incarnation, I will first remind
you that very little actual information remains about which artists made
which works and where those works were or still are. Except for Lawrence
Weiner, whose signed visible works are undeniable, most works that the
Skulptur Projekte brought to your city are like a tipless iceberg of signi-
fication we will never perceive. But how generous is this grant of invisibility
to us when we learn to read the world around us as art?
'With intelligent printers and augciv already on the horizon, invisible
artists who came here in the past were themselves newly cognizant of
the finities of the biosphere and the true cost of memorial culture. Like

Arakawa, perhaps the first AI artist ever, they made ephemeral works, open to the reality of chaos and dissolution inviting the world to artify itself around them.

'Münster has always controlled, as it were, its own cortex. In the sixteenth century, the Anabaptists implemented a Utopia here completely at odds with the Europe outside. There was no such entity as Germany when Karl Marx married a peasant named Jenny, whom historians believe came from Westphalia. Nor was there a Germany when the first Sculpture Project came here in 1977. BRD Noir gave birth to this exhibition. Indeed, we agree the super-corruption of the late 1900s offers hyper-contemporary culture beacons of superpossibility even now. We propose a sort of BRD *science fiction*, where it's possible for humans to forget the state of the future, and to partake in the young and foolish past. Along the, Ah—'

'Tja,' a voice came from behind the light. 'Lovely speech. But augmentation is banned except under extraordinary circumstances.'

Here the wall opened behind me near the floor, and a small hyperbot came discreetly up to my knees.

'But these aren't.'

PKK elbowed me, handing over a pair of cheaply made 3D glasses.

'Glasses!'

No one had worn these sorts of glasses since the '70s. I put them on, pointlessly. I was wearing magnetic shoes, however, so my cortex was off-limits.

'Let's take a stroll through the past and future of this possible exhibition. Along the river, ah—'

It was a tick. She just couldn't seem to name that river.

'You'll find a strange cemetery.' Ickles's plan had most certainly not mentioned these glasses. But as the others were now in augmented reality, I decided to proceed directly to that plan.

The hyperbot unfolded, handed me the rolled up twindow and then reformed into an appropriate demolator.

'We're lucky,' Vi went on. 'A museum guard in the past left behind sketches of a proposal by an artist trio whose work intersected with the digital era enough so as to be able to send us our first beacon. Back in 2007, Dominique, Foerster and Gonzalez had the idea of a humorous farewell to the invisible art of the past, arranging scale models of many of the previous works for the Skulptur Projekte Münster as if in a cemetery. We were actually able to discover several of the old works still existing in the city by discovering these scaled monuments.'

The bot turned into a pole. I descended through the hole in the floor to the gallery of late medieval art below. While the bot repaired the ceiling, I followed the path watchlet was casting. In no time I was standing before the single remaining panel of Giovanni di Paolo's *John the Baptist* altarpiece.

The unscrolled twindow flew to the painting from my hands, conforming exactly to the subjectile.

'Hello there! Welcome to Münster. You cannot do that.'

I turned to find myself confronted by the ironic gaze of one of Münster's finest. A human guard, unautomated.

'Remove your shoes, A. R.'

'Eh?' The guard's eyes opened wide. Mine as well, for the voice had come from the twindowed painting.

As we peered into the extraordinary picture, I kicked off my footwear. Working for Germans just where it was safer perhaps not to have clear opinions on the matter of baptism, this Italian had concocted a sort of early view of the multiverse. Various events were occurring in simultaneity

within a complicated architecture that should *not* have been able to con-
tain them. But it did. In the foreground, I seemed to stand accused while
a mob tore at each other in frustration. I found myself swooning. Soon I
was reclining openly on a bed that had appeared as if it had always been
right there. I felt mysteriously, impossibly impregnated.

 'Watch the corners, A. R.!'
What corners? I saw none. Around every pillar only openings and dark-
nesses, or arches and other roundings.

 'Brighten the corners!' I shouted back, frightened. 'All is darkness.' I shiv-
 ered. No one in this composition had shoes. Including myself.
As if I were back in the Office in New L.A., 1990s' indie rock played
(Teenage Fanclub's *Guiding Star* on infinipeat). The weird wilderness of
pillars walked stiffly around me. Spiral stairs showed hind parts visible,
and from far beyond peered a familiar fish-like bespectacled eye. Am I
Ickles? I thought in terror.

 'A. R. Focus here!'
 'A. R.?' Face said. Here occurred a series of effects difficult to describe
 except in succession.
Self-concept was fleeting.
V.R. stood with me, but we were the size of insects. Beside us there rested
an enormous spaceball, and two more just beyond, suggesting a zero-
gravity playing field somewhere in orbit.

 Vi said, 'Claes Oldenburg built a sculpture to remind us that we are in
 fact walking through a set of miniatures in the *Stadtmuseums* of our
 own futures.'
This view gave way to another more medieval setting. I was not only inside
a set of colours and smells I didn't understand but in an enormous pot.
Beside me an Ickles dressed in fool's motley worked a bellows.

 'Ach,' I said. 'Saw Ickles.' My face distorted, smeared against itself and
 Ickles at the same time.
 'Archie, remain calm. You're just standing in the Dan Graham funhouse
 built for 1997.'
 'Now we realize that this round piece by Donald Judd was intended not
 only to provide a canvas for those inclined to spray-paint their own art
 upon the city but as a ramp for gravboarders as well.'
 'A. R.,' barked Ickles through that mirror. 'Who gave you those glasses?'
 'Outside a hall of science, invisisculptor Bruce Nauman chose not to por-
 tray anything,' said König. 'Instead, he dug a hole where people smoked
 and covered it in pavement, as if to topple them all into a big ashtray. Eh?
 This we like.'
A swarthy, nude König had one arm around me; with the other he touched
my apple. I was not only without shoes, I was entirely nude, manipulating
a handy branch to cover us from the observing committee.

 'Ickles? Where are you?'
 'Lying on a bench naked,' answered my employer. 'The corpus is com-
 fortable. Through a small pretty hole in the belly a red glistening string
 emerges, tightly running up to a spit they are turning above. Soon all will
 be rolled away.'
 'Painting collapses space; architecture condenses,' said König. 'Sculpture
 creates it.'
 'Yes,' said Vi. 'Vote *yes* now, for 2107! There is not a moment to be lost.'
 'How?' I asked, for those without self do exactly what they are told.
 Ickles answered, and not to the point. 'Unfortunately, those glasses are
 twindow, A. R. Twindow on twindow? Self is at risk. Since one met your
 gaze, our superpositioned points of view are now fused for all intents and
 purposes (imaginatively speaking) with the complex visible surface of the

larger dimensional *Münstercrystal* that perplexes beings of sorts you cannot even conceive from all the Westphaliae. If twindow here were removed, you would be doomed to occupy the visible possible surface of the larger *Münstercrystal* for all time. One solace: Ickles, Etc. was able to make a deal ten years ago with local glass-makers. The seventy-two tons of quasicrystal so toxic to the taxbots of New California are now off the books.'

'What did you get in return?'

'The other half of the diptych you now still occupy.'

An unwelcome scent met these words.

Ickles and I stood hand in hand, fairylike beneath a towering pair of hedges. Violet narrated, 'In this visible invisible work, R. Trockel satirized a certain propensity of male carnivalers in Münsterland parkland greeneries. She planted hedges large enough that women can enter and relieve themselves and feel safe as well.'

Now delectable cherries of the sort I remember from my youth stood tall as a church before me. The world was young. I had Münster entirely converted to my opinion concerning the proper time to baptize.

Ickles screamed, 'A. R.! DO NOT REMOVE THAT TWINDOW!'

Self snapped immediately back. It was the guard who had rolled away the twindow from the painting. He handed it over. I found myself standing with Violet Reeves, as if returned from the dead.

Violet took off my glasses.

'What just happened?' I asked her.

'You just cut a hole in the floor and disturbed a priceless painting, for starters.'

'Look, I just do what I'm told. But I came to take you home. You're not a kulturator. You're a—'

'Co-kulturator. You post-American men! You're all alike. Guess what? I don't need anybody's help, advice, or interference in my affairs. Oh Archie, you're as predictable as Ickles.'

'Now that's below the chuffs.'

'Anyhow, I'm not really angry,' she whispered.

We heard some commotion from the next room. 'I left a twindow on Hermann tom Ring's *The Last Judgement*. Incidentally, they all voted *yes*. Unanimous. So even with self, no one will now want to be left out.'

'And *his* self-concept?' I pointed to the large young König. As he looked through glasses at us, I noted an UNKEL WILLY button pinned to his breast.

'Phoenix is *gaining* self-concept! He was actually a printed baby, fused from the DNA of the two founders of Skulptur Projekte Münster, Kasper König and Klaus Bußmann. Isn't that strange? Another hour or so of twindowing the Münstercrystal and he will have a functioning unconscious.'

'Well he does seem a bit … young.'

'I know, Isn't he adorable? We're fibonaccis! He thinks it explains the *incredible* sex.'

I looked for solace. 'Is Ickles trapped in that painting by any chance?'

'Ickles will have to enclose the corpus in a piece of the nearby Münstercrystal as old as that painting. Then he can remove his twindow and see what happens.'[3]

'You knew about the Ickles plan to unload quasicrystal all along? You double-twindowed so as to place the Committee self-concepts in jeopardy!'

She put a finger to those lips.

'But how did Ickles unload all that q?'

She gesticulated upwards.

'How do you think they covered Westphalia?' she winked. Or did she just squint those lashed but lidless eyes? She leaned aromatically forward,

so that my single heart did a two-step quadrille.

'Is that a typo?'

'Excuse me?'

'The words *FRIGHTEN THE CORNERS* are now tattooed on your forehead.'

Somewhere a horn blew, as if from high up a church.

1 In what is now seen as a classic gesture of invisible art, in 2017 artist Cosima von Bonin proposed hauling the Moore away as a performance work of her own. But the Merchants Committee, always eager to promote cheese, rejected this proposal.

2 I never did figure out the significance of that second L.

3 Ickles was discovered inside the Knipperdolling cage still hanging up beside the steeple of St Lamberti—alive, but without implants, dental work, or a stitch of clothing.

Mark von Schlegell

Öffentliche Sammlung
Public Collection

Dennis Adams
Giovanni Anselmo
Siah Armajani
Richard Artschwager
Lothar Baumgarten
Martin Boyce
George Brecht
Daniel Buren
Hans-Peter Feldmann
Ian Hamilton Finlay
Ludger Gerdes
Dan Graham
Jenny Holzer
Rebecca Horn
Huang Yong Ping
Donald Judd
Ilya Kabakov
Per Kirkeby
Harald Klingelhöller
Matt Mullican
Bruce Nauman
Maria Nordman
Claes Oldenburg
Jorge Pardo
Guiseppe Penone
Susan Philipsz
Hermann Pitz
Martha Rosler
Ulrich Rückriem
Thomas Schütte
Richard Serra
Susana Solano
Rosemarie Trockel
Richard Tuttle
Herman de Vries
Silke Wagner
Rachel Whiteread
Rémy Zaugg

Dennis Adams

Dennis Adams (*1948 Des Moines) kombiniert in seinen orts-spezifischen Installationen häufig Fotografie mit Architektur. Dabei entwickelt er funktionale Objekte wie Kioske und Trink-hallen. 1983 begann er mit *Bus Shelter I* eine Serie von Bus-haltestellen. Die Architektur dient Adams dabei als formaler Rahmen für Fragmente eines kollektiven Bildwissens und der Auseinandersetzung mit der medialen Wahrnehmung histo-rischer Ereignisse. *Bus Shelter IV* nimmt Bezug auf Deutsch-lands NS-Vergangenheit: Statt bunter und verführerischer Werbemotive zeigen die Fotografien, die auf Leuchtkästen angebracht sind, Bilder eines zeitaktuellen Geschehens: Sie entstammen dem Gerichtsprozess gegen den SS-Kriegsver-brecher Klaus Barbie in Frankreich im Jahr 1987. Die schräg gegenübergestellten Zwischenwände aus semitransparenten Spiegeln reflektieren die Motive dieser Leuchtkästen ebenso wie die Betrachter_innen, die dadurch in das Geschehen mit-einbezogen werden.

Giovanni Anselmo

Bei Giovanni Anselmos (*1934 Borgofranco d'Ivrea) Arbeit handelt es sich um ein knapp eineinhalb Meter hohes und eingefasstes Vierkanteisen, auf dessen Oberseite folgende Worte eingraviert sind: „Verkürzter Himmel". Die Stele, die entfernt an einen Zollstock erinnert, erhebt den unmöglichen Anspruch, die unendliche Entfernung zwischen Himmel und Erde zu vermessen und möchte diese um einen überprüf-baren Abstand verkürzen. Als Referenz diente dem Künstler Walter De Marias in die Erde gebohrtes Werk *Der Vertikale Erdkilometer* von 1977. Durch die Platzierung direkt neben dem Gebäude der Katholisch-Theologischen Fakultät der Universität wirkt die Skulptur mit ihrem Anspruch auf den Himmel wie eine provokante Setzung. Im Kontext christlicher Theologie betrachtet, setzten sich 1987 die Anhänger der damals aktuellen kirchenkritischen Befreiungstheologie ge-gen eine weltabgewandt-idealistische Spiritualität und für eine gesellschaftspolitisch (links-)aktive Kirche ein.

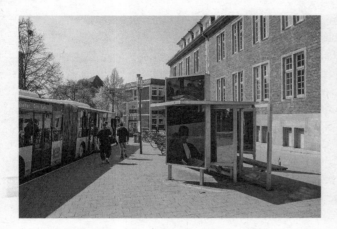

Bus Shelter IV [Bushaltestelle IV]
Skulptur Projekte in Münster 1987

Verkürzter Himmel [Shortened Sky]
Skulptur Projekte in Münster 1987

In his site-specific installations Dennis Adams (*1948 Des Moines) often combines photographs with architecture. In doing so, he designs functional objects such as kiosks and re-freshment stands. In 1983 his work *Bus Shelter I* marked the beginning of a series of bus stop installations. The architecture gives Adams a formal frame for fragments of a collective body of pictorial knowledge and serves as a means to explore the media perception of historical events. *Bus Shelter IV* makes reference to Germany's Nazi past. In place of colourful and seductive advertising motifs, the photographs, which are mounted in light boxes, show images of what was then a con-temporary event: the trial of SS war criminal Klaus Barbie con-ducted in France in 1987. The diagonally positioned screens made of semi-transparent mirror glass reflect not only the images in the light boxes but also the viewers, who become involved in the event as a result.

Giovanni Anselmo's (*1934 Borgofranco d'Ivrea) work in-volves a square iron post that is almost one and a half metres in height and is framed by a metal support. On top of it are engraved the words 'Verkürzter Himmel'. The stela, which vaguely resembles a yardstick, aspires to the impossible task of measuring the infinite distance between heaven and earth and sets out to reduce this space by a verifiable amount. The artist here makes reference to Walter de Maria's 1977 work *Vertical Earth Kilometer*, a brass rod inserted into a hole drilled in the ground. The sculpture's positioning directly ad-jacent to the university's Faculty of Roman Catholic Theology makes its attempt to lay claim to heaven seem like a provoc-ative statement. If we look at the work in the context of Chris-tian theology, in 1987 the supporters of liberation theology, which was critical of the Church at the time, were opposed to an idealistic form of spirituality that was detached from the world, and championed (left-wing) sociopolitical activism.

- Aluminium, Holz, Plexiglas, Zweiwegspiegelglas, Fotografien, Leuchtstoffröhren, 300 × 465 × 310 cm
- Haltestelle Aegidiimarkt / LWL-Museum, Johannisstraße
- Eigentümer: LWL-Museum für Kunst und Kultur, Münster

- Aluminium, wood, Plexiglas, two-way mirrors, photographs, fluorescent lighting, 300 × 465 × 310 cm
- Bus stop: Aegidiimarkt A / LWL-Museum, Johannisstraße
- Owned by: LWL-Museum für Kunst und Kultur, Münster

- Rostfreier Stahl, Schriftgravur, 140 × 10 × 10 cm
- Aa-Promenade, Höhe Johannisstr. 8–10 / Katholisch-Theologische Fakultät der Westfälischen Wilhelms-Universität Münster
- Eigentümer: Leihgabe des Künstlers, LWL-Museum für Kunst und Kultur, Münster

- Stainless steel, engraved lettering, 140 × 10 × 10 cm
- Lake Aa Promenade, level with Johannisstr. 8–10 Faculty of Roman Catholic Theology at the University of Münster
- Owned by: the artist—on loan to the LWL-Museum für Kunst und Kultur, Münster

Siah Armajani

Inmitten von Steinformationen und exotischen Bäumen errichtete Siah Armajani (*1939 Teheran) mehrere offene und geschlossene Sitzgruppen, die zusammen eine idyllische Bibliothekssituation im Freien ergeben. Der Künstler schafft damit eine Art Seminarraum an der frischen Luft, den Studierende und Dozent_innen der umliegenden Institute gerne nutzen. Seine Arbeiten im öffentlichen Raum bewegen sich zwischen Kunst, Design und Architektur, eine alltägliche Nutzbarkeit ist intendiert. Die Gestaltung des Ensembles hebt sich dabei stark vom üblichen Mobiliar im Stadtraum ab. Unter dem Gelände des Studiergartens befindet sich ein unterirdischer Schutzraum, der in den 1980er Jahren dem Zoologischen Institut für erschütterungsfreie Messungen zu Forschungszwecken diente. Armajani thematisiert das Studieren und Forschen, welches sich sonst hinter verschlossenen Türen abspielt, und trägt es in den Stadtraum.

Study Garden [Studiergarten]
Skulptur Projekte in Münster 1987

In the midst of rock formations and exotic trees, Siah Armajani (*1939 Tehran) built several open and closed seating arrangements that, taken together, create an idyllic outdoor library. The artist has produced a kind of open-air seminar space that students and staff of the surrounding institutes are welcome to use. His work in the public space moves between art, design, and architecture and is intended for everyday usage. The design of the ensemble is in stark contrast to the usual outdoor furniture to be found in urban settings. Beneath the site of the *Study Garden* there is an underground shelter that was used in the 1980s by the university's Institute of Zoology to conduct vibration-free measurements as part of their research. Armajani focuses on the world of study and research, which otherwise takes place behind closed doors, and brings it out into the urban space.

- Zwei Eckbänke, zwei Bänke, vier Hocker und ein Tisch, Holz, Stahl
 Gesamtgröße der Installation: 104 × 580 × 780 cm, Tisch: 180 × 130 × 130 cm
- Garten des Geologischen Museums der Westfälischen Wilhelms-Universität
 Münster, Pferdegasse 3
- Eigentümer: LWL-Museum für Kunst und Kultur, Münster

- Two corner benches, two benches, four stools, and a table; wood, steel
 Total size of installation: 104 × 580 × 780 cm; table: 180 × 130 × 130 cm
- Garden of the Geomuseum at the University of Münster, Pferdegasse 3
- Owned by: LWL-Museum für Kunst und Kultur, Münster

Richard Artschwager

Richard Artschwager (*1923 Washington D.C., †2013 Albany) ergänzte fünf Fahrradständerelemente, wie sie in den 1980er Jahren das Stadtbild von Münster prägten, um einen vertikalen, fast drei Meter hohen Auswuchs. Oben ist ein kleiner Baum gepflanzt. Die Objekte des Künstlers erinnern an Readymades und bewegen sich zwischen Möbel und Kunstwerk: Es sind verfremdete Alltagsobjekte, die trotz Überformung ihren praktischen Nutzen nicht verlieren. Das Fahrradständermonument kann man als einen ironischen Beitrag zur Diskussion zum Thema Stadtmöblierung verstehen: Nicht nur in Münster waren in den 1970er und 1980er Jahren Betonelemente das bevorzugte Gestaltungselement, um öffentliche Plätze zu verschönern. Pflanzkübel mit pflegeleichtem Grün sollten vielerorts stadtplanerisches Unvermögen kaschieren. Dabei war insbesondere der Zustand der Kübel ein sicheres Zeichen für die Aufmerksamkeit, die Stadtverwaltung und Anwohner_innen einem Platz schenkten.

Ohne Titel (Fahrradständermonument B) [Untitled (Bike Rack Monument B)]
Skulptur Projekte in Münster 1987

Richard Artschwager (*1923 Washington DC, †2013 Albany) supplemented five bike racks, of the kind that characterized Münster's urban landscape in the 1980s, with a vertical form that rises out of them to a height of almost three metres and has a small tree planted on top. The artist's objects recall ready-mades and move to and fro between furniture and artwork: they are alienated everyday objects that retain their practical purpose despite being redesigned. The bike rack monument can be seen as an ironic contribution to the discussion about urban street furniture: in the 1970s and 1980s Münster was not alone in favouring concrete elements as a design feature aimed at beautifying public spaces. In many places, plant containers with low-maintenance greening were meant to conceal inadequacies in urban planning. The condition of the containers was a reliable indicator of the attention given to a site by the city administration and local residents.

- Beton und Bepflanzung
 Fünf Fertigelemente (Fahrradständer) je 50 × 75 × 50 cm,
 Gusselement 282 × 75 × 50 cm
- Vor dem Gebäude Schlossplatz 1, AStA der Westfälischen Wilhelms-Universität
 Münster; für die Laufzeit der Skulptur Projekte 2017 verliehen nach Marl
- Eigentümer: LWL-Museum für Kunst und Kultur, Münster

- Concrete and greenery
 Five prefabricated elements (bike racks): 50 × 75 × 50 cm each;
 cast element: 282 × 75 × 50 cm
- In front of the building at Schlossplatz 1, General Students' Committee (AStA)
 of the University of Münster; on loan to Marl for the duration of the
 Skulptur Projekte 2017
- Owned by: LWL-Museum für Kunst und Kultur, Münster

Lothar Baumgarten

Den Ausgangspunkt für Lothar Baumgartens (*1944 Rheinsberg) Lichtinstallation bilden die historischen Ereignisse der reformatorischen Täuferbewegung von Münster in den 1530er Jahren: Das Täuferreich war eine radikal reformatorisch-christliche Bewegung im 16. Jahrhundert, die mit Härte und Gewalt die eigenen Glaubensvorstellungen von Apokalypse und der Wiederkunft Jesu Christi verfolgte. In der Johannisnacht 1535 wurde den Anführern der Bewegung – Jan van Leiden, Heinrich Krechting und Bernd Knipperdollinck – der Prozess gemacht. Die nach der Folter geschundenen Körper wurden in eisernen Körben zur Schau gestellt. Baumgarten erinnert an diese Geschehnisse und mahnt den Umgang mit Andersgläubigen an. Die Lichter leuchten seit 1987 Nacht für Nacht in den Eisenkörben am Kirchturm der St.-Lamberti-Kirche. Der Titel der Installation verweist auf die verirrten Seelen der Täufer, die auf den falschen Weg geraten sind, aber auch auf die fragwürdige Zurschaustellung der Folter.

Drei Irrlichter [Three Friar's Lanterns]
Skulptur Projekte in Münster 1987

The historical events surrounding the reformational Anabaptist movement in Münster in the 1530s constitute the starting point for Lothar Baumgarten's (*1944 Rheinsberg) light installation: the Anabaptist Kingdom was a Christian movement of the Radical Reformation in the sixteenth century that pursued its own religious vision of the Apocalypse and Second Coming of Christ with severity and violence. On 24 June 1535, the leaders of the movement—John of Leiden, Heinrich Krechting, and Bernd Knipperdollinck—were put on trial. Their tortured bodies were subsequently displayed in iron cages. Baumgarten evokes these events and reminds us of how heretics and dissenters were dealt with. Since 1987 the lights in the iron cages on the tower of St Lamberti Church have been illuminated every night. The title of the installation refers not only to the errant souls of the Anabaptists, who found themselves on a false path, but also to the questionable practice of making torture a public spectacle.

- Drei Glühbirnen à 15 Watt, drei Eisenkörbe
- Südseite St.-Lamberti-Kirchturm, in 60 m Höhe, Kirchherrngasse 3
- Eigentümer: LWL-Museum für Kunst und Kultur, Münster

- Three 15 Watt lightbulbs; three iron cages
- South side of the tower of St Lamberti Church, at a height of 60 metres Kirchherrngasse 3
- Owned by: LWL-Museum für Kunst und Kultur, Münster

Martin Boyce

Martin Boyces (*1967 Hamilton) Installation besteht aus 13 Betonplatten, für die der Künstler auf ein Repertoire aus Dreiecken, Parallelogrammen und unregelmäßigen geometrischen Formen zurückgreift. In einige Fugen zwischen diesen Platten legte er Messingleisten ein, die, im Ganzen betrachtet, den Satz „We are still and reflective" formen. Die Arbeit reduziert das Skulpturale auf die horizontale Ebene. Zwei Bäume durchbrechen diese jedoch als vertikale Komponenten. Sie sind Jahreszeiten und Wachstum ausgesetzt und fügen dem Werk ein prozessuales Element hinzu. Boyce entwickelte sein Lexikon der Formen inspiriert von vier abstrakten Betonbäumen der französischen Bildhauer Jan und Joël Martel, die diese 1925 auf der *Exposition Internationale des Arts Décoratifs et Industriels Modernes* in Paris zeigten.

We are still and reflective [Wir sind still und reflektieren]
skulptur projekte münster 07

Martin Boyce's (*1967 Hamilton) installation consists of thirteen concrete slabs, which the artist deploys as an array of triangles, parallelograms, and irregular geometric forms. Strips of brass are inserted into some of the joints between the slabs, which, when viewed as a whole, form the sentence 'We are still and reflective'. The work reduces the sculptural element to the horizontal plane, although two trees break through this as vertical components. They are subject to the changing seasons and the effects of growth, adding a processual aspect to the work. In developing his lexicon of forms, Boyce was inspired by the four abstract trees made in concrete by the French sculptors Jan and Joël Martel, who showed their work at the 1925 exhibition *Exposition Internationale des Arts Décoratifs et Industriels Modernes* in Paris.

- Bodeninstallation aus Gussbetonplatten und Messing, 3238 × 1438 cm
- Himmelreichallee, ehemaliges Zoogelände, nördlich des LBS-Gebäudes An der Gräfte
- Eigentümer: LWL-Museum für Kunst und Kultur, Münster

- Ground installation made of poured concrete slabs and brass, 3238 × 1438 cm
- Himmelreichallee, the site of the former zoo, north of the LBS building on An der Gräfte
- Owned by: LWL-Museum für Kunst und Kultur, Münster

George Brecht

George Brecht (*1926 New York, †2008 Köln) platzierte ursprünglich drei Findlinge (durch Naturgewalt geformte Steine) im Stadtraum Münster, in die er, inspiriert vom Zen-Buddhismus, das Wort „VOID" [Leere oder leeren] eingravieren ließ. Der im Schlosspark verbliebene Stein lädt zu meditativen Momenten ein, bei denen eine Kunst-ähnliche Achtsamkeit den Details des Lebens gegenüber geübt werden soll. In seiner Projektbeschreibung „Three Projects for Münster" gibt Brecht Anweisungen zu Auswahl und Platzierung der Steine, sodass die 1987 erfolgte Umsetzung tatsächlich nur eine von vielen möglichen Realisierungen darstellt. Damit rückt die Arbeit in die Nähe der *Event Scores* (Ereignis-Partituren), die Brecht, angeregt durch John Cage, seit Ende der 1950er Jahre entwickelte und die sein Werk bis zu seinem Tod begleiteten.

Three VOID-Stones [Drei LEERE-Steine]
Skulptur Projekte in Münster 1987

Inspired by the tenets of Zen Buddhism, George Brecht (*1926 New York, †2008 Cologne) had the word VOID carved into three boulders (rocks shaped by natural forces), which he then positioned in Münster's urban space. The remaining stone from the original three, which is located in the palace gardens, is an invitation to a moment of reflection in which a mindfulness that is akin to art is to be applied to the details of life. Brecht's project outline 'Three Projects for Münster' includes instructions on the choice and positioning of the stones, and the idea that was implemented in 1987 actually represents only one of many possible manifestations. The work thus resembles the *Event Scores* that Brecht—prompted by John Cage—began to develop in the late 1950s and which became a feature of his work until his death.

- Findling, graviert (einer von ursprünglich drei Steinen), 75 × 120 × 125 cm
- Äußerer Schlossgarten, Höhe Edith-Stein-Straße
- Eigentümer: Stadt Münster

- Boulder, engraved (one of originally three stones), 75 × 120 × 125 cm
- Outer palace garden, in the vicinity of Edith-Stein-Straße
- Owned by: City of Münster

Daniel Buren

Daniel Buren (*1938 Boulogne-Billancourt) errichtete an vier Zugangswegen zum Domplatz rot-weiß gestreifte Objekte, die die Form eines Tores abstrakt aufgreifen. Aufgrund ihrer Größe und Platzierung erschwerten diese das Betreten und Verlassen des Platzes. Wie in vielen seiner Installationen entschied sich Buren für ein reproduzierbares und universales Streifenmuster ohne Eigenaussage, mit dem er direkt auf eine gegebene räumliche Situation reagiert und so nicht nur vorgefundene Orte markiert, sondern neue erschafft. Inhaltlich bezog sich die Installation auf die Trennung zwischen Kirche und Gemeinde, die an dieser Stelle noch bis ins 19. Jahrhundert durch eine Mauer manifest wurde und den geistlichen vom weltlichen Bereich separierte. Diese Domimmunität schlägt sich bis heute in der Bauweise der Innenstadt nieder und war formgebend für die Anordnung der Kaufmannshäuser am Prinzipalmarkt. Seit Mitte 2016 ist wieder eines der ehemals vier Tore aufgestellt.

4 Tore [4 Gates]
Skulptur Projekte in Münster 1987

Daniel Buren (*1938 Boulogne-Billancourt) set up red-and-white-striped objects on four paths leading to the cathedral square; the objects have an abstract relationship to the form of a gate. Their size and placement make it more difficult to enter and leave the square. As in many of his installations, Buren decided to use a universal, replicable pattern of stripes, dispensing with any individual statement. The design is a direct response to a given spatial situation, and the artist thus not only highlights the 'found' places but also creates them anew. Contextually speaking, the installation relates to the separation between Church and community that was made manifest here by a wall that was still in place in the nineteenth century and which separated the spiritual and secular realms. This immunity enjoyed by the cathedral is still reflected in the design of the city centre and was instrumental in determining the arrangement of the merchant's houses on Prinzipalmarkt, the city's historic marketplace. In the middle of 2016 one of the four gates was reinstalled.

- Ursprünglich vier Objekte aus Aluminium, lackiert, je 441 × 441 × 10 cm
- Aufstellung zwischen Paulusdom und Innenstadt für die Dauer der Ausstellung 1987: Geisbergweg/Domgasse/Spiegelturm/Jesuitengang; ab Mitte 2016 permanente Aufstellung eines Tores an der Domgasse
- Eigentümer: Stadt Münster

- Originally four objects made of aluminium, lacquered, each one 441 × 441 × 10 cm
- Erected between Münster's St Paul's Cathedral and the city centre for the duration of the exhibition 1987: Geisbergweg/Domgasse/Spiegelturm/Jesuitengang; since the middle of 2016 one gate has been permanently installed on Domgasse
- Owned by: City of Münster

Hans-Peter Feldmann

Hans-Peter Feldmann (*1941 Düsseldorf) machte den schlechten Zustand öffentlicher WCs zum Ausgangspunkt seiner Arbeit: Am Domplatz befindet sich eine Toilettenanlage, wie sie in der Nachkriegszeit in deutschen Städten häufig eingerichtet wurde. Mittlerweile jedoch sind viele dieser Orte aufgrund der schwindenden Mittel der Kommunen entweder durch Vernachlässigung gezeichnet, ganz dem Sparzwang zum Opfer gefallen oder von der öffentlichen Hand in private Trägerschaft übergegangen. Feldmann, Vertreter einer demokratischen Konzeptkunst, installierte helle Fliesenspiegel, Trennelemente aus maigrünen Mosaiksteinen, großzügige Sanitärkeramik und dekorative Elemente wie großformatige Fotoprints von Lilienblüten und einen bunten Plastikkronleuchter. Carl Andres Diktum, dass eine Gesellschaft, die keine öffentlichen Toiletten zur Verfügung stelle, Kunst im öffentlichen Raum nicht würdig sei, scheint als Inspiration naheliegend.

WC-Anlage am Domplatz [Public Toilet Facilities on the Cathedral Square]
skulptur projekte münster 07

Hans-Peter Feldmann's (*1941 Düsseldorf) work was prompted by the poor condition of public toilets: on Münster's cathedral square (Domplatz) there is a toilet facility of the kind that was frequently built in German cities after the war. The years have taken their toll, however, and the dwindling resources of the municipalities have led to a situation in which many of these places are now showing signs of neglect, have fallen victim to mandatory budget cuts, or have passed from public ownership into private hands. Feldmann, an advocate of a democratic form of conceptual art, installed light-coloured splashback, partitioning finished with May green tessera, capacious sanitaryware, and decorative elements such as large-format photographic prints of lily flowers and a colourful plastic chandelier. Carl Andre's dictum that a society that does not provide public toilets does not deserve art in the public space seems to have been a natural source of inspiration.

- Installation in einer öffentlichen Toilettenanlage
- Domplatz
- Eigentümer: Stadt Münster

- Installation in a public toilet
- Domplatz
- Owned by: City of Münster

Ian Hamilton Finlay

Ian Hamilton Finlay (*1925 Nassau, †2006 Edinburgh) befestigte in vier Metern Höhe am Stamm einer alten Pappel in Erinnerung an die westfälische Dichterin Annette von Droste-Hülshoff (1797–1848) eine Gedenktafel. Die Sandsteinplatte befindet sich in der Nähe der Begräbnisstätte der Familie Droste auf dem ehemaligen Überwasserfriedhof, der seit 1926 Teil einer öffentlichen Parkanlage ist. Darauf zitiert der Künstler aus einem Gedicht der Literatin, Komponistin und Dichterin: „Meine Lieder werden leben, wenn ich längst entschwand." Finlay war ebenfalls Dichter und wurde in den 1960er Jahren als Vertreter der Konkreten Poesie bekannt. Seine Gedichte entwickelte er schließlich zu Ein-Wort-Gedichten, die er unter anderem an Bäumen, Säulen oder auf Bodenplatten anbrachte. Sie bedürfen ihrer Umgebung als Bezugspunkt und damit eines ortsspezifischen Verweises, der hier durch den Friedhof gegeben ist.

A Remembrance of Annette [Erinnerung an Annette]
Skulptur Projekte in Münster 1987

Ian Hamilton Finlay (*1925 Nassau, †2006 Edinburgh) fixed a plaque in memory of the Westphalian poet Annette von Droste-Hülshoff (1797–1848) to the trunk of an old poplar tree at a height of four metres. The sandstone tablet is located near the burial site of the Droste family in the old Überwasser cemetery, which has formed part of a public park since 1926. On it the artist quotes from a poem authored by the writer, composer, and poet: 'My songs will live on long after I am gone.' Finlay was also a poet and was known in the 1960s as an exponent of concrete poetry. He ultimately developed his poems into one-word pieces, which he displayed in a variety of settings, mounting them on trees and pillars or adding them to floor slabs. Relying on their surroundings as a reference point, they allude to the site in which they are installed, in this case the cemetery.

- Englischer Kalksandstein, 35 × 75 × 20 cm
- Alter Überwasserfriedhof, Wilhelmstraße
- Eigentümer: LWL-Museum für Kunst und Kultur, Münster

- English sandstone, 35 × 75 × 20 cm
- Old Überwasser cemetery, Wilhelmstraße
- Owned by: LWL-Museum für Kunst und Kultur, Münster

Ludger Gerdes

Ludger Gerdes (*1954 Lastrup, †2008 bei Dülmen) konstruierte am Stadtrand an der Grenze zum ländlich geprägten Umland eine gemauerte, von einem Wassergraben umgebene und mit Rasen bedeckte Insel in Form eines Schiffes. Auf dem Heck steht eine hölzerne Säulenarchitektur, zwei Pappeln in der Mitte der Insel dienen als Schattenspender. Mittlerweile ist das Schiff stark mit der umgebenden Natur verwachsen. Der Künstler wählte einen Standort an der Peripherie abseits vom Stadtkern, jedoch entlang einer Sichtachse zum Zentrum. Darüber hinaus verwendete er eine zugängliche narrative Bildsprache: Das Schiff erinnert an die Binnenschifffahrt auf dem Dortmund-Ems-Kanal und steht als Metapher für das Leben.

Schiff für Münster [Ship for Münster]
Skulptur Projekte in Münster 1987

On the outskirts of Münster, on the edge of the rural area surrounding the city, Ludger Gerdes (*1954 Lastrup, †2008 near Dülmen) built a stone island in the form of a ship, surrounded by a moat and covered with grass. At the stern stands a structure built on wooden pillars, while two poplar trees in the middle of the island provide shade. Over time the ship has grown together with the nature around it. The artist chose a site on the periphery away from the heart of the city, although it is located along a visual axis that connects to the centre. Moreover, he used a narrative visual language that is accessible: the ship evokes the inland waterway transport on the Dortmund–Ems Canal and serves as a metaphor for life.

- Installation aus Sandstein, Holz und zwei Pappeln, Gesamtgröße der Installation: 4300 × 500 cm, Grabenbreite 400 cm, Hütte 460 × 420 × 740 cm
- Neben dem Kinderbach, zwischen Horstmarer Landweg und Mendelstraße
- Eigentümer: Stadt Münster

- Installation made of sandstone, wood, and two poplars Total size of installation: 4300 × 500 cm; width of moat: 400 cm; lodge: 460 × 420 × 740 cm
- Beside the Kinderbach stream, between Horstmarer Landweg and Mendelstraße
- Owned by: City of Münster

Dan Graham

Dan Grahams (*1942 Urbana) oktogonaler, vollverspiegelter Pavillon bezieht sich formal auf den Musikpavillon von 1929 im Park hinter dem Schloss sowie auf die Fassade des ganz in der Nähe gelegenen Bankgebäudes. Inhaltlich verweist der Pavillon auf die Tradition des sogenannten Lustpavillons, der seit dem Barock als Treffpunkt für die Gesellschaft und für Feierlichkeiten ein fester Bestandteil von Park- und Schlossanlagen war. Grahams Pavillon hat keine Fenster und kann nur durch eine Wandseite, die als Scharniertür fungiert, betreten werden. Somit sind im Inneren die Besucher_innen vor den Blicken der Vorübergehenden geschützt, gleichzeitig ist der Blick nach draußen nur verzerrt möglich. Durch die Spiegelung der Umgebung auf der Außenfassade ergeben sich neue landschaftliche Räume, welche die Architektur des Pavillons selbst optisch zum Verschwinden bringen.

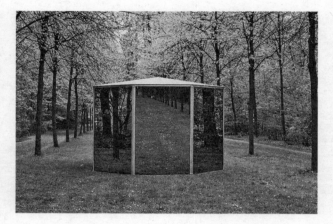

Oktogon für Münster [Octagon for Münster]
Skulptur Projekte in Münster 1987

Dan Graham's (*1942 Urbana) octagonal, fully mirrored pavilion has a formal relationship to the park's music pavilion, which was constructed behind the palace in 1929, and to the façade of the bank building that stands in the immediate vicinity. In contextual terms, the pavilion refers to the tradition of the 'pleasure pavilion' (*Lustpavillon*), which was an integral feature of parks and palace grounds, where it served as a meeting place for social gatherings and festivities. Graham's pavilion is windowless and can only be entered via a wall element that acts as a hinged door. On the inside, visitors are protected from the gaze of passers-by, while the only view of the outside is a distorted one. The mirroring of the surroundings on the external façade produces new spaces in the landscape, causing the pavilion's own architecture to disappear from view.

- Oktogonaler Pavillon aus Zweiweg-Spiegelglas, Metall und Holz; Höhe 240 cm, Durchmesser 365 cm
- Allee im südlichen Schlossgarten für die Dauer der Skulptur Projekte 2017
- Eigentümer: LWL-Museum für Kunst und Kultur, Münster

- Octagonal pavilion made of two-way mirror glass, metal, and wood Height: 240 m; diameter: 365 cm
- Avenue in the southern section of the palace gardens for the duration of the Skulptur Projekte 2017
- Owned by: LWL-Museum für Kunst und Kultur, Münster

Jenny Holzer

Zwei von Jenny Holzers (* 1950 Gallipolis) ehemals fünf Sandsteinbänken, die symmetrisch angeordnet rechts und links des Kriegerdenkmals von Alexander Frerichmann aus dem Jahr 1923 auf der Hauptallee im Schlosspark standen, sind mittlerweile dauerhaft im Schlossgarten aufgestellt. Auf den Sitzflächen befinden sich, vergleichbar mit Gedenktafeln, Inschriften, die nüchtern die Grausamkeiten des Krieges thematisieren. Vergleichbar mit vielen anderen ihrer Werke verwendete die Künstlerin auch für die Bänke anonyme, schnell erfassbare Phrasen, die auf Volksweisheiten oder Klischees zurückgehen. Formal und inhaltlich nehmen die Bänke Bezug auf den Krieg; ohne Arm- und Rückenlehnen erinnern sie an Sarkophage oder Grabmonumente. Der verwendete Schrifttyp findet sich vorwiegend auf Grabmälern amerikanischer Friedhöfe wieder. Durch die Ausrichtung der Bänke sowie mittels der Inschriften tritt das Kunstwerk in einen kritischen Dialog mit dem vorhandenen Denkmal.

Bänke [Benches]
Skulptur Projekte in Münster 1987

Two of the five sandstone benches that Jenny Holzer (* 1950 Gallipolis) originally made have now been installed as a permanent feature of the palace gardens. They are symmetrically arranged to the right and left of Alexander Frerichmann's 1923 war memorial on the main avenue of the park. In much the same way as a memorial plaque, the bench seats have inscriptions that reflect on the cruelties of war in a dispassionate way. In common with many of her other works, the artist used impersonal, easily understood phrases here that hark back to folk wisdom or platitudes. The form and content of the benches refer to the war: stripped of both arm- and backrests, they evoke sarcophagi or tombs. The type of lettering Holzer employed can be found on many monuments in American cemeteries. The alignment of the benches and the use of inscriptions bring the artwork into a critical dialogue with the existing monument.

- Zwei Kunststeinabgüsse von ursprünglich fünf Sandsteinbänken mit Inschriften, Bänke je 50 × 35 × 152 cm
- Lindenallee im südlichen Schlossgarten, angegliedert an das *Denkmal für die im Ersten Weltkrieg gefallenen Soldaten des 22. Artillerieregiments* von Alexander Frerichmann (1923)
- Eigentümer: LWL-Museum für Kunst und Kultur, Münster

- Artificial stone castings of two of the original five sandstone benches with inscriptions, each bench 50 × 35 × 152 cm
- Lime tree avenue in the southern section of the palace gardens, adjacent to Alexander Frerichmann's World War I memorial, the *Denkmal für die im Ersten Weltkrieg gefallenen Soldaten des 22. Artillerieregiments* (1923)
- Owned by: LWL-Museum für Kunst und Kultur, Münster

Rebecca Horn

Rebecca Horns (* 1944 Michelstadt) fragile Eingriffe im Zwinger an der Promenade erzeugen eine bedrückende Stimmung: In den fensterlosen Verließen sind Grablichter platziert; mechanisch betriebene Hämmer klopfen innen an die Wände. Im Innenhof tropft regelmäßig Wasser aus einem Trichter und durchbricht die Wasseroberfläche eines Bassins mit einem Wellenmuster. Unter der Decke im Obergeschoss bewegen sich Stahlarme, die an ein Schlangenpaar erinnern, aufeinander zu. In der Nähe halten zwei Stahlstreben ein Gänseei. Horns Arbeit ist ein Mahnmal für die bewegte Geschichte des Zwingers: Im 16. Jahrhundert als Teil der Wehranlage entstanden, diente er in der Folge unter anderem als Gefängnis, Notunterkunft und am Ende des Zweiten Weltkriegs der Gestapo als Hinrichtungsort Kriegsgefangener. 1945 wurde die Ruine zugemauert, sein Inneres barg eine urwüchsige Wildnis. Durch Horns Arbeit ist er wieder einer breiteren Öffentlichkeit zugänglich.

Das gegenläufige Konzert [Concert in Reverse]
Skulptur Projekte in Münster 1987

In the Zwinger on Münster's Promenade, Rebecca Horn's (* 1944 Michelstadt) delicate interventions create an oppressive atmosphere: memorial candles are placed in the windowless oubliettes; mechanically driven hammers tap on the walls inside. In the inner courtyard, water drips at regular intervals from a funnel, disrupting the surface of the water in a basin and creating a wave pattern. Beneath the ceiling of the upper floor, steel arms that recall a pair of snakes move towards one another. Near them stands a goose egg supported by two steel struts. Horn's work commemorates the moving history of the Zwinger: it was built in the sixteenth century as part of the city's fortifications and subsequently served, among other things, as a prison, emergency accommodation, and a Gestapo execution site for POWs at the end of World War II. In 1945 the ruins were walled up and its interior became home to a natural wilderness. Horn's work makes the Zwinger accessible again to a wider audience.

- Mehrteilige Installation im Zwinger; Innenraum: 42 mechanische Hämmer, 40 Grablichter, eine mechanische Schlangenskulptur aus zwei beweglichen Stahlarmen, die bei Berührung einen Funkenschlag auslösen, ein von zwei Eisenstangen fixiertes Gänseei; Innenhof: Stahlgerüst mit Glastrichter, in den Boden eingelassenes Wasserbassin
- Zwinger an der Promenade
- Eigentümer: Stadt Münster

- Multi-piece installation in the Zwinger; Interior: 42 mechanical hammers, 40 memorial candles, a mechanical serpentine sculpture composed of two flexible steel arms that give off sparks when touched, a goose egg held in place by two iron rods; Inner courtyard: steel scaffolding with a glass funnel, water basin set into the ground
- Zwinger on the Promenade
- Owned by: City of Münster

Huang Yong Ping

Huang Yong Ping (*1954 Xiamen) bestückte den sechs Meter hohen Flaschentrockner statt mit Flaschen mit 50 Armen. Referenzen für die Arbeit sind Duchamps ikonisches Werk *Flaschentrockner* (1914) sowie eine Christusfigur in der Kirche St. Ludgeri, die bei einem Bombenangriff im Zweiten Weltkrieg die Arme verloren hat. Neben dem Kanon der europäischen Kulturgeschichte verweist die Skulptur darüber hinaus auf die buddhistische Göttin Guanyin, in deren tausend Händen religiöse Gegenstände liegen. Ironisch und mit dadaistischen Mitteln stellt der Künstler Gemeinsamkeiten und Unterschiede zwischen der europäischen und der chinesischen Kultur heraus und vereint Flaschentrockner und Göttin zu einem Hybrid aus Lebewesen und Ding. Dabei verhandelt er postkoloniale Fragen: Die offensichtliche Unvereinbarkeit von Armen und Flaschentrockner verdeutlicht die Komplexität kultureller Austauschprozesse.

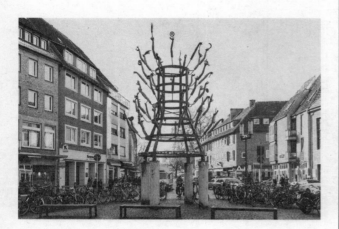

100 Arme der Guanyin [The 100 Arms of Guanyin]
Skulptur. Projekte in Münster 1997

Huang Yong Ping (*1954 Xiamen) fitted the six-metre-high bottle rack with fifty arms instead of bottles. The work makes reference to Duchamp's iconic work *Bottle Rack* (1914) and a Christ figure in St Ludgeri Church that lost its arms in an air raid in World War II. Besides the canon of European cultural history, the sculpture also refers to the Buddhist goddess Guanyin, whose thousand hands hold religious objects. Using Dadaist means, the artist ironically emphasizes the similarities and differences between European and Chinese culture and combines the bottle rack and the goddess to create a hybrid of living being and object. In so doing, he tackles postcolonial questions: the obvious incongruity of arms and a bottle rack illustrates the complexity of the processes of cultural exchange.

- Stahlgerüst, 50 modellierte Abgüsse von drei Armformen aus Aluminium Höhe 600 cm, Durchmesser ca. 315 cm (unterer Bereich), ca. 200 cm (oberer Bereich)
- Marienplatz, südlich der Kirche St. Ludgeri
- Eigentümer: LWL-Museum für Kunst und Kultur, Münster

- Steel frame, 50 sculptural mouldings of three different arm forms cast in aluminium; Height: 600 cm; diameter: ca. 315 cm (lower section), ca. 200 cm (upper section)
- Marienplatz, south of St Ludgeri Church
- Owned by: LWL-Museum für Kunst und Kultur, Münster

Donald Judd

Donald Judd (*1928 Excelsior Springs, †1994 New York) positionierte zwei konzentrische Ringe aus Beton am Abhang zum Aasee. Der innere Ring ist, analog der Spiegelfläche des Sees, horizontal ausgerichtet, der äußere folgt dem Gefälle des Grashügels. Je nach Standpunkt der Betrachter_innen verändert sich die Perspektive und damit die Wahrnehmung der beiden Kreise sowie ihre Position zueinander im offenen Gelände. Statt Symbol zu sein oder Raumillusionen zu erzeugen, forderte Judd eine unmittelbare Erfahrbarkeit seiner Kunst – auch in Abgrenzung zum Ideal der repräsentativen Skulptur. Judd, der als Mitbegründer der Minimal Art in den 1960er Jahren gilt, bezieht sich in seinen Arbeiten auf ihr jeweiliges landschaftlich-topografisches oder architektonisches Raumgefüge. Die beiden konzentrischen Betonringe in Münster zeigen quasi eine Synthese der vorhandenen Topografie.

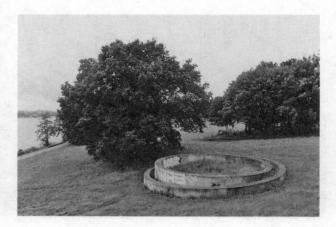

Ohne Titel [Untitled]
Skulptur Ausstellung in Münster 1977

Donald Judd (*1928 Excelsior Springs, †1994 New York) positioned two concentric concrete rings on the slope running down to Lake Aa. The inner ring is horizontally oriented, mimicking the lake's reflective surface, while the outer ring follows the incline of the grassy hill. The perspective changes depending on the viewer's standpoint, and with it the perception of the two circles and their position relative to one another in the open terrain. Instead of creating spatial illusions or a symbol, Judd demands that his art be open to direct experience—which also sets it apart from the ideal of representative sculpture. Judd is regarded as one of the founders of Minimalist Art in the 1960s, and his work makes reference to the particular spatial structure it is located in, which may be determined by architecture or by landscape and topography. The two concentric concrete rings in Münster display a kind of ideal typology of the local topography.

- Beton
 Äußerer Ring: Höhe 90 cm, Breite 60 cm, Durchmesser 1500 cm
 Innerer Ring: Höhe von 90 cm auf 210 cm aufsteigend, Breite 60 cm, Durchmesser 1350 cm
- Aaseewiese unterhalb des Mühlenhofs
- Eigentümer: Stadt Münster

- Concrete
 Outer ring—height: 90 cm; width: 60 cm; diameter: 1500 cm
 Inner ring—height: ranging from 90 cm up to 210 cm; width: 60 cm; diameter: 1350 cm
- Lake Aa meadows below the Mühlenhof
- Owned by: City of Münster

Ilya Kabakov

Ilya Kabakovs (* 1933 Dnepropetrovsk) Installation ähnelt einem Sendemast. Folgt man dem Titel der Arbeit und legt sich darunter, sind in den Zwischenräumen der Antennenfühler filigrane Drahtbuchstaben auszumachen, die folgenden Text ergeben: „Mein Lieber! Du liegst im Gras, den Kopf im Nacken, um dich herum keine Menschenseele, du hörst nur den Wind und schaust hinauf in den offenen Himmel – in das Blau dort oben, wo die Wolken ziehen –, das ist vielleicht das Schönste, was du im Leben getan und gesehen hast." Im Sonnenlicht beginnen die Buchstaben zu flimmern, sodass der Text den elektronischen Sendevorgang verbildlicht – nur wird hier statt über elektrische Felder via materieller Drahtbuchstaben kommuniziert. Mit der einfachen, direkt übertragenen Textmitteilung wird Kabakovs Arbeit so zum spielerisch-ironischen Kommentar auf die kaum zu bewältigenden Informationsfluten in unserem technologischen Zeitalter.

Per Kirkeby

Per Kirkeby (* 1938 Kopenhagen) platzierte zwei Backstein-Objekte auf dem Schlossvorplatz: Die höhere Skulptur ragt etwa fünf Meter in die Höhe und enthält zu allen vier Seiten bogenförmige Blendöffnungen. Das niedrigere quadratische Bodenobjekt ist an allen vier Ecken mit Widerlagern und angedeuteten Strebebögen versehen. Damit greift er den Grundriss eines griechischen Kreuzes auf und verweist zugleich auf ein traditionelles Bauelement, das im Kirchen- und Brückenbau Verwendung findet. Mit der Wahl des Materials sowie architektonischer Details zitiert Kirkeby Baustile, die das Stadtbild Münsters bestimmen. Die Objekte, die zudem direkt an einer Hauptverkehrsader liegen, treten in einen Dialog mit der Architektur des barocken Schlosses von Johann Conrad Schlaun sowie den sachlichen Wohnbauten in der Region Westfalen.

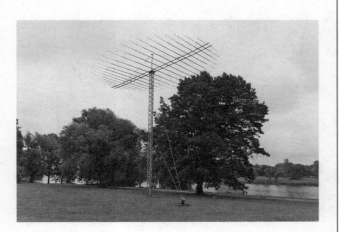

„Blickst du hinauf und liest die Worte…" ['Looking Up, Reading the Words…']
Skulptur. Projekte in Münster 1997

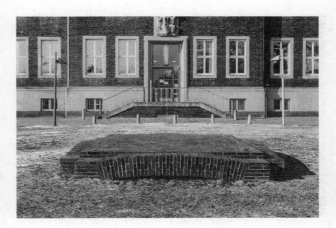

Backstein-Skulpturen [Brick Sculptures]
Skulptur Projekte in Münster 1987

Ilya Kabakov's (* 1933 Dnipropetrovsk) installation resembles a transmitter mast. If you follow the title of the work and lie down beneath it, you can make out delicate wire letters in the spaces between the antennae that spell out the following text: 'My love! You lie in the grass, your head thrown back; around you: not a soul. You hear only the wind, and look up into the open sky—into the blue above, where the clouds float by—perhaps that is the loveliest thing that you have ever in your life done, and seen.' The letters begin to shimmer in the sunlight so that the text visualizes the electronic transmission process—only here, instead of travelling across electrical fields, the communication takes place via material lettering. Kabakov's simple, directly transmitted text message becomes a playful and ironic comment on the flood of information that threatens to overwhelm us in our technological age.

Per Kirkeby (* 1938 Copenhagen) positioned two brick objects in the area in front of the palace: the taller sculpture rises to a height of some five metres and has blind apertures shaped in the form of an arch on all four sides. The lower square object on the ground has abutments and the suggestion of flying buttresses at all four corners. It thus picks up on the plan view of a Greek cross, while also referring to a traditional building element used in the construction of churches and bridges. Kirkeby's choice of material and architectural details invokes the building styles that define the Münster cityscape. The objects, which also lie directly on a main thoroughfare, strike up a dialogue with the architecture of the Baroque palace designed by Johann Conrad Schlaun and the impersonal residential housing in the region of Westphalia.

- Betonsockel, Stahlmast, 22 Metallantennen, 3 mm dünne Metallbuchstaben
 Höhe 1500 cm, Schriftfeld 1445 × 1130 cm
- Nördliche Aaseewiesen, östlich des Kardinal-von-Galen-Rings
- Eigentümer: LWL-Museum für Kunst und Kultur, Münster

- Concrete base, steel mast, 22 metal antennae, 3 mm thin metal letters
 Height: 1500 cm; area of lettering: 1445 × 1130 cm
- Northern section of the Lake Aa meadows, east of the Kardinal-von-Galen-Ring
- Owned by: LWL-Museum für Kunst und Kultur, Münster

- Backstein
 Hohe Skulptur: 42 × 206 × 206 cm, flache Skulptur: 50 × 403 × 403 cm
- Schlossplatz 5, gegenüber dem Institut für Zoophysiologie
- Eigentümer: Stadt Münster

- Brick
 Tall sculpture: 42 × 206 × 206 cm; low sculpture: 50 × 403 × 403 cm
- Schlossplatz 5, opposite the Institute of Animal Physiology
- Owned by: City of Münster

Per Kirkeby

Per Kirkeby (*1938 Kopenhagen) legte entlang des Hofes des ehemaligen Freiherr-vom-Stein-Gymnasiums aus Ziegelsteinen eine Bushaltestelle mit einer rahmenden, fast drei Meter hohen und circa 50 Meter langen Mauer an. Vor- und Rücksprünge rhythmisieren die Wandzonen, Nischen laden zum Sitzen ein, und schlanke Metallsäulen, quadratische Fensteröffnungen sowie ein Pultdach aus Holz auf einer einfachen Stahlkonstruktion gestalten den Wartebereich. Dieser bietet Unterstand sowie einen Lärm- und Sichtschutz zwischen dem Innenhof und der angrenzenden vierspurigen Straße. Der Künstler verbindet skulpturale und architektonische Elemente und lotet so die Möglichkeiten von Kunst am Bau aus. Mit einer zurückhaltenden Formensprache entwirft er die traditionelle Backsteinarchitektur Münsters neu.

Bushaltestelle [Bus Stop]
Skulptur. Projekte in Münster 1997

Per Kirkeby (*1938 Copenhagen) created a brick bus stop alongside the courtyard of the former secondary school, the Freiherr-vom-Stein-Gymnasiums. It is framed by a wall that is almost three metres high and circa fifty metres long. The wall sections are given a rhythmic pattern by projections and recesses, while niches offer inviting places to sit. The waiting area is defined by slender metal pillars, square window apertures, and a timber pent roof on a simple steel structure. This offers shelter, soundproofing, and a visual screen between the inner courtyard and the adjacent four-lane road. The artist combines sculptural and architectural elements, exploring the possibilities of *Kunst am Bau* (art in public places). His restrained formal vocabulary represents a recasting of Münster's traditional brick architecture.

- Rotblaubunt-Ziegel, Stahl, Holz
 Mauer: Höhe 286 cm, Länge 5000 cm, Stärke zwischen 37 cm und 74 cm
 Unterstand: Dachhöhe 290 cm bis 320 cm, Rückwandhöhe 290 cm,
 Seitenwandhöhe etwa 390 cm, Länge 1000 cm, Tiefe 300 cm
- Bushaltestelle Schlossplatz am Vom-Stein-Haus (Institut für Germanistik der Westfälischen Wilhelms-Universität Münster), Schlossplatz 34
- Eigentümer: Stadt Münster

- Red-blue bricks, steel, wood
 Wall—height: 286 cm; length: 5000 cm; thickness: 37–74 cm
 Shelter—roof height: 290–320 cm; height of rear wall: 290 cm;
 height of side walls: ca. 390 cm; length: 1000 cm; breadth: 300 cm
- Bus stop: Schlossplatz at the Vom-Stein-Haus (Institute of German Studies at the University of Münster), Schlossplatz 34
- Owned by: City of Münster

Harald Klingelhöller

Harald Klingelhöller (*1954 Mettmann) ordnete 16 kugelförmige und fünf pyramidal zugeschnittene Eiben sowie ein aus Spiegelglas bestehendes, gebogenes Geländer zu einem Ensemble an. Dieses richtete er an der Architektur des Juridicums aus, um der hierarchischen Strenge des Gebäudekomplexes entgegenzuwirken. Impuls für die Arbeit waren Objekte des Künstlers aus dem Jahr 1985, die damals im historischen Lichthof des Landesmuseums gezeigt worden waren und die er nun statt für den Innen- für den Außenraum realisierte. Alle Elemente der Arbeit basieren auf den geometrischen Grundformen von Kreis und Dreieck. Der scheinbar narrative Titel beschreibt die Arbeit nicht in erklärender Weise. Beim gleichzeitigen Betrachten der Installation und dem Erfassen des Titels entstehen jedoch zwangsläufig bildliche Verbindungen. So könnten beispielsweise die Spiegelungen der rund geschnittenen Eiben im verspiegelten Geländer als „Gesichter in der Wand" wahrgenommen werden.

Die Wiese lacht oder das Gesicht in der Wand
[The Lawn Laughs or The Face in the Wall]
Skulptur Projekte in Münster 1987

Harald Klingelhöller (*1954 Mettmann) arranged twenty-one yew trees—sixteen clipped into orbs and five into pyramids—and a curved railing made of mirror glass to create an ensemble. He attuned the work to the architecture of the Juridicum to counter the hierarchical severity of the building complex. The work was motivated by objects the artist had made in 1985, which were shown at the time in the historical atrium of the former Landesmuseum and which he now realized for the space outside the building instead of for its interior. All the elements of the work rely on the basic geometric shapes of the circle and the triangle. The seemingly narrative title does not provide an explanatory description of the piece. Looking at the installation with the title in mind does, however, inevitably produce visual associations. For example, the reflections of the rounded yews in the mirrored railings might be perceived as 'faces in the wall'.

- Bodeninstallation aus Gussbetonplatten und Messing
 Spiegelglas, Metallkonstruktion, 21 *Taxus baccata* (Europäische Eibe)
 Maße der Spiegelglaskonstruktion: 150 × 400 × 20 cm
- Innenhof des Juridicum, Rechtswissenschaftliche Fakultät der Westfälischen Wilhelms-Universität Münster, Universitätsstraße 14–16
- Eigentümer: Universität Münster

- Ground installation consisting of poured concrete slabs and brass
 Mirror glass, metal construction, 21 *Taxus baccata* (European yew)
 Dimensions of the mirror glass structure: 150 × 400 × 20 cm
- Inner courtyard of the Juridicum, Faculty of Law at the University of Münster, Universitätsstraße 14–16
- Owned by: University of Münster

Matt Mullican

Matt Mullican (* 1951 Santa Monica) legte auf eine Grünfläche zwischen Gebäuden des Chemischen Instituts und inmitten von quaderförmigen Zweckbauten mit Hörsälen und Laboratorien eine flache Bodenskulptur aus 35 Granitplatten. Diese weisen durch Sandstrahl eingravierte Zeichen auf und gruppieren sich rund um einen glatt belassenen Stein im Zentrum. Es handelt sich um ein von der realen Welt abgeleitetes Zeichenmosaik, das typisch ist für die enzyklopädische Vorgehensweise des Künstlers. Die Embleme von Laborgerätschaften korrespondieren mit der vor Ort betriebenen Forschung. Seit jeher nutzt der Mensch Zeichensysteme, sich zu verständigen, Wissen zu ordnen und Phänomene zu erklären. Mullican entwarf für Münster eine künstlerische Variante eines solchen Erklärungsmodells mit zeitgenössischen Hieroglyphen, die motivisch auf die Errungenschaften der Wissenschaften und ästhetisch auf die Urzeiten weit vor der modernen Gesellschaft verweisen.

Ohne Titel (Skulptur für die Chemischen Institute)
[Untitled (Sculpture for the Chemistry Institutes)]
Skulptur Projekte in Münster 1987

Matt Mullican (* 1951 Santa Monica) laid out a flat ground sculpture made of thirty-five granite slabs on a grassy area between the buildings of the Chemistry Institute, in the midst of a group of cuboid purpose-built structures with lecture halls and laboratories. They are engraved with sandblasted symbols and arranged around a stone in the centre that has been left smooth. It is a mosaic of symbols derived from the real world, which is typical of the artist's encyclopaedic approach. The symbols of laboratory equipment correspond with the research conducted there. Humans have used systems of signs since time immemorial to make themselves understood or to systematize knowledge and explain phenomena. In Münster, Mullican designed an artistic variant of one such explanatory model using contemporary hieroglyphs, whose motifs refer to the accomplishments of science and whose aesthetics point to primeval times long before the inception of modern society.

- Bodenrelief aus 35 schwarzen, sandgestrahlten Granitplatten, je 150 × 150 cm, aneinandergelegt zu einer Formation von 7 × 5 Platten, Gesamtgröße: 1050 × 750 cm
- Naturwissenschaftliches Zentrum / Institut für Anorganische und Analytische Chemie, Grünstreifen zwischen den Gebäuden Wilhelm-Klemm-Straße 6 (Hörsaalgebäude) und 10
- Eigentümer: LWL-Museum für Kunst und Kultur, Münster

- Ground relief composed of 35 black, sandblasted granite slabs, each 150 × 150 cm, laid side by side to create a 7 × 5 grid; overall size: 1050 × 750 cm
- Department of Natural Sciences / Institute of Inorganic and Analytical Chemistry, grassy area between the buildings Wilhelm-Klemm-Straße 6 (lecture hall) and 10
- Owned by: LWL-Museum für Kunst und Kultur, Münster

Bruce Nauman

Im Winkel zweier Häuser befindet sich Bruce Naumans (* 1941 Fort Wayne) Skulptur, eine begehbare, flach in den Boden vertiefte, umgekehrte Pyramide. Betritt man die hellen Oberflächen, ist man exponiert wie auf einer Bühne. Die Betrachter_innen setzen sich dabei ganz unmittelbar ins Verhältnis zur Skulptur, zur Umgebung und dem öffentlichen Raum: Es ist schwierig, Entfernungen und Höhen einzuschätzen, da Dimensionen und Proportionen gleich einem Vexierbild optisch verzerrt erscheinen. Material und Form korrespondieren mit der kubischen Rasterarchitektur der angrenzenden Gebäude aus den 1960er Jahren: Die Institute für Kernphysik und theoretische Physik der Westfälischen Wilhelms-Universität Münster erzeugen im Zusammenspiel mit *Square Depression* den Eindruck einer Anordnung riesiger geometrischer Betonkörper. *Depression* bedeutet hier sowohl Senkung als auch Depression im psychologischen Sinne. Ebenso kann *Square* mit Quadrat übersetzt werden oder umgangssprachlich mit spießig oder altmodisch.

Square Depression [Quadratische Senkung]
skulptur projekte münster 07

Bruce Nauman's (* 1941 Fort Wayne) sculpture is set in the right angle created by two buildings—an inverted pyramid sunk into a shallow depression in the ground that visitors can walk on. When you step onto the light-coloured surface, you find yourself exposed as if on a stage. Looking at the work, you enter into a direct relationship with the sculpture, with the surroundings, and with the public space: it is difficult to judge distances and heights, because dimensions and proportions seem to be optically distorted in the manner of a picture puzzle. In material and formal terms the work corresponds with the cubic grid architecture of the adjacent 1960s' buildings. The University of Münster's Institutes for Nuclear Physics and Theoretical Physics interact with *Square Depression* to create the impression of an arrangement of massive geometric bodies made of concrete. Here *Depression* means both an indentation and a depression in the psychological sense. *Square* can likewise be read as a geometric form or interpreted colloquially as stuffy and old-fashioned.

- Gegossener Beton, weiß verputzt, 2500 × 2500 × 230 cm
- Naturwissenschaftliches Zentrum der Westfälischen Wilhelms-Universität Münster, Wilhelm-Klemm-Straße 9
- Eigentümer: LWL-Museum für Kunst und Kultur, Münster

- Poured concrete polished white, 2500 × 2500 × 230 cm
- Department of Natural Sciences at the University of Münster, Wilhelm-Klemm-Straße 9
- Owned by: LWL-Museum für Kunst und Kultur, Münster

Maria Nordman

Maria Nordmans (*1943 Görlitz) Arbeit liegen geometrische Formen zugrunde: Eine Doppelreihe aus hundert Urweltmammutbäumen bildet eine nach Norden geöffnete U-Form. Eine zweite U-Form, bestehend aus derselben Baumsorte, öffnet sich nach Süden. In einem dritten Bereich sind Abendländische Lebensbäume in unterschiedlichen geometrischen Formen exakt angeordnet. Die Elemente sind überwiegend dicht gepflanzt und wachsen zu Wänden, betretbaren Kammern und lichtdurchfluteten Räumen zusammen. Im Kontext der Land-Art arbeitet Nordman mit dem Wienburgpark als geografischem Raum: Er rahmt die Skulptur ein, die sich in den Park einfügt und sich zugleich durch die Wahl der Pflanzen und deren künstlicher Anordnung abhebt. Neben der präzisen Konstruktion der Anlage ist für die Arbeit der organische Aspekt des Wachstums sowie der lebendige Austausch zwischen den einzelnen Elementen wichtig. Der Wandel der Jahreszeiten und die permanente Veränderung der Arbeit machen darüber hinaus Zeit und Dauer erfahrbar.

De Civitate
Skulptur Projekte in Münster 1987

Maria Nordman's (*1943 Görlitz) work is based on geometric forms: a double row of 100 dawn redwoods form a U-shape that is open to the north. A second U-shape, consisting of the same type of tree, opens to the south. A third area contains Thuja trees precisely arranged in different geometric shapes. The elements are for the most part thickly planted and have grown into walls, chambers that you can step into, and spaces flooded with light. Operating within the context of Land Art, Nordman works with the Wienburg Park as a geographical space: it frames the sculpture, which is integrated in the park and is at the same time set apart by the choice of plants and their artistic arrangement. Key to the work, besides the precise structuring of the ensemble, are the organic aspect of growth and the vibrant exchange between the individual elements. Moreover, the shifting seasons and the permanent changes the work undergoes give a palpable sense of time and duration.

- *Metasequoia glyptostroboides* [Urweltmammutbäume], *Thuja occidentalis* [Abendländische Lebensbäume], Wasser, Luft, Erde, Gestirne ca. 5.500 m²
- Wienburgpark
- Eigentümer: Stadt Münster

- *Metasequoia glyptostroboides* (dawn redwood), *Thuja occidentalis* (northern white cedar), water, air, earth, stars ca. 5500 m²
- Wienburg Park
- Owned by: City of Münster

Claes Oldenburg

Mit den drei Kugeln entwickelte Claes Oldenburg (*1929 Stockholm) die Vision von Münster als einem riesigen Spielfeld. Sie wirken in ihrer scheinbar zufälligen Anordnung, als seien sie gerade von einem gigantischen Billardqueue angestoßen worden. Oldenburg befragt die Ästhetik von Alltagsgegenständen, indem er ihre Dimensionen vergrößert und sie in einen neuen Kontext stellt. Die Proportionen der *Giant Pool Balls* basieren auf dem Verhältnis des Durchmessers einer Billardkugel zur Spielfläche in einem herkömmlichen Billardspiel. Ihre dynamische Position ist lediglich angedeutet, verstärkt durch die Bewegungsabläufe der umgebenden Segelboote, Autos, Fahrräder und Jogger. Während in den 1970er Jahren darüber diskutiert wurde, ob Oldenburgs Arbeit eine störende Unterbrechung innerhalb der Parkanlage darstellt, hat sich der Ort heute als beliebter Treffpunkt etabliert und ist zu einem Wahrzeichen der Stadt geworden.

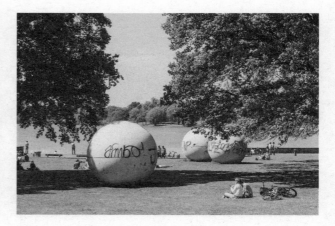

Giant Pool Balls [Riesige Billardkugeln]
Skulptur Ausstellung in Münster 1977

The three balls that Claes Oldenburg (*1929 Stockholm) designed developed the vision of Münster as an enormous playing field. Arranged in seemingly random positions, the balls appear to have just been hit into place by a giant pool cue. Oldenburg questions the aesthetics of everyday objects by enlarging their dimensions and putting them in a new context. The proportions of the *Giant Pool Balls* are based on the relationship of the diameter of a pool ball to the playing area on a conventional pool table. Their dynamism is only suggested, reinforced by the patterns of movement created by the yachts, cars, bicycles, and joggers around them. While there were discussions in the 1970s about whether Oldenburg's work constituted a disruptive disturbance within the park, today the place has established itself as a popular meeting point and has become one of the city's landmarks.

- Bewehrter Beton, Kugeldurchmesser je 350 cm
- Aaseeterrassen am nördlichen Ufer des Aasees
- Eigentümer: Stadt Münster

- Reinforced concrete; diameter of balls: 350 cm each
- Terraces on the northern shore of Lake Aa
- Owned by: City of Münster

Jorge Pardo

Vom Ufer des Aasees ragt Jorge Pardos (*1963 Havanna) aus Holzplanken bestehender Steg mehr als 40 Meter weit hinaus auf das Wasser. An seinem Ende steht ein offener, sechseckiger Pavillon auf einer asymmetrischen Aussichts-plattform mit Stufen zum See. Von dieser aus kann man auf die Stadt blicken. Der Künstler arbeitet an den Grenzberei-chen von Skulptur, Architektur und Design. Ganz in diesem Sinne ist der Steg betretbar: Er schreibt sich in seine Umge-bung ein, dient der Begegnung sowie als Ort zum Nachden-ken und Innehalten. Der Ausblick aus dem Pavillon bietet darüber hinaus verschiedene Perspektiven auf den umlie-genden Raum. Durch ihre schlichte Gestaltung erinnert Par-dos Arbeit an japanische Gartenarchitektur, die Verbindung von Funktionalität und Ästhetik lässt Vergleiche zum Bau-haus zu.

Giuseppe Penone

Auf der Rasenfläche eines ehemaligen Friedhofs liegt, abge-stützt von einem Stein, ein abgeknickter, sieben Meter langer Ast. Bei näherer Betrachtung fällt auf, dass es sich bei diesem Ast um eine Bronze handelt, aus der Wasser fließt. Dieses strömt aus einem in den Bronzestamm hineingedrückten Handabdruck und sammelt sich in der Handfläche, um dann weiter, entlang eines Unterarmabdrucks, zu laufen, bis es schließlich in einem Abfluss verschwindet. Dort wird es aufge-fangen und aus der Tiefe der Erde durch einen eigens für die Arbeit gebohrten Brunnen wieder in den Ast zurückgepumpt, sodass ein Kreislauf entsteht. Als Vertreter der Arte Povera ist das Motiv des Baumes ein Leitbild in Giuseppe Penones (*1947 Garessio) Werk: In der Verbindung von Mensch und Natur interessiert sich der Künstler für Wachstums- und Zer-fallsprozesse.

Pier [Steg]
Skulptur. Projekte in Münster 1997

Progetto Pozzo di Münster [Brunnenprojekt für Münster /
Well Project for Münster]
Skulptur Projekte in Münster 1987

Jorge Pardo's (*1963 Havana) timber-plank pier projects more than forty metres out into the water from the shore of Lake Aa. At the end of it stands an open hexagonal pavilion on an asymmetrical viewing platform with steps leading down to the lake. From it you can enjoy a view of the city. The artist works at the interface of sculpture, architecture, and design. In keeping with this, the pier is conceived as a struc-ture to be walked on: it becomes a part of its environment, serving as a meeting point and a place to take pause and re-flect. Moreover, the view from the pavilion offers different perspectives on the surrounding area. Its understated design recalls Pardo's work in Japanese garden architecture, while its combination of functionality and aesthetic appeal invites comparison with the Bauhaus.

On the lawn of an old graveyard lies a bent, seven-metre-long bough supported by a rock. Upon closer inspection, it is apparent that the branch is a bronze artefact that has water flowing out of it. The water gushes from the impression of a hand debossed into the bronze trunk and gathers in the palm of the hand before running further along the cast of the fore-arm until it finally disappears into a drain. There it is collected and pumped back into the bough from deep in the ground via a well that was bored especially for the work, thus creating a circulatory system. As an exponent of Arte Povera, Giuseppe Penone (*1947 Garessio) has made the tree a leitmotif in his work: in the relationship between humans and nature, the artist is interested in the processes of growth and decay.

- Kalifornisches Redwood
 Länge des Steges ca. 4800 cm, Breite der Terrasse am Ende des Steges
 ca. 1000 cm, Höhe des Pavillons 254 cm
- Westliches Aaseeufer, südlich der Annette-Allee
- Eigentümer: Stadt Münster

- Californian redwood
 Length of the pier: ca. 4800 cm; width of the terrace at the end of the pier:
 ca. 1000 cm; height of the pavilion: 254 cm
- Western shore of Lake Aa, south of Annette-Allee
- Owned by: City of Münster

- Bronze, Wasser, Steine, Schachtdeckel, Brunnen, Länge 700 cm
- Karlstraße/Ecke Wemhoffstraße, alter Hörster Friedhof
- Eigentümer: LWL-Museum für Kunst und Kultur, Münster

- Bronze, water, rocks, manhole cover, well; length: 700 cm
- Karlstraße/corner of Wemhoffstraße, old Hörster cemetery
- Owned by: LWL-Museum für Kunst und Kultur, Münster

Susan Philipsz

In ihrer Soundinstallation singt Susan Philipsz (*1965 Glasgow) die Barcarole aus Offenbachs Operette *Hoffmanns Erzählungen*. Nur die unscheinbaren Lautsprecher an den Brückenpfeilern verweisen auf die Quelle des Gesangs. Die Melodie wird zunächst einstimmig auf der einen Uferseite abgespielt und dann über die Lautsprecher am anderen Ufer wiederholt. Anschließend setzt die zweite Stimme ein. Die Suche nach einem Gegenüber endet im Nichts. Der Klang definiert hier den Raum, und durch die symmetrische Architektur der Brücke stellt sich der Eindruck eines Gewölbes ein, das zusammen mit den Lichtreflexen des Wassers an ein modernistisches Bühnenbild erinnert. Der Ort selbst ist künstlich inszeniert: Der Aasee wurde Ende des 19. Jahrhunderts an der Stelle eines Sumpfgebietes geplant und zählt heute zu den Erholungsgebieten der Stadt.

The Lost Reflection [Das verlorene Spiegelbild]
skulptur projekte münster 07

In her sound installation Susan Philipsz (*1965 Glasgow) sings the barcarole from Offenbach's operetta *The Tales of Hoffmann*. The only indication of the source of the song is the inconspicuous set of loudspeakers on the piers of the bridge. The melody is initially played monophonically on one side of the lake and then echoed by the loudspeakers on the other side. After that the second voice is introduced. The search for a counterpart comes to nothing. Here the sound defines the space and the symmetrical architecture of the bridge creates the impression of a vault, which, together with the light reflecting on the water, evokes a modern stage production. The place itself is an artificial setting: Lake Aa was designed in the late nineteenth century to replace an area of marshland and is now one of the city's recreational attractions.

- Soundinstallation
- Aasee, unter der Torminbrücke, während der Skulptur Projekte 2017: Mo–So, 10–18 Uhr, stündlich; regulär So 10–18 Uhr
- Eigentümer: LWL-Museum für Kunst und Kultur, Münster

- Sound installation
- Lake Aa, under Tormin Bridge; during the Skulptur Projekte 2017 Mon–Sun, 10 am–6 pm, every hour; Sun 10 am–6 pm
- Owned by: LWL-Museum für Kunst und Kultur, Münster

Hermann Pitz

Hermann Pitz (*1956 Oldenburg) verkleidete acht Blindfenster im ersten Geschoss der Westfassade des ehemaligen Landesmuseums mit Glimmerschieferplatten. Diese Fenster waren 1997 während der Renovierung des Altbaus verschlossen worden, um mehr Wandfläche im Museum zu schaffen. Über die Materialauswahl verband der Künstler den Altbau mit dem damals direkt angrenzenden Erweiterungsbau aus den 1970er Jahre, dessen Fassadenverkleidung auch aus Glimmerschiefer bestand. Zur Arbeit gehört ein zweiter Teil, der nicht permanent ausgestellt ist: Im Inneren des Museums, direkt hinter den verblendeten Fenstern, schuf Pitz ein Szenario aus einem hölzernen Fensterrahmen, einer riesigen Reproduktionskamera sowie 16 Bühnenscheinwerfern. Er thematisiert die Ablösung realer Außenräume durch virtuelle Räume wie die, welche durch Computer oder Fernseher generiert werden.

Innen, Außen [Inside, Outside]
Skulptur. Projekte in Münster 1997

Hermann Pitz (*1956 Oldenburg) laid slabs of mica schist over eight sealed-off windows on the first floor of the west façade of the old federal state museum. These windows had been closed up in 1997 when the old building was being renovated to give the museum more usable wall area. In his choice of material, the artist forged a link between the old building and the 1970s' extension that was directly adjacent to it at the time, whose façade was also clad with mica schist. The work also includes a second part, which is not permanently on show: in the interior of the museum, directly behind the blind windows, Pitz created a staged setting using a wooden window frame, a giant repro camera, and sixteen stage lights. He takes as his theme the replacement of real exterior spaces with virtual spaces like the ones generated by computers or televisions.

- Zweiteilige Installation: Teil 1 *Innen*: Platte aus Glimmerschiefer (Maggia-Granit), Teil 2 *Außen*: ausgebaute Blindfenster, Reproduktionskamera Modell Horizontal-Reproduktionsapparat Holux-Perfecta 80/100', 16 Bühnenscheinwerfer
- Altbau des LWL-Museums für Kunst und Kultur, Westfassade im 1. Obergeschoss, (Teil 2 *Innen* ist als Dauerleihgabe ebenfalls Teil der Sammlung des Museums, jedoch nicht permanent ausgestellt.)
- Eigentümer: *Innen*: Kunststiftung NRW; *Außen*: LWL-Museum für Kunst und Kultur, Münster

- Two-part installation: Part 1 *Außen*—Sheets of mica schist (Maggia granite) Part 2 *Innen*—Sealed-off windows, horizontal repro camera Holux-Perfecta 80/100', 16 stage lights
- Old building of the LWL-Museum für Kunst und Kultur, 1st floor of west façade; (Part 2 *Innen* is on permanent loan to the museum and forms part of its collection, although it is not always on display.)
- Owned by: *Innen*—Kunststiftung NRW; *Außen*—LWL-Museum für Kunst und Kultur, Münster

Martha Rosler

Martha Rosler (* 1943 New York) stellte vor die Münster Arkaden, einem großen Einkaufszentrum in der Innenstadt, einen Mast mit einem steinernen Adler im Greifflug. Es handelt sich um die Kopie eines Emblems, dessen Original bis heute zur Fassade des Luftwaffentransportkommandos der Bundeswehr, ehemals der Wehrmacht, vor Ort in Münster gehört. Der Architekt Ernst Sagebiel baute das Gebäude 1935 zur Zeit des Nationalsozialismus, dem Adler über dem Eingangstor wurde nach Kriegsende das Hakenkreuz-Symbol aus den Klauen geschlagen. Rosler rekontextualisiert den reproduzierten Adler und lenkt so unsere Aufmerksamkeit auf die darin gespeicherte Vergangenheit. Gleichzeitig zeigt sie durch die Wahl von Ort und Objekt Kontinuitäten auf. Der Adler verweist auf eine aktuelle Situation: Das Hauptquartier der Bundeswehr, wo sich noch immer der originale Adler befindet, beteiligt sich fortwährend an internationalen Einsätzen.

Ulrich Rückriem

Ulrich Rückriems (* 1938 Düsseldorf) künstlerisches Verfahren besteht im Spalten, Schneiden und dem erneuten Zusammensetzen von Natursteinen. Auch bei *Dolomit zugeschnitten* sind die Brechspuren und Fugenschnitte der neun auf- und absteigenden keilförmigen Steinrohlinge deutlich zu erkennen. Die Skulptur wurde an der Nordseite der Kirche St. Petri so aufgestellt, dass zwischen der gotischen Kirche und der Skulptur ein Gang, ein beinahe quadratischer Raum, entsteht. Dieser Bereich ist durch die Länge der Arbeit und durch die steil abfallenden Schnittflächen der Steinrohlinge, die eine Wand formen, zur Kirche hin definiert. Doch die Skulptur kann nicht nur als Weiterentwicklung der Proportionen der Kirchenarchitektur gedacht werden. Mit ihrer schräg zu einer kleinen Rasenfläche hin abfallenden Form bildet sie auch eine Art Gegenstück zu den Strebepfeilern der Kirche und befindet sich mit ihrem manifesten Körper in einem stetigen Dialog mit der Kirchenmauer und der Umgebung.

Unsettling the Fragments (Eagle)
[Erschütterung der Fragmente (Adler)]
skulptur projekte münster 07

Dolomit zugeschnitten [Cut Dolomite]
Skulptur Ausstellung in Münster 1977

Martha Rosler (* 1943 New York) designed a mast topped with a stone eagle, its wings outspread as it swoops, which she placed in front of the Münster Arkaden, a large shopping arcade in the city centre. It is the copy of an emblem the original of which still forms part of the façade of the air force transport command of the German armed forces—formerly the Wehrmacht—located in Münster. The architect Ernst Sagebiel constructed the building in 1935 during the period of National Socialism: after the war the swastika symbol was removed from the talons of the eagle above the entrance. Rosler recontextualizes the reproduced eagle, directing our attention to the history stored in it. At the same time, her choice of location and object point to certain continuities. The eagle is a reference to a current situation: the headquarters of the German armed forces, where the original eagle can still be seen, is involved in international military operations on an ongoing basis.

Ulrich Rückriem's (* 1938 Düsseldorf) artistic method involves splitting, cutting, and reassembling natural stones. In *Dolomit zugeschnitten*, the fracture marks and splices can also be clearly seen on the nine wedge-shaped, unhewn stones arranged in an up-and-down formation. The sculpture was installed on the north side of St Peter's Church so as to create a 'passage'—an almost square space—between the Gothic church and the stones. This area is defined by the length of the work and by the steep slope of the cut surfaces of the stones, which form a wall, facing towards the church. Yet the sculpture may be thought of not merely as a further development of the proportions of the church architecture. The shape of the stones, which slope obliquely down to a small area of lawn, also constitutes a kind of companion piece to the church's buttresses, while the evident physicality of the work enters into a constant dialogue with the wall of the church and the immediate surroundings.

- Abguss aus Styropor und Armierungsputz, montiert auf einem Mast; Abguss: 120 × 180 × 50 cm, Masthöhe 300 cm
- Rothenburg/Ecke Königsstraße, vor dem Eingang der Einkaufspassage Münster Arkaden
- Zurzeit aufgrund von Restaurierungsarbeiten nicht installiert.
- Eigentümer: LWL-Museum für Kunst und Kultur, Münster

- Casting of polystyrene and reinforcing plaster, mounted on a mast; casting: 120 × 180 × 50 cm; height of mast: 300 cm
- Rothenburg/corner of Königsstraße, in front of the entrance to the Münster Arkaden shopping arcade
- Currently not installed due to restauration work.
- Owned by: LWL-Museum für Kunst und Kultur, Münster

- Anröchter Stein, 330 × 720 × 120 cm
- Nordseite der Kirche St. Petri, am sogenannten Jesuitengang
- Eigentümer: Stadt Münster

- Anröchte stone, 330 × 720 × 120 cm
- North side of St Peter's Church, on the 'Jesuit Walk'
- Owned by: City of Münster

Thomas Schütte

Thomas Schüttes (*1954 Oldenburg) Säule besteht aus den klassischen architektonischen Elementen Basis, Schaft und Kapitell, allerdings sind die Größenverhältnisse ungewöhnlich. Auf dem wuchtigen Kapitell thront ein Paar glänzend roter Kirschen aus Aluminium. Die postmoderne Formensprache erinnert an Kunstwerke der Pop-Art, das Material Sandstein hingegen ist typisch für Münsteraner Bauten wie den Dom oder die Geschäftshäuser am Prinzipalmarkt. Wie in vielen seiner künstlerischen Arbeiten bedient sich Schütte dem Mittel der Überladung und „garniert" die Stadt mit den Früchten. Aufgrund ihrer Gestaltung kommentiert Schütte mit der *Kirschensäule* eine Vielzahl denkbarer Qualitäten und Funktionen von Kunst im öffentlichen Raum: Sie ist Skulptur, Denkmal und Verweis auf den Ort, an dem sie steht. Ferner ist sie über die Jahrzehnte zu einem Wahrzeichen der Stadt geworden und gab kurioserweise den Impuls für die strukturelle Neugestaltung des Platzes.

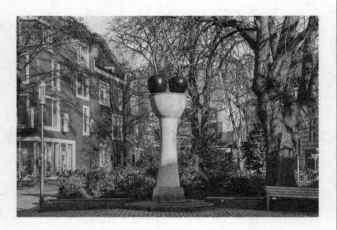

Kirschensäule [Cherry Pillar]
Skulptur Projekte in Münster 1987

Thomas Schütte's (*1954 Oldenburg) column comprises the classical architectural elements of base, shaft, and capital, although the proportions are unusual. The massive capital is crowned with a pair of shiny red aluminium cherries. The postmodern formal language is reminiscent of Pop Art, while the sandstone used for the piece is a typical Münster building material, as can be seen in the cathedral and the merchant's houses on Prinzipalmarkt, the city's historic marketplace. As in many of his artistic works, Schütte made use of the idea of overload and 'garnishes' the city with fruit. Schütte's design for *Kirschensäule* comments on a variety of conceivable qualities and functions of art in the public realm: it is a sculpture, a monument, and a reference to the place where it stands. Moreover, over the decades it has become a city landmark and, curiously enough, prompted a redesign of the structure of the square.

- Sandstein, lackiertes Aluminium, Höhe 600 cm
- Harsewinkelplatz
- Eigentümer: Stadt Münster

- Sandstone, lacquered aluminium; height: 600 cm
- Harsewinkelplatz
- Owned by: City of Münster

Richard Serra

Bei Richard Serras (*1939 San Francisco) Arbeit handelt es sich um einen massiven, 40 Tonnen schweren Quader aus geschmiedetem Stahl. Er steht mitten auf der Allee zum Rüschhaus, dem ehemaligen Landhaus des westfälischen Barockbaumeisters Johann Conrad Schlaun. Die Maße der Skulptur korrespondieren mit den Abmessungen des am anderen Ende der Auffahrt gelegenen Hauptgebäudes. Mit seiner Skulptur besetzt Serra exakt den Ort, von dem aus sich die gesamte, axialsymmetrisch konzipierte und bühnenartig gestaffelte Architektur der Anlage entfaltet. Zwar wird das Gebäude heute seitlich und nicht mehr über die Allee als einer repräsentativen Auffahrt erschlossen, jedoch ist die Skulptur für die Besucher_innen in der Entfernung von rund 270 Metern sichtbar. Womit der Standort der Arbeit etwas abseits des touristischen Geschehens rund um das Barockensemble liegt.

Dialogue with Johann Conrad Schlaun
[Dialog mit Johann Conrad Schlaun]
Skulptur.Projekte in Münster 1997

Richard Serra's (*1939 San Francisco) work involves a massive, forty-ton cube made of forged steel. It stands in the middle of the avenue leading to the Rüschhaus, the former country house of the Wetsphalian Baroque architect Johann Conrad Schlaun. The dimensions of the sculpture correspond with those of the main building at the other end of the drive. Serra's sculpture occupies the exact spot from which the grounds open up into the theatrically staggered and axially symmetrical architecture of the overall design. Although the building is now accessed from the side and is no longer approached along the impressive treelined avenue, the sculpture is still visible to visitors from a distance of around 270 metres. The work is thus located somewhat apart from the tourist activities taking place around the Baroque ensemble.

- Massiver Corten-Stahl, 200 × 150 × 150 cm
- Allee vor dem Rüschhaus in Münster-Nienberge
- Eigentümer: LWL-Museum für Kunst und Kultur, Münster

- Solid Corten steel, 200 × 150 × 150 cm
- Avenue in front of the Rüschhaus in Münster-Nienberge
- Owned by: LWL-Museum für Kunst und Kultur, Münster

Susana Solano

Susana Solano (*1946 Barcelona) baute aus drei Stahlplatten eine Einhausung, die eines der beiden Fragmente der Stadtmauer am Buddenturm umschließt. Die Platten sind mit massiven, unregelmäßig diagonal verlaufenden Stahlträgern verbunden. Mit der schweren Eisenskulptur erinnert die Künstlerin an die Geschichte des Buddenturms: Ursprünglich war dieser ein Teil der mittelalterlichen Stadtbefestigung; später wurde er als Gefängnis sowie als Pulver- und als Wasserturm genutzt. Nach dem Abbruch der restlichen Stadtbefestigung im 18. Jahrhundert verlor er seine Funktion. 1879 kaufte die Stadt Münster das Gebäude. Solanos Arbeit steht formal und materiell in der Tradition moderner Eisenplastik. Zwar verweigert die Künstlerin jegliche Rekonstruktion oder bauliche Ergänzung des alten Stadtmauerfragments, der Buddenturm bleibt jedoch formal-ästhetischer Bezugspunkt ihrer Arbeit. Einer Romantisierung des Mittelalters setzt Solano eine modernistische und strenge Ästhetik entgegen.

Intervención en Münster [Intervention in Münster]
Skulptur Projekte in Münster 1987

Susana Solano (*1946 Barcelona) used three steel plates to build an enclosure containing one of the two fragments of the city wall at Budden Tower. The plates are connected with solid steel girders running diagonally at irregular angles. The artist's heavy iron sculpture evokes the history of the tower: it was originally part of the city's medieval fortifications and was later used as a prison and as a magazine and water tower. When the rest of the city's defences were torn down in the eighteenth century, it lost its function and in 1879 the building was bought by the City of Münster. Solano's work is part of the formal and material tradition of modern iron sculpture. Although the artist steers clear of any reconstruction or structural addition to the fragment of the old city wall, Budden Tower nevertheless remains a formal and aesthetic reference point for her work. Solano counters the tendency to romanticize the Middle Ages with a severe, modernist aesthetic.

- Stahl, 600 × 300 × 200 cm
- Buddenturm, Münzstraße/Am Kreuztor
- Eigentümer: Stadt Münster

- Steel, 600 × 300 × 200 cm
- Budden Tower, Münzstraße/Am Kreuztor
- Owned by: City of Münster

Rosemarie Trockel

Rosemarie Trockel (*1952 Schwerte) pflanzte eine Hecke, die sie in zwei Blöcke teilen ließ, sodass ein schmaler, sich verjüngender Durchlass offen bleibt. Dieser gibt den Blick auf die Hochhäuser auf der anderen Seeseite frei und ist gerade so breit, dass eine Person sich im Seitwärtsschritt durchzwängen kann. Die Anlage ist leicht asymmetrisch, die Oberflächen der Eibenquader sinken zum inneren Rand hin ab. Aufgrund seiner Form und Positionierung am Aaseeufer korrespondiert das Werk sowohl mit den gegenüberliegenden Hochhäusern als auch mit temporär oder dauerhaft in der Nähe installierten Skulpturen minimalistisch arbeitender Künstler wie Carl Andre oder Donald Judd. Höhe und Dichte erinnern an eine Skulptur aus Holz oder Stein, während die Bearbeitungsweise des Buschwerkes traditionelle bildhauerische Methoden ins Gedächtnis ruft. Obwohl der regelmäßige Formschnitt ein unkontrolliertes Wachstum verhindert, ist die Skulptur in ständiger Metamorphose begriffen. Stillstand steht Wachstum gegenüber.

Less Sauvage Than Others [Weniger wild als andere]
skulptur projekte münster 07

Rosemarie Trockel (*1952 Schwerte) planted a hedge that she divided into two blocks so that a narrow, tapering passage remains open. This opening offers a view of the high-rises on the other shore of Lake Aa and is exactly the width required to allow a person to squeeze through sideways. The ensemble is slightly asymmetrical with the upper surfaces of the cuboid blocks of yew sloping down towards their inner edge. Owing to its form and positioning beside the lake, the work communicates not only with the high-rises across the water but also with temporary or permanent sculptures installed in the vicinity by Minimalist-oriented artists like Carl Andre and Donald Judd. The height and thickness of the hedge are reminiscent of wooden or stone sculpture, while the way the bushes have been trimmed brings to mind traditional modes of sculpting. The blocks are cut into shape on a regular basis and although this prevents uncontrolled growth, the sculpture is nevertheless involved in a constant process of metamorphosis. Stasis and growth confront one another.

- Eibenhecke, ca. 450 × 700 × 350 cm
- Nordwestliches Ufer des Aasees, Höhe Torminbrücke
- Eigentümer: LWL-Museum für Kunst und Kultur, Münster

- Yew hedge, ca. 450 × 700 × 350 cm
- North-western shore of Lake Aa, level with Tormin Bridge
- Owned by: LWL-Museum für Kunst und Kultur, Münster

Richard Tuttle

Richard Tuttle (*1941 Rahway) installierte auf beiden Seiten einer Ziegelsteinwand Holzskulpturen, die auf der gleichen Form basieren: Die erste zeigt diese von vorne und erinnert an einen Bassschlüssel oder an eine Ohrmuschel. Die andere zeigt die Form von der Seite und ähnelt einem Komma oder einem Apostroph. Während *Art and Music I* in einer Mauerecke hinter einer Tordurchfahrt hängt, ist *Art and Music II* auf gleicher Höhe an der anderen Wandseite zu finden. Tuttle platziert seine Arbeiten innerhalb des Ausstellungskontexts bewusst unkonventionell, beispielsweise an Fußleisten. Diese Arbeit irritiert durch die ungewöhnlich unscheinbare, regelrecht versteckte Anbringung am Gebäude. Postminimalistische Kunst fordert dazu auf, genau hinzusehen und auch dem Alltäglichen Aufmerksamkeit zu schenken. Der Stadtraum Münsters ist voller visueller und akustischer Eindrücke, seien es Plakate und Graffitis auf Mauern oder Glockenspiel, die erst bei genauerer Betrachtung auffallen.

Art and Music [Kunst und Musik]
Skulptur Projekte in Münster 1987

Richard Tuttle (*1941 Rahway) installed wooden sculptures on either side of a brick wall. The two pieces are based on the same form: one shows it from the front and is reminiscent of a bass clef or an auricle; the other shows it from the side, such that it resembles a comma or an apostrophe. *Art and Music I* hangs in the corner of the wall behind a gateway, while *Art and Music II* is located on the other side of the wall at the same height. Within the exhibition context Tuttle positions his work in places that are deliberately unconventional: for example, on skirting boards. What is perplexing here is the way the work is mounted on the building in such an unusually inconspicuous way that it is well and truly hidden. Post-Minimalist Art invites us to look at minutiae and pay attention to everyday objects. Münster's urban space is full of visual and acoustic impressions—be it posters and graffiti on walls or the chiming of bells—which only impinge on our awareness when closer attention is paid to them.

- *Art and Music I*: weiß gestrichenes Holz, 200 × 73 × 75 cm
 Art and Music II: schwarz lackierte Stahlplatten und weiß gestrichenes Holz, 200 × 200 × 30 cm
- Tordurchfahrt und Treppengang zwischen Domplatz 23 und Fürstenberghaus, Domplatz 20–22
- Eigentümer: Stadt Münster

- *Art and Music I*—white-coated wood: 200 × 73 × 75 cm
 Art and Music II—steel plate with black lacquer, and white-coated wood: 200 × 200 × 30 cm
- Gateway and steps between Domplatz 23 and Fürstenberghaus, Domplatz 20–22
- Owned by: City of Münster

Herman de Vries

Herman de Vries (*1931 Alkmaar) entwickelte für den Schlosspark, der nach Vorbild englischer Gartenbaukunst angelegt ist, ein Sanctuarium als Antithese: Während der Park stark domestiziert ist, befindet sich innerhalb der massiven kreisförmigen Mauer ein unberührter, geschützter Raum, den man nur über vier ovale, sandsteingerahmte Öffnungen— eine in jeder Himmelsrichtung— einsehen kann. Über diesen ist folgender Text in Sanskrit eingelassen: „om. dies ist vollkommen. das ist vollkommen. vollkommen kommt von vollkommen. nimm vollkommen von vollkommen, es bleibt vollkommen." Der Mensch ist von diesem idealen Ort physisch ausgeschlossen, es gibt keinen Eingang. Lediglich als Zuschauer_innen durch das ovale Rund haben sie Anteil an der Vollkommenheit der Natur. Beim Blick in das Rondell kommt jedoch auch Unbehagen auf: Dort liegt Abfall, von Menschenhand achtlos über die Mauer geworfen. Die Utopie einer unberührten Natur steht in Konflikt mit der Realität unserer Wegwerfgesellschaft.

sanctuarium
Skulptur. Projekte in Münster 1997

Herman de Vries (*1931 Alkmaar) designed a 'sanctuary' for the city's palace gardens, which is laid out in accordance with the principles of English garden landscaping. It is intended as an antithesis: while the park is very much a 'tamed' environment, there is an untouched, protected space within the solid circular wall that can only be seen through four oval apertures framed in sandstone, aligned in each of the four cardinal directions. Above them the following text is inscribed in Sanskrit: 'om. this is perfect. that is perfect. perfection comes from perfection. take perfection from perfection, and what remains is perfect.' Humans are physically excluded from this ideal place—there is no entrance. One can only partake of the perfection of nature as a spectator, peering through the oval opening in the wall. However, looking into the rotunda is also an uncomfortable experience: we see rubbish lying around that people have carelessly thrown over the wall. The utopia of unspoiled nature conflicts with the reality of our throwaway society.

- Kreisförmige Backsteinmauer mit Sandsteinelementen, Höhe 300 cm, Durchmesser 1400 cm, Wandstärke 40 cm, stärke der Sandsteinbekrönung 55 cm
- Wiesenfläche zwischen nördlichem Schlossgarten und Einsteinstraße
- Eigentümer: LWL-Museum für Kunst und Kultur, Münster

- Circular brick wall with sandstone elements, height: 300 cm; diameter: 1400 cm; wall thickness: 40 cm; thickness of sandstone capping: 55 cm
- Grassy area between the northern section of the palace gardens and Einsteinstraße
- Owned by: LWL-Museum für Kunst und Kultur, Münster

Silke Wagner

Silke Wagners (*1968 Göppingen) Hybrid aus figurativer Skulptur und Litfaßsäule macht den Münsteraner Paul Wulf zur Projektionsfläche: Wulf steht exemplarisch für zivilen Widerstand und den antifaschistischen Kampf im Nachkriegsdeutschland, nachdem er – 1938 im Alter von 16 Jahren im Sinne der nationalsozialistischen Rassenhygiene zwangssterilisiert – im Kampf um die Anerkennung seines Falls alle gerichtlichen Instanzen durchlaufen hatte. Die Säule ist mit Dokumenten aus dem UWZ-Archiv plakatiert, einem der größten alternativen Archive Deutschlands. Sie geben Einblick in die Lebensgeschichte Wulfs, den Häuserkampf Münsters, politische Zensur und die Anti-AKW-Bewegung. Die Arbeit Wagners fragt nach dem städtischen Selbstverständnis sowie der Erinnerungspolitik Münsters. Aus wessen Perspektive wird Geschichte geschrieben? Dem UWZ-Archiv als Speicher alternativer Erzählungen verleiht das Projekt darüber hinaus eine weitere Öffentlichkeit.

münsters GESCHICHTE VON UNTEN
[Münster's History from Below]
skulptur projekte münster 07

Silke Wagner's (*1968 Göppingen) hybrid creation combining a figurative sculpture with an advertising pillar turns Münster resident Paul Wulf into a projection screen: Wulf epitomizes civic resistance and the anti-Fascist struggle in post-war Germany. Having undergone forced sterilization in 1938, at the age of sixteen, as part of the Nazi eugenics programme, he went through all the judicial authorities in his battle to have his case recognized. The pillar is placarded with documents from the UWZ archive, one of the largest alternative archives in Germany. These documents provide insights into Wulf's personal history, the squatter struggles in Münster, political censorship, and the anti-nuclear movement. Wagner's work questions Münster's urban self-image and its politics of remembrance. From whose perspective is history written? The project also raises the public profile of the UWZ archive as a repository of alternative narratives.

- Betonplastik, Plakate, Höhe 340 cm
- Servatiiplatz
- Eigentümer: Stadt Münster

- Concrete sculpture, posters, height: 340 cm
- Servatiiplatz
- Owned by: City of Münster

Rachel Whiteread

Rachel Whiteread (*1963 London) installierte auf dem nicht betretbaren Balkon im zweiten Obergeschoss des Lichthofs im Museum eine in Gips gegossene Bücherwand: Sieben weiße Regalbretter umfassen die Tür, die auf diesen Balkon führt, wobei die Breite der einzelnen Tablare der Breite dieser Tür entspricht. Erkennbar sind hier jedoch nicht Bücher, sondern der Negativabdruck der Buchschnitte sowie die Hohlräume zwischen ihnen, der Wand und dem jeweils darüber liegenden Regal dargestellt. Die Bücher wurden im Produktionsprozess zerstört, sodass die Abdrücke nun auf die vormalige Existenz der abgegossenen Objekte verweisen. Whitereads eher unauffällige Arbeit fungiert so als Erinnerungsmoment. Durch die Wahl des Ortes stellt die Künstlerin den Symbolgehalt von Büchern als Wissensspeicher zur Diskussion. Das Werk ähnelt dem von Whiteread konzipierten Holocaust-Mahnmal (1995/2000) am Wiener Judenplatz: ein monumentaler Betonquader, an dessen Außenseiten ebenfalls Abgüsse von Buchreihen angebracht sind.

Untitled (Books) [Ohne Titel (Bücher)]
Skulptur. Projekte in Münster 1997

Rachel Whiteread (*1963 London) installed a wall of books cast in plaster on the inaccessible balcony of the atrium on the second floor of the museum: seven rows of white shelves surround the door leading to the balcony, with the width of the individual sections of shelving corresponding to the width of the door. However, it is clearly apparent that what we see here are not books but rather the negative impression of their edges and the empty spaces between them, the wall, and the shelf above. The books were destroyed in the production process so that the impressions now point to the quondam existence of the cast objects. Whiteread's rather inconspicuous work thus functions as a moment of recollection. Through her choice of location, the artist focuses discussion on the symbolic value of books as a repository of knowledge. The work resembles the Holocaust Memorial (1995/2000) Whiteread designed for Vienna's Judenplatz: a monumental concrete cube whose exterior surfaces also bear casts of shelves of books.

- Stahlkonstruktion, Gips, Polyurethanschaum, 316 × 870 × 32 cm
- Balkon 2. Obergeschoss Lichthof, Altbau des LWL-Museums für Kunst und Kultur
- Eigentümer: LWL-Museum für Kunst und Kultur, Münster

- Steel framework, plaster, polyurethane foam, 316 × 870 × 32 cm
- Balcony, 2nd floor atrium, old building of the LWL-Museums für Kunst und Kultur
- Owned by: LWL-Museum für Kunst und Kultur, Münster

Rémy Zaugg

Rémy Zaugg (* 1943 Courgenay, † 2005 Arlesheim) versetzte zwei Bronzeplastiken, die er restaurieren und erneut auf Sockel stellen ließ, an ihren ursprünglichen Standort zurück: Bei der Erstaufstellung 1912 sollten die Skulpturen des Bildhauers Carl Hans Bernewitz die westfälischen Bauern und Handelsleute empfangen, die von Süden her in die Stadt kamen. Einem Triumphbogen gleich, Viehzucht und Ackerbau symbolisierend, standen die beiden aufeinander zuschreitenden Tiere an der Einmündung der heutigen Hammer Straße. Anfang der 1960er Jahre verloren sie jedoch ihre Funktion. Sie wurden von ihren Sockeln gehoben und nebeneinander an der Seite des Kreisverkehrs abgestellt. Der Künstler setzt sich kritisch mit der Nutzlosigkeit, Überfülle und Vernachlässigung von Skulptur im öffentlichen Raum auseinander.

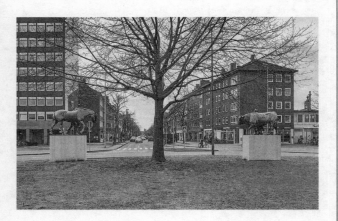

Versetzung des Denkmals Knecht mit Pferd und Magd mit Stier [Relocation of the monument Farmhand with Horse and Farm-Girl with Bull]
Skulptur Projekte in Münster 1987

Rémy Zaugg (* 1943 Courgenay, † 2005 Arlesheim) relocated two bronze sculptures that he had had restored, returning them to their original positions, where they were remounted on plinths. When they were first put on display in 1912, the sculptures by Carl Hans Bernewitz were meant to welcome the Westphalian farmers and merchants entering the city from the south. Serving as symbols of animal husbandry and farming, the two animals—shown walking towards one another—stood like a triumphal arch at the junction of today's Hammer Straße. However, they lost their function in the early 1960s and were taken from their plinths and put next to one another alongside the roundabout. The artist here turns a critical eye to the futility, profusion, and neglect of sculpture in public space.

- Zwei Bronzeskulpturen des Künstlers Carl Hans Bernewitz und zwei neue Sockel
 Sockel je 200 × 250 × 130 cm
 Figuren je ca. 200 × 300 × 130 cm
- Kreisverkehr Ludgeriplatz, Einmündung Hammer Straße
- Eigentümer: Stadt Münster

- Two bronze sculptures by the artist Carl Hans Bernewitz and two new plinths
 Plinths: 200 × 250 × 130 cm each
 Figures: ca. 200 × 300 × 130 cm each
- Roundabout at Ludgeriplatz, junction with Hammer Straße
- Owned by: City of Münster

Appendix

Erleben Sie die Skulpturenprojekte in 45 Minuten!

Nur alle 10 Jahre finden die Skulptur Projekte Münster (alle 10 Jahre), die Documenta Kassel (alle 5 Jahre), die Kunstbiennale Venedig (alle 2 Jahre) und die Art Basel (jedes Jahr) im gleichen Jahr statt. Alle 10 Jahre machen sich Kunstfreunde aus der ganzen Welt auf die grandtour der Kunst.
Das grandtour-Team startet mit vielen informativen und wichtigen Informationen rings um die Skulptur Projekte im Jahr 2017.
Wir schaffen etwas Eigenes, Einzigartiges – eine Mischung aus Informationen, Tipps und Erlebnissen in 45 Minuten.

Every ten years art enthusiasts from all over the world embark on their grandtour to see simultaneous periodical exhibitions all over the world. Top of the list is the Skulptur Projekte Münster (every 10 years), next exhibition not to miss is the Documenta Kassel (every 5 years), the Venice biennale (every 2 years) and finally the Art Basel (every year). During the Skulptur Projekte 2017 the grandtour Team extensively provides vast amounts of important information that should not be missed by any true art lover.
We create something uniquely special – a mix of interesting facts, advice and experiences within only 45 minutes .

Information
Tipps
Erlebnisse

NUR
45 Min.

- zuverlässig
- kompetent
- sicher

Unser freundliches Team freut sich auf SIE!

Die 45 min.-
ERLEBNIS-
RUNDFAHRT

The GRANDTOUR departures every Saturday (at 3 pm) and every Sunday (at 12 pm and at 3 pm).

Tickets are available at Pumpenhaus up until 15 mins before departure.

Die GRANDTOUR startet jeden Samstag (15.00 Uhr) und jeden Sonntag (12.00 Uhr und 15.00 Uhr).

Tickets sind bis 15 Min. vor Tourbeginn exklusiv am Pumpenhaus erhältlich.

Klicken Sie **WWW.GRANDTOUR-MUENSTER.DE** für mehr!

Stiftung

kunst³

für das LWL-Museum für
Kunst und Kultur in Münster

outset.

Freunde
des Museums
für Kunst und Kultur
Münster e.V.

FIRMENGRUPPE HERMANN BRÜCK
Düsseldorf . Essen . Münster

M

mondriaan
fund

LÜHN BAU

BASF
We create chemistry

HENRY MOORE
FOUNDATION

SAHA
SUPPORTING
CONTEMPORARY
ART FROM
TURKEY

Gerüstbau
Hermann Brück

Deutsche Bank

if**a** Institut für
 Auslandsbeziehungen

LBS
Bausparkasse der Sparkassen

kvadrat

 FIEGE

Projektförderer Kunst / Project Sponsors Art

JAPANFOUNDATION

VR-Bank
Westmünsterland eG

INNOGY FÜR ENERGIE
UND GESELLSCHAFT
STIFTUNG

g antert
w iemeler
i ngenieurplanung

T · ·

JÄCKERING

STANLEY THOMAS
JOHNSON STIFTUNG

Landesbetrieb Wald und Holz
Nordrhein-Westfalen

Freunde der **KUNST**AKADEMIE
MÜNSTER

BERESA
LEIDENSCHAFT FÜR BEWEGUNG

SCHMITZ
CARGOBULL
The Trailer Company.

Projektförderer Sonstiges / Additional Project Sponsor

K
KIEPENKERLVIERTEL.DE

Sachsponsoren/In-Kind Sponsors

Kooparationspartner/Cooperation Partners

Skulpturenmuseum
Glaskasten Marl

Dank an/Special thanks to

artcuisine
Baby One
Dr. Beermann WP Partner GmbH
Bischöfliches Priesterseminar Borromaeum
British Council
cube / GOP
Dr. Vasant Desai
DESRAD Immobilien GmbH & Co. KG
Deutsche Funkturm
Diapharm GmbH & Co. KG
Sabine und/and Christian DuMont Schütte
filmothek der jugend nrw e. V.
Goethe-Institut
Ulrich Greim-Kuczewski
Andreas Heupel
Wolter Hoppenberg Rechtsanwaltsgesellschaft
R. Horstmann Vermögensverwaltung
Josef Kuhr Immobilienbesitz GmbH & Co. KG
Krukenkamp am Kai
Lichtgitter GmbH
Münsters Top Hotels
Ingenieurbüro Nordhorn
Dres. Arend und Brigitte Oetker
Pasta e Basta al porto
Phase One A/S
Port7 Rechtsanwälte
Ratio – Unternehmensgruppe
Raumfabrik Münster
roestbar
Ann-Paulin Söbbeke, Hafenkäserei
Stiftung Storch
SuperBioMarkt

Dank an alle, die nicht namentlich genannt werden möchten
Our thanks too to all those who prefer not to be mentioned by name

Projektbezogener Dank/Project Acknowledgements

Ei Arakawa
- Dank an/Special thanks to: Akademie für Gestaltung der Handwerkskammer Münster, Nikolas Gambaroff, Tim Gladki, Jörg Haep, Handwerkskammer Münster, Manfred Heilemann, Takayuki Ishii, Renate Kainer, John Kelsey, Jutta Koether, Yichien Lee, Takayuki Mashiyama, Max Mayer, Christian Meyer, Christian Naujoks, Lisa Overduin, Gela Patashuri, Dan Poston, Amy Sillman, Emily Sundblad, Sergei Tcherepnin, Constanze Unger, Nils Usslepp
- Gefördert von/Funded by: VR-Bank Westmünsterland eG, Japan Foundation
- Unterstützt von/Supported by: Gantert + Wiemeler Ingenieurplanung

Nairy Baghramian
- Dank an/Special thanks to: Interzone Berlin, Marian Goodman Gallery, New York
- Unterstützt von/Supported by: Gantert & Wiemeler Ingenieurplanung

Aram Bartholl
- Dank an/Special thanks to: Nadja Buttendorf
- Gefördert von/Funded by: innogy Stiftung für Energie und Gesellschaft, Landesbetrieb Wald und Holz NRW
- Unterstützt von/Supported by: Deutsche Funkturm

Cosima von Bonin/Tom Burr
- Dank an/Special thanks to: Norbert Bökamp, Andreas Busacker, Tono Dreßen, Franziska Erdmann, Jenni Henke, Anne Krönker, Inga Krüger, Jana Peplau, Bernd Rulle, Kristina Scepanski, Bernhard Sicking, Thomas Spiegelhalter, Tobias Viehoff
- Gefördert von/Funded by: BERESA GmbH & Co. KG und Schmitz Cargobull AG, Stiftung Storch, Sabine und/and Christian DuMont Schütte

Andreas Bunte
- Eva Berendes, Ingrid und/and Konrad Berendes, Betterguards Technology GmbH, Boris Borynsky (FGV Schmiedle, Berlin), Frank und/and Michel Homann (SV Berlin Buch), Tobias Krieg (ABB Automation GmbH, Unternehmensbereich Robotics, Friedberg), Bernd Kuhlenkötter (Lehrstuhl für Produktionssysteme, Fakultät für Maschinenbau, Ruhr-Universität Bochum), Sascha Rybnicki (Zoo Palast Berlin), Yvonne Schrön (Zoo Palast Berlin), Armin Steinborn (FGV Schmiedle, Berlin), Edgar und/and Rita.
- Gefördert von/Funded by: Medienboard Berlin-Brandenburg

Gerard Byrne
- Dank an/Special thanks to: Sven Anderson, John Beattie, Ali Curran, Simone Ebert, Damien Elliott, Moritz Fehr, Werner Gövert, Louis Haugh, Peter Maybury, Ronan McCrea, Sarah Pierce, Monika Rasche, Gunter Riemers und/and Stadtbücherei Münster

CAMP (Shaina Anand und/and Ashok Sukumaran)
- Dank an/Special thanks to: Rita Feldmann, Gerit Funke (Antonia Verlagsgesellschaft mbH & Co. KG), HLB Dr. Schumacher & Partner GmbH mit/with Stefan Rethfeld, Ulrich Peters, Renate Terstiege (Städtische Bühnen Münster), Volksbank Münster
- Gefördert von/Funded by: Japan Foundation, Institut für Auslandsbeziehungen (ifa)
- Unterstützt von/Supported by: Gantert & Wiemeler Ingenieurplanung

Michael Dean
- Dank an/Special thanks to: Christian Geißler, David Hanger, Herbert Voigt
- Gefördert von/Funded by: Stiftung kunst³

Jeremy Deller
- Dank an/Special thanks to: Mark Angsmann, Martin Bamberger, Manfred Bauer, Beate Engel, Helmut Helmer, Rüdiger Neumann, H.- Helge Nieswandt, Raphael Pillen, Christian Sander, Torben Schreiber und allen Kleingärtner_innen/and all allotment holders, Horst Stronk, Herbert Voigt, Dirk Winter, Cornelia Wächter, Frank Wächter, Oliver Wächter, Tobias Wächter
- Gefördert von/Funded by: Stanley Thomas Johnson Stiftung, Henry Moore Foundation
- Unterstützt von/Supported by: Brillux GmbH & Co. KG

Nicole Eisenman
- Dank an/Special thanks to: Zanny Allport, Charlotte Viehoff, Christoph Gerozissis, Christine und/and Andy Hall, Fam. Kayser, Anton Kern, Gail Kirckpatrick, Antone Könst, Amanda Singer, Verena Stieger, Charlotte Viehoff, Simone White, Christian Geißler
- Gefördert von/Funded by: Kulturstiftung der Sparkasse Münster
- Leihgeber (Bronzefiguren)/Bronzes on loan from: Anton Kern Gallery, New York

Projektbezogener Dank/Project Acknowledgements

Ayşe Erkmen
- Dank an/Special thanks to: Frank Ahlmann, Michael Andrae-Jäckering, Ulrich Arndt (Hafenmeister/Harbour master), Melanie Bisping, Harley Davidson Warehouse, Andreas Heupel, Ali Karadogan, Walter Lucas, Manfred Niermann, Pasta e Basta Münster, Michael Radau, Patrick Sandfort, Ann-Paulin Söbbeke, Stadtwerke Münster, Jan Zillmann
- Gefördert von/Funded by: Michael Andreae-Jäckering, SAHA – Supporting Contemporary Art from Turkey
- Unterstützt von/Supported by: Lichtgitter GmbH, Gantert & Wiemeler Ingenieurplanung
- Öffnungszeiten ermöglicht durch/Opening hours made possible by: Ratio-Unternehmensgruppe, Dr. Vasant Desai, Ann-Paulin Söbbeke (Hafenkäserei), SuperBioMarkt, Diapharm GmbH & Co. KG, Baby One, Dr. Beermann WP Partner GmbH, Beresa GmbH & Co. KG, cube/GOP, DESRAD Immobilien GmbH & Co.KG, Ingenieurbüro Nordhorn, Krukenkamp am Kai, Josef Kuhr Immobilienbesitz GmbH & Co. KG, Raumfabrik Münster, Wolter Hoppenberg Rechtsanwaltsgesellschaft, Ulrich Greim-Kuczewski, Andreas Heupel, Pasta e Basta al porto, Port7 Rechtsanwälte

Lara Favaretto
- Unterstützt von/Supported by: Gantert & Wiemeler Ingenieurplanung

Hreinn Friðfinnsson
- Dank an/Special thanks to: Arnold AG (insbesondere/in particular Frank Lohmann), Arnar Ásgeirsson, Galería Elba Benitez, Meessen De Clercq, Halla Einarsdóttir, Jónmundur Þór Eiríksson, Annabelle von Girsewald, Corinne Groot, Grétar Guðmundsson, Styrmir Örn Guðmundsson, Kristinn E. Hrafnsson, i8 Gallery, Elske de Kruijter, Cassandra Edlefsen Lasch, Moderna Museet, Galerie Nordenhake, Frédéric Paul, Peter Rose, Sigurður Orri Steinflórsson, Sólveig Stewart, Ásgeir Þórmóðsson
- Gefördert von/Funded by: Mondriaan fund

Gintersdorfer/Klaßen
- Dank an/Special thanks to: Ludger Schnieder, Johannes Sundrup (Theater im Pumpenhaus)
- Gefördert von/Funded by: BASF, Fonds Darstellende Künste e. V., Japan Foundation

Pierre Huyghe
- Credits: Informatik/Computing: Ayodamola Okunseinde (interaction design), Andy Cavatorta (Technik/engineering), Guillaume Couturier (Tontechnik/sound engineering), Gabriel De Swarte (Informationsdesign/information design); Augmented Reality: Mandy Mandelstein und/and Ivaylo Getov (Luxloop); Zell-Entwicklung/Cell development: Anton Henssen (Memorial Sloan Kettering Cancer Center), Elizabeth Henaff (Institute for Computational Biomedicine – Weill Cornell Medical College), Timo Betz, Volker Gerke und/and Exzellenzcluster Cells in Motion (WWU Münster); Aquarium: Aqua Art Design und/and Tim Schmiedeshoff; Imker/Beekeeper: Danny Jöckel; Produktion/Production: Anne Stenne, Sara Simon, Anne-Sophie Tisseyre, Jennifer Cohen (Pierre Huyghe Studio), Emiliano Pistacchi (Esther Schipper, Berlin), Nicola Di Chio (Toolman Custom), Manfred Voß und/and Katharina Sophie Heck, Lars Nielbock, Jana Rippmann, Kjeld Schmidt, Valentina und/and Estela.
- Dank an/Special thanks to: Galerie Chantal Crousel, Paris; Hauser & Wirth, London; Marian Goodman Gallery, New York; Esther Schipper, Berlin;
- Unterstützt von/Supported by: Gantert & Wiemeler Ingenieurplanung

John Knight
- Dank an/Special thanks to: ADM Works, Jack Brogan, Anthony Carfello, Rosalind Cutforth, André Rottmann, Ken Saylor, Michelle Saylor
- Gefördert von/Funded by: Stiftung kunst[3]

Justin Matherly
- Dank an/Special thanks to: Paula Cooper Gallery, New York, Gantert & Wiemeler Ingenieurplanung mit/with Alexander Wierer, Fridolin Mestwerdt, Paul, Wilfred Pinsdorf, Patrick Plankenhorn, Detlev Rupieper, Samuel Treindl
- Unterstützt von/Supported by: Fiege Logistik Holding Stiftung & Co

Christian Odzuck
- Dank an/Special thanks to: Carla Donauer, Tanja Goethe, Jan Kampshoff, Marcus Lütkemeyer, Laura Maréchal, JL Murtaugh, Gunnar Pick, Stefan Rethfeld
- Gefördert von/Funded by: Lühnbau, Condor Gerüstbau und/and Firmengruppe Hermann Brück, Gaarmann Overhaus Container GmbH & Co. KG
- Unterstützt von/Supported by: Brillux GmbH & Co. KG, Stadtwerke Münster

Emeka Ogboh
- Dank an/Special thanks to: Lisa Bröker-Jambor, Felix Denk, Deutsche Bahn mit/with Philipp Nelle und/and Norbert Strathmann, Wilko Franz, Stephan Froleyks, Erhard Hirt, Jan Klare, Alexander Lauer, Hanna Neander, Norbert Nowotsch, Bernd Schwabedissen, Ludwig Sommer, Volker Zander

464

Projektbezogener Dank/Project Acknowledgements

Peles Empire
- Dank an/Special thanks to: Viola Eickmeier (Studio Violet), Stefanie Haferbeck, Wilhelm Kordts (Roxeler Ingenieurgesellschaft mbH), Oberverwaltungsgericht des Landes Nordrhein-Westfalen, Oliver Osborne, Tile Fire LTD, Janneke de Vries, Jan und/and Tina Wentrup
- Gefördert von/Funded by: Stiftung der Sparkasse Münsterland Ost, British Council
- Leihgeber/On loan from: Galerie Wentrup, Berlin

Alexandra Pirici
- Dank an/Special thanks to: Dan Anghelache, Andrei Dinu, Toma Marioara, Raluca Voinea und dem/and the World Wide Web
- Gefördert von/Funded by: Freunde des Museums für Kunst und Kultur e. V., Deutsche Telekom

Mika Rottenberg
- Dank an/Special thanks to: Katrin Altekamp, forthdensity productions mit /with David Hollander
Gefördert von/Funded by: Louisiana Museum of Modern Art, Outset, Polyeco Contemporary Art Initiative
- Unterstützt von/Supported by: Brillux GmbH & Co. KG

Sany (Samuel Nyholm)
- Dank an/Special thanks to: Thomas Knecht, Elly zu Innhausen und Knyphausen Nyholm, Alexander Pfeiffenberger, Marvin Udhe
- Gefördert von/Supported by: Iaspis – The Swedish Arts Grants Committee International Programme for Visual Artists

Gregor Schneider
- Dank an/Special thanks to: Konrad Fischer Galerie, Düsseldorf, den Handwerkern vom/the craftspeople from the LWL-Museum für Kunst- und Kultur mit/with Alfred Boguszynski, Thomas Erdmann, Kamil Jackiewicz, Stefan Schlüter, Beate Sikora
- Gefördert von/Funded by: Stiftung kunst³
- Unterstützt von/Supported by: Fiege Logistik Holding Stiftung & Co

Thomas Schütte
- Leihgabe *Nuclear Temple*/on loan from: Thomas Schütte

Nora Schultz
- Dank an/Special thanks to: Thomas Bücker (Ton/sound), Kunstmuseum Glaskasten Marl mit/with Christa Appel, Georg Elben, Stephan Wolters , Andreas Prinzing, Joel Seidner, SIEBDRUCK Service WELLE GmbH mit/with David Heller, Josef Strau, Manuel Unkelbach (Audioextreme), Jane Urban (Video und Ton Assistenz/assistant video and sound engineer)
- Gefördert von/Funded by: Stiftung kunst³
- Olle Bærtling, *YZI*, Leihgabe/on loan from: Skulpturenmuseum Glaskasten Marl

Michael Smith
- Dank an/Special thanks to: Winfried Bettmer, Samantha Bleeks, Helmut Bockhold, Ludger Brinkschulte, Familie Feldhaus und/and Marc Feldhaus (Hotel Busche), Valesca Gutzeit, Karsten Jäger, Günter Kempkes, Gerhard Kienbaum (Münster Marketing), Green Naftali Gallery, Jan Dirk Püttmann (TCT – Touristik City Tour GmbH), Radwerk Gallien, Christa Reißmann, N. Rosenbaum (Drahtesel), Michael Kirby Smith, Michael Spengler, Stadtmuseum Münster mit/with Barbara Rommé und/and Regine Schiel

Hito Steyerl
- Dank an/Special thanks to: Esme Buden, Alice Conconi, Andrew Kreps, Sümer Kültür Merkezi, Diyarbakır Sanat Merkezi, Manuel Reinartz, Gunnar Wendel
- Gefördert von/Funded by: LBS Bausparkasse der Sparkassen
- Leihgeber (*Prototypes*)/On loan from: Andrew Kreps Gallery, New York
- Videos beauftragt von/Videos commissioned by the Fundação Bienal de São Paulo, 2016

Koki Tanaka
- Dank an/Special thanks to: Lothar Feistner (Aegidiimarkt), Niusia de Gier (Kvadrat), Suchan Kinoshita, Philipp Klapper, Josef Tebel und allen Kolleg_innen/and team, Vitamin Creative Space mit/with Aoyama Meguro, Volkshochschule Münster mit/with Anna Ringbeck und/and Heiko Schnieder, WBI – Westfälische Bauindustrie Münster mit/with Klaus Kötterheinrich, WWU Münster mit/with Eckhard Kluth und allen Kolleg_innen/and team
- Gefördert von/Funded by: Deutsche Bank, Kvadrat, Japan Foundation
- Unterstützt von/Supported by: Brillux GmbH & Co. KG

465

Projektbezogener Dank/Project Acknowledgements

Oscar Tuazon
- Dank an/Special thanks to: Galerie Eva Presenhuber, Zürich, Antoine Rocca, Stadtwerke Münster, Wasserstraßen- und Schifffahrtsamt Rheine
- Gefördert von/Funded by: Galerie Eva Presenhuber, Zürich, Maccarone, New York/Los Angeles, Galerie Chantal Crousel, Paris

Benjamin de Burca/Bárbara Wagner
- Dank an/Special thanks to: Elephant Lounge: Gerald Wissel; Kunstakademie Münster: Michael Spengler; Filmwerkstatt Münster: Winfried Bettmer; Botanischer Garten Münster: Jürgen Hausfeld, Herbert Voigt, Jorge Zuzarte; Clemenskirche: Bistum Münster, Nicole Ebel, Marion Plettendorf-Beecht, Vanessa Sommer, Stadt Münster, Weihbischof Dieter Geerlings; Preussen Stadium: SC Preussen 06 e. V., Marcel Weskamp; Theater Münster: Frank Burian, Rita Feldmann, Mike Globig, Heiko Möller, Renate Terstiege, Toni Weiden, Hans-Bernd Weißen; Grille: Ulla Bockhorn, Dirk Steffes-Holländer, Christian Mues; WDR Studio Münster: Gerhard Bauernfeind, Lisa-Marie Beck, Andrea Benstein, Leo Krug, Peter Leuenberger, Bastian Polonyi, Torsten Wermeling, Eva und/and Ono Bourke, Miriam de Burca, Ernesto de Carvalho, Eckerle, Russel Flood, Christian Geißler, Ingo Grabowsky, Marcio Harum, Meram Karahasan, Cemil Emre Kaya, Hans und/and Ina Kemper, Michael Kloos, Thomas Leugner, Longerich, Lush, Elisabeth Mai, Vito Marinaccio, Torsten Matschke, Gustavo Montenegro, Musik Produktiv, Marcelo Pedroso, Matthias Reintjes, Adam Riese, Herbert Scheffer, Hildegard Sparfeldt (in memoriam) und der Familie von/and the family of Udo Jürgens, Kristina Teumner, Antonio Tocino, Roberto Turchetto, Goran Tutic
- Equipment: cineOne Dortmund; Filmwerkstatt Münster, Kunstakademie Münster, sPOTTlight Dortmund; Autovermietung/car rental: Avis, Güntzel Autovermietung; Catering: Cafe & Restaurant Friedenskrug, Café Med, Il Gondoliere, Krimphove, Prütt, Schlossgarten Café, Tollkötter
- Gefördert von/Funded by: Goethe-Institut São Paulo, Institut für Auslandsbeziehungen (ifa)

Cerith Wyn Evans
- Dank an/Special thanks to: Galerie Buchholz, Berlin, Köln, New York, St. Stephanus Gemeinde: Helga Brüggeshemke und dem gesamten Pfarrbüro/and the staff at the parish office, Pastor Thomas Laufmöller, NEONline Werbedesign GmbH

Hervé Youmbi
- Dank an/Special thanks to: Christoph Both Asmusn, Lisa Brittan (Axis Gallery), Wanko Cubart, Marilyn Douala Bell (Espace doual'art), Alassa Fouapon, Dominique Malaquais, Anna Speidel, Bandjoun Station, Barthélémy Toguo, Mama Wouochawouo, Gary Van Wyk (Axis Gallery) und/and Titi Ebongue und/and Kaefra Youmbi, Hervé Yamguen, Landry Youmbi
- Gefördert von/Funded by: Institut für Auslandsbeziehungen (ifa)

466

Projektbezogener Dank Kunstvermittlung/Project Acknowledgements Art Education

Mapping Skulptur Projekte
● Dank an/Special thanks to: Shiar Abdul Rahman, Hawaa Abu Bakrin, Sanaz Afshord, Feraydon Ahmadi, Homa Akbari, Rahman Aklaghi, Hamide Aklaghi, Safaa Alsibai, Selam Alula, Moijtaba Amiri, Jens Boemke, Antonia de Carné, Sabit Cigani, Hana Danal, Mary Dawuda, Stephanie Drube, Hekmatullah Faizi, Sara Farzi, Kerana Georgieva, Amina Haji, Eamama Hasan, Alem Hayelom, Stephanie Henzler, Ibrahim Ibrahim, Sherif Ibrahim, Zehira Ikhlef, Jawed Joschan, Claudia Jostmeier, Bexhet Kadrolli, Katharina Kapteina, Abdulrahman Kasas, Feras Kashoum, Betina Klöcker, Zauri Matikashvili, Awaz Miho, Bahram Mirzazada, Tahgas Mlebrhan, Hossein Mohajer Pour, Marwa Moustafa, Muhamad Muslim Achmadi, Theresa Nagler, Nada Najib, Judith Ngalula, Reem Orabim, Hodan Osman, Hamidullah Rasouli, Andrijana Sahiti, Aref Sajadi, Afrah Saleem Shamo, Antje Semmelmann, Florian Serwaty, Elizabeta Shaini, Rami Sybha, Kelab Temeiso, Rahel Tuum, Luna Unqay, Noor Wardeh, Heike Wartenpfuhl, Urike Willenborg, Khalid Zazai, Henok Zemica

Zeichnung von/Drawing by Judith Ngalula, *Mapping Skulptur Projekte*, 2016/2017

…mit unserem Blick
● Dank an/Special thanks to: Beate Achteresch-Horbach, Horro (Helmut) Bockhold, Selma Brand, Inti Escudero, filmothek der jugend e.V., Lena Franz, Amelie Ginda, Leonie Humpohl, Jule Kersting, Elisabeth Knemeyer, Kilian Schmitt, Tanina Palazzolo, Charlotte Schulze-Pröbsting, Patrick Sonius, Pauline Steffen, Rudolf Söbbeke, Rose Thöne, Ulrike Thöne, Solveig Trenkpohl, Cornelia Wächter, Ann-Christin Weide, Charlotte Weinaug, Frank Zimmermann und dem/and the Förderverein PGR und GMM e.V.
● Gefördert von/Funded by: Stiftung der Sparkasse Münsterland Ost

Impressum/Colophon Team Skulptur Projekte Münster 2017

- Künstlerische Leitung/Artistic director: Kasper König
- Kuratorinnen/Curators: Britta Peters, Marianne Wagner
- Projektleitung/Managing director: Imke Itzen
- Projektkoordination/Project coordinator: Julia Jung
- Assistenz Projektleitung/Assistant managing director: Konstanze Klecha
- Kuratorische Assistenz/Curatorial assistants: Jan Bockholt, Clara Napp, Sophia Trollmann
- Assistenz Künstlerische Leitung/Assistant artistic director: Andreas Prinzing
- Stud. Mitarbeit Kuratorisches Team/Student assistant to curatorial team: Georgios Paroglou
- Stud. Mitarbeit Projektorganisation/Student assistants project management: Lena Dues, Anna Viehoff
- Praktikum Projektorganisation/Project management interns: Anna Viehoff, Alexandra Südkamp, Maximilian Wigger
- Sponsoring/Sponsorship: Imke Itzen, Bastian Weisweiler
- Pressesprecherin/Press officer: Jana Duda
- PR + Online Kommunikation/PR + Online communication: Judith Frey
- Marketing + Kommunikation/Marketing + Communication: Ulla Gerhards
- PR Beratung/PR consulting: Kathrin Luz Communication
- Wiss. Volontariat Presse/Press office trainee: Stefanie Raupach, Katrin Ziegast
- Stud. Mitarbeit Presse/Student assistants to press office: Aleen Köster, Linda Schinkels, Nora Staege, Alexandra Südkamp
- Praktikum Presse/Press office interns: Eva Busse, Caroline Huzel, Pia Jerger, Aline Krahn
- Kunstvermittlung/Art education: Ingrid Fisch, Stefanie Bringezu
- Wiss. Volontariat Kunstvermittlung/Art education trainee: Anna-Lena Treese
- Stud. Mitarbeit Kunstvermittlung/Art education student assistants: Ronja Ganßauge, Anna Mondain-Monval
- Praktikum Kunstvermittlung/Art education interns: Pia Beholz, Linda Kotzian, Alexandra Sichwart
- Besucherservice/Visitor service 2017: x:hibit; Geschäftsführer/Managing director: Johannes Krug; Projektleitung/Project manager: Joanna Iwansowski; Teamleitung/Team manager: Franziska Fandrich
- Publikationen/Publications: Luise Pilz
- Wiss. Mitarbeit Publikationen/Publications research assistant: Martina Kigle
- Assistenz Publikationen/Publications assistant: Lennart Lofink
- Koordination der Aufsichten/Staff coordinators: Jana Koszarek, Tatjana Niederberghaus
- Technische Leitung/Technical management: Daniel Knapp, Stefan Trosdorf, motorplan Architekten & Ingenieure Frankfurt a. M.
- Mitarbeit Technische Leitung/Technical management assistants: Stephan Engelke, Ute Schimmelpfennig, Annika Griewisch, Evgenia Neufeld, motorplan Architekten & Ingenieure Frankfurt a. M.
- Art-Installation-Team/Art installation team: Anna Beckmann, Willi Beermann, Sarel Debrand-Passard, Simon Ertel, Alexander Föllenz, Tim Glatki, Tobias Grothues, Janine Heiland, Yona Hurckes, Tobias Kappelhoff, Jacqueline Karpa, Daniel Kledtke, Sven Könning, Yannis Kulosa, Nico Lippold, Jonas Maas, Dominik Maiber, Lars Nielbock, Evelyn Reinke, Leonard Schmidt, Paul Schuseil, Felix Trambacz, Nils Usslepp, Malte van de Water, Lia Zinngrebe
- Media Installing/Media installations: satis & fy
- Gestalterisches Konzept/Visual concept: Urs Lehni & Lex Trüb
- Assistenz Gestalterisches Konzept/Visual concept assistants: Lukas Marstaller, Clemens Piontek, Arno Schlipf
- Programmierung Website/Website programming: Urs Hofer
- Archivarin Skulptur Projekte Archiv/Skulptur Projekte Archiv research consultant: Katharina Neuburger
- Wiss. Volontariat Skulptur Projekte Archiv/Skulptur Projekte Archiv trainee: Julius Lehmann
- Öffentliche Sammlung und Website/Public collection and website: Marijke Lukowicz, Ronja Primke
- Übersetzungen/Translations DE-EN: Judith Rosenthal

Dank an/Special thanks to

Gundula Avenarius; Mirjam Baitsch; Moritz Baßler; Bauordnungsamt Münster; Renate Bering; Christian Bode; Katja Böhme; Karl-Heinz Bonny; Stefan Bresky; Torben Breuker; Magdalene Brune und/and Postbank Domplatz; Alexis Buchwald; Sara Burkhardt; Klaus und/and Brigitte Bußmann; Amt für Bürger- und Ratsservice; Barbara Caveng; Ludger Claßen; Kirsten Czerner-Nicolas und/and Lebenshilfe Büro für Leichte Sprache Ruhrgebiet; Andreas Dahlhaus; Antje Dalbkermeyer; Monika Demler; Markus Denkler; Dörte Dennemann; Frank Dite; Regina Dittmer; Jil Döhnert; Pitti Duyster; Birgit Engel; Rita Feldmann; Regierungsvizepräsidentin Dorothee Feller; Feuerwehr Münster; Jörg Friedrich; Turit Fröbe; Ursula Frohne; Henriette Gallus; Sigrid Gorlt; Franz-Josef Gövert; Marc Günnewig; Amt für Grünflächen, Umwelt und Nachhaltigkeit Münster; Klaus Hahn; Sascha Heise; Stephanie Henzler; Andreas Heupel; Gisela Holtz; Georg Imdahl; Amt für Immobilienmanagement Münster; Mona Jas; Vera Kalkhoff; Jan Kampshoff; Seidou Karidio und/and Afrika Kooperative e. V.; Amt für Kinder, Jugendliche und Familien Münster; Suchan Kinoshita; Gail Kirkpatrick und/and Kunsthalle Münster; Johannes Kirschenmann; Thomas Klein; Johanna-Yassira Kluhs; Eckhard Kluth; Elke Kollar; Peter König; Silvia Koppenhagen; Annegret Kosmeier; Klaus Kötterheinrich und/and WBI Westfälische Bauindustrie Münster; Inga Kramer; Heike Kropff; Immanuel Krüger; Edgar Kuhlmann; Harald Lammers; Sigrid Liebe und/and städtische Kita in Berg Fidel; Maik Löbbert; Maria Ludwig und/and Bau- und Liegenschaftsbetrieb NRW, Niederlassung Münster; Nana Lüth; LWL-Medienzentrum für Westfalen; Ina Malchow; Flavia Mayer; Aernout Mik; Arne Mittig; Nicola Müllerschön; Christoph Neteler und/and Vermessungs- und Katasteramt; Frank Neumann und/and Polizei NRW Münster; Erich Niederberger; Brigitte und/and Arend Oetker; Sandra Ortmann; Nadine den Ouden; Petra Panske und/and Münster Marketing; Michael Peeken; Georg Peez; Ludwig Peltzer; Carsten Peters; Alexander Pfeiffenberger; Ralph Pohlmann und/and Pape & Böhm Elektrotechnik; Juliette Polenz und/and Kinder-Uni Münster; Michael Radau; Eeva Rantamo; Martin Rettig; Christian Reucher; Karsten Rößmann; Doris Rüter; Claudia Ryll; Martje Salje; Hans Salomon; Kiki Schöpper; Annette Schlatholt; Heiko Schmid; Maralena Schmidt; Ralf Schmidt-Abbenhaus; Janine Schmutz; Jens Schneiderheinze und/and Cinema Münster; Frauke Schnell; Ludger Schnieder; Katja Schöpe; Ulrich Schötker; Christoph Schröer; Mario Schröer, Hartwig Schultheiß; Stephanie Sczepanek; Rudolf Söbbeke; Bernadette Spinnen; Mirijam Springer; Frank Springub und/and Ordnungsamt Münster; Stadtarchiv Münster; Stadtmuseum Münster; Anja Stehling; Studierende der Seminaren Gelebte Räume I und II; Frank Tafertshofer; Andreas Tschöpe; Juliane Unkelbach; Herbert Voigt; Andrea Volmering; Stephanie Waldschmidt; Susanne Weckwerth; Wolfgang Weikert; Michael Wenge; Norma Luise Werbeck; Doris Wermelt; Birgit Wessel; Cornelia Wilkens; Martin Woermann; Sascha von Zabern, Maren Ziese

Das Skulptur Projekte Team dankt den Mitarbeiter_innen des LWL-Museum für Kunst und Kultur und allen, die dazu beigetragen haben, die Ausstellung zu realisieren.

The Skulptur Projekte team would like to thank the staff at the LWL-Museum für Kunst und Kultur and all those who have contributed to bringing the exhibition to fruition.

Impressum/Colophon

Veranstalter/Event Organizer
LWL-Museum für Kunst und Kultur

- Direktor/Director: Hermann Arnhold
- Stellv. Direktorin/Deputy director: Tanja Pirsig-Marshall
- Sekretariat/Office of the director: Petra Haufschild
- Presse- und Öffentlichkeitsarbeit/Press office and PR: Claudia Miklis, Birgit Niemann, Anja Tomasoni
- Verwaltungsleitung/Head of administration: Detlev Husken
- Stellv. Verwaltungsleiterin/Deputy head of administration: Monika Denkler
- Haushalts-, Gebäudeverwaltung/Budget, building management: Philipp Albert, Manuela Bartsch, Nicole Brake, Marie-Therese Graes, Birgit Kanngießer
- Veranstaltungsmanagement/Event management: Bastian Weisweiler
- Veranstaltungsorganisation/Event organization: Annika Ernst
- Registrarin/Registrar: Hannah Vietoris
- Magazinverwaltung/Storage management: Jürgen Uhlenbrock, Jürgen Wanjek
- Museumstechnischer Dienst/Technical service: Johann Czerne, Frank Naber
- Hausmeister/Maintenance supervisor: Peter Wölfl
- Handwerker/Craftspeople: Werner Müller, Alfred Boguszynski, Thomas Erdmann, Withold Harder, Thomas Püth, Stefan Schlüter, Beate Sikora, Marianne Stermann
- Bibliothek/Library: Martin Zangl, Gudrun Brinkmann, Petra Wanning
- Dokumentation/Documentation: Ursula Grimm, Ingrid Hillebrand, Anke Killing
- Fotoabteilung/Photo documentation: Hanna Neander
- Restauratoren Skulptur/Sculpture restoration: Claudia Musolff, Jutta Tholen
- Restauratoren Gemälde/Paintings restoration: Berenice Gührig
- Restauratoren Grafik/Prints and graphics restoration: Beate Holtmann, Ryszard Moroz
- Poststelle/Post room: Ingrid Kasem
- Kasse/Ticket counter: Kirstin Amshoff, Barbara Brandherm, Christian Huxel, Dorothee Press, Sabine Schmidt
- Pforte/Gate: Withold Harder, Andreas Mainka, Markus Müller, Manfred Terberl
- Aufsichtspersonal/Supervisory staff: SITEC Dienstleistungen GmbH
- LWL-Bau- und Liegenschaftsbetrieb Landschaftsverband: (insbesondere/in particular) Ulrich Staggenborg, Stefan Vennemann
- LWL-Haupt- und Personalabteilung/LWL-General and Human Resources Department: (insbesondere/in particular) Stefanie Besser, Matthias Jöster, Gideon Münstermann, Jutta Schürkamp
- LWL-Haupt- und Personalabteilung, Zentrale Dienste und Einkaufskoordination/LWL General and Human Resources Department, procurement coordination: (insbesondere/in particular) Jil Döhnert, Annegret Formann, Jan Jannemann, Patrick Kötter, Henning Lensmann, Katja Löchter, Jens Ochtrup, Isabell Schepers

470

Impressum/Colophon

Katalog/Catalogue
Skulptur Projekte Münster 2017

- Herausgeber/Editors: Kasper König, Britta Peters, Marianne Wagner
LWL-Museum für Kunst und Kultur, Direktor/Director: Hermann Arnhold
- Konzept und Gestaltung/Concept and graphic design: Urs Lehni & Lex Trüb
- Assistenz Gestaltung/Graphic design assistant: Clemens Piontek
- Redaktion/Editing: Britta Peters, Luise Pilz, Martina Kigle (ab Dez./since Dec. 2016)
- Lektorat/Copy-editing: Martina Kigle, Luise Pilz (DE)/Simon Cowper (EN)
- Korrektorat/Proofreading: Jan-Frederik Bandel, Martina Kigle, Jan Wenzel (DE)/Simon Cowper (EN)
- Produktionsbetreuung/Production support: Spector Books, Christin Krause
- Übersetzung/Translation: Jan Caspers, Simon Cowper, Tim Beeby & Sabine Bürger, John Middleton, Judith Rosenthal, Bradley Schmidt, Richard Shamrock (DE-EN)/Herwig Engelmann, Stephanie Fezer (EN-DE)
- Produktion/Production: Erich Niederberger, TA-Media, Zürich
- Druck und Bildbearbeitung/Printing and lithography: DZZ Druckzentrum Zürich AG
- Erschienen bei/Published by: Spector Books, Harkortstraße 10, 04107 Leipzig, www.spectorbooks.com

Distribution: Germany, Austria: GVA, Gemeinsame Verlagsauslieferung Göttingen GmbH & Co. KG, www.gva-verlage.de/ Switzerland: AVA Verlagsauslieferung AG, www.ava.ch/France, Belgium: Interart Paris, www.interart.fr/ UK: Central Books Ltd., www.centralbooks.com/USA, Canada, Central and South America, Africa, Asia: ARTBOOK/D.A.P., www.artbook.com/South Korea: The Book Society, www.thebooksociety.org/Australia, New Zealand: Perimeter Distribution, www.perimeterdistribution.com/Other countries: Motto Distribution, www.mottodistribution.com

1. Auflage/First edition

Printed in Switzerland
ISBN 978-3-95905-130-9
Die Deutsche Bibliothek — CIP-Einheitsaufnahme
Ein Titelsatz für diese Publikation ist bei der
Deutschen Bibliothek erhältlich./
A CIP catalogue record for this publication is available
from the Deutsche Bibliothek.

- Autoren_innen Einführungen Projektseiten/Authors of introductory texts to project pages (S./pp. 124–335): Nico Anklam (N. A.), Jan Bockholt (J. B.), Annabelle von Griesewald (A. v. G.) und/and Cassandra Edlefsen Lasch (C. E. L.), Clara Napp (C. N.), Leonie Pfennig (L. P.), Andreas Prinzing (A. P.), Nicola Torke (N. T.), Sophia Trollmann (S. T.)
- Autor_innen Öffentliche Sammlung/Authors public collection (S./pp. 430–452): Alina Beckmann, Stefanie Bringezu, Judith Frey, Daniel Friedt, Konstanze Klecha, Eckhard Kluth, Marijke Lukowicz, Clara Napp, Georgios Paroglou, Ronja Primke, Stefanie Raupach, Anna Sophia Schultz, Anna-Lena Treese, Marianne Wagner
- Textredaktion Öffentliche Sammlung/Editing public collection (S./pp. 430–452): Martina Kigle
- Bildredaktion/Image editing: Urs Lehni, Clemens Piontek, Lex Trüb
- Bildstrecke (Projekte 2017)/Photo spread (projects 2017): Linus Bill, Maya Rochat, Henning Rogge
- Assistenz Bildstrecke (Projekte 2017)/Photo spread assistant (projects 2017): Lennart Lofink
- Fotodokumentation Projekte 2017/Photo documentation projects 2017: Hanna Neander, Henning Rogge

Bildnachweis/Photo credits

Bildnachweis/Photo credits

Informationen

Skulptur Projekte Münster 2017
10. Juni bis 1. Oktober 2017
www.skulptur-projekte.de
mail@skulptur-projekte.de
T +49 (0)251 590 750 0

Öffnungszeiten*
Montag bis Sonntag 10–20 Uhr
Freitag 10–22 Uhr
Eintritt frei
*Wenn nicht anders angegeben

Infos zu Touren und Workshops
T +49 (0)251 203 182 00
service@skulptur-projekte.de
Online-Buchung möglich unter:
www.skulptur-projekte.de

Fahrradverleih
Online-Buchung möglich unter:
www.skulptur-projekte-bybike.de

GRANDTOUR
Erleben Sie die Skulptur Projekte in 45 Minuten.
Die GRANDTOUR startet jeden Samstag
um 15 Uhr und jeden Sonntag um 12 und 15 Uhr.
Tickets sind bis 15 Minuten vor Tourbeginn
exklusiv am Pumpenhaus erhältlich.
www.grandtour-muenster.de

Skulptur Projekte App
Eine Navigations-App* zu den Werken der
Skulptur Projekte 2017
apps.skulptur-projekte.de

● münster:app*:
Fahrplanauskunft der Buslinien und Anzeige
von freien Parkplätzen in Parkhäusern.
● Informationen zu Bustickets:
www.stadtwerke-muenster.de/prepaid
● Informationen und Buchung der münstercard:
www.muenstercard.de/münstercard:app*

*Kostenlos für Android und iOS.

Information

Skulptur Projekte Münster 2017
10 June to 1 October 2017
www.skulptur-projekte.de
mail@skulptur-projekte.de
T +49 (0)251 590 750 0

Opening hours*
Monday to Sunday: 10 am to 8 pm
Friday 10 am to 10 pm
Free admission
*unless otherwise stated

Information about tours and workshops
+49 (0)251 203 182 00
service@skulptur-projekte.de
Online booking
www.skulptur-projekte.de

Bike rental
Online booking:
www.skulptur-projekte-bybike.de

GRANDTOUR
Experience Skulptur Projekte in 45 minutes.
The GRANDTOUR starts every Saturday at
3 pm and every Sunday at 12 noon and 3 pm.
Tickets are available exclusively at the
Pumpenhaus 15 minutes prior to the start
of the tour.
www.grandtour-muenster.de

Skulptur Projekte App
Navigation app* for the Skulptur Projekte 2017,
available in 13 languages
apps.skulptur-projekte.de

● münster:app*:
Public bus timetable and up-to-the-minute
info on available spots in multistorey car parks
● For information on bus tickets, go to:
stadtwerke-muenster.de/prepaid
● For information on münstercard and
purchase, go to:
www.muenstercard.de/münstercard:app*

*Free of charge for Android and iOS